"As a filmmaker, fan, and forever student of LGBTQ+ history, I couldn't be more thrilled about Leighton Brown and Matthew Riemer's *We Are Everywhere*, a topical, timely, and timeless resource. In the book's intersectional showcasing of the under-recognized and the unforgettable, the roots of our activism, anger, and community are more important and profound than ever. From the Mattachine Society to ACT UP, S.T.A.R. House to the Transgender Menace, queer history comes alive in the pages of this tremendous collection."

RHYS ERNST
filmmaker of *We've Been Around* and *Transparent*

"Drawing from their vast Instagram encyclopedia of essential queer ephemera, @lgbt_history, Matthew Riemer and Leighton Brown restore their digital trove to its original state, the object warmth of paper. Open this book to any page and there will be something you've never seen, something you've never heard of, or something to fill you with ideas."

AVRAM FINKELSTEIN
artist, writer, activist, and founding member of the Silence=Death and Gran Fury collectives

"Matthew Riemer and Leighton Brown's visually stunning account of the Queer Liberation Movement is populated by the fierce and brave dykes and fags, militants, sluts, pinkos, gender benders, and regular queer folk who have made history fighting for love, life, and liberation. Attuned to the victories, sorrows, conflicts, and complexities of queer movements, this book deflates historical amnesia and brings the obscure to light."

DEBORAH B. GOULD
associate professor of sociology at the University of California, Santa Cruz, and former member of ACT UP/Chicago and Queer to the Left

"These stunning photographs—many never before published—convey the fierce diversity, defiance, sorrow, and joy of queer life across the twentieth century. Along with the lively tour of the last century of LGBTQ politics in the accompanying text, they will change the way you see the queer past."

GEORGE CHAUNCEY
DeWitt Clinton professor of history at Columbia University and author of *Gay New York*

"A revelation of accessibility and inclusion; a love letter to the queer revolution our ancestors deserve."

GINA MAMONE
creative director of @QueerAppalachia

"Turning these pages and finding the faces of old friends—at the barricades, in the streets, confronting the powerful, calling for attention to be paid to stricken bodies—is an experience I will never forget. Now our historical journey has been fleshed out, showing the joy of collective action, the living texture of our determined struggle for our right to be, in the fullness of our differences. Beware liberations that create new exiles. Matthew Riemer and Leighton Brown have created a provoking text we need now more than ever, allowing each reader to evaluate the strategies of our past encounters with a bigoted State and with our own, sometimes limited, visions of what was needed. Whether you know little of queer history, or were a part of our tumultuous past, every page will hold you. Once again we are called to the streets, this time to take on Trump's America. *We Are Everywhere* is a handbook for action, cherishing those who risked so much, and is a living bridge between our communities of the past and present. This seventy-eight-year-old fem is so grateful to be able to turn its pages, in constant conversation with the images and interpretations. This is history that reaches into the now with a visual richness that makes memory a living body."

JOAN NESTLE
co-founder of the Lesbian Herstory Archives and author of *A Restricted Country* and *A Fragile Union*

WE ARE
EVERYWHERE

WE ARE EVERYWHERE

Protest, Power, and Pride in the History of Queer Liberation

PRESSION?

JOIN US

Matthew Riemer and Leighton Brown
creators of @lgbt_history

Ten Speed Press

California | New York

This book is dedicated to the liberated spirits of

Ancestors

Magnus Hirschfeld, Henry Gerber, and Manuel boyFrank

Founders

Edythe Eyde, Harry Hay, Jim Kepner, W. Dorr Legg, Del Martin, Mabel Hampton, Christine Jorgensen, Reed Erickson, Marty Robinson, Brenda Howard, and Craig Rodwell

Radicals

Barbara Gittings and Frank Kameny

Outlaws

James Baldwin, Jeanne Córdova, Audre Lorde, and Pat Parker

Warriors

Sylvia Rivera and Leslie Feinberg

People With AIDS

Ortez Alderson, Michael Callen, Bobbi Campbell, John Lorenzini, Ray Navarro, Bob Rafsky, and Lou Sullivan

Victims

Gaétan Dugas, Marsha P. Johnson, Hattie Mae Cohens, Brian Mock, Brandon Teena, and Chanelle Pickett

And to
all those whose stories are waiting to be told.

books don't say much about what I did but I was there & I kept on moving

Pat Parker,
Movement in Black

CONTENTS

Acknowledgments

Because of the nature of this project, our gratitude has no beginning and no end. It's impossible for us to adequately thank all those who've made possible @lgbt_history, *We Are Everywhere*, our lives as proud queer people, or the incredible history we strive to convey. Above all, we are infinitely grateful to the queer community, our multi-faceted, extraordinarily complicated, exceedingly frustrating, underappreciated, beautifully diverse, inspiring, loving, angry, butch, flaming, non-binary, resilient family that refuses to be ignored. This book is for and about you; we hope we make you proud.

Over the past few years, we've had the honor of getting to know and work with some of the countless photographers, historians, archivists, and activists who've spent their lives making, capturing, and protecting queer history, and we're proud to call many of them our friends and family. We owe special thanks to Lynn Harris Ballen, Daniel Nicoletta, Dona Ann McAdams and Brad Kessler, Robert Fisch, Kim Peterson, Eric Marcus and Barney Karpfinger, Gerard Ilaria and Steve Wilkinson, Lance Black, Mariette Pathy Allen, Rich Wandel, Allan Clear, Marc Geller, Rick Gerharter, Kay (Tobin) Lahusen, Randy Wicker, David Robinson, Doreena Wong and Jenny Pizer, Sara Burningham, Ken Lustbader, Jay Shockley, Amanda Davis, Levi Jackman and Jake Connolly, Mark Segal, Gerard Koskovich, Gwenn Craig, Lori Seid, Peter Staley, Avram Finkelstein, Sue Hyde, Urvashi Vaid, Carolina Kroon, Saul Bromberger and Sandra Hoover, Martin Boyce, Stephen Vider, Tyger Latham, Jesse Whiting, Elvert Barnes, David Prasad, Alan Light, Saskia Scheffer, Morgan Gwenwald, J. D. Doyle, Larry Criscione, Adam Werner, Pat Rocco, Jason Baumann, Ken Selnick, Will Brant, Bob Skiba, Caitlin McCarthy, Bob Civil, Tommi Avicolli Mecca, Joseph Hawkins, Patricia Delara, Kevin T. Jones, Nancy Toder, Andrew Gould, Loni Shibuyama, the family of Fred W. McDarrah, Janson Wu, Mara Keisling, Professor Max Kirkeberg, Gary O'Neil, Christina Moretta, Craig Simpson, Michael Key, and all those at Ten Speed Press, the USC/ONE National Gay & Lesbian Archives, the GLBT Historical Society in San Francisco, the LGBT Community Center National History Archive in New York City, Houston's Botts Collection of LGBT History, the Digital Transgender Archive, Chicago's Gerber/Hart Library and Archives, the Lambda Archives of San Diego, the John J. Wilcox, Jr. Archives at the William Way Center in Philadelphia, the Lesbian Herstory Archives, the History Project in Boston, the San Francisco History Center at the San Francisco Public Library, the Special Collections of the New York Public Library, the Schlesinger Library at Harvard University, the San José State University Special Collections & Archives, the *Washington Blade*, the *Bay Area Reporter*, and the Library of Congress.

We stand on the shoulders of those who've demanded our community look beyond dominant narratives in search *not* for the stories we want but instead for the history we have. We've been inspired particularly by the works of James Baldwin, Allan Bérubé, Judith Butler, George Chauncey, Douglas Crimp, John D'Emilio, Madeline D. Davis,

> History is made and preserved by and for particular classes of people. A camera in some hands can preserve an alternate history.
> —David Wojnarowicz, 1990

Lillian Faderman, Leslie Feinberg, Deborah Gould, Lani Ka'ahumanu, Jonathan Ned Katz, Elizabeth Lapovsky Kennedy, Audre Lorde, Kevin J. Mumford, Joan Nestle, James T. Sears, Susan Stryker, James F. Wilson, and David Wojnarowicz.

This book wouldn't exist if not for the intelligence and patience of its designer, Annie Marino, and editor, Kaitlin Ketchum. Our appreciation and respect for them know no bounds.

We thank our families: Linda Brown and John Gallagher; Dottie and Steve Hall; Neil Riemer; Emily, Owen, Maddy, and Aidan Cottone; Mary Alice, Ben, Scarlett, Ginger, Rosalie, and Maria Gunther-Riemer; Jon and Amy Brown; Lindsay Brown; Morganne Pollie; Graham Ball; Dave Tierney; Coco Curtis; and Peter Reichertz.

Matthew thanks Kathryn Respess, may she rest in power, and Laura Camp, two incredible history teachers who found joy in the details that others ignored.

Matthew also thanks Leighton for his ceaseless capacity to inspire, challenge, excite, and brighten. You are my home, my heart, and the source of all the best things I know.

We both give special thanks to our dog, Virgil, for bearing with us.

And we thank Dick Leitsch, whose death shortly before we finished this book reminded us why we started in the first place: "This is the gay community, not some heterosexual suburb where everyone has to be just like everyone else."

▲ Patch on an unidentified panel of the AIDS Memorial Quilt. Photographer unknown.

The strong sisters told the brothers
that there were two important things
to remember about the coming revolutions.
The first is that we will get our asses kicked.
The second is that we will win.

ANONYMOUS QUEERS, 1990
adapted from Larry Mitchell,
The Faggots & Their Friends
Between Revolutions, *1977*

▶ Harry Hay (right), cofounder of the radical
Mattachine Foundation, the organizational
precursor to the better-known—and distinctly
more conservative—Mattachine Society, and his
lover, John Burnside, Christopher Street West,
West Hollywood, June 27, 1982. Photographer
unknown. Courtesy of the ONE Archives at the
USC Libraries (CSW collection; 2012-135).

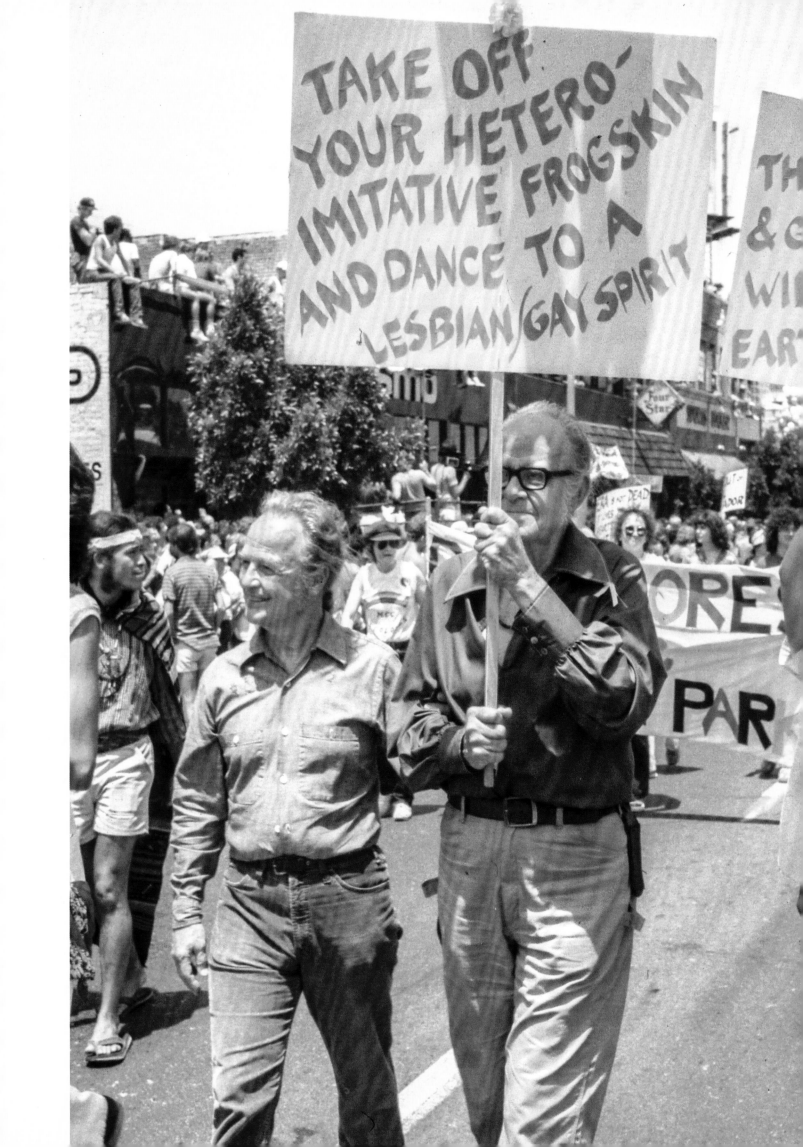

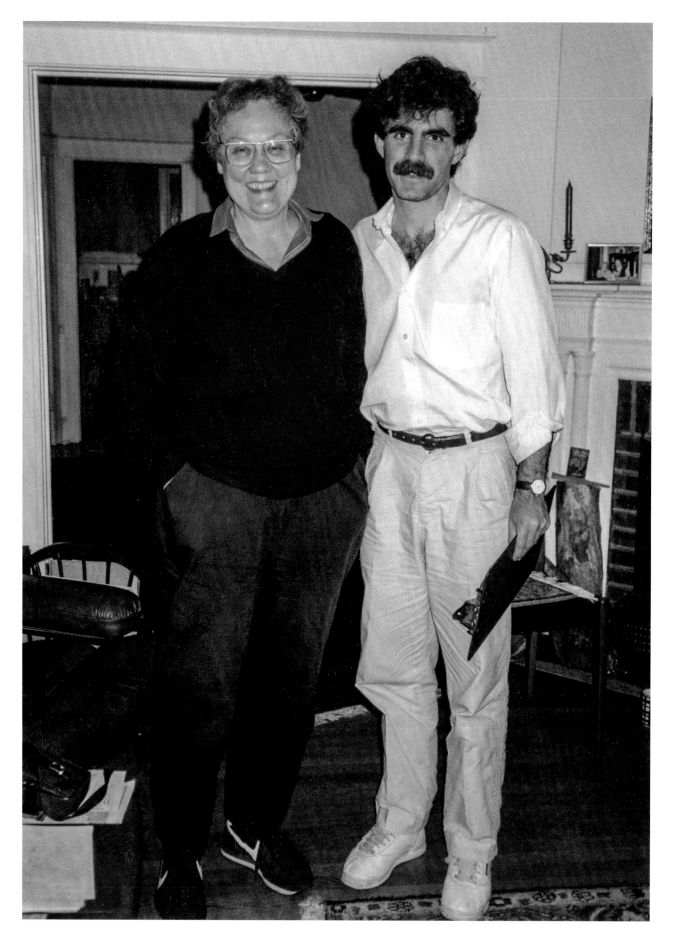

▲ Eric Marcus (right) with trailblazing lesbian activist
Barbara Gittings at the home she shared with Kay (Tobin)
Lahusen, West Philadelphia, May 17, 1989. Photo by Kay
(Tobin) Lahusen. Courtesy of Eric Marcus.

Foreword by Eric Marcus

Attention, time travelers! Your adventure across decades of queer history is about to begin. Your guides—Matthew Riemer and Leighton Brown—are two of the fiercest, most passionate citizen historians I know. They don't just uncover history. Like the best archaeologists, they excavate it, examine it, illuminate it, and bring it to vivid life.

I first got to know Matthew and Leighton from their highly addictive @lgbt_history Instagram account. Each image I clicked on came with a brief description or pint-size essay that told me something I hadn't known before—about a person, place, or event. Some of those images included photos they'd posted of a treasured pinback button saved for years or decades that proclaimed pride or outrage or expressed a wicked bit of transgressive humor. Together, these tiny black-and-white or full-color windows into history added up to a rich and proud and confounding and exciting story that wasn't part of the curriculum at Hillcrest High School in Jamaica, Queens, back in the 1970s when I was a student. And it still isn't today.

Matthew and Leighton's transporting book takes its inspiration from @lgbt_history. So don't expect a relentless march through time, like the kind that used to put you to sleep in seventh-grade social studies class. Matthew and Leighton aren't fans of the Interstate. They can't help but get off the highway when tempted by obscure or faded historical markers. And the reader—this reader—can't help but turn to the next page, examine the next photograph, and read what Matthew and Leighton want us to know, because their curiosity is infectious. And seductive. You'll want to go where they take you as they explore the bits of history that are all too easily missed when you're only looking straight ahead.

I urge you to take your time exploring the pages that follow, because the images that Matthew and Leighton share require us to look deeper. The buttons, the picket signs, the places, the diversity of the people, their makeup, clothes, the expressions on their faces, it all becomes so much more real when you know the story *and* see the companion images.

So I invite you to join me in joining them on a riveting journey back through time. Buckle up. No, I mean it. Buckle up. Matthew and Leighton are about to take you on a wild and inspiring ride that will widen your eyes, challenge your assumptions, and fill your heart. Ready? Now turn the page.

———————

Eric Marcus is the creator and host of the award-winning Making Gay History podcast and is the author of a landmark book on the history of the LGBTQ civil rights movement of the same name.

Seeing QUEER HISTORY

There's a sign hanging in the John J. Wilcox, Jr. Archives in Philadelphia—*YOU ARE GAY HISTORY*—that lets those who enter the space know they've come home. Queer archives—the Wilcox, the Lesbian Herstory Archives in Brooklyn, the Botts Collection of LGBT History in Houston, the ONE National Gay & Lesbian Archives at USC in L.A., San Francisco's GLBT Historical Society, Gerber/Hart Library and Archives in Chicago, and New York City's LGBT Community Center National History Archive, among others— are some of the few distinctly and specifically queer spaces left in the world. In these places, you're surrounded by miles of materials—books, banners, periodicals, papers, photographs, and ephemera—all of which point to a truth that members of the dominant culture take for granted: you've always been here, you always will be here, and you are everywhere.

In his seminal book *Gay New York*, Professor George Chauncey tells of when the Dean of the Harlem Renaissance, Dr. Alain LeRoy Locke, sent poet Countee Cullen a copy of Edward Carpenter's *Ioläus*, a 1917 anthology outlining the cultural tradition of romantic male friendship and love. Cullen reported back that he'd read the book in one sitting; the history, he said, made that which people called unnatural seem natural, even beautiful. "I loved myself in it," Cullen wrote. Today, in cities around the world, archivists and volunteers maintain spaces in which queer people can love themselves and all those who made their lives possible. These places need you, and you need these places.

On Veterans Day 2015, we—Matthew and Leighton—knew almost nothing about queer history, so it's tough to explain why we ended up at the unveiling of Frank Kameny's headstone. As a gay couple in D.C., we knew *of* Kameny, and, while the rest of the city paused to honor those who'd served in the military, we thought it fitting to pay tribute specifically to a queer vet. Gathered at Congressional Cemetery, the small crowd listened as speakers remembered Kameny, the curmudgeonly, brilliant gay rights leader, and we were introduced to a history of which we'd barely heard, details we'd never considered, and people whose names we didn't know, although they'd dedicated their lives to queer liberation. By the end, we felt overwhelmed, isolated, and angry; we didn't know *our* history.

That's how it started.

Matthew killed time reading old queer periodicals he found online, while Leighton scoured the Internet for queer photographers and photographs. Looking at the pictures together, we'd get lost for hours; we had a visceral, emotional reaction, as if we'd discovered a family album full of people to whom we were deeply connected—infinitely indebted—and about whom we knew next to nothing. While everyone says a picture is worth a thousand words, that assumes, as William Saroyan wrote, you can "look at the picture and say or think the thousand words." In the beginning, we didn't know what the images said; we didn't have the words. We didn't know that the queen with the stone-cold stare was Lee Brewster, who helped create Gay

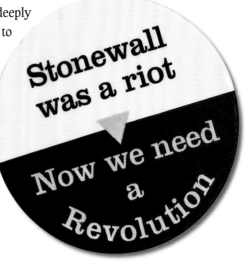

▶ Pinback marking the twenty-fifth anniversary of the Stonewall Riots, 1994. From the authors' collection.

Liberation in New York City only to be forgotten; we didn't know that the badass butch in L.A. was Jeanne Córdova, who seemed always to be on the right side of history; and we didn't know that the militant AIDS activist from Chicago was Ortez Alderson, whose militance was legendary long before AIDS. Only with time and research did the words and images align.[1]

What began as a hobby became an obsession: we *had* to figure out as many details about as many photographs as we could; that, in turn, led to @lgbt_history, the Instagram account we started in hopes of sharing what we were learning. We thought we might engage a few hundred people; within a few months, there were ten thousand followers; in just over a year, we'd hit one hundred thousand. As the account grew, we heard from the photographers responsible for, and the people appearing in, the images we posted, those who'd been at the events or who knew the names of the faces featured. We were corrected on details, challenged on choices of language and perspective, and pushed toward grassroots histories that delve into the deep divisions populating the queer past. We faced criticism from people who *knew* we'd missed something and demanded we do better. And we got emails, usually from isolated young people, telling us that the accessible introduction to history made them feel less alone.

With few exceptions, those following the account seemed willing to grapple with history, illustrating what James Baldwin said of Black America in 1962: "We are capable of bearing a great burden, once we discover that the burden is reality and arrive where reality is." The burdensome reality is that queer people in the United States have what Baldwin called "an invented past," a *story* but not a *history*. Our truth is not the popular tale of steady progress interrupted by momentary lapses of backlash, but rather a history of constant struggle interrupted by moments of triumph. Because the "Love Always Wins" narrative—the story of a people whose liberation is inevitable, thanks to a generally just society—is easier to market, however, we're constantly battling a type of "historical amnesia," as Audre Lorde wrote, that "keeps us working to invent the wheel every time we have to go to the store for bread."[2]

A fundamental part of the oppression queer people experience at the hands of the dominant culture is a denial of our history, an erasure of our unique existence in decades and centuries past. Although the majority is ultimately responsible for this oppression, "*we* must be responsible for our liberation," and we therefore have an obligation not only to each other but also to those who came before and those yet to arrive. "Each one of us is here because somebody before us did something to make it possible," Lorde taught. If more queer people had access to their history, and if those who *had* access took advantage of it, perhaps, as activist/photographer Morgan Gwenwald observed, "they would be more sensitive to the possibility that their event/idea/product might not be a 'first' and that some acknowledgment to those who have come before should be made."[3]

"We choose the history that we say is ours and by so doing," wrote Lesbian Herstory Archives cofounder Joan Nestle, "we write the character of our people in time." Our queer invented past—the character of *our* people—too often consists of stories of

strikingly American gays who wanted to be "like everybody else," presented by strikingly American gays who want to be "like everybody else." Names, places, events, and issues are picked from the infinite past as those most likely to further the finite aims of the present: we've *always* been in your military, let us serve openly; we've *always* had families, give us your blessing; we've *always* run your companies and your towns, let us do so free from sanctioned discrimination. Although this approach isn't in and of itself problematic, we mustn't "use history to stifle the new or institutionalize the old." Queer military members, queer parents, queer politicians, and queer businesspeople deserve the respect they've earned—which, in many cases, is infinite—but so do queer pacifists, queer sex workers, queer artists, and queer communists. Today, one need look no further than the White House or the local police station to know that the institutions into which lesbian, gay, bisexual, and transgender people continue to seek acceptance harbor deep reservoirs of hate, chauvinism, homophobia, and paranoia. Why, then, are we trying to be "like everybody else"? You can "never be *like them*," Sylvia Rivera said, and, by longing for normality, "you are forgetting your own individual identity." The very source of queer power, Nestle wrote, is that our "roots lie in the history of a people who were called freaks."[4]

We—the authors—didn't understand or embrace this power until we started to *see* queer history through photographs that provide, as Susan Sontag wrote, "the principal access to realities of which we have no direct experience." Photographs, Gay Liberation-era photographer Steven Dansky notes, "make visible what is concealed and become evidence of reality—a photograph is a powerful record of the social space." For queer people, being the subject of a photograph will *always* be "daring and risky," a "physical declaration of political and sexual identity" that may or may not fit into simple definitions and dominant narratives. "Our visibility is a sign of revolt," bisexual activist Lani Ka'ahumanu said in 1993. "We cannot be stopped. We are everywhere."

Ultimately, we think queer history is about the fight to be, and the celebration of being, *seen*. We don't choose to be queer, but we *do* choose to be visible in whatever way possible. With that in mind, this book is about and for all those who choose to incorporate queerness into their lives, whether you flaunt your faggotry or you're furiously dreaming of being free, whether you stand before the world ready to fight for queer liberation or you stand before the mirror fighting to recognize your endless beauty and worth. "To place an object or writing that contains what is invisible because of legislation or social taboo into an environment outside myself," artist David Wojnarowicz wrote, "makes me feel not so alone; it keeps me company by virtue of its existence." No matter what, we hope our work inspires others—through either joy or anger—to go further, dig deeper, and show us what we've missed. When in doubt, start at the archives; start in the spaces reserved for celebrating, preserving, and *seeing* queer history.[5]

YOU ARE GAY HISTORY, as the sign at the Wilcox says, but gay history is *not* all about you. It's about *all* of us, and none of us is free until all of us are free. It's time all of us—everywhere—see that.

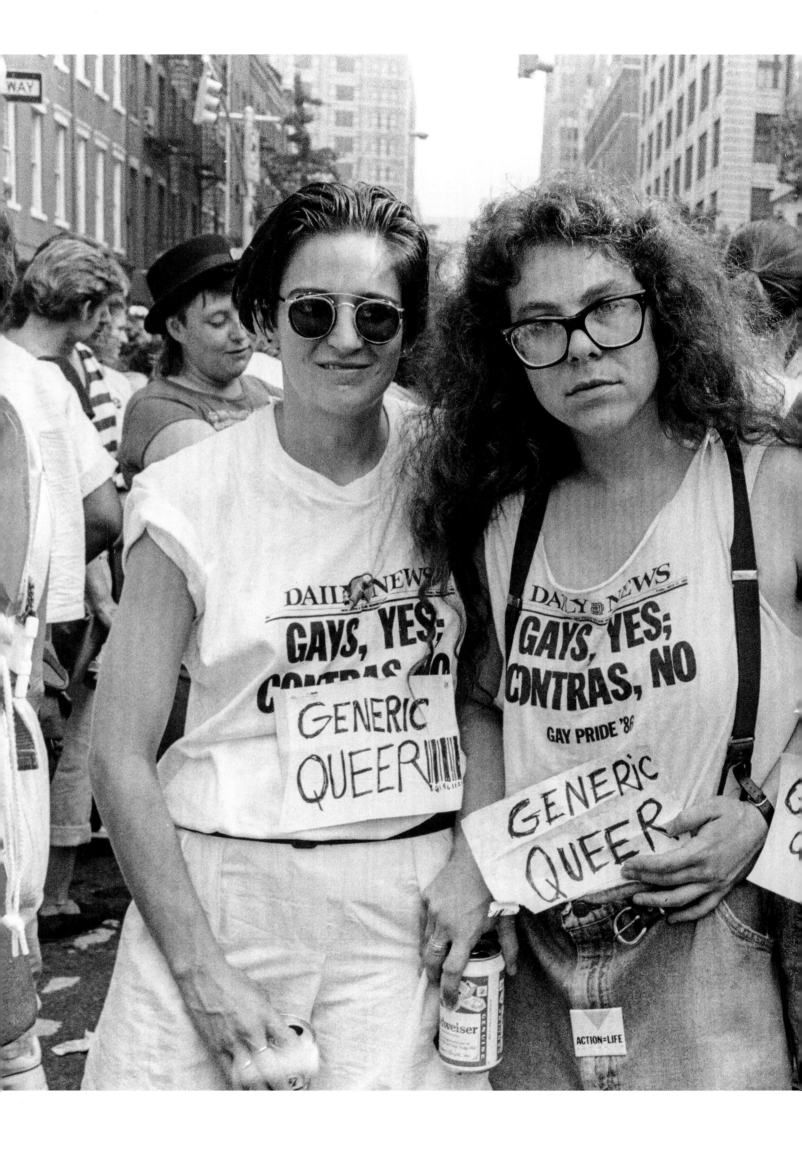

◄ Generic Queers, includ-
ing Lori Seid (second from
left), Heritage of Pride, New
York City, June 25, 1989.
Photo/copyright © by Dona
Ann McAdams.

How to Use This Book

"Whoever tells the history of a movement shapes it as well," Deborah Gould writes in *Moving Politics*, her essential study of how emotion drove AIDS activism. "There is an immense responsibility, then, in recounting the history of a movement that was made up of thousands of participants." This is particularly true where, as here, many of those participants are dead or otherwise unable to control the narrative of their legacies; after all, Gould notes, "we will never know the content, sound, and texture of their histories of the movement."

More than anything, *We Are Everywhere* represents our attempt to contribute to the telling of the expansive history of what we call the Queer Liberation Movement—a movement populated by countless individuals of every conceivable background, all of whom played some role in shaping the reality we experience today—in an accessible, respectful, engaging, and inclusive way. In order to achieve this, we've made editorial decisions that bear directly on how you'll experience the book; some of these decisions become evident as the book unfolds, while others are best covered before you dive in.

Fairy, Dyke, and Queer. Because self-identification is an essential aspect of being queer, we understand and respect that readers may take issue with, or have questions about, the language we employ to identify certain individuals, communities, or organizations. Throughout the text, you'll be confronted by words—*fairy*, *dyke*, *faggot*, *transsexual*, *transvestite*, and *sissy*, to name a few—that may cause discomfort. Unless otherwise noted, our choice of language represents our best attempt at balancing countless interests, including historical accuracy, accessibility, clarity, respecting individual identity, and the selfish interest of having our own voice cut through in certain places. For the sake of inclusivity and accuracy, we employ the word *queer* whenever possible to refer to "different kinds of people who come together in the same space or for a common cause." As Professor Susan Stryker explains, we use *queer* because we don't want to say "'gay, lesbian, bisexual, transgender, drag, and butch individuals, along with [others] who might well be heterosexual' every time [we] need to refer to the group collectively." Like Stryker, the idea we're "trying to get across is that many different kinds of people might in fact have something in common with one another in their opposition to an oppressive situation." Similarly, as Catherine Lord and Richard Meyer note in *Art & Queer Culture*, we write "in the knowledge that no single word can accommodate the sheer expanse of cultural practices that oppose normative heterosexuality. In its shifting connotation from everyday parlance to phobic epithet to defiant self-identification, 'queer' offers more generous rewards than any simple inventory of sexual practices or erotic object choices." But our use of *queer* isn't only a practical editorial decision, as we're very much aware of the word's political implications. As members of Queer Nation wrote in 1990, "using 'queer' is a way of reminding us how we are perceived by the rest of the world . . . a way of telling ourselves we don't have to be witty and charming people who keep our lives discreet and marginalized in the straight

world." At the same time, we recognize that the use of umbrella terms—*queer*, *gay*, *transgender*—can diminish the visibility of unique subcommunities; we've made every effort to avoid minimizing the identities and communities populating our history. Above all, we ask the reader to keep in mind the words of transgender warrior and queer activist icon Leslie Feinberg: "While the slogans lettered on the banners may change quickly, the struggle will rage on." The language we use in this book, as Feinberg wrote, is "not aimed at *defining* but at *defending* the diverse communities that are coalescing."[6]

Pronouns. At times, we use the singular *they* to refer to individuals who eschewed gender-specific pronouns. At all times, the pronouns employed reflect our best efforts at respecting the identity of a given individual.

American. For purposes of this book, we use *American* as an adjective limited in application to the United States; i.e., a word describing places, persons, communities, institutions, or ideas that are more aptly defined as *being of, from, in, among, or otherwise specifically connected to the United States*. We recognize and respect that many places, persons, communities, institutions, and ideas outside of the United States are American. Moreover, although we focus on the United States, every country has a beautiful queer history. Queer history, in other words, is *not* the same thing as queer U.S. history.

Sources. We relied heavily on primary sources while researching and writing *We Are Everywhere*. In addition to months spent in physical archives, we benefited immeasurably from having access to hundreds of thousands of pages of primary sources available online, thanks to the incredible digitization efforts of countless individuals, particularly those at the New York Public Library, the DC Public Library, the GLBT Historical Society in San Francisco, the ONE National Gay & Lesbian Archives, and the Lesbian Herstory Archives. Whenever possible, the details included herein are supported by multiple contemporaneous firsthand accounts, backed by secondary sources with which, at times, we take issue. Please make use of our endnotes, especially if there are questions or concerns about our work.

Quotations. Although we've made every effort to provide quotes as they originally appeared, we've also made basic editorial changes such as removing unnecessary sentence fragments and supplying words (e.g., *a*, *the*, *and*, and *but*) to clarify meaning. There are instances in which we've combined quotations from different interviews or articles by the same speaker or writer, which our endnote citations indicate. All such edits were made only for the sake of clarity.

Chronology. Time may move in a straight line, but history is queer. With that in mind, our narrative is not entirely chronological. Most notably, each chapter starts at the end of the period discussed in the rest of that chapter; "A Century of Subtle Attack," for example, covers 1867 to 1968, but the chapter starts in 1968.

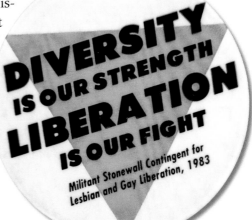

▶ Militant Stonewall Contingent for Lesbian and Gay Liberation pinback, Christopher Street Liberation Day, New York City, June 26, 1983. From the authors' collection.

Photographs. Respecting our history means respecting those who captured and maintain our history. The photographers featured in this book have earned our unyielding respect and gratitude. When you reproduce their work without giving them credit and compensation, you disrespect them, and you disrespect queer history. The same can be said of the historians, activists, and archivists on whom we rely. We've spent years working to identify the photographers responsible for, subjects appearing in, and copyright holders of the images included herein. To the extent such information is missing or inaccurate, we welcome any and all corrections and additions. There are some instances in which we chose not to publish the names of individuals featured in certain images, either because we've not had contact with that person or we've not otherwise been able to confirm their willingness to be identified. Generally speaking, no assumptions should be made about the sexuality, gender, gender identity, or self-identification of anyone. Ever.

Finally, we ask you to keep the words of historian James T. Sears in mind as you delve into the complicated stories that follow: "I am as indebted to my queer ancestors for their work as I am troubled by some of their choices, viewpoints, and alliances." Nobody in our history was perfect, but they all deserve respect.[7]

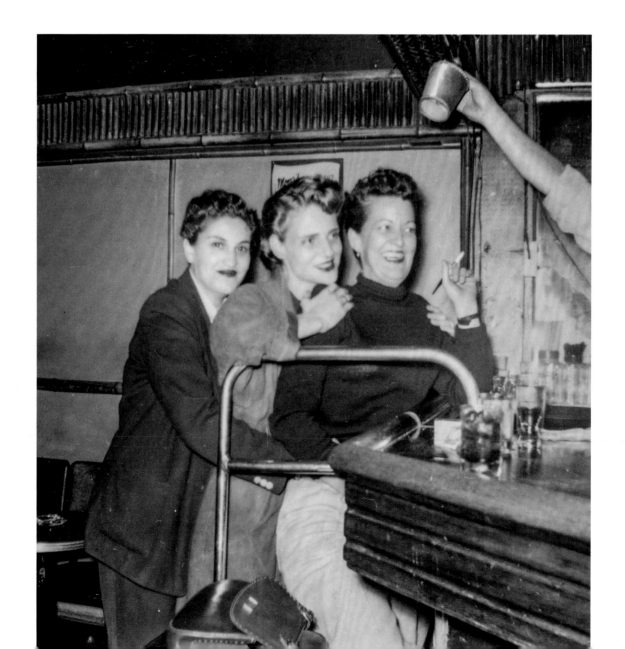

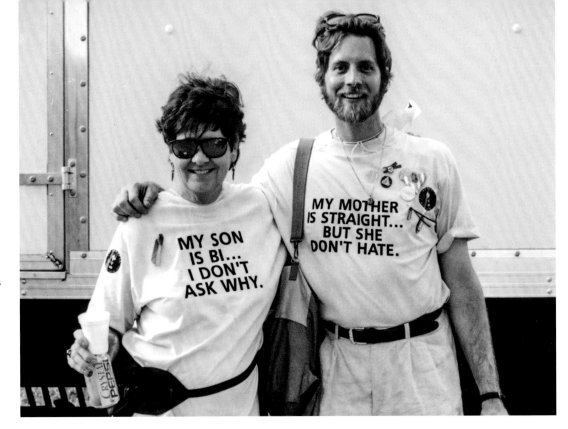

◀ **Opposite** Grace Miller (front) and friends at a bar (possibly Tommy's Place), San Francisco, c. 1953. Photographer unknown. Courtesy of San Francisco History Center, San Francisco Public Library (Grace Miller collection; GLC 69).

▶ **Right** Michael Szymansky (right) and his mother, National March on Washington for Lesbian, Gay, and Bi Equal Rights and Liberation, Washington, D.C., Apr. 25, 1993. Photo/copyright © by Lynn Harris Ballen. Courtesy of the ONE Archives at the USC Libraries (Córdova collection; 2008-064).

▼ **Below** From left to right: Mary McChrohan, Linda Sichel, and Crystal Jang, Peg's Place, San Francisco, Sept. 17, 1987. Photo/copyright © by Daniel Nicoletta.

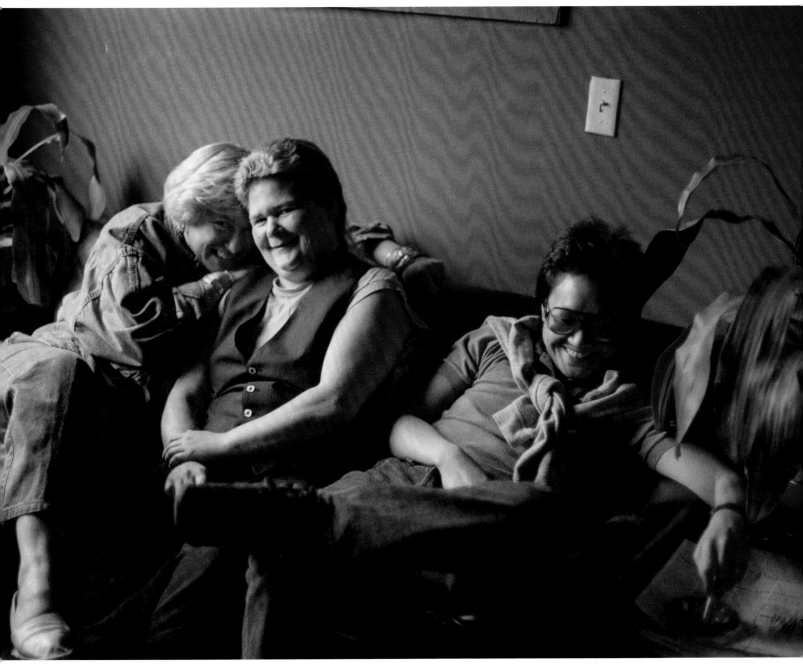

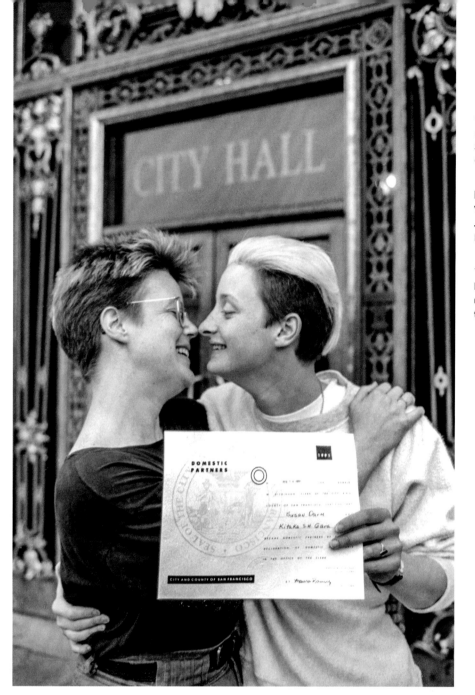

◀ **Left** Kitaka and D.P. celebrate municipal recognition of their domestic partnership, San Francisco, Feb. 14, 1991. Photo/copyright © by Marc Geller.

▶ **Opposite** Annie Sprinkle and Veronica Vera, Heritage of Pride, New York City, June 28, 1992. Photo/copyright © by Dona Ann McAdams.

▼ **Below** Christopher Street West, Los Angeles, June 28, 1970. Photographer unknown. Courtesy of the ONE Archives at the USC Libraries (CSW collection; 2012-135).

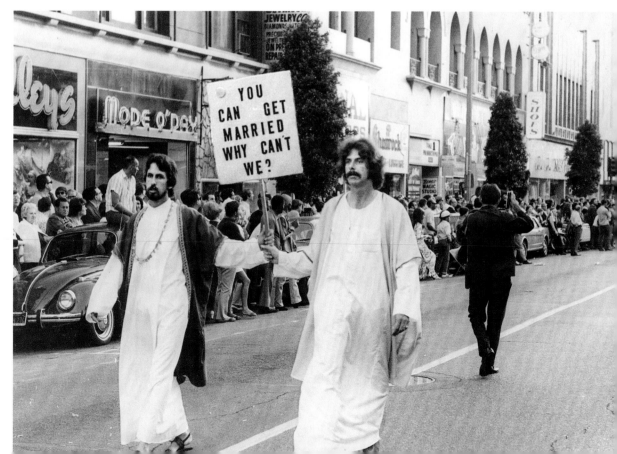

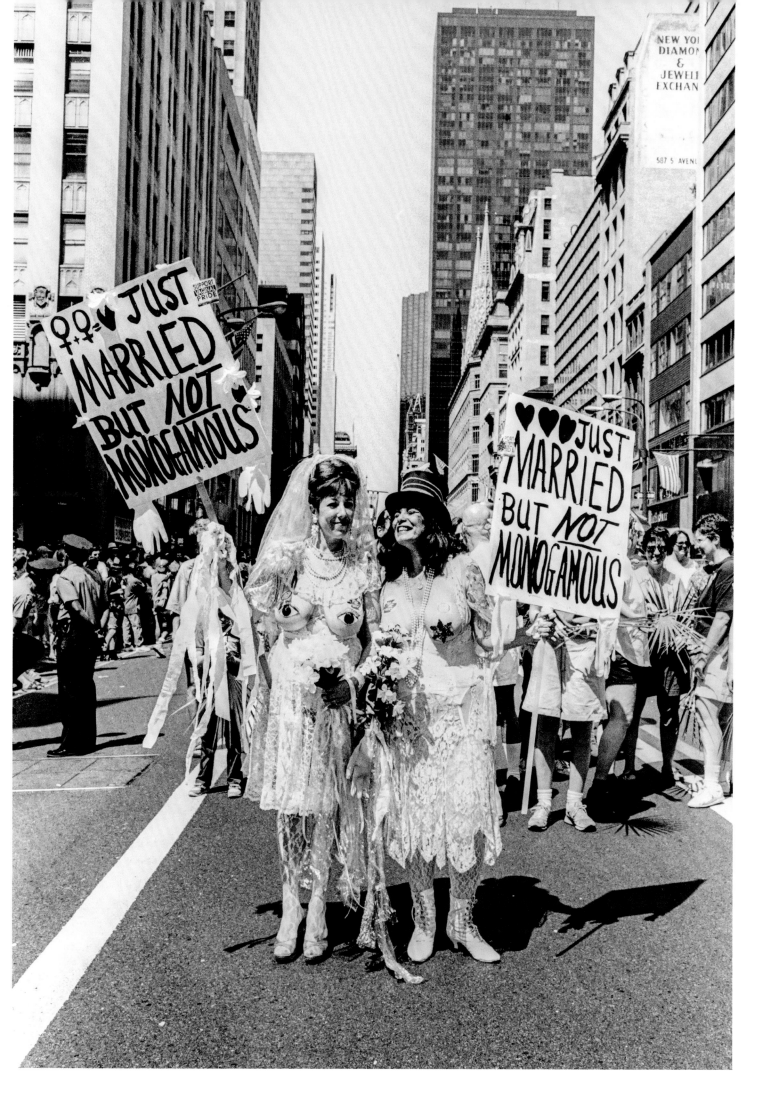

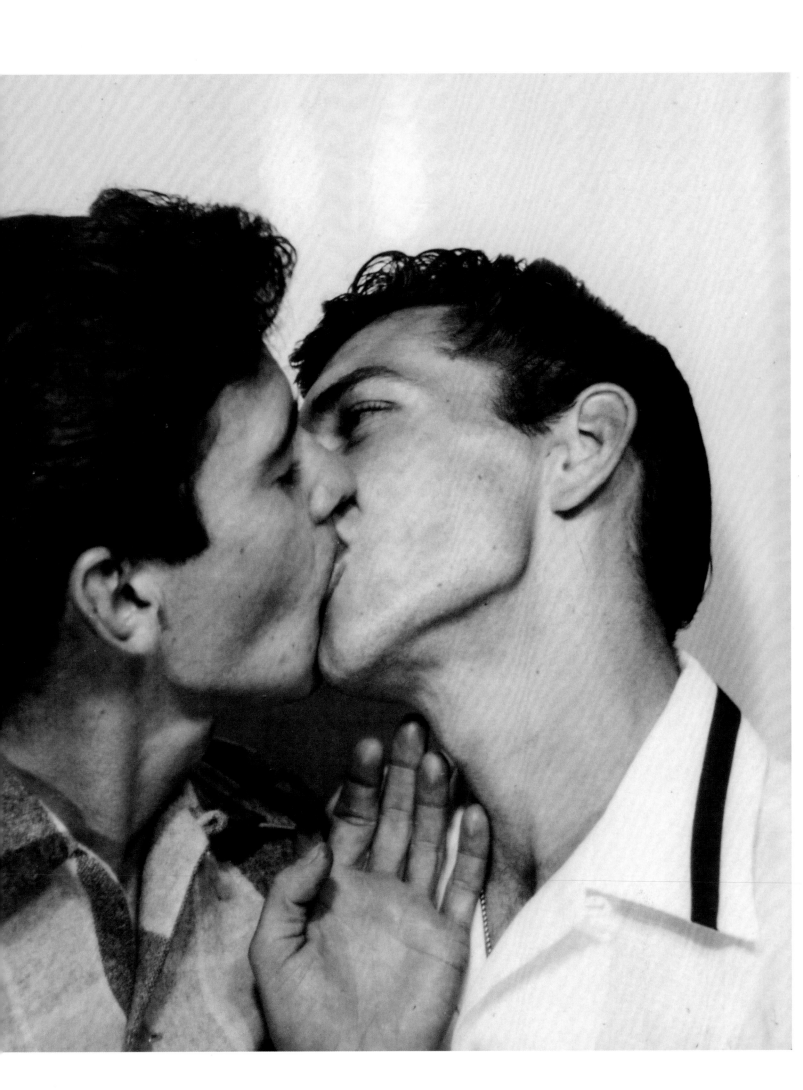

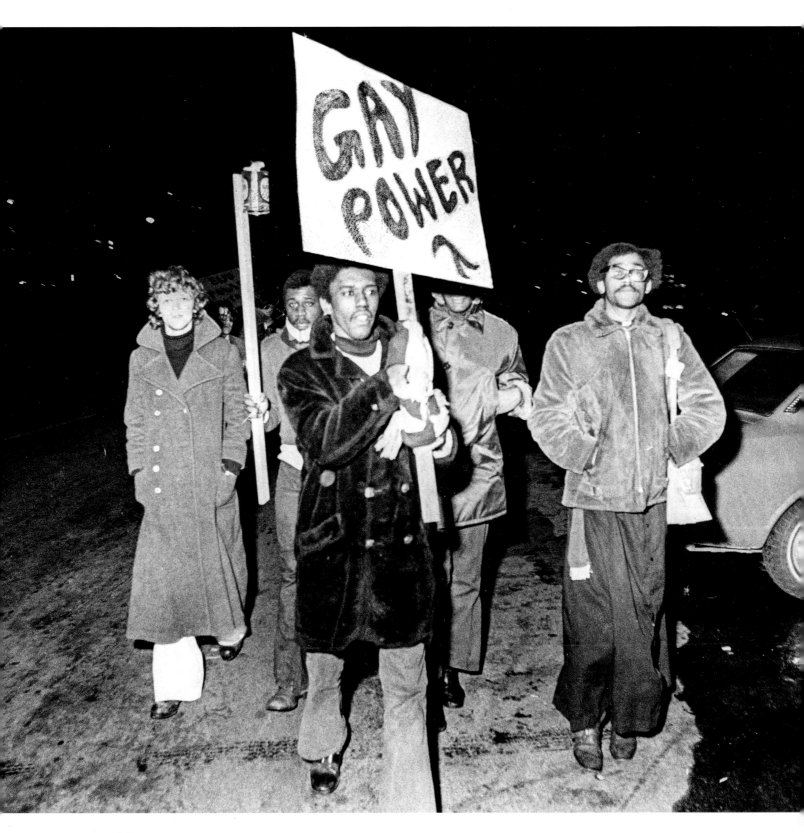

▲ **Above** Gay Activists Alliance-D.C. members, Arlington, Virginia, Jan. 5, 1972. Photo by John Bowden. Reprinted with permission of the DC Public Library, Star collection; copyright © by the *Washington Post*.

In early 1972, after police arrested more than sixty people for "obscene and indecent acts" in a wooded area near the Iwo Jima Memorial, Gay Liberation groups from around D.C. launched a series of demonstrations against police harassment.

◀ **Opposite** Robert Block (left) and J. J. Belanger (right), photo booth, Hastings Park, Vancouver, British Columbia, c. 1953. Courtesy of the ONE Archives at the USC Libraries (Belanger collection; 2011-035).

After serving in the Royal Canadian Air Force, J. J. Belanger was, among other things, an active member of the Mattachine Society in the mid-1950s. He ultimately devoted much of his life to studying and preserving queer culture and history.

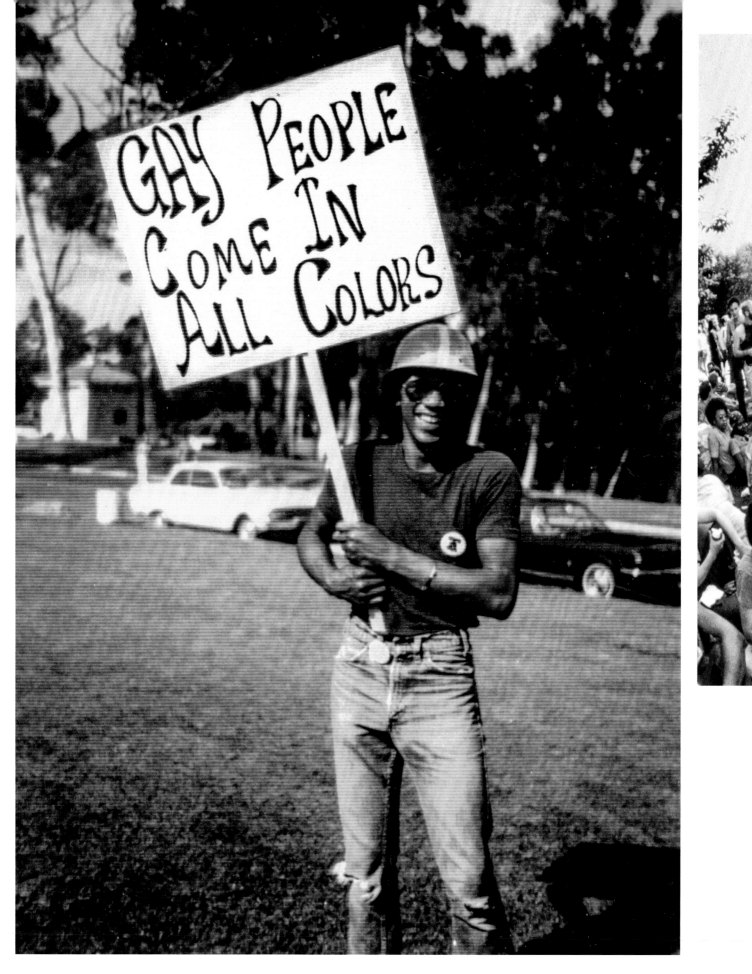

▲ Thomas Carey, longtime gay
activist, Gay Pride, San Diego, 1978.
Photographer unknown. Courtesy
of Lambda Archives of San Diego
(LASD Internal).

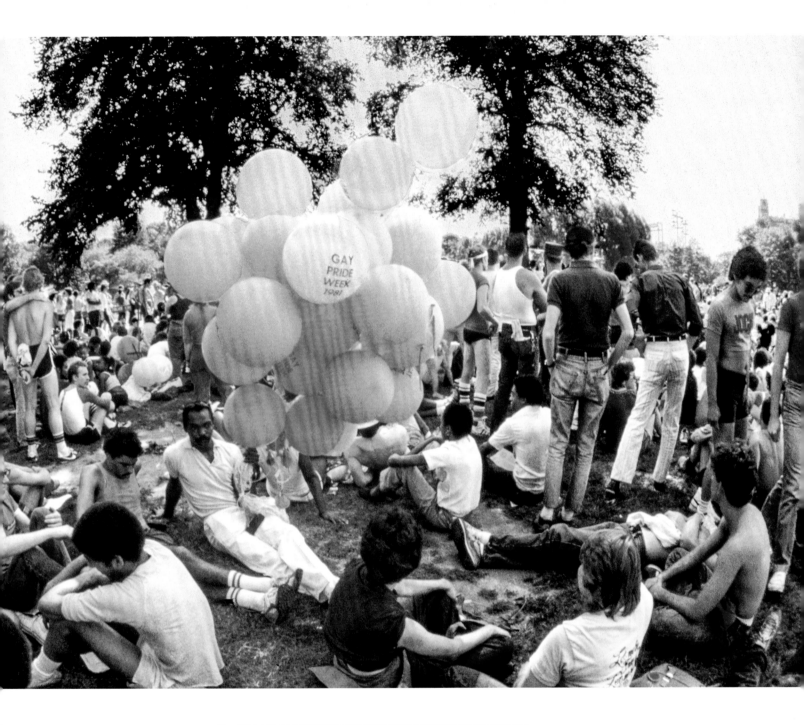

▲ **Above** Christopher Street Liberation Day, Central Park, New York City, June 28, 1981. Photographer unknown. From the authors' collection.

◀ **Left** Lesbians of Color contingent, Christopher Street West, West Hollywood, July 1, 1979. Photographer unknown. From the authors' collection.

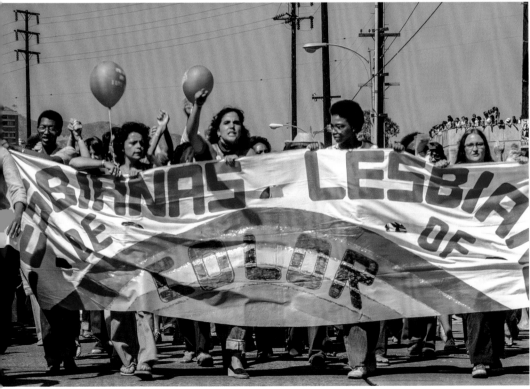

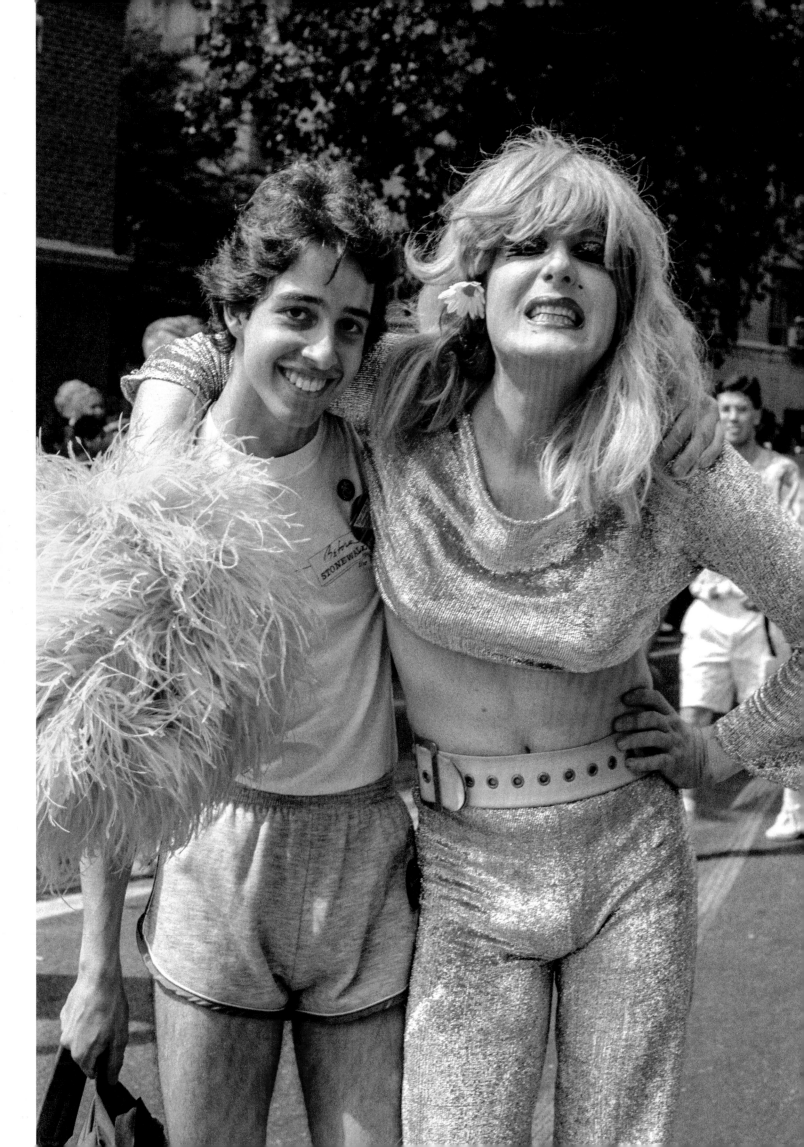

▲ **Above** Members of Chicago Gay Men's Chorus, including Coco Curtis (third from left), Chicago, Aug. 1987. Photo courtesy of and copyright © by Coco Curtis.

never in a million Queers will there be another You

◀ **Left** Pinback, c. 1990s. From the authors' collection.

◀ **Opposite** Robert Fisch (left) and a friend, Heritage of Pride, New York City, June 30, 1985. Photo courtesy of and copyright © by Robert Fisch.

▶ **Following Spread** AIDS Coalition To Unleash Power/New York (ACT UP/NY) protests an appearance by then-president George H. W. Bush, New York City, July 1990. Photo/copyright © by Dona Ann McAdams.

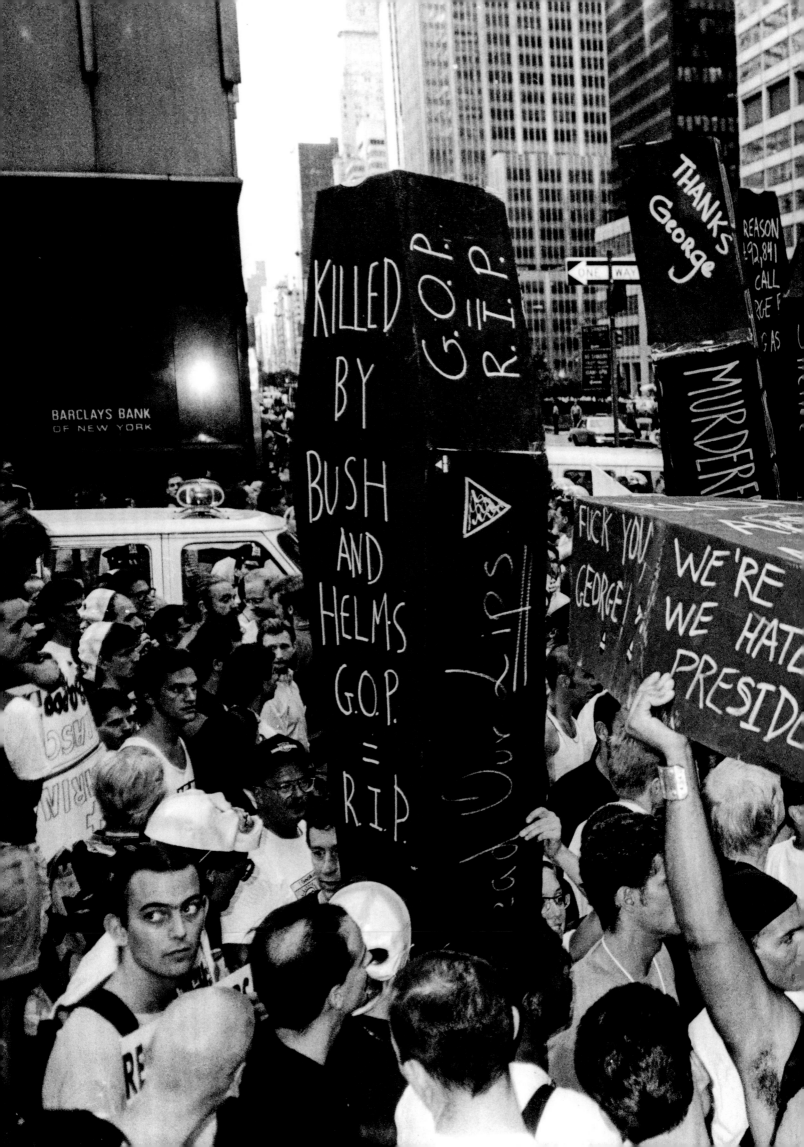

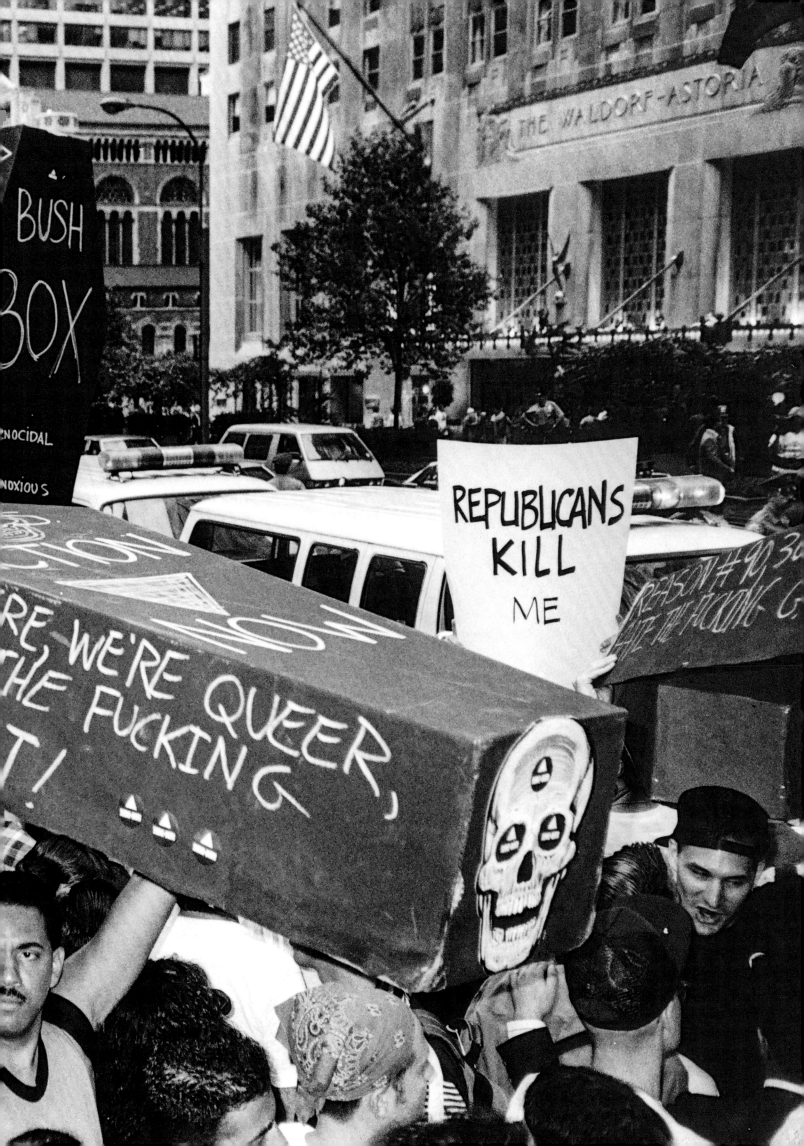

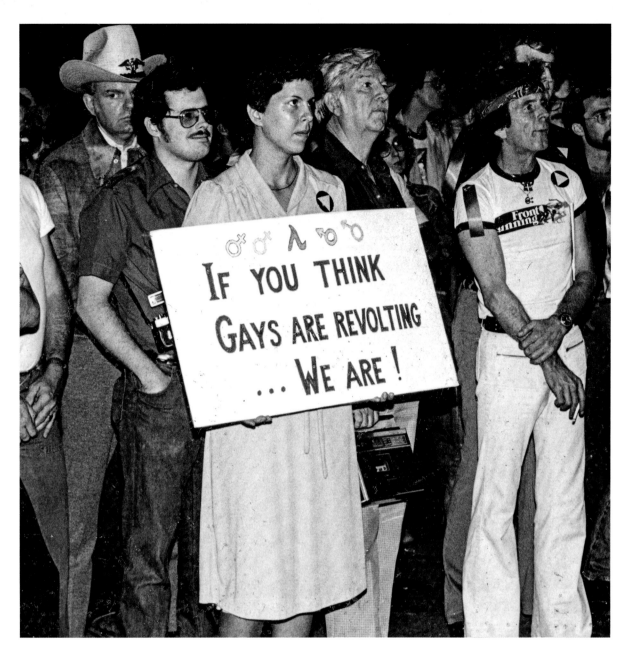

▲ **Above** Queer activists lead a citywide demonstration against ongoing police brutality, Houston, Apr. 1979. Photographer unknown. Courtesy of Botts Collection of LGBT History (Upfront collection).

▶ **Right** Christopher Street West, West Hollywood, June 27, 1982. Photographer unknown. Courtesy of the ONE Archives at the USC Libraries (CSW collection; 2012-135).

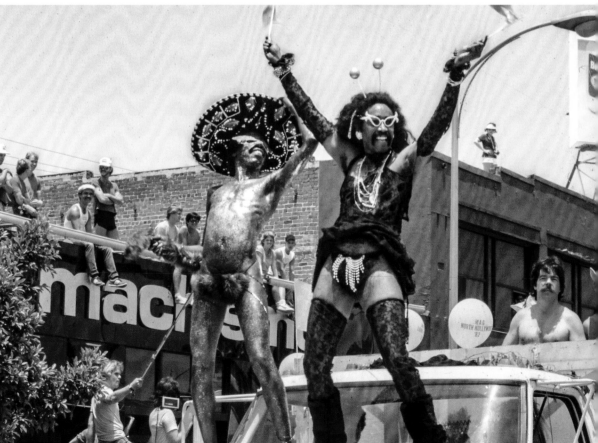

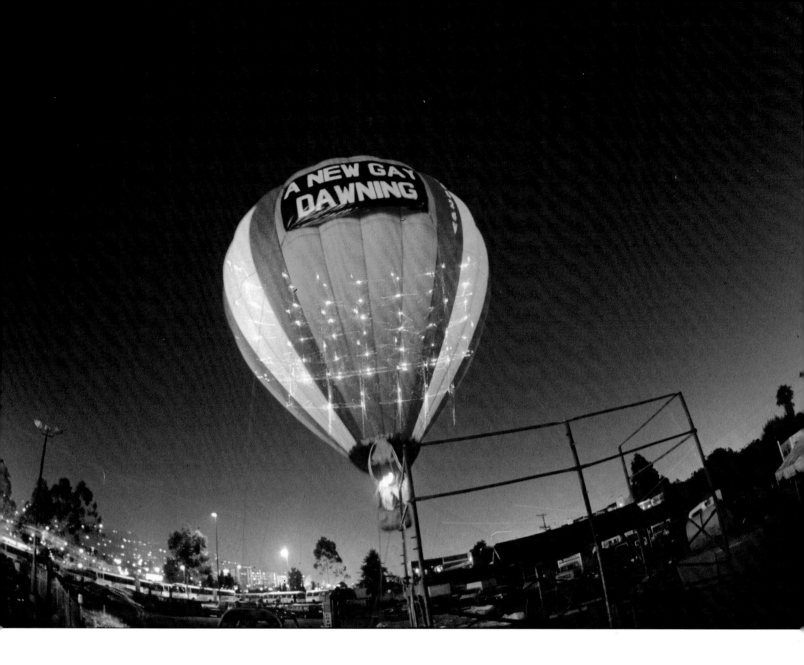

I DON'T MIND *STRAIGHT PEOPLE* AS LONG AS THEY *ACT GAY* IN PUBLIC

▲ **Above** Hot-air balloon, Christopher Street West, West Hollywood, June 27, 1982. Photographer unknown. Courtesy of the ONE Archives at the USC Libraries (CSW collection; 2012-135).

◀ **Left** Pinback, 2000s. From the authors' collection.

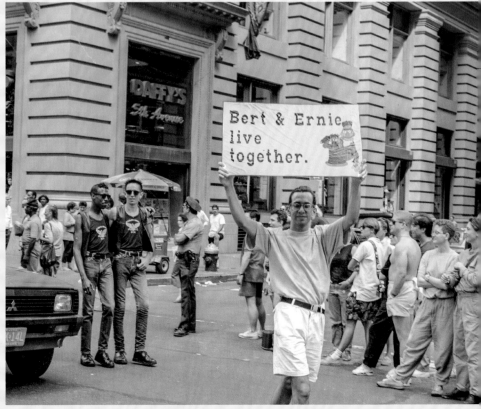

▲ **Above** National March on Washington for Lesbian, Gay, and Bi Equal Rights and Liberation, Washington, D.C., Apr. 25, 1993. Photo/copyright © by Lynn Harris Ballen. Courtesy of the ONE Archives at the USC Libraries (Córdova collection; 2008-064).

▶ **Right** Heritage of Pride, New York City, June 24, 1990. Photo/copyright © by Robert Fisch.

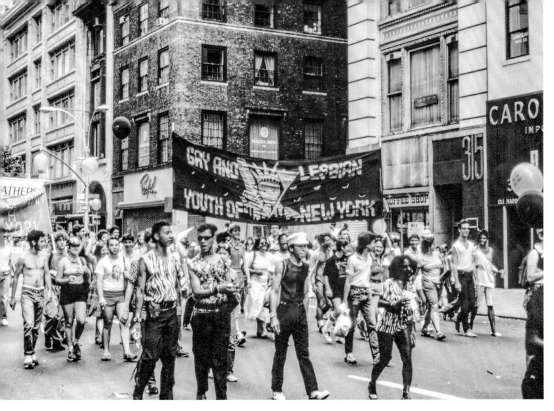

◀ **Left** Gay & Lesbian Youth of New York (GLYNY) contingent, Christopher Street Liberation Day, New York City, June 26, 1983. Photo by Steve Zabel. Courtesy of The LGBT Community Center National History Archive (Zabel collection; 10-3689).

◀ **Left** Gay & Lesbian Youth of New York (GLYNY) contingent, Christopher Street Liberation Day, New York City, June 26, 1983. Photo by Steve Zabel. Courtesy of The LGBT Community Center National History Archive (Zabel collection; 10-3689).

▼ **Below** Gay Youth member, Christopher Street Liberation Day, New York City, June 30, 1974. Photo by Richard C. Wandel. Courtesy of The LGBT Community Center National History Archive (Wandel collection; 4a-005).

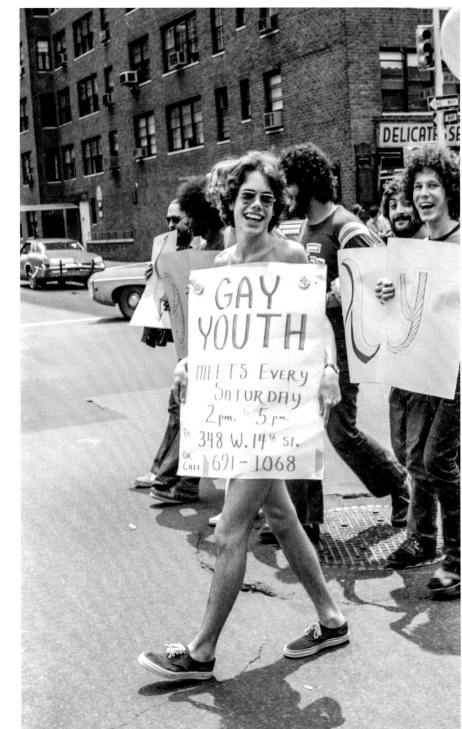

▶ Marsha P. Johnson (center) and a friend, Christopher Street Liberation Day, New York City, June 27, 1976. Photo/copyright © by Biscayne/Kim Peterson.

▲ **Above** Orange County Gay Pride Festival, Santa Ana, California, June 1991. Photo by Vaughn Taylor. Courtesy of the ONE Archives at the USC Libraries (Taylor [Vaughn] photographs; 2011-007).

▶ **Right** Senior Action in a Gay Environment (SAGE) contingent, Christopher Street Liberation Day, New York City, June 24, 1984. Photo by Steve Zabel. Courtesy of The LGBT Community Center National History Archive (Zabel collection; 28-2346).

▶ **Opposite** Christopher Street Liberation Day, New York City, June 24, 1979. Photo by Leonard Fink. Courtesy of The LGBT Community Center National History Archive (Fink collection; 26-105).

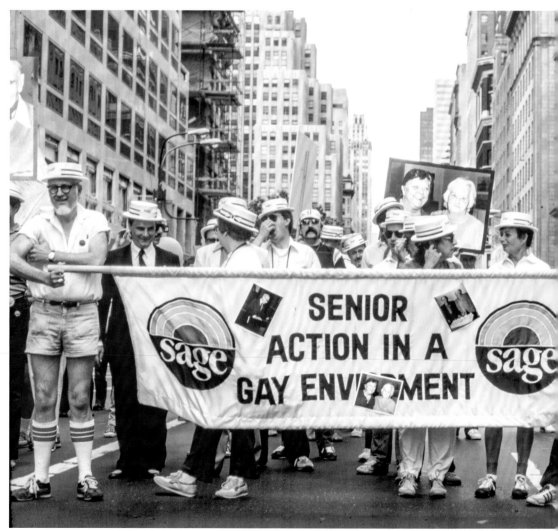

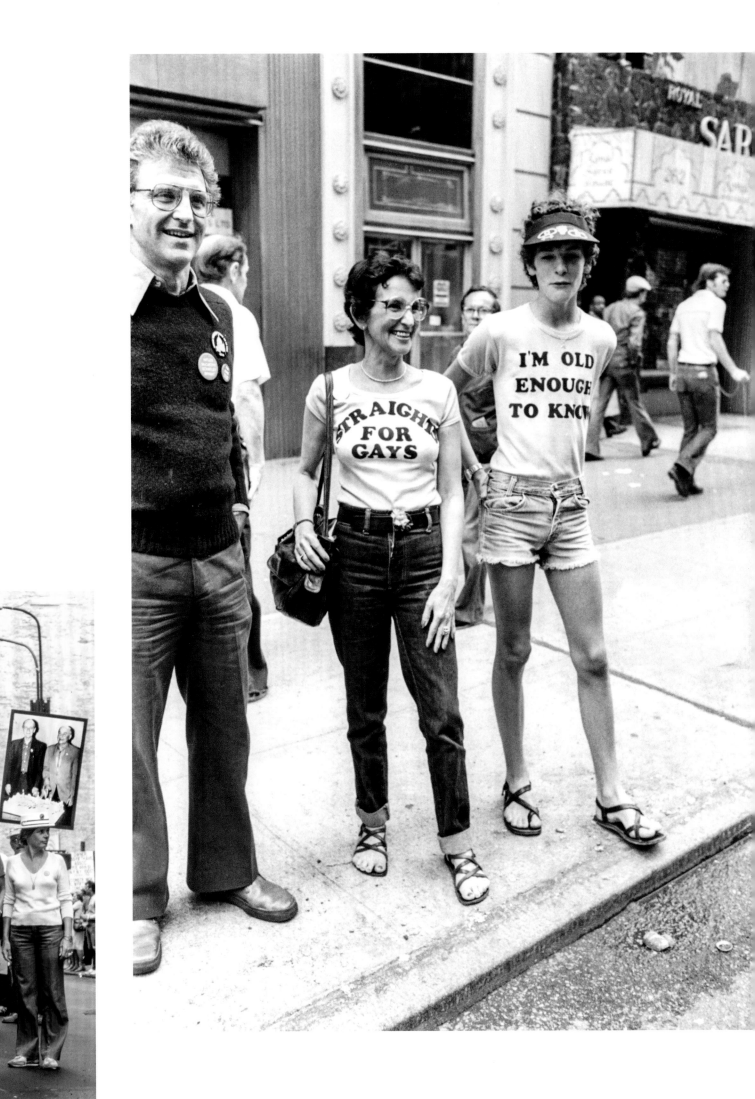

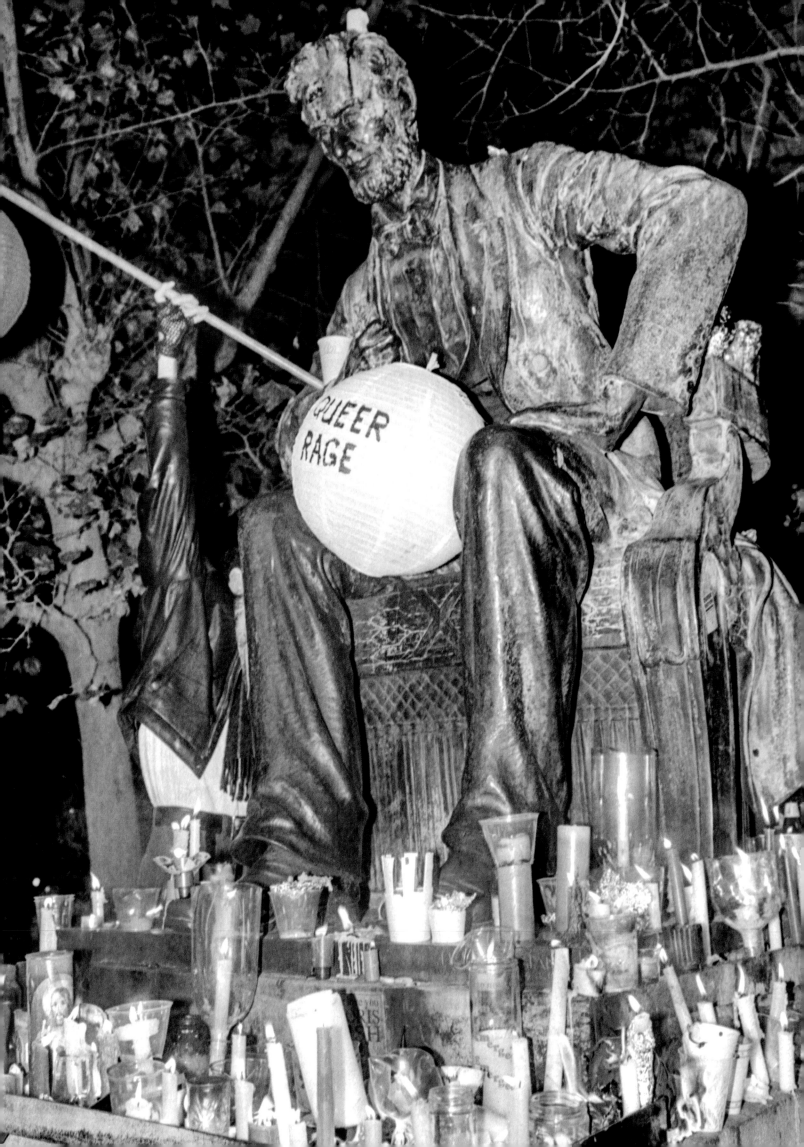

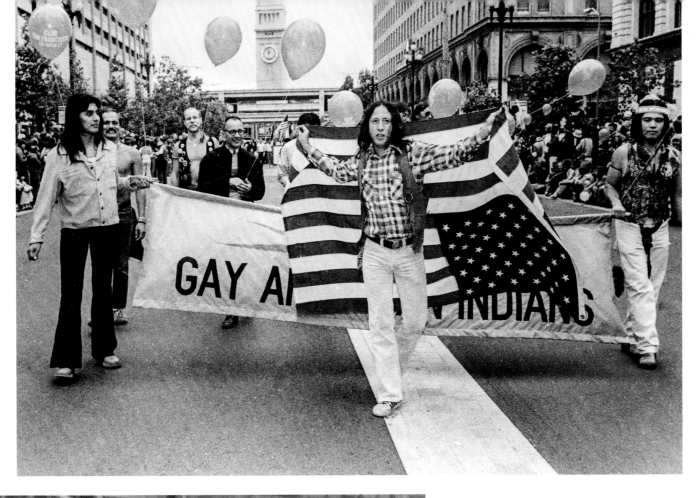

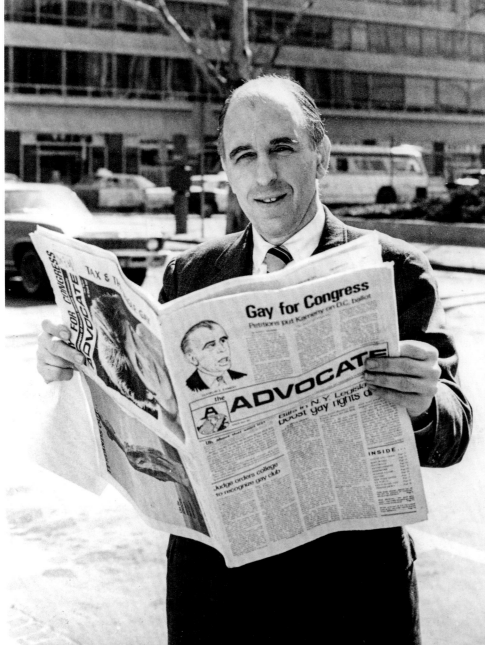

▲ **Above** Gay American Indians contingent, Gay Freedom Day, San Francisco, June 24, 1979. Photo by Ted Sahl. Courtesy of San José State University Special Collections & Archives.

◄ **Left** Frank Kameny reads about his congressional campaign in *The Advocate*, Washington, D.C., 1971. Photographer unknown. Courtesy of the ONE Archives at the USC Libraries (Advocate records; 2012-030).

◄ **Opposite** A sculpture of Abraham Lincoln in San Francisco's Civic Center is covered in candles and other remnants of the annual Candlelight March & Vigil celebrating the lives—and marking the anniversary of the assassinations—of Mayor George Moscone and City Supervisor Harvey Milk, San Francisco, Nov. 27, 1990. Photo/copyright © by Marc Geller.

▶ **Following Spread** Christopher Street Liberation Day, New York City, June 24, 1984. Photo by Steve Zabel. Courtesy of The LGBT Community Center National History Archive (Zabel collection; 28-2342).

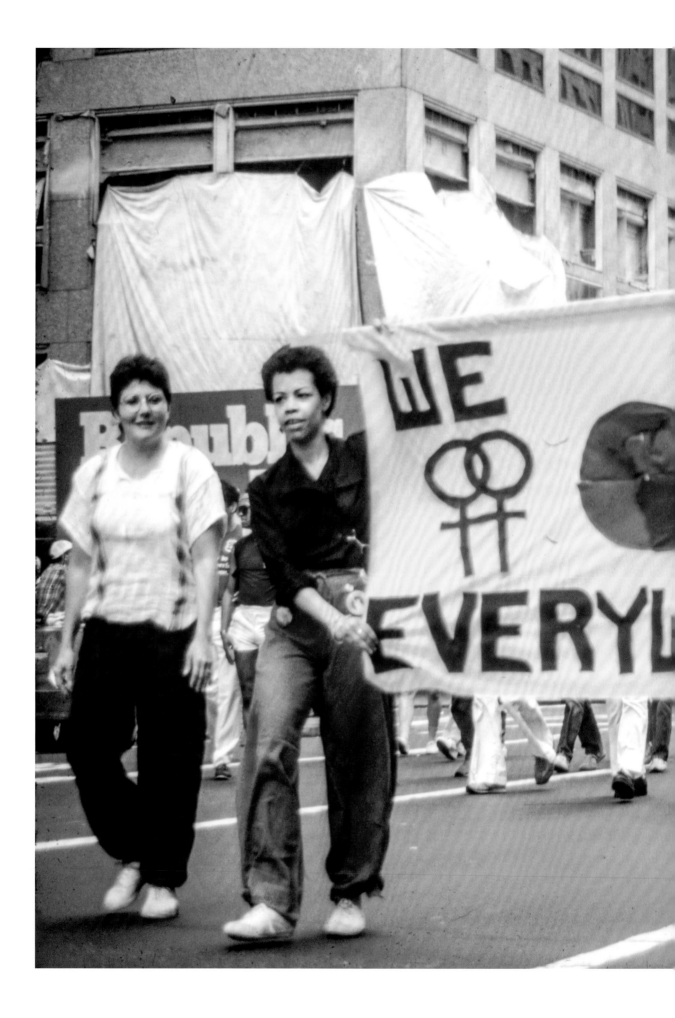

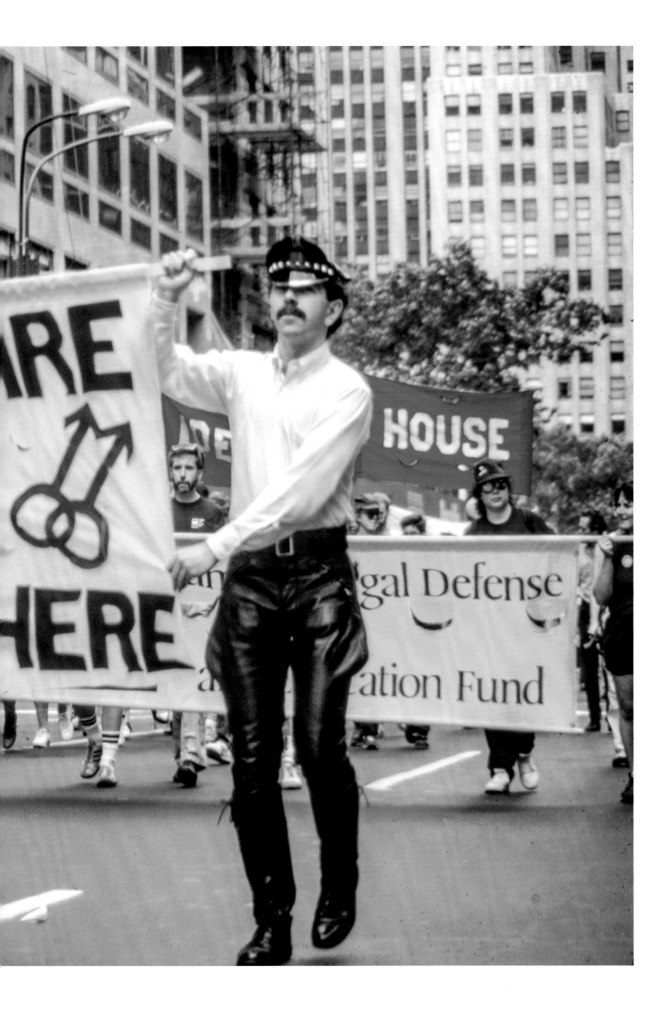

▲ **Above** PWA Health Group executive director Derek Hodel (left) and deputy director Steve Wilkinson (right), on the group's holiday card, c. 1988. Courtesy of Gerard Ilaria and Steve Wilkinson.

Founded by Michael Callen, Thomas Hannan, and Dr. Joseph Sonnabend, the PWA Health Group provided access to information, education, and promising experimental anti-HIV drugs not otherwise available in the United States.

▶ **Right** David Thackery (left) and Peter Reichertz (right), Gay and Lesbian Pride Day, Washington, D.C., c. 1982. Courtesy of Peter Reichertz.

▲ Elvert Barnes on Santa's lap, The Hub Store, Lexington Park, Maryland, Dec. 1972. Photo from the collection of Elvert Barnes. Licensed under a Creative Commons Attribution 2.0 Generic License, available at creativecommons.org/licenses/by/2.0/legalcode.

A Century Of

SUBTLE

ATTACK

1867–1968

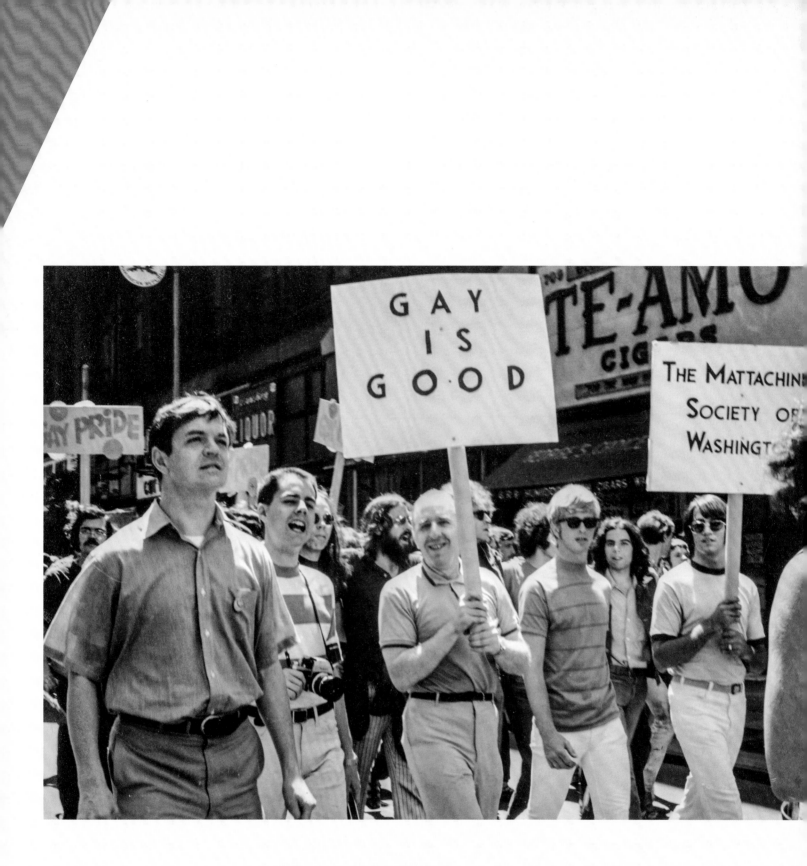

Where shall I begin?
For everything is connected with everything else . . .

—MANUEL boyFRANK, 1974

Chicago, 1968

As the mid-August meeting of the North American Conference of Homophile Organizations (NACHO) dragged into its sixth day, most of the attendees—about a hundred people from twenty-six homophile* groups—were restless. But not Frank Kameny, who deserved much of the credit for the historic gathering. Dismissed from the U.S. Army Map Service in 1957 because of his homosexuality, Kameny spent years building the Movement, including cofounding and serving as the first president of the Mattachine Society of Washington.

On August 17, 1968, the NACHO (rhymes with *Waco*) delegates were huddled at The Trip—a once-popular Chicago gay bar that had lost its liquor license after a police raid—to consider, among other things, a "Homosexual Bill of Rights" calling for an end to antisodomy laws, bar raids, discrimination, and harassment. Before 1968, a strong statement of ideology eluded the homophiles, and the "bill of rights" might have filled that void.

But Kameny, who believed it was necessary "to adopt a strongly positive approach, a militant one," had something better. Noting the power of the Black is Beautiful campaign, which served as both a liberationist rallying cry and a marketing tool in Black communities, Kameny wanted gays to proclaim that "homosexuality is GOOD—positively and without reservation," as opposed to the weak "homosexuality is a valid way of life for some people" argument. In Chicago, he moved that NACHO adopt "GAY IS GOOD" as a slogan; Barbara Gittings seconded and the motion passed overwhelmingly.[1]

At the time, though, very few people thought gay was good. In fact, according to religion, law, and science, "homosexual acts" (including gender nonconformance) meant "moral weakness, criminality, or pathology." Unsurprisingly, many homophiles felt it their responsibility to *do* and *be* better in order to change society's attitudes.

In 1965, for example, a debate over whether queer people should picket on their own behalf caused Del Shearer, the leader of Chicago's chapter of the Daughters of Bilitis, to resign. To Shearer, it was "ridiculous if not utter insanity" to picket without more support from straights. "The homosexual is not the Negro," she declared, frustrated by comparisons between the struggles for liberation. According to Shearer, pickets for Black liberation resonated only because decades of chipping away at institutionalized racism meant "a large and significant population was already very much aware of the cause." The types of subtle attacks launched over the years by countless Black individuals and organizations, those that had won recognition and praise from the dominant culture—literature, art, Christian ethics, a slow march toward legislative parity—were "all but missing" from queer history.

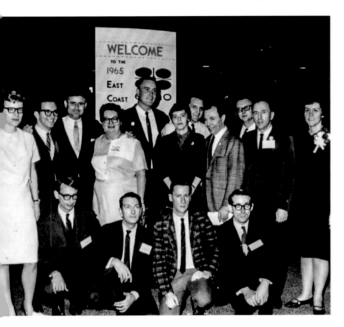

▲ **Above** East Coast Homophile Organizations (ECHO) conference attendees, 1965. Standing, from far left: Marjorie McCann, Clark Polak, Evander Smith, Shirley Willer, Jack Nichols, Carole LeHane (a.k.a. Carol Randall), William Beardemphl, Robert Sloane Basker, Neale Secor, Frank Kameny, Joan Fleischmann (a.k.a. Joan Fraser). Kneeling, from left to right: Julian Hodges, Dick Leitsch, Terry Grand, and John Marshall. Photographer unknown. From the Manuscripts and Archives Division, The New York Public Library.

◀ **Page 49** Frank Kameny (center) and members of the Mattachine Society of Washington participate in the first Christopher Street Liberation Day, New York City, June 28, 1970. Photo by Kay (Tobin) Lahusen. Courtesy of Manuscripts and Archives Division, The New York Public Library.

* The term *homophile* served a number of purposes for early queer activists. For the founders of the Mattachine Foundation, *homophile* was an alternative to *homosexual*, which had "clinical and pathological" connotations. In the mid-1960s, activists adopted the following definition of *homophile*: "adj., pertaining to the social movement devoted to the improvement of the status of the homosexual, and to groups, activities, and literature associated with the movement; as, homophile organizations, homophile conferences, homophile publications." Based on this definition, and in order to be more welcoming *and* more welcomed, activists made clear that those involved in the homophile movement were not necessarily homosexuals.

"You will find a history of suffering behind both causes," Shearer said. "You will not find a century of subtle attack in the history of both."[2]

In fact, the subtle attacks in the battle for queer liberation had started 101 years earlier, in August 1867, when writer Karl Heinrich Ulrichs, arguably the first queer activist, spoke out against a proposed German law criminalizing male sodomy. To Ulrichs, men with sexual urges for other men—*Urnings*—were no more responsible for their desires, and thus no more criminal, than men who desired women. The explanation was obvious: "The *Urning* is not a true man. He is a mixture of man and woman." Although the law was enacted and remained in place until 1994, Ulrichs, an *Urning* himself, forever redefined sexuality by introducing the concept of *the* homosexual.*

At the turn of the twentieth century, German sexologist Magnus Hirschfeld articulated the "third sex" theory, casting the homosexual as a discrete third gender with the body of one sex and the soul of another. Later, in 1910, Hirschfeld descibed a more nuanced view, *sexual intermediacy*, endorsing "an infinite range of orientations," including those which today we identify as bisexual and transgender.

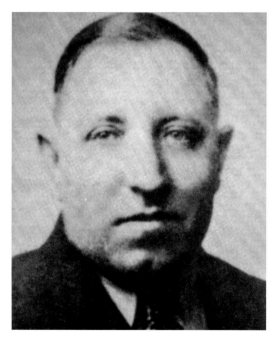

▼ Henry Gerber, founder of Chicago's Society for Human Rights, the first-known homophile organization to be legally incorporated in the United States, c. 1940. Photographer unknown.

Progress in pursuit of queer liberation always ebbed and flowed. Early advances in Great Britain, for example, stalled when Oscar Wilde, the country's most visible homosexual, was arrested, tried, and imprisoned for sodomy in 1895. "A sheer panic prevailed over *all* questions of sex," Edward Carpenter wrote, "and especially of course questions about the Intermediate Sex."[3]

Until the mid-twentieth century, most people in the United States couldn't imagine "*a* homosexual"; there were homosexual *acts*, not homosexual *people*. In 1911, for example, the Chicago Vice Commission detailed a "great increase of sex perversion," including "whole groups and colonies of men who are sex perverts." A few years later, Henry Gerber, a Bavarian-born postal clerk, settled into Chicago's lodging-house life, though he returned to Europe after World War I as a printer and proofreader with the Army of Occupation. Stationed near Berlin from 1920 to 1923, Gerber read homophile magazines and traveled to the capital city, where Magnus Hirschfeld's work had a profound impact on him. Having experienced the German homosexual emancipation movement, Gerber grew frustrated upon his return to Chicago in 1924. No longer able to keep quiet about the persecution of "those who deviated from the established norms in sexual matters," Gerber decided to organize.

On December 10, 1924, Gerber legally incorporated the Society for Human Rights (SHR) on behalf of those "who by reasons of mental and physical abnormalities are

* While Ulrichs is credited with conceptualizing same-sex attraction as an identifying characteristic, the word *homosexual* first appeared in the writings of Karl-Maria Kertbeny in the late 1860s. We note that until the mid-twentieth century, *homosexual* generally encompassed identities across the queer spectrum. Thus, today, many of the early *homosexual* activists would likely identify as bisexual, transgender, or queer.

abused and hindered in the legal pursuit of happiness." SHR's officers were John Graves, a Black preacher; Al Meininger, "an indigent laundry queen"; and Ralph, "whose job was in jeopardy when his nature became known." Gerber sought other members, producing two issues of a newsletter, *Friendship and Freedom*, but he found no additional support. In July 1925, shortly after publication of the newsletter's second issue, SHR's members were exposed, arrested, and ruined when Meininger's wife discovered the group. Gerber avoided jail, thanks only to lawyers who "fixed" the trials, but he lost his job, his savings, and the Society. With nothing left in Chicago, he traveled to New York City.[4]

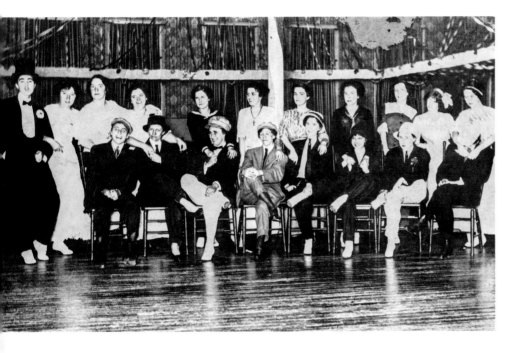

▲ **Above** Friends at a dance, c. 1912. Photographer unknown. From the authors' collection.

▶ **Right** Mugshot of man arrested for "infamous crime vs. nature" (i.e., sodomy) and sentenced to six years in San Quentin State Prison, Dec. 1914. Photo from San Francisco Police Department. Courtesy of the ONE Archives at the USC Libraries (Mugshot collection).

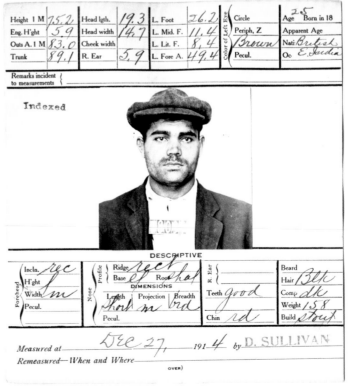

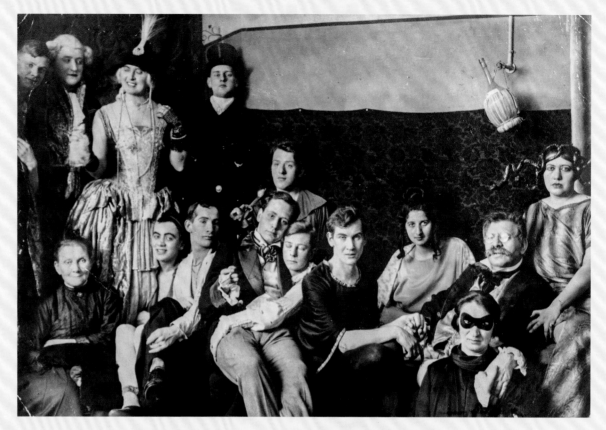

▶ **Right** Dr. Magnus Hirschfeld (second from right; with moustache and glasses) and his partner, Karl Giese (holding Hirschfeld's hand), attend a party at Hirschfeld's Institute for Sexual Science, Berlin, Germany, c. 1920. Photographer unknown.

▼ **Below** Transvestites (the identifier used in the original notes to the photograph) in front of the Institute for Sexual Science during the First International Congress for Sex Reform on the Basis of Sexology, Berlin, Germany, 1921. Photo by Willy Römer. Copyright © by bpk/Art Resource.

At the turn of the twentieth century, as access to commercial goods expanded, the economic necessity of the household diminished, and migration boomed, life in the United States moved to the cities. For the first time, women and people of color moved relatively freely, and the country's population exploded as immigrants fueled economies and infused urban centers with distinct cultures.[5]

Within this milieu, queer people found each other. Chicago's "perverts" had their own vocabulary; California's "social vagrants" had private clubs; New York's "fairies" would "call each other sisters and take people out for immoral purposes"; New Orleans' lesbians were "virtuous—so far as repelling the advances of men"; and Salt Lake City's "bohemian literary club" was predominantly homosexual.

Despite our popular impression of "pre-Stonewall" queer life—a world of lonely, isolated, self-loathing individuals whose collective lot only improved with the passing of time—many queer people had fulfilling lives *as* queer people in the early twentieth century; though they had to be cautious, they nonetheless built "spheres of relative cultural autonomy," as Professor George Chauncey describes. Prior to 1950, for example, queer people didn't speak of coming out *from* a restrictive, isolated closet; instead, they came out *into* an expansive gay world. The early history of queer liberation extends beyond the formal organizational efforts of activists like Henry Gerber and necessarily includes more informal "strategies [used] to claim space in the midst of a hostile society."[6]

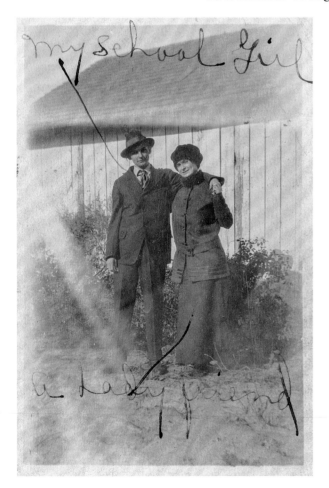

Not surprisingly, as American life tilted toward urban centers and away from traditional families, conservatives fought back. Scores of private antivice organizations emerged, using strict surveillance methods to enforce laws and norms. But the queer community has always been shaped, in part, by moralists' tools of oppression. For example, fearing that the close quarters of lodging houses encouraged immoral sexual contact between males and females, the Young Men's Christian Association (YMCA) created massive single-sex dormitories that, in turn, served as centers of gay life for decades.

Concern over the increasing "urban decay" also led to ratification in 1919 of the Eighteenth Amendment, which prohibited the manufacture or sale of liquor from 1920 until its repeal in 1933. As a result, for nearly fourteen years, no matter who you were, drinking liquor in the United States made you a criminal, and the speakeasy clubs that sprang up to satiate the public's continued thirst for booze erased any line "between respectability and criminality, public and private," as people socialized with those they otherwise never would have met. White people heard Black music; "normal" people mingled with queers. And they loved it.

◀ Left Schoolgirl and lady friend, 1930s. Photographer unknown. From the authors' collection.

▶ Opposite Performers, 1910s. Photographer unknown. From the authors' collection.

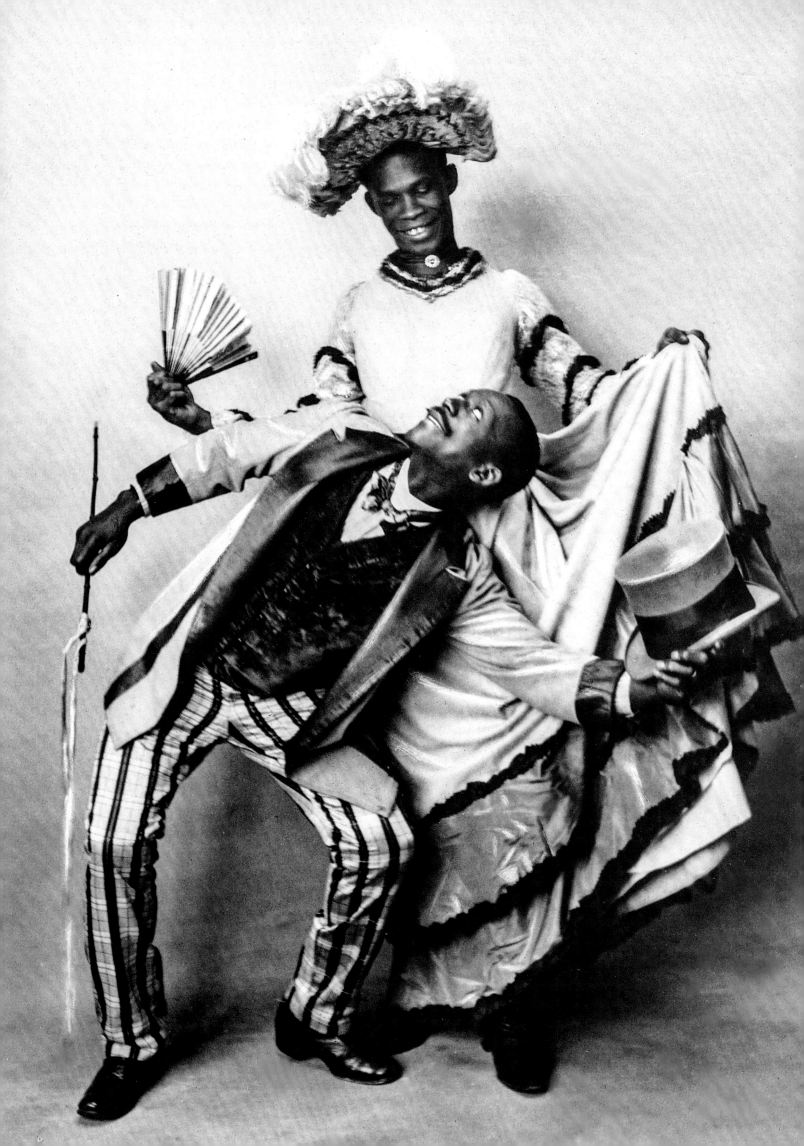

Looking to entice customers, New York club owners hired pansy acts to perform. In Times Square, entertainers like Bert Savoy and Karyl Norman packaged drag shows for consumption by a wide audience. Texas Guinan, the "big, loud lesbian" owner of the Argonaut, hired Nan Blackstone to serenade crowds. Queer-focused establishments also appeared. A sign greeted customers at Eva Kotchever's Greenwich Village tearoom: "MEN ARE ADMITTED BUT NOT WELCOME." In 1930, Bonnie's Stone Wall, one of the Village's "more notorious tearooms," opened on Christopher Street. By naming the tearoom Stone Wall, Bonnie likely was trying to attract lesbian customers by referencing *The Stone Wall*, a rare story of lesbian life by "Mary Casal" published earlier that year. Decades later, a bar at the same location as Bonnie's Stone Wall gained notoriety of its own.[7]

At the same time, queer people led a renaissance in Harlem. Legendary poets Langston Hughes and Countee Cullen, philosopher Alain LeRoy Locke, and blues greats Alberta Hunter, Gertrude "Ma" Rainey, and Bessie Smith all were "in the life." "All of them girls were," said lesbian trailblazer Mabel Hampton, a dancer during the Harlem Renaissance. "Every last one of them."

In 1928, Gladys Bentley, a 250-pound Black lesbian—"an avowed 'bull-dagger'"—arrived on the scene, taking her musical talents from private "rent" parties to the best nightclubs in town. Bentley, whom Langston Hughes described as "something worth discovering," generally appeared in traditionally male clothing, famously married her white lesbian lover in 1931, and made no bones about who she was.

▶ **Right** The Parade of the Fairies, drag ball, Webster Hall, Greenwich Village, New York City, 1920s. Photo by Jessie Tarbox Beals. Photo in the public domain.

▶ **Opposite** Gladys Bentley at the Ubangi Club, Harlem, New York City, early 1930s. Photo by Sterling Paige. Courtesy of the Visual Studies Workshop.

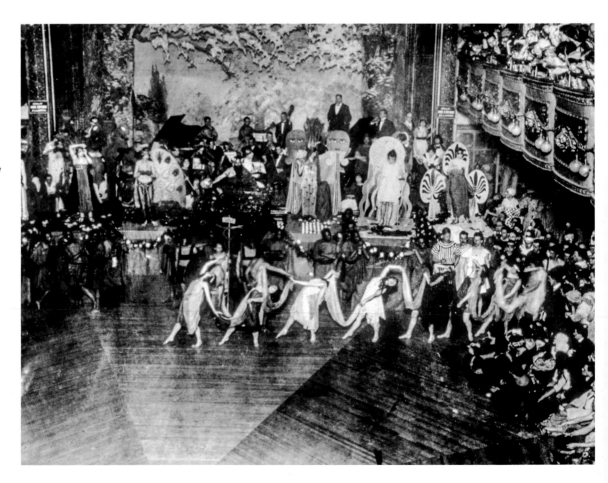

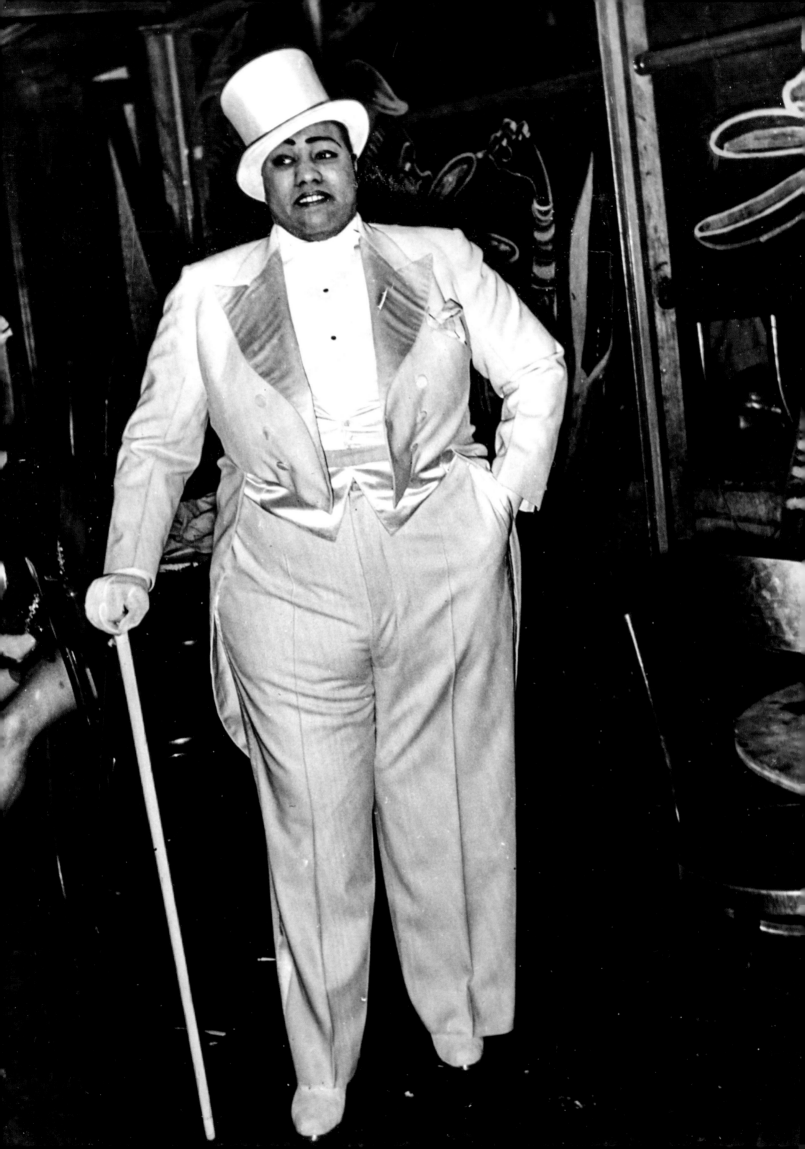

The growing popularity of drag balls in the 1920s and 1930s illustrated the new visibility (not to be confused with acceptance or safety) of queer people. In 1923, for example, seven hundred people attended Harlem's Hamilton Lodge Ball; by 1929, ticket sales had reached seven thousand, as more and more "normal" people came to witness the spectacle of the growing fairy underworld. The balls—and particularly the main event, "the parade of the fairies"—brought solidarity to a queer culture centered on gender inversion.[8]

Hollywood also fueled the national obsession with gender bending. Heartthrob Rudolph Valentino, for example, seemed to take great delight in flouting gender norms, and the androgyny of Marlene Dietrich altered notions of female beauty. Predictably, moralists demanded stricter control, and in 1930, the Hays' Motion Picture Producers and Distributors of America created the Motion Picture Production Code, which technically banned "any inference of sex perversion." Few objected, though, when queer characters appeared as villainous sissies or treacherous dykes, most of whom wound up dead by suicide.[9]

With the stock market crash of 1929, many Americans believed the "excesses" of the Prohibition era had come home to roost. As the 1930s got under way, so too did a moral crusade.

And queer people got pushed into the closet.[10]

After Prohibition, the gay bar emerged as *the* central institution of queer life, serving as a social center and "a crucible for politics." By the 1920s or 1930s, activist Chuck Rowland said, "any thinking person" at a bar decided that gays "should get together and have a gay organization."[11]

This new political consciousness emerged as the majority's need to identify "others" fueled recognition of a strict heterosexual-homosexual binary and identity increasingly hinged on the object of *sexual desire* rather than *gender performance*. This, in turn, minimized the space for those beyond the binary, including bisexuals and transgender people. And, under post-Prohibition state laws, bar owners could lose their liquor licenses if "disorderly or immoral conduct" took place on the premises. While Prohibition-era police raids involved illegal alcohol, post-Prohibition raids were about "illegal patrons."

In addition, President Franklin D. Roosevelt's New Deal expansion of the federal bureaucracy—decried by conservatives as a "powerful, emasculating, immoral force"—created something of a safe haven for queer people. In Washington, D.C., where the federal workforce exploded from 70,000 in 1930 to 270,000 in 1942, the civil service was "overwhelmingly

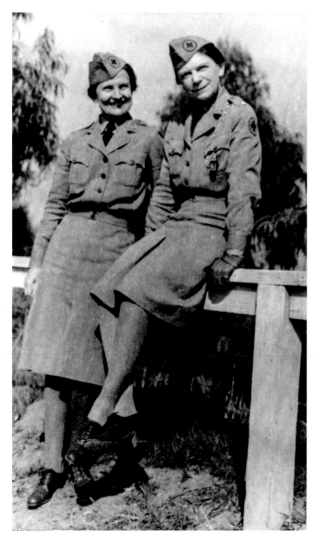

◀ Lois Mercer (left) and Dorothy Putnam (right), long-time partners and early members of the Los Angeles homophile community, in uniform as members of the Women's Ambulance and Transport Corps of California (W.A.T.C.C.) during World War II. Photographer unknown. Courtesy of the ONE Archives at the USC Libraries (Putnam & Mercer papers; 2008-038).

populated" by queer workers who weren't "particularly secretive" or fearful of losing their jobs.[12]

The armed services also offered queer people the opportunity to find each other, as the threat of international totalitarianism brought massive domestic military expansion

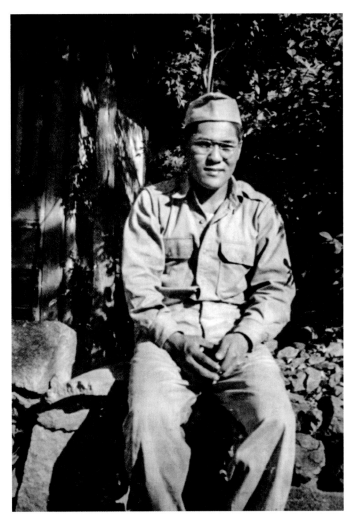

and the end of a period of U.S. "neutrality." Even before the 1941 attack on Pearl Harbor, millions registered for a peacetime draft, and the surplus of enlistees allowed officials to set "strict qualification standards," including a ban on "homosexual persons." The military had always banned homosexual *activity*, but never before had it recognized homosexual *persons*.

Of the eighteen million draftees and enlistees asked about their sexuality by military screening officers during the United States' involvement in World War II, only 5,000 were excluded from the military for being homosexual, even though, based on studies from the era, as many as 1.8 million of those servicemen likely were attracted predominantly to other men. The corresponding number was likely even higher among the nearly 300,000 enlisted women. Clearly an ineffective strategy for keeping queer people out of the armed forces, the screening procedures did spread the word about *the* homosexual, sometimes giving gays, lesbians, and bisexuals the first indication that they weren't alone.[13]

Queer communities emerged in military camps, fueling the evolution of a bar-centered gay culture. "By uprooting an entire generation," historian Allan Bérubé notes, "the war helped to channel urban gay life . . . away from stable private networks and toward public commercial establishments serving the needs of a displaced, transient, and young clientele."

But not all patrons were transient. In Buffalo, New York, a vibrant lesbian bar culture emerged even though few members of that community served in the military. Generally, lesbian bars catered to working-class white women (a relatively new phenomenon at the time), who abided strict butch-femme roles—the "butches defied convention by usurping male privilege in appearance and sexuality, and with their [femmes], outraged society by

▶ **Right, top** John Nojima, founding member of ONE, Incorporated, in uniform, undated. Photographer unknown. Courtesy of the ONE Archives at the USC Libraries (Legg personal papers; 2010-004).

▶ **Right, bottom** Postcard, 1940s. From the authors' collection.

creating a romantic and sexual unit within which women were not under male control." There was more cross-class socializing among gay men, but only some bars welcomed effeminate men, while others shunned or banned them entirely.[14] In either case, those who manipulated gender expectations were the most visible, and the most vulnerable, queer people.*

Bars weren't always an option. The mostly white bar crowds were as hostile to people of color as the rest of society. Black queer communities therefore tended to center around house parties, which played a central role in Black communities generally. Fear of job loss also kept some middle-class women, many of whom were enjoying economic independence for the first time, away from bars. For wealthier lesbians, like the well-to-do "Fun Gay Ladies" in Cherry Grove, New York, financial circumstances allowed them isolated physical enclaves where "they could be, quote, 'themselves.'"

Meanwhile, Henry Gerber kept dreaming of organizing homosexuals. After Pearl Harbor, he focused on laying "the foundations for a future society to spring up after the war."[15]

In early 1942, President Roosevelt authorized the secretary of war "to prescribe military areas" to any extent deemed necessary "from which any or all persons may be excluded." Although the order wasn't specific, the intended consequences were clear. The internment of 110,000 persons of Japanese descent—70 percent of whom were American citizens—was the most visible, and among the vilest, manifestations of Roosevelt's capitulation to wartime fear. As everywhere, there were queer people in the internment camps, as the records of Jiro Onuma, who spent part of his internment in the same camp as his boyfriend, starkly illustrate.[16]

The wartime panic also resulted in the labeling, and further stigmatization, of queer people. Early in the war, an "enlightened" group of military officials attacked the traditional approach used to punish "Sodomists"—prosecution and imprisonment—as archaic, urging instead a process of diagnosis and discharge. By focusing on diagnosis, the military validated the emerging, but widely criticized, field of psychiatry, and by 1943, sexual deviance was seen as "a medical rather than a criminological problem." Under the new administrative discharge approach, nine thousand sailors and soldiers—mostly men—received a "blue discharge," marking them as "sexual psychopaths" and making reintegration into society virtually impossible. Precluded from social, legal, and financial benefits enjoyed by other vets, those with the "blue discharge" had few options. "Many of them kind of crumbled," said one vet.[17]

But for those leaving the service without prejudice, new options seemed possible, as waves resettled in large cities, and new queer subcommunities emerged in Denver, Kansas City, Cleveland, Boise, and Buffalo. The postwar high, however, was temporary for those living outside gender and sexual norms. After fifteen years of economic and military turmoil, most Americans sought desperately to create "a tranquil family

* It would be wrong, attorney and scholar Allen Drexel notes, "to equate the political meanings and significance of gay male drag and the role of the butch lesbian from the 1930s through the '50s; after all, gender-crossing performances of 'the feminine' and 'the masculine' by gay men and lesbians have distinct histories and meanings, and have tended to evoke very different public responses over time. . . . Still, the styles of the butch and the drag queen were similar in that both were predominantly working-class styles involving explicit stylistic/performative transgressions of gender and sexual norms."



▲ **Top** House party, Philadelphia, c. 1954. Photographer unknown. Courtesy of Black LGBT Archivists Society of Philadelphia.

▲ **Above** Gay bar, Philadelphia, 1960s. Photo by Jack van Alstyne. Courtesy of John J. Wilcox, Jr. Archives, William Way LGBT Community Center (van Alstyne collection; Ms. Coll. 28).

◄ **Left** Location unknown, 1950s. Photographer unknown. From the authors' collection.

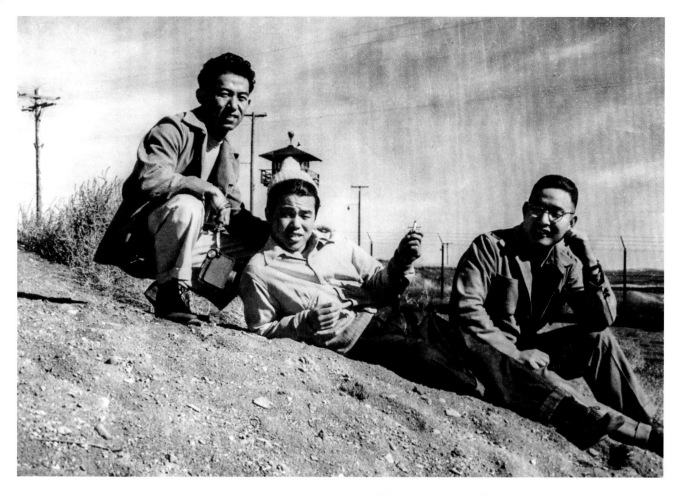

▲ **Above** Three men by guard tower, including Ronald (last name unknown; center), boyfriend of Jiro Onuma, Tule Lake concentration camp, Siskiyou County, California, early 1940s. Photographer unknown. Courtesy of Gay, Lesbian, Bisexual, Transgender Historical Society (Onuma papers).

▶ **Right** Jiro Onuma (center) and friends, c. 1930. Photographer unknown. Courtesy of Gay, Lesbian, Bisexual, Transgender Historical Society (Onuma papers).

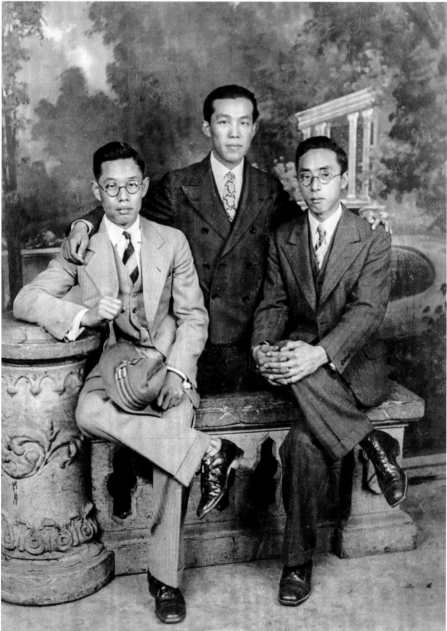

environment." On a base level, historians Madeline D. Davis and Elizabeth Lapovsky Kennedy argue, "virulent antihomosexuality was a way of reinstitutionalizing male dominance and strict gender roles." As the Cold War began after World War II, the United States committed itself to containing threats abroad *and* to "the containment of all forces which could disrupt home life." By 1947, homophile Shirley Willer recalled, "just the assumption" of being queer was enough to justify violence.[18]

At the same time, the world was "becoming more and more aware that there are those in our midst who feel no attraction for the opposite sex." This increased visibility, and the danger it brought, drove many queer people away from the bars. Increasingly, men relied on what George Chauncey calls the privacy of public spaces, namely city parks, washrooms, and bathhouses. For women who could afford it, house parties were the best options.

In this context, a young working-class lesbian in Los Angeles, Edythe Eyde (a.k.a. Lisa Ben), who couldn't afford a place of her own and was concerned about bar raids, came up with an alternative way to meet girls: a magazine. Although not the first lesbian magazine—1920s Berlin had at least three—nor the first gay magazine in the United States—that likely was Gerber's *Friendship and Freedom*—Eyde's *Vice Versa* offered an alternative to the bar-centered social scene of the war era. Through *Vice Versa*, Eyde met "dozens of lesbians" before bringing the magazine to an end in early 1948.[19]

The queer community's increased visibility also brought negative attention at the federal level. In July 1947, a U.S. Senate subcommittee warned the secretary of state of "a deliberate, calculated program" aimed at protecting communist government employees *and* advancing the employment "in highly classified positions of admitted homosexuals, who are historically known to be security risks." A national security crackdown on queers—whose "lifestyle" supposedly made them more susceptible to blackmail—was under way.

And, thanks to media sensationalism over a handful of particularly vile sex crimes against children, a "moral panic" spread. "The most rapidly increasing type of crime," FBI Director J. Edgar Hoover—himself a homosexual—declared, "is that perpetrated by degenerate sex offenders."[20]

The government also began to focus more on the matter of public sex. Particularly among working-class men, "privacy could only be had in public," meaning public sex often was the norm. In D.C., Lafayette Park, directly across Pennsylvania Avenue from the White House, was the "epicenter of the gay male world" for nearly a century; even Henry Gerber was spotted seeking companionship there. By the late 1940s, however, moralists pointed to Lafayette as proof that D.C. was "more or less a haven for sexual perverts," and in October 1947, the U.S. Park Police launched the "Pervert Elimination Campaign," a program mandating the "harassment and arrest of men in known gay cruising areas." Hundreds were arrested on flimsy charges, and almost four times as many were "apprehended, questioned, and released without arrest."[21]

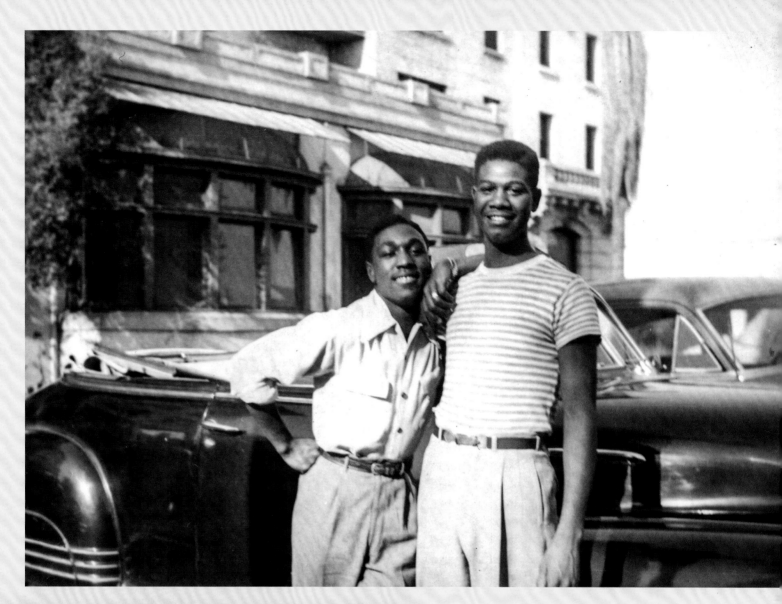

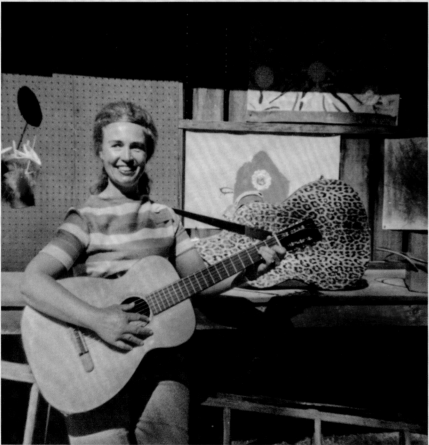

▲ **Above** Marvin Edwards (right) and a friend, 1940s. Photographer unknown. Courtesy of the ONE Archives at the USC Libraries (Legg personal papers; 2010-004).

◄ **Left** Edythe Eyde (a.k.a. Lisa Ben) plays the guitar, 1960s. Photographer unknown. Courtesy of the ONE Archives at the USC Libraries (Ben papers; 2015-009).

In addition to her trailblazing work as founder of *Vice Versa*, the pseudonymous Lisa Ben (an anagram of "lesbian") also became known as "the first gay folksinger," writing and performing gay-themed parodies of popular songs; "I'm Gonna Sit Right Down and Write Myself a Letter," for example, became "I'm Gonna Sit Right Down and Write My Butch a Letter."

◄ **Opposite** Location unknown, 1950s. From the authors' collection.

But the subtle attacks kept coming.

The 1948 release of Dr. Alfred Kinsey's *Sexual Behavior in the Human Male* "blasted this damn country wide open." Despite growing concerns about "sexual psychopaths," Kinsey's data—based on interviews of thousands of white men—indicated an astounding 37 percent of men had had at least one sexual interaction with another man since adolescence. Using a spectrum—*The Kinsey Scale*—ranging from 0 (exclusively heterosexual) to 6 (exclusively homosexual), Kinsey ranked subjects based on the extent of homosexual activities at various times in their lives. Ten percent were "more or less exclusively homosexual" for at least three years during adulthood; 8 percent were "exclusively homosexual" for at least three years in the same period; and 4 percent were "exclusively homosexual" throughout their lives. Among other things, Kinsey's data illustrated that the heterosexual-homosexual binary "makes no allowance for the nearly half of the population which has had sexual contacts with, or reacted physically to, individuals of their own as well of the opposite sex."

Because each subject's rating depended on the frequency of activity (i.e., if you didn't *do* it, you *weren't* it), Kinsey's study also helped reinforce the idea that people (especially children) could be protected from homosexuality—that one is only homosexual if one acts on same-sex desires. Nonetheless, the study represented the first significant crack in the "conspiracy of silence" surrounding homosexuality, taking queer people "from invisibility to a central place in the nation's consciousness." For the first time, Donald Webster Cory wrote in his 1951 book *The Homosexual in America*, among "the millions who are silent and submerged, I see a potential, a reservoir of protest, a hope."

Then, in August 1948, while working for the campaign of Progressive Party presidential candidate Henry Wallace, L.A.'s Harry Hay captivated a group of gay men with his vision of organized homosexuals rising up to fight for their place in society; he even suggested working a sexual freedom plank into the Progressive platform using a cover: "Bachelors for Wallace." Hay had dreamt of forming such a group since 1929, when Champ Simmons, whom Hay had met while cruising Pershing Square, told him about a short-lived homosexual organization formed in Chicago—Henry Gerber's Society for Human Rights. But Hay spent the next two decades organizing for the American Communist Party, which denounced homosexuality as a decadent bourgeoisie indulgence, and the pursuit of his vision had to wait.

Homosexuals are outlaws against the public policy; they cannot expect assistance from the law. —Henry Gerber, 1957

After Hay was finally able to share his dream in 1948, there was real excitement for those few drunken hours, so much so that he wrote out his vision in a manifesto. "The Call," as it was known, had at its core the idea that homosexuals weren't just a collection of afflicted individuals but rather an oppressed minority. The next morning, Hay phoned those he'd met, but in the sober light of day, none were interested.[22]

In 1949, Los Angeles got swept up in a homosexual panic when Dr. Paul DeRiver, the police department's chief psychiatrist, published *The Sexual Criminal*, expounding on his theory that homosexuals were potential killers and "seducers of children." The book, which became a manual for police nationwide, recommended preventive treatment, including electric shock therapy. Other California officials also were negatively impacting queer life. The same year, Val Barry (a pseudonym), who was labeled male at birth but lived as a woman, contacted Dr. Harry Benjamin—a disciple of Magnus Hirschfeld—in hopes of undergoing a "sex change." After Benjamin began administering hormones at his San Francisco office, he wrote then-district attorney (and later governor) Edmund Brown about the legality of castration. On the advice of doctors Karl Bowman and Alfred Kinsey, who said surgery wouldn't solve the "underlying psychological problem," Brown declared that "genital modification" would "constitute 'mayhem' (the willful destruction of healthy tissue)," and thus any surgeon performing it would face criminal liability. The decision impeded the evolution of transsexual medical procedures in the United States for years, hindering efforts by transgender people to freely exist and organize for recognition.[23]

The cultural climate worsened in early 1950, when U.S. senator Joseph McCarthy of Wisconsin claimed to have a list of 205 Communists working at the State Department. If the United States were to survive the Cold War, he said, the traitors had to be weeded out. As he went through eighty-one "loyalty risks" on the Senate floor in February, McCarthy focused on two cases involving queer people, both of which gave what he described as a "rather interesting picture of some rather unusual mental twists" of people "who are tied up with some of the Communist organizations." To McCarthy, homosexuality was the psychological disorder that led perverted minds to communism. McCarthy gave the Red Scare, in historian David K. Johnson's phrase, "a tinge of lavender."

The dam broke on February 28, 1950, when Senator Styles Bridges asked Secretary of State Dean Acheson for a definition of "security risk," and Acheson said it depended on whether the person had, "as a matter of character, any defect" that might cause problems. "Such as homosexuality?" Bridges asked. "That would be included," Acheson replied. When Bridges asked a follow-up about recent resignations at the State Department, Acheson's deputy undersecretary John Peurifoy jumped in: "In this shady category, there are ninety-one cases, sir." Unsatisfied, Bridges pressed for clarification. "Most of these were homosexuals," Peurifoy finally said, his answer setting off a chain of events that dictated security policies impacting queer people for decades.[24]

The anti-queer Lavender Scare was in many ways far worse than the Communist-inspired Red Scare, though the attack on queers receives a fraction of the attention. While this is likely a product of bias, David K. Johnson's work reveals that language also plays a significant role. Specifically, historians often treat "security risk" and "Communist" as synonymous, but McCarthy-era citizens knew the difference between "security risks," on one hand, and "loyalty risks," on the other. *Loyalty* risks, like

Communists, were ideologically opposed to "American values"; they *wanted* to betray the country. *Security* risks couldn't help it; they were drunks, gossips, and queers. In reality, *security risk* often just meant "sexual deviant," the theory being that the secret one held regarding one's sexuality or gender identity opened one up to blackmail.

Whatever the reason, lumping the queer purges together with McCarthy's crusade against alleged Communists diminishes the Lavender Scare's scope. By December 1950, *every* government agency agreed that "sex perverts in Government constitute security risks" and had policies in place to identify and fire such deviates. The federal government's stance in turn validated and amplified widespread bigotry; *any* company doing business with the government had to have similar policies to avoid employing sexual deviates. Thus, by 1958, an estimated one in five employed adults had been subjected to "some form of loyalty or security screening." For queers in white-collar jobs, the threat of discovery, job loss, and financial ruin was everywhere. And the policies set during the Lavender Scare often remained for decades.

To put it mildly, it was a difficult time to be queer in the United States.[25]

On July 8, 1950, as Harry Hay watched his daughter at dance rehearsal, he realized he, too, was being watched. Eventually, his gorgeous admirer, Rudi Gernreich, approached him, and the two made plans. Before their date, Hay reworked "The Call," which he passed to Gernreich during dinner. "It's the most dangerous thing I've ever seen," Gernreich said, "and I'm with you one hundred percent." But Gernreich, an Austrian-born Jew, urged caution. Before fleeing Vienna in 1938, he'd heard of Magnus Hirschfeld, the drive for homosexual emancipation, and how the Nazis used confiscated records from Hirschfeld's Institute for Sexual Science to send queer people to death camps.

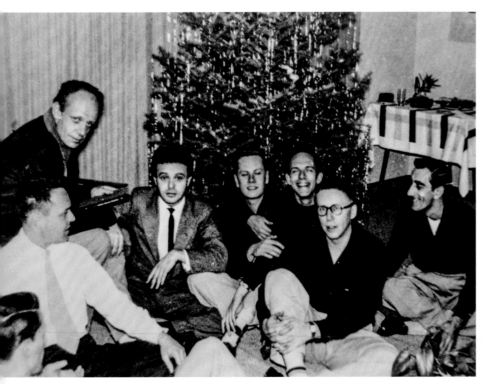

Hay and Gernreich fell in love, and they soon had a scheme to recruit members for the organization envisioned in "The Call." At a gay beach, ostensibly seeking signatures for a petition against the Korean War, they'd mention the Kinsey report to beachgoers and ask if they were interested in attending a discussion on sexual deviancy. While five hundred people signed the petition, *no one* committed to talking openly about homosexuality.

▲ Founding members of the Mattachine Foundation, from left to right: Konrad Stevens (partially obscured), Dale Jennings, Harry Hay, Rudi Gernreich, Stan Witt, Bob Hull, Chuck Rowland, and Paul Bernard, Los Angeles, Dec. 1951. Photo by James Gruber. Courtesy of the ONE Archives at the USC Libraries (Hay papers; 2011-003).

After months with no success, Hay gave "The Call" to one of his music students, Bob Hull, who called days later to ask if he and some friends could come to Hay's home to discuss the treatise. Harry and Rudi nervously waited until they saw a large bespectacled man running up the street, excitedly waving "The Call" over his head, grinning from ear to ear. It was Chuck Rowland, Bob Hull's ex-boyfriend and roommate. Behind Rowland came Hull and his sometimes-lover Dale Jennings. They went inside and pulled the shades.

"We sat there," Hay wrote, "with fire in our eyes and far-away dreams, *being* Gays."

"What is our basic principle that we're building on?" Rowland asked the group.

"We are an oppressed cultural minority," Hay responded.

No one had put it that way before, and nothing would ever be the same.[26]

In December 1950, Harry Hay, Rudi Gernreich, and the others held the first semipublic meeting of what they called the "Society of Fools"; eighteen people attended: sixteen white men, one Black man, and one white lesbian. In every way, men—specifically white men—dominated what would become the Mattachine Foundation, and the organization was never very successful in attracting lesbian members. While Mattachine was somewhat more successful in attracting men of color, there's no indication that nonwhite members were able to discuss the particular issues they faced. Elsewhere in L.A., though, W. Dorr Legg and Merton Byrd had started the Knights of the Clock specifically for interracial gay couples. When that group folded, some of its members, including Legg, joined Harry Hay's new group. Despite the early homophile era's white male predominance, there's no question transgender people, women, bisexuals, and people of color were part of the Movement from the beginning.

Hay soon suggested the name *Mattachine* for the group, inspired by tales from the fifteenth century, when the Holy Roman Empire banned political satire at the Feast of Fools, sending the fools into underground secret societies, including the Mattachine. From behind elaborate, and often gender bending, disguises, these early activists mocked the Catholic Church and "ridiculed the false pretenses of society," speaking truth to power. Centuries later, Hay's Mattachine registered as a nonprofit, listing three heterosexual women—his mother and two others—as the board of directors.

This was the Mattachine Foundation.

▲ W. Dorr Legg (left) and partner Bailey Whitaker (right) with friends, c. 1950. Photographer unknown. Courtesy of the ONE Archives at the USC Libraries (Legg personal papers; 2010-004).

While all of the founding members of the original Mattachine (i.e., the Foundation) had some experience with Communist Party politics, the group's structure was based as much on older fraternal orders as anything else, resulting in a "cross between the Masons and the Communist cell structure of the 1930s." There were five tiers, or orders, with the Founders—Hay, Gernreich, Hull, Rowland, and Jennings—representing the Fifth Order. The tiered structure guaranteed secrecy, essential to Mattachine's existence; the "leaders and the rank-and-file were separate, and the latter did not know who the former were."

Because many early Mattachine members were gripped by intense self-hatred, the Founders had to start with "a pretty low level of group therapy," focusing on "overcoming the negative, cynical mentality about gay life so prevalent in homosexual gathering places." Hay and Rowland emphasized the need for an "ethical homosexual culture," in which queer people were supportive rather than "sexually competitive and acid-tongued." Although Hay initially found it "a glorious shock" to feel "at home and 'in family,' perhaps for the first time in our lives," as Mattachine grew, a wave of conservative members sowed dissent by pointing to the "homosexual culture" rhetoric as evidence of the Founders' communism.

But growth wasn't an issue for quite some time. In fact, no one returned for a second meeting until Konrad "Steve" Stevens and James "Jim" Gruber came back, and they eventually became Fifth Order members. With no background in communism, Steve and Jim, a "dream couple" known as Stem, brought a new enthusiasm to meetings. In contrast to the Founders, Stem pushed back on the "oppressed cultural minority" theory. In their minds, shackling homosexuals with minority status diminished individuality, invited prejudice, and sought separation, when the goal was an equal place in society, regardless of one's "predilections." This key theoretical split—whether queer people should celebrate themselves as members of a distinct and separate culture or try only to "fit in" among the majority—at first inspired life-affirming debates at early Mattachine meetings, but the ongoing tension ultimately dominated the Movement that emerged.[27]

In February 1952, Dale Jennings got cruised in a public restroom in L.A.'s Westlake (now MacArthur) Park; although Jennings had no interest, the other man followed him home and pushed his way inside. The man then tried to coax Jennings into sex; when Jennings struggled to pull away, the stranger produced a badge and handcuffs and marched Jennings out the door.

Had this been an ordinary case of entrapment, Jennings would have pleaded guilty and been released, not knowing when the ordeal might come back to haunt him. But it wasn't an ordinary case, and Jennings didn't admit anything. After finally being allowed to use the phone, he called Harry Hay, who sensed a potential boon for Mattachine. Paying Jennings's bail and taking him to breakfast, Hay detailed his plan to fight the charge. Jennings would admit he was homosexual *but* deny he made a pass at the cop. They'd argue that sexual entrapment violated the Constitution. Knowing they'd need an experienced attorney, Hay suggested they do something else extraordinary: collect money *from* homosexuals *for* homosexuals. With trepidation, Jennings agreed.

That night, Mattachine's leadership formed the Citizens Committee to Outlaw Entrapment, distributing leaflets across L.A. "NOW is the time to fight," the leaflet declared. "The issue is CIVIL RIGHTS."

With the donations that came in, they hired attorney George Shibley, who announced to the jury in June 1952: "Yes, my client is a homosexual," but the "only true pervert in this courtroom is the arresting officer." After three days of trial, eleven jurors agreed with Shibley, with one holdout promising to vote guilty "until Hell froze over." Viewing a second trial as a waste of time, the district attorney sought dismissal.

Jennings had won.

Mattachine blanketed L.A. with a "Victory!" flyer, membership ballooned, new chapters cropped up, and meetings overflowed. A Southern California surge spread across the state, and soon the Fifth Order heard from would-be members in New York, Chicago, and Saint Louis. Hundreds of people participated in discussion groups, which inevitably brought a new diversity of views. Some, like Jim Kepner, were as radical as Harry Hay or Chuck Rowland; others, like Ken Burns, were conservatives who scoffed at the notion of a "homosexual culture." This second group—"committed to respectability and accommodationism"—was exceedingly uncomfortable with Mattachine's cloak-and-dagger structure. As 1952 progressed, personality disputes deepened, ideological rifts widened, and, for many, the seemingly never-ending discussions got old; some members turned their attention elsewhere.[28]

In mid-October, when a former vice officer gave a presentation about entrapment to a Mattachine discussion group, something clicked. "People don't know these things!" someone shouted. "We've got to tell them!" Then, Dorr Legg remembered, "a little pip-squeak" chimed in: "Well, you need a magazine." Legg agreed.

In the months that followed, Legg and others established *ONE* magazine. Suggested by Bailey Whitaker (a.k.a. Guy Rousseau), the name *ONE* came from a line by Scottish philosopher Thomas Carlyle: "a mystic bond of brotherhood makes all men one." In addition to Whitaker and Legg, the magazine's founders, known collectively as ONE, Incorporated, included partners Don Slater and Antonio Reyes; Merton Byrd, a Black accountant; John Nojima, survivor of a Japanese internment camp; and Martin Block and Dale Jennings, Fifth Order Mattachine members. Even as the Lavender Scare unfolded, *ONE* appeared in cities around the country, selling about five thousand copies each month (with many being passed among countless people).[29]

ONE's early issues—the first of which appeared in January 1953—were dominated by the rift between those who saw homosexuals as an "oppressed cultural minority" (i.e., the culturalists) and those who focused on "equal rights," dismissing the idea of a distinct homosexual culture (i.e., the assimilationists). Homosexuality, according to assimilationist Dale Jennings, "calls for neither fear nor pride, and will require attention only so long as there is legal and religious prejudice against it." Culturalist Chuck Rowland, on the other hand, said members of the homosexual culture admitted, "at least to themselves," that "they are, indeed, homosexual and that their lives, plans, hopes and prospects must, accordingly, be different."

Unsurprisingly, a debate between and about gay men had consequences for other queer people. Assimilationists, for example, pointed to the "omnipresence of bisexuality" to support arguments against the "oppressed minority" theory: according to Dr. Kinsey, those who engaged in non-heterosexual sex were, in fact, the majority. But, culturalists argued, many bisexuals "participate in the homosexual culture, and they are . . . *basically* homosexual in thought, desire, orientation, and culture." Thus, homophiles either ignored bisexuals or used them to deny the existence of a unique queer community. Similarly, debates often revolved around what it meant "to be a man," with assimilationists using gender norms to deny the existence of a "homosexual culture." According to Dr. Karl Bowman, "exclusively homosexual men" fell into one of two groups: first, "the smaller, regard themselves as females and often ask for castrative operations," whereas those in the larger group "are more nearly like the average man." Gay men, in other words, were either "average men" or not men at all.

While most homophiles avoided the more radical gender and sexual outlaws, some recognized their bravery. Jim Kepner, for example, often spoke of his first trip to a gay bar. As he walked toward San Francisco's Black Cat Cafe in 1943, he saw police crash through the doors, hauling a group of butch men and drag queens out of the bar. Though the butches kept quiet, Kepner was delighted to hear a queen scream at a cop, "Don't shove, you bastard, or I'll bite your fuckin' balls off!" The queens, he said, were the reason there were "bars that the rest of us could sneak into."[30]

"EX-GI BECOMES BLONDE BEAUTY," announced the *New York Daily News* on December 1, 1952, introducing the world to Christine Jorgensen, the woman who "made *sex change* a household term." At a time when people in the United States seemed unable to challenge authority, Jorgensen and her European doctors forced them to question everything: individuality, science, gender, sex, and sexuality. And, given her moral objections to homosexuality, Jorgensen stressed that transsexuality was a scientific issue that could be corrected: "Nature," she told her parents, "made the mistake which I have had corrected and I am now your daughter."[31]

A brief note on terminology is necessary here. The umbrella term *transgender*—which Professor Susan Stryker uses "to refer to people who move away from the gender they were assigned at birth, people who cross over (*trans-*), the boundaries constructed by their culture to define and contain that gender"—encompasses, among other distinct groups, *transsexuals* (who desire to change their sex, whether or not they undergo any transformative procedures, generally as a means to affirm their gender identity as different from what they were assigned at birth) and *transvestites* (who "wear gender atypical clothing but do not engage in other kinds of body modification").

◄ **Left** Christine Jorgensen, the first American widely known to seek gender affirming surgery, signs her biography after a 1975 speech at ONE, Incorporated, more than two decades after Dale Jennings called Jorgensen a "eunuch" and "not a woman" in the pages of *ONE*, Los Angeles, Mar. 9, 1975. Photo by Bob Earl. Courtesy of the ONE Archives at the USC Libraries (ONE Incorporated records; 2011-001).

▼ **Below** From left to right: Daisy Erickson, Reed Erickson, and Michele, 1963. Photographer unknown. Courtesy of the ONE Archives at the USC Libraries (Reed L. Erickson papers; 2010-001).

Reed Erickson was a transgender man who used his significant wealth, which he inherited, to fund a number of the earliest organizations in the United States focused on the civil rights and well-being of transgender people. In 1964, he founded the Erickson Educational Foundation, the first organization known to have allocated large sums of money to increasing the visibility and health of the transgender community. Additionally, Erickson gave significant resources to the ONE Institute, though his relationship with the West Coast homophiles ended in a prolonged legal battle. By the time of his death in 1992, Erickson had been married three times, battled drug addictions, and faced federal drug charges. He was a remarkably important figure.

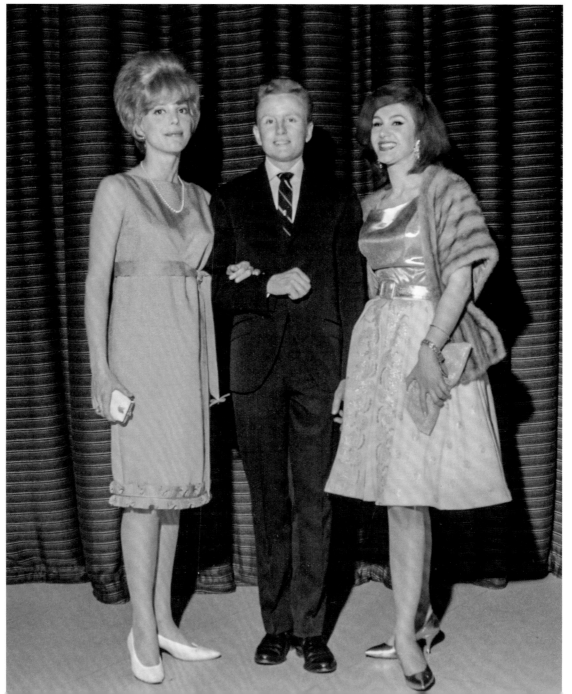

These definitional distinctions are recent, however.* In 1910, Magnus Hirschfeld had differentiated between *transvestites* and *homosexuals*, but transvestites included both "those with crossgender identification as well as those who crossdressed." In Hirschfeld's formulation, *transvestite* served as an umbrella term that included those who today would identify as *transsexual*. In 1949, D. O. Cauldwell introduced the term *transsexual* as it's currently used, but it wasn't until *after* Christine Jorgensen made headlines that Harry Benjamin helped popularize *transsexual* as separate and distinct from *transvestite*. In other words, to most midcentury Americans, *transvestites* were cross-dressers, and *transsexuals* didn't exist. So, when Jorgensen's European doctors referred to her as a *transvestite*, it was enough for many in the United States to call her gender into question.[32]

Unsurprisingly, the homophiles did little to support Jorgensen. In an open letter in *ONE*, for example, Dale Jennings summarized the vitriol and ignorance of many gay men, calling Jorgensen a "eunuch" who'd turned to surgery as a "solution" for homosexuality. "You're not a woman," he said. "A dress and high heels will not provide you with a baby." In essence, Jennings saw Jorgensen as a traitorous homosexual man who weakly accepted the notion that castration was the cure.

But to those whose identities weren't accounted for by the dominant gender and sex binaries, Leslie Feinberg said, Jorgensen's "struggle beamed a message that I wasn't alone." Tens of thousands reached out to her. One woman "had been praying to God that in some way I could be a girl, and then almost like a miracle I read of you."

ONE likewise received countless letters from across the country. For one writer in D.C., *ONE* represented the next step in "our struggle to get recognition." Although he signed his July 1953 letter "G.S.," his story was familiar: "In 1925 [*sic*] I met several inverts in Chicago and conceived a society on the order of that existing in Germany at that time, Society for Human Rights and we published a few issues of a paper, called Friendship and Freedom and even had a charter from the State of Illinois." "G.S.," or Henry Gerber, supported *ONE* for years.

In March 1958, another letter writer confessed that he found being gay "a very happy but lonely life," and that he often felt "like committing suicide, but I shouldn't be so cowardly." The man simply hoped that, someday, he wouldn't "be so lonely anymore." *ONE*, he closed, "is terrific and I pick up a copy each time it comes out."

The letters to Jorgensen and the emerging homophile organizations illustrate a key point: despite activists' focus on ideological nuance between, for example, culturalism and accommodationism, most queer people weren't terribly concerned with such "esoteric hogwash." At midcentury, homophile George Mendenhall said, "there was nowhere to go for your freedom." But then came Mattachine. And *ONE*. And Jorgensen. And the Daughters of Bilitis. Suddenly, "almost like a miracle," it seemed there were others who understood. There was light in the darkness.[33]

* "Because it is our entire spirit—the essence of who we are—that doesn't conform to narrow gender stereotypes," transgender warrior Leslie Feinberg wrote, "many people who in the past have been referred to as cross-dressers, transvestites, drag queens, and drag kings today define themselves as trans*gender*."

Though the government had always harassed *ONE*, the editors apparently went too far with the eighth issue, which authorities seized before it shipped. The problem was the bold lettering on the cover, announcing the issue's main topic: "HOMOSEXUAL MARRIAGE?"

While the solicitor general deemed that issue "safe," L.A.'s postmaster Otto Olesen wasn't done, declaring a later issue obscene and again seizing all copies. *ONE*'s attorney, Eric Julber, sought an injunction, but the judge refused to entertain the suggestion that "homosexuals should be recognized as a segment of our people and be accorded special privilege as a class." The appeals court agreed. With no other choice, Julber petitioned the U.S. Supreme Court, which, to everyone's surprise, issued a one-sentence order in January 1958 reversing the trial court's decision and thereby extending the Constitution's First Amendment protections to the early homophile magazines.

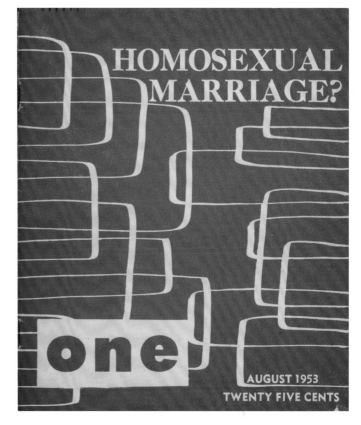

▲ Because of its provocative cover, federal authorities seized all copies of the August 1953 issue of *ONE*. From the authors' collection.

Although *ONE* had prevailed, the Supreme Court did not address whether homosexuals should be "recognized as a segment of our people and accorded special privileges as a class."

That question ripped Mattachine in two.[34]

After the war, Harold "Hal" Call finished his journalism degree, and worked in Chicago until he was arrested on false morals charges. Much like Henry Gerber decades earlier, Call avoided jail but lost his job. With nothing left in Chicago, Call and his lover drove to San Francisco, arriving in time to spend Halloween 1952 at the famed Black Cat. The Cat, as it was known, always had a reputation as a place for people "on the fringes of acceptability." By the early 1940s, when Jim Kepner saw the queens fight back, the bar catered primarily to queer people; after the war, it became exclusively gay, thanks in large part to José Sarria, who'd started working at the Cat after his return from the army in 1947. At first, Sarria was a "social hostess," greeting people, getting drinks, and occasionally singing a song; over time, he started performing more and then started his female impersonations. Using a cluster of tables as a stage, with piano by James Willis McGinnis (Hazel, to friends), Sarria's satiric operas became legendary.

"I became very popular," he said. "I became the Black Cat."

And the Black Cat became more than a bar.

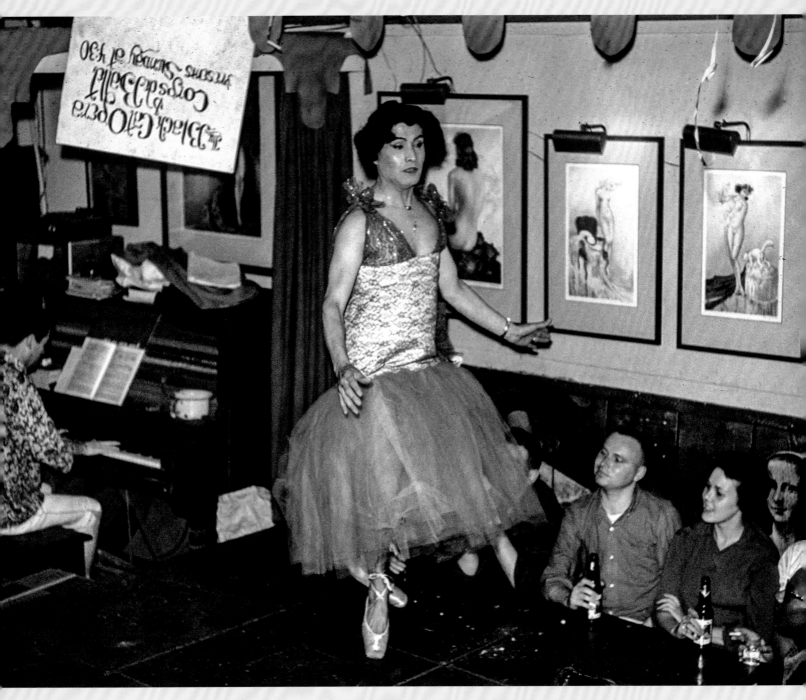

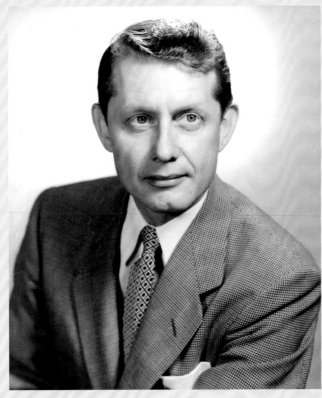

▲ **Above** José Sarria during a performance at the Black Cat, San Francisco, early 1960s. Photo likely by Hal Call. Courtesy of the ONE Archives at the USC Libraries (Call papers; 2008-010).

◀ **Left** Harold "Hal" Call, 1953. Photographer unknown. Courtesy of the ONE Archives at the USC Libraries (Call papers; 2008-010).

"Remember," Sarria announced at closing time each night, "there's nothing wrong with being gay. The crime is getting caught."

He'd then have everyone stand, form a circle, and put their arms around each other. With a flourish, Hazel would start the Cat's anthem, as Sarria sang:

> God save us Nelly Queens
> From every mountainside
> Long may we live and die
> God save us Nelly Queens.

"To be able to put your arms around other gay men," George Mendenhall remembered, "and be able to stand up and say, 'God Save Us Nelly Queens,' we were saying, 'we have our rights, too.'"

But those rights were few and far between. Even on Halloween—the one night when open drag was tolerated—San Francisco police spoiled the fun. While revelers could wear what they wanted on October 31, at the stroke of midnight, the police would pull paddy wagons up to gay bars, which didn't close until 2:00 a.m., and arrest everyone in drag. One year, Sarria launched an ingeniously subtle attack: because the cross-dressing law hinged on a person's "intent to deceive" others into thinking they were another sex, Sarria told queens to pin to their dresses little slips of paper declaring, "I am a boy." By announcing their sex, they theoretically couldn't be accused of an intent to deceive, though police still arrested many of the "boy" queens.[35]

While the Black Cat meant so much to so many, to Hal Call, it was just "a raunchy, Bohemian bar," where one went, if at all, to meet men. But when he heard about a homosexual discussion group forming at Berkeley in March 1953, Call was "absolutely entranced," envisioning a group "banding together to try to get society to erase the stigma against homosexuality." From the beginning, though, Call—a born leader, combat veteran, and rabid anti-Communist—was horrified by what he heard about the Mattachine Foundation's mysterious Fifth Order. "That was the heyday of Senator Joseph McCarthy," he recalled, and any association with Communists made you a "Communist sympathizer." That, he said, "was why we started working against the Foundation."

In March, Paul Coates of L.A.'s *Daily Mirror* looked into Mattachine, finding that they'd worked with an attorney who'd pleaded the Fifth before the House Un-American Activities Committee, which, to most, all but "proved" he was a Communist. "Homosexuals," Coates wrote, "have been found to be bad security risks," and one day, "they might band together for their own protection [and] they might swing tremendous political power. A well-trained subversive could move in and forge that power into a dangerous political weapon."

A wave of rank-and-file confusion, fear, and anger enveloped Harry Hay and the other Founders. Bowing to pressure, the Fifth Order called a constitutional convention. On April 11, 1953, 110 people gathered at the First Universalist Church in Los Angeles. After conservatives Ken Burns and Marilyn Rieger were elected chair and secretary, respectively, the first speaker, militant Chuck Rowland, dove right in:

I know there are some here who believe we should stop talking about our separate culture and strive instead only for integration. But I did not create this separate culture nor did any of you. Actually it was society which created our culture by excluding us. As a result of this exclusion, [we] have developed differently than have other cultural groups. This is a fact.

Call hated that the Foundation sought "an all-inclusive little sub-culture," whereas he and the other conservatives instead "wanted to be assimilated into society and be recognized as distinctive *only* because of our difference in choice of sex partners." Their goal was to end "discrimination and ignorance," and then disband Mattachine. The conservatives, Call explained, "weren't attuned to protesting, carrying signs, and appearing on courthouse steps," preferring instead "social change through evolutionary *not* revolutionary means."[36]

Delegates tried unsuccessfully to negotiate a constitution: the Founders on one side, conservatives on the other. As time ran out, the only option was to schedule a second session for the following month. Tensions grew between the meetings, especially after President Dwight D. Eisenhower issued Executive Order 10450, which barred from federal employment those exhibiting any one of a host of unwanted characteristics, including "sexual perversion." As *ONE* noted, although "sexual perversion" clearly meant *queer*, it "did *not* say 'homosexuals deemed subversive and disloyal.'" Rather, it just meant queer people, patriots or otherwise.

Conservative Marilyn Rieger prepared a one-pager for the second constitutional session; in it, as queer historian James T. Sears details, one finds the roots of today's mainstream Gay Rights Movement. Rieger, like Call, believed that "only by coming out into the open" and "by integrating, not as homosexuals, but as people, as men and women, whose homosexuality is irrelevant to our ideals, our principles, our hopes and aspirations—that we will rid the world of its misconcepts [*sic*] of homosexuality and homosexuals."

The radicals had no chance. By the end of the first day, the constitution was stripped of virtually any reference to a "homosexual culture." Early the next morning, the Fifth Order discussed the inevitable, voting unanimously to dissolve and give the assimilationists the Mattachine name. Soon, the Mattachine Foundation was gone, and a new and decidedly separate organization emerged.

This was the Mattachine Society.

While there certainly were well-meaning moderates in the Mattachine Society, their voices often were drowned out by conservatives like David Finn, who wanted a movement "composed of ambitious, well-educated, reasonably well-integrated persons who can command respect." Without that, Finn argued, Mattachine could never help the poor "faggots" with "such a limited vocabulary they can't understand me, and are hardly the sort of persons anyone would point out with pride." Finn and Call expected these types to "adjust themselves to a respectable, productive position in the dominant culture."

At the Society's November 1953 convention, Dale Jennings went after the new generation of moderates: "Moderation is a form of fear," he declared. "We are exuberantly immoderate in our pastimes." The crowd was not pleased.

The next day, Call moved to add language to the Society's constitution protecting "the priceless integrity and freedom of the individual," which effectively erased any remnant of Harry Hay's vision of a liberation movement built on a communal homosexual experience. According to the Mattachine Society, it was all about the individual; it was all about *you*. When some delegates dissented to the proposed language, rabid anti-Communist David Finn exploded, announcing "he'd reported hundreds of 'subversives' to the FBI," and that he planned on doing the same to former Foundation members and supporters. He even claimed to have a list of names ready to give to the authorities.

The Mattachine Foundation had emerged in 1950 from a climate of fear embodied, though not created, by Senator Joseph McCarthy and his lists of subversives. Now the subversives had lists of their own, proving that some homophiles were willing to use what little power they had to punish those who disagreed with them, just like the dominant culture into which they fought to integrate. Watching his dream die, Harry Hay described assimilation as "a contract between an individual and the engulfing majority whereby the individual tailors himself (regardless of his personal independent requirements) to be acceptable to the community's arbitrary conditions."

In late 1953, on behalf of queer people across the country, the Mattachine Society signed the majority's contract.[37]

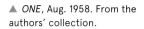

one

AUGUST 1958
FIFTY CENTS

THE HOMOSEXUAL VIEWPOINT

I am glad I am homo-sexual

▲ *ONE*, Aug. 1958. From the authors' collection.

In the spring of 1942, Los Angeles mayor Fletcher Bowron dealt a "crushing blow" to "feminine slack-wearers" when he announced that slacks were fine for women working in defense plants, but "good taste and good sense" dictated they were out of place at City Hall. The next day, Dorothy Foster, a city employee of twenty years, wore slacks to work for the first time. "I don't agree with the Mayor that women employees shouldn't wear slacks; as wartime apparel they increase our efficiency and save us money—with which we can buy bonds." Foster wore slacks again the following day. In January 1943, Chicago police arrested Evelyn "Jackie" Bross and Catherine Barscz for wearing men's clothes. When Bross, a defense plant machinist, explained that the clothes were more comfortable for work, the judge sent her to a psychiatrist.

As World War II ended and many women were forced back into strict gender norms, lesbian bars entered their heyday. "Never before have circumstances and conditions been so suitable for those of lesbian tendencies," Edythe Eyde declared in a 1947 issue of *Vice Versa*. Working-class lesbian communities came to revolve around two central figures: butches and femmes. In the 1950s, the emergence of "a new type of butch," the "tough bar lesbian," who "aggressively created a lesbian life for which she set the standards," vastly expanded the space, visibility, and vulnerability of lesbian communities. The new butch, Madeline D. Davis and Elizabeth Lapovsky Kennedy explain, "dressed in working-class male clothes for as much of the time as she possibly could," went to the bars more often, "fought back physically when provoked by straight society or by other lesbians," and sought to end the double life she and others were forced to live. The growing number of physical confrontations with straight people aggressively invading lesbian territory was rooted in the "desire to claim and hold bar space." Put another way, tough bar dykes "were creating gay space." Just by being visible, butches drastically narrowed their options for employment and upward mobility, marking themselves as "indelibly working-class," increasing stigma, and making the heterosexist world all the more hostile. But it was a matter of pride.

While police harassment of lesbian bars varied from city to city, overall, the frequency never compared with gay male spaces. When police raids happened, though, they reminded lesbians and bisexual women of their criminal status, as with the September 1954 raid and closing of Tommy's Place in San Francisco that "sparked a citywide panic."[38]

———————

Until she met Del Martin in 1950, Phyllis Lyon had never seen a woman carrying a briefcase. Living and working in Seattle, the women became friends, though it took two years of nervous courtship before they became lovers. In 1953, the native San Franciscans returned home, moving in together on Valentine's Day. As was true of many middle-class lesbians, Martin and Lyon were both repelled by bars and dependent on them for social interaction with other lesbians. In fact, they met their first lesbian friend, Rose Bamberger, at Tommy's on Broadway, the bar that replaced Tommy's Place after the 1954 raid.

In September 1955, Bamberger—a "short, brown-skinned" Filipina—called Martin and Lyon about starting a secret society for lesbians. It would be in people's homes, "so we'd be able to dance" and not "get caught up in police raids and stared at by tourists." Four couples—Del and Phyllis, Rose and Rosemary, Noni and Mary, and Marcia and June—met to discuss. At the first meeting, Noni Frey suggested the name Daughters of Bilitis, similar enough to "normal" organizations like Daughters of the American Revolution, but the reference to Bilitis (pronounced *Bill-EE-tis* as opposed to *Bill-EYE-tis*), "a mythical female who seduced the celebrated Sappho," revealed the group's true purpose for those in the know.[39]

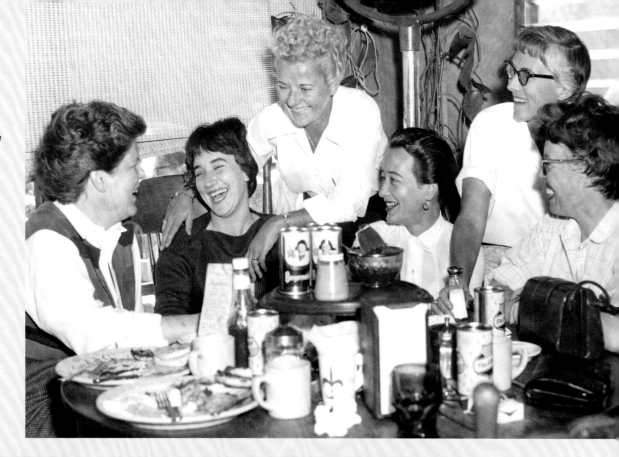

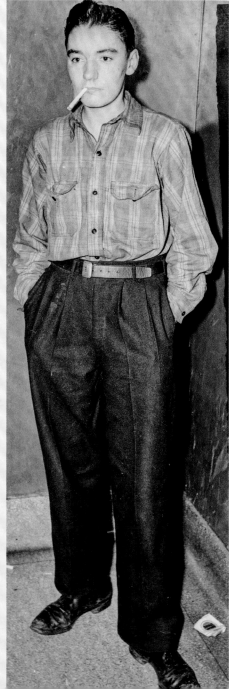

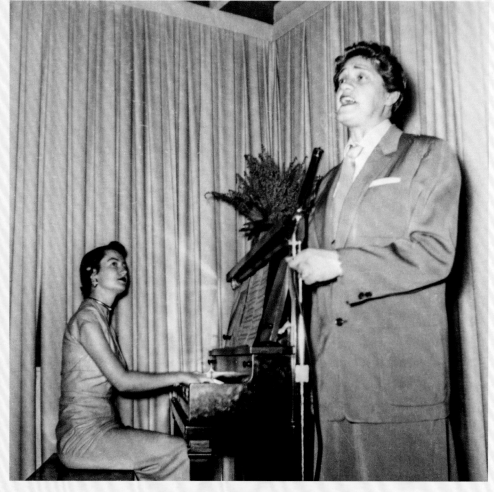

▶ **Right** Daughters of Bilitis breakfast, left to right: Del Martin, Josie,* Jan,* Marge,* Bev Hickok, and Phyllis Lyon (*last name unknown or withheld), San Francisco, c. 1956. Photo by Cecil Davis. Courtesy of Gay, Lesbian, Bisexual, Transgender Historical Society (Lyon and Martin papers).

▲ **Above** Butch-femme duet, lesbian bar (likely Tommy's), San Francisco, c. 1953. Photographer unknown. Courtesy of San Francisco History Center, San Francisco Public Library (Miller collection; GLC 69).

◀ **Left** Evelyn "Jackie" Bross arrives at a Chicago courthouse after she and Catherine Barscz were arrested for wearing men's clothes, Chicago, Jan. 1943. Photographer unknown. From the authors' collection.

From the start, the Daughters were "deeply affected by the values of the dominant society," actively distancing themselves from bar lesbians, whom they saw as "vulgar and limited." Predictably, DOB's founders clashed over purpose and membership, with some wanting the group open only to those meeting certain standards, and others wanting to welcome anyone they invited. In the end, they agreed that a member had to be over twenty-one and a "Gay Girl of good moral character." At the Daughters' first open meeting, four strangers—"very masculine-appearing types"—made the founders uncomfortable. Although Lyon and Martin later said DOB was "desperate" for members in the early days, butches weren't what they had in mind. At the second meeting, they adopted a new rule: "If slacks are worn, they must be women's slacks."[40]

In January 1956, DOB connected with the Mattachine Society (which had moved its headquarters to San Francisco), and Martin and Lyon were impressed by Hal Call's approach: "Mattachine, in its 5 years of existence, has found it much better to grow gradually, to look for quality in members rather than quantity." Later that month, the couple traveled to L.A., where they were welcomed by the homophiles at the ONE Institute;* they even talked to one woman, Stella Rush, about starting a DOB chapter in L.A. As DOB's political consciousness grew, members clashed over whether they were building a private social club or a new addition to the homophile movement. Of the founders, only Lyon, Martin, and Noni Frey remained by summer of 1956, and Frey stayed only a few months longer. With encouragement from new members, Lyon and Martin "decided to throw a party to give DOB one more try." It worked. In June 1956, Martin announced the start of "an all-out publicity campaign," including plans for a newsletter. The group also crafted a statement of purpose with four broad goals: "self-knowledge and self-acceptance; public education; involvement in research; and lobbying to change the laws criminalizing homosexuality."

> I wish the homosexual
> revolution would hurry up!
> It is so desolate, this
> hiding in the catacombs.
> —J. M., 1963

It's clear that the Mattachine Society's conservative approach greatly influenced DOB. The Daughters' statement of purpose, for example, closely tracked Mattachine's, with a focus *not* on staking out distinct queer identities but instead working "to prove that lesbians and gay men were no different from other people." By "no different," DOB meant having "a mode of behavior and dress acceptable to society." Moreover, like Call's Mattachine, which started the *Mattachine Review* in 1955, DOB began publishing its own magazine, *The Ladder*, in 1956. But Mattachine's influence on DOB members often is overstated, glossing over *the* key distinction that made the Daughters' undertaking far more difficult: they were women. To straight society, lesbians were female (and therefore weak) and not heterosexual (and therefore threatening); to gay men, lesbians were of no sexual consequence (which greatly diminished their value) and were viewed as exempt from the "real problems" of police harassment and violence (and therefore had it easy).

It goes without saying that women face a steeper climb regardless of the journey, and lesbians and bisexual women, who threaten the social order, neither had nor have it easier than gay men. Any upwardly mobile women who identified *as* lesbians, whether at the bars or in the Movement, bravely attempted to break down stone walls in their

* In the fall of 1955, W. Dorr Legg and Jim Kepner, with assistance from Julian "Woody" Underwood, Merritt Thompson, and British philosopher Gerald Heard, organized the first classes offered at the ONE Institute of Homophile Studies. Legg in particular bemoaned the "tremendous gaps existing in higher education . . . concerning the homophile's place in history and his true status." The Institute's founders attempted "a specialized study of the whole field of homosexuality," including, as historians Lillian Faderman and Stuart Timmons explain, "history, biology, psychology, anthropology, sociology, law, religion, philosophy, world literature, and 'problematics'—which taught students how to apply their new knowledge to create strategies and goals for the homophile movement."

personal and professional lives, often at great risk to both. With that said, DOB's leaders defended their middle-class privilege zealously, working for many years to limit membership to those who fit a certain standard of "respectability."[41]

New York psychologist Sam Morford first heard of the Mattachine Society in 1956 from Dr. Evelyn Hooker, whose groundbreaking studies on the mental health of gay and bisexual men were the first to take "normal" gays into account. Before Hooker, virtually every related study in the United States had focused on individuals who sought, or were required to seek, "treatment" for their "sexual deviance," an approach roughly equivalent to analyzing the risks of getting cancer from smoking by studying only those smokers who'd been diagnosed with cancer. Dr. Hooker, with the help of gay friends, took it upon herself to study "normal" homosexual men (i.e., those *not* in treatment) and in so doing "rocked the profession by demonstrating that gay men were just as sane as straight men." A popular conference speaker, Hooker often directed the queer people she met to *ONE*, the Daughters of Bilitis (DOB), and Mattachine; that's how Sam Morford met the Mattachine leadership and got a charter for a New York chapter in April 1956. The East Coast homophile presence grew quickly, as did tensions between East and West Coast leaders. In Washington, the militant B. Dwight Huggins founded the first D.C. Mattachine, though he rankled the national leadership from the outset. In one incident, Huggins was reprimanded for his fiery reply to the angry resignation of a D.C. member: "I know your own project of 1924 went by the board," Huggins wrote, "but maybe that was because of you. You'll have to try harder next time and not make an ass out of yourself." Although he never returned to Mattachine, the letter's recipient, Henry Gerber, continued to support the homophiles.[42]

In August 1956, while attending meetings of the American Astronomical Society in San Francisco, a Harvard-educated astronomer was arrested at a well-known cruising spot. As most would in that situation, he paid a fine and took probation in order to have the complaint dismissed. About a year later, however, after government investigators uncovered his original arrest record, the man lost his job with the U.S. Army Map Service, along with any chance of ever working for the government again. With few other options, Frank Kameny decided to fight back.

Two weeks after Kameny's arrest, seventeen people gathered in a San Francisco home for the monthly meeting of the DOB, with much discussion centered on the upcoming inaugural issue of *The Ladder*. The Daughters also talked about a recent crackdown on the city's gay bars, and a guest from Philadelphia told of her recent trip to Europe. Barbara Gittings, the guest from the East Coast, also informed DOB that the group's reference to Bilitis hid its purpose and identity behind "a not-very-good book about an ancient fictional character who was not even lesbian but bisexual." Although Gittings took

▶ Mattachine Society of New York pinback, late 1960s. From the authors' collection.

LOVE THE MATTACHINE

issue with DOB's goal of helping the lesbian "adjust" to society—which she called "a scolding teacher approach"—she dedicated her life to the organization, cofounding the New York chapter in 1958.

Despite nearly crossing paths in 1956, Gittings and Kameny wouldn't meet until 1963. Five years after that, Gittings seconded Kameny's motion to adopt "GAY IS GOOD" as the motto of the national homophile movement.

By then, they'd changed everything.[43]

When the first issue of *The Ladder* appeared in October 1956, Phyllis Lyon hoped the magazine would encourage women "to take an ever-increasing part in the steadily-growing fight for understanding of the homophile minority." Although women "may not have so much difficulty with law enforcement," Del Martin wrote, "their problems are none the less real." She urged readers to get involved, reminding them that "nothing was ever accomplished by hiding in a dark corner."

"I'm glad as heck that you exist," wrote a New York–based *Ladder* reader in April 1957. "As one raised in a cultural experience (I am a Negro) where those within were and are forever lecturing to their fellows about how to appear acceptable to the dominant social group, I know something about the shallowness of such a view as an end in itself." The letter writer, playwright Lorraine Hansberry, offered Martin and Lyon a number of "off-the-top-of-my-head reactions" relating to social difference and, in the process, developed what historian Kevin J. Mumford identifies as a "founding theory of black feminist intersections." By "juxtaposing the progress of the civil rights movement against the question of lesbianism," Hansberry "compared the dictates of black respectability to the homophile's pursuit of a kind of respectable integration."

"What ought to be clear," Hansberry wrote, "is that one is oppressed or discriminated against because one is different, not 'wrong' or 'bad' somehow." And, like her "personal discomfort at the sight of an ill-dressed or illiterate Negro," she longed for a time when "the 'discreet' Lesbian" would not turn away from "the 'butch' strolling hand in hand with her friend in their trousers and definitive haircuts."[44]

Lyon and Martin visited New York in November 1958 and met Hansberry, whom they described as "very nice," but unable to get more involved. By that time, the Daughters of Bilitis (DOB) had tripled in size, with chapters

◀ *The Ladder*, Oct. 1956. From the authors' collection.

founded in L.A. by Helen "Sandy" Sandoz and Stella Rush, and in New York by Barbara Gittings and Marion Glass. While the Daughters tried with some success to reach queer women of color, the group remained open only to lesbians who fit a certain mold. Audre Lorde, who was "young and Black and gay and lonely" in Greenwich Village in the 1950s, said "one read *The Ladder* and wondered where all the other gay-girls were." Because the homophile movement didn't reach out to the "exotic sister-outsiders" of Lorde's world, "we tried to build a community of sorts where we could." Thus, even with homophiles' attempts at traditional organizing, much of queer history was made in homes with curtains drawn and in bars with no windows, on dimly lit streets, with furtive glances, and through coded letters.

But the fact that queer people were organizing at all was significant, as were the attempts at collaboration between gay men and lesbians. Sensing it was "in the self-interest of the Lesbian" to try to "help shape policy of the homophile movement as a whole," DOB participated in a number of Mattachine events, although lesbian input was often ignored. During Mattachine's annual convention in Denver in September 1959, for example, despite the strenuous objection of Lyon and Martin, delegates adopted a resolution praising San Francisco mayor George Christopher, who was running for reelection against Russell Wolden.

▲ *The Ladder*, Nov. 1959. From the authors' collection.

The following month, a San Francisco paper attacked Mayor Christopher for claiming he'd "cleaned up" the city. According to the article, while minor crimes were down, Christopher had allowed "another form of vice—homosexualism—to flourish," turning San Francisco into "the national headquarters of sex deviates." It was so bad, the paper reported, that a recent "convention of deviates" in Denver had passed a resolution praising Christopher for San Francisco's "favorable climate." As it turned out, Wolden, the mayor's opponent, had planted the story in hopes of "really stirring Joe and Suzy San Francisco's emotions." Given the cultural climate across the country, the stunt might have worked. In San Francisco, though, Wolden's "gutter politics" backfired, *not* because San Franciscans were tolerant, but because they didn't want to be publicly associated with homosexuals. Whether the majority liked it or not, however, the city was headquarters for at least *some* sex deviates, including the Mattachine Society and the Daughters of Bilitis, along with countless other queer people subtly attacking the era's suffocating norms.[45]

Had the delegates at Mattachine's Denver convention listened to Martin and Lyon, who saw the proposal as a risk without reward, Wolden may never have "violently interjected" the topic of homosexuality into the mayoral campaign. But the resolution passed, and Wolden soon launched his unsuccessful "sexual deviates" attack, which

DOB's leaders assumed would strike fear into the hearts of most of the traditionally timid Daughters. Instead, the DOB rank and file overwhelmingly wanted "to stand our ground," unafraid of publicity or even violence.

The attacks were growing less subtle.[46]

When police raided his popular L.A. gay bar on August 17, 1968, Lee Glaze snapped.

"It's not against the law to be homosexual, and it's not a crime to be in a gay bar!" Glaze shouted, as police arrested two patrons of The Patch.

"Is there a florist here?" A few hands shot up. "I want to buy all your flowers." Glaze didn't actually buy *all* of the flowers; he left the pansies.

Arriving at the police station, flamboyantly gay Glaze and a group of bouquet-wielding homosexuals, including a young minister named Troy Perry, marched to the desk and demanded the release of their sisters.

"What are your sisters' names?"

"Tony Valdez and Bill Hastings."

> If they close our clubs, we'll all have to take to the streets.
> —Lee Glaze, 1968

That night, a group of smiling queer people merged the resistance of *old*—a century of subtle attack launched by fairies, bar dykes, and queens who'd claimed space in a hostile world—and *new*—the second wave of homophiles who'd worked to change hearts and minds by appealing directly to oppressive institutions. The *old* had made it possible for Glaze and company to wear their queerness for the world to see, and the *new* gave them the courage to demand fairness. And, if the reaction that night was any indication, the *Los Angeles Advocate* said, "a new era of determined resistance may be dawning."[47]

Eight years earlier, no one had imagined a time when flower-wielding fags would demand the release of their sisters and win. In fact, as the 1960s started, Frank Kameny just wanted his job back. A brilliant, logical, and infinitely stubborn man, the D.C. resident tried asking the government to look at him as an individual: "consider ME," he wrote, "and not just a disconnected fact or two about my background." But it wasn't about *him*; it was about his homosexuality.

Having run out of money to pay attorneys' fees, Kameny was desperate but determined. With his only appeal left leading to the United States Supreme Court, he decided to represent himself, producing a monumental legal brief in 1960 that revealed, with a scientist's precision, the government's inability to justify its anti-queer policies. Shifting the focus away from himself as an individual, Kameny brought attention to the queer community, writing on behalf of "10% of our population at the very least" and calling the government's policies:

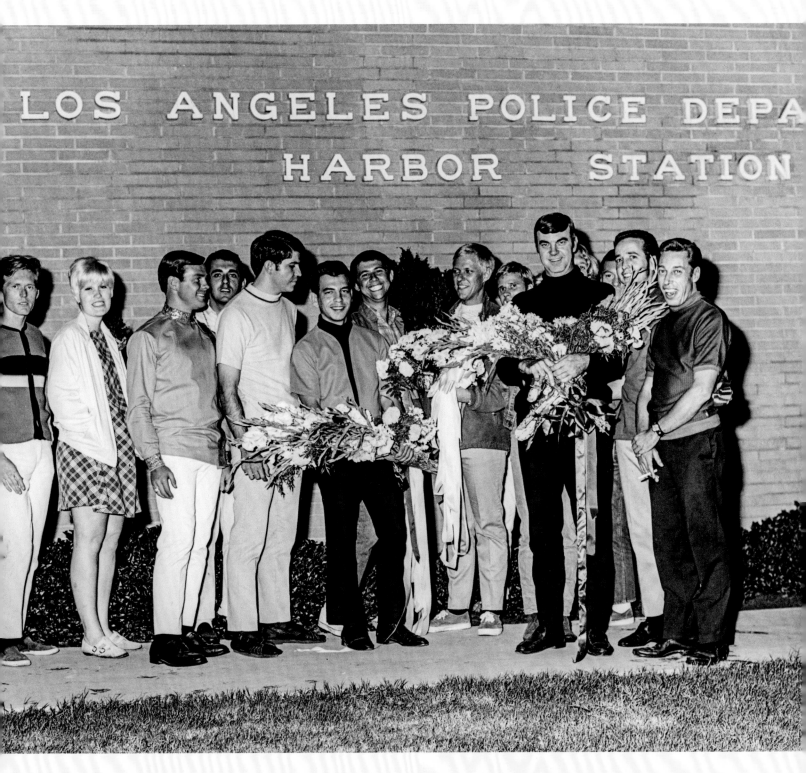

▲ The Patch protesters gather outside the Los Angeles Police Department's Harbor Station after the release of Tony Valdez and Bill Hastings (Reverend Troy Perry is at center, looking to his left at Valdez, who is holding a bouquet and smiling at the camera; Lee Glaze, owner of The Patch, is two people to Valdez's left, holding flowers; Bill Hastings is the tall man in all-dark to Glaze's left), Los Angeles, Aug. 1968. Photo by David of California. Courtesy of the ONE Archives at the USC Libraries (Advocate records; 2012-030).

a stench in the nostrils of decent people, an offense against morality, an abandonment of reason, an affront to human dignity, an improper restraint upon proper freedom and liberty, a disgrace to any civilized society, and a violation of all that this nation stands for.

The glee with which Kameny attacked authority always set him apart, and he was particularly good at using the oppressors' language to serve the oppressed. "If society and I differ on anything," he once told his mother, "I will give society a second chance to convince me. If it fails, then I am right and society is wrong, and if society gets in my way, it will be society which will change, not I."

In March 1961, when the Supreme Court refused to hear his case, society got squarely in Frank Kameny's way.[48]

The same month, the national Mattachine Society dissolved, no longer able to handle tensions between East and West Coast leaders. Almost immediately, a number of independent chapters emerged, including the Mattachine Society of New York (Mattachine-NY). The Daughters of Bilitis (DOB), on the other hand, kept growing. "If we ever hope to win our battle," a frustrated *Ladder* reader, Del Shearer, wrote in April 1961, "we must fight." Soon enough, she founded a DOB chapter in Chicago.

That spring, Kameny and another gay man in D.C., Jack Nichols, contacted Mattachine-NY's Al de Dion and Curtis Dewees with questions about establishing a chapter in Washington. On August 1, 1961, as a small group gathered for an informal organizational meeting at the Hay-Adams Hotel in D.C., an attendee told Kameny that a vice cop was in the room. "I know who you are," Kameny barked at Sergeant Louis Fouchette. Speechless, Fouchette quickly left. In the report he filed that day, Fouchette made one thing clear: homosexuals were organizing.[49]

Two weeks later, police arrested over a hundred people at San Francisco's Tay-Bush Inn. In a rare show of solidarity with the bar crowd, Hal Call announced that the newly independent local Mattachine Society was "prepared to fight this through the courts." But given his conservative reputation, some doubted Call's sincerity. And with good reason. Asked a few weeks later what "other homosexuals think about the so-called 'queens,'" Call reported that "the 'swish,' or the 'queen' represents actually a small minority within the whole homosexual grouping." In most cases, he said, femmes "are not even liked by the rest of their homosexual brethren."

José Sarria was pissed. The local Mattachine, he declared, "is catering to the lawyers and the doctors, and not to the peasants," even though the peasants "are the ones who are getting arrested." As police raids continued, Sarria established the League for Civil Education (LCE), focusing on the civil rights of queer people in and out of the bars. To Sarria, running for local office seemed like the logical next step. "The world knew that I was gay," he said, "and I was going to run as a gay man."

Sarria was one of thirty-three candidates running for five San Francisco city supervisor seats in November 1961. Coming in ninth, he made his point. "From that day," Sarria recalled, "at every election, the politicians in San Francisco have talked to us."[50]

The following week, on November 15, 1961, Kameny and Nichols held the first official meeting of the Mattachine Society of Washington (D.C. Mattachine), adopting a statement of purpose that committed members to act "by any lawful means" to secure basic rights for queer people. As a "political transformist," Kameny merged the competing ideals of culturalists and assimilationists: queers have a right to be different, just like everybody else.

Because government infiltration of homophile groups was a real threat, D.C. Mattachine had a strict screening process for new members. Other than that, the group made little effort to hide. In fact, Kameny announced the group's formation in an August 1962 letter to President John F. Kennedy, all of his cabinet members, and *every* member of Congress. This had consequences. When a local paper reported that D.C. Mattachine had been granted a fund-raising license, Congressman John Dowdy (D-Texas) rushed to introduce a remedial bill to revoke it, arguing that a group "whose illegal activities are banned under the laws of God, the laws of nature, and are in violation of the laws of man" couldn't be allowed "to promote their sexual deviations."

But Kameny and the other D.C. homophiles jumped at the chance to fight, contacting the city commissioners, the American Civil Liberties Union (ACLU), and the *Washington Post*, all of which came out against Dowdy. Even better, when D.C. Mattachine asked for a chance to testify, Dowdy accepted. Kameny would be the first openly gay person to speak in front of a congressional committee, and Dowdy's bill didn't pass.[51]

In October 1962, just after D.C.'s deviates enraged Congressman Dowdy, seventy-five self-identified heterosexual male transvestites, all subscribers to L.A.–based magazine *Transvestia*, made their way to the Chevalier d'Eon (later known as Casa Susanna), a secluded Catskills resort owned by Susanna Valenti (a cross-dressing male who sometimes went by her assigned name, Tito) and her wife. Valenti's guests particularly looked forward to seeing *Transvestia*'s editor, Virginia Prince.

Prince was complicated. Through her magazine and the organizations it spawned—the Hose & Heels Club and the Foundation for Personality Expression—she preached a conservative view on gender and sexuality. Namely, she believed there were inherently "male" and "female" performative characteristics—dress and mannerisms—and that men who expressed "female" characteristics were more enlightened than others. It had *nothing* to do with homosexuality, Prince stressed, and even less to do with transsexuality. In 1963, *Turnabout*, another transvestite magazine, appeared, though it provided space for relatively more liberal views. Nonetheless, most of those speaking for the emerging community of transvestites identified as heterosexual men.

In May 1965, for example, Susanna Valenti responded to the argument that women are an oppressed minority, writing in *The Ladder*: "Come on, honey! Women run the

> If you are going to appear in society as a woman, don't just be a female—be a lady.
> —Virginia Prince, 1961

world and you know it! Their acceptance of the mold which you say men have forced them into is only strategy, marvelous feminine strategy." She didn't stop there. "No, my dear, women have all the breaks. How many times has a woman solved an important problem just by putting on a good cry?" The truth, she said, was that women had forced men to stay within the "rigid frame" of masculinity, "while she keeps for herself all the freedom she wants in life."

As a new generation of lesbian activists came of age, self-identified cross-dressing men like Susanna Valenti provided an exceedingly limited introduction to the perspectives of transgender people.[52]

That Susanna Valenti was published in *The Ladder* at all shocked some readers. But, as of early 1963, *The Ladder*'s new editor, Barbara Gittings, was making a number of radical changes. Soon, a bold subtitle—*A Lesbian Review*—appeared. Gone were the cover illustrations of stick figures climbing ladders into enlightenment; now there were *actual* lesbians. Starting in late 1964 with a photo of "Ger van Braam," a reader from Jakarta, portraits of lesbians became a regular feature, with Kay (Tobin) Lahusen taking most of the photos. Lahusen, an essential addition to DOB, joined the group after meeting, and falling for, Gittings in August 1961. With Gittings focused on *The Ladder*, Shirley Willer, a Chicago transplant and the recently elected president of the Daughters' New York chapter (DOB-NY), took over local DOB operations, with assistance from her lover, Marion Glass.

In early 1963, Frank Kameny's calls for regional coordination produced meetings between Mattachine-NY, D.C. Mattachine, DOB-NY, and Philadelphia's Janus Society. This loose confederation—the East Coast Homophile Organizations (ECHO)—planned a Labor Day convention. This first gathering—"Homosexuality: Time for Reappraisal"—was a minor success and notably brought Kameny and Gittings together for the first time.

Around the same time, Del Martin and Phyllis Lyon met Reverend Ted McIlvenna, a San Francisco minister working with young runaways and the chronically underhoused in the city's Tenderloin neighborhood. After a DOB-sponsored discussion with McIlvenna in early 1964, Lyon and Martin participated with clergy members and other homophile leaders in a weekend retreat, the "greatest accomplishment" of which, the couple wrote, "was the breakdown of stereotypes on both sides and the recognition of a common humanity." Soon, more clergy joined homophiles like Lyon, Martin, and Hal Call to form the Council on Religion and the Homosexual.[53]

By the summer of 1964, New York's Randy Wicker and Craig Rodwell had joined the East Coast insurgency that was rankling more established homophiles from D.C. to San Francisco. Wicker, who'd made waves in Mattachine for years, was a combative militant who'd been among the first gay men willing to publicly self-identify on television and radio, much to the dismay of the old guard. Rodwell, for his part, threw his whole

life into the Movement after his militancy scared off his lover, a closeted banker named Harvey Milk.

In July 1964, Frank Kameny addressed Mattachine-NY, announcing "like a fiery Old Testament prophet" that a militant approach was the only way forward. "It is absolutely necessary," he emphasized, "to be prepared to take definite, unequivocal positions upon supposedly controversial matters." Kameny also believed homosexuals had to *demand* their rights. "These rights *are* ours," he declared, meaning the "established framework of authority must be challenged directly by every lawful means at hand."

The speech sent activists to the streets. In September, Wicker and Rodwell led a small picket at New York's Whitehall Induction Center to protest the U.S. Army's refusal to protect the confidentiality of gay and bisexual draftees. Kameny, who'd declared "the entire homophile movement is going to stand or fall upon the question of whether or not homosexuality is a sickness," also inspired Wicker to confront psychiatrist Paul Dince at one of his lectures, titled "Homosexuality: A Disease." In the first-known public attack on the pathologization of homosexuality, Wicker demanded to know "what kind of 'scientific research' is it that only looks at homosexual patients—people who are in therapy because they're so miserable—and then makes statements about the whole population of homosexuals?" Within months, Kameny and D.C. Mattachine adopted a revolutionary policy that, without valid evidence to the contrary, "homosexuality is not a sickness, disturbance, or other pathology in any sense, but is merely a preference, orientation, or propensity, on par with and not different in kind from, heterosexuality."[54]

When Craig Rodwell and Jack Nichols heard reports in the spring of 1965 that Fidel Castro planned to imprison queer Cubans, they saw an opportunity to draw attention to the homophile cause at home. On April 17, 1965, ten people—three women and seven men—gathered in Lafayette Park and walked across Pennsylvania Avenue to the White House. The group, conservatively dressed and carrying perfectly lettered signs— courtesy of Lige Clarke, Nichols's lover—with messages such as "15 MILLION U.S. HOMO-SEXUALS PROTEST FEDERAL TREATMENT," formed an orderly oval and marched for an hour before leaving with little fanfare. They'd given no warning, so they received virtually no press.

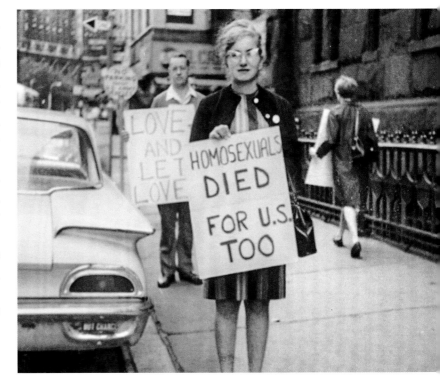

"We'd hoped for more publicity than we got," Nichols recalled. "But we'd done it, and that was what mattered."

The following day, twenty-nine activists picketed the United Nations in Manhattan.

▲ Renée Cafiero (front) and Jack Diether protesting the U.S. Army's refusal to protect queer draftees' confidentiality, Whitehall Induction Center, New York City, Sept. 19, 1964. Photo by Randolfe Wicker. Courtesy of Manuscripts and Archives Division, The New York Public Library; used with permission from R. Wicker.

A few days later, the owners of Dewey's Famous malt shop at 17th and Chancellor Streets in Philadelphia announced they'd no longer serve "homosexuals and persons wearing non-conformist clothing," despite their large base of queer customers. In response, Clark Polak of the Janus Society organized a direct action campaign, starting with a hundred-person sit-in on April 25. After days of pressure, Dewey's relented.*

In May, the East Coast Homophile Organizations (ECHO) again picketed the White House, and in June, they targeted the U.S. Civil Service Commission. Then, on July 4, 1965, activists gathered at Philadelphia's Independence Hall for the first of what turned out to be five "Annual Reminder Days," so named because Craig Rodwell wanted to remind the country that homosexuals still lacked basic rights. For the first time, queer activists had committed themselves to an annual event—same time, same place—at which they'd publicly confront the dominant culture. The Reminder Days, in other words, were the rock on which Gay Pride events were built. Later in July 1965, ECHO picketed the Pentagon, followed by the State Department in August, an action that garnered the homophiles their most significant press attention yet.

With the second ECHO convention approaching, there seemed "to be a militancy about the new groups and the new leaders." There was "a different mood."[55]

◀ **Left** Pinback, design by Randolfe Wicker, c. 1965. From the authors' collection.

In a report on the ECHO conference, a member of the Daughters of Bilitis wrote: "Randolfe Wicker, who couldn't come in person, sent along his controversial lapel buttons which say in lavender letters EQUALITY FOR HOMOSEXUALS. Some people at ECHO wore these buttons, but most displayed the red-and-white ones with the smart ECHO symbol." The author then described being on an elevator with a group of homophiles and a straight couple when the straight woman asked what ECHO meant; after telling her, one of the homophiles felt particularly emboldened, saying, "Here's [a] button that you may not have seen . . . It says EQUALITY FOR HOMOSEXUALS." The homophiles fell out of the elevator laughing. "ECHO Report '64, Part One: Sidelights of ECHO," *The Ladder* 9, no. 4 (Jan. 1965).

▶ **Opposite** ECHO members (including Barbara Gittings, front, and Ernestine Eckstein, fourth from front) picket the White House, Washington, D.C., Oct. 23, 1965. Photo by Kay (Tobin) Lahusen. Courtesy of Manuscripts and Archives Division, The New York Public Library.

* Although the Dewey's protests were related to, and informed by, ECHO's organizational efforts, Susan Stryker explains that the incident also "demonstrates the overlap between gay and transgender activism in the working-class districts of major U.S. cities in spite of tensions and prejudice in both groups." Just after Dewey's, the Janus Society published a remarkable statement, lambasting the "tendency to be concerned with the rights of homosexuals as long as they somehow appear to be heterosexual, whatever that is. The masculine women and feminine men often are looked down upon."

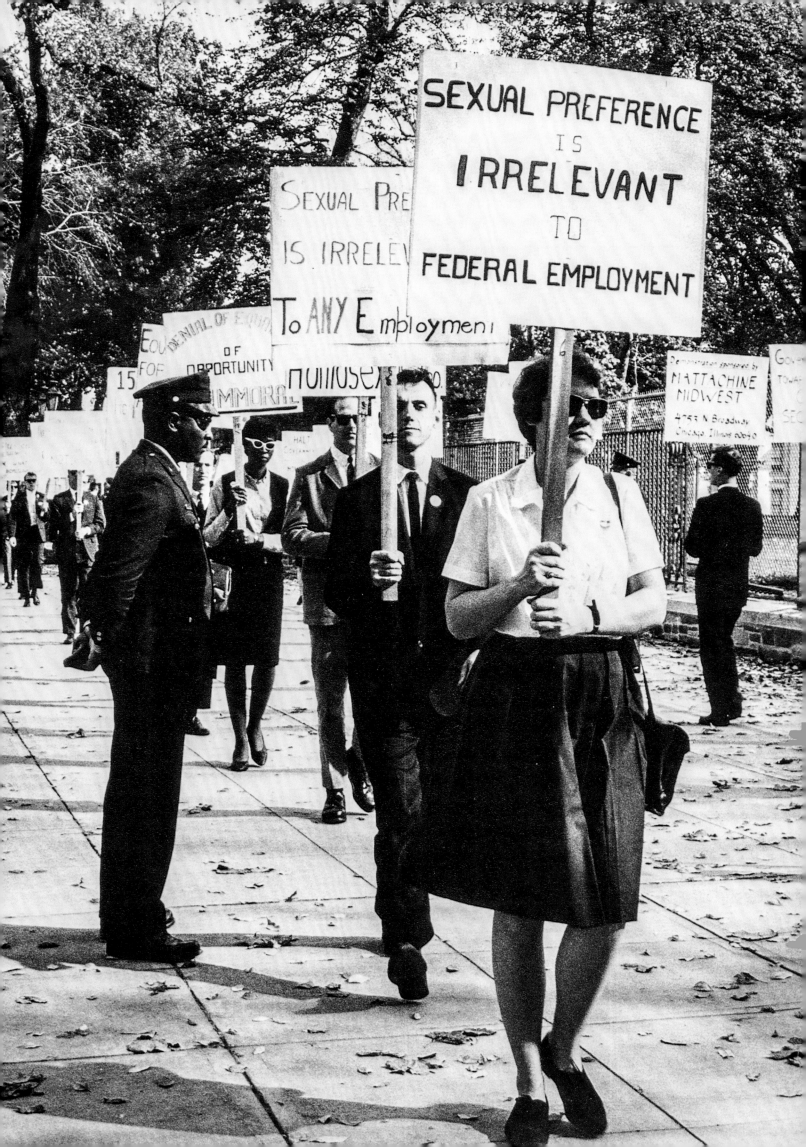

In San Francisco, Del Martin and Phyllis Lyon were adrift by late 1964. They'd had it with Barbara Gittings, who'd changed *The Ladder* with little regard for procedures that didn't suit her and forged ahead with an East Coast Homophile Organizations (ECHO) alliance that made many uncomfortable. To some, the ECHO insurgency was a threat to Daughters of Bilitis (DOB)'s lesbian-only autonomy (and a violation of DOB's constitution, which precluded the organization from partnering with other groups except by a two-thirds vote of the membership); to others, it was a battle over territory and personality; to many, it was both. Martin and Lyon, having long sought "understanding and Christian concern," focused instead on the Council on Religion and the Homosexual (CRH). As 1965 neared, Martin was nostalgic about DOB—"it's been fun"—but excited for CRH, "the biggest breakthrough in many years." Others saw hypocrisy in the CRH alliance, noting the whole thing had "shades of the debate" over ECHO.

At the time, CRH was busy planning a New Year's Mardi Gras Ball, an unprecedented fund-raiser scheduled for the night of January 1, 1965. Straight organizers even negotiated a truce with police for that night. The police, however, had no intention of honoring the agreement. As ball goers, resplendent in drag, arrived at the Ball, "the vice squad openly declared war," and police floodlights and photographers caused the expected crowd of fifteen hundred to drop to (a still impressive) six hundred. When vice officers tried to enter the Ball itself, attorneys Herb Donaldson and Evander Smith demanded the cops buy tickets or get a warrant; they were promptly arrested. None of this shocked San Francisco's queer community, but "the police had never played their hand before Mr. Average Citizen," Martin said. Straight liberals were pissed.

"We have a civil rights issue by the tail," Martin wrote to Gittings, whose participation in ECHO—a civil rights organization—had caused so much concern. "There is no time for debate."[56]

Whether or not Del Martin had time, debates were brewing, and in May 1965, they exploded when *The Ladder* ran Frank Kameny's "Does Research Into Homosexuality Matter?" Participating as research subjects was long a part of homophile activism, and a handful of doctors—Evelyn Hooker, Harry Benjamin, Alfred Kinsey—contributed to relatively positive changes in attitude and policy; nonetheless, the emphasis on research reinforced the homosexuality-as-illness theory.

The burden of proof, Kameny wrote, was on those claiming homosexuality was a disease. "We do not have to prove health," and since "they have not shouldered their burden of proof, we are not sick." In a remarkable rebuke to the medical establishment, Kameny declared that because homosexuals are the "true authorities" on homosexuality, "we ARE right; those who oppose us are both morally and factually wrong." It

was time, he felt, to "DEMAND our rights, boldly, not beg cringingly for mere privileges, and not be satisfied with crumbs tossed to us."

Homophiles needed to take their demands public; homophiles needed to picket. But the picketing issue alienated cautious members of the Daughters of Bilitis—who were "keenly aware" of the male-dominated Mattachine's efforts to control strategy—and infuriated conservative Daughters, who saw picketing as the work of "dirty, unwashed rabble." "My position," Chicago's Del Shearer wrote in a blistering letter of resignation from DOB, "is that picketing by homophile groups at this time or in the very near future is ridiculous if not utter insanity." Shearer pointed to differences between the homophiles and the "Negro cause"—including what she perceived to be the lack of a history of resistance ("a century of subtle attack," she called it) among queer people—as barriers to successful homophile protests.

The issue came to a head during an ECHO meeting in June 1965, when DOB delegates moved to ban picketing as "contrary to the policy or welfare" of their organization. When the motion failed, DOB withdrew from the conference. Writing to Martin and Lyon the next day, Kameny predicted, with "the kindest of feelings," that, if they failed to "keep up with the movement," DOB would "go 'down the drain' as a meaningful organization."[57]

ECHO continued to coordinate with a growing number of homophile groups, including several from San Francisco. At the fall 1965 ECHO conference in D.C., the East Coasters were joined for the first time by representatives from Bay Area organizations, including the Tavern Guild, the Council on Religion and the Homosexual, and the Society for Individual Rights (S.I.R.). Bill Beardemphl, S.I.R.'s delegate, was a particularly popular presence among the East Coast activists, offering tips on how the radical new S.I.R. used weekly dances to engage hundreds of young San Franciscans. Before adjourning, the delegates agreed to meet in Kansas City in early 1966 to build on their collective organizational success.[58]

As planned, an even larger group of homophiles gathered in Kansas City in February 1966. Looking around the room, one could almost forget the previous fifteen years of infighting. Del Martin and Phyllis Lyon were there; so were Barbara Gittings and Kay (Tobin) Lahusen; Clark Polak and Shirley Willer talked; and Frank Kameny mingled with Hal Call. Jack Nichols, Mark Forrester (Council on Religion and the Homosexual), Bill Kelley (Mattachine Midwest), Larry Littlejohn and Bill Beardemphl (S.I.R.), and representatives of the Tavern Guild and certain DOB chapters also attended. Even *ONE* and *Tangents*, the separate magazines that had emerged out of the very public dispute between *ONE* founders Dorr Legg and Don Slater, sent representatives.

On February 19, the newly named National Planning Conference of Homophile Organizations (NPCHO) considered a proposal from Forrester and CRH for "nationwide meetings" to discuss the U.S. military's anti-queer policies, which not only banned queer people from entering the armed forces but continued to ruin the lives of servicemembers discovered to be queer. Although some homophiles questioned why they'd want to participate in what many in the United States increasingly saw as a morally

bankrupt military machine, the plan for regional organizational meetings on Armed Forces Day in May passed. As an olive branch from DOB, Shirley Willer offered to host a second NPCHO meeting, coinciding with the Daughters' annual August gathering. It was time, NPCHO said in a press release, for the American public to "re-examine its attitudes and its laws concerning the homosexual."[59]

L.A.'s *Tangents* contingent—who'd already been fighting the military's ban on homosexuals—welcomed the Armed Forces Day plans, knowing exactly who should organize the city's efforts: Harry Hay.

Although he'd kept a low profile since the Mattachine Foundation crumbled, time had by no means moderated Hay, who'd watched with approval as militants roiled the conservatives who'd dethroned him. Asked to participate in NPCHO's plan, Hay unsurprisingly pushed the envelope, eschewing organizational meetings in favor of direct action. Under his direction, L.A.'s May protests included a thirteen-car motorcade through Hollywood and other areas, with each car carrying a large four-sided protest sign. The remarkable parade reinvigorated Hay and the other older homophiles. "I can honestly say that I did not expect to see such a public demonstration on behalf of homosexuals in my lifetime," Hay told *Tangents*.

Martin and Lyon picketed with dozens of others in San Francisco, and there were small demonstrations in Philadelphia, New York City, and D.C. In Kansas City, the Phoenix Society had an organizational meeting rather than a demonstration, but it was a start.[60]

Of the major homophile groups, only Mattachine-NY opted out of the Armed Forces Day actions, though the New Yorkers made waves of their own that spring. On April 21, 1966, John Timmons, Craig Rodwell (who'd technically quit Mattachine-NY over its conservative strategies), and Mattachine-NY president Dick Leitsch headed to the Lower East Side's Ukrainian-American Village Restaurant with plans to challenge the Depression-era liquor regulations prohibiting "disorderly" conduct, which in practice made virtually every bar unsafe for queer people. With a few members of the press in tow, the activists planned to walk in, identify themselves as homosexuals, and order drinks. If refused service, they'd sue, arguing the liquor regulations were discriminatory.

The Ukrainian-American Village Restaurant, with its prominently placed sign reading, "If You Are Gay, Please Go Away," was the perfect target, until management heard about Mattachine-NY's plan and closed for the day. At a nearby Howard Johnson's, the activists, with Randy Wicker having joined them, climbed into a booth, declared themselves homosexuals, and ordered drinks. Laughing hysterically, the manager served them. At the Waikiki on 6th Avenue, they again were served. The press was losing interest.

At Julius', a *very* discreet gay bar, Leitsch quietly explained the situation to the manager, promising to provide any legal assistance required as a result of the stunt. With that, the manager refused them service, sheepishly saying, "I think it's against the law." The "Sip-In," as the *New York Times* dubbed it, gave rise to legal challenges that put the first cracks in the stone wall of the state's anti-queer regulations.[61]

▶ Del Martin addresses demonstrators during the Armed Forces Day protests, San Francisco, May 21, 1966. Photographer unknown. Courtesy of Gay, Lesbian, Bisexual, Transgender Historical Society (Lyon and Martin papers).

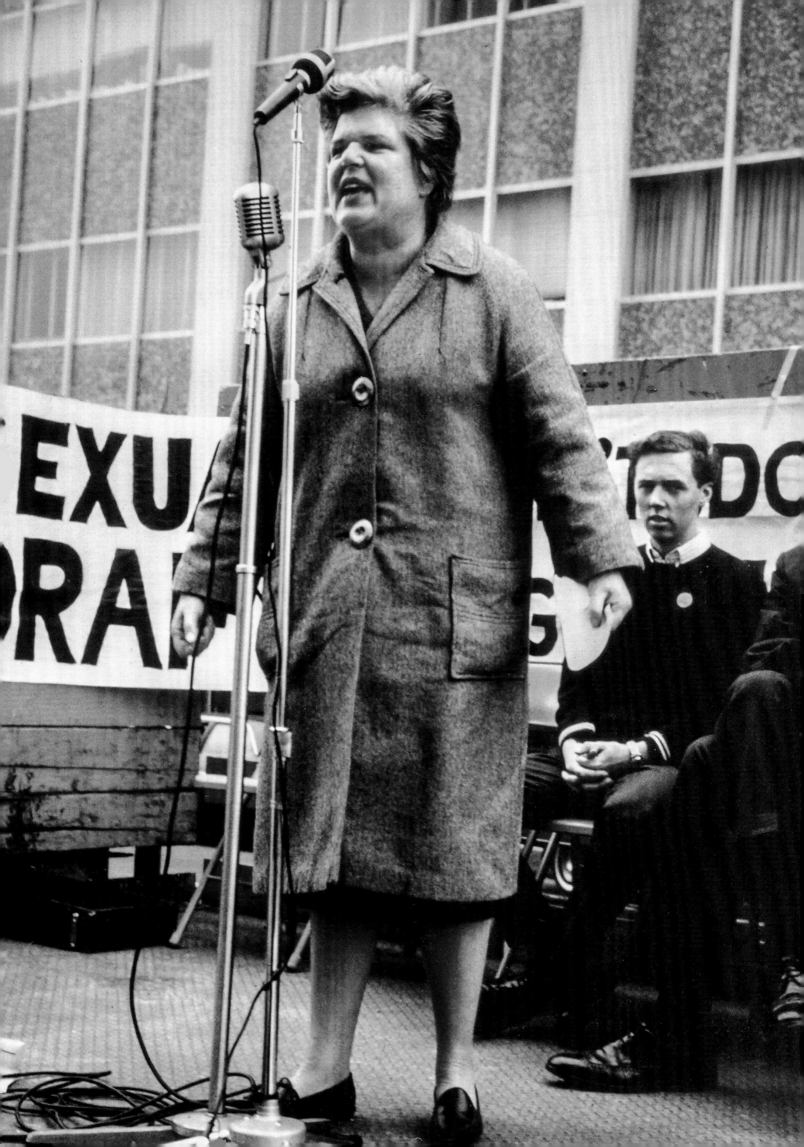

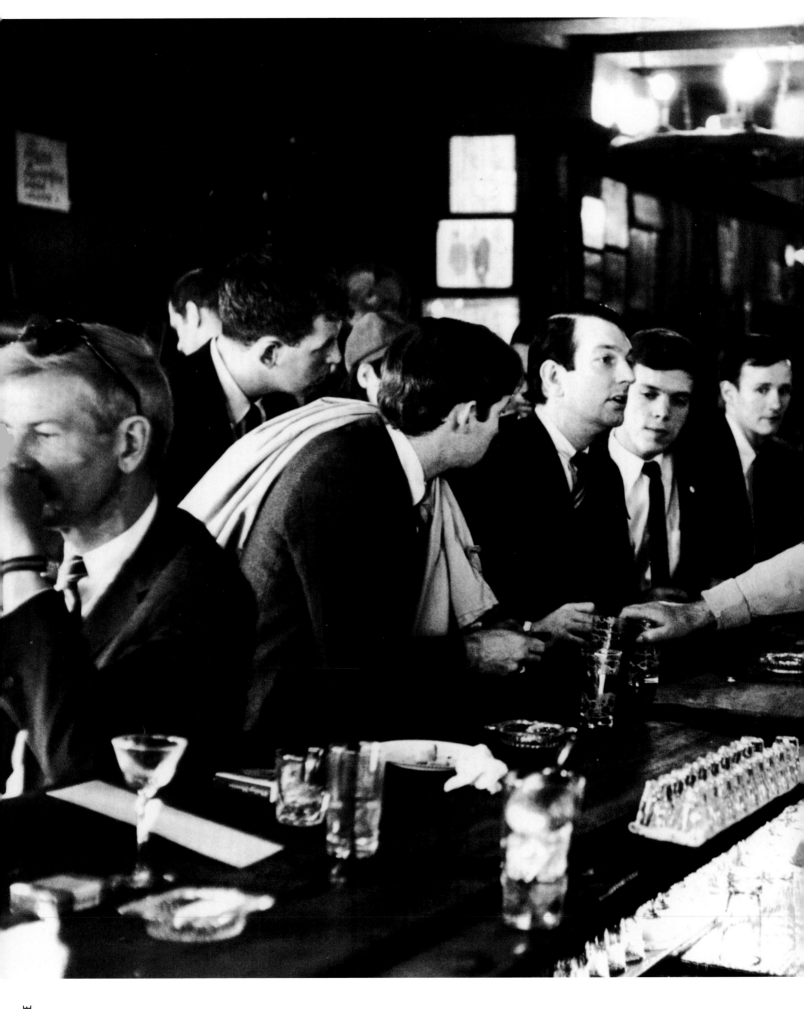

Early homophile groups were significant for many reasons, including the fact that they left copious historical records: traditional documents for traditional analysis. But, historian Joan Nestle writes, as queer people, we "know that much of what [we] call history, others will not," and while homophile groups organized, published, and won hearts and minds, equally significant work was done in bars, homes, jails, and on the streets. These less-formal events are tougher to identify, but memories remain.

In 1945, for example, after Ralph Martin banned a femme lesbian from his Buffalo bar, a small group picketed with signs reading, "Gay people, do not frequent this bar." Joan Nestle learned "the potential power of our people" in the summer of 1960, when a young man's lifeless body was brought to shore at Jacob Riis Park, a gay beach in Queens, and police stood back as his lover "keen[ed] for his loss." A "terrible quiet fell on our beach . . . our silence threatening our anger if this grief was not respected." The "freaks," Nestle recalled, "had turned into a people to whom respect must be paid."

There also was joy, like the Philadelphia wedding in 1957 with the grooms whose names we'll never know. When they took their film to be developed, the clerk confiscated it as inappropriate. Disapproving members of the majority, like that photo clerk, have always had the power to decide whose stories are remembered and whose are lost.

The attack on gender norms picked back up in the 1950s and 1960s, as drag balls returned to a central role in urban queer life, despite the disapproval of white middle-class gays. Philadelphia-born Flawless Sabrina helped organize pageants across the United States, as the lines between drag, transvestism, and transsexualism remained blurry. Crystal LaBeija, one of the contestants in Sabrina's 1967 film *The Queen*, was a legend in New York's ball scene for decades. On the West Coast, Empress José I (José Sarria) built the Imperial Court System, a network of queer social organizations known for its Gala Drag Balls.[62]

◀ Newlyweds, Philadelphia, 1957. Photographer unknown. Courtesy of the ONE Archives at the USC Libraries (Philadelphia Gay Wedding collection; 2012-034).

▲ **Above** Location unknown, 1960s. Photographer unknown. From the authors' collection.

▶ **Right** Royalty, San Francisco, c. 1965. Photo by Henri Leleu. Courtesy of Gay, Lesbian, Bisexual, Transgender Historical Society (Leleu papers).

▼ **Below** House party, 1950s. Photographer unknown. From the authors' collection.

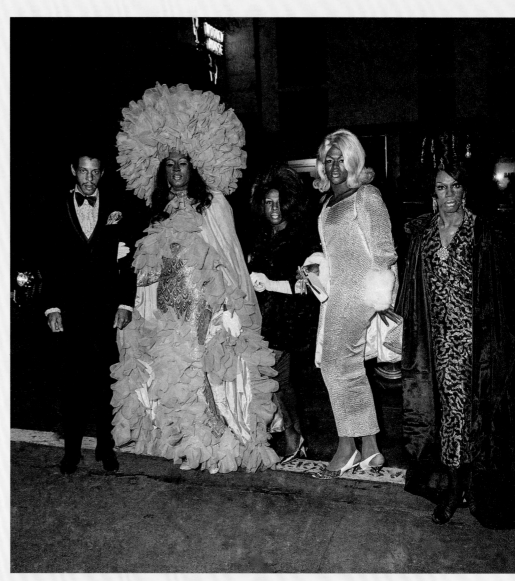

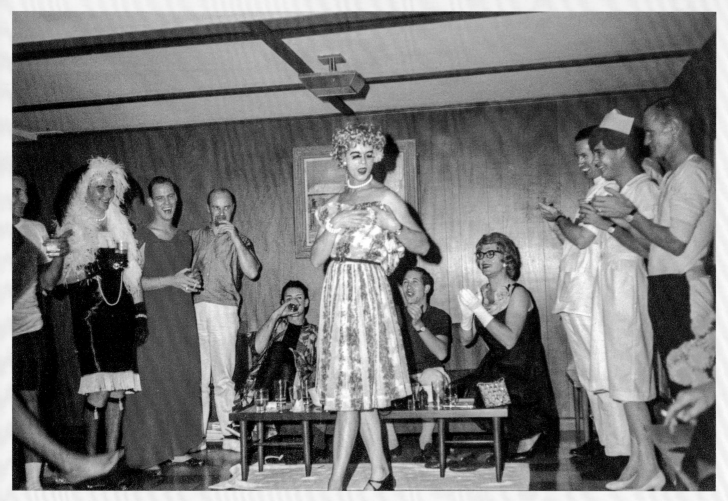

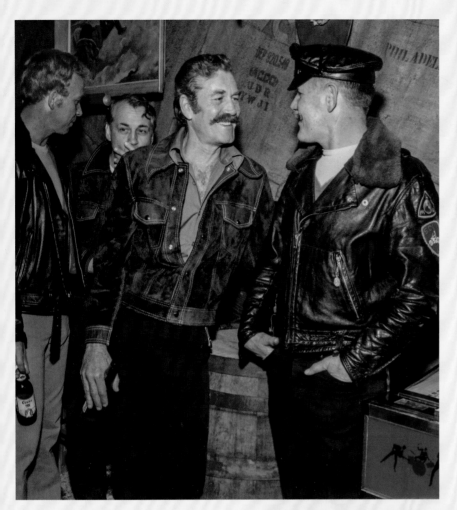

▲ **Above** Rittenhouse Square; from left to right: Marilyn, unknown, Henrietta, Sarah Vaughn, unknown, Philadelphia, 1953. Photo by Jack van Alstyne. Courtesy of John J. Wilcox, Jr. Archives, William Way LGBT Community Center (van Alstyne collection; Ms. Coll. 28).

▼ **Below** Bradley's Corner Bar, San Francisco, Halloween 1968. Photo by Harold (Bill) Giddings. Courtesy of San Francisco History Center, San Francisco Public Library (Giddings collection; SFP 95).

▲ **Above** Members of an unidentified motorcycle club, c. 1970. Photographer unknown. Courtesy of the ONE Archives at the USC Libraries (Blue Max Motorcycle Club records; 2013-055).

Beginning in the 1960s, when queer space remained constantly at risk of invasion, motorcycle clubs offered alternatives to bars, particularly in California, where wide-open roads offered chances for escape.

By 1966, the increasingly popular Society for Individual Rights (S.I.R.) had given many queer youths in San Francisco a voice, leading to intergenerational tensions within the older, more moderate homophile groups. In the Council on Religion and the Homosexual (CRH), for example, tensions peaked during a debate over an antipoverty program aimed at the Tenderloin neighborhood, an area where one could engage in "prostitution, gambling, drug taking, and sexually explicit entertainment." The Tenderloin's economy, in other words, depended on nonresidents partaking in activities that police ignored, which, in turn, depended on bribery. The well-being of local residents was *not* a concern. In fact, Tenderloin residents—most of whom were of color and many of whom were queer, underhoused, and underemployed—regularly were the target of police aggression, which was especially brutal for "street queens"—transgender women often engaged in sex work—who were "considered bottom-of-the-barrel" and "the least able to complain."

In CRH, arguments over outreach to the Tenderloin revealed sharp theoretical differences, with more conservative homophiles seeing government-funded antipoverty programs as opportunities to "lift up" underrepresented neighborhoods by imposing "middle-class standards," and more radical queer activists recognizing a connection in the fight against oppression and a commonality among all oppressed people, including themselves and those in the Tenderloin. Lambasting the old guard's moralism and condescension, Mark Forrester predicted that queer Tenderloin residents would soon be "publicly demonstrating for their rights," and it "might undermine the image of the so-called respectable homosexual" that CRH so desperately sought.[63]

That's exactly what happened.

In August 1966, just before the second National Planning Conference of Homophile Organizations (NPCHO) brought the country's homophiles to San Francisco, Jean-Paul Marat (a nom de guerre) and Mark Forrester helped establish Vanguard, an organization specifically for "the youth in the Tenderloin attempting to get a sense of dignity and responsibility too long denied." Vanguard held meetings at a relatively queer-friendly diner, Compton's Cafeteria, though tensions rose when Compton's instituted a "service charge" for patrons who sat too long. One weekend night in August—the exact date is unknown—all hell broke loose when management called the police on a rowdy group of queer customers and a queen threw her coffee in the face of a cop who'd grabbed her arm. Customers turned over tables, smashed through plate-glass windows, and charged into the streets, forcing the patrolmen to retreat and call for backup. The queens caused "general havoc," fighting police tooth and nail—literally—until reinforcements arrived. While the riot didn't appear in the mainstream press, there was some mention in local queer outlets.[64]

Something similar to the Compton's incident had happened in L.A. in May 1959, when police harassed transgender and queer customers of color at Cooper's Donuts and a routine roundup turned into a street fight. Cooper's, Susan Stryker notes, "was no doubt typical of other unrecorded and previously unremembered acts of spur-of-the-moment resistance."

From bar dykes in Buffalo to the queens of Cooper's and Compton's, the struggles of the least represented were the front lines in the battle for liberation.[65]

▲ **Above** Compton's Cafeteria, San Francisco, c. 1965. Photo by Henri Leleu. Courtesy of Gay, Lesbian, Bisexual, Transgender Historical Society (Leleu papers).

▶ **Opposite** Activists participate in Personal Rights in Defense and Education's protest of the Black Cat raid, Los Angeles, Feb. 11, 1967. Photographer unknown. Courtesy of the ONE Archives at the USC Libraries (Advocate records; 2012-030).

In July 1966, Jim Kepner and Steve Ginsburg started a new group in Los Angeles: Personal Rights In Defense and Education (P.R.I.D.E.). Inspired by the Society for Individual Rights (S.I.R.), Kepner wanted "a truly effective drive for equality for sexual minorities." While P.R.I.D.E. tried to break from "the stodginess of the homophiles," the group was a product of its era, remaining for some time a male-only organization.

But bars kept getting raided, and police got more brutal. At midnight on New Year's Eve, as gay men at L.A.'s Black Cat Tavern went in for the first kisses of 1967, a squad of uniformed policemen swept in, randomly beating and arresting patrons. For the first time, though, when a collective outrage emerged, it was backed by organizational power. On February 11, 1967, P.R.I.D.E. launched a series of large street demonstrations around the Black Cat, signaling the rise of a West Coast militancy that informed young queers across the country.

The press, however, paid little attention to the struggle, spurring P.R.I.D.E. member Richard Mitch, his lover Bill Rau, and colleagues Sam Allen and Aristide Laurent to transform the organization's small newsletter into the *Los Angeles Advocate*. Later, Richard Mitch, a.k.a. Dick Michaels, bought the paper from the others for $1 and, after dropping the geographical qualifier from its title, ran *The Advocate* until 1974, when he sold it to investment banker David Goodstein for $350,000.[66]

In August 1968, a few hours before L.A. cops swarmed into The Patch and Lee Glaze led a group of bouquet-wielding queers to free their sisters, Frank Kameny addressed the North American Conference of Homophile Organizations (NACHO) delegates in Chicago, including Barbara Gittings, Kay (Tobin) Lahusen, Shirley Willer, Bill Beardemphl, Larry Littlejohn from the Society for Individual Rights (S.I.R.), and the Council on Religion and the Homosexual's Robert Cromey. Steve Donaldson, a young bisexual activist, represented Columbia University's Student Homophile League, and activists from *Tangents* and *ONE*, Mattachine-NY, the Phoenix Society, and Mattachine Midwest joined fresh faces from the Mattachine Societies of Cincinnati and Dayton. Rita Wanstrom and small-time crook Ray Hill represented Houston's Promethean Society, and Pete Peters and Paul Russell came on behalf of Dallas's Circle of Friends.

For days, the delegates thoroughly debated every proposal raised, no matter how small the detail. Kameny's motion to adopt "GAY IS GOOD," however, passed without issue. Kameny had gotten his way, as he typically did. "In essence," one group wrote, Kameny's "position is this: Either you must agree with me or you are acting against the Movement."[67]

Changing the social order in one fell swoop, Henry Gerber wrote in 1940, is "like trying to push over a big stone wall with your skull." It can't be done. But "we can undermine the wall by little individual blasts and it will topple down by-and-by." Or, as Del Shearer said in 1965, social revolution required at least "a century of subtle attack" on the dominant culture.

As riots engulfed the United States in 1968, Frank Kameny saw similarities between homophiles and those Black Americans taking to the streets to express centuries of anger. "BUT," Kameny said, "the Negro has truly explored and exhausted well-nigh, if not actually *all*, other avenues, and has gotten to the firm, unyielding stone wall of prejudice which blocks them. WE have run into this, but have not yet reached the end of all avenues."

Queer people soon hit the end of all avenues, crashing into an unyielding stone wall.[68]

◄ Pinback, 1968. Printed by Randolfe Wicker. From the authors' collection.

Freaking

FAG

REVOLUTIONARIES

1968–1973

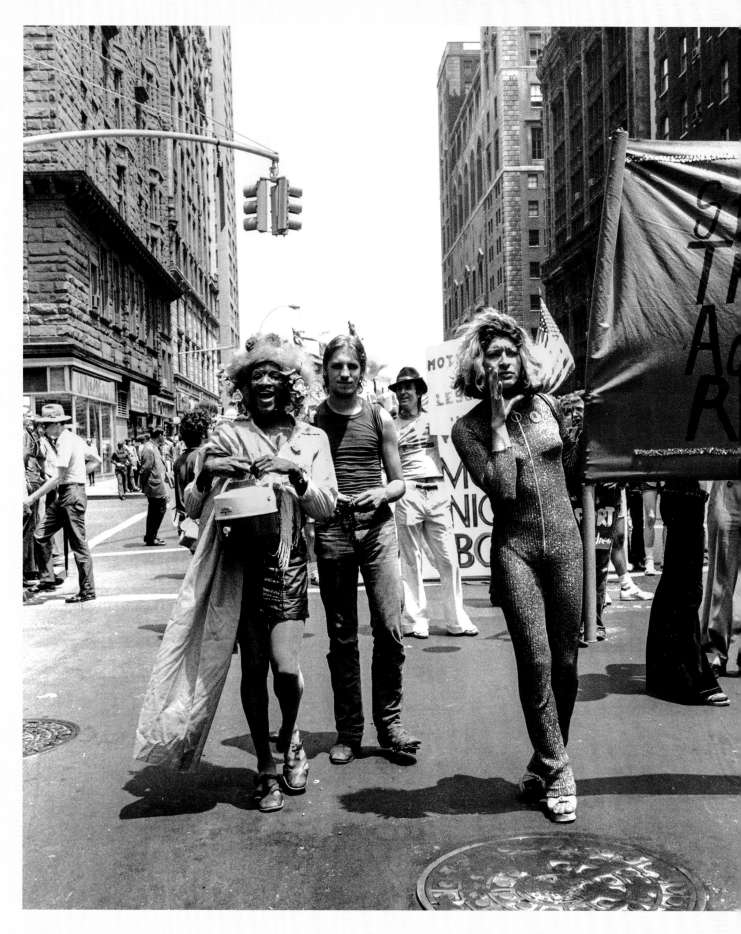

If you want Gay Power, then you're going to have to fight for it. And you're going to have to fight until you win.

—SYLVIA RIVERA, 1970

New York, 1973

Barbara Gittings bounded onto the makeshift stage in Washington Square Park, greeted by enthusiastic cheers from twenty thousand proud gay people.

"Would you believe," she asked the crowd at New York's fourth annual Christopher Street Liberation Day, "the first gay meeting that grew into the Gay Liberation Movement took place over twenty-one years ago in someone's apartment in Los Angeles?" And now, Gittings shouted, "we are everywhere!"

She was right. In the five years since the North American Conference of Homophile Organizations (NACHO) had declared "GAY IS GOOD," the number of gay organizations in the United States had gone from about sixty to over twenty-five hundred. As San Francisco activist Carl Wittman wrote in his 1969 essay, "A Gay Manifesto," there'd been "an awakening of *gay liberation* ideas and energy." Queer people, Wittman explained, "are full of love for each other and we are showing it; we are full of anger at what has been done to us. And we are euphoric, high, with the initial flourish of a movement." Between 1969 and 1973, the euphoria Wittman described flourished in an overwhelming amount of activity under the banner of Gay Liberation. It was an era marked by deep divisions—"gay men oppress gay women, white gays oppress black gays, and straight-looking gays oppress transvestites"—and key differences in theory, strategy, and personality, but Gay Lib nonetheless represented an early attempt to grapple with oppression "as a movement, not as different segments of a movement."[1]

But it couldn't last.

By empowering "drag queens, bar dykes, street people, feminists, radical students, leftists, Socialists, Marxists, Maoists, anarchists, libertarians, hippies, and former Yippies," activist Karla Jay wrote, Gay Lib sowed the seeds of its own destruction. It was only a matter of time before an emphasis on "unity" and "gay issues only" alienated those facing multiple layers of oppression. "There is no such thing as a single-issue struggle," Audre Lorde wrote, "because we do not live single-issue lives," and "unity does not mean unanimity" but "implies the coming together of elements which are, to begin with, varied and diverse in their particular natures." By the summer of 1973, however, leaders of an increasingly assimilationist gay mainstream emphasized sameness as a virtue, perpetuating the "institutionalized rejection of difference" that allowed straight society to reject queer people as much as it allowed mainstream gays to reject those who didn't fit some *mythical norm*," including virtually all those living beyond the binaries of gender and sexuality.

Across the country, in fact, long-simmering ideological arguments boiled over in the months leading up to June's Gay Pride celebrations. In New York, the Christopher Street Liberation Day Committee—encouraged by owners of gay bars hoping to profit off the festivities—went to great lengths to focus on "Gay Unity," filling the June 24 post-parade rally with generally inoffensive entertainment and only allowing speeches by two well-liked activists, Barbara Gittings and L.A.'s Morris Kight. These attempts to silence the "varied and diverse" elements within New York's queer community backfired, as "'fringe'

> I'd like to say Happy Birthday to the Stonewall Nation.
> —Arnie Kantrowitz, 1973

◀ Page 109 Marsha P. Johnson (left) and Sylvia Rivera (right) lead the Street Transvestite Action Revolutionaries (S.T.A.R.) contingent, Christopher Street Liberation Day, New York City, June 24, 1973. Photo by Leonard Fink. Courtesy of The LGBT Community Center National History Archive (Fink collection; 24-03).

groups and a mental case managed to dampen a lot of spirits," according to Randy Wicker. Although the event "could have been much worse," Wicker was disgusted by the open display of anger that erupted onstage between Lesbian Feminist Liberation's Jean O'Leary, Queens Liberation Front's Lee Brewster, and "Ray 'Sylvia' Rivera, the mentally-disturbed, destructive leader of Street Transvestites [*sic*] Action Revolutionaries (S.T.A.R.)," who, Wicker wrote, "managed to cause constant commotion and

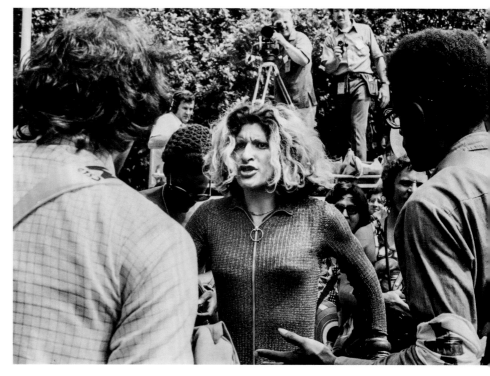

▲ Sylvia Rivera (center), Christopher Street Liberation Day, New York City, June 24, 1973. Photo by Bettye Lane. Copyright © by the Estate of Bettye Lane; courtesy of Schlesinger Library, Radcliffe Institute, Harvard University.

In every way, Sylvia Rivera and other members of S.T.A.R. fought to survive in a world hostile to their existence. During the chaos at Christopher Street Liberation Day 1973, for example, as Sylvia pleaded for fully inclusive queer solidarity, she wore a jumpsuit that had belonged to Lady June, a S.T.A.R. member who'd "passed on to her reward" (i.e., died from "methadone poisoning and booze"). Cohen, *Gay Liberation Youth Movement in New York*, 134, 142.

eventually succeeded in laying her hate trip on the annual gathering of love in Washington Square Park." The commotion, historian Stephan L. Cohen describes, consisted of "Sylvia storming the stage to speak out for imprisoned transgender half-sisters, O'Leary condemning men who impersonated women for entertainment and profit, and Brewster castigating lesbians for their refusal to let drag queens be themselves." And, as Wicker acknowledged, it "had been brewing for months, even years."[2]

More than anyone, Sylvia Rivera embodied the chaos of the Gay Liberation era. In fact, Lee Brewster later said, Sylvia "*was* gay liberation." Frenetic, uncompromising, "consumed by anger," idealistic, and easily manipulated, Sylvia saw "anyone's oppression as her own oppression." After being arrested gathering signatures for Gay Activists Alliance in 1970, she committed herself fully to the Movement, announcing to her "sister queens" that, after waiting "for the day we could get together with other gays and be heard . . . the time and days are here and Gay Activists Alliance is here to stay." Over time, though, Sylvia's militant otherness became a liability for mainstream gays, who increasingly framed "the need for unity . . . as a need for homogeneity."[3]

The hostility at Christopher Street Liberation Day 1973 was rooted in this "institutionalized rejection of difference," a failure by those with greater political power to acknowledge the struggles of those with less. When organizers refused Jean O'Leary's request to read a statement denouncing drag as sexist, it proved a need for Lesbian Feminist Liberation (LFL), the lesbian-only group of which O'Leary was president. To Lee Brewster, LFL's hostility toward drag showed a lack of respect for the queens who'd been on Gay Lib's front lines. And, to Sylvia Rivera, who wanted to speak on behalf of queer people imprisoned on "gay charges," her exclusion from the rally marked a collective retreat from the ideals that had brought her to the Movement in the first place.

As opposed to O'Leary, though, Sylvia hadn't approached organizers beforehand; if she had, Brewster wrote at the time, there's a small chance they'd have let her speak, given that "all groups are in favor of the rights of gay prisoners." As it was, Sylvia

spent the day fighting—that is, literally clawing, punching, and kicking—her way to the stage, refusing to leave until given a chance to address the crowd.*

> Y'all better quiet down! I've been trying to get up here all day for your gay brothers and your gay sisters in jail that write me every motherfucking week and ask for your help, and you all don't do a goddamn thing for them.
>
> I will not put up with this shit. I have been beaten. I have had my nose broken. I have been thrown in jail. I have lost my job. I have lost my apartment for gay liberation and you all treat me this way? What the fuck's wrong with you all?
>
> I believe in the gay power. I believe in us getting our rights, or else I would not be out there fighting for our rights.
>
> The people are trying to do something for all of us, and not men and women that belong to a white middle class white club. And that's what you all belong to!
>
> REVOLUTION NOW!
> Gimme a G!
> Gimme an A!
> Gimme a Y!
> Gimme a P!
> Gimme an O!
> Gimme a W!
> Gimme an E!
> Gimme an R!
> Gay power! Louder! GAY POWER![4]

The festivities got back on track when Sylvia finished, at least for a bit, as emcee Vito Russo joked with the crowd, singer-activist Madeline Davis performed her anthemic song "Stonewall Nation," and songwriter Lucy Wilde sang her prescient "Since I Met You, I Dropped Out of the Movement," an up-tempo song about falling in love and quitting activism. "No pamphlets get read, I'm loving instead," went one line. And, in direct reference to the efforts of Sylvia Rivera and her S.T.A.R. cofounder Marsha P. Johnson, Wilde sang,

> And Sunday morning, Marsha said that Sylvi's in jail
> Nobody put up the bail, somebody censors her mail
> And if we don't start marching on Christopher soon,
> We'll dig our own tomb, you'll see.

Just before drag duo Billy and Tiffany came out, Russo acknowledged the tension simmering offstage, saying that "because Sylvia had her say, as was right, after Billy and Tiffany's act, Jean O'Leary of LFL will make a short statement." What's often overlooked is that LFL's statement—written days in advance—specifically endorsed "the right of every person to dress in the way that he or she wishes" *except* where it involved "exploitation of women by men for entertainment or profit." Focusing on drag and

* Although the popular narrative universally casts Rivera's demands to speak as "a violent takeover" of the rally, it's important to note that Committee officials took an informal survey of the crowd before allowing any "political" speeches. Video footage of the event clearly shows the crowd agreed that Sylvia should be allowed to speak.

prostitution, LFL's *prepared* statement did not attack transgender people per se. Once onstage, however, O'Leary extemporaneously took a dig at "one person—*a man*, Sylvia." It was an unnecessary provocation, directing attention away from the exploitation of women and toward the exclusion of transgender people.

O'Leary knew the crowd wasn't on her side, so a burst of applause in the middle of her speech startled her. It turned out the crowd was greeting the arrival onstage of Lee Brewster, whose appearance clearly pissed off O'Leary. Rushing to her applause line— "Let men tell each other what they think of women; let us tell you who we are"—she charged offstage.

"I apologize for this outburst," Brewster said, "but I cannot sit and let my people be insulted. They've accused me of reminding you too many times that the day you're celebrating was a result of what the drag queen did at the Stonewall."

But the popular queen seemed determined to prove O'Leary's point: "You go to bars because of what drag queens did for you and yet these *bitches* tell us we're offensive?!?"

Vito Russo clutched Brewster, imploring him to stay calm.

"We gave you your pride!" Brewster yelled. "Gay Liberation: Screw you!"

At that point, on the fourth anniversary of the riots popularly credited with unleashing the Gay Revolution, a beleaguered Russo whispered to the incensed drag queen berating the twenty thousand people in Washington Square Park:

"Don't start a riot, *please.*"[5]

Five years earlier, Frank Kameny was worried about the threat of riots at the 1968 Democratic National Convention (DNC), set to start in Chicago just a week after the North American Conference of Homophile Organizations (NACHO) meeting ended. The city "will be becoming a 'madhouse,'" he wrote in February. "There are murmurings of civil disorders."

By summer, the nationwide "murmurings" were deafening: huge antiwar demonstrations brought cities to a standstill; Robert F. Kennedy's assassination reinvigorated the New Left's attack on the Democratic establishment; student activists occupied college campuses; and the April assassination of Dr. Martin Luther King Jr. led to one of the most spectacular waves of rioting in U.S. history. As all eyes turned to Chicago ahead of the DNC, Mayor Richard M. Daley promised that his police would respect civil liberties, though they'd operate "under the motto of law and order." The phrase *law and order* should always give the underrepresented pause, and by the time the convention started, police had occupied most of Chicago's Black neighborhoods, and all but one of the North Side gay bars had been closed "for redecoration."

As ten thousand progressive protesters gathered in Chicago's Grant Park on August 28, 1968, some twenty-three thousand

▶ Pinback, c. 1970. From the authors' collection.

members of the Chicago Police Department and the Illinois National Guard unleashed a remarkable display of violence, forcing the lawful demonstration out of the park and into the streets. That evening, the battle raged in front of the Chicago Hilton, beaming a police riot—captured under television floodlights—into homes across the United States for seventeen uninterrupted minutes. The violence marked a turning point in the U.S. culture wars. To many, Mayor Daley had no choice but to maintain "law and order." Many others, however, were aghast at the sight of young *white* protesters facing unhinged police. "Maybe now," one Black man said, "people will listen when we're talking about police brutality."

In March 1969, eight activists were indicted on various charges of conspiracy and incitement to riot, all related to the DNC in Chicago. The Chicago Eight (later the Chicago Seven) became folk heroes, and judge Julius Hoffman and prosecutor Tom Foran played the perfect villains. In early 1970, Foran warned a group of parents that the nation's youth were being swept up in a "freaking fag revolution."

He was right.[6]

The Democratic National Convention riots radicalized Leo Laurence, a "tiny, angry man," who returned to San Francisco with promises of a "Homosexual Revolution of '69.'" Attacking the city's gay establishment, Laurence served briefly as editor of *Vector*, the magazine of the Society for Individual Rights (S.I.R.), though he was removed after he and his lover, Gale Whittington, publicly lambasted S.I.R. as "middle-class bigots," urging other gays to come out. Whittington lost his job at the States Line Company as a result of the publicity.

Declaring "war on both gay and straight establishments," Laurence founded the Committee for Homosexual Freedom (CHF)—which Jim Kepner described as "the first full-fledged Gay Lib type group"—in April 1969. For months, the group picketed the States Line Company and other antigay businesses, but, by Friday, June 27, one CHF member was so frustrated with non-violent tactics, he predicted confrontations with police.[7]

In the early hours of Saturday, June 28, New York's Craig Rodwell was heading home from his Greenwich Village bookstore when he saw a crowd gathered outside the Stonewall Inn. Although Rodwell hated the Stonewall—a Mafia-run, police-harassed, condemnable hole-in-the-wall—this felt different. When police had raided the bar a few nights before, no crowd had gathered; in fact, people ran from Deputy Inspector Seymour Pine, as they had during the five other bar raids in the Village that month. No one mingled while cops attacked a popular cruising area at the docks on June 3, nor did anyone stand around as vigilantes descended on a cruising park in Queens on June 20.[8]

Impromptu public gatherings by and for queer people didn't happen in 1969, and, by collecting on the street outside the Stonewall, "people deviated from the script." For Rodwell, who'd participated in virtually every homophile demonstration on the East

Coast since 1964, "everything came together at that one moment," as a simple bar raid backfired into a five-night melee during which queers beat the cops back into the very bar they'd tried to clear; a butch dyke's efforts to avoid arrest triggered a shower of coins, bricks, and Molotov cocktails; the famous "Stonewall Girls"—a kickline of young street queens—taunted the militarized Tactical Police Force through the neighborhood's narrow streets; Marsha P. Johnson climbed a lamppost and dropped a heavy object onto the windshield of a police car; chants of "Liberate Christopher Street!" and "Gay Power!" echoed through the Village; and Allen Ginsberg told Lucian Truscott that the newly militant gays had "lost that wounded look that fags all had ten years ago."[9]

The sense of solidarity, empowerment, and liberation coursing through Greenwich Village was overwhelming. "From going to places where you had to knock on a door and speak to someone in order to get in. We were just out on the streets," Chris Babick recalled. "Can you imagine?" For Joan Nestle, who remembered holding her girlfriend's hand on Christopher Street the weekend the riots started, it felt "like the world, really, had been turned upside down."

The events of 1969 collectively known as the Stonewall Riots* were *not*, by any definition, the "start" of Gay Liberation, nor did they mark the "first time" queer people fought back, physically or otherwise. To emphasize Stonewall, Dorr Legg said, is to act "as though there weren't twenty years before of a hell of a lot of hard work by hundreds and hundreds of dedicated people who put their lives and their jobs and everything else on the line." What set Stonewall apart, though, was that activists now had a nationwide infrastructure to spread the story. The tale was used, from the beginning, to build the Movement, and the riots must therefore be "viewed as an *achievement* of gay liberation rather than as a literal account of its origins." Put another way, as sociologists Elizabeth A. Armstrong and Suzanna M. Crage argue, what "many people assume to be a basic fact about the gay movement—that it started with Stonewall—is a story that the movement successfully promoted."

Nonetheless, activists like Craig Rodwell, Martha Shelley, Dick Leitsch, and Bob Kohler drew on experiences from other social justice movements to harness the queer energy flooding Greenwich Village as the riots unfolded. History's focus on the crowd's physical aggression often diminishes the organizing that took place on Christopher Street. Those passing out pamphlets, in other words, are as historically significant as those throwing bricks.

"DO YOU THINK HOMOSEXUALS ARE REVOLTING?" screamed one pamphlet. "YOU BET YOUR SWEET ASS WE ARE." Another leaflet announced a "GAY POWER" meeting set for July 9.[10]

* Although some writers and activists refer to the events around Stonewall as either the "Stonewall Uprising" or the "Stonewall Rebellion," we consciously use "Stonewall Riots." As an initial matter, *Webster's* defines *riot* as "a violent public disorder . . . *specifically*: a tumultuous disturbance of the public peace by three or more persons assembled together and acting with a common intent," a definition that, by all accounts, perfectly summarizes Stonewall. *Uprising*, on the other hand, is "a usually localized act of popular violence in defiance usually of an established government," and *rebellion*, which appears to be the most popular alternative to *riot* in this context, is defined either as "1. open, armed, and usually unsuccessful defiance of or resistance to an established government" or "2. resistance to or defiance of any authority, control, or tradition."

In a 1985 critique, theorist bell hooks argued that feminist consciousness-raising had failed to "continually confront women with the understanding that the feminist movement to end sexist oppression can be successful only if we are committed to revolution, to the establishment of a new social order." The movement itself was not a revolution, she said, it was a rebellion, which is "a stage in the development of revolution . . . represent[ing] the assertion of their humanity on the part of the oppressed." By creating sustainable communities and customs, rebellions, which generally begin with individual acts of unplanned violence or tumult, "break the threads that have been holding the system together." *Riots* start *rebellions*, in other words, and *rebellions* can lead to *revolution*.

To call the Stonewall Riots a "rebellion" therefore feeds the historically inaccurate narrative placing Stonewall as *the* moment when "everything changed." In fact, the riots didn't change everything; it was the work inspired by the riots—the *rebellion*—that proved paradigmatic.

▶ **Right** Committee for Homosexual Freedom (CHF) leaders Gale Whittington (front) and Leo Laurence protest Whittington's termination from the States Line Company, San Francisco, May 1969. Photo by Roy Hoffman. Courtesy of the ONE Archives at the USC Libraries (Advocate records; 2012-030).

▶ **Opposite** Queer youth celebrate during the Stonewall Riots, Greenwich Village, New York City, June 28, 1969. Those pictured include Drag Queen Chris (with handbag, at left), Betsy Mae Kulo (in window), Michelle (in crop top), Roger Davis (in glasses, at right), and Tommy Lanigan-Schmidt (far right). Photo by Fred W. McDarrah. Copyright © by Getty Images and the Estate of Fred W. McDarrah.

▼ **Below** Outside the Stonewall Inn, Greenwich Village, New York City, June 28, 1969. Photo by Fred W. McDarrah. Copyright © by Getty Images and the Estate of Fred W. McDarrah.

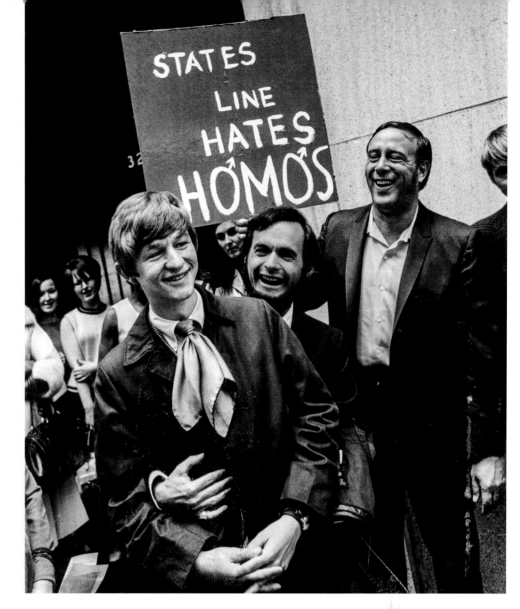

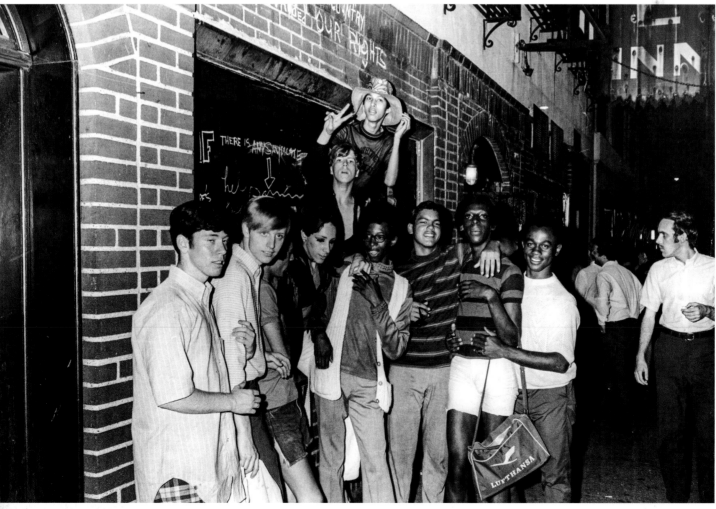

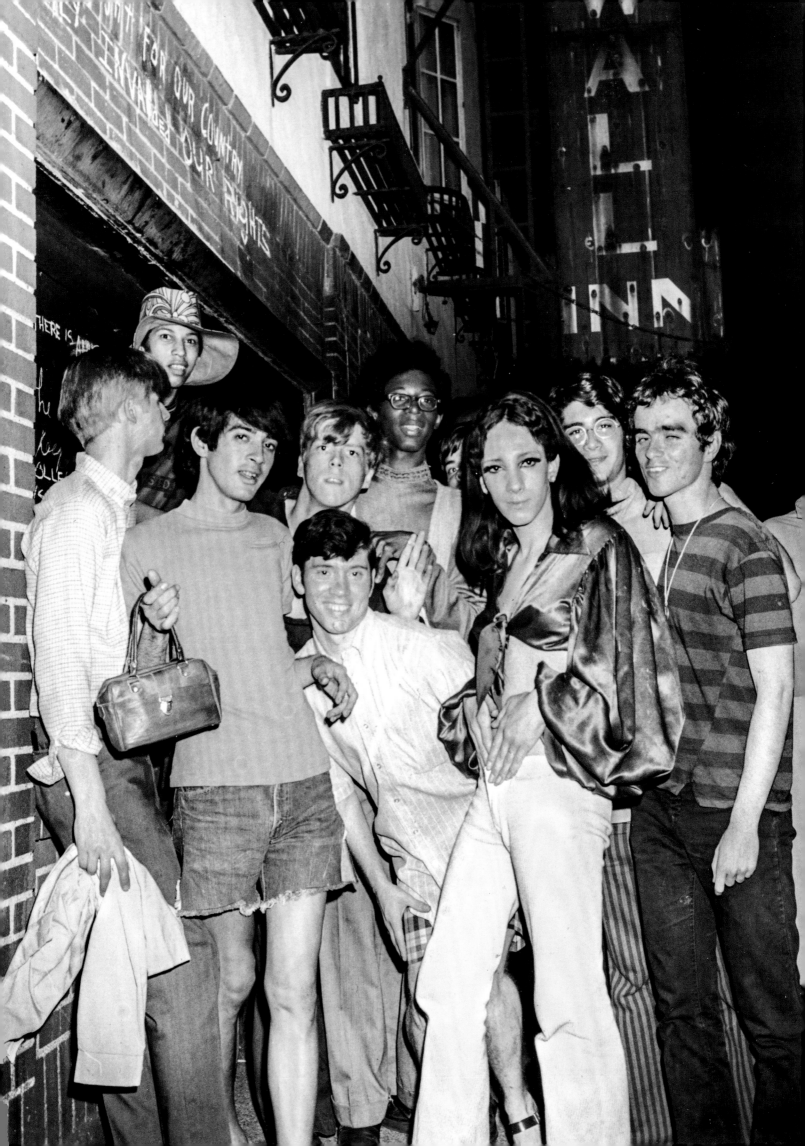

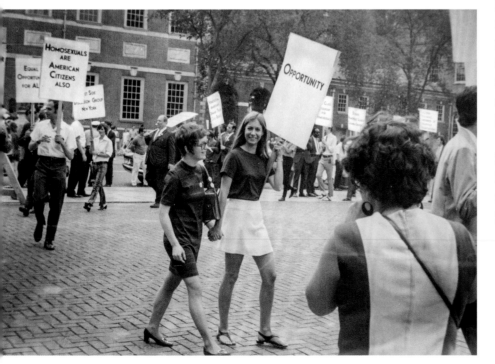

On July 4, 1969, a few days after Stonewall, Craig Rodwell put on a suit and headed to Philadelphia for the Annual Reminder Day, just as he had every Independence Day since 1965. Under the watchful eye of the chairman of D.C. Mattachine's Committee on Picketing and Other Lawful Demonstrations, Frank Kameny, all those participating in homophile demonstrations were expected to adhere to a strict dress code (suits for men, dresses for women), avoid talking to the press, and march in orderly, single-file lines. While there'd always been some displeasure with Kameny's unforgiving enforcement of the rules, there'd been no real effort to push back.

At the Reminder Day in 1969, however, it quickly became clear that the younger activists, many of whom had rioted a few nights before, had their own ideas. Some chanted; some spoke to the press; some of the men refused to wear ties; and, in the most flagrant violation of the rules, two women broke the single-file line and held hands while marching. It was a radical expression of queer identity, and Kameny was apoplectic.

Days later, during the Gay Power meeting in New York on July 9, members of the short-lived Mattachine Action Committee, including Michael Brown, Martha Shelley, and Marty Robinson, planned to commemorate Stonewall with a public demonstration that would look much different from the Reminder Days. At first jokingly referring to themselves as the Gay Liberation Front (a nod to North Vietnam's guerrilla force, the National Liberation Front), the group led five hundred people from Washington Square Park to Sheridan Square on July 27, 1969. Within days, the activists cut ties with Mattachine-NY and formed the independent Gay Liberation Front (GLF), dedicated to ending queer oppression by applying "the militancy generated by the bar bust" to activism that allowed "homosexuals and sexually liberated persons to confront themselves and society."

Gay Liberation Fronts soon formed across the United States and then the world, though each was an independent entity: GLF-NY, for example, explicitly had *no* leadership, while a hierarchy of gay men like Morris Kight, Jim Kepner, and Troy Perry led GLF-L.A. In Louisville, Kentucky, GLFers downplayed their radical image, while those at the Washington State Penitentiary worked closely with the militant Aid for Transexuals in Prison Commission.

From the outset, gay liberationists hit the same targets as the homophiles, albeit with a tone more fitting for the times. The press, for example, came under

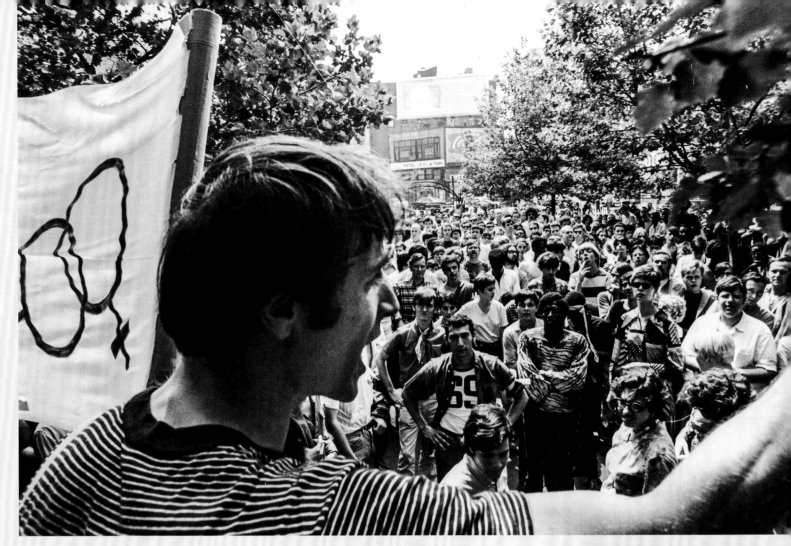

▲ **Above** Marty Robinson addresses the crowd at New York's first Gay Liberation March, Sheridan Square, New York City, July 27, 1969. Also in the photo are Mark Segal (center, front), Martha Shelley (to Segal's right), and Jim Owles (with bandana around his neck). Photo by Fred W. McDarrah. Copyright © by Getty Images and the Estate of Fred W. McDarrah.

▶ **Right** Activists carry the Gay Liberation Front (GLF) banner from Washington Square Park to Sheridan Square, Gay Liberation March, Greenwich Village, New York City, July 27, 1969. Mark Segal is at right (with a hand to his mouth). Photo by Fred W. McDarrah. Copyright © by Getty Images and the Estate of Fred W. McDarrah.

◀ **Opposite, top** Gay Liberation Front pinback, c. 1969. From the authors' collection.

◀ **Opposite, bottom** Fifth Annual Reminder, Independence Hall, Philadelphia, July 4, 1969. Photo by Nancy Tucker. Courtesy of Lesbian Herstory Archives.

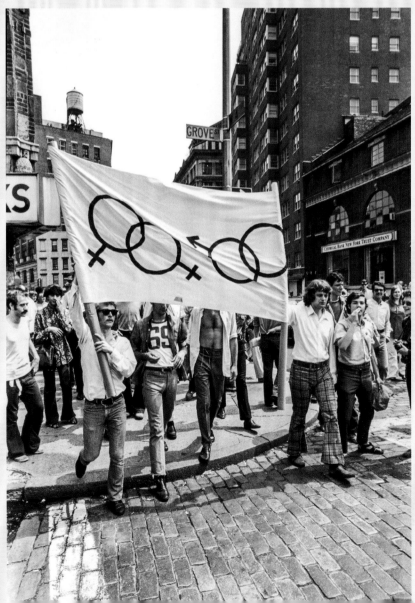

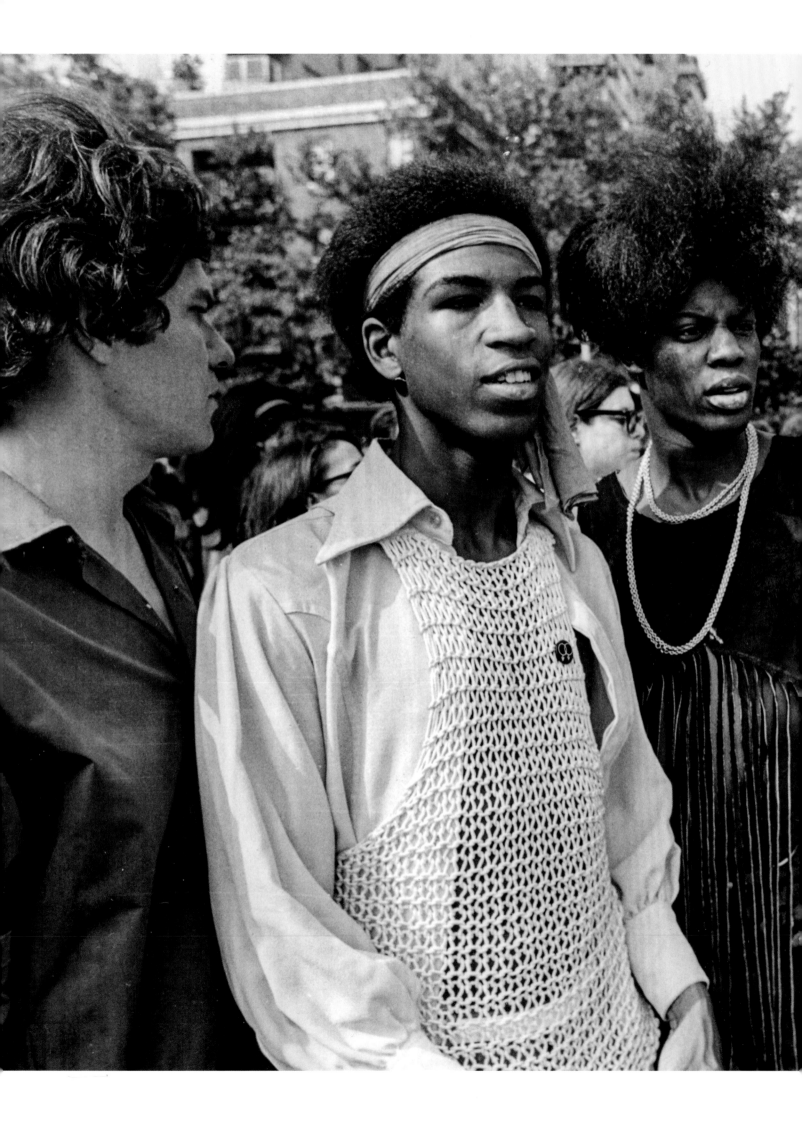

◄ Queer youth, Gay Liberation March, Sheridan Square, New York City, July 27, 1969. Photo by Fred W. McDarrah. Copyright © by Getty Images and the Estate of Fred W. McDarrah.

early fire. In September 1969, GLF-NY picketed the *Village Voice* for its poor treatment of the community. In October, when San Franciscans picketed the *Examiner* for consistently printing the names and addresses of men arrested in bar raids and cruising sweeps, newspaper staff poured printers' ink onto protesters, who marked the building with their purple-inked hands before police cracked heads and made arrests. The violent day came be to known as "the Friday of the Purple Hand." In Los Angeles, activists targeted the *Los Angeles Times* for its refusal to run the word *homosexual* in ads.[11] But the new generation didn't just attack straight media. Harnessing the power of the underground press, activists created a wave of queer periodicals that spread Gay Liberation *and* helped emerging subcommunities articulate their identities.[12]

When any movement starts, Audre Lorde explained, "immediately within it, you are going to get those people whose differences are not being articulated," so there's "immediately another step." Thus, Lesbian Feminists soon sought the empowerment of women-only spaces, and transgender people formed organizations focused on issues of particular concern. Queer people of color established Third World Gay Revolutionaries, and young gays—those under twenty-one who were dismissed as "jail bait" and denied entry to homophile groups across the country—followed the lead of New York's Mark Segal and formed Gay Youth cells. In the midst of this splintering-off, there emerged a schism within Gay Lib, the theoretical split that shaped subsequent queer activism. GLF-NY, for example, emphasized "the struggle for *total* human liberation," placing the queer community as "one of many oppressed groups, the roots of whose oppression lies within a diseased capitalist system." Because "homosexual liberation cannot develop in a vacuum," some within GLF-NY argued, it was necessary to ally with radical antiwar groups, Black Panthers, and similar revolutionary collectives.[13]

But by late 1969, many felt the emphasis on other groups meant that *gay* issues were "sluffed over for the big picture," leading some disenchanted New Yorkers to form a group "based solely on homosexual liberation." With elected officers, structured meetings, and a formal constitution, the Gay Activists Alliance (GAA) did *not* "intend to 'overthrow the system,' but to improve life for homosexual men and women" from *within* the framework of existing political and social structures. The shift away from "*total* human liberation" was monumental, providing a bridge between Gay Lib and what ultimately became the Gay Rights Movement, with one side determined

▼ **Below** GAA contingent (including Vito Russo, in striped pants), Christopher Street Liberation Day, New York City, June 27, 1971. Photo by Leonard Fink. Courtesy of The LGBT Community Center National History Archive (Fink collection; 26-08).

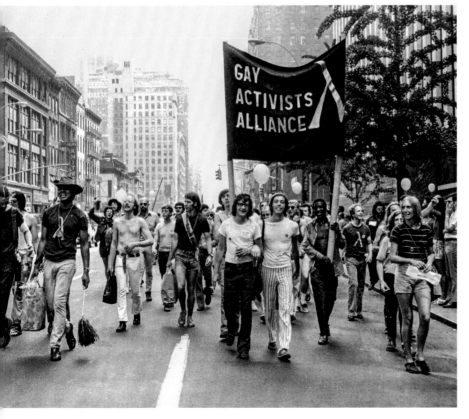

▶ **Opposite** Zazu Nova, Gay Liberation Front meeting, c. 1970. Photo by Diana Davies. Courtesy of Manuscripts and Archives Division, The New York Public Library.

Trailblazing photographer Diana Davies misidentified the subject of this photograph as Marsha P. Johnson, and the image has therefore been incorrectly cited for decades. In fact, this is a photo of Zazu Nova, a Stonewall Rioter, member of GLF and S.T.A.R., and a founding member of Gay Youth. Bob Kohler remembered how artist Tommy Lanigan-Schmidt once declared, "'Well Nova, you were queen of the sixties, but the seventies belong to Marsha.'" See endnote 13, page 338.

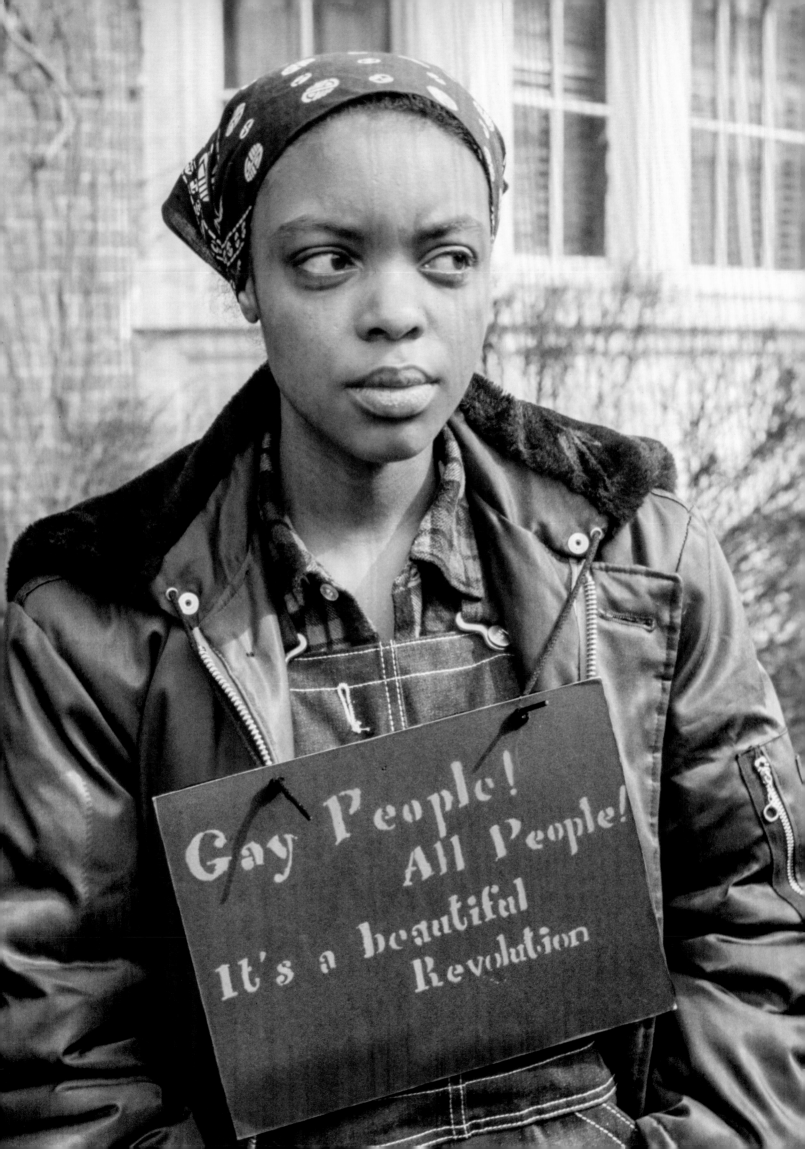

to reform the dominant culture and the other set on creating an independent queer culture.

Too often, though, GAA is discussed in terms of what it became rather than what it was. While the group's structure did inspire a powerful new generation of moderates, it was initially as radical as anything before it, leading activists around the country to form local GAAs. Guided, as New York City's Marc Rubin said, by a belief that "any point of view which is opposed to gay rights is a wrong point of view, categorically, by fiat, and word of God," GAA unapologetically got in the dominant culture's face. Combining graphic design—specifically the lambda (λ), which designer Tom Doerr said was shorthand for "that moment or span of time that's witness to absolute activity"—and an expert use of "confrontation politics," New York's GAA in many ways drew the blueprint for all queer visibility actions that followed.[14]

In March 1970, after the group's first protest at City Hall resulted in a brief and unproductive meeting with a city official, GAA was "ready and eager for another full-scale attack on the forces that oppressed us." Days later, when Deputy Inspector Seymour Pine—who'd led the Stonewall raid the previous summer—hit the Snake Pit, an after-hours gay club on West 10th Street, GAA got its chance. After storming the bar, Pine herded patrons outside, where frustrated gays started congregating. Desperate to avoid another Stonewall, Pine ordered 167 people arrested, including Diego "Tito" Vinales, a young Argentinean with an expired visa, who panicked at the police station and tried to escape by jumping from a second-floor window onto the roof of an adjacent building. He didn't make it, however, falling onto a fence and impaling himself on six iron spikes.

"He's dead," a cop said snidely, "and if he's not, he's not going to live long."

Miraculously, Vinales survived, and gay activists blanketed the Village with flyers—"Any way you look at it, that boy was PUSHED!!"—turning out five hundred people for a march on the Sixth Precinct, a remarkable show of force by the fledgling Gay Liberation Movement.[15]

Taking its cue from early radical feminist organizations, GAA developed a unique style of street theater protest—also known as agitprop (i.e., "agitation" and "propaganda")—which GAA called *zaps*. More than anyone, Marty Robinson was responsible for the vision behind the zaps, which were "playful, mischievous, and dead serious," allowing "good guys to publicly embarrass the bad guys." At a definitive zap, GAA hit Fidelifacts, an employment agency known for vigilance in warning clients about queer applicants. "Establishing that someone is homosexual is often difficult," the company's CEO said, "but I like to go on the rule of thumb that if one looks like a duck, walks like a duck, associates only with ducks, and quacks like a duck, then he probably is a duck." In January 1971, GAA descended on Fidelifacts' Midtown offices, with dozens picketing alongside Marty Robinson, who, naturally, dressed like a duck.

Later that year, GAA infiltrated City Clerk Herman Katz's offices, demanding he issue same-sex marriage licenses. Katz seethed as Arthur Evans, Marc Rubin, Vito

▲ **Above, right** GAA pinback, c. 1970. Design (λ) by Tom Doerr.
From the authors' collection.

◀ **Opposite** Gay Liberation March on Albany,
Albany, New York, Mar. 14, 1971. Photo by Diana Davies.
Courtesy of Manuscripts and Archives Division,
The New York Public Library.

◄ **Left** Marty Robinson, dressed as a duck, leads GAA's zap on Fidelifacts, New York City, Jan. 18, 1971. Photo by Richard C. Wandel. Courtesy of The LGBT Community Center National History Archive (Wandel collection; 4a-002).

▼ **Below** Arthur Evans (right) makes a point during GAA's zap of the Board of Examiners, New York City, Apr. 1971. Courtesy of The LGBT Community Center National History Archive (Wandel collection; 4a-003).

Russo, and others held mock same-sex weddings, complete with cake and coffee for city workers.* And GAA took its fight on the road, traveling to Provincetown, Massachusetts, and Bridgeport, Connecticut, to conduct zaps with local activists.[16]

These new tactics were everywhere. In early 1970, Harry Hay and other familiar faces led Gay Liberation Front-L.A. (GLF-L.A.) in multiple demonstrations at Barney's Beanery, a dive diner in a gay neighborhood with a prominent sign behind the bar: "FAGOTS [*sic*]—STAY OUT!" In response to the "no touching" rule in local gay bars, Morris Kight led protests of The Farm, a popular gay club; when the owner finally cracked, GLF proudly declared: "THE FARM IS LIBERATED." Activists shut down the White Horse in San Francisco, made a scene at Chicago's Astro Restaurant, sat in at Morrie's in Ithaca, picketed racist bars in D.C., and sought marriage licenses in Minneapolis, Seattle, and Louisville. When cops killed queer people in L.A., Chicago, and New York, activists raised hell. And, in the face of ongoing homophobia in the greater Women's Liberation Movement, Lesbian Feminists in New York City launched the infamous Lavender Menace zap, shutting down the Second Congress to Unite Women and demanding liberation for all women.[17]

Despite a growing emphasis on political awareness, social interaction remained at the core of Gay Liberation. More aptly, as Carol Hanisch wrote, "the personal is political," and battles for queer space grew more intense. Gay dances, for example, which allowed younger queer people the opportunity to simply be together, were fundamental to the growth of Gay Lib, helping to bring radical gay activism to Austin, Texas, and Athens, Georgia. In cities across the United States, community centers became central gathering places for queer people, and the battle to liberate bars from organized crime, police harassment, and draconian laws raged on.[18]

The hundreds and thousands of people flocking to Gay Liberation in the late 1960s and early 1970s shared, at their core, a common bond not only with each other, but also with those who'd made Gay Lib possible. As had the fairies at the turn of the century, Henry Gerber in the mid-1920s, gay and lesbian servicemembers during World War II, bar dykes in the 1950s, members of the Mattachine Foundation *and* Society, Del Martin, Barbara Gittings, Frank Kameny, and the Compton's Queens, Gay Liberationists wanted to connect, to belong, to live, and to simply exist without fear or harassment. In cruising parks, house parties, bars, balls, homophile meetings, and in the pages of early queer periodicals, those living outside established norms of gender and sexuality built spaces, physical or otherwise, on which they could rely for support.

> The time will come when we march down Hollywood Boulevard arm in arm, proclaiming our pride in our homosexuality.
> —Chuck Rowland, c. 1953

* This wasn't Herman Katz's first run-in with queer people seeking marriage licenses. In 1959, he denied Christine Jorgensen and her fiancé a license due to "inadequate proof of [Jorgensen] being a female." Not only had the entire country heard of Jorgensen's gender affirming procedures, but her passport confirmed her womanhood. Nonetheless, Katz didn't budge.

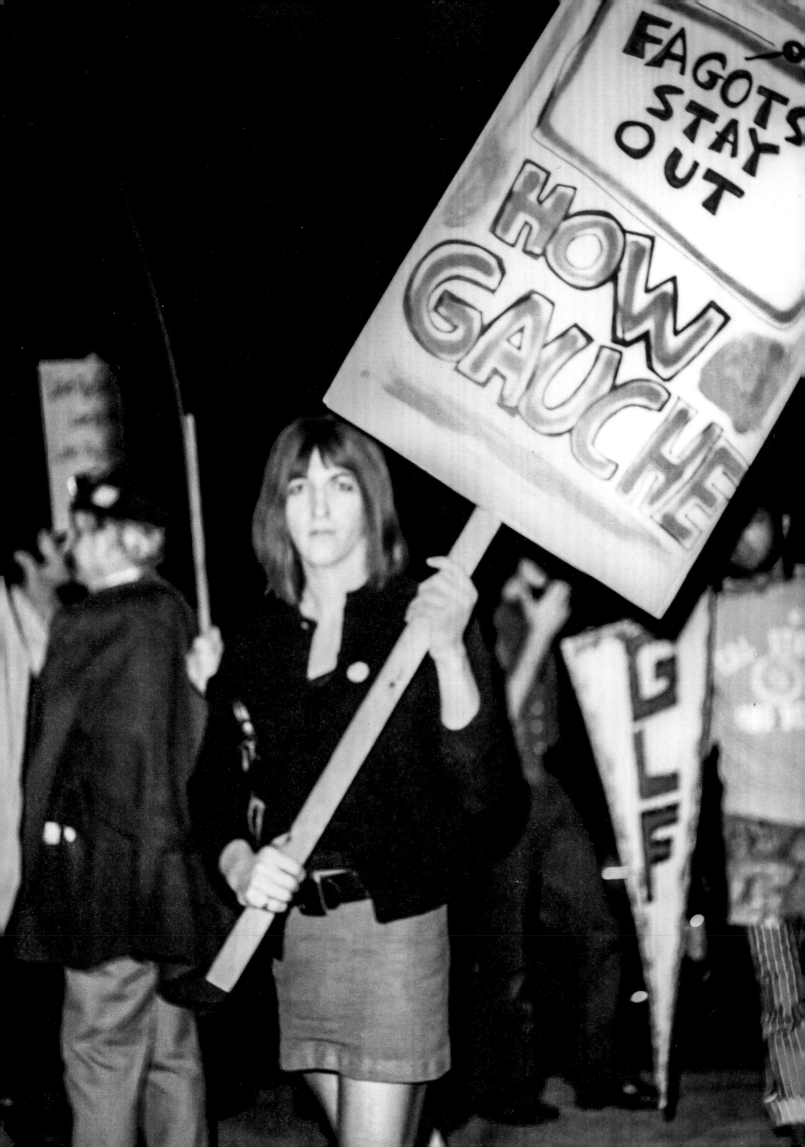

◀ **Opposite** Angela Douglas and other members of Gay Liberation Front-L.A. picket Barney's Beanery, West Hollywood, Feb. 1970. Copyright © by Pat Rocco. Courtesy of the ONE Archives at the USC Libraries (Rocco photographs and paper; 2007-006).

▶ **Right** "FAGOTS–STAY OUT!" sign hanging behind the bar at Barney's Beanery, West Hollywood, 1970. Photographer unknown. Courtesy of the ONE Archives at the USC Libraries (Advocate records; 2012-030).

◀ **Left** Gay Liberation Front-L.A. members (among them Morris Kight, far left, Don Kilhefner, with beard and glasses, and Stan Williams, to the right of Kilhefner) celebrate the liberation of The Farm (i.e., the end of the bar's no-touching rule), West Hollywood, 1970. Photo by Lee Mason. Courtesy of the ONE Archives at the USC Libraries (GLF-L.A. records; 2012-031).

▼ **Below** Lavender Menace members (including Martha Shelley, far right) during the zap of the Second Congress to Unite Women, New York City, May 1, 1970. Photo by Diana Davies. Courtesy of Manuscripts and Archives Division, The New York Public Library.

Although often remembered solely for the in-your-face optics of their famous zap, the Lavender Menace were driven by a revolutionary theory of inclusivity for all women, one that confronted the unique experiences, for example, of queer women and women of color. We note that it is difficult, if not impossible, to say with certainty whether the Lavender Menace, as of May 1970, included transgender women in its definition of "all women." The Menace was an organization made up of individuals, some of whom were hostile to trans women, some of whom were not, and some of whom likely were transgender.

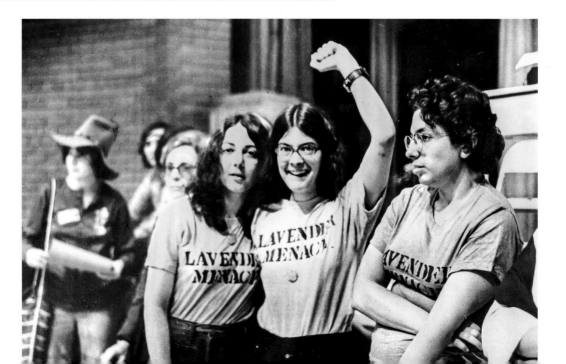

In the mid-1960s, as some activists started to move the struggle for liberation onto picket lines, the idea of queer space expanded. Craig Rodwell, for example, never felt as free as he did proudly declaring himself a homosexual during the 1965 ECHO protests around D.C. In fact, Rodwell never wanted the picketing to end, which is what inspired him to suggest the Annual Reminder Days at Philadelphia's Independence Hall (intended to "remind" others that a large group of U.S. citizens still lacked their basic rights), the first of which took place on July 4, 1965. By marching every year at a historically significant time and place, East Coasters blazed the trail not only for queer visibility but also for a collective memory, a commemorative approach to history based on particular images and events.

After Stonewall and the tense Annual Reminder Day of 1969, however, Rodwell knew something had to change. Then, with the success of GLF's March to Sheridan Square in late July 1969, as more and more queer people sought space of their own, Rodwell got an idea for an event that could welcome them all. In November, as moderate homophiles and radical liberationists clashed during a combative meeting of the Eastern Regional Conference of Homophile Organizations, Rodwell, his lover Fred Sargeant, Linda Rhodes, and Ellen Broidy moved to make significant changes to the Annual Reminder Day. Specifically, "in order to be more relevant, reach a greater number of people and encompass the ideas and ideals of the larger struggle in which we are engaged," the Reminder should be moved "both in time and location." They needed a demonstration—Christopher Street Liberation Day—"held annually on the last Saturday in June in New York City to commemorate the 1969 spontaneous demonstrations on Christopher Street." Even more ambitiously, Rodwell wanted a committee—the Christopher Street Liberation Day Committee—to "contact homophile organizations throughout the country and request that they hold parallel demonstrations on that day." In other words, the activists "proposed a nationwide show of support," at which "no dress or age regulations shall be enforced."

Remarkably, despite tensions between new- and old-guard activists, the resolution passed.

There was no guarantee the Christopher Street Liberation Day Committee could deliver. If previous attempts at national coordination showed anything, it was that queer activists had different approaches to everything. In order to make the first Christopher Street Liberation Day a success, New Yorkers—such as Brenda Howard, Michael Brown, and Foster Gunnison—had to convince activists in other cities to commemorate Greenwich Village as *the* birthplace of Gay Liberation; that, in turn, required building the Stonewall myth, "the legend about that night, and the following days of rage."[19]

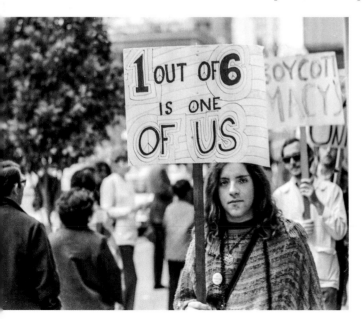

◀ Left GLF-S.F. members protest Macy's department store after dozens of men were arrested during a "morals crusade" in which police entrapped those seeking sexual encounters in one of the store's bathrooms, a well-known cruising spot, San Francisco, Aug. 1970. Photographer unknown. Courtesy of the ONE Archives at the USC Libraries (GLF-L.A. records; 2012-031).

▶ Opposite Gay Vietnam Vets and Gay Caucus-Youth Against War & Fascism contingents, Christopher Street Liberation Day, New York City, June 25, 1972. Photo by Leonard Fink. Courtesy of The LGBT Community Center National History Archive (Fink collection; 25-01).

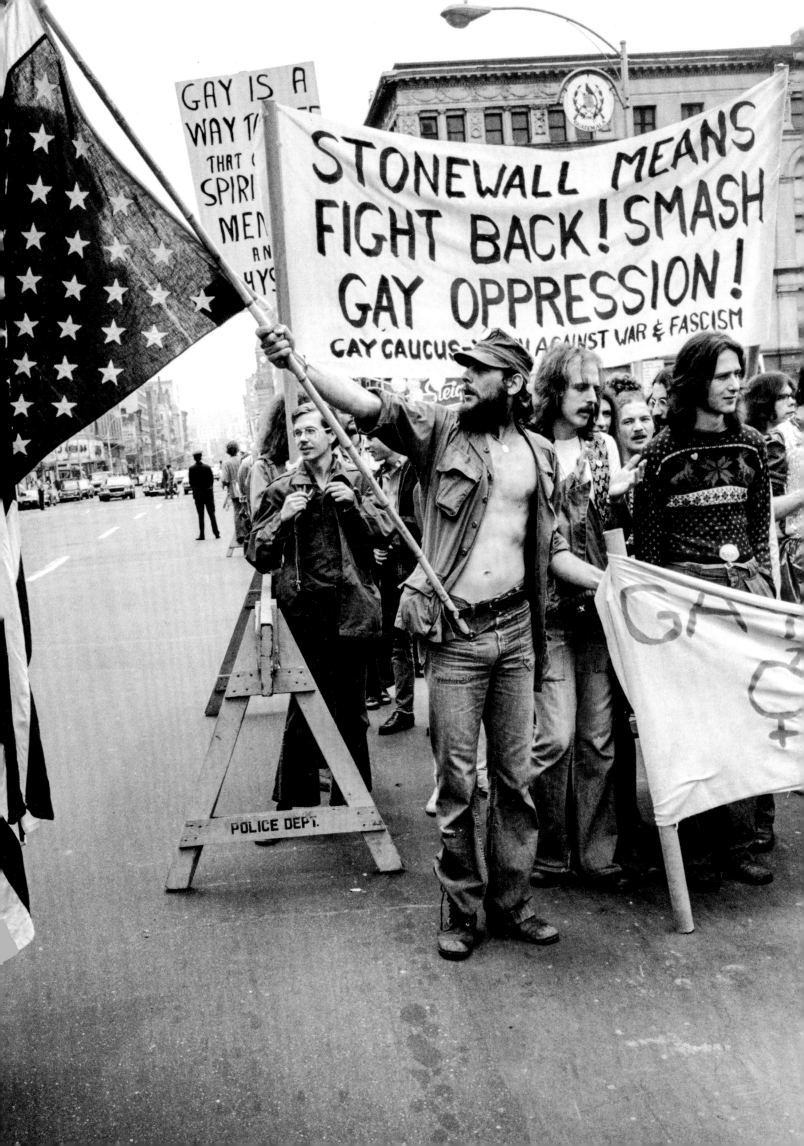

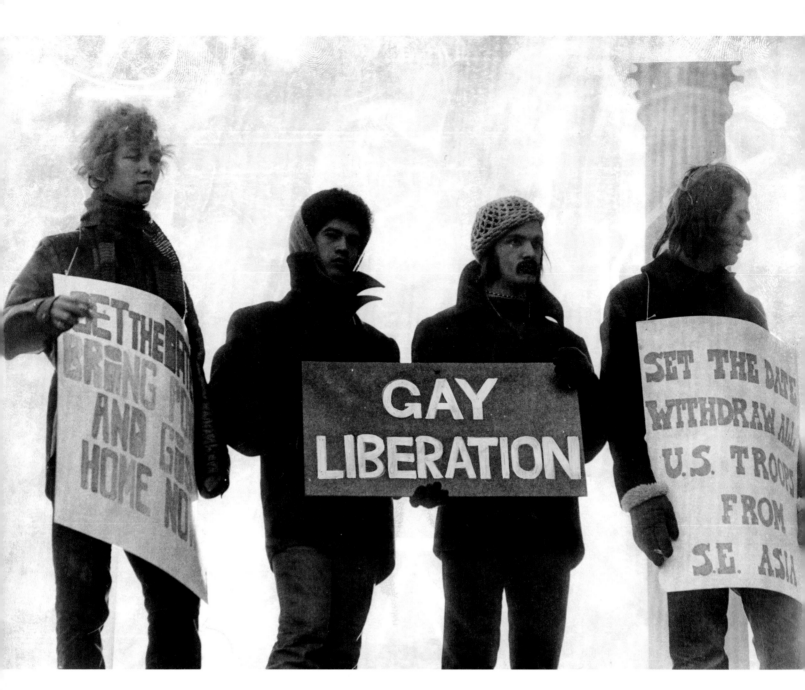

▲ **Above** GLF-D.C. members participate in a protest against the Vietnam War, Washington, D.C., c. 1970. Photo by Joseph Silverman. Reprinted with permission of the DC Public Library, Star collection; copyright © by the *Washington Post*.

▶ **Right** Pinback, c. 1970. From the authors' collection.

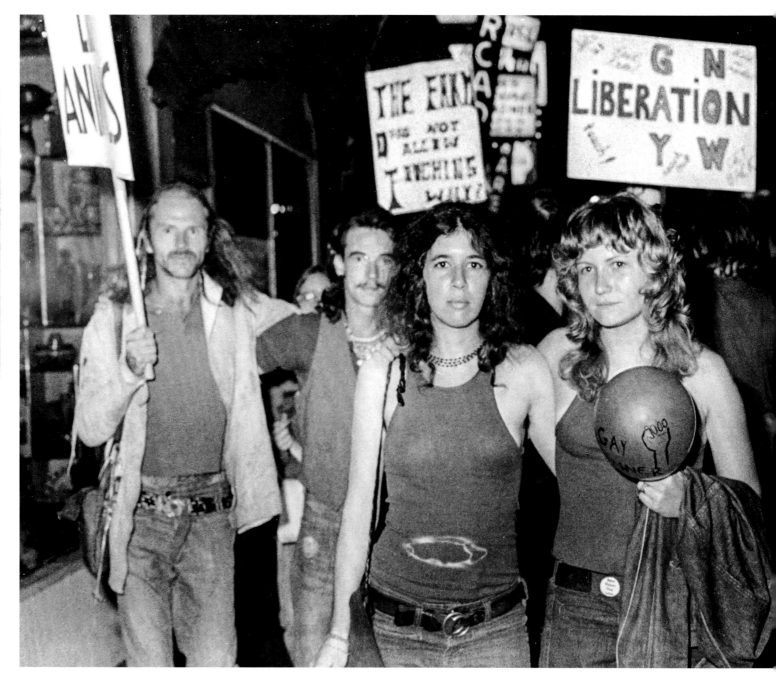

◀ GLF-D.C. members, Washington, D.C., c. 1971. Photographer unknown. Courtesy of the Rainbow History Project.

◀ **Left** Christopher Street West, Los Angeles, June 28, 1970. Photographer unknown. Courtesy of the ONE Archives at the USC Libraries (CSW collection; 2012-035).

▼ **Below, left** Christopher Street West 1970 pinback, Los Angeles, June 1970. From the authors' collection.

▼ **Below, right** Gay-In, Griffith Park, Los Angeles, Apr. 1970. Photographer unknown. Courtesy of the ONE Archives at the USC Libraries (GLF-L.A. records; 2012-031).

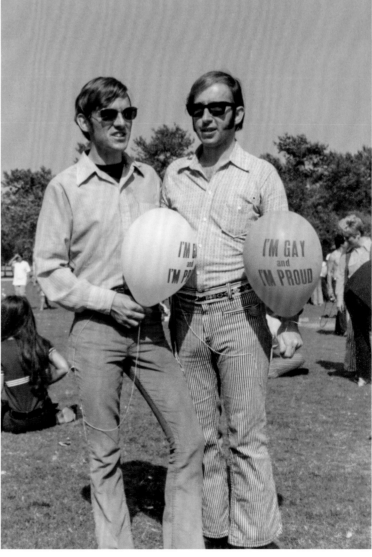

In Los Angeles, Morris Kight didn't see Stonewall as a particularly noteworthy event, at least not at first. "I felt it was important," he said, "wished I were there, but deep in my heart I could not sort it out."

Activists in L.A. had tried already to establish commemorative events around which the community could rally. In March 1970, for example, Gay Liberation Front (GLF) members marked the anniversary of the murder of Howard Effland, a gay man beaten to death in 1969 by cops who were later exonerated for "excusable homicide." In an eerie coincidence, 250 activists marched on LAPD headquarters right as New Yorkers protested the Snake Pit raid. Even more ominously, while crews removed Tito Vinales from a Greenwich Village fence the previous night, the LAPD shot and killed Laverne Turner, a Black transgender woman who, police claimed, appeared armed.

In early April 1970, GLF-L.A. held its first Gay-In in Griffith Park, "a lighter, and more inclusive" event than the typical pickets and memorials. Inspired by the Human Be-Ins that started in San Francisco in 1967, the Gay-Ins promised "a Day of Liberation, Love and Togetherness."[20] With nearly two thousand attendees, the April event was huge, and it almost went off without police interference. Near the end of the day, though, cops arrested one reveler and a scuffle broke out; after an emergency meeting, activists marched to the Hollywood police station. By 1970, L.A.'s queer community was overwhelmed by police harassment, "stunned by the reign of terror which the LAPD has brought on them." So, a few weeks later, when New Yorkers approached activists in L.A. with a plan to commemorate Stonewall—the riots that represented "a victory over police"—Christopher Street West (CSW) was born. As Morris Kight rushed to get permits, LAPD Chief Ed Davis announced he'd sooner grant a license to "burglars or robbers" than homosexuals, leading CSW's attorney, Herb Selwyn, and lawyers from the American Civil Liberties Union to seek an injunction against Davis. Two days before the march was supposed to step off, Judge Richard Schauer not only granted the injunction, but ordered the LAPD to provide protection for the gays. In a matter of hours, Kight spread the word and activists scrambled to assemble floats; in L.A., "of course, no major event would be complete without floats."[21]

Since hosting NACHO '68, Mattachine Midwest's Jim Bradford had become increasingly frustrated with the moderates in Chicago's gay community. As police kept attacking queer spaces, Bradford begged locals to let "the new militancy emerge."

"Put your body on the line," he wrote. "Those who 'can't afford' to stand up and be seen are not willing to pay the price of freedom." Finally, in early 1970, Gay Liberation groups started to emerge across Chicago, debuting in public in mid-April during a week of citywide antiwar demonstrations. On April 15, Gay Lib groups participated in a large rally, "bringing the existence of organized gays to the consciousness of both the general public and their politically radical compatriots." Over the following days, the gay groups held their own rally in Grant Park, an impromptu march to the city's main courthouse, and a citywide Gay-In. When talk of a nationwide Gay Pride event came along,

Chicago's activists were ready, with Bill Kelley telling Mattachine Midwest members that "the single historical event of the Christopher Street riots had come to be seen as the 'official' start of Gay Liberation." And, with a march on June 27, 1970, Chicago became the first city to mark what one writer exuberantly called "the first time that large numbers of gay people stood up against repression."[22]

After planning and participating in the Armed Forces Day protests of 1966, San Francisco's homophiles stayed away from public demonstrations for over two years. Then, on July 3, 1968, two dozen well-dressed men and women—including Chicago's Jim Bradford—picketed the Federal Building, calling for "completion of the American Revolution." Clearly inspired by the East Coast Homophile Organizations' Annual Reminder Days, the San Franciscans apparently neither coordinated with nor acknowledged the work of the East Coast homophiles who would gather the following day for the fourth Annual Reminder Day.

San Francisco's gay establishment generally never cared for direct action nor were they particularly gracious when it came to coordinating with other cities. So, after Stonewall, while most of the country's homophile press actively reported on, and helped spread the story of, the "first gay riot," Bay Area periodicals went silent, with only one Stonewall-related article appearing in the year after the riots. In spring 1970, the Society for Individual Rights, the Daughters of Bilitis, and the Council on Religion and the Homosexual all ignored appeals from New York to join the national Gay Pride commemoration; as one San Franciscan said, they "did not think a riot should be memorialized." Local gay leaders had no interest in using another city's event to mark the "beginning" of a movement they'd been building for decades. Although a small group of radicals—including Leo Laurence—staged a Gay-In on June 28, police quickly broke it up.

But San Francisco's general silence didn't quell the Stonewall legend; if anything, local leaders, by not staking their claim as trailblazers of Gay Lib, let the Stonewall myth run unchecked. Organizing the city's first official Pride events in 1972, Reverend Ray Broshears tried to highlight San Francisco's contributions to Gay Liberation, with the parade commemorating *not* Stonewall but an earlier riot: Compton's Cafeteria. But, by then, it was too late; Stonewall was *the* story.[23]

Craig Rodwell got to Sheridan Square early on June 28, 1970, not knowing what to expect with just hours before the first Christopher Street Liberation Day March. Of the ambitious Gay Pride Week events planned by Brenda Howard and the Christopher Street Liberation Day Committee, only Friday's dance at NYU's Weinstein Hall was well attended. With the march set to start at 2:00 p.m., it seemed as if the committee hadn't even been able to turn out a thousand people.

◀ Gay-In, Golden Gate Park, San Francisco, June 28, 1970. Photo by Crawford Barton. Courtesy of Gay, Lesbian, Bisexual, Transgender Historical Society (Barton collection).

"There weren't many at first," but they came, "drifting out, massing out at the last moment as if they were watching to see if the others were going to show." At 2:10, the NYPD—there to protect the queers—insisted they get going. And so it began.

Following the lead banner—"CHRISTOPHER STREET GAY LIBERATION DAY 1970"—representatives from various groups, cities, schools, and all different walks of life stepped off the sidewalk and into the street: Gay Liberation Front, Gay Activists Alliance, Mattachine-NY, D.C. Mattachine, various chapters of the Daughters of Bilitis, Philadelphia's Homophile Action League, Lavender Menace, contingents from Boston and Baltimore, Lee Brewster's Queens Liberation Front, and students from Yale, Columbia, and Rutgers.

"The courage that it took for some people to make those first steps from Sheridan Square into Sixth Avenue and out of the Village," GLF member Perry Brass wrote, "was the summoning up of a whole lifetime's desire to finally come clear." At first, nerves propelled the crowd forward at a near jog; some later referred to the march as the "first run." But, one writer said, "we got more militant as we marched along. Today we owned the streets. We felt liberated and free."

Soon, a familiar shout cut through the air:

"Gimme a G!"

"G!" hundreds responded.

"Gimme an A!"

"A!"

"Gimme a Y!"

It was Sylvia Rivera, whose "voice was imperious, [her] expression selfless, then and as [she] cheer-led hoarsely along the sixty-block hike that was to end an hour later."

Sylvia cheered the whole way.

Moving uptown, it seemed every marcher saw a queer person they knew in the crowd on the sidewalks, not quite ready to take the step. "Come on out or I'll point you out!" someone yelled. And they did. "Tearing off the masks of anonymity," giving up the relative safety of the sidewalk, hundreds of people took "the first step in our liberation." And as more and more people joined, the pace slowed, the spirit lightened, and a sense of liberation connected thousands.[24]

"In that March up Sixth Avenue," Frank Kameny said, "I was moved to a feeling of pride, exhilaration, and accomplishment, a feeling that this crowd of five thousand was a direct lineal descendant of our ten frightened people in front of the White House five years ago!" Among the brightly colored signs and banners was an inconspicuous placard reading "San Juan Pueblo." Although Harry Hay and his lover John Burnside had moved to an isolated area of New Mexico, he had managed to keep up with his Movement, arranging to be represented in his own, uncharacteristically subtle way.

By the time they reached Central Park, the lines of queer people stretched back twenty blocks, though few had any sense of just how big the crowd had gotten. Entering the park's Sheep Meadow area, marchers came to a rocky rise on the western end, turning around to look down on thousands of their "known and unknown friends." None of them—no one—had ever seen anything like it. People hugged, many cried, and

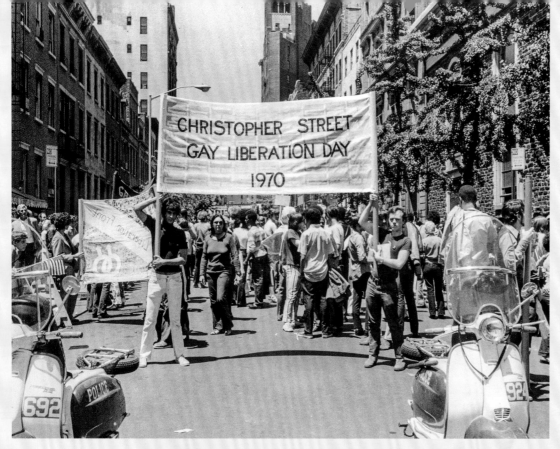

◀ **Left** Lead banner, Christopher Street Liberation Day, New York City, June 28, 1970. Photo by Leonard Fink. Courtesy of The LGBT Community Center National History Archive (Fink collection; 28-01).

▼ **Below** Christopher Street Liberation Day, New York City, June 28, 1970. Photo by Leonard Fink. Courtesy of The LGBT Community Center National History Archive (Fink collection; 28-03).

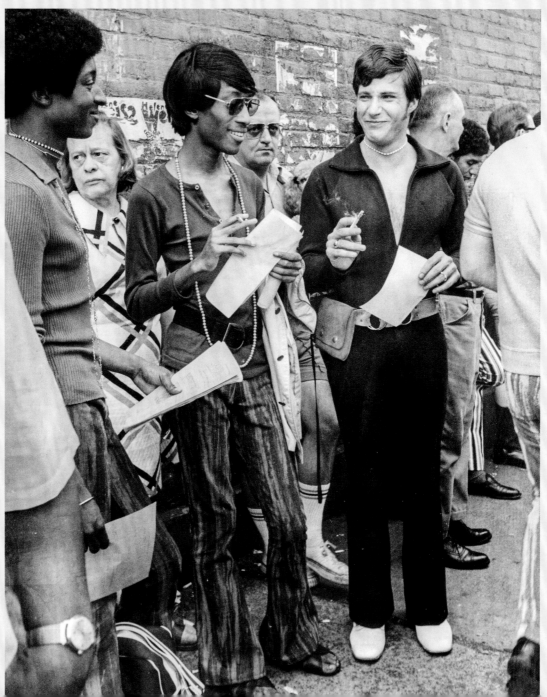

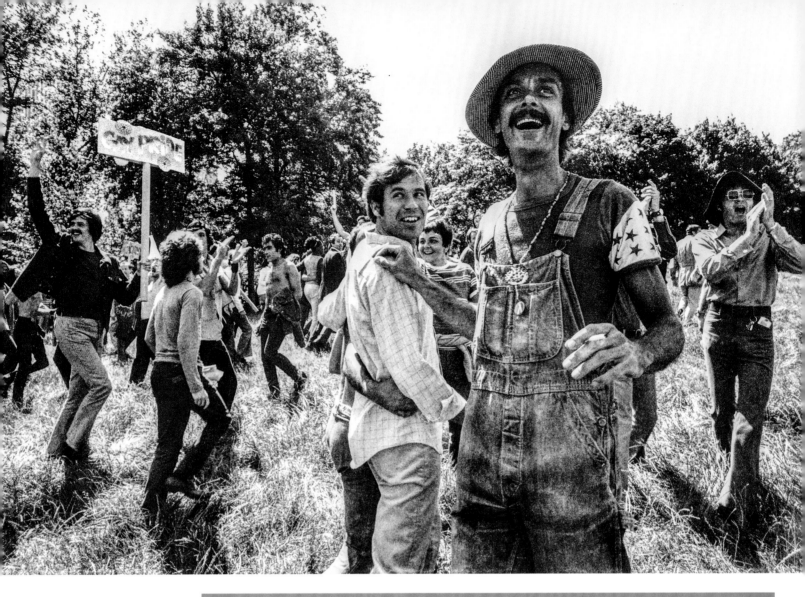

▲ **Above** Marchers react as they reach Central Park's Sheep Meadow and, for the first time, see the size of the first Christopher Street Liberation Day March, Central Park, New York City, June 28, 1970. Photo by Steve Rose. From the authors' collection.

▶ **Right** Gay Pride, Christopher Street Liberation Day, Central Park, New York City, June 28, 1970. Photographer unknown. From the authors' collection.

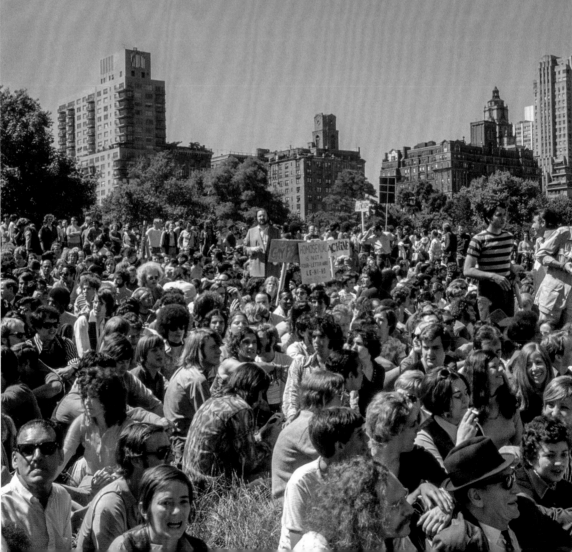

spontaneous bursts of applause broke out; thousands of queer people were celebrating themselves and each other.

It was Gay Pride.

There was no program that afternoon, no agenda, no speakers; just a large group of gays dancing, chanting, kissing, relaxing, and occupying Central Park. It was "a family reunion, and the tattered carpeting of the park became a living room in which we all, under the beneficent sun, lived, touched, smiled and—not tolerated, but welcomed—one another's differences not as a lessening of our own particular selves, but as endless complements to that spark of self which is the sum of one soul."

For one afternoon, two lesbian writers noted, people experienced "the smiles of those unafraid of each other." But, they said, "you can only do it once."

The day ended, but the work had just begun.[25]

Just weeks after the first Christopher Street Liberation Day, the NYPD cracked down on queer life in and around Times Square. In a particularly brazen move, gay activists left the Village for a late-August march on 42nd Street. The march itself went peacefully, but things changed when the group decided to head home. As the liberationists marched down Seventh Avenue, bottles crashed into the crowd, sending several demonstrators to the hospital. Reaching Sheridan Square, activists found police raiding a gay bar, The Haven, and a perfect storm generated Gay Liberation's most violent interaction with police yet, as cops attacked a vigilant crowd and dozens were arrested.

Describing what became known as "the Forgotten Riot," one demonstrator said that "only afterwards did people begin to realize how different it was from the Stonewall riot of a year ago. Different: because we now accepted struggle as a fact of our lives."[26]

A few weeks later, after NYU canceled a gay dance on September 20, liberationists occupied Weinstein Hall, resulting in another standoff. Over the course of five days, dozens of queer activists from different factions made camp and, for a time, raised each other's consciousness.

"I've never known any drag queens before," said a member of the Radicalesbians to Sylvia Rivera.

"Transvestites," Sylvia interjected. "Transvestites."

When the Tactical Police Force stormed Weinstein Hall on June 25, "Sylvia was nuts," said Bob Kohler. "She almost got us killed." With weapons drawn, police gave the occupiers ten seconds to leave, but "Sylvia starts screaming, 'GIVE ME A G!'"[27]

Weinstein inspired Sylvia to start Street Transvestites for Gay Power, later called Street Transvestite Action Revolutionaries (S.T.A.R.), a group formed to fight the violent oppression of transgender people "by heterosexuals and homosexuals of both sexes." S.T.A.R.'s revolutionary rhetoric—both violent and comforting—was groundbreaking. "We don't believe in cooperating with The Man," Sylvia said. "We're dedicated to blowing up the next building and killing the next cop." And her cofounder Marsha P. Johnson explained that they "believed in picking up the gun, starting a revolution if

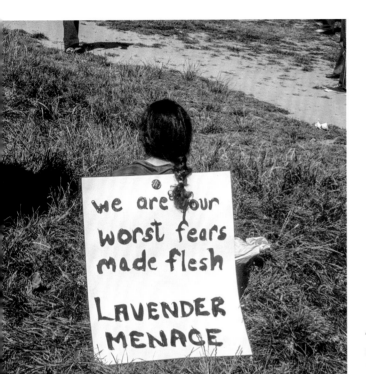

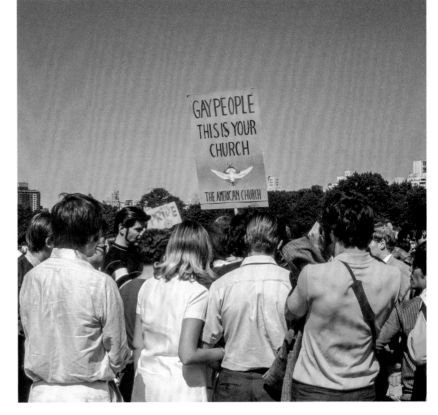

This Page Christopher Street Liberation Day, Central Park, New York City, June 28, 1970. Photographers unknown. From the authors' collection.

▶ Opposite Gay activists march in Times Square to protest increased police harassment, New York City, Aug. 29, 1970. Photo by Steve Rose. From the authors' collection.

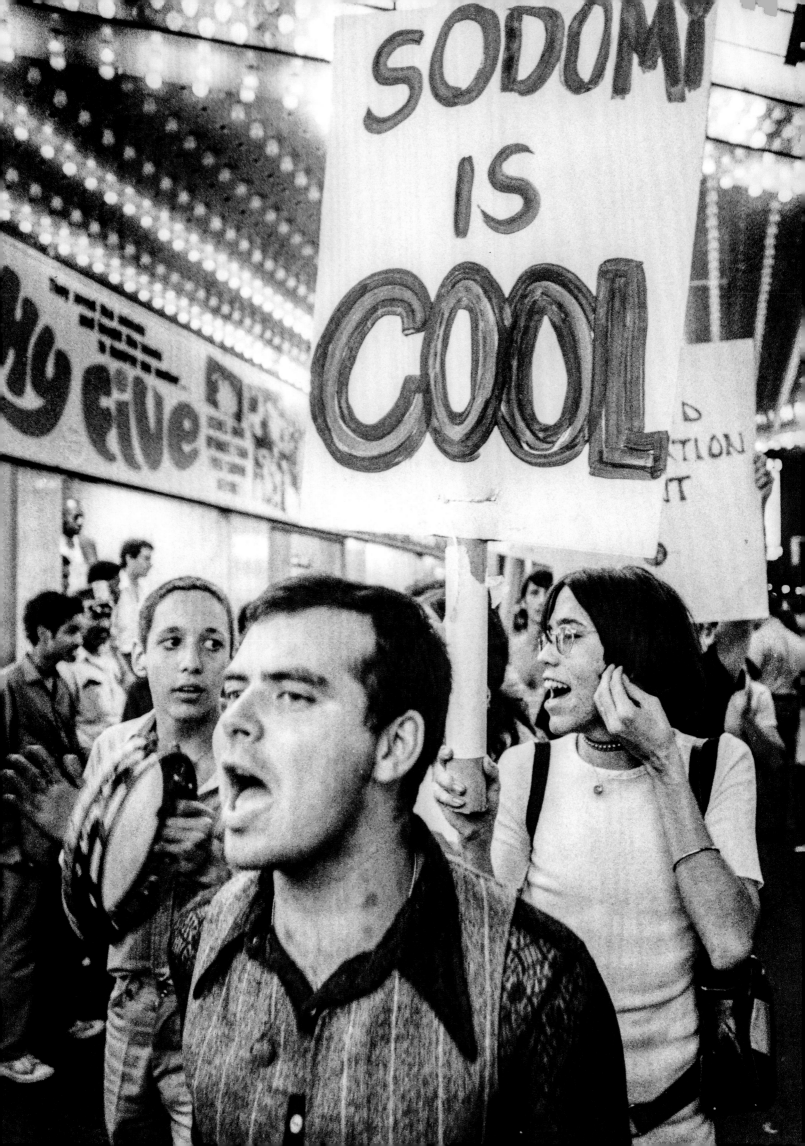

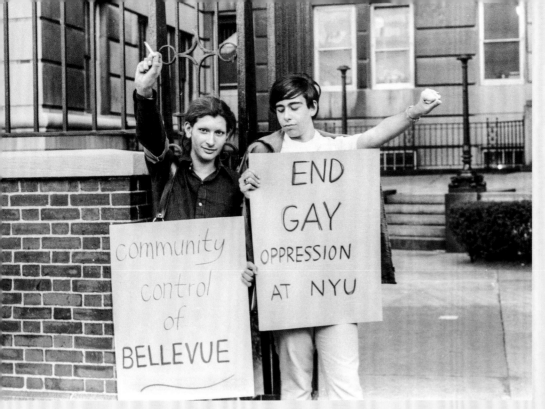

▲ **Above** Sylvia Rivera (left) and Bebe Scarpinato (a.k.a. Bebe Scarpi) protest New York University's treatment of the queer community in the wake of the Weinstein Hall occupation, New York City, Oct. 1970. Photo by Richard C. Wandel. Courtesy of The LGBT Community Center National History Archive (Wandel collection; 4a-002).

▶ **Right** Marsha P. Johnson holds the Street Transvestite Action Revolutionaries (S.T.A.R.) banner, Christopher Street Liberation Day, New York City, June 25, 1972. Photo by Leonard Fink. Courtesy of The LGBT Community Center National History Archive (Fink collection; 25-13).

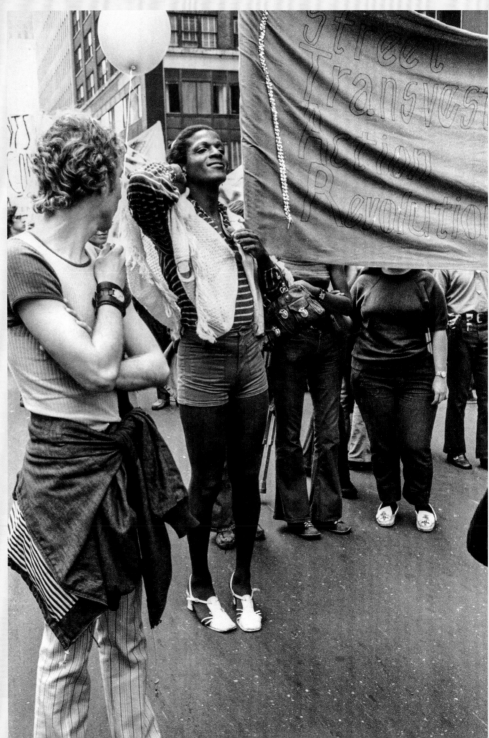

necessary." At the same time, Sylvia envisioned S.T.A.R. as a social services organization. With S.T.A.R. House, a dingy four-bedroom apartment without electricity, she established the first recorded housing facility explicitly for transgender people.[28]

Although focused on street youth, S.T.A.R. was committed to Sylvia's broad vision of "gay solidarity," a fight for "the rights of those disenfranchised due to gender, youth, imprisonment, homelessness, and sexuality." But rarely was this inclusive spirit reciprocated by the broader queer community, the leadership of which manipulated Sylvia's dedication, taking advantage of her willingness to fight. The "crux of the problem with Sylvia," Bebe Scarpi said, was "she was good to go." Whenever "you wanted someone to storm City Hall, or to lay down in traffic and get the shit beat out of her, you would call for Sylvia." But, Arthur Bell remembered, with "their third-world looks and their larger-than-life presences," S.T.A.R. simply didn't "fit," and when cameras showed up, gay leaders shuffled Sylvia out of view.[29] She was an asset as a soldier and a liability in terms of public relations.

Not all transgender activists were equally radical. Bebe Scarpi, for example, remained an active member of the increasingly reformist GAA while serving on the Christopher Street Liberation Day Committee. Lee Brewster, a former Mattachine-NY member, not only originally formed Queens Liberation Front specifically for "elegant drag queens" but also bankrolled many of Gay Lib's early legal fights.[30]

Moreover, there were countless transgender people involved in Gay Liberation who, due to institutionalized prejudice, threats of harassment, lack of access, or as a matter of personal preference, participated *not* as openly transgender activists, instead presenting as cisgender gay men or lesbian women fighting for the rights of gays and lesbians. Before the 1970s, butch and femme lesbians created space for those who didn't fit neatly into one gender category or another. Leslie Feinberg said the working-class bars of Buffalo provided their first glimpse of "a world in which I *fit*." And Jeanne Córdova later explained how one can see butch identity as a trans identity: "It could certainly be seen as a type of gender-nonconforming identity," she said. But by the early 1970s, many lesbian activists disassociated from gender roles, especially butch-femme identities, which they saw as reproducing the patriarchy's sexism.[31]

Feminism had long been ignored in male-dominated queer communities. Shirley Willer, for example, had sounded the alarm in 1966 when she'd said there'd been "little evidence" that gay men had "any intention of making common cause." As Rita LaPorte took over as president of the Daughters of Bilitis (DOB) soon after NACHO '68, the once great lesbian organization stopped being lesbian-focused, emphasizing the gap between men and women over that between gay and straight. When every homosexual, "male and female, have their rights as homosexuals," LaPorte wrote in 1969, "we Lesbians will have all the rights that *women* have." By 1970, *The Ladder* wasn't "A Lesbian Review" at all, nor was it connected to DOB, which, like the Mattachine Society, dissolved into a collection of disconnected local chapters.[32]

GAY POWER,
BLACK POWER
WOMEN POWER
STUDENT POWER
ALL POWER
TO THE
PEOPLE

As some women focused on integrating Lesbian Liberation into the broader Women's Movement, a new generation of West Coast activists sought to keep DOB's lesbian-centric spirit alive. These activists, particularly L.A.'s Jeanne Córdova, weren't feminists who happened to be lesbians—they were Lesbian Feminists, women who recognized that, in addition to "all the oppressions that are laid on straight women, we as gay women must maintain secrecy or be subject to expulsion from our jobs and our houses." Córdova revitalized L.A.'s DOB, created a vanguard lesbian center, organized successful lesbian conferences, and launched *Lesbian Tide*, the radical heiress to *The Ladder*.[33]

In San Francisco, the loss of the *The Ladder* left "a great need for an exclusively lesbian magazine," leading a reenergized DOB-SF to found *Sisters*, a magazine dedicated to spreading the word that lesbians were "alive and well and still fighting." In their first issue, *Sisters* published Del Martin's essay "If That's All There Is," in which DOB's cofounder "bid adieu to the male chauvinists of the homophile movement, to co-ed organizations like S.I.R., to the gay bars that discriminate against women, to the drag shows, to NACHO, and to Gay Liberation." Lesbians were done being taken for granted by other progressives, as DOB-SF's vice president Beth Elliott made clear when an antiwar group touted DOB as an endorser of an upcoming march. Because Vietnam was not "immediately relevant to the goals for which we are working," she wrote in 1971, "it would not be consistent with our publically stated aims either to endorse or denounce this action."[34]

While DOB-SF didn't officially participate in that march, many queer women did. "As a transsexual," Angela Douglas wrote in the *Berkeley Barb*, "it was an act of self-affirmation for me to carry a banner reading 'women unite for peace' several miles with other sisters." Douglas, the West Coast's most visible transgender activist, also expressed regret if she "offended any sisters by my participation," but she felt that "the discrimination directed against transsexual women by non-transsexual women—particularly those of us in the pre-operative phase—must be confronted openly and in a sisterly way if at all possible."[35]

Beth Elliott, like so many women connected to Women's Liberation *and* Gay Power, was deeply committed to Lesbian Liberation, particularly DOB-SF. After being violently forced from her home upon coming out, Beth disconnected from her biological family, choosing instead to welcome the lesbian community as family. With her commitment "to

ending all sexism and all hatred and exploitation by any and all means," she was well-regarded as a Lesbian Feminist activist, writer, and singer. It was no secret that Beth was a "pre-operative male-to-female transsexual," something she'd disclosed upon joining DOB-SF, and there'd been little objection to her participation for well over a year.[36]

During the same period, though, Women's Liberation fragmented, and more militant ideologies emerged. Radical Feminist groups—seeking a "revolution in which women free themselves from male definitions and domination in all areas of society: politically, economically, socially, psychologically and sexually"—developed as an alternative to older organizations. With an emphasis on *sexual* freedom from men, Radical Feminism produced "political lesbians," women who weren't born queer but who had "decided to sleep with other women as an act of political solidarity." Ti-Grace Atkinson best captured the convergence of Radical Feminism and Lesbian Liberation, writing, "Feminism is the theory; lesbianism is the practice." Thus, dismissing bisexual identity altogether, Radical Feminists looked to turn lesbianism into a political identity by expanding "the definition of lesbianism irrespective of sexual attraction." And they relied, in part, on a fundamental tenet of Women's Liberation: a woman's freedom "to define herself, her goals, her identity, her purpose—without interference, interpretation, or judgment from others."[37]

The presence of "political lesbians"—or, as Del Martin and Phyllis Lyon called them, "instant Lesbians"—in DOB-SF had very real consequences, as the definition of "who a lesbian was and how she should live her life" became the center of painful debates. By the spring of 1972, an increasingly vocal group decided that "lesbian" did *not* include transgender women, launching an attack on Beth Elliott and her supporters. Although Beth had been honest about her identity and had support from DOB stalwarts—including Martin and Lyon, at least privately—those seeking her exclusion forced a vote on the issue, winning 35 to 28.

The reaction was swift, though not surprising. Everyone knew the core membership—including Karen Wells and the rest of the *Sisters* staff—would leave in solidarity with Beth. Just after the vote, an announcement ran in *Sisters*: "The previous staff of SISTERS has resigned. This issue was hastily assembled by the Sisters Collective." And other voices chimed in, including Jeanne Córdova and *The Tide* collective, who said those voting against inclusion "vote with our oppressors," whereas those siding with Beth "recognize that none of us is free unless all of us are free." *Tide* readers were asked to "please advise our transsexual sisters that . . . they are most welcome in the city of Los Angeles."[38]

> I believe in the sisterhood of all women.
> —Beth Elliott, 1971

It wasn't clear, however, that the vitriol of a few San Franciscans would resonate far beyond DOB-SF, especially with most Lesbian Feminists focused on the upcoming West Coast Lesbian Conference. While not the first large lesbian gathering, the April 1973 conference in L.A. was meant to be the birth of Lesbian Nation, bringing together sisters from everywhere. A group of organizers—*including* Beth Elliott—had worked on the event since October, trying to coordinate housing, workshops, day care, entertainment, and speakers Kate Millett and Robin Morgan.[39]

Despite the organizers' efforts, however, the conference plunged into chaos almost as soon as it started. On the first night, as Beth Elliott took the stage to perform "some far-out feminist songs," tensions exploded when members of the separatist Gutter Dykes collective interrupted, accusing Beth of being the leader of "a new trend of men that are invading and draining our lesbian community." Even after a vote went overwhelmingly in Beth's favor, the Gutter Dykes kept shouting, leading many attendees to walk out. It was just the start.[40]

The following day, Robin Morgan, one of the most famous "political lesbians" on the scene, announced in her keynote that, instead of unity, "my purpose in this talk here today is to call for further polarization." Morgan, whose credentials as a Radical Feminist were impeccable but whose bisexuality and marriage to a man raised doubts about her commitment to lesbianism, seemed aghast. "I identify as a lesbian because I love the People of Women and certain individual women with my life's blood," she announced, before proceeding to attack both Women's *and* Lesbian liberation. But Morgan saved her most intense vitriol for Beth Elliott, "a man [*sic*]," whom she characterized "as an opportunist, an infiltrator, and a destroyer—with the mentality of a rapist." With that, lesbians and bisexual women from across the country came to know of Beth Elliott as representative of "male transvestites" who, at best, sought to "pit woman against woman," and, at worst, sought to infiltrate lesbian spaces with "an ingenious new male approach for trying to seduce women."[41]

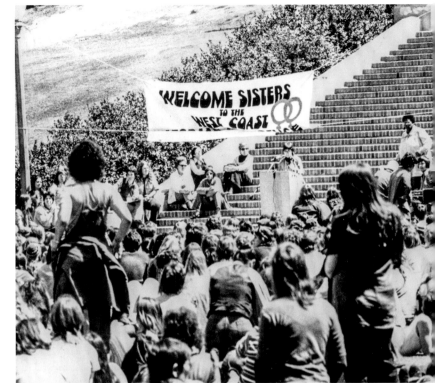

▲ Robin Morgan gives the keynote address at the West Coast Lesbian Conference, Janss Steps, UCLA, Los Angeles, Apr. 14, 1973. Photographer unknown. Courtesy of the ONE Archives at the USC Libraries (Córdova papers and photographs; 2008-064). Used with permission of Lynn Harris Ballen.

Just before heading to L.A. for the West Coast Lesbian Conference, Jean O'Leary announced that New York's Lesbian Feminist Liberation (LFL) committee was separating from the male-dominated Gay Activists Alliance (GAA). Returning to New York after seeing the melee among Beth Elliott, the Gutter Dykes, and Robin Morgan, O'Leary was more determined than ever to make LFL a success, and, with Christopher Street Liberation Day 1973 just two months away, she saw an opportunity to introduce the group to tens of thousands of people.[42]

In June, LFL announced they'd be marching behind the official Pride March "as an effort to strengthen lesbian identity." At first, the separation seemed to be the result of concerns about the direction of Gay Pride, literally and figuratively. As opposed to previous marches—which headed uptown from Stonewall to Central Park without speeches

or entertainment—the 1973 March would start uptown and head toward Greenwich Village, ending at Washington Square Park, steps away from most of the city's gay bars. The change came at the urging of bar owners who'd decided to bankroll the festivities, turning a radical political march into a commercial venture.

"We're back to supporting our local syndicate bars and we're back in the ghetto again," Craig Rodwell lamented. "We've gone the full circle."

LFL eventually backed away from the separatist March idea, announcing plans to march "as a unit—last in the parade (but not separate)," though O'Leary lobbied for a chance to speak at the after-March rally. Inspired, in part, by the trans-exclusionary talking points on display at the West Coast Lesbian Conference, O'Leary redoubled her efforts to be named an official speaker after organizers announced that drag duo Billy and Tiffany would be performing. But political speeches weren't going to be happening, as "advertising and exploitation were the leitmotifs of the day."

And the Lesbian Feminists were ignored.

"The whole thing with the bars and the baths and the women and the transvestites and the ideologies and the middle class and the attitudes is so fucking complex," Arthur Bell wrote a few days after the 1973 March. "The liberals, the establishment, and the hardhat gays are into protecting the status quo." If the "system is good now," why "bother with the crazies?" Those who "aren't willing to compromise, who have visions of a new and better world and an alternate life-style, constitute the crazies. They are also the true liberationists."

At one point, he explained, "we were all crazies." But as Gay Lib grew and the middle class moved in, "our ideology changed, and we acquired property for our functions." Then money was necessary to support the property, so activists "went to the bars and baths and we got cash." But then it was *all* about money and "the crazies dropped out." People like Sylvia Rivera were needed "only for zaps where the spectacle of an angry looked terrific on the TV cameras."

"And Sylvia would go to jail for us. But nix on the outrage at the social functions."

As Gay Liberation moved toward the mainstream, in other words, more and more queer people came to see full integration into the dominant culture—i.e., assimilation—as a real possibility. To that end, more and more queer people ramped up efforts to appear "just like everybody else," adopting the "institutionalized rejection of difference" on which so much of straight society relied. The moderate mainstream gays were no longer willing to make space for those failing to fit what Audre Lorde called the "*mythical* norm," pushing members of underrepresented subcommunities within the queer world further away from "a society within which we can each flourish."

Christopher Street Liberation Day 1973, Sylvia Rivera told Bell, "was the worst day of her life." Sitting "battered and bruised on the sidewalk" after a day spent fighting to be heard, Sylvia said she'd been "raped by the movement for the last time."

"She asked me if there was a God," Bell wrote. "I told her I didn't know."[43]

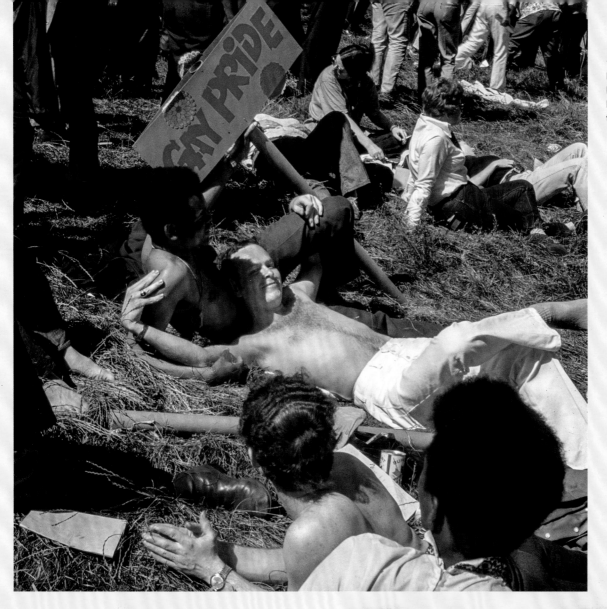

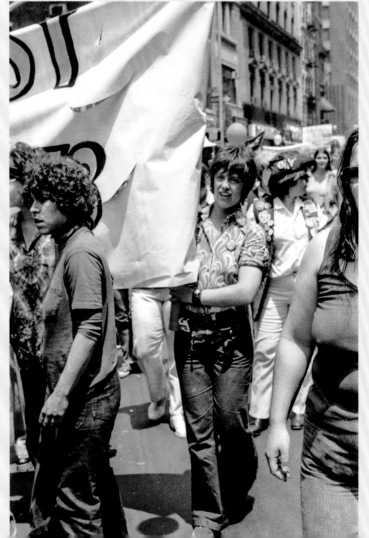

LESBIAN FEMINIST LIBERATION

▲ **Above** Lesbian Feminist Liberation pinback, c. 1973. From the authors' collection.

▶ **Right** Jean O'Leary marches with the Lesbian Feminist Liberation contingent, Christopher Street Liberation Day, New York City, June 24, 1973. Photo by Richard C. Wandel. Courtesy of The LGBT Community Center National History Archive (Wandel collection; 4a-004).

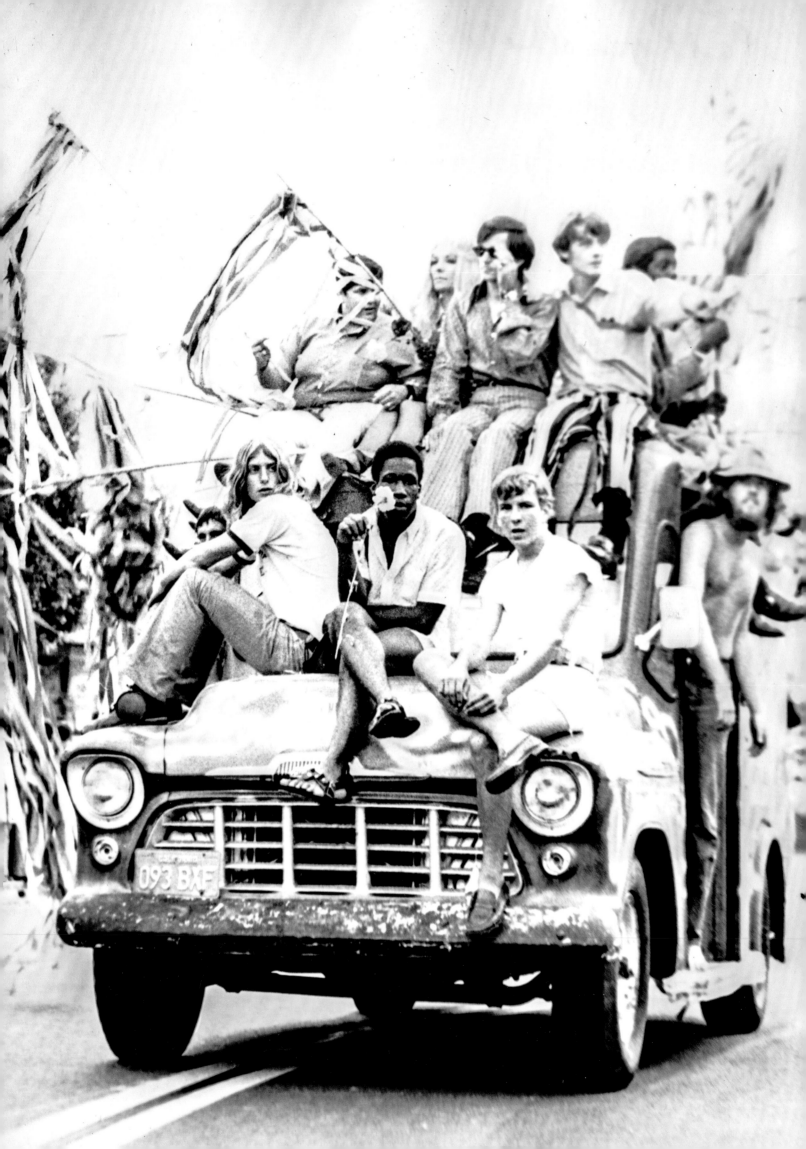

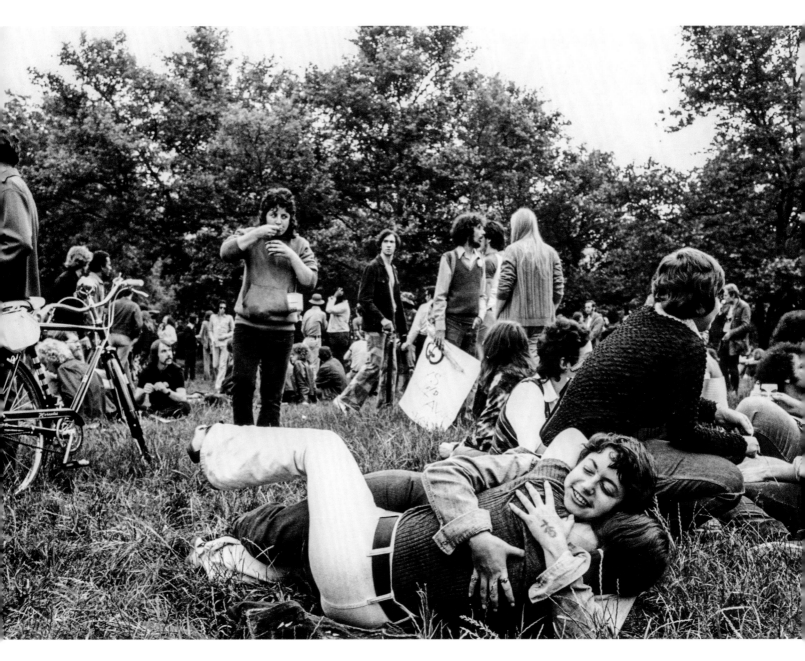

▲ **Above** Christopher Street Liberation Day, Central Park, New York City, June 25, 1972. Photo by Leonard Fink. Courtesy of The LGBT Community Center National History Archive (Fink collection; 25-23).

◄ **Opposite** Christopher Street West, Los Angeles, June 27, 1971. Photo/copyright © by Pat Rocco. Courtesy of the ONE Archives at the USC Libraries (Rocco photographs and paper; 2007-006).

▶ **Following Spread** Lead banner, Christopher Street Liberation Day, New York City, June 24, 1973. Photo by Fred W. McDarrah. Copyright © by Getty Images and the Estate of Fred W. McDarrah.

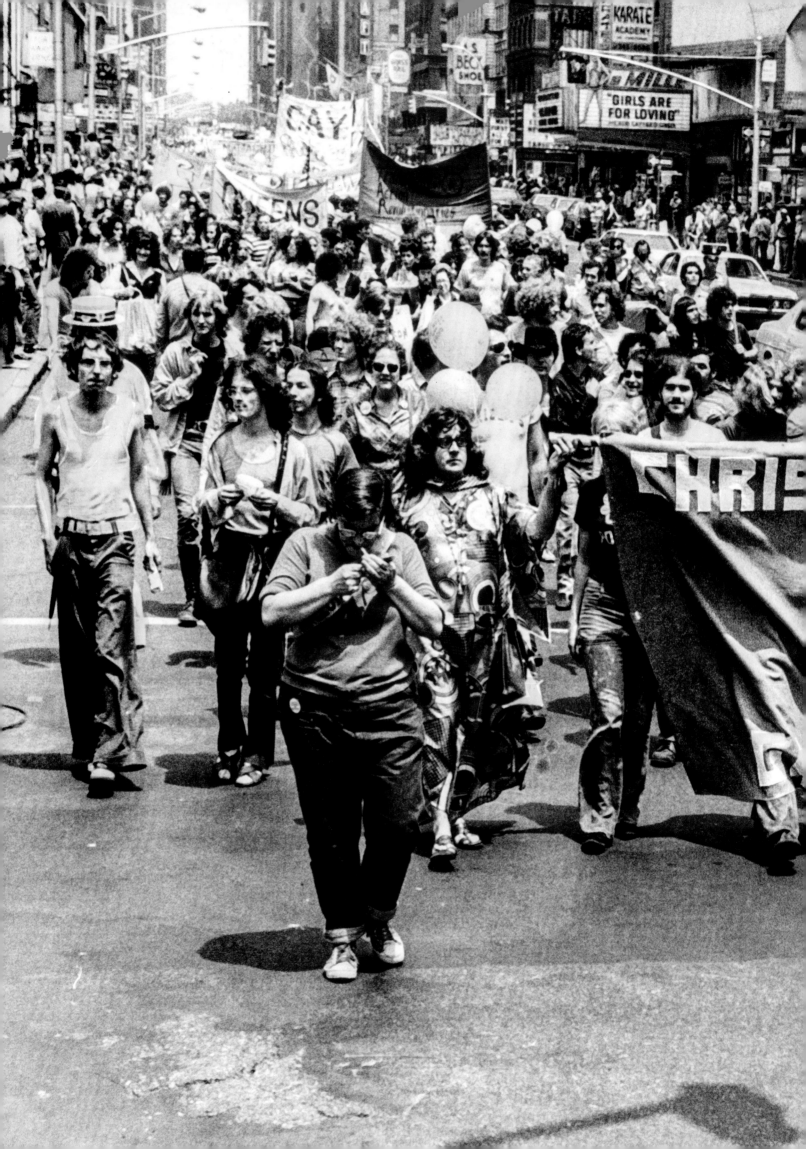

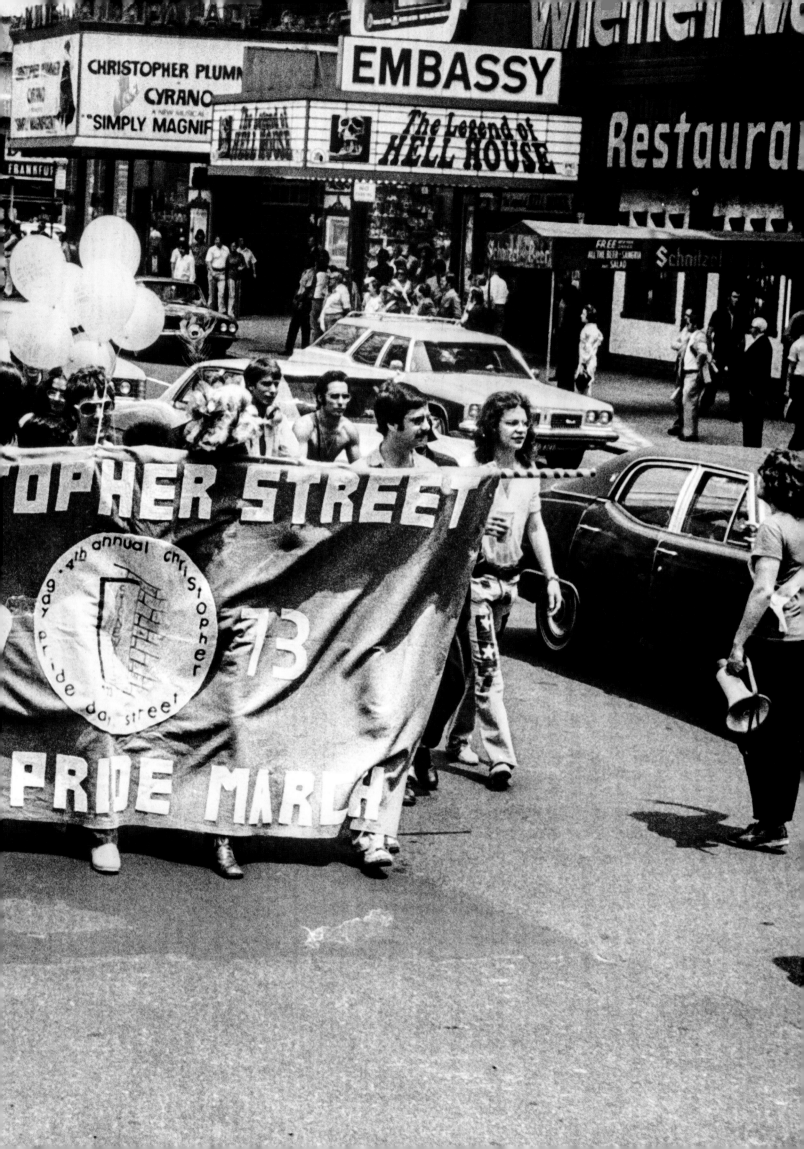

PART III

Sissy,

THE CLOSET DONE BURNED DOWN!

1973–1979

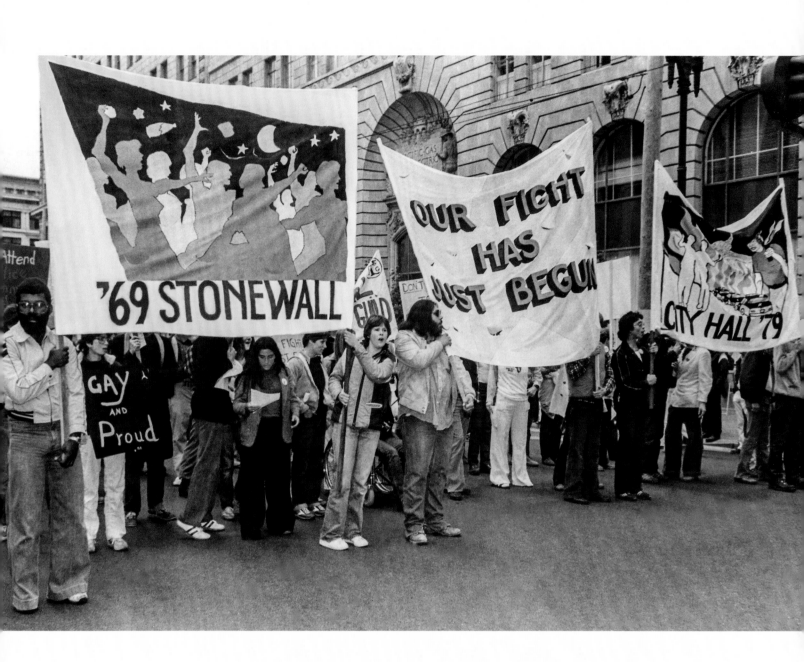

The court system will take care of the archaic laws, and re-education will do the same for the public at large. Then again, if all else fails, you can always break their windows.

—BEBE SCARPI, 1973

Washington, D.C., 1979

After months of debate, organizers of the 1979 National March on Washington for Lesbian and Gay Rights agreed to one primary demand: *An end to all social, economic, judicial, and legal oppression of Lesbian & Gay people.* Beyond that, the messages brought to D.C. in October 1979 were as diverse as the messengers themselves. Tens of thousands of people representing every facet of queer life from the fifty states, D.C., Puerto Rico, and at least a dozen foreign countries made their way through the District. The Pope, who'd been in D.C. earlier that month, hadn't had a crowd like this.

In the six years since the clashes at the West Coast Lesbian Conference and Christopher Street Liberation Day 1973, there'd been a great deal of progress for many gays and lesbians in the United States, and there was reason to be proud. "To have survived the oppression that you've survived for centuries," comic-activist Robin Tyler told the National March crowd, you're not "as good" as straights, "you're better!" But in the late 1970s, oppressive forces in the United States were reinvigorated, and the relative progress achieved under the banner of Gay Rights seemed to be buckling under pressure from a powerful new conservative movement.

In San Francisco, for example, the queer community celebrated the defeat of a state-wide antigay law in November 1978, only to mourn the murder of openly gay city supervisor Harvey Milk later that month. By the time San Franciscans arrived in D.C., Milk's death and the riots that followed the lenient sentencing of his killer, Dan White, were rallying cries. San Francisco's White Night Riots hadn't surprised Reverend Troy Perry, who'd seen his share of violence. Perry, founder of the Metropolitan Community Church, the Los Angeles–based queer religious organization with a presence in cities across the country, told the crowd gathered at the National March that, since 1973, twelve of his churches had been burned to the ground. "In one case," he said, referencing a fire in New Orleans that had taken place the same day as Christopher Street Liberation Day 1973, "our minister and ten of our church members were burned to death because of oppression."

"We don't owe apologies to anyone."[1]

At the beginning of the decade, as activists in Los Angeles organized the Christopher Street West (CSW) events of 1971 and 1972, sharp disagreements pitted militants against reformists, commercial interests against purists, and, particularly, women against men. During the second annual CSW in 1971, for example, the Cockapillar, a twenty-foot papier-mâché penis that featured in the parade, disgusted "respectable" gays, alienated even the most unity-conscious lesbians, and infuriated police. The hostility grew so bad that, in 1973, organizers canceled the parade altogether.[2]

Much had changed since the police raided The Patch in August 1968 and Lee Glaze had led Troy Perry and others to demand the release of Bill Hastings and Tony Valdez.

◀ Page 159 Gay Freedom Day, San Francisco, June 24, 1979. Photo by Ted Sahl. Courtesy of San José State University Special Collections and Archives.

▶ **Right** National March on Washington for Lesbian and Gay Rights, Washington, D.C., Oct. 14, 1979. Photo by Donald Eckert. Courtesy of San Francisco History Center, San Francisco Public Library (Eckert collection; GLC 185).

▼ **Below** The Cockapillar, Christopher Street West, Los Angeles, June 27, 1971. Photo by Lee Mason. Courtesy of the ONE Archives at the USC Libraries (Mason photographs; 2012-078).

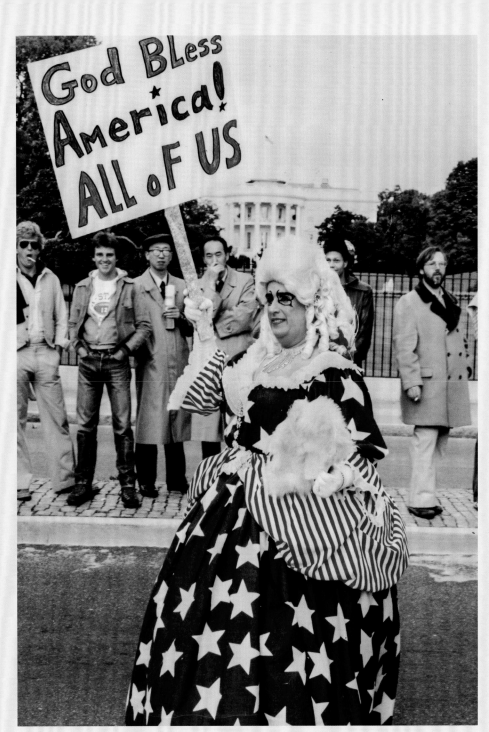

▲ Reverend Troy Perry (in black), his partner Steve Jordan (in sunglasses), and Perry's mother Edith Allen Perry (in the passenger seat), Christopher Street West, Los Angeles, June 28, 1970. Photographer unknown. Courtesy of the ONE Archives at the USC Libraries (CSW collection; 2012-035).

While the flower-powered hours at the police station turned out to be liberating for many of those involved, Valdez was deeply upset by his arrest, taking it as proof that no one—not even God—cared about him. Unable to comfort Valdez, Perry took his friend's crisis of faith as a sign, and announced the first meeting of the Metropolitan Community Church (MCC) in September 1968. What started as a dozen people in Perry's living room grew so rapidly that, by 1973, MCC had fifteen thousand members across forty U.S. cities.[3]

Although the 1973 CSW parade was canceled, L.A. still had informal Pride celebrations. On June 24, Troy Perry went to a party, returning home around midnight. Finding a note on the door—something about a fire—he rushed inside to grab the ringing telephone. "It's a very bad fire in New Orleans," Reverend John Gill of MCC-Atlanta said, "and they say a lot of people have been burnt to death."

Perry asked if any MCC folks were hurt.

"Yes," Gill said, "apparently a lot. I think Bill Larson, the pastor, was one."

Perry immediately knew it was arson. There'd been fires at MCCs and gay community centers in San Francisco, Nashville, and Buffalo. And in January, someone had torched Perry's base of operations, the L.A. MCC. It made his people stronger, Perry said, especially after one thousand worshipers showed up for an outdoor service the Sunday after the L.A. fire; it was a bravely public response to the violence. Only the singers in MCC's Metrochords balked, asking to perform behind screens so they couldn't be publicly identified; Troy Perry and music director Willie Smith were outraged.

"Sissy," Smith shouted, "the closet done burned down!"[4]

Perry flew to New Orleans on June 25, 1973, connecting first with Reverend John Gill and then Morty Manford and Morris Kight, who flew in from New York; they then gathered information about the inferno that had consumed the Up Stairs Lounge.

A second-floor, three-room bar on Decatur Street, the Up Stairs, according to one regular, was "a place to find friends if you were in need." At 7:00 p.m. on June 24, sixty people were wrapping up the bar's weekly beer bust: David Gary played piano while Stewart Butler and Lindy Quinton sang along; Buddy Rasmussen tended bar; and brothers Jimmy and Eddie Warren drank with their mom, Inez. MCC was well represented, as was often true on Sunday evenings: Reverend Bill Larson and Deacon Courtney

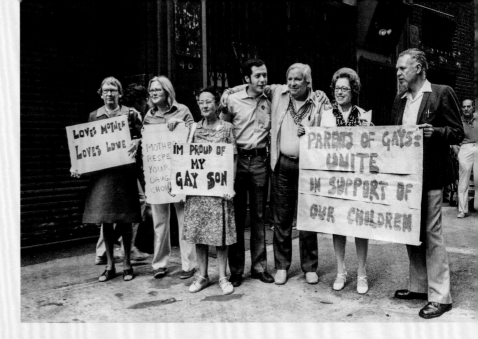

▲ **Above** Morty Manford (fourth from left), Morris Kight (third from right), and Parents of Gays (including Jeanne and Jules Manford, to Kight's right), Christopher Street Liberation Day, New York City, June 24, 1973. Photo by Leonard Fink. Courtesy of The LGBT Community Center National History Archive (Fink collection; 26-09).

◀ **Left** The Up Stairs Lounge, c. 1973. Photographer unknown.

▼ **Below** Metropolitan Community Church contingent, Christopher Street Liberation Day, New York City, June 27, 1976. Photo/copyright © by Biscayne/Kim Peterson.

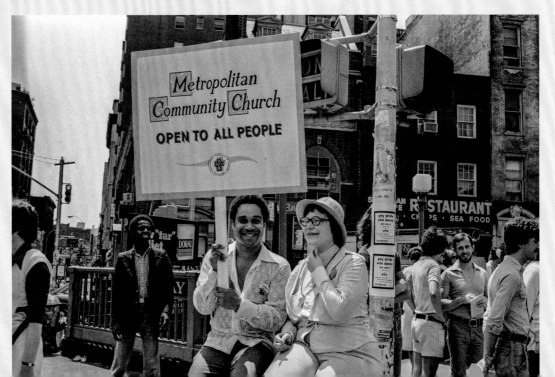

Craighead milled about; and George "Mitch" Mitchell, an assistant pastor, spent time with his lover, Louis "Horace" Broussard.

Right after seven o'clock, when Rodger Dale Ñunez got into a scuffle with a regular, someone grabbed Ñunez, dragged him down the bar's thirteen steps, and threw him into the street. When the service buzzer rang downstairs just before eight o'clock, Luther Boggs went to answer the call, opening the big steel door to a burst of fire that spread up the stairwell into the main rooms.[5]

It lasted sixteen minutes.

Some folks were able to slide through the iron bars covering the windows and jump to the street; some followed Rasmussen to a hidden exit. A few survivors couldn't risk being seen near a gay bar, so they ran. Nothing could stop Mitch Mitchell, who'd made it out alive before realizing Louis wasn't with him, from storming back into the bar. Somehow, they found each other, and firefighters found them together, Mitch's arm covering Louis's body. David Gary was near his piano, and one of the Warren boys had his mom in his arms. Everyone could see what had happened to Reverend Larson, who wasn't able to force his way out of a window; his charred remains sat in plain sight of the street for hours.

Twenty-nine people—one woman, twenty-eight men—died Sunday night; fifteen were hospitalized. Luther Boggs, identified as a homosexual by the local press, lost his teaching job while he lay in a hospital bed; he died soon thereafter, as did two others.

There were thirty-two dead. Reverend Larson's family wouldn't claim his body, nor would the family of Ferris LeBlanc, who was buried in a pauper's grave along with two unidentified victims. The Up Stairs was one of the worst fires in local history, but the victims weren't afforded much respect. "What will we bury the ashes of queers in?" a local radio host asked. "Fruit jars."[6]

Troy Perry castigated the media at a press conference before he and Morty and Morris spread the word that donations of blood and money were needed. Queer communities held memorial services across the country on Sunday, July 1, as Perry prayed with over 250 mourners in New Orleans, a huge crowd for a queer event in that city. As they sang "United We Stand," an Up Stairs anthem, Perry learned there were television cameras waiting outside.

"I cannot control what is happening across the street," he announced. "I just want to tell you that you can go out of the side door." Decades later, Troy Perry still can't tell the story without sobbing. "In a city where people were *really* frightened, nobody left by the back door. People held themselves high; they walked out with their heads held high."[7]

After the turmoil at Christopher Street Liberation Day 1973, New Yorkers were pissed.

"Does Gay Lib expect straights to approve of what they saw?" a reader wrote to *Gay Scene.* "The acceptance of gays is hindered by neurotic 'camping,' which only

frightens straight people." The sentiment was nothing new. In 1944, Henry Gerber had imagined a society for "the better sort of homosexuals." In 1953, Marilyn Rieger said Mattachine had to emphasize "that we are people *like other people.*" And Hal Call simply "wanted to be assimilated into society."[8]

In the mid-1970s, a new generation of moderates was taking charge, shifting attention from Gay *Liberation* to Gay *Rights.* "All we want are equal civil rights, simple legal reform," journalist Randy Shilts paraphrased. "You get that by showing liberals that you're decent, respectable people, just the same as they are." In big cities, a growing number of moderates and reformists—most of whom were white men—lived relatively comfortably in the straight world and scoffed at the notion of a revolutionary movement. Those that cared about a movement at all wanted a businesslike national effort, staffed by professionals.[9]

On October 15, 1973, Dr. Howard Brown, a former New York City health official who'd recently come out, announced the formation of the National Gay Task Force (NGTF), a clearinghouse for other gay groups and a lobbying shop for legislation outlawing antigay discrimination and repealing antisodomy laws. Dr. Bruce Voeller, NGTF's first executive director, had just resigned as president of the Gay Activists Alliance (GAA) because, he said, that group "had been taken over by the Socialist Workers Party." (Morty Manford, GAA's new president, called the claim "unmitigated nonsense.") Frank Kameny and Barbara Gittings were on NGTF's Board, as were GAA alumni Ron Gold, Pete Fisher, and Marc Rubin; Lesbian Feminist Liberation's Ginny Vida; City College professor Martin Duberman; and politico David Rothenberg.

NGTF's media guru Ron Gold, writing in the first issue of the group's newsletter, *It's Time,* explained that the "'political' things we do"—zaps, pickets, appeals for legislative reform—"are simply tools to dramatize our existence as real human beings—public relations tools." Those who believed, as Gold did, "that there'll be no more need for a gay movement when everybody comes out of the closet" should also accept his logical corollary: "The whole gay movement is public relations."[10]

▲ From left: Ron Gold, Howard Brown, Bruce Voeller, and Nathalie Rockhill (seated behind them is Frank Kameny) announce the formation of the National Gay Task Force, New York City, Oct. 15, 1973. Photo by Fred W. McDarrah. Copyright © by Getty Images and the Estate of Fred W. McDarrah.

In late 1973, the Board of Trustees of the American Psychiatric Association (APA) delivered perhaps the greatest "public relations tool" imaginable when it adopted two resolutions: first, removing homosexuality per se* from the *Diagnostic and Statistical Manual of Psychiatric Disorders* (*DSM*); or, said one gay paper, "Psychiatrists Say Gay Not Sick." Second, the organization called for the repeal of all laws discriminating based on sexuality, including those criminalizing private sexual activity between consenting adults.

* "While some gay groups and prominent individuals described this as the 'greatest gay victory,' others were not so thoroughly impressed," the *Gay Liberator* explained. "Particularly annoying was the new psychiatric category offered by the APA called 'sexual orientation disturbance.'" The new category represented a capitulation to doctors like Irving Bieber and Charles Socarides who'd built careers on treating homosexuality as a pathology. "Sexual orientation disturbance" applied to individuals "whose interests are directed primarily toward people of the same sex and who are either bothered by, in conflict with, or wish to change their sexual orientations." The existence of the "sexual orientation disturbance" category provided the basis for "conversion therapy" practices for decades.

"VICTORY!!!! We have been 'cured'!" Frank Kameny wrote.[11]

It was Kameny who'd started the fight in the early 1960s against the homosexuality-as-sickness theory, insisting to government officials that homosexuality is "a matter of personal taste and preference" and not, "in any sense, whether physical or pathological, a disease, illness, ailment, or malfunction." In 1964, he'd proclaimed the entire homophile movement would "stand or fall" on the sickness question, explaining the following year that, because anyone going to a psychiatrist almost necessarily is "going to have problems of one sort or another," the sickness theory was based on an "abysmally poor sampling." For years, Kameny and Barbara Gittings had fought to influence American Psychiatric Association (APA) members, few of whom had reason to listen. But Gay Liberation brought radical reinforcements.[12]

In May 1970, militant queers and feminists had invaded the APA's Annual Conference in San Francisco, bursting into a speech by antigay psychiatrist Irving Bieber. "You are the pigs who make it possible for the cops to beat homosexuals," gay liberationist Gary Alinder shouted. "You make possible the rapes in prisons, you are implicated in the torturous cures perpetrated on homosexuals."

"I never said homosexuals are sick," Bieber responded. "What I said was that they have displaced sexual adjustment."

"That's the same thing, motherfucker!"

Weeks later, Chicago Gay Liberation zapped Dr. Charles Socarides at the American Medical Association convention. That fall, Gay Liberation Front-L.A. hit the Annual Behavioral Modification Conference.[13]

The following May, amid the massive May Day 1971 antiwar protests on the National Mall, over two thousand psychiatrists gathered in the Regency Ballroom of D.C.'s Shoreham Hotel. The calm faces of Kameny and Gittings, who sat in the front row as invited guests, belied their sense of anxiety and glee at what was about to happen. Just as former U.S. attorney general Ramsey Clark settled into his keynote address, the ballroom's fire doors—having been propped open the previous night with small wedges—burst open and dozens of flaming fairies flooded in. Amid shouts of "Psychiatry is the enemy," some doctors fought back, pushing a few activists out of the room and slamming the doors shut. D.C.'s Cliff Witt, who'd been picked to seize the microphone and address the crowd, was among those locked out during the scuffle. Sensing a problem, Kameny lunged onstage, unleashing a torrent of "the most revolutionary things anyone had ever heard him say."

"We are here to denounce your authority to call us sick or mentally disordered!" he shouted. "For us, as homosexuals, your profession is the enemy incarnate. You may take this as a declaration of war against you!"

It was chaos. And it worked. After the melee, doctors approached Kameny and Gittings offering help. At next year's conference in Dallas, they said, the homosexuals could have their own exhibition.[14]

As it turned out, the "Gay, Proud, and Healthy" booth in Dallas at the APA conference in 1972 was just the start. The evening's panel—"Psychiatry: Friend or Foe to Homosexuals?"—was planned as a dialogue among Kameny, Gittings, and two friendly straight psychiatrists, but Kay Lahusen thought something was missing: a *gay* psychiatrist. Although few doubted the potential impact of Lahusen's idea, and while Gittings knew about a secret group of gay psychiatrists—the GayPA, they called themselves—coming out publicly would be career suicide for a doctor. Dr. John Fryer wanted to help, Gittings discovered, but it was too risky.

▲ From left: Barbara Gittings, Frank Kameny, and Dr. H. Anonymous (a.k.a. Dr. John Fryer), American Psychiatric Association conference, Dallas, May 2, 1972. Photo by Kay (Tobin) Lahusen. Courtesy of Manuscripts and Archives Division, The New York Public Library.

"What if we disguise you?" she asked.

So on May 2, 1972, Gittings and Kameny introduced a packed auditorium to Dr. H. Anonymous, a startling figure in an oversized tuxedo, a warped Richard Nixon mask, and a fright wig.

"I am a homosexual. I am a psychiatrist. I am a member of the APA."

The audience sat silent.

"As psychiatrists who are homosexual," Anonymous told his straight colleagues, "we cannot be seen with our real friends—our real homosexual family—lest our secret be known and our dooms sealed." Anonymous urged other homosexual psychiatrists not to try to "cure" gay patients but to "develop creative ways" to tell them "they're all right." While such an approach might mean discovery and job loss, the bigger risk was "not accepting fully our humanity." This, he said, "is the greatest loss: our honest humanity. And that loss leads all those others around us to lose that little bit of their humanity as well. We must use our skills and wisdom to help them—and us—grow to be comfortable with that little piece of humanity called homosexuality."

A brief silence filled the room. Then, almost as one, the audience stood and cheered.[15]

Dr. Robert Spitzer, a member of the APA's Nomenclature Committee, was intrigued. In New York that fall, after Ron Gold and GAA had zapped a therapy conference, Spitzer agreed to arrange a meeting with his committee, which determined what went into the *DSM*. In early 1973, Gold and Jean O'Leary led a delegation to challenge the sickness theory. "Being told you're sick makes you sick," Gold summarized.

Spitzer and his colleagues organized a final symposium for the next APA conference, and doctors filled another convention hall to see Irving Bieber and Charles Socarides debate Ron Gold and Dr. Judd Marmor, a trailblazing (straight) psychiatrist. Despite a positive reaction, Gold knew the decision rested with the Nomenclature Committee. With that in mind, he invited Spitzer to a GayPA happy hour on one condition: the heterosexual doctor should observe, not speak. But Spitzer wasn't prepared to see doctors from government agencies and prestigious universities at a *homosexual* gathering; he "started asking all these absolutely dimwitted questions," Gold recalled, "questions that no gay person would ever ask," and people got nervous.

In the midst of the whispered chaos, a young man in an army uniform walked in and looked around. Recognizing Gold from the panel, the stranger burst into tears. It turned out he was a deeply closeted army psychiatrist who hadn't been around other homosexuals before; now he'd come home.

"Let's go," Spitzer told Gold, and they left to draft a resolution removing homosexuality from the *DSM*.[16]

Despite Charles Socarides's last-ditch effort to reverse the board's decision, a 1974 vote by the entire American Psychiatric Association (APA) membership was unambiguous: homosexuality per se no longer constituted a mental illness. And a second resolution went even further: if homosexuality was no impairment, then all laws codifying public and private antigay discrimination had to end, as did those criminalizing private sexual activities between consenting adults.

With publicity from the APA's decision, the Gay Rights Movement hit the ground running. Just a month after the National Gay Task Force (NGTF) formed, D.C.'s Title 34 became law, banning discrimination in housing and employment. In short order, similar laws passed in Boulder, Columbus, Minneapolis, St. Paul, Palo Alto, Portland (Oregon), Madison, Austin, and Chapel Hill. And those were in addition to laws previously passed in Ann Arbor and Seattle.[17]

Then antisodomy laws came crashing down. Before 1970, only Illinois and Connecticut had decriminalized consensual sodomy (often vaguely defined to include oral sex). Starting with Idaho in March 1971,* however, they fell like dominos: Colorado and Oregon (1971); Hawaii, Delaware, and Ohio (1972); North Dakota (1973); Arkansas, New Mexico, California, Maine, New Hampshire, and Washington (1975); and Indiana, South Dakota, West Virginia, and Iowa (1976).[18]

And then came a wave of openly gay political figures, the first of whom were too radical for the mainstream to support. In San Francisco, a militant named Harvey Milk ran for city supervisor in 1973, but it would be years before he got much attention. Similarly, when progressive Ann Arbor city council members Nancy Wechsler and Jerry DeGrieck *both* came out in 1973, gays beyond the Midwest didn't notice. And the Human Rights Party's Kathy Kozachenko received little more than a mention when she became the first openly gay person elected to public office.[19]

But the mainstream perked up when Elaine Noble was elected to the Massachusetts state legislature in November 1974. Here, finally, was the candidate gay moderates wanted: well-spoken, well-educated, not too butch, not too femme; Noble, most importantly, was at once openly gay—indeed, proudly and bravely gay—while also eager to discuss just about anything else. "According to Elaine," said one reporter, "it's not a victory for

◀ Gay rights pinback, c. 1975. From the authors' collection.

* Idaho's state legislature recriminalized sodomy in April 1972.

the gay community, but a victory for someone who's ready to deal with the issues in her district."[20]

▲ Pinback, Harvey Milk's first campaign for city supervisor, San Francisco, 1973. From the authors' collection.

A month after Noble's election, Minnesota state senator Allan Spear came out, announcing he was tired of state house rumors. "There's nothing I'm ashamed of." Fearing he'd be thought of as "just another gay person," however, he emphasized he was also "lots of other things."[21]

At the federal level, (straight) New York City congressperson Bella Abzug introduced a bill in 1974 to amend the 1964 Civil Rights Act, a move that would have banned discrimination on the basis of *sex, sexual orientation, and marital status* in housing, public accommodations, and federal programs, including federal employment. While Abzug was unsuccessful in pushing Congress, federal courts helped chip away at the government's discriminatory hiring and firing practices. In late 1973, after years of legal battles—many waged by Frank Kameny—two federal courts rejected government attempts to justify discrimination. One court upheld a decision against the Pentagon regarding gay security clearance applicants, one of whom, Dick Gayer, had been at NACHO '68. In the other case, brought by the Society for Individual Rights (S.I.R.), the court effectively demanded the government end its homosexual employment ban.[22]

Finally, on July 3, 1975, Kameny got word that his persistence had paid off: the Civil Service Commission would implement new rules providing that homosexuals couldn't be barred or fired from federal employment because of their sexuality. Although not applicable to the FBI, the CIA, or the military, the policy shift marked the end—officially, at least—of a painful era that had started with the early queer witch hunts in the beginning of the Lavender Scare. And Kameny reacted as one would expect, telling his mother, "I have brought the very government of the United States to its knees."[23]

Meanwhile, in March 1974, Leonard Matlovich, a highly decorated, deeply closeted air force sergeant, read an article in the *Air Force Times* about gays in the military. The piece, Matlovich recalled, quoted "a man by the name of Dr. Frank Kameny." After an initial phone call with Kameny—during which Matlovich spoke of "a friend" who might want to fight the military's homosexual ban—the Vietnam veteran needed another year before calling again. This time, though, he made clear it was he, not a friend, who wanted to challenge the military's policy. In March 1975, Matlovich gave his superiors a letter declaring his homosexuality and requesting a waiver of the ban because his sexual preference in no way impaired his ability to serve. The next month, the Air Force initiated discharge proceedings.[24]

With his rugged good looks and uniformed-demeanor, Matlovich was exactly the spokesman NGTF wanted, and he embraced the role, appearing on the cover of *Time* in September 1975. You couldn't miss it: "**I Am a Homosexual**," in big bold letters, emblazoned across the air force sergeant's chest. Inside the magazine, though,

Matlovich got only half a page of the six-page spread. The cover story, as it turned out, wasn't so much about Leonard Matlovich as it was about NGTF's campaign to destroy "the negative, stereotyped images and replace them with real ones." These "real" images were of ranchers, bankers, oilmen, and politicians; doctors, lawyers, architects, and businessmen; a Maryland teacher, a Texas minister, an Ohio professor, and "a variety of people who could be anybody's neighbor." There were gay studies courses, gay churches and synagogues, gay Alcoholics Anonymous groups, a lesbian credit union, and *The Advocate*—under the new ownership of businessman David Goodstein—described as "a largely political biweekly tabloid for gays with a nationwide circulation of sixty thousand."

The "sexual marketplaces" known as gay bars were proliferating, *Time* said, as police harassment declined. "Once seedy, dark and dangerous, many gay bars are now bright and booming." And gay bathhouses were everywhere, revealing, according to the magazine, that "the most obvious aspect of the male gay culture is its promiscuity."[25]

In the two paragraphs reserved for the lesbian community, readers learned that "publicly, at least, lesbianism is far less flamboyant than male homosexuality," and "politically, young lesbians are facing an identity crisis," torn between gay rights and feminism. As for other subcommunities, mention was made of "bars for writers, artists, blacks, collegians, businessmen, middle-class women, 'drag queens,' transsexuals, male prostitutes and sadomasochists." As usual, though, bisexuals were ignored.

In an increasingly common refrain, *Time* observed with some awe that "since homosexuals began to organize for political action six years ago, they have achieved a substantial number of victories." But those who had been on the front lines of the Movement saw it differently. "Every so often I hear someone say that our movement is just a few years old," Jim Kepner told a group in Milwaukee, "and I wonder what the hell I've been doing the past twenty-one years." But *Time* didn't talk to Kepner, and the Stonewall-as-origin narrative made the Gay Rights Movement seem unstoppable, even while the path forward was anything but clear.[26]

In October 1973, as the National Gay Task Force (NGTF) prepared for its debut press conference in New York, the owner of Ann Arbor's Rubaiyat bar punched a lesbian in the face. The woman was one of many members of the Gay Awareness Women's Kollective (GAWK), who'd been going to the Rubaiyat on Sunday nights for months to hear singer Iris Bell. After owner Greg Ferneli banned them from dancing, tensions grew until an argument broke out and Ferneli threw a punch. Relying on the city's antidiscrimination ordinance, GAWK called the police, though the responding officers refused to do anything. When the Rubaiyat incident came up at the next city council meeting, council members Nancy Wechsler and Jerry DeGrieck both came out publicly for the first time. Having cosponsored the fifteen-month-old antidiscrimination ordinance with DeGrieck, Wechsler said the law had only served to make gay rights a little

more public. "Discrimination against homosexuals," she said, "will not end because of one ordinance, or a hundred ordinances." By early 1974, with Wechsler and DeGrieck stepping down (due to their growing disillusionment with local government), the local Human Rights Party put its energy into the campaign of Kathy Kozachenko, a twenty-one-year-old lesbian who won her seat by fifty-two votes, quietly becoming the first openly gay person to win office in the United States.[27]

In the mid-1970s, while some Gay Rights got attention, only the "right gays" got the benefits. "Gays who formerly were paralyzed with fear are now beginning to play a role in the movement," said Bruce Voeller, as moderate leaders insisted on finding ways to include closeted gay people "from the safety of their closets." An intense focus on this "Silent Majority," coupled with a fetishization of *professional, middle-class,* and *prominent* homosexuals, shrank the space for visible queers, dismissed for exhibiting "self-demeaning personal patterns."[28]

▲ Leonard Matlovich, Houston, c. 1977.
Photographer unknown. Courtesy of Botts
Collection of LGBT History.

▲ Gay Pride, Chicago, June 30, 1974.
Photo by Jay. Courtesy of the ONE
Archives at the USC Libraries (Jay
photographs; 2012-044).

We owe this culture nothing but our
determination to replace it.

—ALLEN YOUNG, 1975

The purists must recognize that the gay movement is not "a totally revolutionary movement."

—RON GOLD, 1975

▼ National Gay Task Force (NGTF) contingent, Christopher Street Liberation Day, New York City, June 30, 1974. Photo by Richard C. Wandel. Courtesy of The LGBT Community Center National History Archive (Wandel collection; 4a-005).

In San Francisco, where straight liberals saw moderates Rick Stokes, Jim Foster, and David Goodstein as *the* gay leaders, radical Ray Broshears founded the Lavender Panthers, a short-lived group of armed gay vigilantes patrolling the streets, in the summer of 1973. At a press conference, Broshears cited a spike in anti-queer violence to explain the group's necessity.

In L.A., police sweeps of Griffith Park netted dozens of arrests in September 1973, a month that saw bomb threats against Chicago's Gay Alliance, a bombing at a gay bar in Massachusetts, and a police raid of the Metropolitan Community Church (MCC) congregation in Indianapolis. In October, D.C.'s Lost & Found bar doubled down on its well-known discriminatory practice of excluding women and people of color. In November, the U.S. Supreme Court upheld Florida's antisodomy statute, while in December, a California court declared Lynda Chaffin an unfit mother *because* she was lesbian, ordering her to surrender custody of her daughters. And despite the work of Street Transvestite Action Revolutionaries (S.T.A.R.) and Queens Liberation Front, deadly violence against drag queens, transvestites, and transsexuals was on the rise.[29]

In April 1974, just after the Supreme Court let stand a Texas cross-dressing ban,

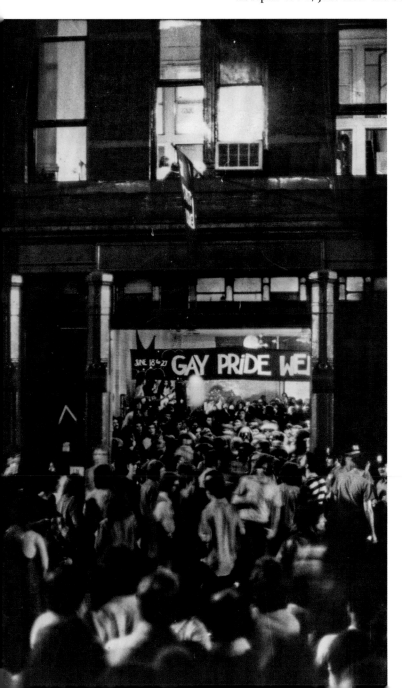

the Court of Appeals upheld D.C.'s antisodomy law; arrests in the District skyrocketed 500 percent. April also brought betrayal, when New York City's long-stalled antidiscrimination bill headed for a full city council vote *without* any transgender protections. Although Bebe Scarpi, Sylvia Rivera, Lee Brewster, and others had fought for the bill from the beginning, they eventually gave up on being included because gay leaders and politicians "were using the transvestite as a 'scapegoat.'" The bill still failed, leaving even gays and lesbians without basic legal protection against public discrimination.[30]

In D.C., "fear of a homosexual takeover" got the local MCC kicked out of its temporary home, and MCC-L.A. was burned a few months later. In October 1974, days after Gay Activists Alliance (GAA) president Morty Manford resigned, someone set fire to GAA's beloved Greenwich Village Firehouse. In San Francisco, tensions between police and the queer community spilled into the streets of the Castro after a brutal raid at Toad Hall. "One cop," local merchant Harvey Milk told the *Berkeley Barb*, "took off his badge and started beating people up." Tensions between radicals like Milk

◄ Gay Activists Alliance Firehouse, Wooster Street, Greenwich Village, New York City, June 1971. Photo by Fred W. McDarrah. Copyright © by Getty Images and the Estate of Fred W. McDarrah.

and establishment gays such as Rick Stokes flared up at a community meeting the following week.[31]

Queer activists still zapped and picketed, but the tactics were falling out of style. "More often all that's required is to write a letter of complaint," Ron Gold said. Even in defeat, NGTF praised "the benefits of backlash," announcing that publicity gained from the loss in New York would be good in the long run. For those being fired, evicted, separated from children, or punched by bar owners, though, calls to "play our public-relations cards right" were insulting. And, to make matters worse, the once-radical owners of the country's most popular gay publication sold *The Advocate* to politically conservative, overtly assimilationist David Goodstein in late 1974.[32]

Things got worse in 1975, as local queer communities struggled for resources in the shadow of the "National Movement" imagined by the National Gay Task Force (NGTF) and David Goodstein. That summer, for example, Nath Rockhill, NGTF's legislative director, praised "the leaders of the magnificently organized Minnesota gay rights lobby" without mentioning that those leaders had fought to exclude transgender people from a bill that *still* failed. The praise heaped upon the involvement of "middle class professional people" around the United States echoed against the silence greeting discriminatory practices at baths and bars trying to attract as many "middle class professional people" as possible. The revolution was waning.[33]

In Los Angeles, the Gay Community Services Center (GCSC), which had been founded on the revolutionary ideals of Gay Liberation, got less radical as it got bigger, much like Gay Lib itself. With a shoestring budget, *someone* at GCSC had to decide which services took priority, and, unsurprisingly, the white gay men in charge tended to prioritize the interests of white gay men. When activists Brenda Weathers and Lilene Fifield successfully sought an unprecedented $1 million federal grant for GCSC's Alcoholism Program for Women in 1975, management tried to funnel some of the money to other (male) programs. Long-brewing frustrations with the "top-down, hierarchical power structure" boiled over as staff members circulated charges of racism, sexism, and fiscal malfeasance in an internal newsletter, a copy of which got to David Glasscock, a gay, "middle class professional," and aide to L.A. county supervisor Ed Edelman. Because part of GCSC's funding came from the L.A. Board of Supervisors, management jumped at every demand from Glasscock, who was furious about the existence of the newsletter and the potential fallout should it be made public. Implying that GCSC might lose Supervisor Edelman's support, Glasscock insisted that those responsible for the newsletter either sign a "statement of fidelity" or be fired; none of the staff signed. True to his word, Glasscock saw to it that, on May 1, 1975, eleven of L.A.'s most dedicated activists, including Jeanne Córdova, lost their jobs at GCSC. When a strike followed, then a boycott, the jarring sight of queer people picketing what was once a beloved queer institution became a daily occurrence.

The schism between L.A.'s radicals and moderates took on greater meaning as Christopher Street West 1975 approached, and the CSW board unsuccessfully tried to ban the socialists of the Lavender & Red Union. Instead, the Liberation Contingent was

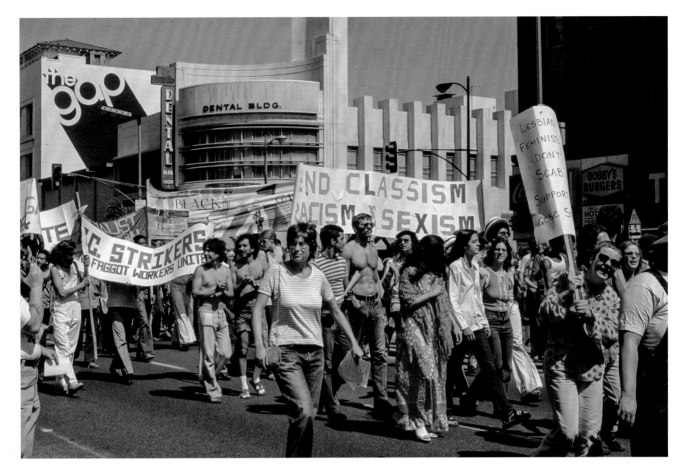

▲ **Above** Liberation Contingent, Christopher Street West, Los Angeles, June 29, 1975. Photographer unknown. From the authors' collection.

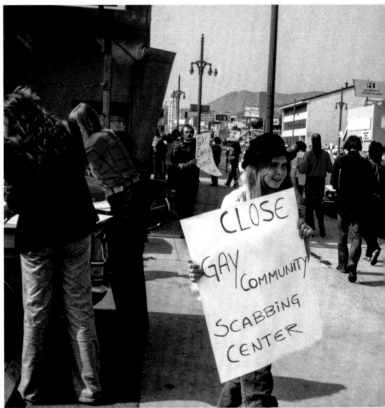

▲ **Above** Picketers at the Gay Community Services Center (GCSC), Los Angeles, May 1975. Photo by Denise Crippen. Courtesy of the ONE Archives at the USC Libraries (Weathers collection; 2011-038). Used with permission of Carolyn Weathers.

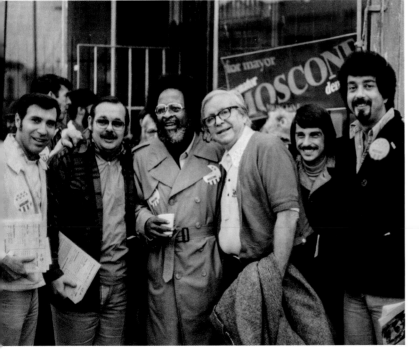

◄ **Left** Activists from Los Angeles (from left: Pat Rocco, Dave Glasscock, San Francisco's Reverend Cecil Williams, Morris Kight, Frank Zerilli, and Howard Fox) campaign for mayoral candidate George Moscone, San Francisco, 1975. Copyright © by Pat Rocco. Courtesy of the ONE Archives at the USC Libraries (Rocco photographs and papers; 2007-006).

the parade's largest, proudly marching in solidarity with all oppressed people, including the Center's fired staff.[34]

Internal strife among the queer community also raged in New York City as Christopher Street Liberation Day 1975 approached. Not only did Lesbian Feminist Liberation organize a separate Pride, but Ron Gold asked the press *not* to take pictures of "drag queens," saying they're "not truly representative of the gay lifestyle." A few months later, as the gay rights bill again headed for a city council vote, Ira Glasser, executive director of the New York Civil Liberties Union, asked the straight community for support, connecting the modern gay struggle to that of homosexuals in Nazi Germany. Because so many queer people still had "to hide in order to avoid the penalties of 'coming out,'" Glasser wrote in a September op-ed for the *New York Times*, solidarity could be expressed by wearing a pink triangle every day until the bill passed.[35]

▲ Christopher Street West pinback, 1978. From the authors' collection.

That took another eleven years.

As gay rights seemed to gain more attention with each passing month, young queer people everywhere learned of the enclaves in big cities to which they could escape. Houston, Chicago, Atlanta, New York, and L.A. all had booming gay bastions. But in the 1970s, nothing compared to San Francisco, where the excesses, limits, successes, and failures of the queer community were laid bare. By 1971, according to S.I.R.'s monthly magazine *Vector*, the "welcome mats [were] out in the Castro Street area for members of the gay community."

A year earlier, when the United States invaded Cambodia, protests had erupted around the country, including in San Francisco, where a New Yorker who'd once supported the Vietnam War joined an antiwar demonstration, marking a radical left turn that meant the end of Harvey Milk, *the banker*, and the beginning of Harvey Milk, *the activist*. Back in New York City on his forty-first birthday in May 1971, Milk met Scott Smith at the Christopher Street Subway Station, steps away from what had been the Stonewall Inn (which had closed months after the 1969 riots). Milk returned west in early 1972; when Smith followed, the couple drove through California for a year with their dog, The Kid. In early 1973, when Milk and Smith ran out of money, they moved to the new gay enclave in the Castro, where Milk opened a camera shop, hanging a sign in the window of 575 Castro Street that read: "Yes, We Are Very Open."[36]

Castro Camera was one of dozens of gay businesses that popped up in the Castro in the early and mid-1970s, and Milk and Smith were among thousands of the neighborhood's "early invaders." In 1973, thousands of queer people—predominantly, but not entirely, men—came from everywhere to make the Castro home. Having escaped the rigid norms of the outside world, though, the radical fags and genderfucking queens—with flowing dresses and thick beards—were soon replaced by the ultra-macho "Castro Clones" and a new set of rigid norms: denim, plaid, short hair, and muscles.[37]

The camera shop had barely opened when Milk announced his first run for city supervisor, infuriating San Francisco's slow-paced gay establishment, who had their

own candidates and strategies in mind. But Milk had no use for David Goodstein's coddling of liberal Democrats. "You're never given power," he said. "You have to take it." Only one prominent queer person—José Sarria—backed Harvey's first run, forging an alliance with the drag community that never wavered (though it did little to help Milk's standing among lesbians). Milk didn't win in 1973, nor in 1975, but his popularity grew with each race. By 1976, he had enough clout to get appointed to the Board of Permit Appeals by new mayor George Moscone. But when he disobeyed Moscone's public warning *not* to run for a State Assembly seat the Democrats were reserving for Art Agnos (a heterosexual), the mayor fired Harvey.[38]

David Goodstein hated gay liberationists. In 1973, he'd blasted California's gay progressives—especially Morris Kight and Jeanne Córdova—for allegedly hindering his efforts to lobby against the state's antisodomy law. Because straights see gays as "freaks," he wrote in *Vector*, and the behavior of gay liberationists "confirms the stereotypes, our spokespersons must be able to argue intelligently, rationally, and quietly." And they "must wear Establishment clothes."

In January 1976, a year after buying *The Advocate*, Goodstein introduced tens of thousands to his unabashed conservativism. Lambasting "movement people" as "unemployable, unkempt and neurotic to the point of megalomania," he praised the so-called "'silent majority.'" Virtually "everything of any significance," he said, was being done behind the scenes by those who didn't want "to be known or exposed to harassment by other Gay people." Goodstein's forces apparently scoffed at theoretical connections between gay rights and "fascism, racism, imperialism, socialism," and "are outraged by Gay contingents in leftist and 'Third World' demonstrations." (One activist described Goodstein's "leftist and 'Third World'" barb as a blatant "appeal to the worst prejudices among us, to racism and Red-baiting.") Goodstein famously pointed with pride to "the many new, well-lighted, expensively decorated bars and clubs that are rapidly replacing the dingy toilets of old," emphasizing the need to engage closeted gays "from the safety of their closets." Most important, the Movement had "to keep the emotionally disturbed members of our community out of stage-center roles and on the counseling couches where they belong."

There was a time, Detroit's relatively liberal *Gay Liberator* responded, when "we could think of two opposing groups, gay and antigay, but no longer: the enemy is among us." But Goodstein doubled down, announcing plans for the Advocate Invitational Conference, an invitation-only event in Chicago that, by Goodstein's admission, wasn't designed to be inclusive of a wide range of opinions. Instead, he wanted gays who'd help him establish a formal lobbying organization. So, while those who gathered in Chicago almost unanimously condemned Goodstein's divisive language, they also supported his drive to establish a national gay lobby group. The delegates, however, rejected Goodstein's attempt to give the new organization "an 'innocuous name'

▶ Harmodius and Hoti, Castro Street Fair, San Francisco, Aug. 1975. Photo/copyright © by Daniel Nicoletta.

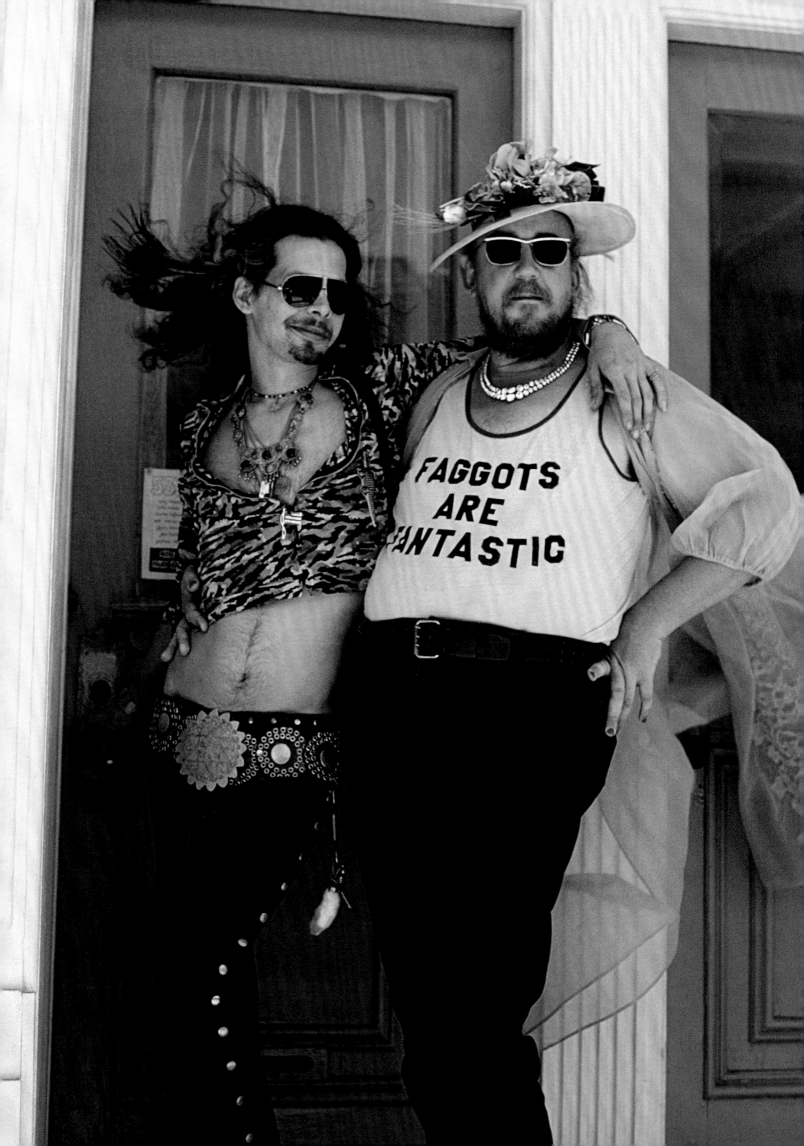

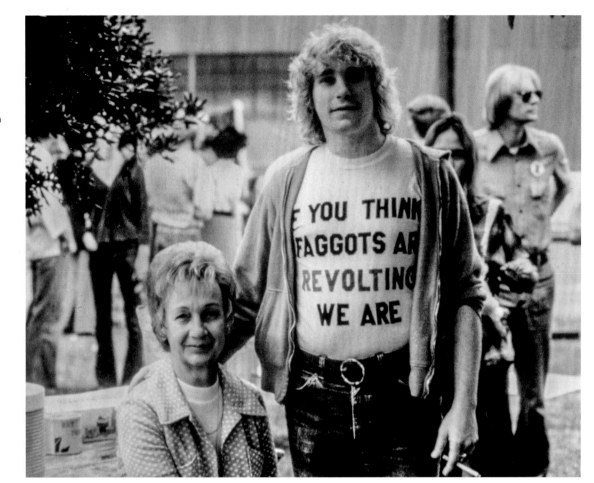

In 1976, CSW organizers scheduled the events for the first week in July in order to coincide with nationwide celebrations of the U.S. bicentennial. While the July 4 Pride Parade started peacefully, the last of the marchers were barely onto Hollywood Boulevard when riot gear–equipped police converged behind them, blocking onlookers from filling in behind the parade. A melee between police and activists ensued.

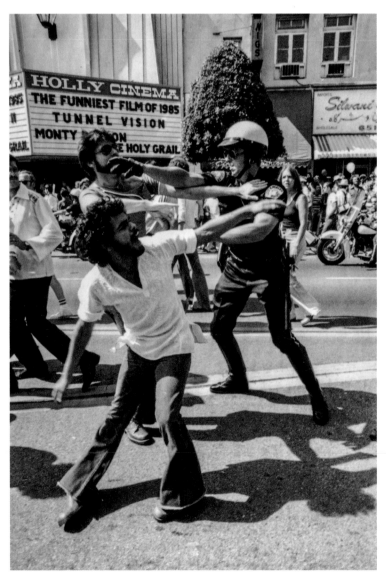

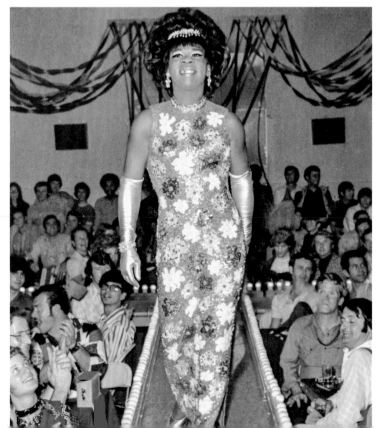

without the words 'gay' or 'homosexual' in it," instead choosing the National Gay Rights Lobby (NGRL). A few years later, Steve Endean, who served as NGRL's first director, formed a separate organization that ultimately enveloped NGRL. Following Goodstein's lead, Endean chose to give his group an innocuous name: the Human Rights Campaign Fund.[39]

As Harvey Milk's campaign against Art Agnos heated up in the fall of 1976, Goodstein pulled out all the stops to prevent Milk from winning. It took calling in favors from virtually every elected California Democrat—*plus* flying in Elaine Noble from Massachusetts to campaign *against* a fellow gay politican—but Agnos won by a small margin. Despite Goodstein's efforts, Milk dominated the gay areas. Soon, he formed the San Francisco Gay Democratic Club, a radical alternative to the Alice B. Toklas Democrats, rallying support to change the city's election process. Starting in 1977, city supervisors would run in-district campaigns, as opposed to citywide; neighborhoods, in other words, would elect their own representatives.

And the Castro loved Harvey.[40]

As 1976 ended, Bruce Voeller and his recently named National Gay Task Force (NGTF) co-executive director, Jean O'Leary, hailed the year as productive. O'Leary had served openly as a delegate to the Democratic National Convention, and she'd been one of three lesbians named to President-elect Jimmy Carter's committee on the concerns of women. NGTF's board expanded to include Houston's Pokey Anderson and Gary Van Ooteghem, and, in Pennsylvania, Mark Segal—who, as founder of Gay Youth and publisher of *Philadelphia Gay News*, remained a relatively radical voice in the midst of a moderate boom—got the governor to declare a statewide Gay Pride Week in June.[41]

NGTF even managed to put a positive spin on the U.S. Supreme Court's decision to uphold the constitutionality of state antisodomy laws—including those based on "the promotion of morality and decency." Voeller and O'Leary told NGTF members that the Court's decision, which allowed states to continue treating consensual same-sex activity as criminal, would "raise the consciousness of lawmakers and the courts."

The few leaders who tried to sound the alarm about the rising tide of conservatism were ignored.

"If you have been waiting safely in your closet for a modern Moses to lead you out, forget it!" NACHO '68 vet Ray Hill wrote in Houston. "We, collectively, are the Moses of gay liberation." Maybe, said Hill, "when the gay lawyer, gay doctor, or gay middle class businessman or woman realize that they too are the target of homophobia, prejudice, and ignorance, then we will begin to show progress."

And that's exactly what happened.[42]

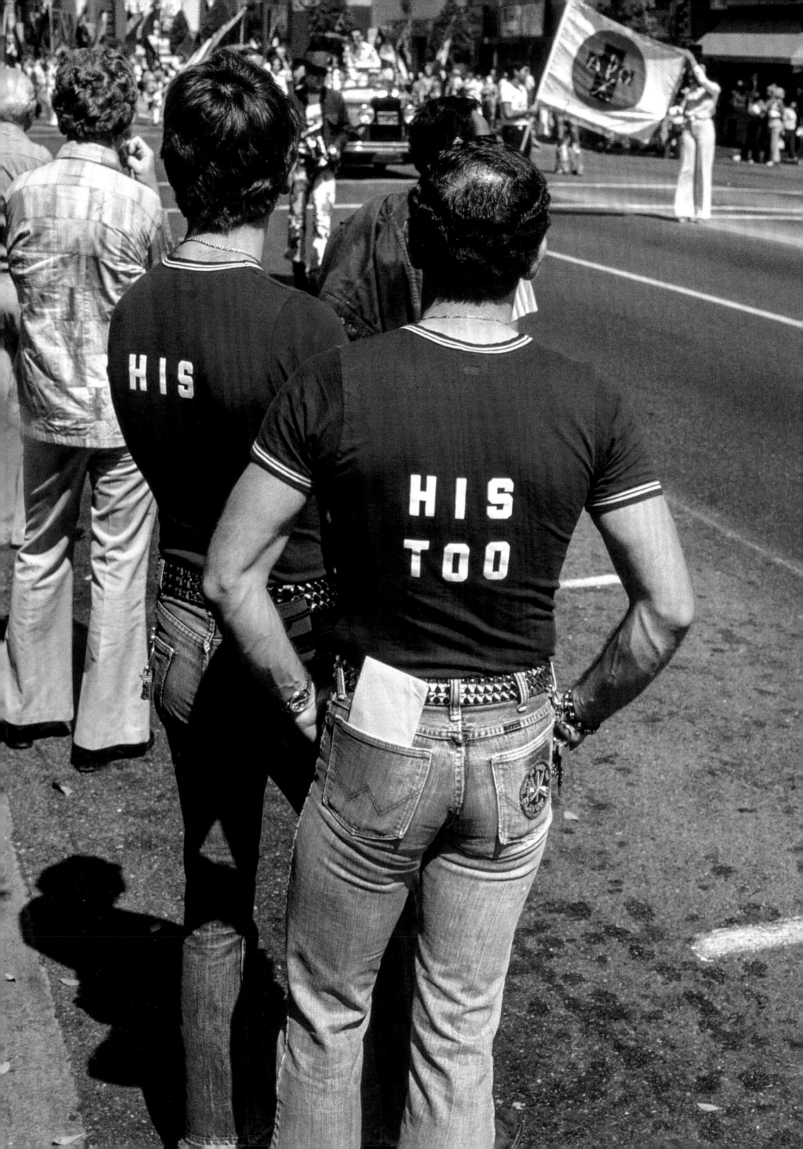

In January 1977, Florida's Metropolitan Dade County Commission ignored the objections of a vocal contingent of local evangelicals and adopted an antidiscrimination ordinance covering Miami's gays, lesbians, and bisexuals. The ordinance, co-written by bisexual psychologist Alan Rockway, "condones immorality," Anita Bryant charged, "and discriminates against my children's rights to grow up in a healthy, decent community." Within weeks, Bryant, a pop singer, former beauty queen, and well-known Florida Citrus Commission spokesperson, launched a drive to collect the ten thousand signatures needed to put the ordinance to a popular vote. She had a simple message: *Save Our Children*. Because "homosexuals cannot reproduce," Bryant said, "they want to recruit our school children under the protection of the laws of the land."

For NGTF moderates, the Bryant spectacle was almost too good to be true. Everyone was talking about gay rights! And Bryant wasn't even trying to seem rational. In South Florida, activists confidently told the press they "welcomed the possibility of a referendum," which "would offer an opportunity for consciousness raising." But the news that Bryant's petition gathered not ten thousand but over sixty-four thousand signatures—easily guaranteeing a popular vote on the antidiscrimination ordinance—caused some pause in the gay press.[43]

A few months earlier, NGTF had scored a public relations coup that even the most cynical radicals had to appreciate: Bruce Voeller, Jean O'Leary, Frank Kameny, Troy Perry, and others had met at the White House in March with Midge Costanza, Assistant to President Jimmy Carter for Public Liaison (and O'Leary's then-lover). Although Carter wasn't there, no one could deny the event's significance. No one, that is, except Anita Bryant, who said that NGTF was simply "asking to be blessed in their abnormal lifestyle by the office of the President of the United States."[44]

To all those gays who feel it's not their concern, I say, "In time, your life may depend on what you do now."
—Bob Salamone, 1977

Meanwhile, David Goodstein was taking no chances, demanding a *very* specific campaign against Bryant. Fearing the radical "Harvey Milk style" tactics he'd seen in California, Goodstein discouraged volunteers, relying instead on straight liberals and "respectable" gays to curry favor with locals in Miami. On June 7, 1977, the locals voted 202,319 to 89,562 to repeal the gay rights ordinance, thanks largely to Bryant's anti-gay campaign. Elated by the repeal, Bryant declared "the normal majority" had said "enough, enough, enough," and publicly prayed for God's assistance to take her fight to other cities.[45]

"Say, 'I'm gay and I'm proud,'" an emotional Leonard Matlovich barked at a room of dejected queer activists across town. "When you walk out of here tonight, walk with your shoulders square and head up." Others walked out that night, too. About five hundred people marched in Greenwich Village, while thousands followed Harvey Milk into the streets of San Francisco. The next morning, Mike Sedberry of the Gay People's Union in Indianapolis held a press conference at the state capitol. "We

◄ Christopher Street West, Los Angeles, June 29, 1975.
Photographer unknown. From the authors' collection.

expect violence," he announced. That afternoon in Norfolk, Virginia, still high from the previous day's victory, Bryant paid no attention to protesters outside the revival where she was set to speak and perform, though she couldn't ignore the hundreds who'd infiltrated the event. When her speech turned to homosexuality, protesters groaned, hissed, and walked out; Bryant broke into tears onstage. That night, five thousand marched in New York, and protests continued for days in San Francisco. In mid-June, three thousand queer people greeted Bryant in Chicago, and no one expected the ten thousand angry protesters who showed up in Houston. Across the United States, the queer community appeared "to have taken only hours to mobilize an offensive which matches our 1969 birth in strength and anger."[46]

On June 18, 1977, radicals in Boston went to Pride in order "to deliberately and purposefully reject Gay Rights as our focus" and call for a return to the ideals of Gay Liberation. During the afternoon's rally, Professor Charley Shively forcefully condemned the institutions he blamed for queer oppression. Holding up his Harvard PhD, Shively declared it "only worth burning," and set it aflame. Denouncing banks and insurance companies, he torched a dollar bill and an insurance card, as chants of "*Burn them!*" went up. People were in a frenzy when Shively burned the state sodomy laws. But when Shively quoted the Bible's death sentence for

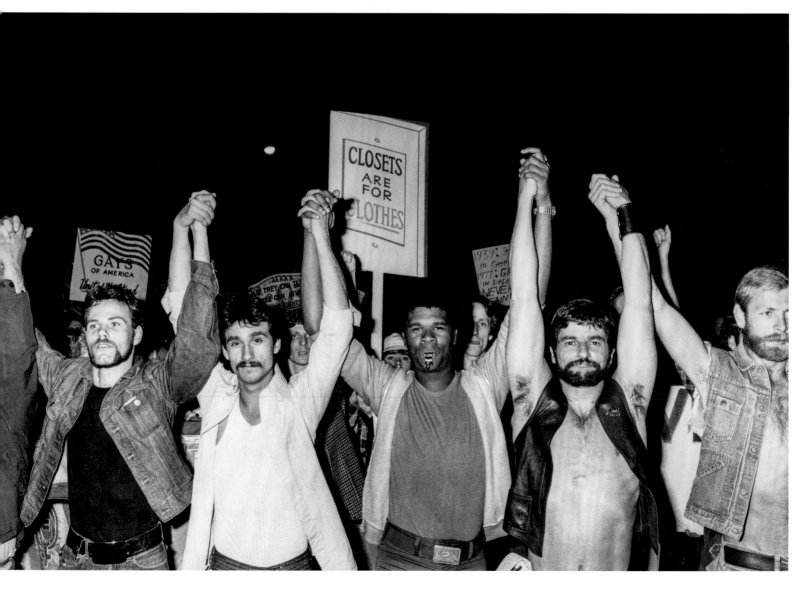

homosexuals, the crowd seemed less sure. "You can't burn the Bible!" someone yelled. But he could. And he did. A riot almost broke out.[47]

The previous day, Vice President Walter Mondale had only to say the words "human rights" at a Democratic fund-raiser in San Francisco and members of Harvey Milk's Gay Democratic Club held up signs demanding he make a statement on gay rights. When a flustered Mondale paused, Arthur Evans, the New York firebrand who'd headed west, shouted, "When are you going to speak out on gay rights?" In an interview released a week later, President Carter let gay moderates know exactly how much their support meant, saying, "I don't believe homosexuals are a threat to the American family but I do not view it as normal."

Acts of random anti-queer violence—"not robberies or muggings, just violent attacks"—had skyrocketed since Miami. Gays carried whistles and formed street patrols in the Castro, banding together to ward off some of the worst assaults. Some, but not all.

Just after midnight on June 22, Jerry Taylor and Robert Hillsborough nervously climbed from their car, having just escaped a threatening group of young men. When four attackers suddenly reappeared, Taylor got away, but Hillsborough couldn't. "Faggot, faggot, faggot!" John Cordova shouted as he stabbed Hillsborough—a well-liked city gardener—to death. Just before the fifteenth and final stab, Cordova yelled, "This one's for Anita!"

In the wake of the tragedy, Mayor Moscone ordered flags flown at half-mast, linking the murder to Bryant and California's "demagogue" state senator John Briggs, who planned a referendum banning queer people from working in public schools. With no arrests in the case and Pride just days away, people feared a riot. But when Cordova and three others were arrested on June 26, just hours before Gay Freedom Day, there was "a massive opening of closet doors" as two hundred fifty thousand people paraded down Market Street. The parade's most dramatic contingent was an intense display of queer anger with five marchers, led by a lone drummer, carrying pictures of Stalin, Hitler, the KKK, Idi Amin, and Bryant. Others created a shrine for Robert Hillsborough at City Hall. Amid the competing displays of pride, joy, and rage, Harvey Milk announced his third run for city supervisor.[48]

In the lead-up to Christopher Street Liberation Day 1977 in New York, for the first time since the early days of Gay Lib, "no fiat was issued by the planning committee with regards to who would be acceptable as speakers, marchers and entertainers." And tired of settling for Sixth Avenue year after year, one hundred thousand queers marched up iconic Fifth Avenue without a permit.

Speaking at the post-parade rally, writer and Gay Liberation Front veteran Karla Jay told the crowd that she'd never been asked to speak at Pride in New York, which she assumed was "because I'm one of those radical dykes some people have been trying to keep away from the media." The militant John Paul Hudson also spoke, as did someone introduced only as Kathy Kozachenko of the East Coast Lesbian Mothers Defense Fund; if anyone in New York knew about Kozachenko's historic election in

▲ Anti–Anita Bryant pinback, 1977. From the authors' collection.

◄ "Orange Tuesday," activists march toward New York's Sheridan Square after voters in Florida's Miami-Dade County repealed a gay rights ordinance, New York City, June 7, 1977. Photographer unknown. From the authors' collection.

Ann Arbor a few years earlier, it didn't make it into the gay press. Members of Salsa Soul Sisters—formed in late 1976 under the official name Third World Gay Women's Organization—also spoke.

And while the National Gay Task Force (NGTF) still worked to hide drag queens from the press, a familiar face came out of retirement with a reminder: "AND GOD CREATED HE AND SHE BUT HE ALSO CREATED ME!" blared Sylvia Rivera's sign.[49]

Anita Bryant's attacks presented lesbian activists with a dilemma: gay men still did little to make common cause, but the right wing wasn't just attacking gay men. On top of everything, rampant misogyny now seemed acceptable if directed at "that bitch" Bryant. Nonetheless, three radical Lesbian Feminists—Jeanne Córdova, Judy Freespirit, and Ivy Bottini—called on their sisters to coalesce to fight Bryant's conservatism. The situation went "much deeper than the gay issue," Córdova said. "The country is heading into a reactionary period." Republicans, she said, were "in deep trouble and that has given a lot of weight to a new right wing." The economy, said Freespirit, was so bad, and the middle class so afraid, that "somebody's got to go." Agreeing, Bottini said, "they are testing the water with the gay issue," but once voters get "out of control with fear, nobody's safe." Political realities required what Córdova called "coalition politics."[50]

There was some good news. Officials in Wichita adopted an antidiscrimination ordinance in September 1977, though that only drew Bryant's attention. In November, Harvey Milk won his race for city supervisor, despite David Goodstein, Leonard Matlovich, and Elaine Noble backing gay moderate Rick Stokes. Ten days later, an amazing collection of lesbian activists oversaw the adoption of an antidiscrimination proposal at the National Women's Conference in Houston. When delegates voted overwhelmingly for the pro-lesbian plank, balloons fell into the crowd: *WE ARE EVERYWHERE*, they read.[51]

In the first days of 1978, Harvey Milk's inauguration—including lavish parties paid for by David Goodstein—drew attention to California just as State Senator John Briggs ramped up his efforts to ban queer people from working in public schools. In New York, Ed Koch, the new mayor, issued a limited antidiscrimination order on his first day in office. And Anita Bryant reinvigorated queer activists wherever she went, including D.C., where three thousand protestors greeted her in late January. "Anita Bryant is deeply immoral and profoundly un-American, and will roast in hell through all eternity," Frank Kameny told the crowd. "She is a symbol of a whole group and we must fight her on these terms." Kameny knew Bryant had galvanized more than just queer people, though. For every new gay and lesbian activist or organization, there was at least one—and likely more—new right-wing activists or organizations. Evangelical Christian leaders struck fear in the hearts of angry voters, and Bryant worked particularly closely with fundamentalist preacher Jerry Falwell, whose vision extended far beyond a few city ordinances.[52]

In April 1978, there was barely time to react to the repeal of St. Paul's gay rights ordinance before John Briggs announced he'd collected twice as many signatures as

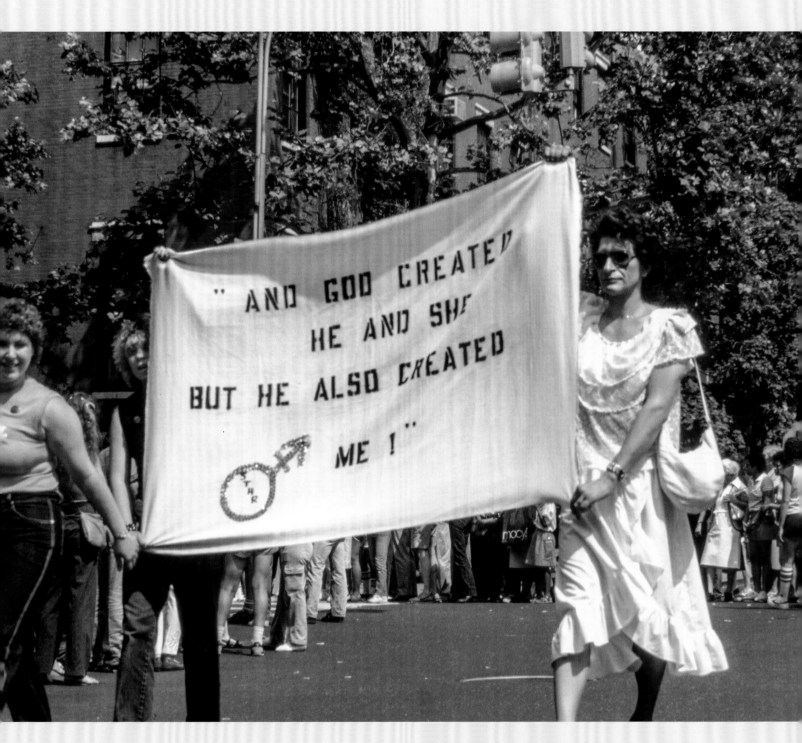

▲ Sylvia Rivera (right), her banner emblazoned with one of the original S.T.A.R. logos, Christopher Street Liberation Day, New York City, June 26, 1983. Photo by Steve Zabel. Courtesy of The LGBT Community Center National History Archive (Zabel collection; 16-3805).

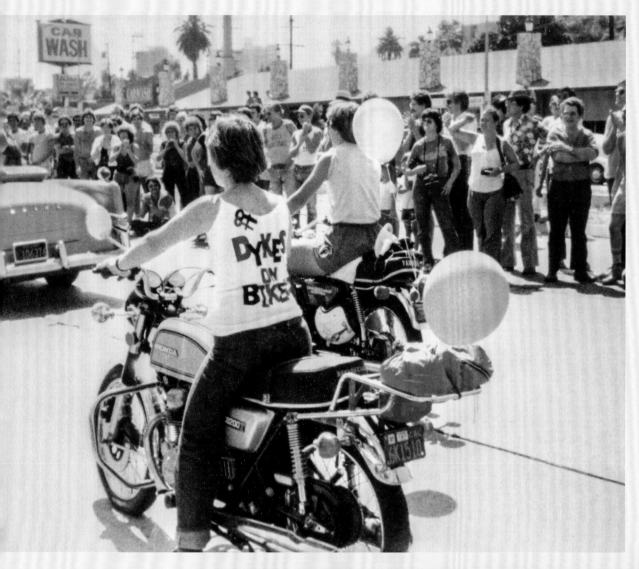

▲ **Above** Dykes on Bikes, Christopher Street West, West Hollywood, July 1, 1979. Photographer unknown. Courtesy of the ONE Archives at the USC Libraries (CSW collection; 2012-135).

▶ **Right** Dyketactics! protest the violently misogynistic film *Snuff*, Philadelphia, Feb. 1976. Photo by Harry Eberlin. Courtesy of John J. Wilcox, Jr. Archives, William Way LGBT Community Center (Eberlin photos).

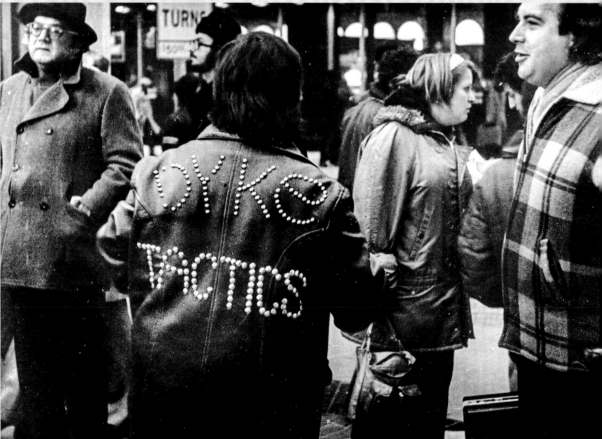

necessary to get his anti-queer proposal targeting school workers on the California ballot. Days later, Wichita voted 5 to 1 to repeal its gay rights law, and Eugene, Oregon, repealed its antidiscrimination ordinance in May. In Seattle, which was set to vote on a gay bill in November, the queer community debated whether they should even hold Pride lest they do something to offend the straight community.

The Gay Rights Movement was faltering, but NGTF preached respectability and inevitability, announcing that "how far we've got to go in relation to public attitudes shouldn't be a source of discouragement, it should strengthen our resolve." Activists in New York kept marching, though. At a rally in early May, Marsha P. Johnson spoke about the oppression faced by transgender people, promising they'd march at Christopher Street Liberation Day. In June, Houston's queer community held Town Meeting I, a large political conference featuring Phyllis Frye, an outspokenly proud transsexual woman, and Larry Bagneris, who'd just formed the Gay Chicano Caucus.[53]

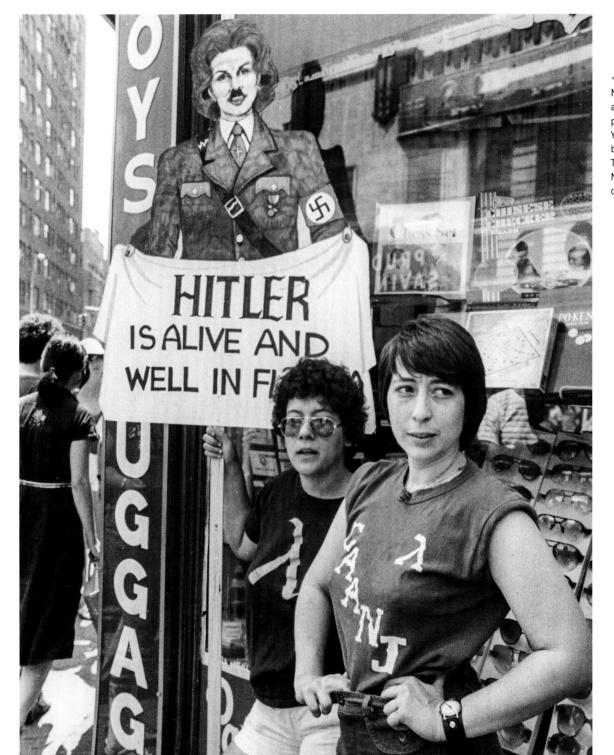

◄ A Gay Activists Alliance–New Jersey member holds an anti–Anita Bryant sign, Christopher Street Liberation Day, New York City, June 26, 1977. Photo by Leonard Fink. Courtesy of The LGBT Community Center National History Archive (Fink collection; 26-57).

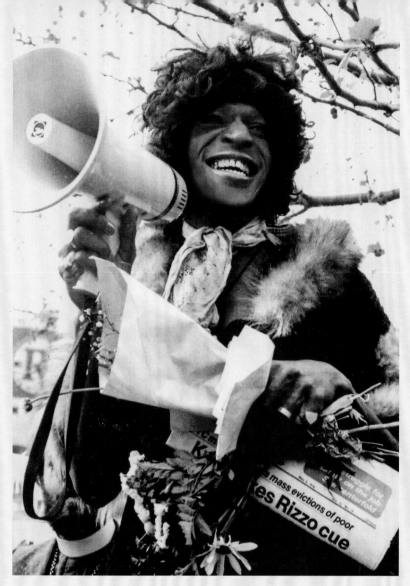

▲ **Above** Marsha P. Johnson addresses a crowd in Sheridan Square, New York City, May 10, 1978. Photo by Bettye Lane. Copyright © by the Estate of Bettye Lane; courtesy of Schlesinger Library, Radcliffe Institute, Harvard University.

▶ **Right** Christopher Street Liberation Day, New York City, June 26, 1977. Photo by Leonard Fink. Courtesy of The LGBT Community Center National History Archive (Fink collection; 26-57).

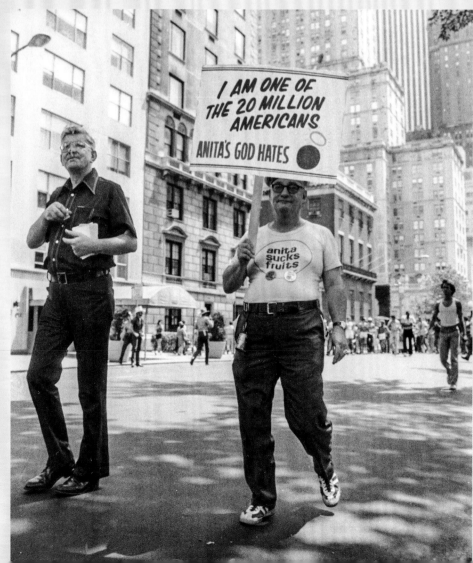

▲ **Above** Harvey Milk arrives at Castro Camera just after being elected city supervisor, San Francisco, Nov. 8, 1977. Photo/copyright © by Daniel Nicoletta.

▶ **Following Spread** Marchers carry signs representing cities where voters had repealed gay- and lesbian-inclusive civil rights ordinances, Gay Freedom Day, San Francisco, June 25, 1978. Photo/copyright © by Daniel Nicoletta.

I have never considered myself a candidate. I have always considered myself part of a movement, part of a candidacy. . . . Almost everything was done with an eye on the gay movement.

—HARVEY MILK, 1977

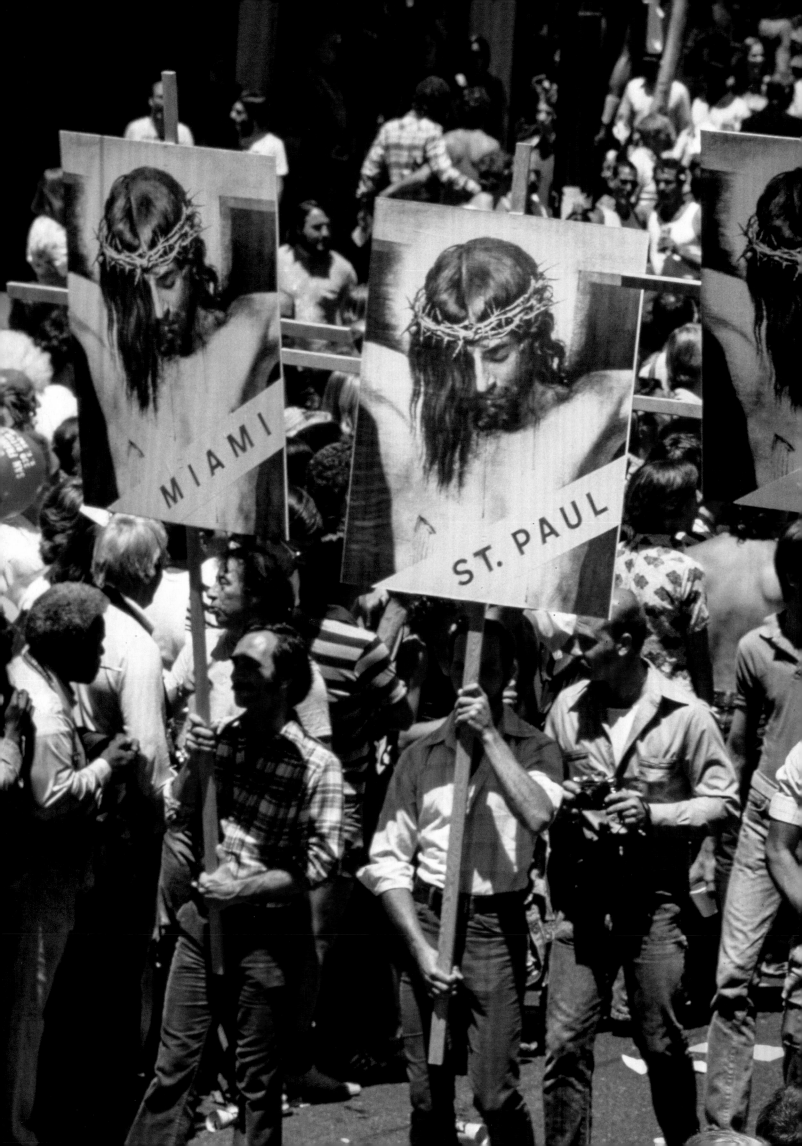

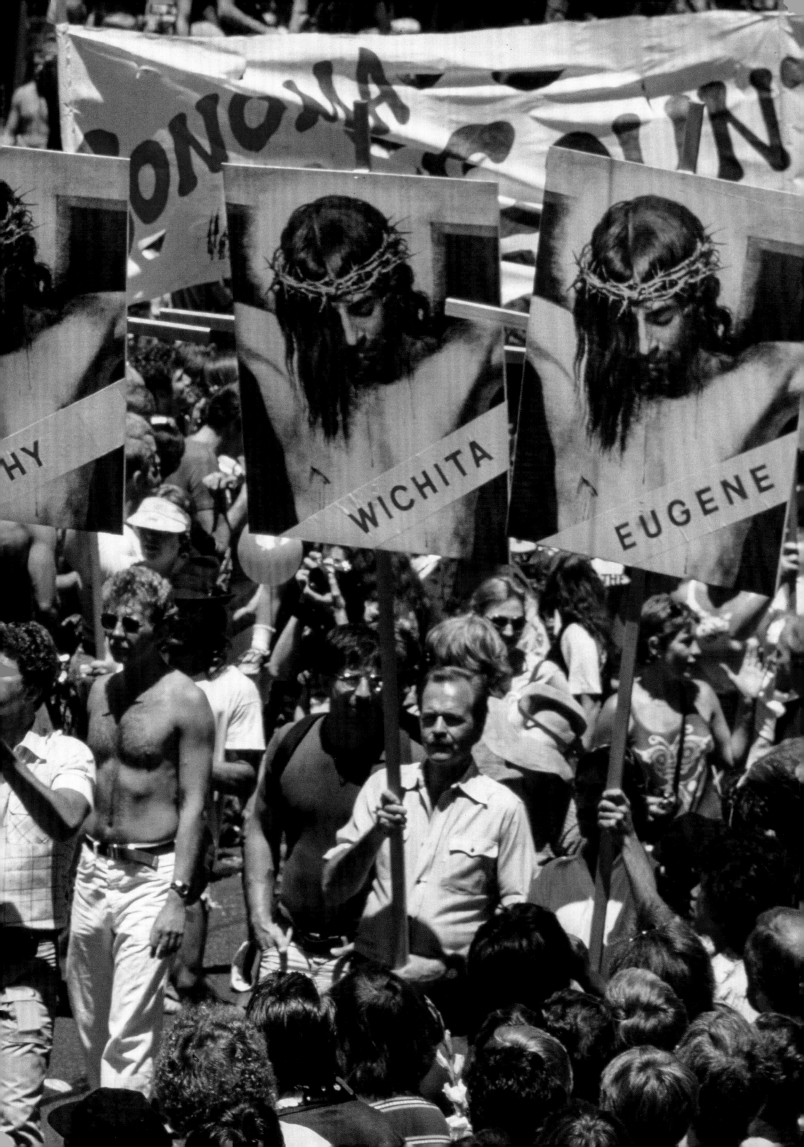

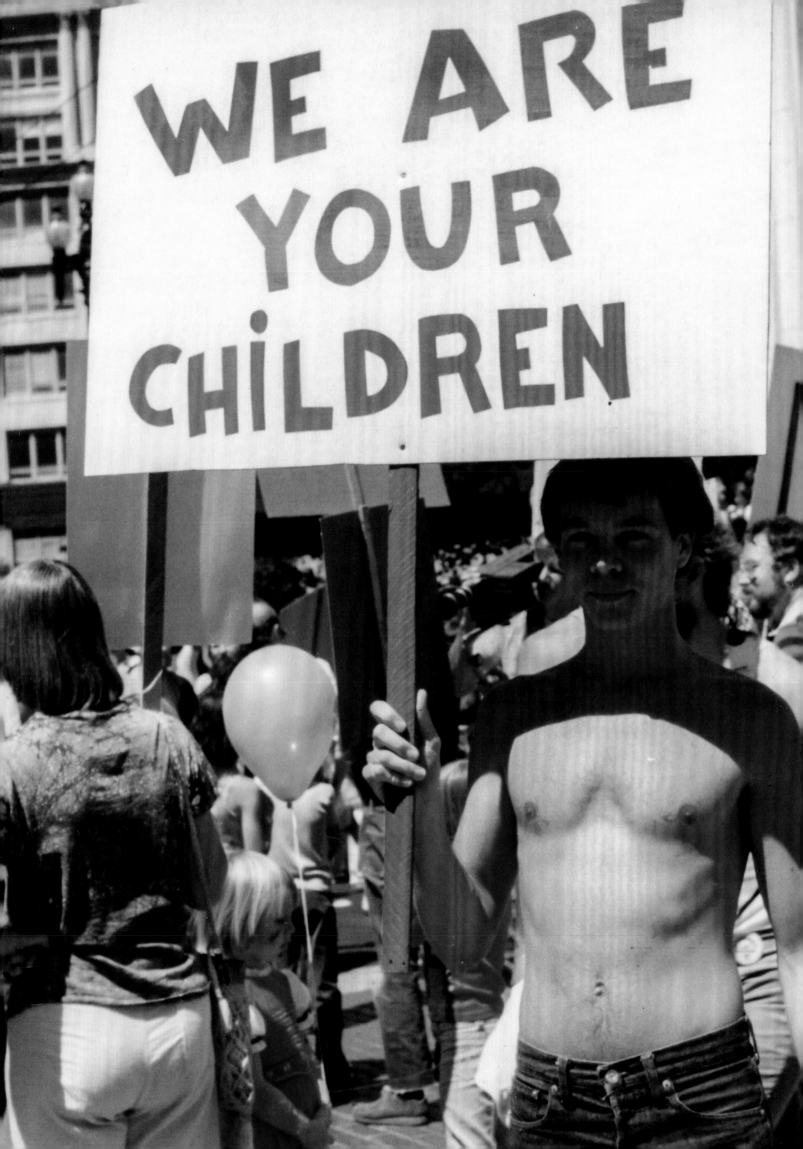

"My name is Harvey Milk, and I want to recruit you," Milk announced to three hundred fifty thousand people at San Francisco's Gay Freedom Day 1978. Lighting into David Goodstein's "silent majority," he continued: "We will not win our rights by staying quietly in our closets." Lambasting President Jimmy Carter's silence on gay rights, Milk called for a March on Washington in 1979.

With all eyes on California and the fight between Senator John Briggs and the queer community, Jeanne Córdova's "coalition politics" came to fruition. Córdova, Ivy Bottini, Harvey Milk, and other street organizers rallied the grassroots, while the respectable set—Steve Lachs, David Mixner, Roberta Bennett, and Diane Abbitt—raised enormous amounts of money through innocuously named organizations like the Municipal Elections Committee of Los Angeles (MECLA). Stalwart Morris Kight organized L.A.'s Coalition for Human Rights, and Troy Perry fasted to raise $100,000.

Early polls showed little sign of hope: John Briggs's proposal to ban queer people from working in public schools—known as the Briggs Initiative (i.e., Proposition 6)—was *going* to pass; the only question was by how much. In the fall, though, after months of tireless street organizing and fund-raising, the other shoe dropped when a closeted Republican reached out to queer activists to ask if a statement from former governor Ronald Reagan might help. "I don't approve of teaching a so-called gay lifestyle in our schools," Reagan announced a few days later, "but there is already adequate legal machinery to deal with such problems if and when they arise." Appealing to conservative principles, Reagan warned that Proposition 6 had "the potential for real mischief."

An August poll showed Briggs winning 61 to 31 percent; within days of Reagan's statement, the margin was 45 to 43 percent. When the votes were counted in November, the tally was 58 to 42 percent to defeat Proposition 6. The gays had won by almost a million votes. Radicals and moderates not only coexisted in the face of imminent defeat, but coalition politics prevailed. To make it all the sweeter, Seattle voters affirmed their support for gay rights the same night, rejecting an attempt to repeal the city's antidiscrimination ordinance.[54]

▶ **Right** Morris Kight (left) and Harvey Milk (right), c. 1978. Photographer unknown. Courtesy of the ONE Archives at the USC Libraries (Kight papers and photographs; 2010-008).

◀ **Opposite** As Anita Bryant's "Save Our Children" campaign attacked gay rights on the premise that children needed protection from queer people, activists across the country answered: "We Are Your Children," Gay Freedom Day, San Francisco, June 25, 1978. Photo by William S. Tom. Courtesy of the ONE Archives at the USC Libraries (William S. Tom photographs; 2008-017).

▶ Clones kissing on steps, Castro Street, San Francisco, 1977. Photo by Crawford Barton. Photo courtesy of Gay, Lesbian, Bisexual, Transgender Historical Society (Barton collection).

© C.BARTON '77

By 1978, the Castro looked much different than it had when Harvey Milk and Scott Smith arrived five years earlier. Housing prices in the area had nearly quintupled, and small gay shops, including Castro Camera, had been forced out. Even more noticeably, the neighborhood was dominated by men performing a new brand of machismo; it was the age of the Castro Clone, masses of gorgeous men cruising Castro Street in blue jeans and as little else as possible. Consequently, space for lesbians, people of color, the gender nonconforming, and those of lesser means virtually disappeared.

"They're coming here to be free and they all look alike!" Rick Nichols told Milk.

The Castro had become a white man's world. But Milk was on top of that world. The Proposition 6 fight had made him a national figure, and local politics kept getting better. Just days after voters rejected the Briggs Initiative, Milk's sometimes-nemesis, Supervisor Dan White—the only true conservative on the Board of Supervisors—abruptly resigned. Although White quickly told Mayor Moscone he'd made a mistake and wanted to rescind his resignation, his predicament was overshadowed by news from Guyana.[55]

Reverend Jim Jones had spent years cultivating relationships with San Francisco's elite, including George Moscone. And despite the cultish behavior of Jones's Peoples Temple—beatings, brainwashing, and pilgrimages to "Jonestown," the temple settlement in South America—his message resonated with a growing group of disaffected people. In 1977, as allegations of abuse by Jones mounted, he joined followers in a final pilgrimage to Guyana. Seeking utopia, Jonestown residents found hell: forced manual labor, sexual abuse, and constant mental and physical torture.

Hearing of a hostage situation at Jonestown, California congressman Leo Ryan flew to Guyana to investigate. Peoples Temple security ambushed his delegation as they prepared to return to the United States, shooting Ryan twenty times; he died along with four others. At the same time, Jim Jones led hundreds to their deaths in what some call mass suicide by poison, but what was actually mass murder by duress.

"It was poison or a bullet," one survivor said.

News of Ryan's death hit the United States first. Then came word of three to four hundred dead at Jonestown. On November 25, 1978, news broke that the death toll had more than doubled, reaching over nine hundred, with children making up a third of the victims.

In this context, Dan White lobbied to get back on the Board of Supervisors.[56]

◀ A sign in the window of Castro Camera announces the store's upcoming move, San Francisco, Mar. 22, 1978. Photo by and courtesy of Professor Max Kirkeberg.

It'd be bad politics, Milk told Mayor Moscone, who agreed, scheduling a press conference for November 27 to announce White's replacement. Learning of Moscone's decision and Milk's efforts to keep him off the board, White sneaked into City Hall before the announcement, demanded to see the mayor, and shot Moscone four times, including twice in the head. After killing Moscone, White made his way to the supervisors' offices, changing ammunition as he strode across City Hall; he had "special bullets" for his next task.

According to White, he'd only wanted to talk to Milk, "to explain to him that I was always honest, and they were devious." But when White tried to say how much his reputation meant, Milk "just kind of smirked, as if to say, 'too bad,'" and White "got all flushed, and hot, and shot him." That was White's story.

In reality, though, there wasn't any time to talk. Milk only got out one word: "No." The first three bullets wouldn't have killed him, but the fourth cleared his skull, killing him instantly. White then shot Milk a fifth time.[57]

Activist and professor Sally Gearhart described that night's vigil as perhaps "the most eloquent expression of a community's response to violence." Tens of thousands marched in San Francisco, not in anger—though many were angry—but with love and respect for Harvey Milk the symbol, if not the person. And that's what he'd wanted. In a brilliant final act of political theater, Milk had recorded his "political will," articulating what should happen in the event of his death. Today, the recordings are best known for the applause lines—"If a bullet should enter my brain, let that bullet destroy every closet door"—but there's more to them, including Milk's wish that power be kept from gay moderates. "I think there's a delineation between those who use the movement and those who are part of the movement," he said. "I think I was always part of the movement."

In a press release the day after the killings, activist and Milk-protégé Cleve Jones asked Milk's friends not to send flowers but instead "to help fulfill Harvey's dream" of a March on D.C. The message was simple: "Wake up America. No more racism, no more sexism, no more ageism, no more hatred. No more!"[58]

▶ A playful image of Harvey Milk hangs on a poster emblazoned with a quote from Dan White's murder confession, Castro Street Fair, San Francisco, Aug. 1979. Photo by Donald Eckert. Courtesy of San Francisco History Center, San Francisco Public Library (Eckert collection; GLC 185).

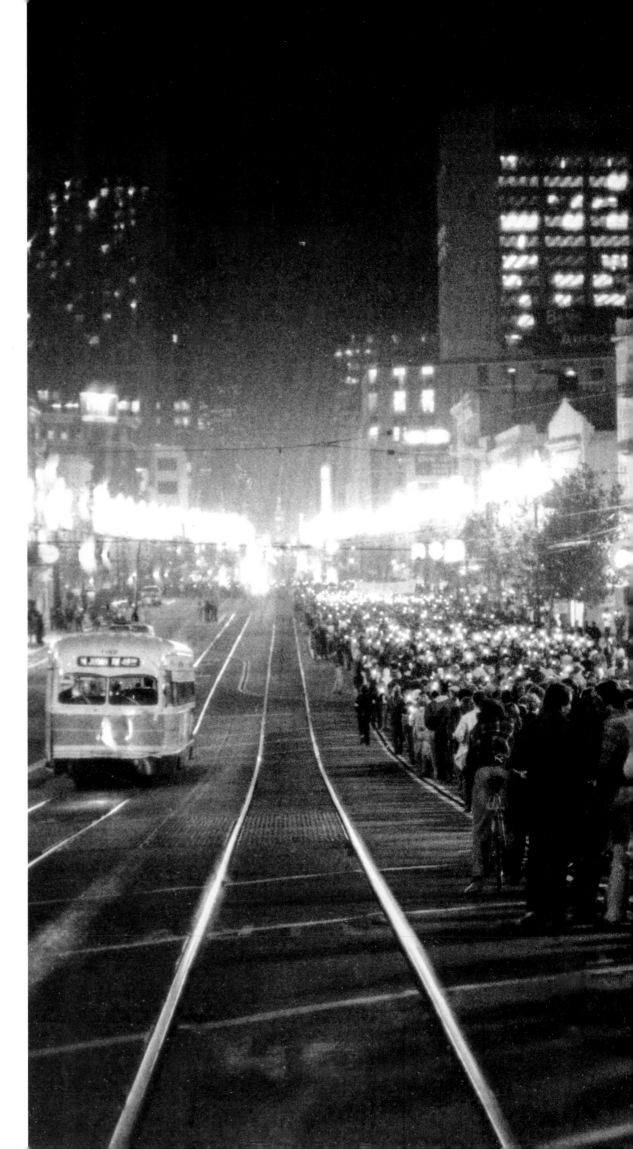

▶ Mourners march after the assassinations of Harvey Milk and George Moscone, San Francisco, Nov. 27, 1978. Photo by Donald Eckert. Courtesy of San Francisco History Center, San Francisco Public Library (Eckert collection; GLC 185)

▲ Vito Russo reacts dur-
ing a city council debate
on a long-stalled gay rights
bill, New York City, Nov. 8,
1978. Photo by Bettye Lane.
Copyright © by the Estate
of Bettye Lane; courtesy
of Schlesinger Library,
Radcliffe Institute, Harvard
University.

A gay writer from New York who'd been in San Francisco when Milk was shot wrote an op-ed for the *New York Times* a few weeks later. He'd marched and mourned with thousands, including California's governor; San Francisco's new mayor Dianne Feinstein; and the entire Board of Supervisors, "all for a man I had never known and only vaguely heard about."

But New York's City Council still wouldn't let a gay rights bill out of committee. What would happen if a similar tragedy hit New York? the writer wondered. Would the governor be in the front row at the funeral? Would churches and synagogues welcome queer mourners? Would masses of homosexuals march solemnly in the streets?

The obvious answer, at least to the editorialist, was *no*, which explained the city's stalled gay rights ordinance. "We are not ready for our rights in New York. We have not earned them. We have not fought for them." The op-ed writer, Larry Kramer, did himself few favors by casting aspersions on gay activists, especially since he'd not yet lifted a finger for the Movement.

In early 1979, New York's gay rights bill failed for the eighth time, and the year never got much better. Reports of discrimination against lesbian moms kept coming, an antigay lobby formed in D.C., violence against queer people skyrocketed, and bar raids came raging back.[59]

On May 21, 1979, despite hearing a lengthy confession, a jury convicted Dan White of only two counts of voluntary manslaughter, the most lenient sentence possible. The next day would have been Harvey Milk's birthday.

Thousands took to the streets that night in anger, rioting at San Francisco City Hall, burning police cars, confronting cops; it was bedlam. As the rioting died down, police invaded the Castro in retaliation. The next morning, Harry Britt, appointed to fill Milk's seat on the board, announced that Milk's people had nothing to apologize for. "Now anyone who wants to kill us can just go out and do so," Britt said. The night of May 22, the Castro went ahead with a long-planned street party to celebrate Milk's birthday, complete with entertainment by Castro legend Sylvester.

Riots one night, a party the next; *that* was the Castro.[60]

In late June, someone in Greenwich Village tore down a plaque dedicated to Stonewall, "not because of homophobia, but because of the factional nature of Gay politics in New York City." Although there was no proof, most gays around Sheridan Square blamed two "informal associations of street Gays and drag queens" who'd long been angry about the plaque's limited wording. "How can you put up a plaque talking about the Stonewall riots without recognizing drag queens?" a sympathetic passerby asked.[61]

Controversy erupted in July as delegates from across the country gathered in Houston to finalize details for the proposed National March on Washington. While Milk's assassination brought attention to the march, which had originally been comic-activist Robin Tyler's idea, a planning conference in early 1979 had left many wondering if it could actually happen. It started to come together in July, though.

The main point of contention—described as "very heated" and "agonizing"—was Houston activist Phyllis Frye's resolution to add "transpersons"—defined as "drag queens, transvestites, transsexuals, and transgenderists (transsexuals who choose not to undergo a sex change operation)"—to the march's title. After predictable divisions emerged, San Francisco activist Paul Boneberg offered a compromise that would limit the title to "Lesbian and Gay," but include transpersons in certain literature.[62]

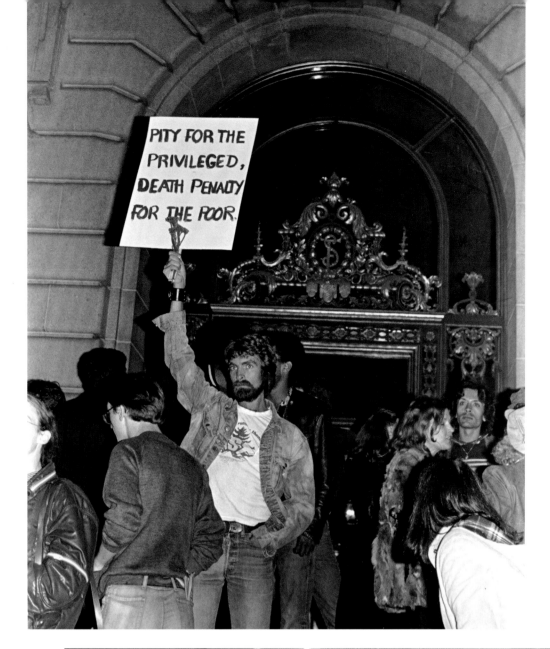

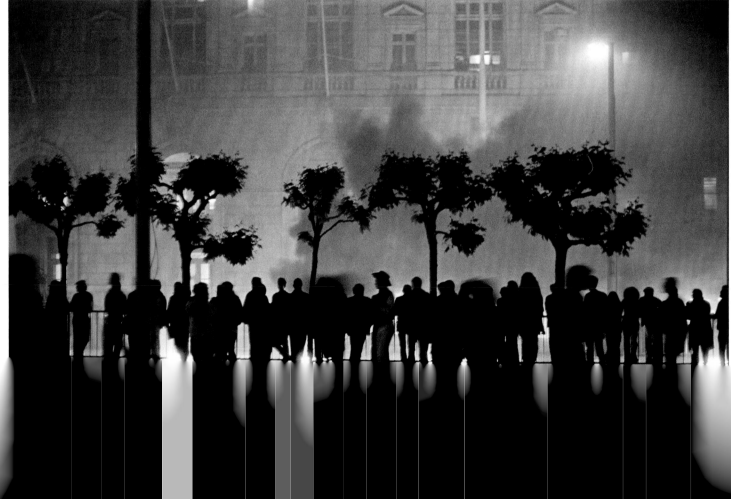

◀ **Left** Sylvester sings, San Francisco, c. 1976. Photo by Harvey Milk. Courtesy of San Francisco History Center, San Francisco Public Library (Milk/Smith collection; GLC 35).

◀ **Opposite, top** Demonstrators gather at City Hall after learning of Dan White's lenient sentencing, San Francisco, May 21, 1979. Photo/copyright © by Daniel Nicoletta.

◀ **Opposite, bottom** The White Night Riots, San Francisco, May 21, 1979. Photo/copyright © by Daniel Nicoletta.

▼ **Below** Members of Gay Walk for Freedom, an "informal association of street Gays and drag queens," gather outside the Bowl & Board (a restaurant in the space that had once housed the Stonewall Inn), Christopher Street Liberation Day, New York City, June 27, 1976. Photo/copyright © by Biscayne/Kim Peterson.

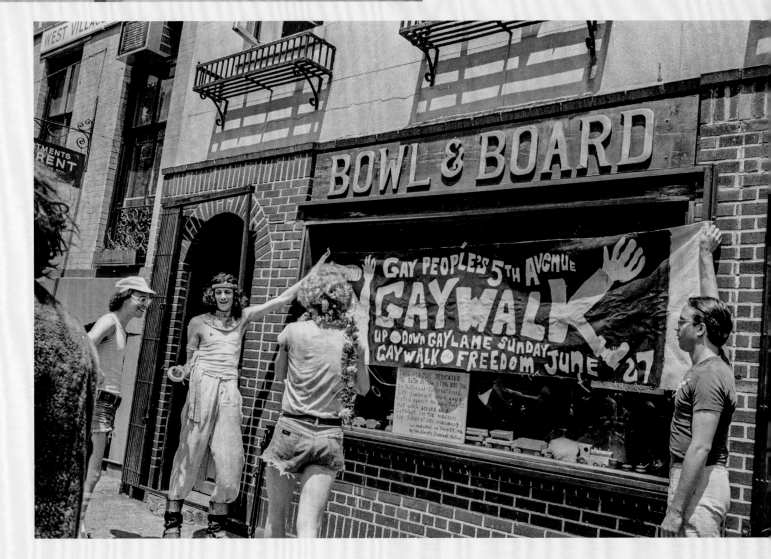

On October 14, 1979, the Houston delegation stepped to the front of the Texas contingent, which was the first of the fifty states in the National March on Washington for Lesbian and Gay Rights. The Montrose Marching Band and its director Clint Moncrief set the pace as the masses marched toward the Washington Monument.

While disappointed by the Houston vote, Phyllis Frye had a plan. There'd be a lot of outrageous sights and sounds at the March, she knew, much of which couldn't be sent to America's living rooms. Proudly marching in front of a banner emblazoned with the upside-down pink triangle, Frye, dressed modestly in earth tones, carried an American flag and a copy of the Bible. The cameras couldn't resist such a wholesome figure.

Leading the March was a contingent of women of color, including warrior-poet Audre Lorde, who'd been at the Third World Lesbian and Gay Conference in D.C. in the days just before the March. In a flurry of activity, six hundred Black, Latinx, Asian American, and Native American queer people spent days working together, and ultimately, they committed themselves to building a national network for Third World queer people. There was finally a small chance that mainstream queer leaders might focus on the pervasive racism inside and outside the queer community.

Michiyo Cornell, speaking on behalf of the newly formed Lesbian and Gay Asian Collective at the Washington Monument, put the huge crowd on notice: Third World queer people were not only demanding the right to their sexuality and queer identity but also "to our racial identity, something that sets us apart from and challenges white lesbians and gay men." Demanding that white gays address their "white-skin privilege," Cornell said, until the mainstream actively supported queers of color, "you will not have our support."

Audre Lorde similarly urged the crowd to carry its professed solidarity back to the myriad communities it represented, "for not one of us will ever be free until we are all free."

◀ Clint Moncrief leads Houston's Montrose Marching Band, National March on Washington for Lesbian & Gay Rights, Washington, D.C., Oct. 14, 1979. Photo by Larry Butler. Courtesy of Botts Collection of LGBT History (Butler collection).

◀ **Left** Phyllis Frye marches with a Bible and an American flag, National March on Washington for Lesbian & Gay Rights, Washington, D.C., Oct. 14, 1979. Photo by Larry Butler. Courtesy of Botts Collection of LGBT History (Butler collection).

▼ **Below** Lead banner (held by, among others, Audre Lorde, sixth from right), National March on Washington for Lesbian & Gay Rights, Washington, D.C., Oct. 14, 1979. Photo by Larry Butler. Courtesy of Botts Collection of LGBT History (Butler collection).

▶ **Right** Christopher Street West, West Hollywood, June 22, 1980. Photographer unknown. Courtesy of the ONE Archives at the USC Libraries (CSW collection; 2012-135).

▶ **Opposite** First annual Milk/Moscone Memorial March & Vigil; activist Cleve Jones, with bullhorn, is at front, San Francisco, Nov. 27, 1979. Photographer unknown. From the authors' collection.

▼ **Below** Christopher Street Liberation Day, New York City, June 24, 1979. Photo by Leonard Fink. Courtesy of The LGBT Community Center National History Archive (Fink collection; 26-105).

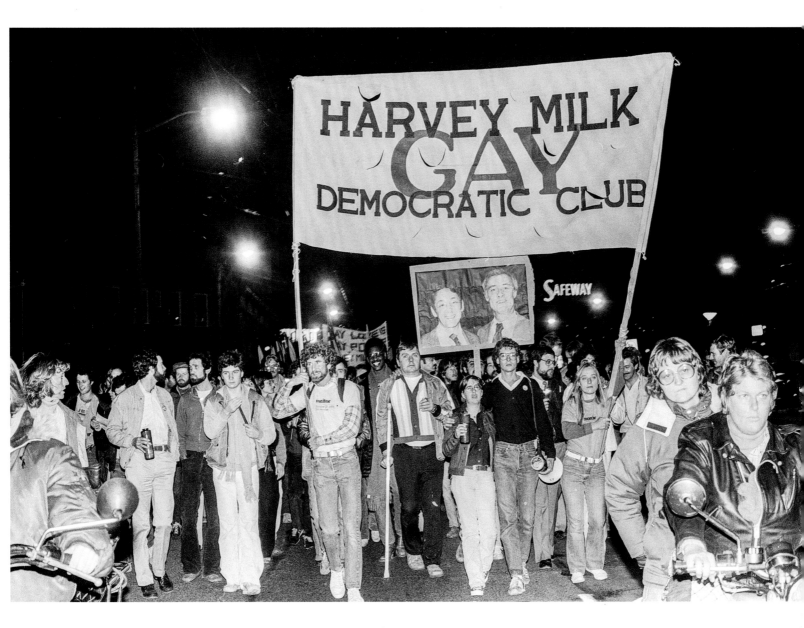

Maybe, *maybe*, the 1980s would bring a collective fight against the inseparable "diseases of racism, of sexism, of classism, and of homophobia." More likely, though, mainstreamers would continue to emphasize traditional politics that marginalize the already-marginalized. "In the '80s," Arlie Scott said, "we are moving from Gay Pride to Gay Politics!"[63]

While queer leaders debated which battle to wage next, a new enemy had arrived and was gaining strength. Maybe some of the men in D.C. were too tired to party as they used to; perhaps the boisterous Clint Moncrief complained of fatigue; and some of the New Yorkers probably knew Rick Wellikoff, who a month earlier had been diagnosed with Kaposi's sarcoma, a typically benign disease that seemed to be killing him.

"So while we party tonight," Audre Lorde told the Third World delegates, "let a little drop fall, call it a libation, which is an ancient African custom, for all our sisters and brothers who did not survive. For it is within the context of our past as well as our present and our future that we must redefine community."[64]

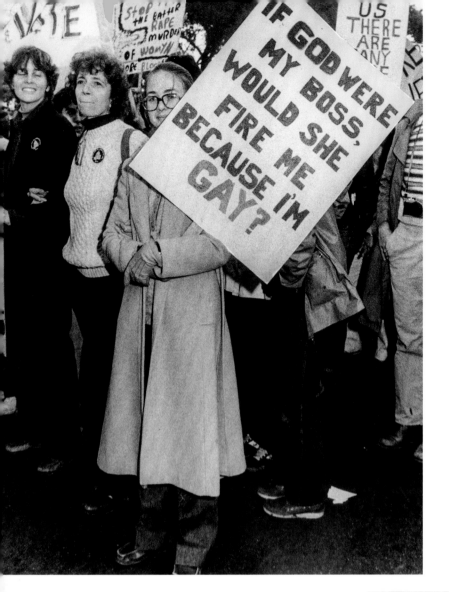

▲ **Above** National March on Washington for Lesbian & Gay Rights, Washington, D.C., Oct. 14, 1979. Photo by Ted Sahl. Courtesy of San José State University Special Collections and Archives.

▶ **Right** Christopher Street Liberation Day, New York City, June 24, 1979. Photo by Leonard Fink. Courtesy of The LGBT Community Center National History Archive (Fink collection; 26-105).

▶ **Opposite** Christopher Street Liberation Day, New York City, June 26, 1977. Photo by Leonard Fink. Courtesy of The LGBT Community Center National History Archive (Fink collection; 26-57).

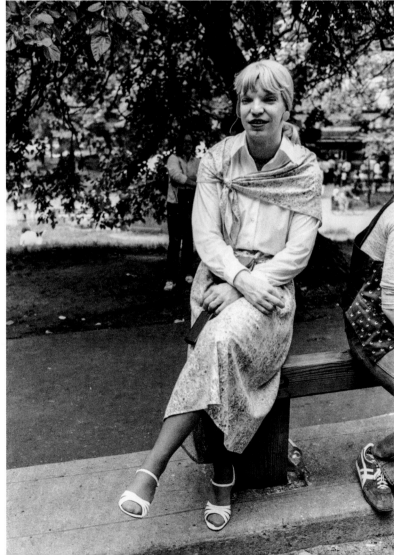

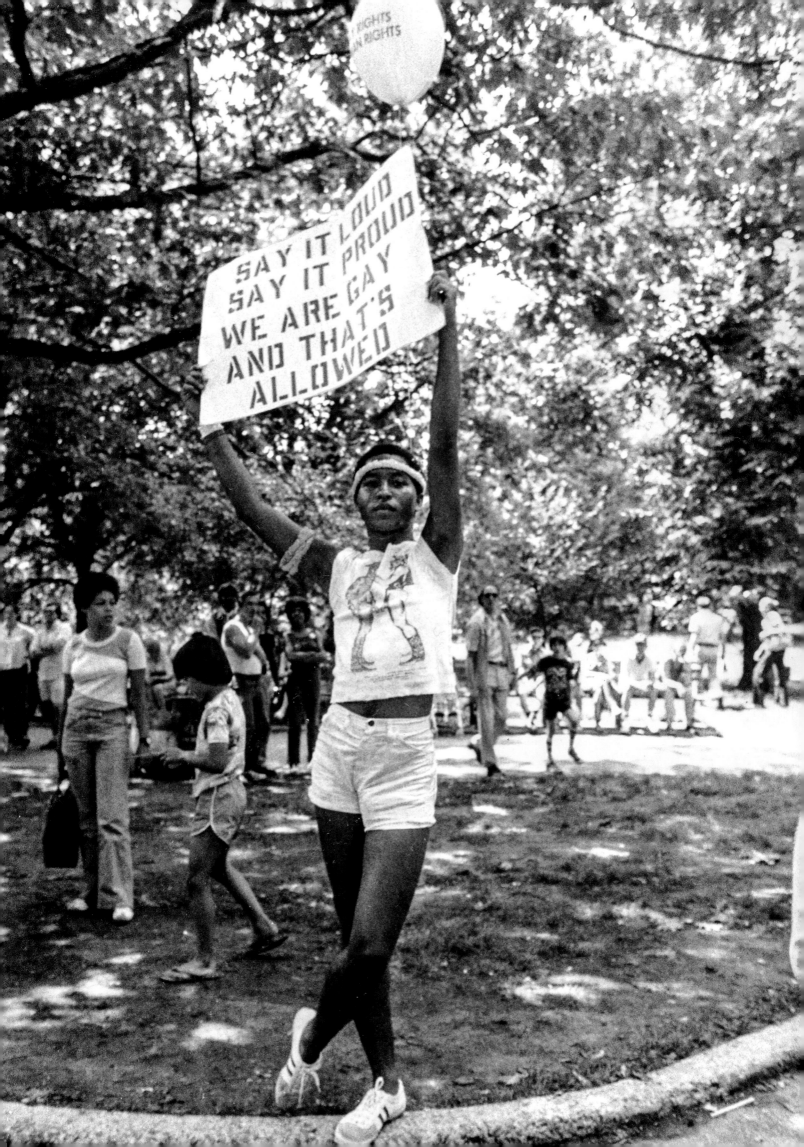

PART IV

FIGHTING For Our LIVES

1980–1994

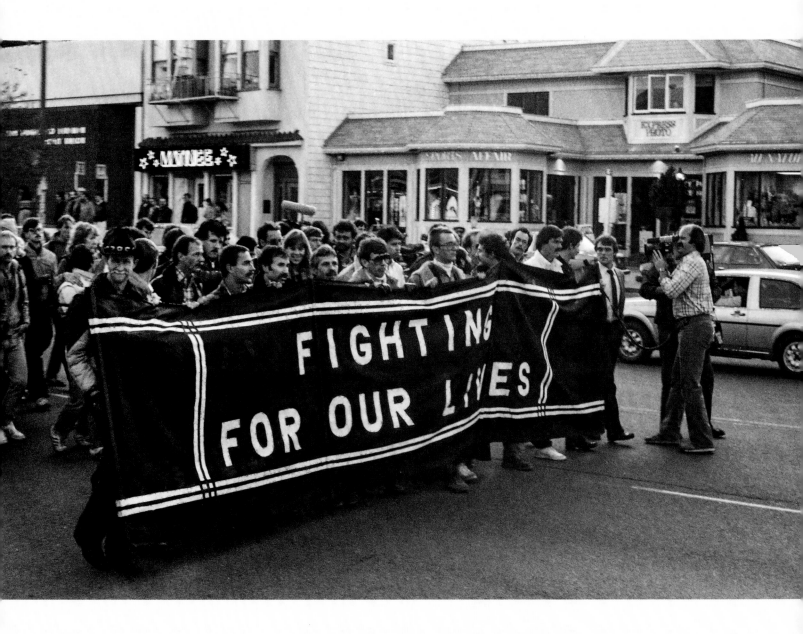

You know, there is always the storm that
strike you when at least less expected.

—GAÉTAN DUGAS, 1982

Los Angeles, 1994

For those unfamiliar with the history of the West Coast homophiles, the late August 1994 gathering at the ONE Institute in L.A. may have seemed like just another memorial service for a well-regarded colleague. But those who convened on August 28 to pay respects to *ONE* founder Dorr Legg were those who'd helped start a revolution: Jim Kepner and Morris Kight, for example, sat near Hal Call and Harry Hay, the two old rivals who'd managed to put aside their rivalry for the day.

"Now the Old Ones are dying," journalist Karen Ocamb wrote after the memorial. "Before AIDS, before Stonewall," she explained to a new generation, "a handful of daring queers met secretly to strategize about helping each other and going public." And Dorr Legg, who'd died at home on July 26, 1994, had been at the center of it all.

Addressing the small crowd at the informal service, Kepner spoke of Legg's dedication to the preservation of queer history, and Kight paid tribute to the love Legg shared with John Nojima, his partner of thirty-seven years. Harry Hay shared stories of the friend he'd loved from the minute they'd met at an early Mattachine meeting. In each century, Hay said, there are those who "singlehandedly, against enormous odds, attain the stature, the impeccable integrity, of giants in their chosen fields. Dorr—with his vision and steadfastness of purpose—was such a one. Our beloved Gay and Lesbian Movement will look long to discover the likes of him again."[1]

Stonewall 25—New York City's massive celebration in June 1994, marking the twenty-fifth anniversary of the Christopher Street riots—was chaos.

Writing in *TransSisters*, activist Mustang Sally summarized the tension "between the common queer masses and the A-list wannabes," neither of whom seemed to understand that "we could celebrate both mainstream clout and pride in our various subcultures; that Stonewall belonged not just to the sweater-boy set but to the colored, the female, and the transgendered." Undeniably, though, from amid Stonewall 25's corporate-backed galas, competing protests, a mile-long rainbow flag, and stark reminders that AIDS was everywhere, there emerged signs of a queer commonality, some recognition of a shared history of violence, oppression, and occasional triumph.

For some, the visibility of the long-ignored bisexual community proved that the gay and lesbian mainstream was still able to expand beyond its own binary interests. For others, New York's Second Annual Dyke March was a reminder of the vitality and resilience of

◀ **Left** Harry Hay speaks at the memorial of W. Dorr Legg, Los Angeles, Aug. 28, 1994. Photo by David Hensley. Courtesy of the ONE Archives at the USC Libraries (Hensley photographs; 2012-036).

◀ **Page 213** Bobbi Campbell (above "ing" in "FIGHTING"), Dan Turner, Mark Feldman, and other People With AIDS (PWAs) lead the first AIDS Candlelight March, San Francisco, May 2, 1983. Photo/copyright © by Daniel Nicoletta.

the lesbian community. For Mustang Sally, most meaningful was an event hosted by Lesbian Feminists to raise funds for transgender activists headed to the Michigan Womyn's Music Festival in August. Using an ambiguous "womyn-born-womyn" policy, the legendary festival's producers refused to admit "openly transsexual" women; when volunteers removed Nancy Jean Burkholder in 1991, however, "Camp Trans for Human-Born-Humans" became ground zero for protests and consciousness-raising across the highway from the festival grounds.

▲ Sylvia Rivera leads the Alternative March, New York City, June 26, 1994. Photo by Justin Sutcliffe. Copyright © by the Associated Press.

But the Lesbian Feminists in New York came not only to support Camp Trans, but to claim "its cause as part and parcel of lesbian feminism." That a new generation of Lesbian Feminists was supporting transgender women elated Beth Elliott, who'd kept a low profile since her expulsion from the 1973 West Coast Lesbian Conference. An activist by nature, though, she still spoke up from time to time, often writing under pseudonyms. In 1994, she went by the pen name Mustang Sally. "With all the brouhaha," she wrote, "it appears we are the ones to have the last laugh."

For many, though, the Alternative March—organized by a coalition of radical organizations and individuals to protest the mainstreaming of Pride—best illustrated the new hope for Queer Liberation. In the spirit of the original Christopher Street Liberation Day Marches, the radicals eschewed Stonewall 25's official parade route along Manhattan's East Side, choosing instead to march up Fifth Avenue from Sheridan Square. Harry Hay, Randy Wicker, Mama Jean Devente, Larry Kramer, nine cars of drag royalty, thousands of members of ACT UP, the Lesbian Avengers, the Transsexual Menace, and the ever-controversial NAMBLA were led by "a glittering drag queen [sic] who was at the original Stonewall riots." And, a reporter noted, the queen "walked all the way uptown in heels."

Her name was Sylvia Rivera, and she'd been marching in heels for decades.

As the official March cut west across Fifth Avenue toward Central Park, the Alternative March hit 57th Street and, without much fanfare, the groups peacefully merged into one queer mass. The physical coalescence of the largest groups of culturalists and reformists yet assembled didn't signal the end of the ideological disputes that had fueled decades of struggle for queer identity and liberation, of course. But, for one afternoon, or maybe just for that one moment, everyone seemed content coming together, as Harry Hay once described the first meeting of the Mattachine Founders, "with fire in our eyes and far-away dreams, *being* Gays."[2]

▶ Second Annual Dyke March, New York City, June 25, 1994. Photo/copyright © by Carolina Kroon.

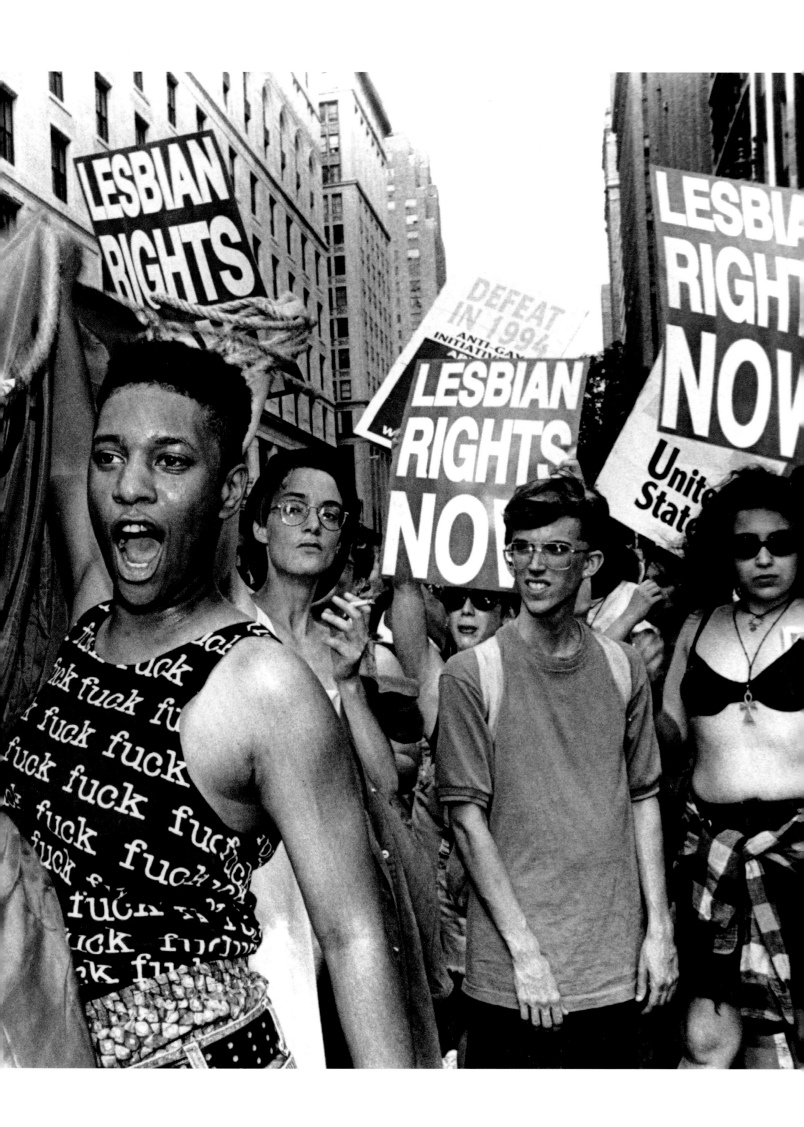

At the same spot fourteen years earlier, just as the 1980 Christopher Street Liberation Day Parade hit Fifth Avenue and 58th Street, a group of disgruntled queer activists broke off for an alternative celebration; Sylvia Rivera and Marsha P. Johnson, however, paid it no mind. Buoyed by Eve Adams, head of Gay Liberation Allows Drag (G.L.A.D.), who'd been invited to speak at the day's rally, the Street Transvestite Action Revolutionaries (S.T.A.R.) cofounders delighted in being recognized for "the important part they have played in the development of gay awareness." In Central Park, Adams spoke of "equality, unity, and basic human rights for all gay people, especially the most neglected: TRANSPEOPLE."

A tedious lineup of over twenty speakers followed Adams, sending most of the crowd home—or to the bars and baths—early. New Yorkers wanted something different for Pride, "a day for unity through entertainment and joy," like San Francisco. "That day of fun and frolic," someone said, "must serve as a wonderful release from the necessary political and social stresses and tensions with which we are so familiar in our daily lives."[3]

In fact, the organizers of San Francisco's 1980 Gay Freedom Day wanted to give their Pride events the "festive feeling of a state fair," though they welcomed traditional politicking. A group of Harvey Milk's protégés—Bill Kraus, Gwenn Craig, and Harry Britt—led the 1980 parade, touting their place among the seventy-seven openly queer delegates headed to New York for August's Democratic National Convention (DNC). "It was a time," Randy Shilts wrote, "when the outsiders who once marched angrily on the government were becoming insiders learning how to use the power they had gained." But San Francisco still had radicals. "You can't celebrate when you're still being oppressed," said activist Alberta Maged. "We have the illusion of freedom in San Francisco, but the right-wing movement is growing quickly. It's right to be proud to be gay, but it isn't enough if you're still being attacked."[4]

In Houston, Pride 1980 was promoted as a celebration of the community's resilience, and Larry Bagneris's upcoming trip to the DNC made the event all the more meaningful. As the weekend started, though, any cause for celebration disappeared as news spread of Fred Paez's death. Paez, a beloved young activist, was shot and killed by an off-duty police officer during what cops said was an attempted arrest for public lewdness. Those who knew Paez never bought the reports of the "accidental shooting."[5]

Much like Chicago's police before the riotous 1968 DNC, New York's cops cracked down in preparation for the 1980 DNC, declaring war on an "influx of transvestite prostitutes" around Times Square. "You know what they did in China during the '50s to solve the addict problem?" Manhattan Borough President Andrew Stein asked about the "transvestite problem." "They just shot everyone who was an addict. Now, is there any way we could do something like that?"

Marsha P. Johnson got arrested in the crackdown, though friends insisted her only crime was "being a black drag queen." There is "so much racism, sexism, and classism

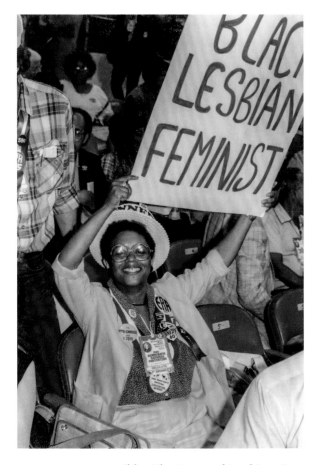

even within our own community," activist Robert D'Avanzo wrote, queer people couldn't see that regardless of any "concessions" from those in power, the minute "a shift in the wind came, most of them would gladly march us off to concentration camps."[6]

Larry Bagneris hated rhetoric about concentration camps and death. "Damn it!" he thought. "Every time we talk about gay rights, we talk about death, or going to jail, or something negative." He insisted on a positive tone from the DNC's first official Gay and Lesbian Caucus. In an amazing show of force, DNC delegates Virginia Apuzzo and Bill Kraus helped secure the first gay rights plank ever included in a major party platform, while Gwenn Craig, Mel Boozer, and Jeanne Córdova seemed to be everywhere, lobbying as many Democratic Party stalwarts as possible. The Gay and Lesbian Caucus even gathered enough signatures to place Boozer's name on an early ballot for the vice presidential nomination. "Would you ask me how I'd dare to compare the Civil Rights struggle with the struggle for lesbian and gay rights?" Boozer asked from the podium. "I know what it means to be called a nigger. I know what it means to be called a faggot. And I can sum up the difference in one word: None."[7]

◄ Gwenn Craig, member of the Gay & Lesbian Caucus, Democratic National Convention, New York City, Aug. 1980. Photo by Allen G. Shores. Courtesy of the ONE Archives at the USC Libraries (Shores photographs; 2012-009).

"God created Adam and Eve, not Adam and Steve!" Jerry Falwell bellowed from the steps of the New Jersey State House in mid-November 1980, just a week after Ronald Reagan's victory over Jimmy Carter. As pundits rushed to declare Falwell's Moral Majority *the* factor that turned a close presidential race into an electoral landslide, Falwell was riding high. Building on Anita Bryant's crusades, the Moral Majority had registered four million new voters in 1980 and brought at least ten million inactive voters back to the polls. Manipulating Judeo-Christian orthodoxy, fear, and hate, Falwell inspired a wave of conservative political organizations, all part of a loose coalition called the New Right. Conservative strategists Richard Viguerie and Terry Dolan, a closeted gay man, revolutionized electoral politics with massive networks of evangelical voters focused on domestic issues such as limiting women's rights, expanding religious education, and negating queer existence. With an uncanny ability to drive media cycles, frighten voters, and unseat opposition, the New Right seemed bent on destroying everything in its path.

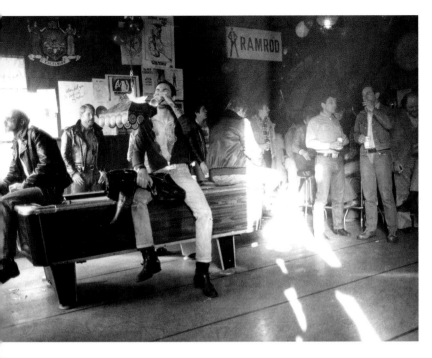

On November 19, two weeks after Reagan's election, former New York City transit cop Ronald Crumpley pulled up to the Ramrod, a famous leather bar in Greenwich Village, and opened fire, spraying the Ramrod's plate-glass windows and those of an adjoining gay bar. All told, Crumpley shot eight people, killing two. The next night, a thousand marchers made their way down Christopher Street, struggling to come to grips with the terrifying signals flashing all around: "The past really can be undone," gay journalist Charles Ortleb wrote. "In a world of montage, we're about to cut away to a fascistic point in time: yesterday."

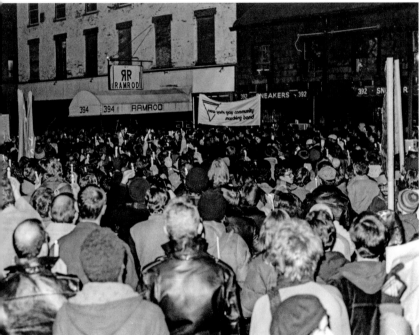

The marchers, including Gay Liberation stalwarts Arthur Bell and Craig Rodwell, weren't there only to mourn those at the Ramrod, though, nor were their thoughts centered on Crumpley. "If people weren't numb," Ortleb wrote weeks later in the first issue of the *New York Native*, "they were trying to incorporate the image of a man with a machine gun into their notions of gay life in New York City." More than that, they were "thinking about Ronald Reagan, the Moral Majority, and the very meaning of gay life itself." And they were thinking about fate, Ortleb wrote, "for only fate had made them the mourners rather than the mourned." On top of everything else, a people "who had been denied too much for too long now had to invent their own form of mourning."[8]

In 1981, Reverend Roger Fulton opened the Neighborhood Church on Greenwich Village's Bleecker Street and proudly displayed a picture of Jerry Falwell in the window. The locals were pissed, with *Big Apple Dyke News* hoping that "Sylvia and the other queens are man enough to lead another Stonewall. If not, we know some dykes who are." And then the Moral Majority moved into the Castro, announcing plans to spend millions in San Francisco on a media campaign attacking homosexuals. *They* were everywhere.

By spring, Ronald Reagan's plans for an economic overhaul—domestic cuts, tax breaks for the wealthy, and massive increases in defense spending—threatened what little

▲ Top Charley sits on a pool table inside The Ramrod, Greenwich Village, New York City, 1976. Photo by Leonard Fink. Courtesy of The LGBT Community Center National History Archive (Fink collection; 26-52).

▲ Above Mourners outside The Ramrod, Greenwich Village, New York City, Nov. 20, 1980. Photo/copyright © by Morgan Gwenwald.

remained of the social safety net. Concerned about the devastation, a group of physicians, including openly gay Walter Lear, staged a protest *inside* the White House on June 2, hoping "to stop the transfer of federal funds from health and human services to military programs."

On June 5, hundreds participated in San Diego's Lesbian Solidarity March, where speakers addressed "the nexus between the attacks of the New Right on women, the handicapped, the poor, racial minorities, the elderly, and Lesbians and Gay Men." The same day, the Coalition Against Racism, Anti-Semitism, Sexism and Heterosexism (CRASH), a loose collection of Third World and socialist queer groups in New York, confronted Reverend Fulton's Neighborhood Church. "Believe it or not," activist Maxine Wolfe recalled, "five hundred people showed up, and we ended up blocking all the traffic. It was, like, the best thing that had happened in years." Although the church may have looked small and unthreatening, one demonstrator said, "It's part of something that seems to be growing in this country, something that's racist, that's sexist, that's homophobic." A straight passerby dismissed the activists' concerns, announcing that Manhattan is "a nice place to live if you are gay" and "people don't have to demonstrate against churches in New York." The Moral Majority, according to the straight naysayer, "is not a threat here, not the way it was in Germany in 1933."

▲ Dykes Against Racism Everywhere (D.A.R.E.) pinback, New York City, c. 1982. From the authors' collection.

In this context—daily attacks on entitlements, waves of anti-queer violence, the rise of a powerful new conservative force—the Centers for Disease Control (CDC) published a notice about a rare type of pneumonia afflicting gay and bisexual men in Los Angeles. On June 5, 1981, in fact, as San Diego's lesbians marched and CRASH hit the Village, the CDC described five otherwise healthy gay men under the age of forty who'd been treated for *Pneumocystis carinii* pneumonia (PCP). By the time the report appeared, two of the five were dead. In the weeks that followed, only a few gay periodicals—and virtually *none* of the mainstream press—ran stories on what Boston's *Gay Community News* called "gay pneumonia."[9]

Meanwhile, Drs. Linda Laubenstein, Joseph Sonnabend, and Alvin Friedman-Kien were among a handful of physicians in New York City treating a growing number of gay and bisexual patients diagnosed with Kaposi's sarcoma (KS), a disease equally as rare as the pneumonia seen in Los Angeles. And, like gay pneumonia, KS was killing otherwise healthy young men. In April 1981, Dr. Friedman-Kien spoke to San Francisco's Dr. Marcus Conant, who reported that the Bay Area also had a cluster of KS patients; the news suggested an epidemic, and typically would've been met with press releases and public health alerts.

Instead, there was silence.

Finally, on July 3, 1981, the *New York Times* ran Lawrence Altman's article "Rare Cancer Seen in 41 Homosexuals," which said most KS cases involved gay men under forty having "multiple and frequent sexual encounters with different partners, as many as 10 sexual encounters each night up to four times a week." Like many sexually active men—gay, bisexual, and straight—most of the patients had a history of sexually

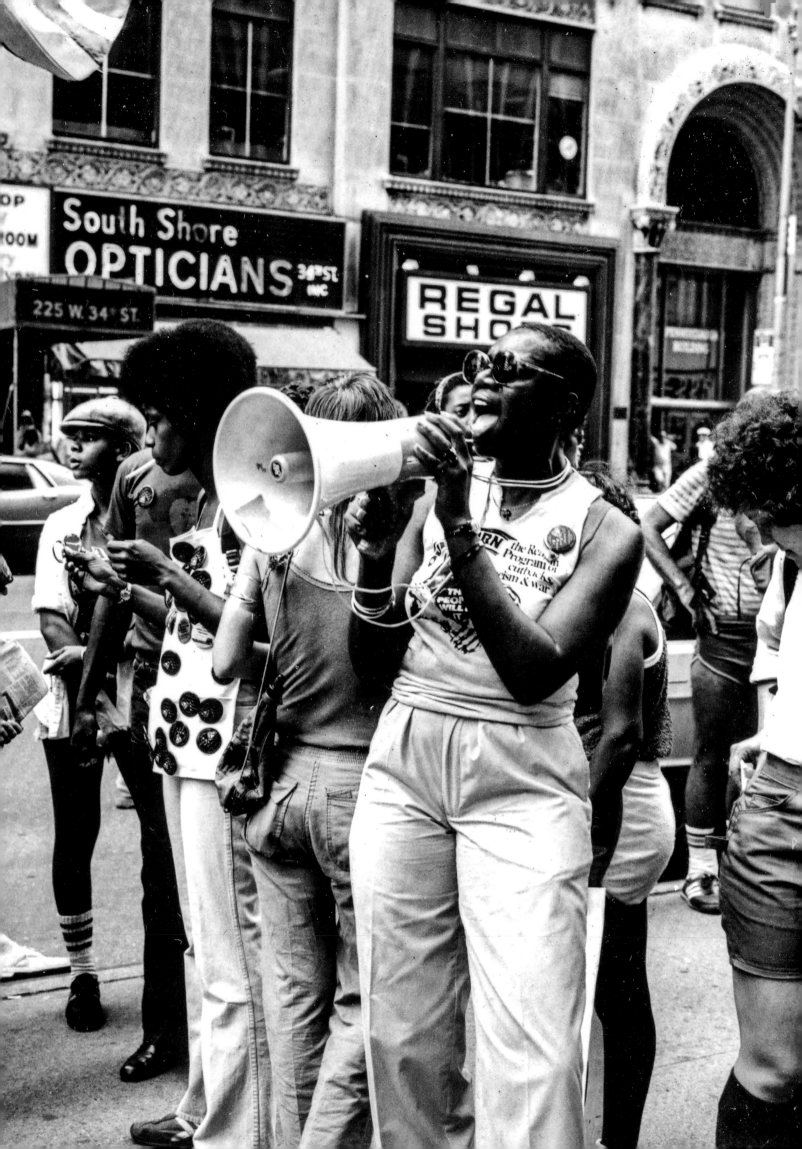

transmitted infections and recreational drug use. But by highlighting the most sexually active patients—the "partiers"—and failing to mention those who, for example, had been in monogamous relationships for years, Altman cast what some were referring to as "gay cancer" as a disease striking a particular kind of man: *those* gays.*

While Dr. Friedman-Kien's patients had "severe defects in their immunological systems," Altman reported it was unclear "whether the immunological defects were the underlying problem or had developed secondarily to the infections or drug use." In any event, the CDC's Jim Curran said, "there was no apparent danger to nonhomosexuals from contagion."

Once the *Times* ran the "Rare Cancer" story, patients and doctors had good reason to be optimistic about the flood of assistance that was sure to follow. Five years earlier, for example, Altman's first *Times* article on a strange illness afflicting American Legion conventioneers resulted in nine front-page stories in the paper in a single month. From there, the CDC spent $10 million containing what they called Legionnaires' Disease, which claimed 34 victims. By comparison, as of late July 1981, at least 43 people had died of what doctors designated Gay-Related Immune Deficiency (GRID); if the responses to previous mystery outbreaks were any guide, certainly the national infrastructure—hospitals, emergency workers, researchers, government officials, and the media—would turn its attention to these inexplicable maladies.

Instead, there was nothing.[10]

Writer Larry Kramer was terrified when he read the "Rare Cancer" piece, and he quickly called in favors to get a late July appointment with Dr. Friedman-Kien. Allowing Kramer a moment of relief after a thorough examination revealed no signs of KS, Friedman-Kien pulled him back to reality: "We're only seeing the tip of the iceberg," he said. "We don't know what it is. It would appear to be a virus, but we don't have any concrete evidence." It was clear that neither the press nor the government particularly cared, "and it's really up to you guys to do something." Most immediately, researchers needed money. As "somebody who's known in the community," Friedman-Kien said, Kramer could help raise funds and awareness.

Though he wanted to help, Kramer doubted that he was the right person to rally the troops. Not only had the writer consciously avoided the "dirty and unwashed" radicals of gay activism for most of the 1970s, but his one attempt to contribute to the struggle had backfired spectacularly when, in the wake of Harvey Milk's assassination, he'd written his *New York Times* op-ed describing gay New Yorkers as "not ready" for their rights. "We have not earned them," Kramer declared. "We have not fought for them." Among those who'd spent years fighting for Kramer's right to be blasé, the critique was not well-received.

As it turned out, Kramer had been in San Francisco on a book tour in November 1978 when Milk was shot, and his publisher had urged him to pen the *Times* op-ed as a plug

◀ **Opposite** Coalition Against Racism, Anti-Semitism, Sexism and Heterosexism (CRASH) protests the Family Protection Act, a proposed federal law prohibiting, among other things, federal funds being allocated to "any organization which presents male or female homosexuality as an acceptable alternative lifestyle," New York City, July 1981. Photo by Richard C. Wandel. Courtesy of The LGBT Community Center National History Archive (Wandel collection; 4a-007).

* In his seminal 1987 book, *And The Band Played On*, Randy Shilts imagined a world in which early AIDS-related articles were written by authors attempting to walk a fine line between competing political interests: "Don't offend the gays and don't inflame the homophobes." Based on our research, the notion that there was *anyone* particularly concerned about not offending "the gays" is preposterous. We echo Douglas Crimp's observations: "Language destined to offend gays and inflame homophobia has been, from the very beginning—in science, in the media, and in politics—the main language of AIDS discussion, although the language has been altered at times in order that it would, for example, offend Haitians and inflame racism, or offend women and inflame sexism."

▲ Larry Kramer signs copies of *Faggots*, Wilde n' Stein bookstore, Houston, Aug. 22, 1979. Photographer unknown. Courtesy of Botts Collection of LGBT History.

for his novel *Faggots*. A "highly personal, deeply moral book," *Faggots* followed Kramer's doppelganger, Fred Lemish, through "saunas, baths, parties, discos, bars and clubs, private homes and public cruising areas" as he searched for "real" love. Instead of finding love, though, in countless scenes of "graphically described sexual acts which at best could be described as eccentric, at worst as uncomfortable, unpleasant or seemingly impossible," Lemish found only unsatisfying sex. Alone and nearing forty, he blamed not himself but the gay world, painting a scene of faceless faggots fucking in the dark, wholly incapable of—and hostile to—love.

Gay Liberation stalwart Vito Russo, among the book's more thoughtful critics, took issue with Kramer's condemnation of "an entire lifestyle because it hasn't brought him what he was taught to look for, namely Prince Charming." As Russo acknowledged, there was "an entire lifestyle" in urban gay communities centered on backroom bars and bathhouses, shadowed by a network of public cruising grounds. But what some referred to as "promiscuity," others saw as progress: queer people didn't have to deny themselves sexual experiences that had for so long been forbidden. And owners of bars and baths filled the demand, building a world of "profit-making, butch posturing, and competition for sex." A sharp rise in sexually transmitted diseases was inevitable, so community centers organized clinics and urged gay and bisexual men to "take personal responsibility for being tested periodically so that the chain of transmission can be broken."

In an interview with Robert Chesley soon after his *Times* op-ed, Kramer did little to silence the critics who saw him as a self-loathing, sex-negative moralist. Insisting that monogamy is "essential," refusing "to go to the barricades" for public sex, and admitting he still frequented baths and bars, Kramer almost proved their point. "Underneath the satire," Chesley wrote, "is moralism; underneath the moralism is guilt and (to a degree) a horror of sex; and underneath all is self-hatred—a faggot self-hatred that ultimately calls for punishment and repression by society."[11]

So while Dr. Friedman-Kien correctly saw Larry Kramer as "somebody who's known in the community," there was reason to doubt his efficacy as an organizer. Leaving the

doctor's office in July 1981, though, Kramer ran into his friend Donald Krintzman, and the two men tried to avoid the topic on both their minds. "Yes," Krintzman finally said, "I've got Kaposi's sarcoma."

From the beginning, the epidemic was personal. And the personal was political. Kramer had to do *something*.

Two weeks later, he opened his apartment to Krintzman and about a hundred other gay men for a fund-raiser, during which Dr. Friedman-Kien discussed the prevailing theory of GRID: patients' weak immunological systems likely were a result *not* of previous sexually transmitted diseases but of *treatments* for the diseases, which weakened the body's resistance to the rare ailments they were seeing. Although there was no solid evidence to prove that KS or PCP was sexually transmittable, the doctor strongly urged sexual restraint.

It would've been impossible for gay and bisexual men to sit in Larry Kramer's apartment, listening to a straight doctor tell them to stop screwing, and *not* think of Fred Lemish warning other faggots not to "fuck yourself to death."

Still, the men collected nearly $7,000, and a core group—including Kramer, Edmund White, Paul Rappoport, Paul Popham, Larry Mass, and Enno Poersch—soon formed Gay Men's Health Crisis (GMHC), one of the first and most important AIDS-related services organizations. In late August, the *Native* ran a fund-raising appeal from Kramer. Noting that cases of KS and PCP had tripled—from 40 to 120—in a month, he said it was "easy to become frightened that one of the many things we've done or taken over the past years may be all that it takes for a cancer to grow from a tiny something-or-other that got in there who knows when from doing who knows what." This, Kramer wrote, "is our disease, and we must take care of each other and ourselves."

Robert Chesley had seen this before. "Read anything by Kramer closely," he responded. "I think you'll find the subtext is always: the wages of gay sin are death." In *Faggots*, Chesley said, Kramer wrote "that we ought not to be doing what we're doing," but "we didn't listen to him; nooo—we had to learn the hard way, and now we're dying." While "not downplaying the seriousness of Kaposi's sarcoma," Chesley concluded, "something else is happening here, which is also serious: gay homophobia and anti-eroticism."

He was right. As someone who hadn't been involved in Gay Liberation, Kramer's rhetoric evoked and often seemed to legitimize "an unspoken but widespread anxiety" among queer men that somehow *who* they were was killing them. Paul Popham, GMHC's first president, wrote that "something we have done to our bodies has brought us all, in a sense, closer to death," and gay and bisexual men, said writer Michael Lynch, seemed "ripe to embrace a viral infection as moral punishment."

Someone had to tell them it wasn't their fault.[12]

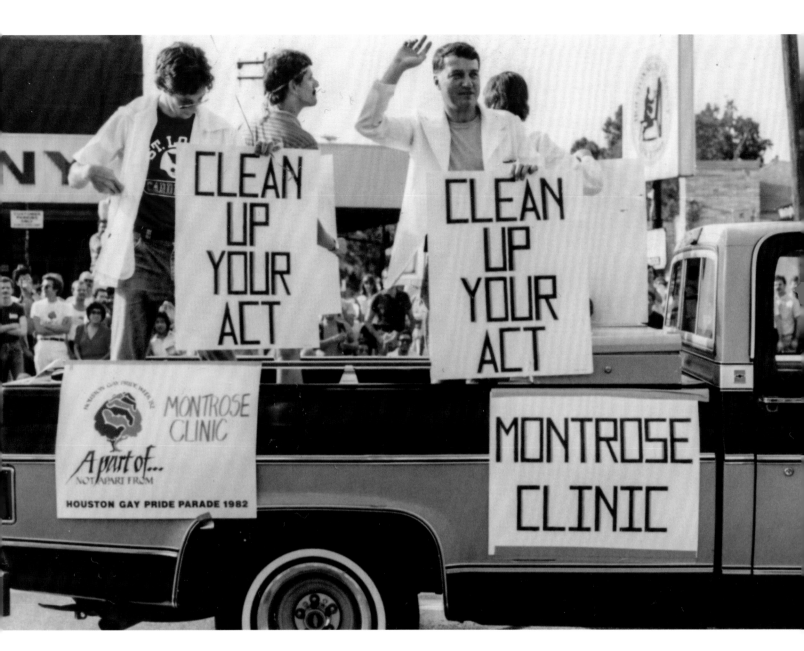

▲ Montrose Clinic contingent, Gay Pride,
Houston, June 1982. Photo by Mike Kelley.
Courtesy of Botts Collection of LGBT
History (Kelley collection).

Our lifestyle has created the present epidemic of
AIDS among gay men.

—MICHAEL CALLEN & RICHARD BERKOWITZ, 1982

We do not need to justify ourselves. We have nothing to be sorry for. . . . We may have at times been careless, but we were never immoral.

—MARIE GODWIN, 1983

▼ Christopher Street West, West Hollywood, July 1, 1984. Photographer unknown. From the authors' collection.

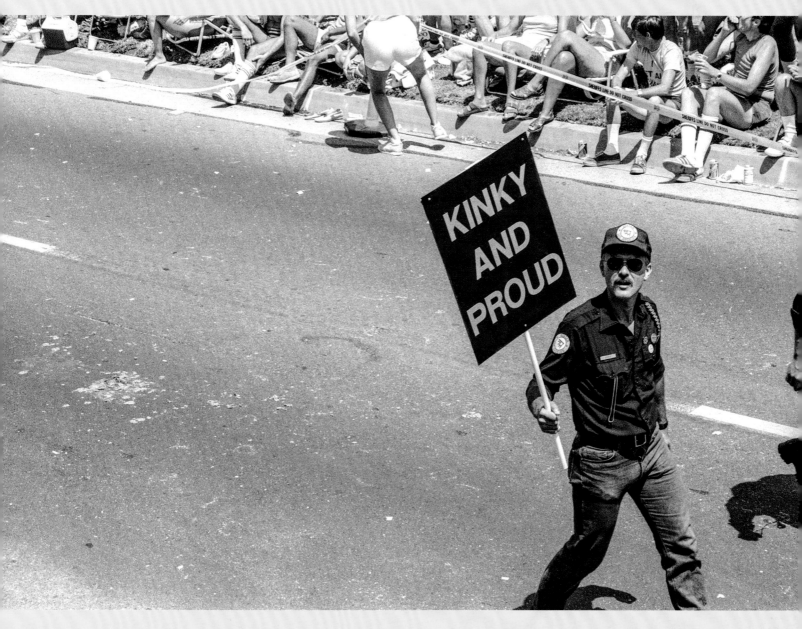

"I'm Bobbi Campbell, and I have 'gay cancer.'"

With those words, a twenty-nine-year-old registered nurse in San Francisco became the first person with KS to go public. "I'm not lucky *because* I have Kaposi's Sarcoma," he wrote in the *Sentinel* in December 1981. "I'm lucky, and happy, because in my time of crisis, I've found out who my real friends are." Using easy, accessible language, Campbell told the story of his diagnosis and what he planned to do about the "serious business." He knew the statistics were bad, but he was optimistic: "I'm not going to die—not yet at least."

San Francisco's doctors were "treating the KS patients beautifully from a medical perspective," Campbell reported. Because of decades of queer activism, elements of the city's government responded when members of the medical, political, and queer communities identified potentially devastating new diseases. Even before Larry Kramer's fund-raiser in New York, a task force of Bay Area doctors started investigating, and by late August 1981, a meeting was held with gay leaders "to plan a local strategy for educating doctors and gay men about the illnesses."

But Campbell was concerned because few patients knew each other, and even fewer had any emotional support. In early 1982, at the suggestion of Dr. Marcus Conant, Campbell met another gay man with KS, Dan Turner, and the pair formed perhaps "the first organization of, for and by people with AIDS." That summer, during Pride Week, San Francisco's Sisters of Perpetual Indulgence—a group of gay and bisexual men in "nun" drag (including Bobbi Campbell, a.k.a. Sister Florence Nightmare, R.N.) who'd taken "vows to promulgate universal joy and expiate stigmatic guilt"—handed out thousands of copies of *Play Fair*, an "illustrated pamphlet outlining the symptoms, transmission, complications, and treatment of 11 sexually transmitted diseases (including guilt) which are prevalent in the gay male community." It was one of the first times gay men were encouraged to use condoms to avoid spreading "whatever you might have," including KS or PCP.[13]

In July 1982, Dr. Joe Sonnabend in New York suggested that his patients Michael Callen and Richard Berkowitz connect to discuss their experiences. Like Campbell and Turner in San Francisco, Callen and Berkowitz believed people with the newly designated acquired immune deficiency syndrome (AIDS)* deserved to be more than patients. Unlike their West Coast counterparts, though, the New Yorkers had no support from city officials.

It's essential to analyze any moment from the past with an eye on what the players *knew* then, not what we *know* now. In 1982, for example, the cause of AIDS remained unknown, and doctors treated many early KS patients as cancer patients, with virtually nothing to suggest cancer was transmissible. So while an increasing body of evidence favored a single-virus theory, some doctors continued to adhere to what Joe Sonnabend called the "immune-overload model," a theory—ultimately disproven—premised on the idea that "accumulation of risk" through unhealthy practices broke down the

* "Official use of the acronym began in the summer of 1982 and, owing to its use in the CDC reports, rapidly expanded thereafter. It was actually fashioned during a CDC meeting in Atlanta. Those attending, unaware of its future importance, took no notice of precisely who among them created the word. . . . [S]ome believe they can recall Don Armstrong, a New York epidemiologist, inventing the moniker. Still others recall it being proposed by Bruce Voeller, at the time a Rockefeller Institute biochemist."

immune system. People accumulated risk, the theory went, the more they were exposed to common viruses, an inevitability for those "leading a promiscuous gay urban lifestyle." In other words, promiscuity made gay and bisexual men vulnerable to death.

In November 1982, Berkowitz and Callen, neither of whom made any secret of his promiscuous past, let rip in the *New York Native*, announcing that "our lifestyle has created the present epidemic." Declaring "War on Promiscuity," they said the obvious solution was the end of "urban gay male promiscuity as we know it." To them, Sonnabend's theory meant someone new on the scene could "enjoy a couple of years of the circuit" before accumulating "sufficient risk," but "for those of us who have been 'pigging out' over the last decade, mere moderation is not enough." Again, *those* gays needed to worry, but this wasn't the same moralism. "We know who we are. . . . We are the gay men who are becoming the victims of AIDS."

Despite immediate and intense backlash to their first effort, Callen and Berkowitz quickly wrote a follow-up piece. Hoping to share their own treatment experiences, they articulated an early outline of patient-empowerment for persons with AIDS: because AIDS is a "new syndrome" and there "are NO authorities," they wrote, patients had to "get as broad a view and as many different opinions as possible." Patients, in other words, had a voice in the fight. Wanting to sound official, the authors attributed their piece to a new group, Gay Men with AIDS. Around the same time, Callen and Berkowitz learned of Bobbi Campbell, whose articles they read at Craig Rodwell's bookstore. "How progressive those San Francisco queens are!" they thought, growing more vocal in their criticisms of New York's slow response. They weren't alone.

The New York AIDS Network, a coalition convened in 1982 by recently named National Gay Task Force director Virginia Apuzzo, observed from the start that there were "problems between NYC and the rest of the country," including "complaints of New York chauvinism." At the federal level, despite the work of congressmen Ted Weiss, Henry Waxman, and Pete Burton (and, specifically, the gay men on their staffs) and health officials pleading for funding, the White House dispatched agency heads to tell Congress they already "had all the funding they could use."

In October 1982, the deaths of a handful of Chicago-area residents from what appeared to be cyanide-laced Tylenol activated a massive governmental response. More than one hundred government agents investigated; eleven hundred FDA employees tested 1.5 million capsules; the Department of Health and Human Services issued new regulations

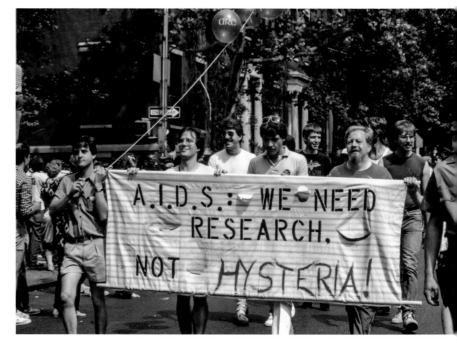

▲ Christopher Street Liberation Day, New York City, June 26, 1983. Photo by Steve Zabel. Courtesy of The LGBT Community Center National History Archive (Zabel collection; 17-3817).

on tamper-resistant packaging; and Tylenol's parent company, Johnson & Johnson, spent $100 million during the fallout. Only seven people died from contaminated Tylenol that month, while the CDC reported that 634 Americans had AIDS and 260 had died.

To San Francisco's Cleve Jones, the government's message, echoed by the press and private industry, was unmistakable: "Let them die."[14]

By 1983, Larry Kramer was disgusted with the descent of Gay Men's Health Crisis (GMHC) into "a social service organization, rather than an advocacy one." Under the leadership of Paul Popham, a closeted gay man with whom Kramer was very much in love, GMHC's board was overly cautious, refusing even to issue recommendations on sex, so Kramer felt obligated to circumvent the organization at every turn. Emboldened by the New York AIDS Network's militants, who also wanted to see "more aggressive tactics," Kramer was particularly taken with Virginia Apuzzo, who brought a voice of righteous anger to the mainstream years before moderates were ready, insisting that queer women intended to fight what was then still considered a "gay man's disease." In March 1983, the AIDS Network sent New York mayor Ed Koch an open letter, complete with twelve detailed points for "consideration and action," stating "the gay community is growing increasingly aroused and concerned and angry" with what seemed to be his total lack of concern. Predictably, Koch didn't respond, but Larry Kramer had had it.

Days later, the *Native* ran Kramer's "1,112 and Counting," an article aimed at striking fear into the hearts of everyone. In the eighteen months since Kramer's first fund-raising appeal, reported AIDS cases had jumped from 120 to 1,112, and the death toll from around 30 to 418. Other than gay and bisexual men, those getting sick were "members of groups just as disenfranchised: intravenous drug users, Haitians, hemophiliacs, black and Hispanic babies, and wives or partners of IV drug users and bisexual men."

"If this article doesn't scare the shit out of you, we're in real trouble," the *Native* piece began. "If this article doesn't rouse you to anger, fury, rage, and action, gay men may have no future on this earth."

In seven thousand blistering words, Kramer attacked doctors, medical journals, politicians, government officials, *The Advocate*, "gay men who won't support gay charities," "closeted gays," "guys who moan that giving up sex until this blows over is worse than death," and, with particular venom, Ed Koch, whose "silence on AIDS . . . is helping to kill us." It was time, Kramer declared, for gay men to be seen for what they were: "an angry community and a strong community, and therefore a threat," even if that meant organizing "to conduct sit-ins or tie up traffic or get arrested."

"Why isn't every gay man in this city so scared shitless that he is screaming for action?" he demanded. "Does every gay man in New York want to die?" Closing with the names of twenty dead friends—including Rick Wellikoff, Donald Krintzman, and "one more, who will be dead by the time these words appear in print"—Kramer attached a call for those willing to engage in civil disobedience.

"1,112 and Counting," Randy Shilts wrote in his book *And The Band Played On*, "irrevocably altered the context in which AIDS was discussed in the gay community, and, hence, in the nation." According to George Mendenhall, a NACHO '68 vet, gays and bisexuals in San Francisco suddenly "talked of nothing else." In fact, when the *Bay Area Reporter* ran the article, editor Paul Lorch felt compelled to explain: "We've made a very deliberate decision to up the noise level on AIDS and the fatal furies that follow in its wake." In other words, "the time has come to start scaring some of the shit out of ourselves." While many welcomed the shift, others thought it fueled "the fire of fear." Responding directly to Kramer, Bobbi Campbell said, "Hysteria and panic are as deadly to our community as the diseases themselves." In Manhattan, Ed Koch gave an inch, finally agreeing to meet with activists. When the GMHC Board voted *not* to send Kramer to the meeting, he threatened to quit; no one protested.

Without a doubt, "1,112 and Counting" sent "a shockwave through lesbian and gay communities," though it didn't trigger the type of militant action Kramer had imagined.[15]

In San Francisco, activists organized the first March led *by* AIDS patients for May 1983, emblazoning their lead banner with a call to arms: "FIGHTING FOR OUR LIVES." As Bobbi Campbell, Dan Turner, Mark Feldman, and others proudly—*visibly*—marched down Market Street, sister marches stepped off in Houston, Chicago, Atlanta, and Milwaukee. In New York, where five thousand people marched to Federal Plaza, Michael Callen spoke, as did Kramer, and a defiant Virginia Apuzzo warned of a coming storm. "If something is not done soon," she said, "we will not be here in Federal Plaza in this quiet. We will be on Wall Street at noon!"

Not long after the May Marches, Callen, Richard Berkowitz, Joe Sonnabend, and Richard Dworkin finished their most enduring work: *How to Have Sex in an Epidemic: One Approach*. "Sex doesn't make you sick—diseases do," they declared, and "once you understand how diseases are transmitted, you can begin to explore medically safe sex."

And that's when gay people invented safe sex.

"Our challenge is to figure out how we can have gay, life-affirming sex, satisfy our emotional needs, and stay alive!" After a primer on "Ethics and Responsibility," the booklet gave an overview—from a risk perspective—of every type of sex a queer man might seek. From "sucking" to "getting fucked," "creative masturbation" to "rimming," "fisting" and "dildoes," it was all there, along with a look at "the baths," "balconies, meatracks, and tearooms."

Importantly, the authors noted that an emphasis on promiscuity was "misplaced morality," and focusing "only on numbers" to the exclusion of "ways to interrupt disease transmission" is faulty.

▲ Larry Kramer (left) and Virginia Apuzzo (center), AIDS Candlelight March and Vigil, New York City, May 2, 1983. Photo by Richard C. Wandel. Courtesy of The LGBT Community Center National History Archive (Wandel collection; 4a-008).

"What's over isn't sex—just sex without responsibility."

Distributing the booklet in early June, the authors waited for a backlash. It never came. In fact, the printing sold out. As did a second printing. And a third. Letters poured in, condoms appeared in queer social spaces; safe sex got chic.* And disease transmission rates plummeted.[16]

In June 1983, AIDS activists from both coasts insisted on attending the upcoming Lesbian and Gay Health Conference in Denver. Bobbi Campbell, Dan Turner, and Bobby Reynolds represented San Francisco—Mark Feldman had planned to attend, but he'd died days earlier—and Callen and Berkowitz led the New York contingent. In the midst of hundreds of queer health care workers, the San Francisco/New York team—joined by individuals from L.A., Kansas City, and Denver—commandeered a hospitality suite and got to work. Despite different approaches to virtually everything, the group forged common ground and produced the founding document of the People With AIDS Movement.

"We condemn attempts to label us as 'victims,' a term which implies defeat," the Denver Principles began, "and we are only occasionally 'patients,' a term which implies passivity, helplessness, and dependence upon the care of others. We are 'People With AIDS.'" Having taken ownership of language, the men recognized PWAs "as catalysts for social change," insisting they "could and should be their own health experts." PWAs had a right to "full and satisfying sexual and emotional lives," "to be involved at every level of decision-making," and "to quality medical treatment without discrimination." These ideas, while largely based on feminist health principles, nonetheless "marked the beginning of a new form of patient advocacy, one that fundamentally rearranged the roles of patients, doctors, researchers, and pharmacists." In other words, a group of gay and bisexual men in a Denver hospitality suite, inspired by Lesbian Feminists, changed millennia of medical practice.

Meanwhile, the health workers who'd gathered for the general conference were exhausted, having spent years witnessing the onset of a plague. Once a collegial gathering of queer professionals, the event had been overwhelmed by egos and anger. "Like AIDS," Dr. Paul Paroski told the crowd at the conference's final session, "this antipathy is killing us." But when the PWAs stormed in, taking the stage and unfurling the "FIGHTING FOR OUR LIVES" banner, the Lavender Menace–style bravado reinvigorated the room. And, as each man read one of the Principles—ending with Callen declaring that PWAs had the right "to die—and LIVE—in dignity"—there were "very few dry eyes in the house."

Virginia Apuzzo, the conference's last speaker, stood silently on stage for ten minutes, visibly moved, collecting herself as the crowd wept and hugged. "Well," she said with a crack in her voice, "it *is* Gay Pride Month." The room erupted. "There is no longer any debate regarding the link between the lethargy of the federal government to respond to AIDS and that so many of those stricken are gay men and over 40 percent are people of color," Apuzzo continued. "The implications are shocking, unacceptable and unavoidable . . . these lives are thought to be expendable. . . . Frankly, brothers and sisters, it ought to put us back into the streets!"[17]

* An enormous caveat is required here: safe sex got "chic" for those with access to liberal city governments, gay bars, queer community centers, queer chosen families, or other progressive support networks, and thus transmission rates dropped in those communities. For lower-income communities and communities of color—to say nothing of at-risk women and IV drug users—the federal government's unwillingness to launch education and prevention campaigns meant rising transmission rates and more death.

By the time safe sex and the Denver Principles entered queer consciousness, the vast majority of the tens of thousands who would die in the late 1980s and early 1990s were already infected. Although few knew at the time, the years-long incubation period between transmission and manifestation of illness was such that, without a crisis-level response from the federal government, it was too late. But the government seemed intent on making things worse. When a sensational report claimed AIDS might be transmitted through casual contact, for example, leading government clinician Dr. Anthony Fauci was quoted as agreeing. It turned out to be a misunderstanding of sorts, but the damage was done: images of rubber gloves, face masks, and scared parents removing children from schools dominated what news there was about AIDS, and anti-queer violence skyrocketed. And then came reports that a feud between French and U.S. scientists had delayed by months the announcement of the discovery of human immuno-deficiency virus (HIV)—which causes AIDS—thereby setting "treatment and research back immeasurably." Ego and institutional competition were killing people.[18]

On June 20, 1983, days after the Denver Conference, the board members of AIDS Vancouver met and discussed "G.," a local PWA who'd been "seen in circulation" at the baths. As one of the earliest known cases of Kaposi's sarcoma, G. lived for years as a cancer patient, long before anyone knew "gay cancer" was transmissible. Armed with new information about transmission, safe sex, and the Denver Principles, a board member approached G., and the evidence suggests G., like so many PWAs, dramatically changed his sexual habits.

In a 1982 study analyzing the sexual histories of gay and bisexual men with AIDS in Southern California, doctors benefited from one man having kept particularly detailed records of past sexual partners, information that shed light on transmission patterns. Because the specific patient was from Outside California, researchers referred to him as Patient O; later, doctors at the Centers for Disease Control called him Patient 0 (Zero), though not for any particular reason. In 1987, years after the patient had died, journalist Randy Shilts published his book *And The Band Played On*, in which the story of Patient O—a fairly typical gay man caught in an overwhelmingly confusing situation—morphed into the tale of "Patient Zero," the sex-crazed, psychopathic killer who willfully spread "gay cancer" around the country.

Patient O's real name was Gaétan Dugas; he was a well-liked French Canadian airline steward from Vancouver, where the board of the local AIDS organization referred to him simply as "G."[19]

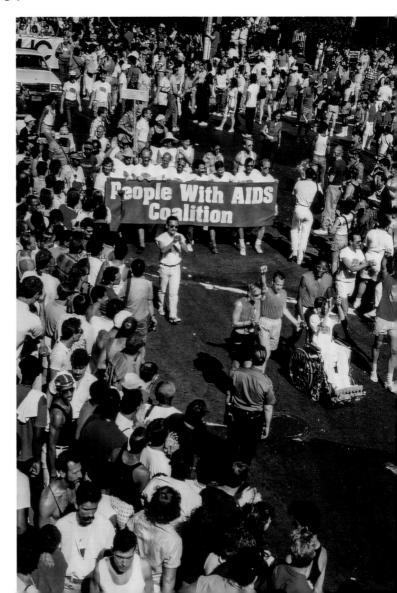

▶ People With AIDS Coalition, Christopher Street Liberation Day, New York City, June 24, 1984. Photo by Steve Zabel. Courtesy of The LGBT Community Center National History Archive (Zabel collection; 001-Misc.).

"We are fighting for our lives," Virginia Apuzzo told the crowd at New York's Christopher Street Liberation Day 1983. "This is the Second Stonewall and we stand at the crossroads of our struggle." Larry Kramer announced he was "prouder now of gay people than ever," telling those at the rally that "each of us must put aside our fear and recognize the great courage within us. . . . We must do nothing less now than remake the soul of our time." He then went directly to the airport and headed to Europe, where a visit to the Dachau extermination camp inspired him to write *The Normal Heart*, considered by many to be the quintessential dramatic telling of the epidemic's early days.

For most at Pride, though, AIDS wasn't the whole world—not yet, at least—and, looking back, one can see just how many agendas were to be pushed aside in order for the community to coalesce around AIDS. As the epidemic took hold, other struggles didn't disappear; in fact, they got amplified by hysteria.

In summer 1981, for example, a wave of murders had hit D.C.'s gay community, while San Francisco saw an increase in attacks on transgender people. In New Orleans, Chicago, and Boston, police raided gay bars with abandon, while a Houston jury let Fred Paez's killer walk. Activists across the country protested a law barring foreign homosexuals from entering the United States due to "psychopathic personalities." And, in October, the U.S. House of Representatives repealed a D.C. ordinance that had decriminalized sodomy. More frightening than the repeal itself was the onslaught of constituent pressure led by the New Right's Richard Viguerie, who used computerized mailing lists to elicit 250,000 letters from right-wing activists.[20]

When San Francisco activist Larry Brinkin's lover died in 1981, Brinkin assumed his employer's three-day funeral leave policy extended to him; he was wrong. Losing a lawsuit—the first in which the term *domestic partner* appeared—Brinkin lobbied the Board of Supervisors for a domestic partnership bill that would grant benefits to partners of city employees. To the surprise of many, Mayor Dianne Feinstein vetoed it, refusing to embark on a "voyage into the unknown" in fear of "setting precedent for the entire nation for partnerships that may be fleeting and totally vacant of any mutual sense of responsibility or caring." In the summer of 1982, judges ordered another San Franciscan, Dr. Tom Waddell, to drop the word *Olympic* from his upcoming Gay Olympic Games, which became, simply, the Gay Games. The legal battle continued for years, however, growing particularly nasty thanks to the brutal litigation tactics

◄ **Left** Christopher Street Liberation Day, New York City, c. 1981. Photographer unknown. From the authors' collection.

▶ **Opposite** Christopher Street West, West Hollywood, June 21, 1981. Photographer unknown. Courtesy of the ONE Archives at the USC Libraries (CSW collection; 2012-135).

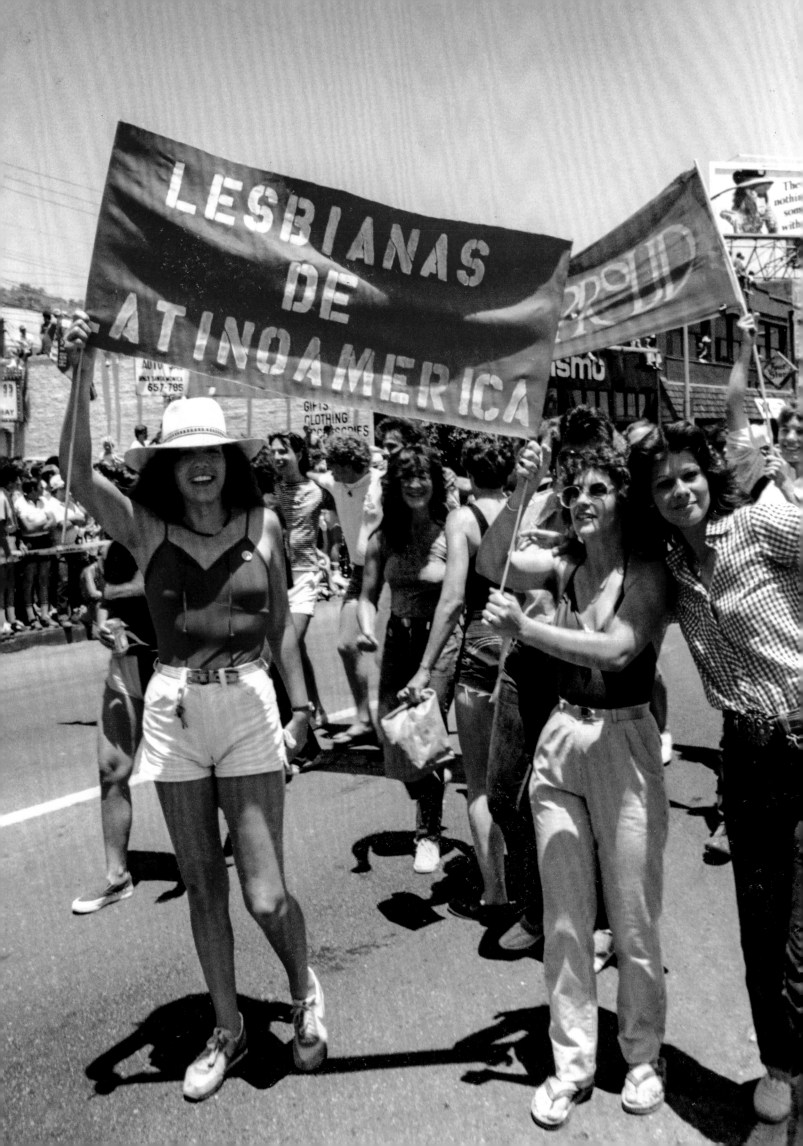

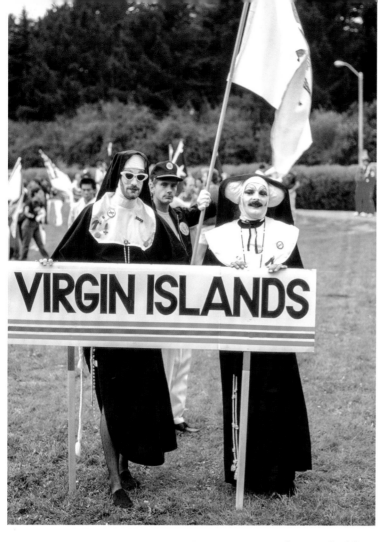

of the Olympic Committee's lawyer, who was later nominated for a federal judgeship. While the queer community managed to delay the lawyer's confirmation once, he eventually became a judge. In 2010, nearly three decades after he'd made life miserable for Tom Waddell, that lawyer-turned-judge, Vaughn Walker, overturned a voter-adopted ban on same sex marriage, California's Proposition 8, in one of a string of cases leading the U.S. Supreme Court to rule on marriage equality. Retiring in 2011, Walker promptly came out as gay.[21]

In August 1982, New Yorkers June Chan and Katherine Hall established Asian Lesbians of the East Coast (ALOEC). Hall, who'd been an activist since joining the Daughters of Bilitis in 1969, rarely saw other active Asian lesbians; to her, ALOEC meant everything. "I have no question about who I am or where I belong," she wrote. "I am a multi-ethnic asian lesbian and damn proud of it." Soon, ALOEC connected with West Coast activists, including San Francisco's Doreena Wong, who was building a network so that Asian lesbians "do not feel isolated and used as tokens" in other groups.

In Boston, after a late 1982 lecture on bisexuality at the Cambridge Women's Center, eight activists formed the BiVocals, a support group for bisexual women. In June 1983, thirty women attended an open meeting of the renamed Boston Bisexual Women's Network (BBWN), and the network grew exponentially from there. The same year, a group of San Francisco activists—including Maggi Rubenstein, who'd cofounded the city's Bisexual Center in 1976; Alan Rockway, who'd fought Anita Bryant in Florida; Lani Ka'ahumanu; and David Lourea—established BiPOL, an organization that demanded greater visibility for the emerging bisexual community. BiPOL, and particularly Rubenstein and Lourea, played a crucial role in expanding San Francisco's AIDS education and prevention services to include bisexual men.

In the early 1980s, people across the queer spectrum—Asian lesbians, bisexuals, Men of All Colors, seniors—"empowered themselves by organizing together." In the face of growing bigotry and death, the idea of *community* took on renewed importance. And as connections brought individual and collective strength, queer anger grew.[22]

In late 1983, James Credle—"a gay black man, an assistant dean of students at Rutgers University, a Vietnam veteran, and a member of Black and White Men Together"—testified about police brutality before

▲ **Above** Sisters of Perpetual Indulgence, Gay Games II, San Francisco, Oct. 1986. Photographer unknown. From the authors' collection.

◀ **Left** Gay Olympic Games pinback, issued before the U.S. Olympic Committee won an injunction forcing Dr. Tom Waddell to drop "Olympic" from the title of his event, 1982. From the authors' collection.

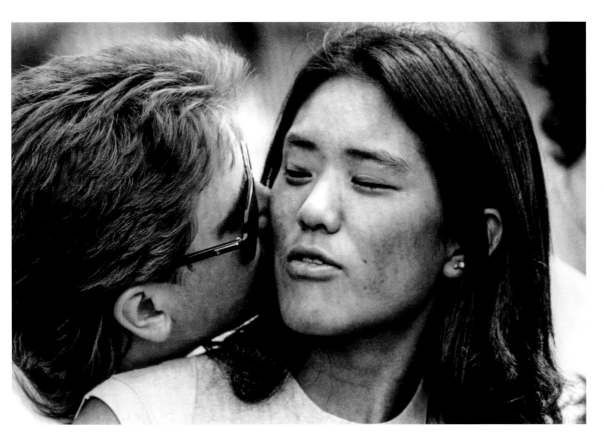

◀ **Left** International Lesbian & Gay Freedom Day, San Francisco, c. 1985. Copyright © by Saul Bromberger and Sandra Hoover.

▼ **Below** Asian/Pacific Lesbians and Gays, Christopher Street West, West Hollywood, June 27, 1982. Photo by Leigh Mosley. Courtesy of the ONE Archives at the USC Libraries (Mosley photographs; 2012-049).

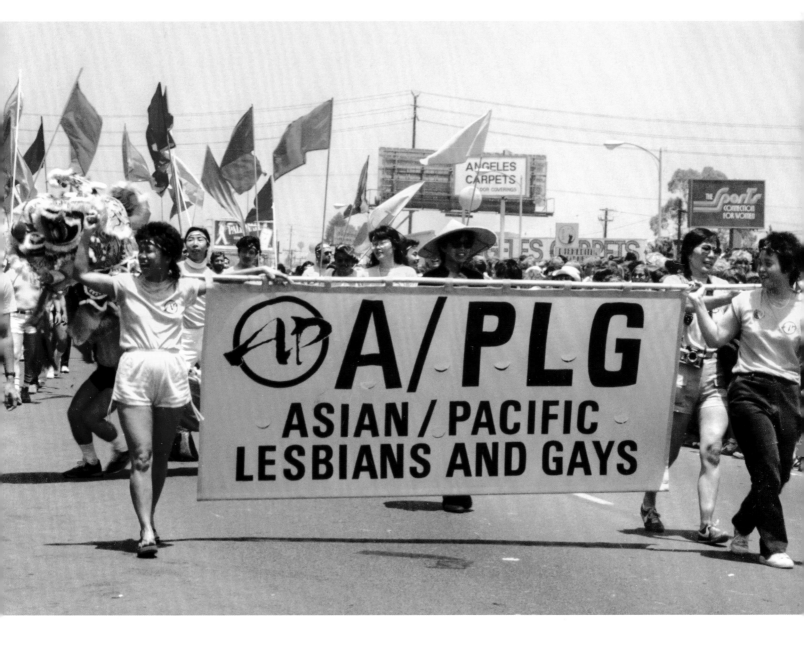

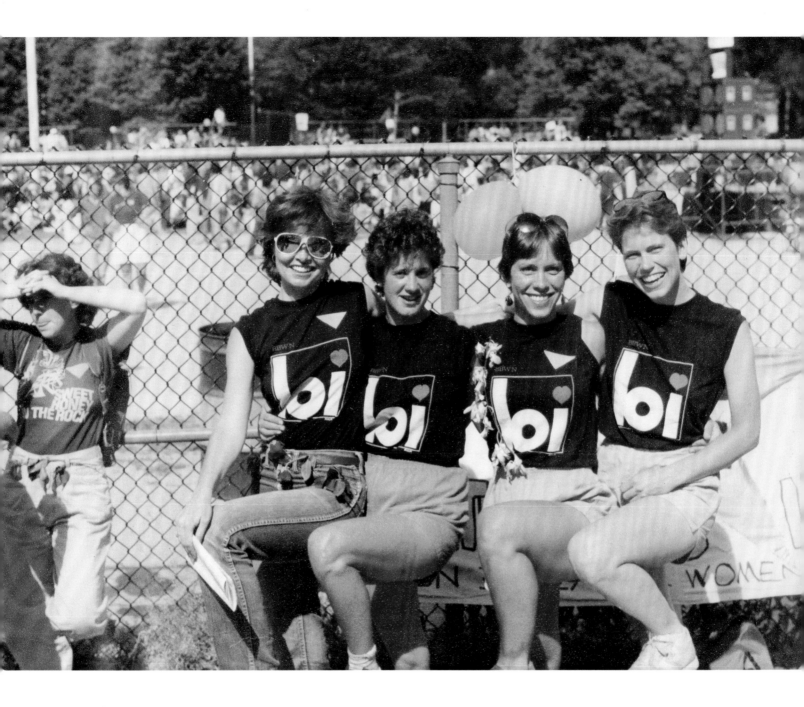

▲ **Above** Boston Bisexual Women's Network members (including Robyn Ochs, second from right), Christopher Street Liberation Day, New York City, June 26, 1983. Photographer unknown. Courtesy of Lesbian Herstory Archives.

▶ **Right** Pinback, 1980s. From the authors' collection.

▶ **Opposite** Arete–The Bisexual Center of Southern California contingent, Christopher Street West, West Hollywood, June 27, 1982. Photo by John Soroczak LMFT. Courtesy of the ONE Archives at the USC Libraries (Soroczak collection; 2014-058). Used with permission of John Soroczak LMFT.

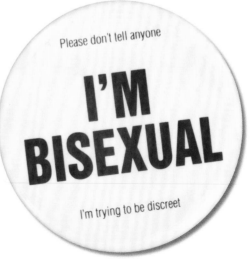

Please don't tell anyone

I'M BISEXUAL

I'm trying to be discreet

a congressional subcommittee convened in New York City. "It was because of police brutality against our gay community," he said, "that Stonewall is celebrated today, tomorrow and will be forever!" But, because homophobia and racism continued, the brutality continued, "sometimes reaching such blatant proportions that they seem unreal." On September 29, 1982, for example, thirty to forty cops had stormed Blues Bar, a predominantly Black and Hispanic queer bar near Times Square, and proceeded, "without provocation or justification, to line up the patrons and employees against the wall and brutally beat them." Just as at Stonewall, "the most vulnerable of the mostly Black patrons—women and drag queens—were beaten the most severely." Even though Blues literally sat across the street from the offices of the *New York Times*, neither the raid nor the street protests that followed made the straight press.[23]

What *did* get covered, though, was a banquet at the Waldorf Astoria, hosted by the Human Rights Campaign Fund (HRCF), on the same night as the Blues raid. By then, the upstart HRCF had outpaced David Goodstein's National Gay Rights Lobby as *the* best hope for merging gay political activity into the mainstream, and even Goodstein himself had taken up HRCF's banner. Most saw the Waldorf gala as evidence of HRCF's success, and keynote speaker and former vice president Walter Mondale received a warm greeting, even though he never said "gay," "bisexual," "lesbian," or even "homo-sexual" in his speech. It was a far cry from when Arthur Evans had demanded Mondale "speak out on gay rights" in 1977. Now the only protesters were a small group of "Moral Majority types," and most banquet attendees thought "it was great [they] were outside protesting and we were inside." Marty Robinson didn't think it was great, though. The person most closely associated with the development of the *zap*, Robinson didn't hesitate to confront "those hatemongers" outside the Waldorf.[24]

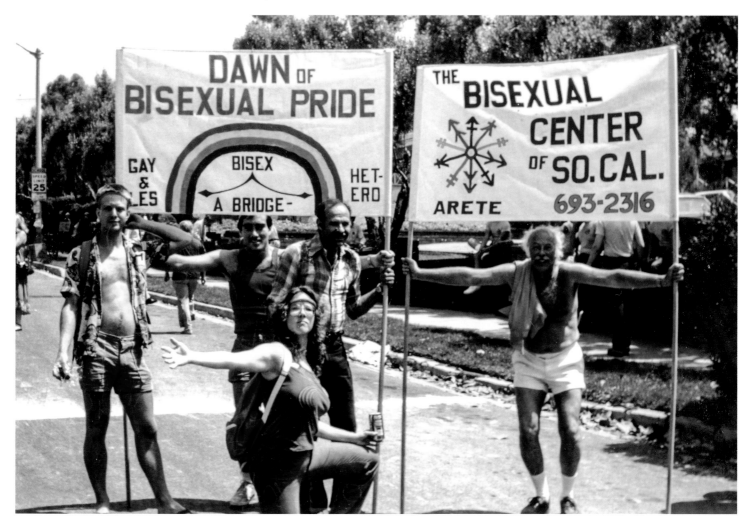

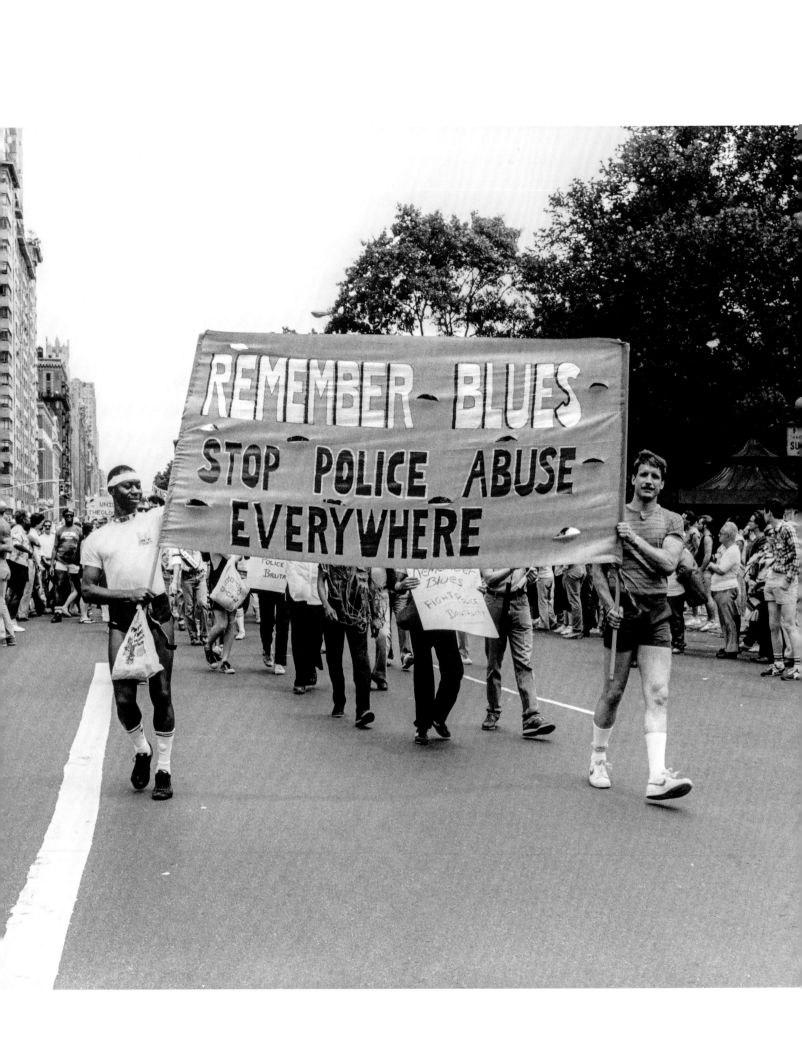

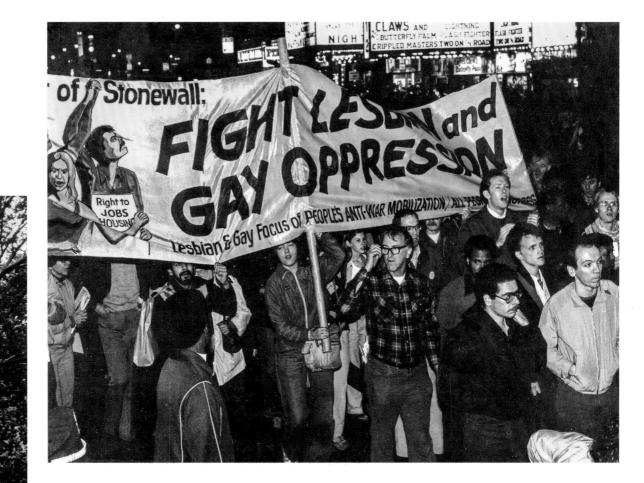

▲ **Above** Demonstrators protest the
Blues Bar raid, Times Square, New York
City, Oct. 15, 1982. Photo by Richard C.
Wandel. Courtesy of The LGBT Community
Center National History Archive (Wandel
collection; 4a-007).

◀ **Left** Christopher Street Liberation
Day, New York City, June 24, 1984. Photo/
copyright © by Dona Ann McAdams.

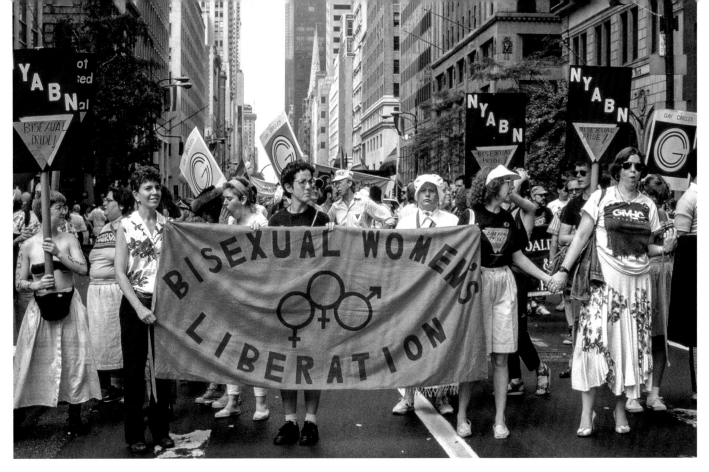

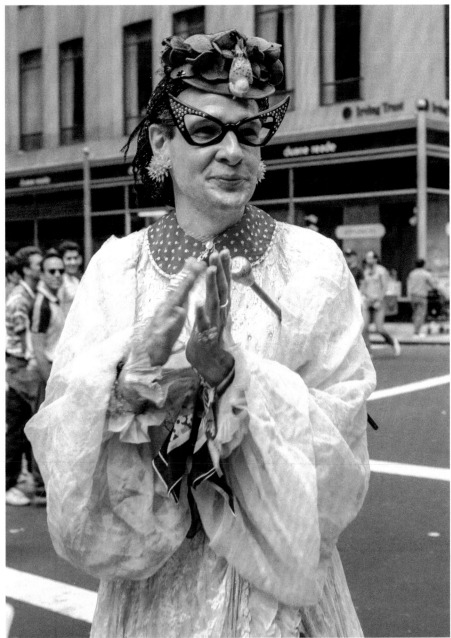

▲ **Above** New York Area Bisexual Network (founded by Brenda Howard, an organizer of New York's first Gay Pride week) and Bisexual Women's Liberation contingents, Heritage of Pride, New York City, c. 1985. Photo by Bettye Lane. Copyright © by the Estate of Bettye Lane; courtesy of Schlesinger Library, Radcliffe Institute, Harvard University.

▶ **Right** Rollerena, The Fairy Godmother, Heritage of Pride, New York City, June 30, 1985. Photo/copyright © by Robert Fisch.

▶ **Opposite** Christopher Street Liberation Day, New York City, June 24, 1984. Photo by Bettye Lane. Copyright © by the Estate of Bettye Lane; courtesy of Schlesinger Library, Radcliffe Institute, Harvard University.

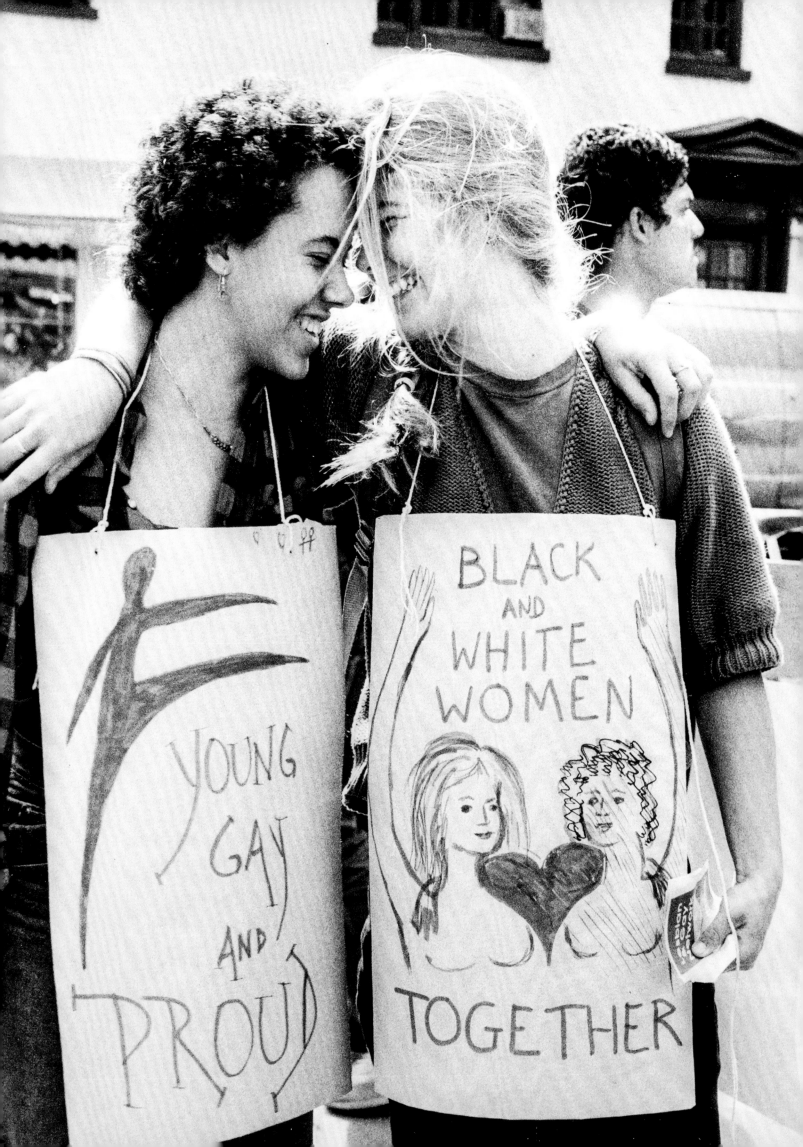

Having served five years, one month, and nine days in prison for killing Mayor George Moscone and City Supervisor Harvey Milk, Dan White was paroled in January 1984. "Today," Sister Boom Boom of the Sisters of Perpetual Indulgence announced at a midday rally in San Francisco, "Dan White begins a life sentence, and I'm sorry to say I don't think it's going to be a long one." People *truly* wanted White dead.

In March, the San Franciscans' rage turned inward when Larry Littlejohn—a veteran of NACHO '68—announced he'd be launching an effort to shut down the city's gay baths. Specifically, as AIDS increasingly was associated with queer "promiscuity," Littlejohn wanted the Board of Supervisors to make sex at the baths illegal. Not fifteen years after Stonewall, in other words, a gay man was inviting police into gay establishments to stop people from fucking. In fairness, bathhouse owners rarely posted AIDS information or provided condoms, nor did they donate time or money to the growing number of AIDS-related organizations. The line between sexual liberation and self-preservation remained unclear, and many who publicly decried Littlejohn hoped privately for the baths to close. Randy Shilts, on the other hand, a longtime critic of gay and bisexual "promiscuity," vocally supported closing the baths. After a debilitating bout of hepatitis in 1976—which, he said, happened "all because [he] slept with the wrong person"—Shilts saw the baths as warehouses of disease and, in the AIDS era, potential killing grounds.[25]

Ronald Reagan was reelected as president in November 1984 with 59 percent of the popular vote, carrying forty-nine states, and winning 525 electoral votes, the largest electoral vote total in U.S. history. The incredible landslide was regarded by conservatives as a complete endorsement of Reagan's political agenda. Although few in the queer community needed proof of Reagan's contempt for them, it was nonetheless shocking when, just weeks after Reagan's second inauguration in January 1985, an independent government analysis proved conclusively that his administration had deliberately ignored AIDS for years, leading to untold delay and needless death.

It was getting more and more difficult for queer people to hide their collective rage, though some still tried to keep anger and activism separate. During San Francisco's annual AIDS March in May 1985, for example, activist Dean Sandmire had silenced the "loud catcalls and hisses" greeting the mention of Republican governor George Deukmejian's name: "This is not why we're here," Sandmire snapped. "We're here to honor the dead and those who are still living." Paul Boneberg, another longtime San Francisco activist, was less sanguine: "We are not going to rule out confrontational tactics," he said, even if it "means the occupation of the Health and Human Services Building." The following month, San Francisco's Pride celebrations were dedicated to the memory of Bobbi Campbell, who'd

The world knows and cannot ignore it. . . . Silence is death.
—Ludwig Frey, 1896

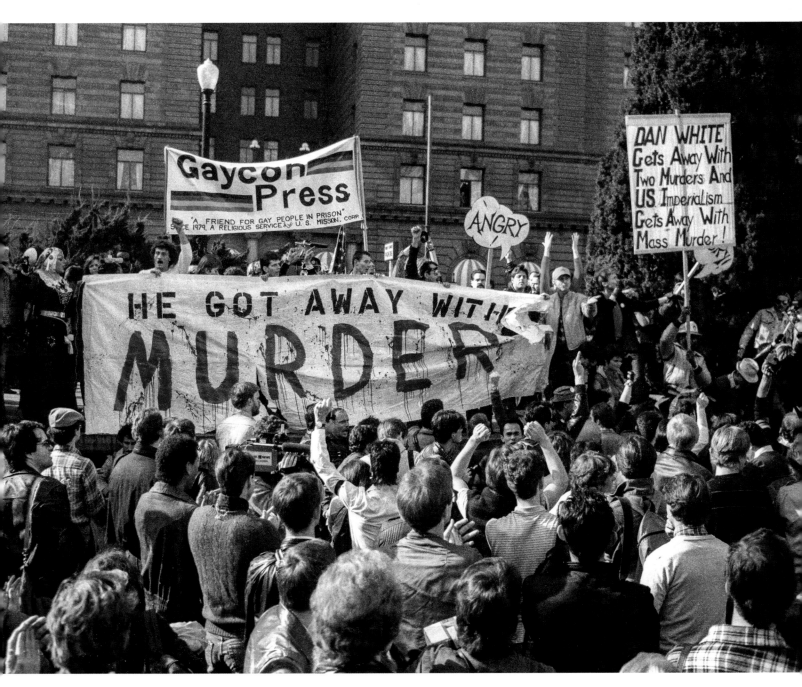

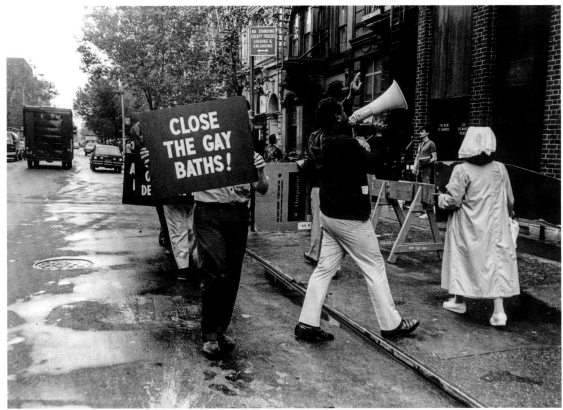

▲ **Above** Demonstrators protest Dan White's parole, San Francisco, Jan. 6, 1984. Photo/copyright © by Daniel Nicoletta.

◄ **Left** Protesters demand the city close St. Mark's Baths, New York City, 1984. Photo/copyright © by Dona Ann McAdams.

died in August 1984 at the age of thirty-two; what most people remembered from Pride 1985, though, was the overwhelming number of rainbow flags along the parade route. A familiar sight in the Bay Area since 1978, the flag wasn't ubiquitous until its adoption in late 1985 as the international symbol of Pride.

In August, activists John Lorenzini and Thunderhawk, both gay, briefly chained themselves to the Federal Building in downtown San Francisco, protesting the transfer of $5 million from the Indian Health Service agency to AIDS research, a budgetary ploy to pit the underrepresented against each other. In October, Dan White went into his garage, turned on his car, and waited. When news of his suicide hit the Castro, some celebrated; most were just relieved he'd done it himself. Days later, a group of PWAs chained themselves to the Federal Building; this time, though, they planned to stay.[26]

Rage had been building within the queer community for years, and the work done by activists in the first half-decade of the AIDS epidemic made it possible for that rage ultimately to be channeled into action. "Feeling anger," Professor Deborah Gould notes, "is sometimes an achievement, and not always easily accomplished." In late 1985—consumed by illness, death, fear, and panic—the queer community *achieved* anger. As otherwise healthy—and typically young—gay and bisexual men were "facing decimation beyond their wildest imagination," the community of those who failed to conform to the heteronormative ideal "struggled to accept the overwhelming horrors accumulating all around: contemporaries dying painful deaths, acts of desire becoming acts of contagion, the homophobe's wildest dreams finding fulfillment." And, almost as one, queer people in the United States let rage "sweep over the tribe."

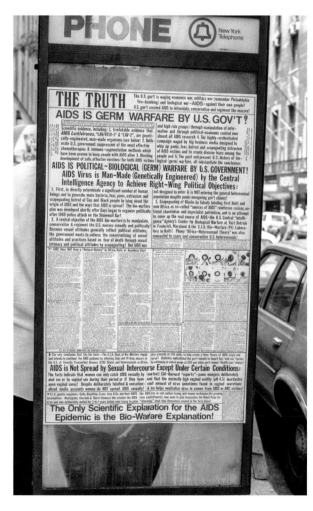

Before San Francisco's annual Milk/Moscone Memorial March in November 1985, Cleve Jones announced he'd expanded the scope of the memorial to include those lost to AIDS, urging marchers to write the names of the dead on poster board to carry along the route. "The simple truth of this tragedy," Jones told the mourners at City Hall, "is so simple that even the small children dying from transfused blood . . . can understand it easily: 'Let them die.'" That, he said, "was the decision in Washington, whispered in the cloakrooms of Congress, emblazoned in the silence over the White House: 'Let them die.'" Walking from City Hall to the Federal Building, marchers taped the names of the dead to the façade.

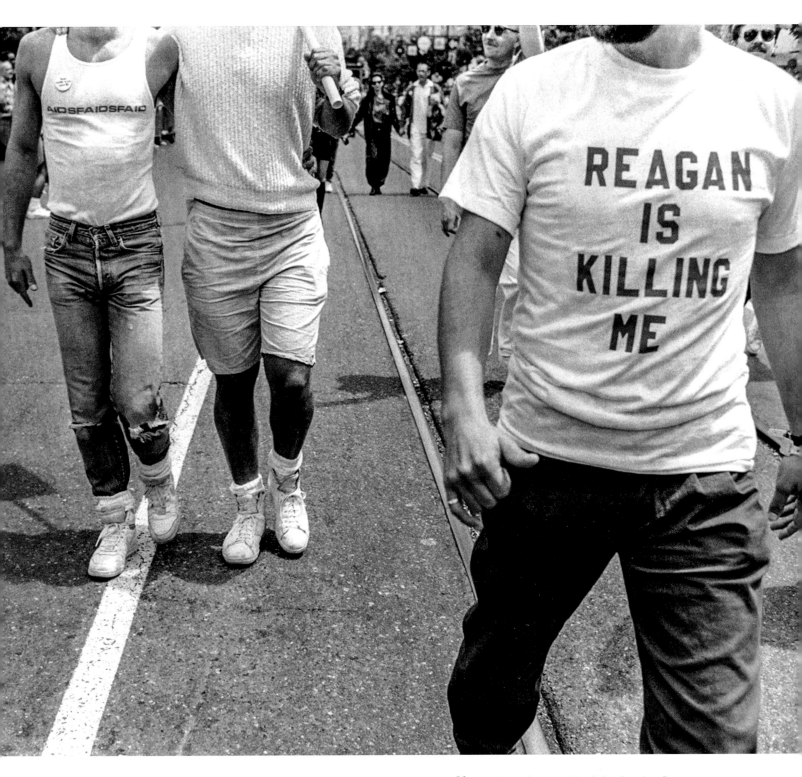

▲ **Above** International Lesbian & Gay Freedom Day, San Francisco, c. 1987. Photo/copyright © by Saul Bromberger and Sandra Hoover.

◄ **Opposite** Wheatpasting, New York City, June 29, 1986. Photo/copyright © by Robert Fisch.

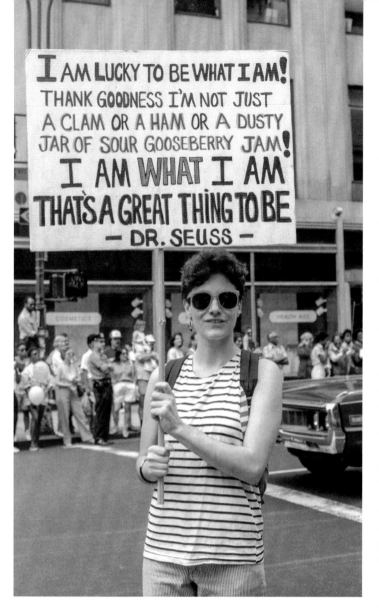

As the final placards were set, Jones took a breath and looked at the patchwork of names covering the walls. It looked like a quilt.[27]

The same month, veteran New York activists gathered with young militants to respond to the *New York Post*'s sensationalistic AIDS coverage, which was rife with infected grandmothers and terrified schoolchildren. Forming the Gay and Lesbian Anti-Defamation League (GLADL), Vito Russo and others picketed the *Post* in December 1985. Within months, GLADL (which later changed its name to the Gay and Lesbian Alliance Against Defamation, and then to just GLAAD) lost its militant street activists, the Swift & Terrible Retribution Committee, who reemerged as the Actions and Demonstrations Committee of the Coalition for Lesbian and Gay Rights.

In March 1986, after a decade and a half of infighting, political wrangling, and broken promises, the New York City Council adopted an antidiscrimination law protecting gays, lesbians, and bisexuals from certain types of public discrimination. It was a victory, and a meaningful one, but it almost had to happen when the State Supreme Court threw out the limited antidiscrimination order that Ed Koch had issued on his first day in office.[28]

In San Francisco in late May, ten thousand people marched somberly from the Castro to the Civic Center, candles lighting up Market Street for blocks. At the front, a group of PWAs carried the "FIGHTING FOR OUR LIVES" banner, just as the original marchers had in 1983. Of those who'd led the first March, though, only Dan Turner was still alive in 1986. "The first time I was interviewed by a reporter," he'd say, "he asked me how it felt to know I'd be dead in two months." As the March reached City Hall, Tim Wolfred, director of the San Francisco AIDS Foundation, told the crowd that the men he knew who'd died would "be honored and very pleased by our rage." As a community, Wolfred said, "we need our rage."

In late June, queer New Yorkers celebrated Heritage of Pride, which had replaced Christopher Street Liberation Day following an embezzlement scandal. Despite all the turmoil, organizers hoped Pride 1986 would be "a celebration, not a protest." And it was, to an extent.

But that was June 29. On June 30, war came.[29]

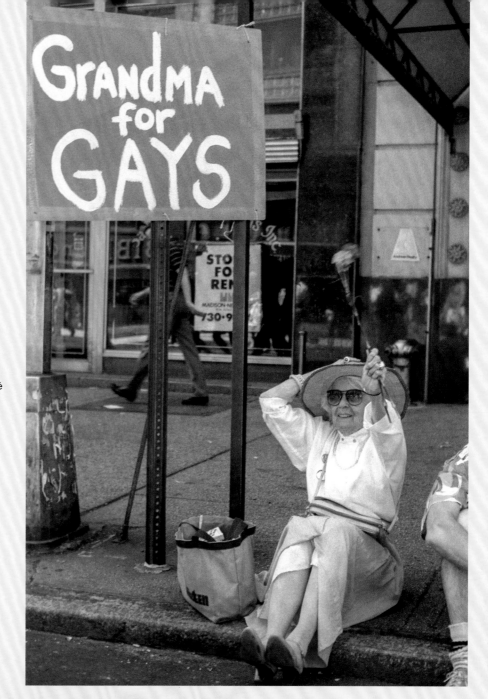

◀ **Opposite** Heritage of Pride, New York City, June 30, 1985. Photo/copyright © by Robert Fisch.

▶ **Right** Heritage of Pride, New York City, June 29, 1986. Photo/copyright © by Robert Fisch.

▼ **Below** The Dyketones, Daybreak Bar, Mountain View, California, 1985. Photo by Ted Sahl. Courtesy of San José State University Special Collections and Archives.

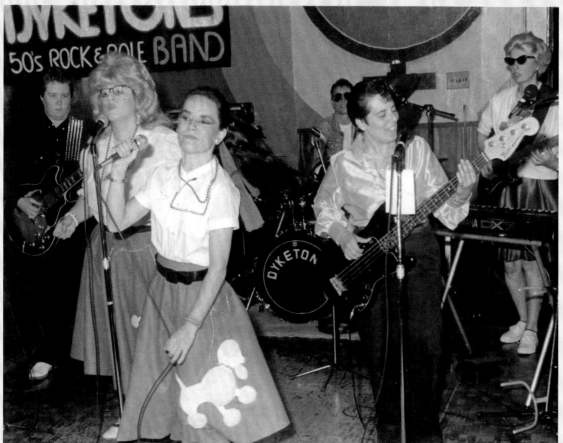

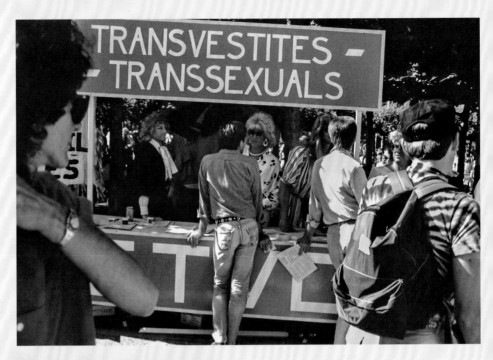

▲ **Above** International Lesbian & Gay Freedom Day, San Francisco, June 29, 1986. Photo by Alan Light. Licensed under a Creative Commons Attribution 2.0 Generic License, available at creativecommons.org/licenses/by/2.0/legalcode.

◄ **Left** International Lesbian & Gay Freedom Day, San Francisco, c. 1986. Photo/copyright © by Saul Bromberger and Sandra Hoover.

▼ **Below** Virginia Apuzzo, International Lesbian & Gay Freedom Day, San Francisco, June 29, 1986. Photo by Alan Light. Licensed under a Creative Commons Attribution 2.0 Generic License.

Not twenty-four hours after Pride, the Supreme Court issued its decision in *Bowers v. Hardwick*, upholding the constitutionality of state antisodomy laws by a vote of 5 to 4 and pushing the queer community to its breaking point. It wasn't just that the decision allowed states to continue to criminalize private, consensual sex; it was the Court's reasoning that so enraged queer people. Declaring that homosexual relationships had nothing in common with the familial relationships protected by law, the Court mocked as "facetious" any claim to "a fundamental right to engage in homosexual sodomy." As Justice Harry Blackmun wrote in dissent, however, the case wasn't about the right to engage in sodomy, but about something more important, "namely, 'the right to be let alone.'"

Artist David Wojnarowicz recalled reading an article about "a supreme court ruling which states that homosexuals in america have no constitutional rights against the government's invasion of their privacy. The paper stated that homosexuality is traditionally condemned in america and only people who are heterosexual or married or who have families can expect these constitutional rights." Reading the article, Wojnarowicz said, "I felt something stirring in my hands. . . . Realizing that I have nothing left to lose in my actions I let my hands become weapons, my teeth become weapons, every bone and muscle and fiber and ounce of blood become weapons, and I feel prepared for the rest of my life."

> I've never seen our people so pissed.
> —Reverend Troy Perry, 1986

For a century, queer communities in the United States had been propelled forward by a core tension: militants—from Village fairies to Buffalo bar dykes, unapologetic homophiles to Tenderloin transsexuals, Stonewall street queens to freaking fag revolutionaries—created space for moderates and mainstreamers to set up shop and strike compromises. Radicals made scenes so that respectables could say, "We're not *all* like that." And in some ways, it worked. Those who'd built the Movement grew up feeling alone, and now they marched alongside hundreds of thousands of others every year. But there'd been a cost, as revolutionaries were sidelined in hopes of winning "the right to be let alone": if queers were less obvious, less militant, prettier, whiter, richer, less sexual, more presentable, less *queer*, then *maybe* straights would let us alone.[30]

But in 1986, they were still in our bars, our baths, and our bedrooms; they still took our children away; refused us access to dying lovers and the funerals that followed; denied us a relationship with God; attacked and killed us as the police watched or joined in; they passed laws to make our lives harder and then blamed us for not giving them enough money or turning out enough votes. The *only* time the dominant culture left queer people alone was when we were most in need, when we yelled the loudest for help.

So when five Supreme Court justices made clear that the Constitution didn't extend to the most intimate expressions of ourselves, enough was enough. For too long, there'd

been a sense that the hate and death was somehow *our* fault, and it's hard to be angry if you think it's your fault. But *Hardwick* wasn't our fault; even the *New York Times* knew it was "a gratuitous and petty ruling." And, finally, the message was clear: "Freedom," said the *Bay Area Reporter*, "comes only to those who take it." As even the "most apolitical queers" hit the streets, familiar faces waited to teach the new radicals how to fight.[31]

"I lived in the era twenty years before Harvey Milk came to prominence," lawyer John Wahl told the thousands that gathered in San Francisco after the Court's decision. "I saw his body and blood on the floor of City Hall and I will not go back to that time." Instead, he predicted "social disruption and chaos. And that's not a threat; that's a prophecy."

In Boston, 200 people rallied at the State House, 250 gathered in Dallas, and a large group descended on the Supreme Court building in D.C. That was the first night.[32]

In New York, *Hardwick* triggered "the most intense mobilization" of the city's queer community in years. On July 1, 1986, three thousand people poured into Sheridan Square, shutting down Sixth Avenue with a massive sit-in. "It's time to return to the streets," Marty Robinson shouted. "It's time to remember Stonewall!" A few days later, as the city celebrated July 4th and the Statue of Liberty's one hundredth anniversary, seven thousand queers marched to Wall Street, where hundreds of thousands of revelers enjoyed the patriotic brouhaha. As the gay masses approached, police barricaded the entry to Battery Park, but all the protesters had to do was break into smaller groups, make their way into the park, and reconvene. "Look like Americans, if you can," said Robinson. Making their way through the mob, the fifteen hundred demonstrators "were in real physical danger." It was a group of queers *protesting the Fourth of July*, and plenty of punches and beer cans flew their way. At one point, an aggressive straight man got a surprise "when a furious gay man threw his knapsack to the ground and started to beat the shit out of him."[33]

> We're trying to nudge the community toward a consciousness of gay liberation, rather than the compromise of gay rights.
> —Marty Robinson, 1986

Two weeks later, on July 17, four thousand people marched behind Sister Sadie, Sadie, the Rabbi Lady; Cleve Jones; and Gilbert Baker to greet U.S. Supreme Court Justice Sandra Day O'Connor, who'd voted with the *Hardwick* majority, at an event in downtown San Francisco. Familiar chants of "Out of the bars and into the streets!" echoed against new favorites such as "What do we want? *Sodomy!* When do we want it! *Now!*"

"There is no turning back," activist and city health official Pat Norman told the demonstrators, who also protested Lyndon LaRouche's ballot initiative allowing the state to quarantine PWAs, one of many campaigns in the late 1980s calling for local, state, and federal government agencies to *require* quarantine for PWAs. As the issue of mandatory AIDS testing heated up, the stakes couldn't have been higher: if a required government test showed you had AIDS, you could end up being sent to die in a government camp. "We are taking our stand and we are here to fight," Norman said as she announced plans for an October 1987 National March on Washington.

In August 1986, Chief Justice Warren Burger received a similar welcome in New York City. But as a thousand protesters in Midtown were held back by only three dozen

mounted policemen, the young crowd seemed lost as to what to do next. "They were dumbfounded," activist Philip Bockman wrote. "For an instant, I felt the old despair, the sense of futility of the days before Stonewall. But only for an instant."

"What can they do if we all keep pushing?" someone shouted. The answer was obvious, at least to the older activists who'd confronted police before: just push. "One by one!" activists chanted, and the crowd barreled toward Lincoln Center, where a dinner for Burger was underway. Switching to riot mode, police couldn't stop forty activists from getting inside, where they terrified the dinner guests before being ejected.

"The epithets were flying," one zapper said, "but one woman at the head table said, 'Yea.'" That lone banqueter applauding the gays became legend, as did Leslie Feinberg, the zapper who told the tale.[34]

The Lavender Hill Mob, the group of street activists—formerly known as the Swift & Terrible Retribution Committee—who'd left the Gay and Lesbian Alliance Against Defamation in late 1985 for more militant pastures, led the return to the streets. Merging confrontational direct action with the PWA focus on treatment, the Mob—Marty Robinson, Bill Bahlman, Sara Belcher, Jean Elizabeth Glass, Buddy Noro, and Henry Yeager—brought militant AIDS activism to New York. In San Francisco, it was Citizens for Medical Justice, and Chicago had DAGMAR (Dykes and Gay Men Against Repression) and C-FAR (Chicago For AIDS Rights).[35]

In October 1986, almost exactly three years after confronting "those hatemongers" outside the Human Rights Campaign Fund gala, Marty Robinson was back at the Waldorf. This time, though, it was for the Catholic Archdiocese's Alfred E. Smith Dinner—*the* social event of the year—where all of Manhattan's elite gathered by invitation of Archbishop John O'Connor, who brought the room to a hush as he approached the microphone.

That's when the Mob zapped.

"Gays and lesbians will not be silenced!" they shouted. Marty Robinson was in heaven. "The Cardinal looks squarely at me," he remembered. "I return his gaze, confident that I represent the morality and peace he only pretends to. Security closes in."

Later that month, the Vatican issued its strongest condemnation yet of homosexuality, blaming AIDS and antigay violence on the queer community. "When civil legislation is introduced to protect behavior to which no one has any conceivable right," the Church proclaimed, it's no surprise that "other disordered notions" result in "irrational and violent reactions." The following Sunday, Mobsters slipped into St. Patrick's Cathedral to stand in protest while O'Connor led his flock.

Near the end of 1986, a poster appeared around New York City. A stark black background, a Holocaust-era pink triangle inverted so that the point faced up, and the words "SILENCE = DEATH" in bold white letters. At the bottom, in smaller print: "Why is Reagan silent about AIDS? What is really going on at the Center for Disease Control,

the Food and Drug Administration, and the Vatican? Gays and lesbians are not expendable . . . Use your power . . . Vote . . . Boycott . . . Defend yourselves . . . Turn your anger, fear, grief into action." Rage continued to build.[36]

In early 1987, the black granite tombstone of someone identified only as "A GAY VIETNAM VETERAN" appeared in D.C.'s Congressional Cemetery. A familiar phrase—*When I Was in the Military They Gave Me a Medal for Killing Two Men and a Discharge for Loving One*—had been etched prominently on the stone, along with two pink triangles and the words "NEVER AGAIN, NEVER FORGET."

As of January 1987, the unidentified veteran was still alive, though gravely ill with AIDS. In the lead-up to the National March on Washington in October, the vet revealed his identity in *The Advocate*, urging "those who are facing death to find a method of leaving a lasting record," including the fact they were queer. "I believe that we must be the same activists in our deaths that we were in our lives," he wrote. Leonard Matlovich planned to go out fighting.[37]

In February, the Centers for Disease Control (CDC) in Atlanta convened eight hundred government officials and quite a few representatives from gay and PWA advocacy groups to discuss the health crisis, with most of the attention centered on a White House proposal requiring all hospital patients to submit to a mandatory HIV blood test. Despite a consensus against the idea, Dr. Walter Dowdle, deputy CDC director, referenced mandatory testing in his closing remarks.

That's when the Mob zapped.

Unfurling their banner, a chant came up—"Test drugs, not people!"—and Bill Bahlman grabbed Michael Petrelis—who, along with Eric Perez, was dressed as a concentration camp inmate—and shouted: "It's safe to hug somebody with AIDS!" Kissing him, Bahlman announced kissing was safe, too.

Dowdle gave up, waving his hand to indicate he was done. But the Mob wasn't. As representatives of major gay organizations started a press conference, the Mob shouted them down, too, insisting the mainstream no longer represented the community or its anger.

"I feel your anger," said Urvashi Vaid of the rechristened National Gay *and Lesbian* Task Force (NGLTF).

"No one liked the Lavender Hill Mob," Michael Petrelis said. But they couldn't be avoided.[38]

◀ **Left** Lou Sullivan, San Francisco, 1988. Photo/copyright © by Mariette Pathy Allen, www.mariettepathyallen.com.

Trailblazing FTM (female-to-male) transgender activist Lou Sullivan dedicated his life to fighting for his community's right to more accessible health care and history. Sullivan was instrumental in toppling regulatory barriers to gender affirming surgery and helped establish San Francisco's Gay & Lesbian Historical Society (now the GLBT Historical Society). He died of AIDS-related illness in March 1991; he was thirty-nine.

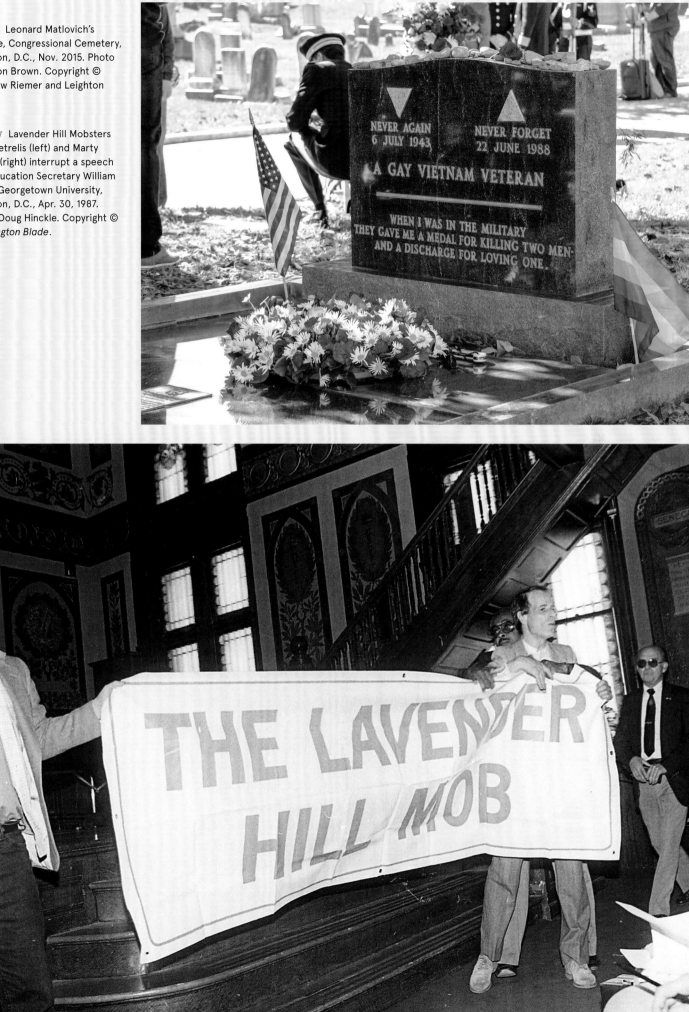

▶ **Right** Leonard Matlovich's headstone, Congressional Cemetery, Washington, D.C., Nov. 2015. Photo by Leighton Brown. Copyright © by Matthew Riemer and Leighton Brown.

▼ **Below** Lavender Hill Mobsters Michael Petrelis (left) and Marty Robinson (right) interrupt a speech by U.S. Education Secretary William Bennett, Georgetown University, Washington, D.C., Apr. 30, 1987. Photo by Doug Hinckle. Copyright © by *Washington Blade*.

Larry Kramer visited Houston's Institute for Immunological Disorders in February 1987, touring Dr. Peter Mansell's remarkable facility, described as the "country's first AIDS hospital." With space for 150 patients, it sat nearly empty because of draconian insurance laws in the Lone Star State. Even worse, Kramer said, was hearing Mansell describe the lifesaving drugs just waiting to be tested and approved by the Food and Drug Administration.

From Kramer's perspective, the only people doing anything productive were the Lavender Hill Mobsters, whose Centers for Disease Control (CDC) antics he'd followed closely. Reaching out in early March, Kramer invited the Mobsters to a speech he was giving at the New York Lesbian & Gay Community Center on March 10. "Almost four years ago to this date," Kramer opened his speech, "I wrote an article in the *New York Native*. When I wrote that, there were 1,112 cases of AIDS nationwide. There are now officially—and we all know how officials count—32,000, with 10,000 of these in New York." Asking two-thirds of the crowd of 250 to stand, he said those standing would all be dead in five years if they didn't "get angry and fight back."

"Did you notice what got the most attention at the recent CDC conference in Atlanta?" he asked. "It was a bunch called the Lavender Hill Mob. They protested. They yelled and screamed and demanded and were blissfully rude." *That's* what queer people needed, and that meant "coordinated protests, pickets, arrests."[39]

"The gay grapevine functioned remarkably well," Kramer recalled, with three hundred people turning up on March 12 for an "AIDS Coalition" organizational meeting. During that first meeting, the group—which adopted the name AIDS Coalition to Unleash Power (ACT UP) the following week—overflowed with ideas and energy, setting out an agenda that guided its early years. With the activists deciding on a Wall Street zap for their debut, Marty Robinson and Larry Kramer scouted logistics, going over details at the next meeting.

"If something is not done soon," Virginia Apuzzo had said in 1983, "we will be on Wall Street at noon!" On March 24, 1987, six hundred queers and PWAs descended on Wall Street during rush hour, all with the express purpose of disrupting business as usual. Although some in the press identified the group as the Lavender Hill Mob, ACT UP had arrived.[40]

In Atlanta, the Mob had put mainstream gay organizations on notice: represent our anger or get out of the way. On Wall Street, ACT UP proved these were no idle threats. So when the White House announced that Ronald Reagan finally would give a speech on AIDS during the upcoming Third International Conference on AIDS in D.C., the big names in the gay world knew it was time to get in the streets.

On June 1, 1987, the day after Reagan's first AIDS address, during which he recommitted to barring HIV-positive immigrants from entering the United States and backed mandatory HIV testing for certain populations—a "hasty step toward detention camps," the *New York Times* said, and a move that earned Reagan boos from his audience—dozens

of gay, lesbian, and bisexual leaders marched to the White House, laid a wreath for the thousands dead, and sat down on Pennsylvania Avenue before police made arrests. Joining Larry Kramer, Ginny Apuzzo, Jean O'Leary, Leonard Matlovich, Cleve Jones, and Troy Perry, Paul Boneberg recalled seeing "the entire gay leadership of America there with their hands behind their backs."[41]

The same month, eight members of San Francisco's Citizens for

▲ Virginia Apuzzo is arrested during a protest at the White House; Leonard Matlovich (face is partially obscured) in his uniform jacket, is to the right, Washington, D.C., June 1, 1987. Photo by Doug Hinckle. Copyright © by the *Washington Blade*.

Medical Justice (CMJ) were arrested during a sit-in at pharmaceutical giant Burroughs Wellcome, the manufacturer of AZT, the first FDA-approved anti-HIV treatment. Though toxic for some patients, AZT was a tangible, albeit fleeting, sign of hope—at least it was until Wellcome priced it at $10,000 for a year's supply, well beyond the means of most PWAs.

At San Francisco's Pride parade a few weeks later, CMJ carried coffins to represent the dead, the Sisters of Perpetual Indulgence mocked the Pope, whose plans for a Bay Area visit in 1987 enraged many, and attorney Mary Dunlap excoriated the Supreme Court, who'd just ruled against Dr. Tom Waddell in the final decision of the years-long battle over the "Gay Olympic Games." Waddell died from AIDS-related illness a few days later.[42]

In New York, ACT UP kept growing as members of the old guard—Marty Robinson, Vito Russo, Bill Bahlman—organized with the new wave—Michael Petrelis, Griffin Gold, Avram Finkelstein, David Robinson, Gerri Wells, Jean Elizabeth Glass, and Peter Staley, a semi-closeted Wall Street hotshot who'd helped finance the Mob's early actions. Above all, the group was intent on giving people the power to participate in whatever way they felt most productive. Raucous Monday-night general meetings became brainstorming sessions that allowed affinity groups to organize, recruit, and report back. "If you had an idea, you could do it," one member recalled. Iris Long's idea, for example, was to learn what she could about treatments and drug trials and teach those in ACT UP who didn't have her medical background. With assistance from Jim Eigo and others, Long's study group helped make ACT UP a revolutionary medical advocacy organization.

For its Pride debut, ACT UP went for the jugular. "This was 1987," Maxine Wolfe remembered. "We're already five years into the crisis, loads of people had died, the community was in a state of shock," and the very real threat of quarantine haunted PWAs. "Gay Pride was supposed to be a way to get away from all of this. And ACT UP had the *chutzpah* to build a concentration camp float."[43]

Wolfe, who'd spent decades fighting for social justice, faced the same dilemma as many lesbian and bisexual feminists in the mid-1980s: while not opposed to organizing with like-minded gay men, lesbian activists were essentially unwelcome by New York's early AIDS organizations. Nonetheless, she came to the next ACT UP meeting, and her contributions over the next decade—as a woman, a dyke, a leftist, and a street organizer—helped define militant AIDS activism.

The concentration camp float didn't shock Ortez Alderson. "This government is guilty of genocide of homosexuals. We have been put in concentration camps, beaten, killed, jailed," he'd written in 1970. "We should remember these things and see to it that it never happens to us again." Back then, Alderson was the leader of Chicago's Third World Gay Liberation, facing eighteen years in prison for breaking into a Selective Service office. Declared "mentally unstable" because he was gay, Alderson spent time in a Kentucky penitentiary. In New York after his release, he made a name for himself as an actor and performance artist.

From the minute he walked into an early ACT UP meeting, Alderson started organizing people of color. He'd "just get up in front of the room and start talking about the issues of people of color all the time," Robert Vazquez-Pacheco remembered. Alderson helped establish the Majority Action Committee (MAC), so-named because the majority of those with HIV/AIDS are people of color. MAC, in turn, gave rise to other vital groups, including Housing Works, which continues to fight homelessness among PWAs.

Alderson was "the most militant queen" ACT UP stalwart Kendall Thomas had ever seen. "He would get arrested anytime. He did not care, because he had nothing to lose."[44]

▲ **Above** Ortez Alderson, ACT UP demonstration, New York City, May 1988. Photo by Phil Zwickler. Courtesy of Division of Rare and Manuscript Collections, Cornell University Library (Phil Zwickler papers, #7564); used with permission of Phil Zwickler Memorial Trust Foundation.

◄ **Opposite** ACT UP members join national gay, lesbian, and bisexual leaders during a protest at the White House, Washington, D.C., June 1, 1987. Photo by Doug Hinckle. Copyright © by the *Washington Blade*.

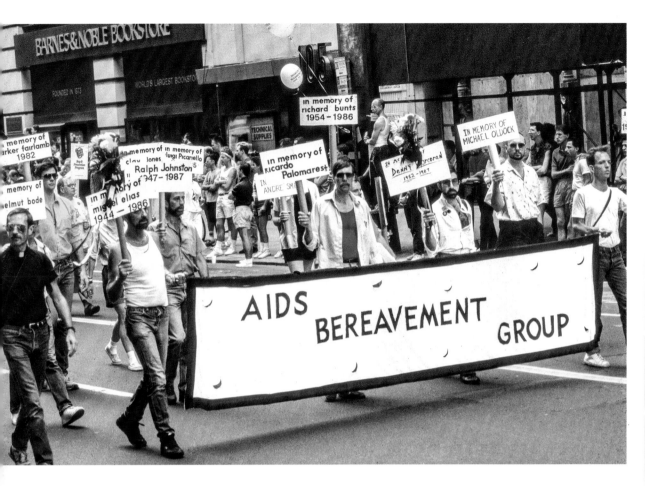

After we kick the shit out of this disease, we're all gonna be alive to kick the shit out of this system, so that this never happens again.

—VITO RUSSO, 1988

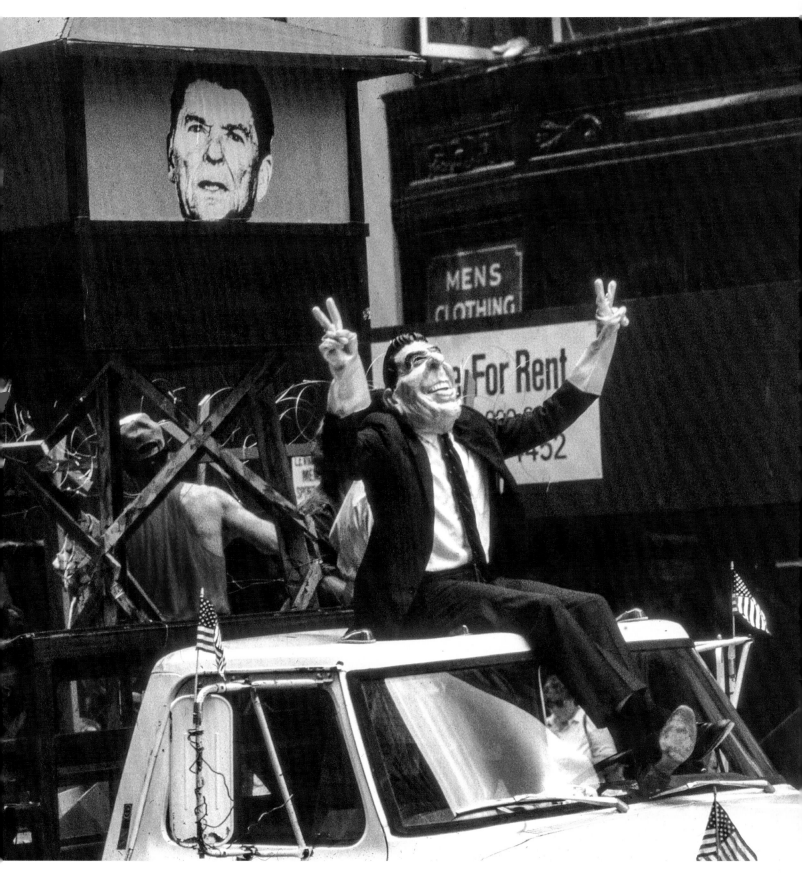

"Gays have nothing to lose," activist Susan Cavin said before the 1987 March on Washington. "We just have no constitutional standing." At sunrise on October 11, as volunteers placed the AIDS Memorial Quilt—made up of about two thousand individual panels—on the National Mall, speakers read the names of the dead. Dick and Amy Ashworth, proud parents of two gay sons, had been a familiar sight at New York Pride since 1973; Dick had even addressed the crowd at the 1979 March on Washington. Now the couple read names, including that of their son Tucker, who'd died in May.

Then came the names of Mel Boozer, who'd told the Democrats what it means to be gay and Black; Bobbi Campbell, who'd given patients a voice; Tom Doerr, who'd given Gay Lib the lambda (λ); Clint Moncrief, whose joyousness launched Houston's Montrose Marching Band; Paul Popham, who'd done the best he could; and Tom Waddell, who'd fought until the end.

> "To Those Who Died Hiding."
>
> "Women of the Sex Trade."
>
> "In Memory of All Haitians Lost to AIDS."
>
> "For All the Women."
>
> "Goodbye Dad."
>
> "For All of Them, Forever."

At the March itself, a group of well-known activists and celebrities carried the lead banner, though everyone marched behind PWAs.[45]

The previous day, after Frank Kameny and Morris Kight carried rainbow flags to lead a color guard into Congressional Cemetery, an emotional Leonard Matlovich told a crowd of two thousand about seeing the Paris graves of lovers Gertrude Stein and Alice B. Toklas. "We need to know the ones who went before us," Matlovich said as he dedicated a memorial to Harvey Milk. But he wasn't just talking about Milk, of course; he was talking about Kameny, Kight, and Troy Perry, all of whom stood nearby. And, as everyone who passed the "GAY VIETNAM VETERAN" headstone knew, Matlovich was talking about himself.[46]

Half a million people marched on October 11, though the press took little notice. Two days later, however, a massive protest against *Hardwick* at the Supreme Court drew attention. Seventeen people had been arrested at ACT UP's first demo in March; sixty-four at the White House in June. On October 13, over eight hundred went to jail.

The 1987 National March reinvigorated the Movement. The country's bisexual activists, for example, gathered for the first time, pledging to build a national network in the following years. And ACT UP seemed to be everywhere during the march, as New Yorkers *knew* that AIDS activists from around the country wanted to connect, organize, and head home with a renewed vision for the fight. And they did.[47]

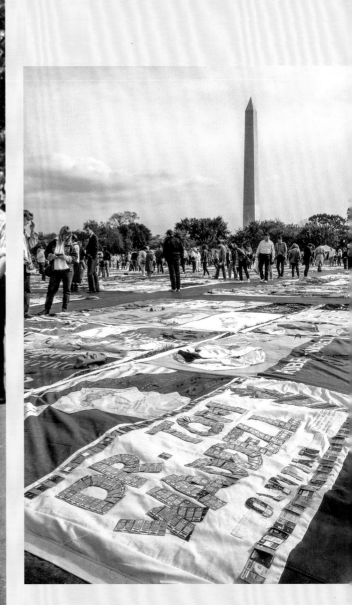

▲ **Above** The AIDS Memorial Quilt (with a panel dedicated to Dr. Tom Waddell, foreground), Washington, D.C., Oct. 1988. Photographer unknown. From the authors' collection.

◀ **Left, top** Dick Ashworth, Christopher Street Liberation Day, New York City, June 30, 1974. Photo by Fred W. McDarrah. Copyright © by Getty Images and the Estate of Fred W. McDarrah.

◀ **Left, bottom** Cleve Jones views the AIDS Memorial Quilt, San Francisco, Dec. 20, 1987. Photo/copyright © by Daniel Nicoletta.

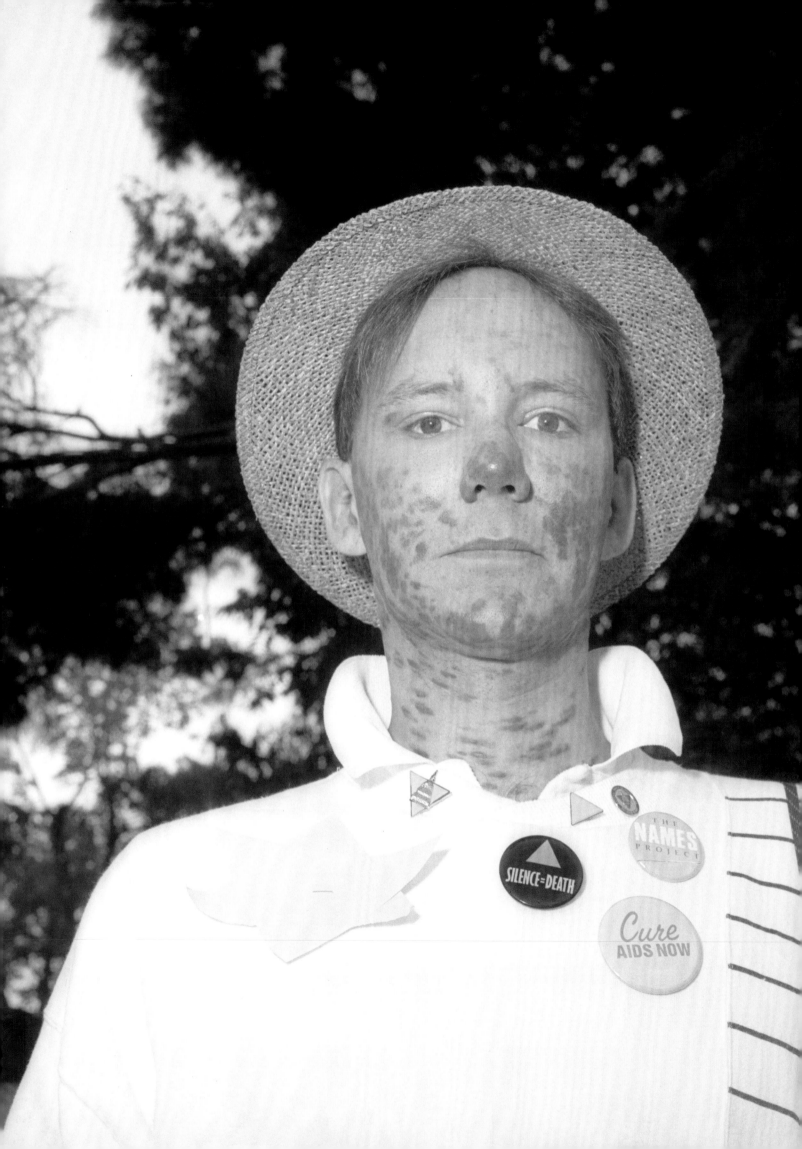

◄ Person With AIDS, National March on Washington for Lesbian & Gay Rights, Washington, D.C., Oct. 14, 1987. Photo/copyright © by Rosalind Solomon, www.rosalindsolomon.com.

The Quilt was four times bigger when it returned to D.C. the next year. Matlovich, who'd died in June, had a number of panels, as did Gaétan Dugas, remembered by friends as a cocky but sweet man who'd been demonized by journalist Randy Shilts in his 1987 book *And the Band Played On*. "His story is traced," one reviewer said of Dugas (now better known as "Patient Zero"), "as he jet-sets between coasts, spreading the AIDS virus in the late 1970s." While Shilts later acknowledged he'd exploited Dugas, whom the *New York Post* branded "The Man Who Gave Us AIDS," it was too late to avoid sparking AIDS panic, and it couldn't stop the apocryphal Patient Zero from being cited as justification for laws criminalizing HIV transmission. *And the Band Played On* helped bring attention to murderous government inaction, but, as Douglas Crimp says, "the fact that Shilts places blame equally on the Reagan administration, various government agencies, the scientific and medical establishments, *and the gay community*," may be reason enough to condemn the book.[48]

ACT UP also returned to D.C. in 1988, with fifteen hundred protesters from around the country bringing the U.S. Food and Drug Administration (FDA) to a standstill. The week after the massive zap, the FDA announced first steps toward speeding up the process of getting "drugs into bodies." Like the Gay Liberation Front (GLF) in the early 1970s, ACT UP quickly spread across the world; and, like GLF, many chapters were founded by activists who'd been in the fight for years. Citizens for Medical Justice in San Francisco and Chicago For AIDS Rights, for example, were advocating direct action before Larry Kramer's speech at New York's Lesbian and Gay Community Center, and both groups ultimately renamed themselves ACT UP.[49]

In early 1989, ACT UP/San Francisco zapped a local hospital, protesting the refusal to provide access to Foscarnet, a drug proven effective for many PWAs who were going blind due to the common opportunistic infection CMV retinitis. Terry Sutton, a leader of the Foscarnet sit-in, was one of countless PWAs who'd started to lose his sight. A few weeks later, Sutton led another group—Stop AIDS Now Or Else—in one of the era's most daring actions, as thirty activists brought morning traffic on the Golden Gate Bridge to a halt. "The commuters and their inconvenience is not the point here," a spokesperson said. "The point is 48,000 have died of AIDS in the U.S." Later that evening, two members of ACT UP/Chicago were arrested when they refused to stop shouting "50,000 dead from AIDS" during a governmental task force meeting.

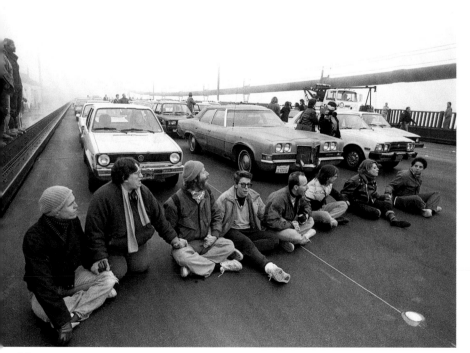

◀ Members of Stop AIDS Now Or Else (SANOE) block morning traffic on the Golden Gate Bridge, San Francisco, Jan. 31, 1989. Photo/copyright © by Rick Gerharter.

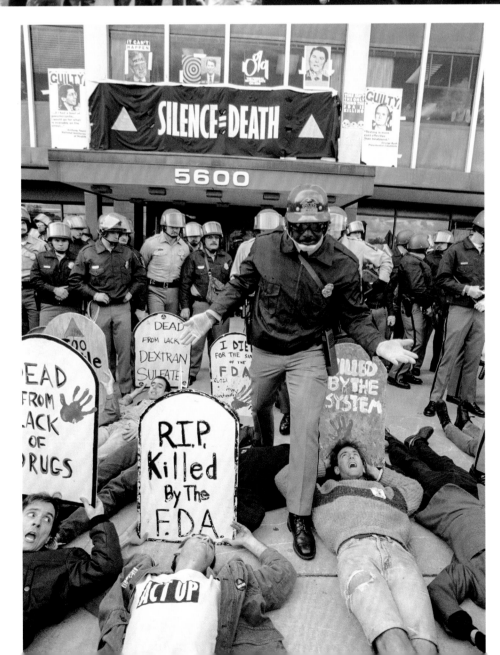

▲ **Above** National March on Washington for Lesbian & Gay Rights, Washington, D.C., Oct. 14, 1987. Photo by Jess Jessop. Courtesy of Lambda Archives of San Diego (Jess Jessop collection).

◀ **Left** ACT UP brings the U.S. Food and Drug Administration (FDA) to a standstill, Rockville, Maryland, Oct. 11, 1988. Photo by J. Scott Applewhite. Copyright © by the Associated Press.

▶ **Page 268** Police make an arrest during ACT UP's second anniversary action, Wall Street, New York City, Mar. 28, 1989. Photo by Fred W. McDarrah. Copyright © by Getty Images and the Estate of Fred W. McDarrah.

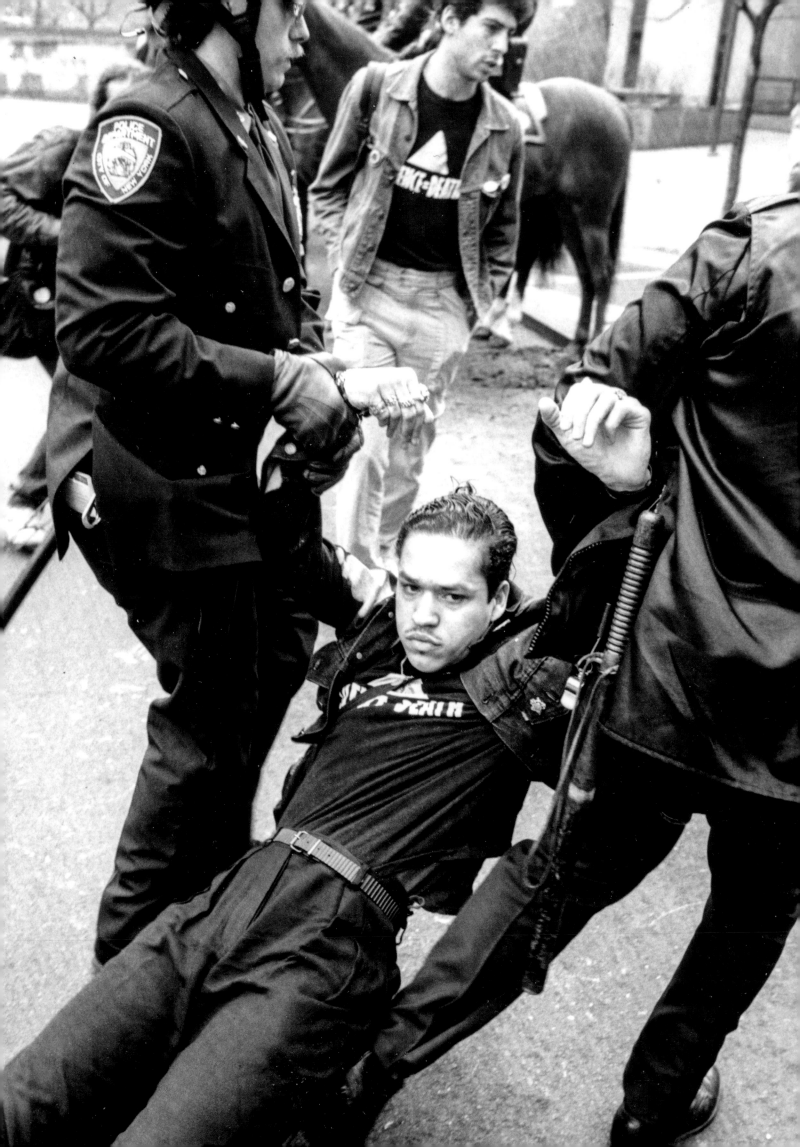

In March, three thousand people hit Wall Street for ACT UP/New York's second anniversary. Police made 190 arrests with classic New York brutality: "In one incident, four police officers repeatedly picked up activist Peter Staley by his four limbs and then dropped him back on the sidewalk." In April, forty-one people were arrested in South Carolina, protesting one of the country's harshest AIDS laws.[50]

Days later, hundreds mourned Terry Sutton, who'd died on April 11, with a march in the Castro. Enraged by the presence of police, the marchers demanded the cops leave or face a riot. They left, but they didn't forget. "When the history of this epidemic is told," Terry had recorded on his answering machine's outgoing message, "let it be known that gay men, lesbians, and women were our warriors; that we took care of our sick and we fought a government that seemed not to care. And we did it with integrity, compassion, and love. Be well everyone, I love you."[51]

In early June 1989, ACT UPers from around the world converged on Montreal in a flurry of working groups and zaps during the Fifth International Conference on AIDS. Collaborating with AIDS Action Now! from Toronto, ACT UP/NY distributed its "Declaration of the Universal Rights and Needs of People Living with HIV Disease." Also called the Montreal Manifesto, the document envisioned "a full reconsideration of the way drugs were tested, evaluated, regulated, and released." It was a direct descendant of the Denver Principles, and Mark Harrington, a New Yorker with a preternatural ability to process treatment and data information, had learned from and worked with Michael Callen for years.* Within months, Harrington, Iris Long, Jim Eigo, Peter Staley, and others from New York's Treatment & Data Committee (T&D) had a foot in the federal door, earning access to high-level meetings and closed-door working groups.

Activism, Harrington said, "is the intervention which treats both people with HIV and the diseased body politic."

Almost immediately, though, the overtures between T&D and the federal government caused strife within ACT UP/NY. After all, there was little reason to trust *anyone* working for or with the government. And this is especially true given the history of tension between those historian Gerard Koskovich called "structural revolutionaries" and "gradual reformists," people in the same organization "with the same ultimate goals but different views on how to carry them out." Starting with the Mattachine Foundation, queer organizations inevitably became victims of their own success: tangible gains brought calls for more moderate approaches, rankling the militants who had rocked the boat in the first place.

But ACT UP *wasn't* a queer organization, despite the overwhelmingly queer membership. ACT UP was "a diverse, non-partisan group of individuals united in anger and committed to direct action to end the AIDS crisis," and, given an opportunity to work with the government and pharmaceutical companies, some wanted the line between *AIDS* activism and *queer* activism more clearly drawn.[52]

* Despite a long and productive working relationship with Michael Callen (one that saved countless lives), Mark Harrington ultimately alienated the PWA icon when he brutally critiqued Callen's Community Research Initiative in 1989. "Within months," David France explains, "Harrington's campaign had succeeded in shutting down CRI and opening a reborn agency called the Community Research Initiative on AIDS, or CRIA. . . . Callen's legacy had been erased, for which he would never forgive Harrington."

By mid-1989, either the queer community had reached an existential crossroads on its own, or the upcoming twentieth anniversary of Stonewall forced a historical reckoning; either way, a distinct search for *our* history collectively emerged. For the most part, of course, the search started at Stonewall.

"This is a trip," Danny Garvin said. "Twenty years ago, if anyone told me this was going to happen, I wouldn't believe it." Garvin, one of the first to fight back at Stonewall, sat with Harry Hay, Mama Jean Devente, Sylvia Rivera, and others for a "Stonewall Reunion" panel at New York's Lesbian & Gay Community Services Center.

"My dears," Hay said, "it's wonderful to be here, but tonight is your night. I've never heard these stories."

"We weren't scared," Devente recalled. "We were fucking angry. The gays came out strong that night. And you got to hand it to the transvestites and transsexuals. They were the ones who fought back first."

"I remember people throwing money at the police first before the real stuff started," Sylvia said. "I thought that night was going to be our unity for the rest of our lives," but "the drag queen was pushed out," and history had failed "to mention what the drag queens gave to the movement in the first four years." By the "first four years," of course, Sylvia meant the idealistic time before the chaos at Christopher Street Liberation Day 1973.[53]

Colin Robinson, a twenty-seven-year-old Black gay man, wrote with frustration in Boston's *Gay Community News* that he didn't "know enough about the details of the riot to wonder why it has become so historically significant." More than likely, he thought, some "white gay male historian" said so, "and now it's become true." Although he'd heard "stories of Black and Puertorriquena drag queens," they weren't emphasized. "Who were they?" he asked. In New York, a bartender on Christopher Street remembered seeing gay men react in horror "when a certain very famous black street queen sashayed past their little group." Jumping to defend the queen—presumably Marsha P. Johnson—the bartender shouted, "Don't you know who that is? If she hadn't been there, you certainly wouldn't be here!" But it was obvious: they *didn't* know who she was.

> If Stonewall is to have a real meaning, we need to create a world in which we can remember it as accurately as possible.
> —Vivian Carlo, 1989

When the queer struggle shifted from Gay *Liberation* to Gay *Rights* in the 1970s, queer history had to be packaged as neatly as David Goodstein's *Advocate*. It's "what always happens to radical protest movements," Martin Duberman said. "A radical cutting edge inaugurates a movement of substantative protest, but the cutting edge is quickly dulled when the effort to win over mainstream America begins to take precedence." When that happens, "emphasis on real differences has to be downplayed." But downplaying the "real differences" of screaming queens, butch dykes and femmes, flaming faggots, and transcendent genderqueers meant toning down queer identity. And that left history a blank canvas, leaving queer people to create their own stories.

Twenty-year-old Randy Rice, for example, said he'd first heard about Stonewall in relation to his favorite singer: "I'm an avid Judy Garland fan and I heard that her funeral was on the same night as the first Stonewall riot." So, said Randy, "I think Judy Garland's death put people in the frame of mind to fight back." It's almost painfully obvious—and most credible sources confirm—that any connection between Garland's funeral and the seething anger at Stonewall was, at most, tenuous, and, more likely, the creation of either straight writers seeking to dull queer rage *or* of gay white men, like Randy, hoping to identify with those present at "the Creation."

The problem with Stonewall, writer and AIDS activist Maria Maggenti noted, was that "when you talk to people it is like the tale of Rashomon; everyone has a different story." So while it clearly "was a rebellion by people who were on the fringes," somehow assimilationists had made it theirs. But in the shadow of an epidemic, a renewed recognition emerged that "those who had been ridiculed the most risked the most—their lives—to fight back." If the mainstream wouldn't adopt "the Stonewall vision of liberation for all," then Stonewall meant nothing.

In 1989, as momentum in ACT UP shifted toward the intricacies of treatment and data, the "Stonewall vision" resonated with those who still sought *Queer* Liberation. The story of Christopher Street's "nights of rage" held "some sense of promise for the present and the future of the queer nation."

"Can Stonewall happen again?" Mama Jean Devente asked. "Yes. It will happen again if they start pushing us against the wall."[54]

A few nights later, on the eve of Heritage of Pride 1989, it almost happened again, as a group of "radical faeries, queer anarchists, and other 'East Village types'" gathered in Sheridan Square to honor the "unorganized rabble" who'd led the 1969 melee. Playfully reenacting the riots, demonstrators threw yellow-foam bricks at the clothing store that had once housed the bar. When someone shouted to "take Seventh Avenue," hundreds danced into the thoroughfare, bringing traffic to a standstill. It was "fun and bubbly," Gerri Wells said, but, as the march gathered steam, the mood changed, and the group headed for the local police station, chanting about anti-queer violence.

With thousands surrounding the Sixth Precinct, the "potential for a riot was there," and the bottleneck triggered violence from angry drivers. When one sped through a line of protesters, "an angry mob chased the car through the streets of the Village," catching up just as police arrived. Besieged by queer people, the cops dragged the attackers into a nearby theater, leaving the mob to destroy the driver's Chevy Cavalier.

A reenactment of a riot turned into a riot.[55]

––––––––––––

On July 1, 1989, the 100,000th case of AIDS in the United States was reported to the Centers for Disease Control; over half of those diagnosed had died. "What am I thinking now that 100,000 has been reached?" Larry Kramer asked. "It is hard to feel good about very much."[56]

For a certain type of gay person, Provincetown, Massachusetts, had long been a welcoming mecca. "The gays have done a lot to clean up Provincetown," said a business owner in the Cape Cod town. "They have good taste, are good neighbors and good friends." But by 1989, it was increasingly clear that many of the queer community's "good friends" were complicit in the destruction all around.

Provincetown Pride started in 1987, though it was an extension of the AIDS Memorial March that started in 1985. Whether an AIDS March or a Pride Parade, displays of queer solidarity in Provincetown were generally "funereal candlelight processions."

"Gay people are merely tolerated, but certainly not accepted," Paul de Renzis of ACT UP/P-Town said. They "never want to shake things up." With Pride 1989 approaching, de Renzis wanted to shake things up.

Enlisting the help of ACT UP/NY and activists from Boston, local queers turned what usually was a two hundred-person vigil into a defiant parade of over a thousand people. New York's Walter Armstrong marched with a sign that couldn't be missed: "LEGALIZE BUTT FUCKING in all fifty states," read one side; "The Queer Nations says LEGALIZE CLIT LICKING," read the other. Most local activists loved it. We're "always nice little gays and they taunt us," Steve Crouch said. "It was time to taunt them back."

But the outrage from onlookers and the local business community was overwhelming. James J. Meads, the local police chief, said Armstrong's sign had "set gay and straight relations back 40 years or more." So intense was the reaction that little attention got paid to Chris Alvarez, a marcher shot by a BB gun during the parade.[57]

For many queer New Yorkers, Labor Day brought a brief respite, as one of the largest drag parties anywhere, Wigstock, took over Tompkins Square Park. In 1989, though, queer bashing was so bad not even Wigstock was safe. Four festivalgoers were attacked in broad daylight and, if a few ACT UP members hadn't jumped into action, the cops would've let the bashers walk.

"It seems like every time I put on my high heels," queer activist Sandy Katz said, "I end up running around town chasing queer bashers." It wasn't that activists wanted to confront attackers—they *had* to. And if something didn't change soon, they were "going to have to form angry mobs chasing down fag-bashers many more times."

"We did *not* create the situation," David Robinson said, "we responded to it."[58]

On October 6, 1989, as activists across the country participated in a day of protest, ACT UP/San Francisco organized what was meant to be a "routine demonstration" at the Federal Building followed by a march to the Castro. When the march got under way, however, police "unleashed a colossal and incomprehensible show of force," knocking demonstrators off the street with unchecked aggression. Though infuriated, Gerard Koskovich wrote, most activists knew the cops would back off at the Castro; there hadn't been a Castro crackdown since the White Night Riots in 1979.

But there they were, blocking Castro and Market Streets, forcing marchers into the commercial center of the neighborhood. A routine march quickly became a full-scale

▶ Provincetown Pride, Provincetown, Massachusetts, July 23, 1989. Photo/copyright © by Tina L. Browne. Courtesy of The LGBT Community Center National History Archive (*OutWeek* collection; 094-176).

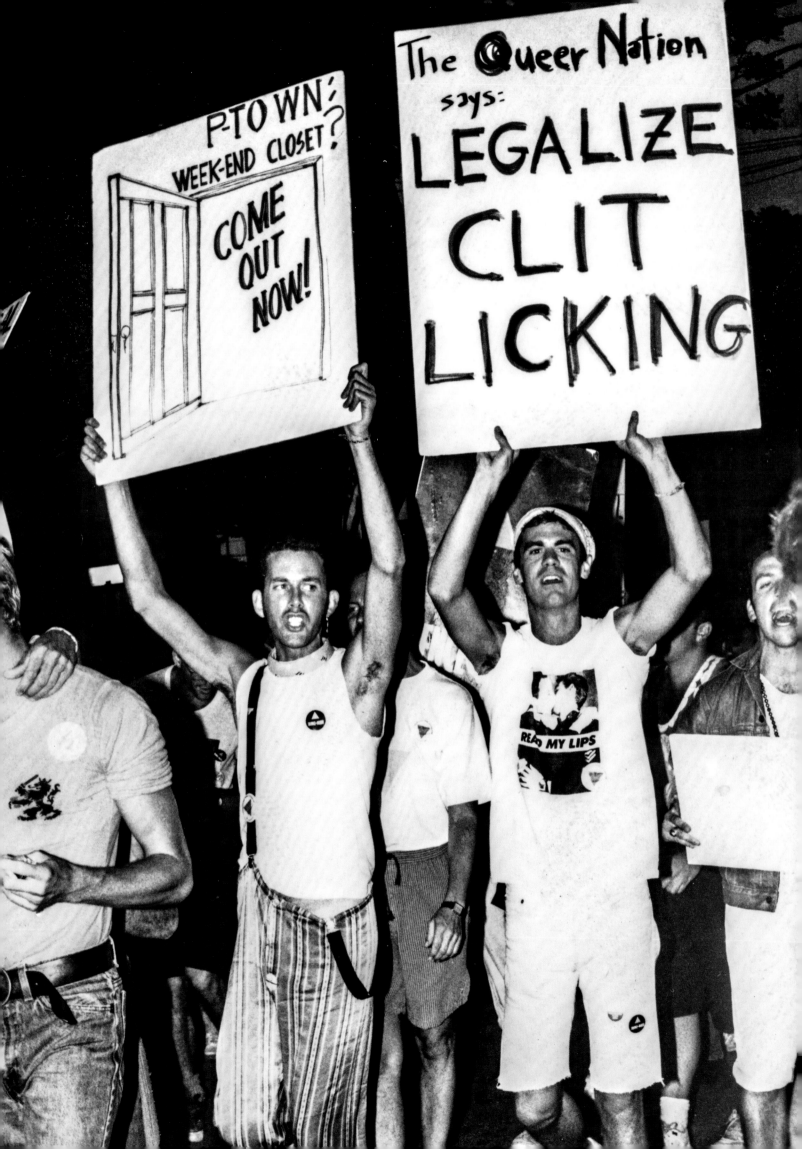

zap, as fifty people sat in the streets and twenty others staged a die-in. After police arrested those blocking traffic, they turned to the rest of the crowd. The locals held their ground, but the cops unleashed brute force after an unmanned police motorcycle fell, or was tipped, over. Finally, declaring the block an unlawful assembly area, an enormous phalanx of cops swept the street clear of anyone out-of-doors. It'd been six months since ACT UP had chased the cops out of the Castro during Terry Sutton's political funeral; the cops hadn't forgotten.[59]

With a new decade on the horizon, ACT UP/NY plunged into an existential crisis that most political organizations—and many ACT UP chapters—couldn't survive. In late 1989 alone, New York activists picketed the city's public housing agency to demand better treatment for homeless PWAs; infiltrated the Stock Exchange, delaying the opening bell for the first time on record; caused a near-riot at Manhattan's Trump Tower; and participated in two actions at the White House, one of which ended with directors of prominent AIDS organizations under arrest. During the same time, bowing to activist pressure, Burroughs Wellcome slashed the price of AZT; Dr. Anthony Fauci joined ACT UP/NY's Treatment & Data Committee for "a working confrontation"; and the Food and Drug Administration finally approved the release of certain experimental anti-HIV drugs on a "parallel track," effectively speeding "drugs into bodies." But each time ACT UP revealed a critical flaw in the response to AIDS, it added to the hodgepodge of vital issues with which activists were grappling. Fauci, for example, seemed unwilling or unable to engage in conversation when it came to the growing number of women with AIDS, and few beyond the Majority Action Committee seemed able to grasp a connection between the silence of most activists on matters of race and the overwhelming proliferation of HIV in communities of color.[60]

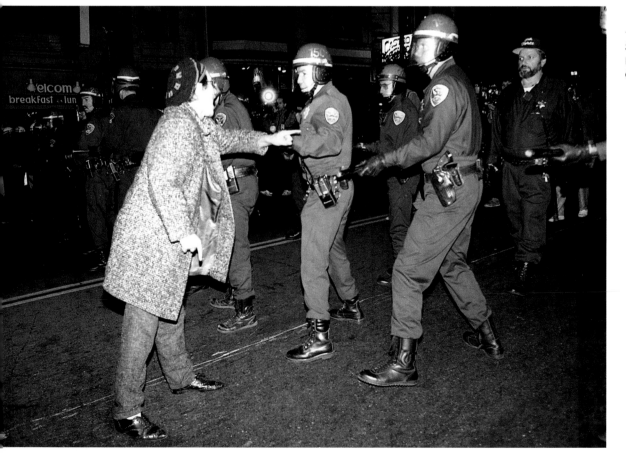

◀ The Castro Sweep, San Francisco, Oct. 6, 1989. Photo/copyright © by Rick Gerharter.

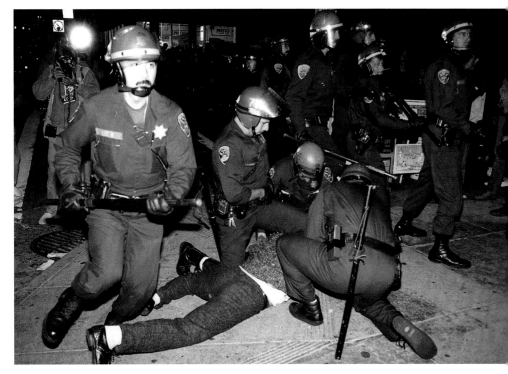

Coincidentally, ACT UP wasn't the only New York organization navigating the boundaries between militant civil disobedience and political norms in the late 1980s. With the New Right deeply entrenched after George H. W. Bush's election, the Catholic Church led a blistering attack on women's access to safe abortions, and, more generally, on the availability of contraceptives and safe-sex education. The Church had its own direct-action group, Operation Rescue,

▲ San Francisco police wreak havoc in the Castro, San Francisco, Oct. 6, 1989. Photo/copyright © by Rick Gerharter.

whose "rescues" consisted of physically blocking entrances to women's health facilities. "I wish I could go on a rescue," Cardinal John O'Connor said in October 1989, adding that his lawyers had advised against it.

O'Connor's endorsement of Operation Rescue infuriated and inspired Vincent Gagliostro and Victor Mendolia, who came to the next ACT UP/NY meeting with plans for a massive demonstration at St. Patrick's Cathedral. Although some worried that such a protest seemed more antireligious than political, a majority endorsed it. After the National Conference of Catholic Bishops adamantly condemned safe-sex education in November, "Stop the Church" took on greater meaning. Thousands hit St. Patrick's on December 10, 1989, decrying the Church's inaction on AIDS and its opposition to women's autonomy. Organized by ACT UP and WHAM! (Women's Health Action and Mobilization), the official protest—an enormous disruption *outside* the church—had the support of most gay, lesbian, and bisexual organizations. Beyond that, no other action had explicit approval, though plenty knew that ACT UP members planned to go inside.

Just before Mass, as the melee unfolded outside, a group of activists made their way into the cathedral. As the service began, dozens of otherwise unremarkable-looking worshipers fell into the aisles in silent protest; police were waiting to make arrests. When O'Connor started his homily and it seemed the demonstration had hardly bothered him, Michael Petrelis, as radical as he'd been in the Lavender Hill Mob, went off-script. "Stop killing us!" he shouted, standing on a pew. "You're killing us!"

Suddenly, a number of people were screaming, and others handcuffed themselves to pews. O'Connor pressed on, leading his flock—including Ed Koch, who'd come to show support for the Church—through a round of long, booming prayers. In the most sensational, and sensationalized, moment, former altar boy Tom Keane went to take communion, only to crumble a wafer and toss it on the floor. It was a horrifying

act of sacrilege to those who claimed a connection to Catholicism, and it dominated news coverage.

Since its early days, ACT UP had more than its share of bad press, but none compared to the condemnation after Stop the Church. "The shit hit the fan," Larry Kramer explained. "Newspapers and TV and politicians and commentators and editorials and front-page headlines *all* screamed hideous condemnations of us all." And while most mainstream gay organizations denounced ACT UP *not* for its anger but for its tactics, a few leaders were painfully submissive to the Church. "It was completely stupid and wrong-headed," Andy Humm told the *New York Post*, explaining that he and other gay leaders were considering handing out leaflets in front of St. Patrick's to apologize.

Officially, ACT UP's response was simple: "No apologies."

But the withering criticism from outside ripped open festering internal tension. Some ACT UP members—Larry Kramer, Maxine Wolfe, Bob Rafsky—were ecstatic with the demonstration; they'd sent a clear message: "No boundaries we will not cross." "If we err, we should err on the side of the radical," Tony Casserta said. Rafsky agreed, urging the unusually large crowd at the December 18 meeting to ignore the backlash.

Many other members, however, thought the action "was a failure," as Peter Staley announced. "We have lost our ability to self-criticize," he said. "And now we self-congratulate." Seconding those concerns, Aldyn McKean warned against silencing moderate or mainstream opinions. "We need to be militant," he said, "but we need to let everyone participate." Kathryn Otter, a proud transsexual lesbian who didn't hesitate to get arrested for the cause, agreed: "We need to end the hostility toward organizations that could be on our side."

"Anger without focus is useless," said David Feinberg, emphasizing his fear that the group had lost its sense of purpose. "Focus on getting drugs and therapies to people," he said. "Non-AIDS issues should take a backseat." All of their work was important, Tom Cunningham offered, "but we can't have issues that don't address AIDS . . . where do we draw the line?"

ACT UP, many said, needed to reclaim the "higher moral ground." But that's the whole problem! Oliver Johnston shouted. The "higher moral ground" mentality "reflects an oppressive way of thinking." "Don't buy into being tolerated," he demanded. "We're fighting for our lives."

Calls to refocus on "AIDS only" soon became powerful tools with which ACT UP could gloss over systemic problems in favor of traditional political avenues. Within a month, for example, proposals to demonstrate against increasing violence in New York were greeted with a simple question: "AIDS related?" And as the answer wasn't a simple yes, the demonstrations were tabled. Hate crimes legislation? Not AIDS related. Bashings in Staten Island and Brooklyn? Not AIDS related. Even more damaging was the dismissiveness toward women and people of color that hid behind the renewed "focus on AIDS." When the Majority Action Committee proposed a discussion about cultural sensitivity, more than one person expressed "concern about making this a race issue rather than a health care issue."

Larry Kramer said that Stop the Church was "the moment in time when ACT UP got its first real power." Then it started to fall apart.[61]

Marty Robinson was on a tirade about Gay Liberaton Front politics when Arthur Bell arrived for the secretive meeting of the new group being planned. It was November 24, 1969, and ten people sat in New York hashing out details for "an activist group, a radical group devoted to the cause of homosexual liberation." They imagined their group taking "carefully planned actions"—what Robinson called zaps—to force oppressors to reckon with Gay Liberation. They dreamt of "setting up a community center" and "looking into job discrimination and low-income housing." They wanted a great name, but they only came up with Gay Activists Alliance (GAA). Bell's lover, Arthur Evans, wasn't there that first night, but he was present a few weeks later when nineteen people finalized GAA's constitution.

In November 1978, Arthur Evans marched in San Francisco with tens of thousands of others, trying to make sense of the month's events. Almost a thousand were dead in Guyana and then Dan White killed George Moscone and Harvey Milk. Somewhere in the crowd of mourners, Larry Kramer marched too.

On November 27, 1989, twenty years after founding GAA and eleven years after losing Milk, Evans once again marched on Market Street. Only 300 people gathered this time—"the core, the faithful, the March junkies." By the end of the year, there'd be 115,786 cases of AIDS reported in the United States; 69,233 people dead. Those lost came from every walk of life, but the queer community was the hardest hit.

There'd been 7,300 cases in San Francisco; 8,200 in L.A.; 3,300 in both Houston and D.C.; and just under 3,000 in Chicago. New York City had 22,125 cases. And the worst was yet to come.

"I feel kind of sad, yet hopeful," Evans said when asked about the time since Milk's death. "It has not been a good period."

But when he marched, he said, "I feel a sense that the community is still alive."[62]

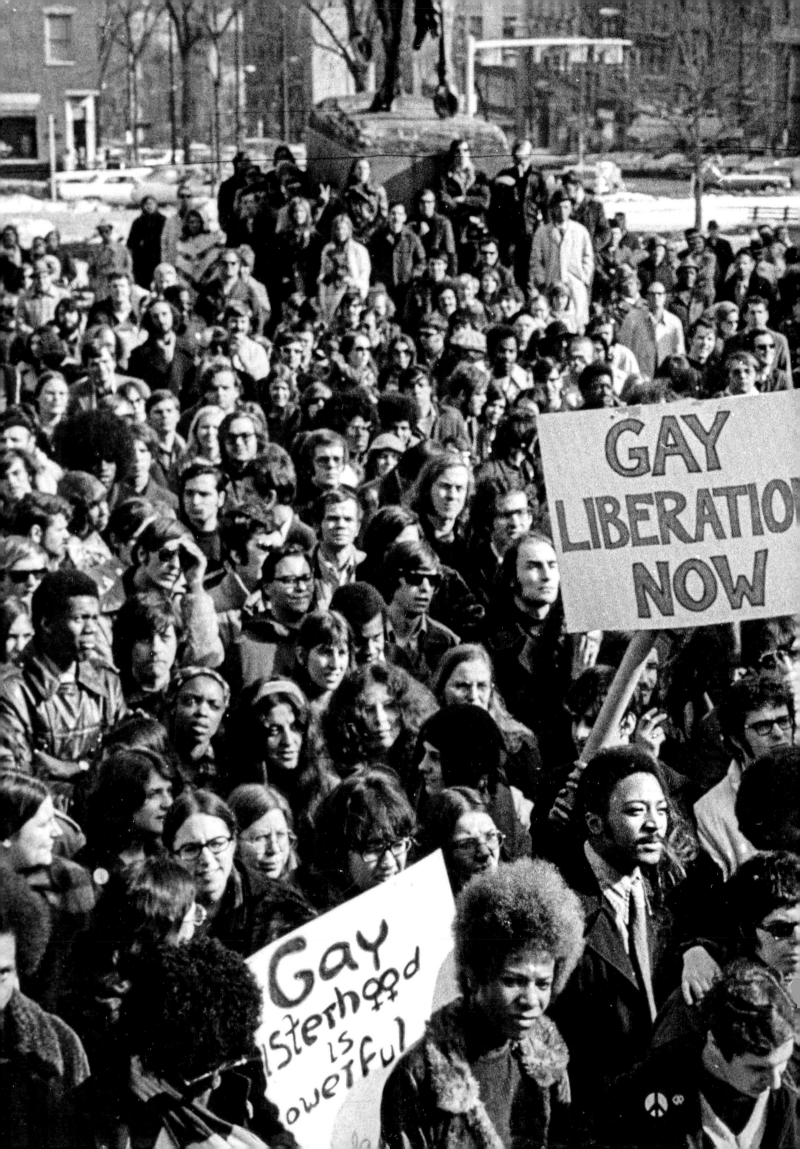

◀ Gay Liberation March on Albany;
Marty Robinson (at center) holds
the "GAY LIBERATION NOW" sign,
Albany, New York, Mar. 14, 1971.
Photo by Richard C. Wandel.
Courtesy of The LGBT Community
Center National History Archive
(Wandel collection; 4a-003).

In the years after Stop the Church, AIDS activists continued to organize large-scale direct-action responses. In early 1990, three hundred demonstrators, including comedian Lea DeLaria, descended on the Georgia State House to protest the state's sodomy law. A few weeks later, one thousand protesters greeted George H. W. Bush in L.A., demanding he "Stop G.O.P. Death Squads" in the United States and Central America. In late March, Urvashi Vaid, the newly named executive director of the National Gay and Lesbian Task Force (NGLTF), made an unforgettable debut as the head of a major gay organization when she twice interrupted Bush's first AIDS address. Holding a sign that read, "Talk is cheap. AIDS care isn't," Vaid shouted, "Mr. President, you're not doing enough. We need more than one speech every fourteen months!" ACT UP/Chicago took on the insurance industry in April and ACT UP/D.C. announced the start of a boycott of Philip Morris products, specifically Marlboro cigarettes, having discovered the company's contributions to the arch-conservative senator Jesse Helms.

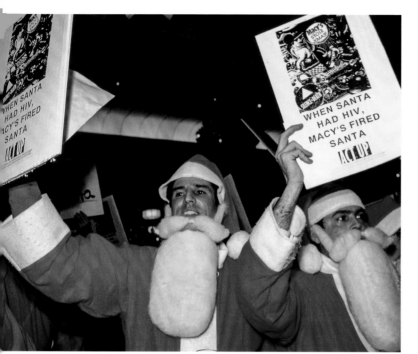

▲ ACT UP/NY members zap Macy's after the department store fired an HIV-positive man who'd been a popular Macy's Santa Claus for years, New York City, Nov. 29, 1991. Photo/copyright © by Allan Clear.

In June, thousands of doctors, patients, pharmaceutical representatives, and activists arrived in San Francisco for the Sixth International Conference on AIDS. While many organizations boycotted to protest Bush's refusal to lift the immigration ban on people with HIV/AIDS, ACT UP/NY bucked the national trend and participated in the conference. As protests unfolded outside, Peter Staley addressed the ten thousand attendees inside, asking all who opposed the travel ban to stand; when the entire hall rose, Staley congratulated them: "You're now all members of ACT UP."[63]

Just after Bush announced U.S. intervention in Kuwait in early 1991, marking the start of the Persian Gulf War, activists staged a Day of Desperation in hopes of keeping much-needed visibility on the war at home. As Americans tuned into the news on January 22, ACT UPers managed to interrupt Dan Rather's *CBS Evening News*. On January 23, ACT UP/NY brought Grand Central Terminal to a standstill as hundreds blocked traffic in the main concourse. Randy Wicker joined the protest; he'd lost his life partner, David Combs, in 1990. On Labor Day 1991, ACT UP brought the battle to idyllic Kennebunkport, Maine, where George H. W. Bush and his family vacationed. When asked about the demonstration, Bush flippantly referred to an earlier protest by a group of unemployed people, saying "that one hit home, because when a family is out of work, that's one I care very much about." A few days later, with the financial

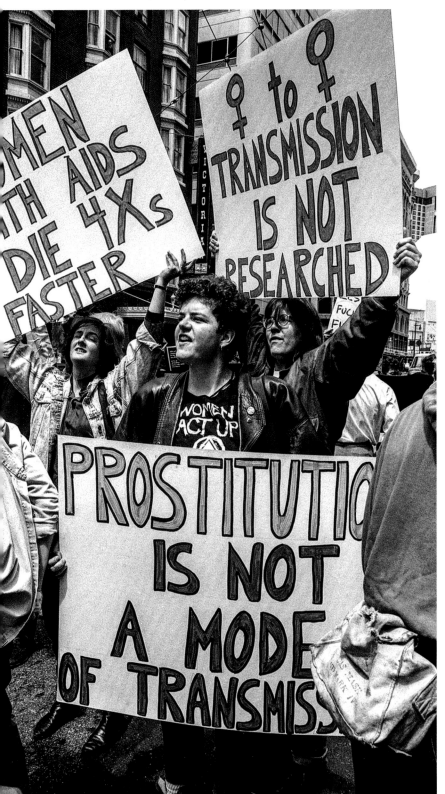

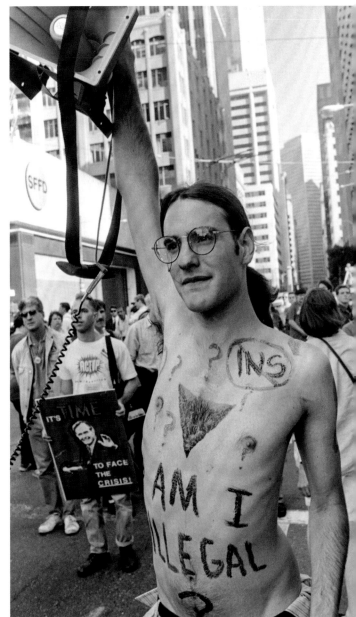

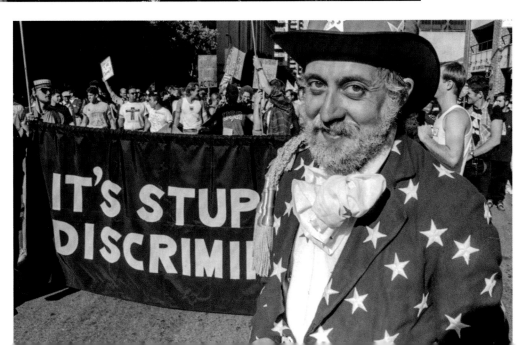

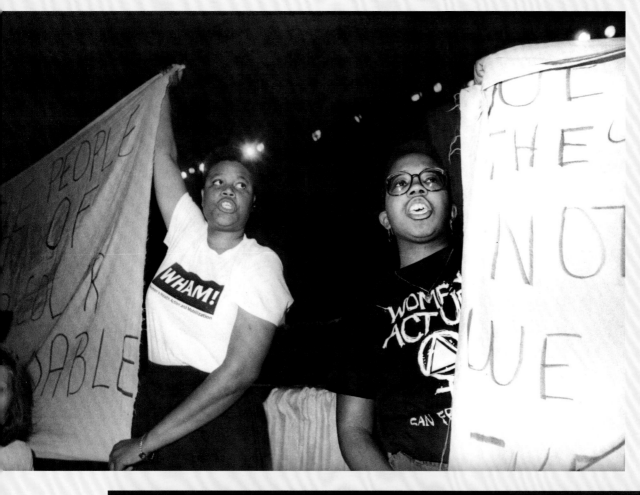

◀ **Left** ACT UP and WHAM! (Women's Health Action and Mobilization) disrupt U.S. Secretary of Health and Human Services Louis Sullivan during the Sixth International Conference on AIDS, San Francisco, June 1990. Photo/copyright © by Marc Geller.

▼ **Below** ACT UP/NY occupies Grand Central Terminal during the Day of Desperation, New York City, Jan. 23, 1991. Photo/copyright © by Dona Ann McAdams.

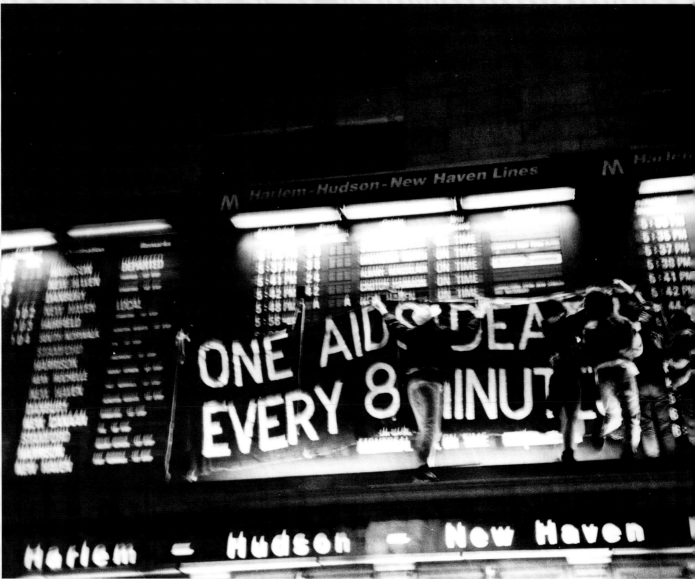

assistance of mogul David Geffen (who, at the time, insisted on closeted anonymity), rogue members of New York's Treatment & Data (T&D) committee, calling themselves the Treatment Action Guerrillas, travelled to Jesse Helms's home in Arlington, Virginia, and covered it with an enormous inflatable condom.[64]

But by late 1990, internal debates had overwhelmed many of ACT UP's largest chapters. San Francisco and Chicago were both headed for dissolution, and Portland and Seattle were close behind. At their worst, the schisms looked like Portland, where a new member led a revolt against the "lesbian bitches" in "the ruling guard" who allegedly undermined PWA empowerment by focusing "on women and people of color to the exclusion of white gay men." In Chicago, beloved activist Daniel Sotomayor hastened the split with charges that ACT UP had "been taken over by ideologues who are more interested in fighting racism, sexism, and homophobia than AIDS." ACT UP had long "been conflicted on the question of whether AIDS activism necessarily entails active work against other social problems," but in the early 1990s the conflict often proved untenable.

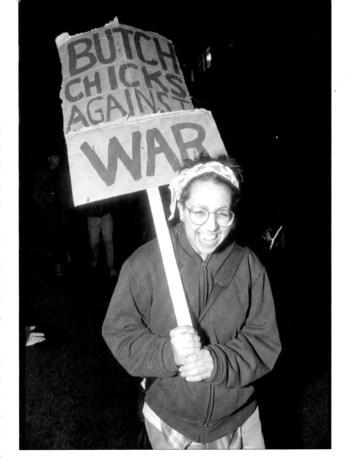

▲ Queer activists protest U.S. intervention in Kuwait, San Francisco, Jan. 1991. Photo/copyright © by Marc Geller.

In New York, ACT UP emphasized what some called the "inside/outside" strategy, or "dual engagement and demonstration," where activists engaged government officials (inside) while using strategic demonstrations to apply public pressure (outside). To an extent, they were quite successful, as illustrated by the siege of the National Institutes of Health (NIH) in May 1990, when twelve hundred members of two dozen ACT UP chapters "rained fire and brimstone" on the Maryland NIH campus and police made nearly one hundred arrests. In the aftermath, NIH officials went on the defensive, decrying the "intimidation tactics" as "not helpful." But then, suddenly, "true reform began," and many of the seemingly intractable federal doors flew open. Anthony Fauci in particular seemed eager to meet with activists, David France wrote, as PWAs were "integrated into every element of government's response" to the crisis.

For many, however, the "true reforms" seemed familiar: white men got seats at the table while people of color experienced the brunt of the loss and women increasingly faced fatal risk of transmission. As the "inside" activists from T&D got further inside, forging relationships and gaining access that revolutionized medical bureaucracy and saved lives, those "outside" went from suspicious to frustrated to angry. As arguments grew more personal and T&D felt more constrained, the committee—Mark Harrington, Peter Staley, Spencer Cox, Garance Franke-Ruta, Gregg Gonsalves, and David Barr—officially broke off, forming the Treatment Action Group (TAG) in January 1992.[65]

As ACT UP's fifth anniversary approached, Harrington wrote what he later described as a "very, very angry letter," in which he unloaded on those he blamed for the "division, confusion, and fragmentation." Specifically, he noted that "among the

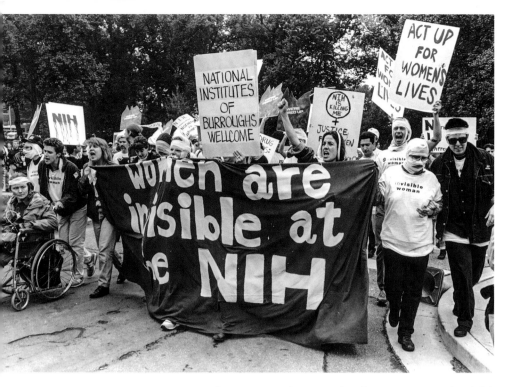

▲ Members of Women ACT UP (and/or various ACT UP Women's Caucuses) lead the charge at the National Institutes of Health (NIH) action, Bethesda, Maryland, May 21, 1990. Photo/copyright © by Dona Ann McAdams.

principal obstacles to ACT UP's growth and effectiveness has been a series of factional critiques ostensibly based on previous, and very different, models of activism." If it was unclear, Harrington spelled out further whom he meant: "several lifelong 'movement activists'" who had "aspirations towards impossible Utopias." In closing, he wrote, "I was not, nor am I, interested in leaving a noble, frustrated legacy erected over a pile of our corpses so that lifelong movement parasites can move on to the next issue."

Chicago, San Francisco, Seattle, and Portland had "ideologues who are more interested in fighting racism, sexism, and homophobia than AIDS," and New York had its "parasites." The radicals were being blamed. "I think the majority came here with AIDS as their number-one fight," a straight member of ACT UP/NY said. "I don't think most ACT UP members want to draw these lines or constantly be demanded to prove their commitment to the just fight against homophobia under risk of being accused of accommodationism."[66]

———

At Heritage of Pride 1990, a small group of New York activists distributed *Queers Read This*, "an anonymously authored series of essays and arresting graphics compiled in a tabloid format." It didn't look different from other handouts you'd get at Pride, but the content grew more intense with each page, ending with a boldly titled piece: "I Hate Straights."

"How can I convince you, brother, sister that your life is in danger," asked one essay. "That everyday you wake up alive, relatively happy, and as a functioning human being, you are committing a rebellious act. You as an alive and functioning queer are a revolutionary." It was a call for Queer Liberation. "Being queer," said another, "means leading a different sort of life. It's not about the mainstream, profit-margins, patriotism, patriarchy or being assimilated. . . . It's about being on the margins, defining ourselves; it's about gender-fuck and secrets, what's beneath the belt and deep inside the heart; it's about the night."

At its core, activist Gerri Wells explained, *Queers Read This* was an announcement that "we were a community under attack, and we were standing up and fighting back."

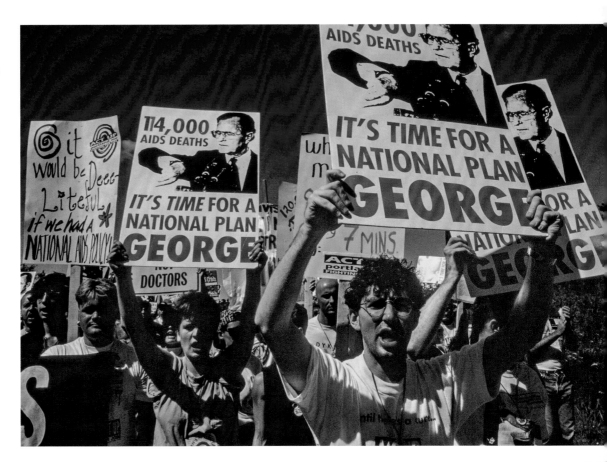

▶ **Right** ACT UP members interrupt George H. W. Bush's Labor Day vacation, Kennebunkport, Maine, Sept. 1, 1991. Photo/copyright © by Allan Clear.

▼ **Below** ACT UP/NY meeting, New York Lesbian & Gay Community Center, New York City, c. 1990. Photo/copyright © by Dona Ann McAdams.

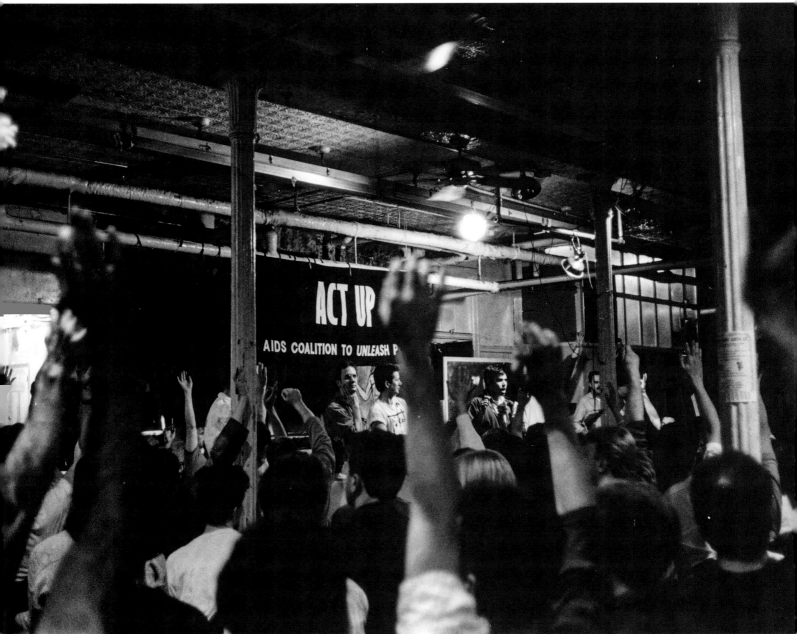

More specifically, at the beginning of the 1990s, the community faced what the National Gay and Lesbian Taske Force's (NGLTF) Kevin Berrill called "the second epidemic," as incidents of queer-bashing spread "with mind-numbing speed." In the months around Pride 1990, for example, bashings in Greenwich Village spiraled out of control, while Brooklyn and Queens grew increasingly unsafe; reports of violence against lesbians spiked, and brutal murders of transgender people continued. And it wasn't just New York. In June, Congressman Gerry Studds, the first openly gay U.S. representative, was bashed after leaving a D.C. gay bar. In separate incidents around Philadelphia Pride, a transgender woman and a lesbian and her son (all of color) were killed on the same day the Pennsylvania legislature rejected a hate crimes bill. The following weekend, Queens resident Julio Rivera was beaten to death, a tragedy providing the impetus for Queens Pride. San Francisco; Pittsburgh; Rochester; Taylor, Kentucky; Columbus, Ohio; Providence, Rhode Island; Seattle; Boston; Boise, Idaho; Houston; and so many other communities saw increased anti-queer violence.[67] "Queers are being attacked on all fronts and I'm afraid it's ok with us," *Queers Read This* announced. "What will it take for this not to be ok? Feel some rage. If rage doesn't empower you, try fear. If that doesn't work, try panic. . . . Do whatever you need to do to tear yourself away from your customary state of acceptance."

Despite the attribution to "anonymous queers," *Queers Read This* generally is considered the work of members of Queer Nation, which was founded by members of ACT UP/NY who wanted "activism targeting homophobic violence and promoting queer visibility, but felt constrained by ACT UP's focus on HIV/AIDS." In April 1990, when a pipe bomb exploded at Uncle Charlie's, a popular Village gay bar, Queer Nation was ready. Their message was simple enough to fit on the lead banner of a march the night after the bombing: "BASH BACK."[68]

Everything about Queer Nation was controversial, from its name to its tactics. "Why Queer?" a flyer asked. "Do we really have to use that word? When will you militants grow up and get over the novelty of being different?" To Queer Nationalists, "using 'queer' is a way of reminding us how we are perceived by the rest of the world . . . a way of telling ourselves we don't have to be witty and charming people who keep our lives discreet and marginalized in the straight world." Unlike *gay*, Queer Nation posited, *queer* "doesn't mean MALE," and, when used within the community, "it's a way of suggesting we close ranks."

But nothing was as controversial as "I Hate Straights," an essay in which the phrase *I Hate Straights* appears only in the title, superimposed over the rest of the text.* The piece, writer Nina Reyes explained, called for queer self-determination—"regardless of how that makes our straight families and friends feel—and reminds us that even putatively gay-friendly straights still relentlessly shove the accoutrements of their heterosexuality in our faces." The authors—David Robinson and Avram Finkelstein—chided queer people who'd "damaged our queer integrity by worrying that we may be flaunting it," when the goal was to amplify the "brave, strong queers" who made up society's "guts and brains and souls."

* Although "I HATE STRAIGHTS," as a stand-alone line, was *not* in the essay—and, in fact, the essay's opening lines read, "I have friends. Some of them are straight"—but *was* prominently superimposed over the text itself, much of the criticism and outrage assumed that the piece was an assault on all straight people, which it plainly was not. But that was the point. Queer people, as the essay said, were no longer willing to tolerate "straight people who can't listen to queer anger without saying 'hey, all straight people aren't like that. I'm straight too, you know,' as if their egos don't get enough stroking." "Why must we take care of them?" the anonymous queers asked. Let straight people "figure out for themselves whether they deserve to be included in our anger." That, of course, "would mean listening to our anger, which they almost never do." In other words, the reaction to the essay by straight people (and many gays) proved one of the piece's essential points: queer anger isn't about individual heterosexuals as much as the oppressive society created by heterosexual normativity and perpetuated by every heteronormative individual. For reference, though, another essay in *Queers Read This*, simply called "I hate," does include the line "I hate straights."

The essay dropped like a bomb into a fractured community, touching the "raw nerve" of an already self-conscious group. "You don't tell people who are being killed not to be mad about it," said Maria Maggenti, articulating one side of the debate. The other side, activist Nick Mulcahy said, believed "hatred, however understandable, corrodes and, in large enough doses, kills." Larry Kramer thought that "only in our immature community would it create such a ruckus."

Activists Omar Andrade and Robert McVey weren't surprised by the uproar, especially not from straight people: "Such a well-written expression of just anger could do nothing but bring to light [people's] most deep-seated homophobic and insecure responses," they wrote. If the straights declaring themselves pro-queer really are, "they will recognize in the instance of this essay that sometimes queers just need to have a sense of community, common experience and language without being apologetic and without having to give Homosexuality 101 lectures." And as for queer people attacking the essay, "by not owning their anger, by making nice to straights, they remain victims forever," incapable of realizing the fundamental truths at the heart of "I Hate Straights": "queers are immeasurably valuable, we have a right to feel angry and defend ourselves, the fact that we are alive at all in this straight-run world is a miracle, the fact that we fuck is a political act."

In July, stickers appeared in the Castro: "Fight Homophobia: Queer Nation meets every Wednesday"; three hundred people showed up for the first meeting. Philadelphia, Boston, Providence, Seattle, L.A., Houston, Salt Lake City, and others soon followed. Queer Nation was about more than antiviolence, attempting to address concerns of queer people *as* queer people. Chapters attacked media misrepresentation, racism, biphobia, transphobia, the Gulf War, heteronormativity in schools, suburban shopping malls, the Church, sexism, and the gay establishment. Known for stark graphics and aggressive chants—"We're here! We're queer! Get used to it!"—Queer Nation ushered in a new wave of identity politics, acknowledging—*finally*—the anger of underrepresented subpopulations within the queer community.[69]

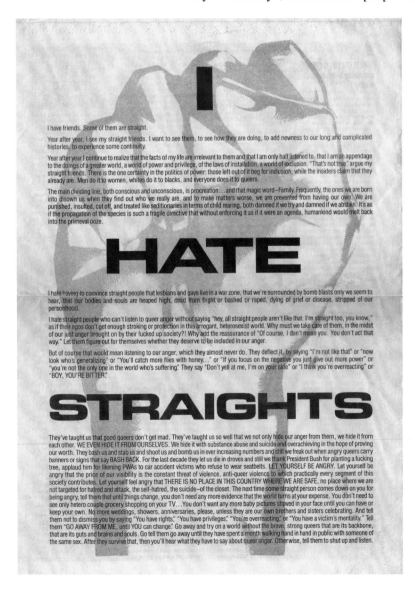

◀ "I Hate Straights," anonymous queers, New York City, June 1990. Image in the public domain, used with thanks to David Robinson and Avram Finkelstein.

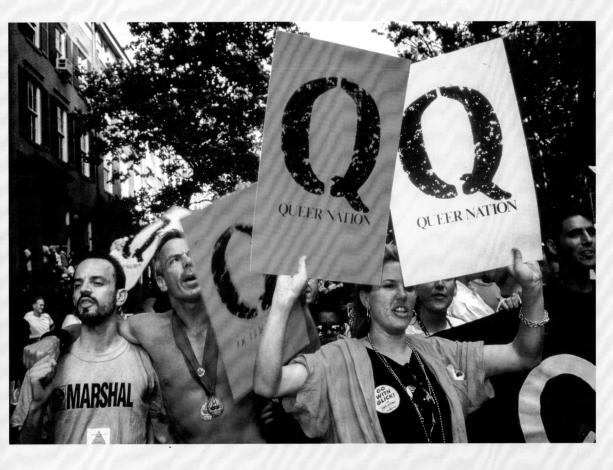

◀ **Left** Queer Nation, New York City, c. 1990. Photographer unknown. From the authors' collection.

▼ **Below** Queer Nation, New York City, 1990. Photo/copyright © by Dona Ann McAdams.

▶ **Following Spread** International Lesbian & Gay Freedom Day, San Francisco, June 24, 1990. Activist Ggreg Taylor is at front. Photo/copyright © by Daniel Nicoletta.

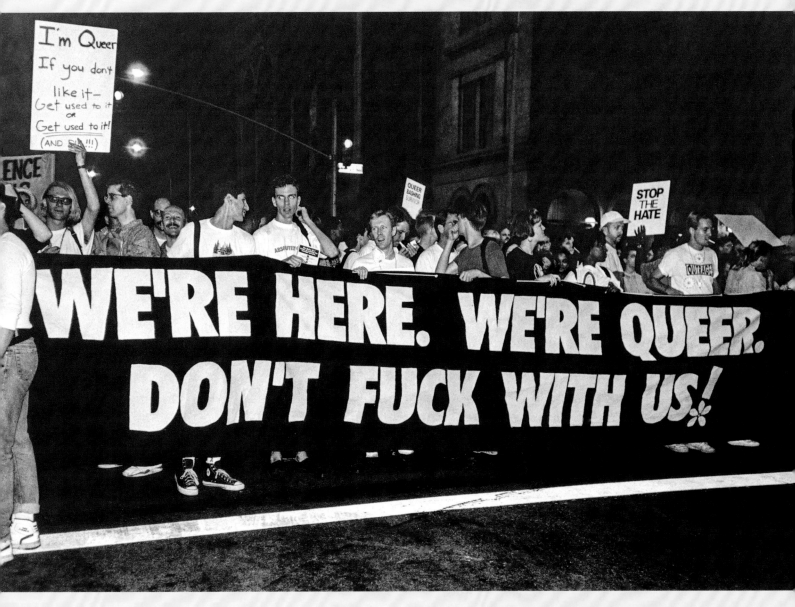

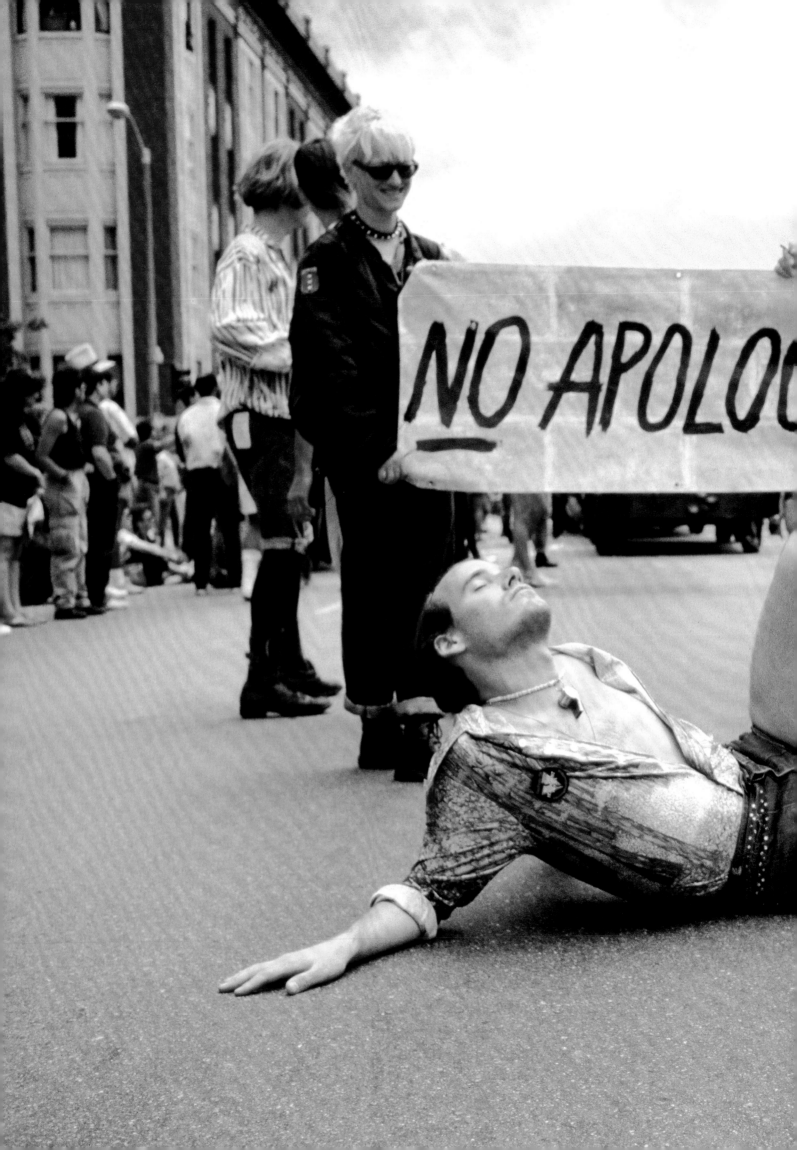

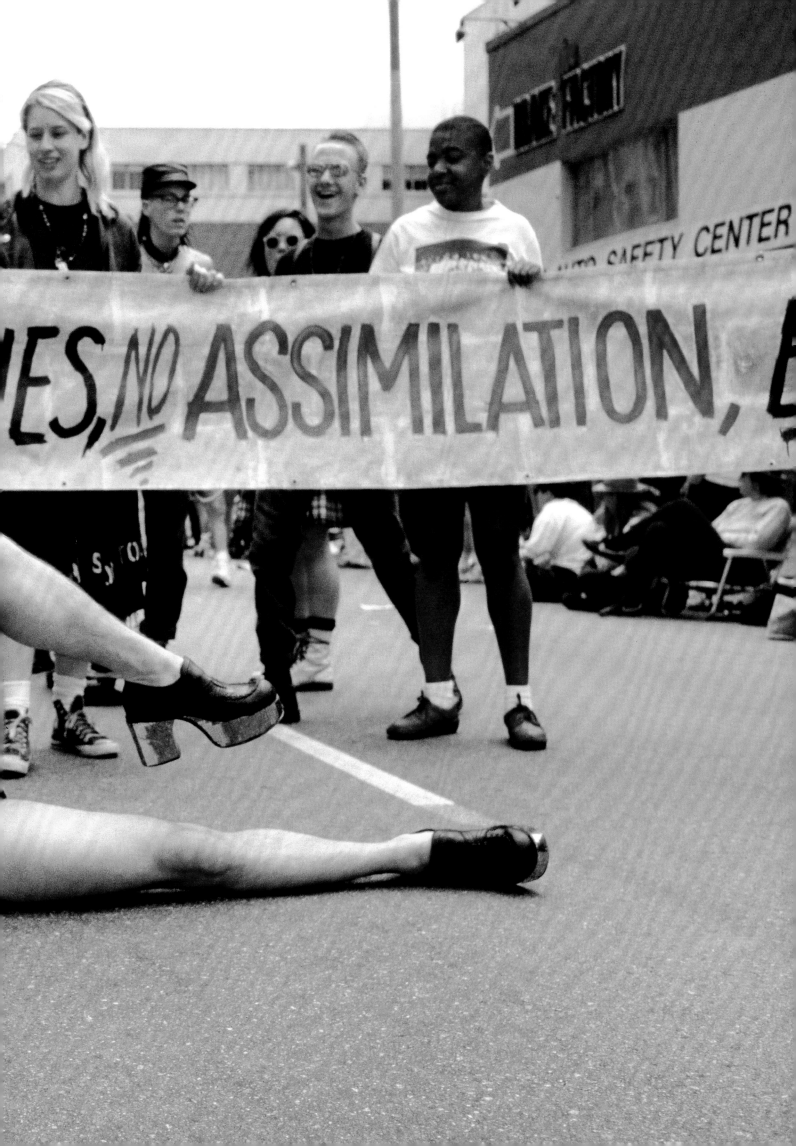

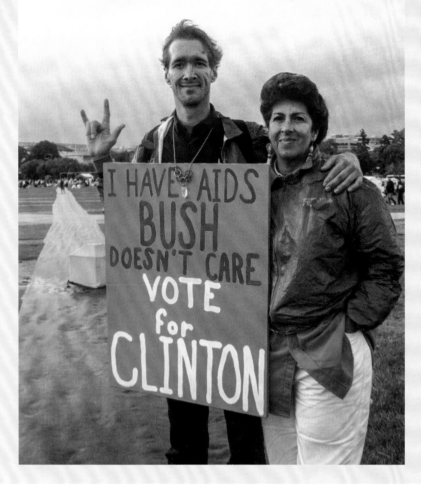

◀ **Left** AIDS Memorial Quilt viewers, Washington, D.C., Oct. 9, 1992. Photo by Elvert Barnes Photography. Licensed under a Creative Commons Attribution 2.0 Generic License, available at creativecommons.org/licenses/by/2.0/legalcode.

▼ **Below** Vito Russo delivers his "Why We Fight" speech, Washington, D.C., Oct. 10, 1988. Photo/copyright © by Rick Gerharter.

▶ **Page 294** Marsha P. Johnson, Gay Liberation March on Albany, Albany, New York, Mar. 14, 1971. Photo by Diana Davies. Courtesy of Manuscripts and Archives Division, The New York Public Library.

▶ **Page 295** Marsha P. Johnson, New York City, May 1992. Photo by Randy Wicker. Used with permission of Randy Wicker.

By early 1992, presidential politics took center stage. After twelve years of a Republican White House, Bush was vulnerable, though none of the potential Democratic candidates were particularly progressive on AIDS. With the media continually disinterested in covering the epidemic, the responsibility to push the issue fell, as always, on activists. Days before New York's primary, as presidential candidate Bill Clinton worked Manhattan for votes and dollars, ACT UP's Bob Rafsky attended a Clinton fund-raiser. Just as the candidate launched into his standard stump speech, Rafsky zapped.

"This is the center of the epidemic," he shouted. "What are you going to do about it? Are you going to start a war on AIDS?"

"I'm listening," Clinton said. "You can talk. I know how it hurts. I've got friends who've died of AIDS."

"Bill, we're not dying of AIDS as much as we are from eleven years of government neglect."

Clinton tried to respond with talking points, but Rafsky wasn't satisfied.

"Would you just calm down?" Clinton barked.

"I can't calm down," Rafsky responded. "I'm dying of AIDS while you're just dying of ambition."

At that point, Clinton lost his temper, grabbing the microphone stand and inching forward on stage. "Let me tell you something," he snapped. "If I was dying of ambition, I wouldn't stand up here and put up with all this crap. I'm fighting to change this country." Gaining strength from the supportive crowd, Clinton got going, telling Rafsky—in a line that defined his candidacy—"I feel your pain." If Rafsky wanted "somebody that'll fight AIDS," Clinton said, "vote for me, because when I come in to do something, I do it, and I fight for it." With that, Bill Clinton became the first presidential contender to unequivocally join the AIDS fight.

When he'd announced he wasn't dying of AIDS as much as from government neglect, Rafksy paraphrased Vito Russo, who would've loved the Clinton zap. And Marty Robinson, who'd made zapping a staple of queer resistance, would've taken delight in the press Rafsky drew. But Russo and Robinson both were dead. Robinson, in fact, had died just a week earlier. The day after Russo's memorial in November 1990, Ortez Alderson had died in Chicago.

"You may think you understand what it's like to face a mortal challenge," Rafsky wrote in an open letter to Clinton soon after he'd won the presidency, "but you don't. It's not enough to have had a college roommate who died of AIDS, or to hold the hand of someone living with it. For the uninfected, it takes a supreme act of the imagination, which is never easy. But only your imagination can put you in touch with the depth of my anger and sadness and fear."

Bob Rafsky died a month after Clinton's inauguration.[70]

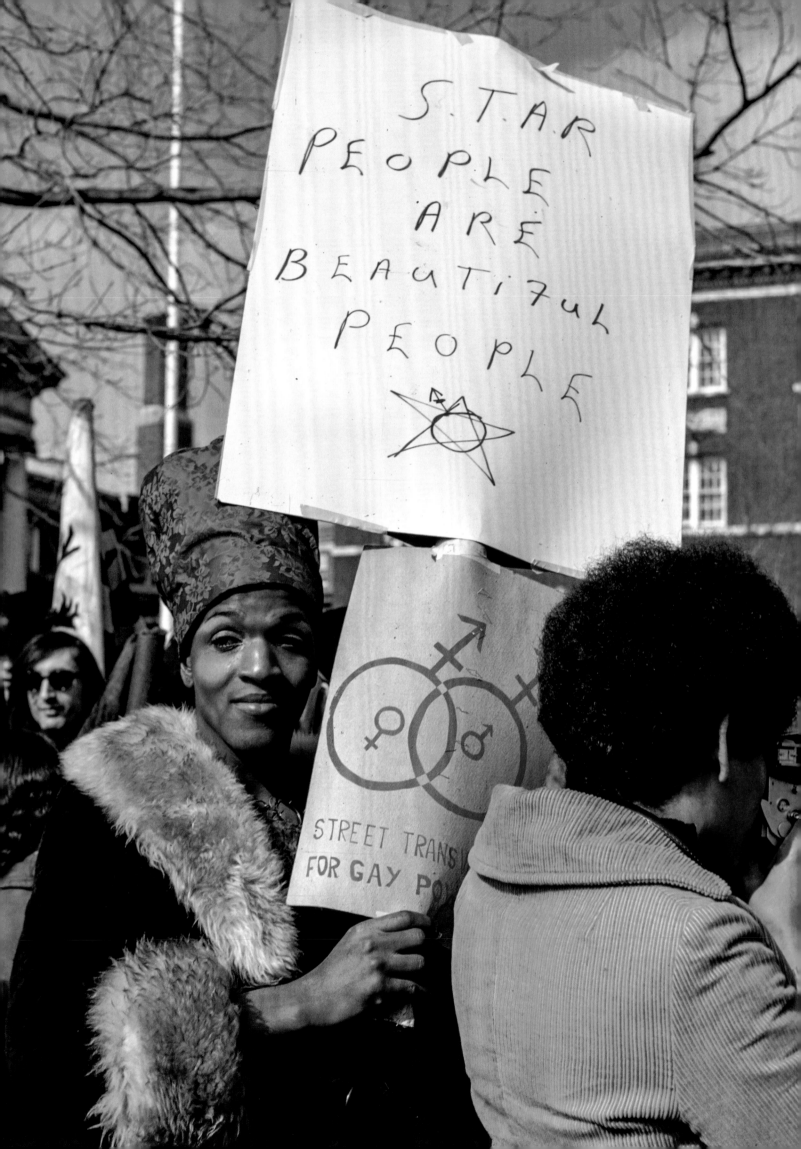

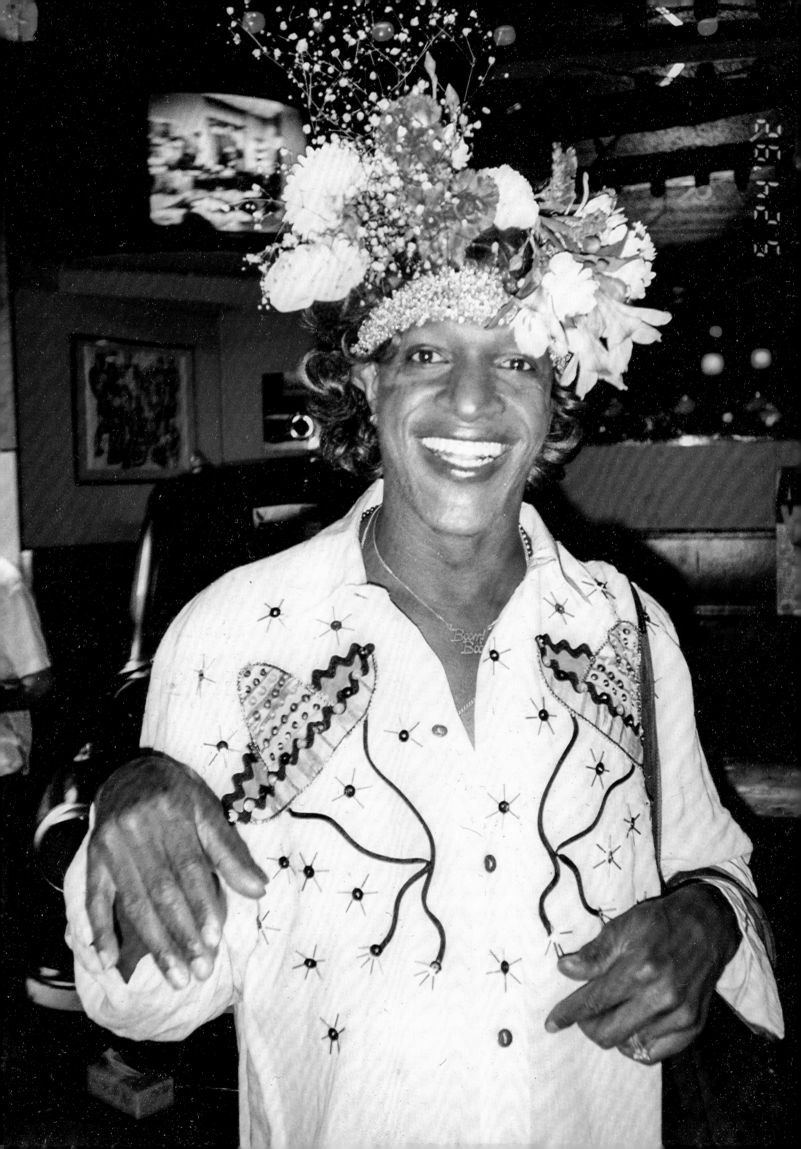

"I don't think that as long as people with AIDS and as long as gay people don't have their rights all across America, there's no reason for celebration. That's how come I been walking for gay rights all these years," Marsha P. Johnson said in June 1992. "Cause you never completely have your rights for one person until you all have your rights." Two days later, June 28, Marsha marched at Pride, as she had for twenty-two years. None of her friends ever saw her again.

A month later, exactly twenty-three years after Marsha and other gay liberationists marched through the Village for the first time as the Gay Liberation Front, hundreds of mourners made their way down Seventh Avenue from 13th Street, turning at Christopher, and ending at the spot on the waterfront where Marsha's body was found on July 6. As always, Bob Kohler took care of the details: police insisted the March stay on the sidewalks, but Kohler demanded the streets be closed. After all, "Marsha Johnson was gonna be carried to the river."

At the Christopher Street Pier, a cry went up as Kohler, Randy Wicker, and Sylvia Rivera opened a bag over the water and let Marsha's ashes fall into the Hudson.[71]

David Robinson, who'd written much of "I Hate Straights" before moving to San Francisco, returned to an ACT UP/NY meeting soon after Marsha's memorial with plans for a political funeral. When the AIDS Quilt came to D.C. in October, Robinson announced, he was going to march to the White House to deposit the ashes of his lover, Warren Krause, who'd died in April. Robinson wanted others to join him, though he planned on marching either way; he wanted George H. W. Bush to see that he and Ronald Reagan had "turned the people we love into ashes and bone chips."

At 1:00 p.m. on October 11, 1992, Robinson watched as Arthur Gursch held up a bag containing the ashes of his lover, Ortez Alderson. "This is Ortez," Gursch said, before he and Robinson and at least fourteen others carrying the cremated remains of loved ones led hundreds of marchers along the National Mall, past the AIDS Memorial Quilt, toward the White House. Except for a lone drummer setting a dirge's pace, the group at first was eerily quiet. As latecomers and onlookers joined, chants came up.

"Bringing the dead to your door / We won't take it anymore!"

"History will recall / Reagan and Bush did nothing at all!"

Approaching the South Lawn, in an amazingly choreographed display, the demonstrators broke into three groups: the first locked hands and cut west, distracting and blocking police; the second, risking arrest and physical harm, locked arms and blazed forward, creating a human barrier for the ash bearers; and the third, the bearers themselves, rushed to the South Lawn fence and emptied the ashes onto the White House's grounds.

In August 1981, Larry Kramer had announced that the number of recorded AIDS cases had tripled—from 40 to 120—in a month; by October 1992, there were 123 AIDS-related deaths in the United States *every day*. Nearly 100,000 queer men were dead already, and the numbers kept growing. The Quilt, which drew tens of thousands to D.C. that weekend, had grown from its original 1,920 panels to 20,064, covering fifteen acres when fully displayed. Breathtaking in its size, scope, and beauty, one couldn't approach the Quilt without being moved. What's more, it was uniquely approachable, its display drawing "a cross-section of America: family members and friends, tourists and casual visitors." The *Washington Post* noted the large number of parents who brought their children to the Quilt that weekend, like the mother and her ten-year-old daughter admiring a panel as a man sobbed nearby.

"This was my lover," he said. "I made that square for him." "You should be very proud of yourself," the woman said before turning to her daughter: "That man was his best friend. He made the quilt because he loved him."

This, the *Post* said, "was the kind of moment many parents sought."

But "that man" hadn't made the panel only for his *best friend*; he'd made it for his *lover*, his *homosexual partner*, someone who'd died because too few people were capable of acknowledging his queerness. "They still don't have a cure for it, and they haven't

▼ ACT UP members, including David Mager (far left) and David Robinson (second from left), deliver the ashes of loved ones who'd died from AIDS to the White House, Washington, D.C., Oct. 11, 1992. Photo/copyright © by Allan Clear.

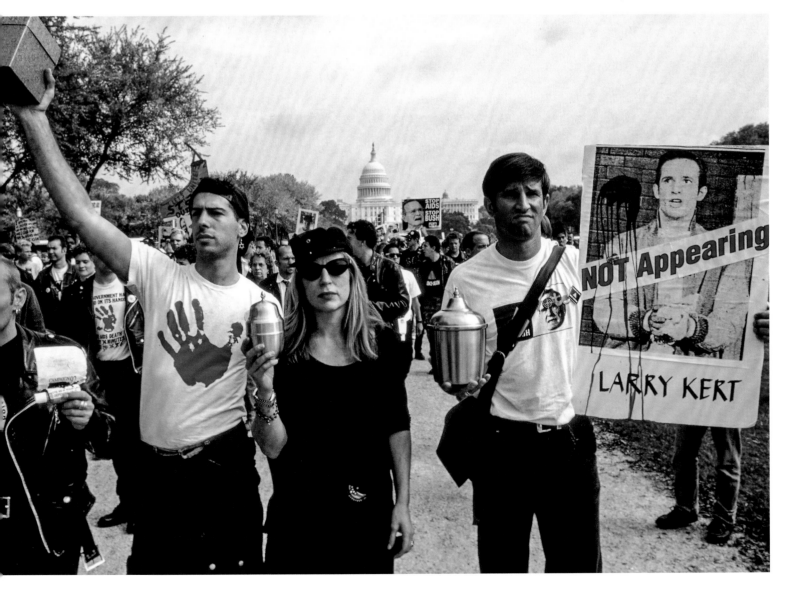

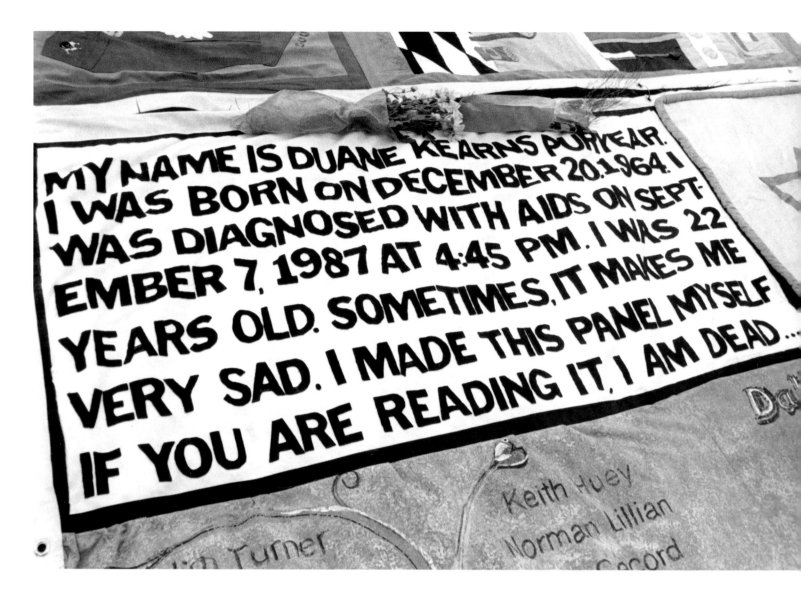

MY NAME IS DUANE KEARNS PURYEAR. I WAS BORN ON DECEMBER 20, 1964. I WAS DIAGNOSED WITH AIDS ON SEPTEMBER 7, 1987 AT 4:45 PM. I WAS 22 YEARS OLD. SOMETIMES, IT MAKES ME VERY SAD. I MADE THIS PANEL MYSELF. IF YOU ARE READING IT, I AM DEAD...

▲ **Above** Duane Puryear, a Dallas AIDS activist, made his own panel for the AIDS Memorial Quilt, seen here in Washington, D.C., Oct. 10, 1992. Photo by Fred W. McDarrah. Copyright © by Getty Images and the Estate of Fred W. McDarrah.

▶ **Right** A panel on the AIDS Memorial Quilt expresses how many in the queer community felt about Republican fund-raiser Terry Dolan, Washington, D.C., Oct. 1992. Photo by Larry Butler. Courtesy of the Botts Collection of LGBT History (Butler collection).

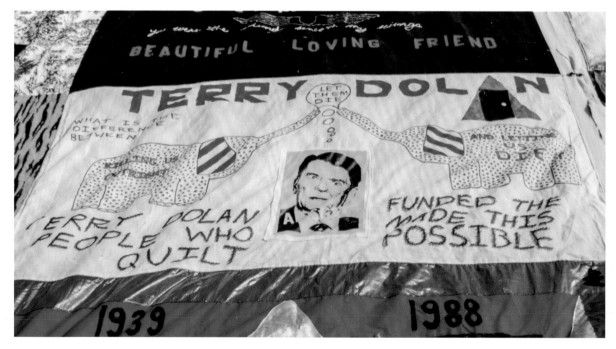

been doing enough to find one," a father told his daughter. "A lot of these names might not be on here if they had done more."

While the Quilt breathed life into faceless statistics, it did little to confront the central reality of AIDS: death. "Each individual AIDS death," British AIDS activist Simon Watney wrote, "is also a political event, a life that American politics has disallowed." And eleven years into the epidemic, the desperation and rage of those disproportionately impacted—the "*specific* lives that have been disallowed"—still didn't get the attention necessary. The media had "shown AIDS in relation to medical researchers; lonely, isolated 'victims'; furious activists; and so on," but "it is *death* that has been consistently ruled out of the picture." For the queer community, though, death was everywhere. "Out of every corner of my eye," Chicago's Jon Henri-Damski said, "I see the faces of people I have lost, and hug the bony bodies of guys who may be gone soon. The loss, the tears, the human terror and disbelief is constant." But AIDS *still* hadn't been treated as a truly serious issue, "let alone an unparalleled tragedy."[72]

The Ashes Action was the culmination of decades of queer activism, "inside" and "outside." Gay men carrying remains of radical queens like Ortez Alderson joined Midwestern mothers taking their sons to rest; longtime activist Alexis Danzig brought ashes to mourn her father, and Bob Rafsky, himself a dad, spoke of the destruction still unfolding. "The procession was the Quilt come to life," Avram Finkelstein wrote. "It connected me for the first time to the anger and grief of thousands of others."[73]

A few weeks later, on November 3, 1992, Bill Clinton beat George H. W. Bush in the race for the presidency, but that wasn't the only closely watched battle at the polls. Among the others were two state initiatives, Oregon's Measure 9 and Colorado's Amendment 2, both of which would substantially limit queer people's access to anti-discrimination protections. Amendment 2 passed, disallowing any law granting "special protections" to gays, lesbians, and bisexuals. The amendment was the work of an ever-more sophisticated right-wing political machine, though a federal judge quickly blocked the law's enforcement, setting up a legal battle that ultimately resulted in the most significant gay victory at the U.S. Supreme Court since the *ONE* decision in 1958.

Oregon's Measure 9 failed, but the vicious anti-queer campaign waged by the Oregon Citizens Alliance, a violently conservative political committee, did lasting damage. On September 26, 1992, for example, just weeks before the vote, a group of white supremacists threw a firebomb into the Salem apartment of Hattie Mae Cohens, a Black lesbian, and Brian Mock, a gay man with an intellectual disability. Mock, who was still recovering from reconstructive surgery he'd needed after a previous attack, had moved in with Cohens for protection. Their deaths received virtually no national attention, though some in the queer community took notice.[74]

"I used to think Anita Bryant was a joke," New York activist Marlene Colburn said, "but she seems to have spawned things that are far more terrifying than anything she could have dreamed up." During an interview for New York's *Radical Chick* magazine, Colburn and writer-activist Sarah Schulman discussed Brian Mock and Hattie Mae Cohens, whose murders profoundly impacted the Lesbian Avengers, a new direct-action

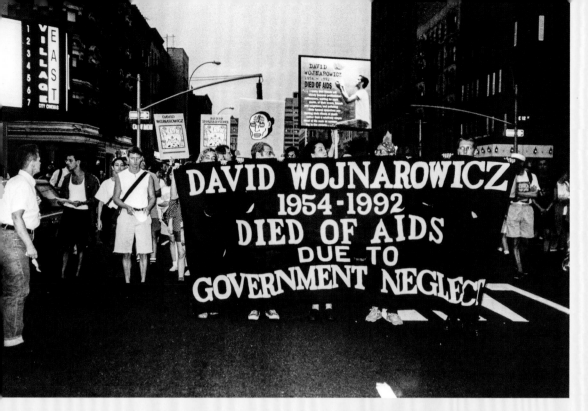

▲ **Top** Political funeral of David Wojnarowicz, New York City, July 1992. Photo/copyright © by Dona Ann McAdams.

"I imagine what it would be like if, each time a lover, friend or stranger died of [AIDS]," David Wojnarowicz wrote in 1991, "their friends, lovers or neighbors would take the dead body and drive with it in a car a hundred miles an hour to washington d.c. and blast through the gates of the white house and come to a screeching halt before the entrance and dump their lifeless form on the front steps." Wojnarowicz's words often are cited as the inspiration for ACT UP's stunning political funerals, including the Ashes Action, during which the fallen were carried through the streets to show the world the reality of AIDS. See Wojnarowicz, "Postcards from America: X Rays from Hell," *Close to the Knives: A Memoir of Disintegration* (New York: Vintage Books, 1991), 122.

▲ **Above** Above Ashes Action, Washington, D.C., Oct. 11, 1992. Photo/copyright © by Allan Clear.

◀ **Left** Maxine Wolfe speaks as the Lesbian Avengers reunite Gertrude Stein and Alice Toklas, New York City, Feb. 1993. Photo/copyright © by Saskia Scheffer.

group cofounded by Maxine Wolfe. In late October, the Avengers—a group "focused on issues vital to Lesbian survival and visibility"—honored Mock and Cohens with a three-day antiviolence vigil, during which members introduced their signature act of resistance: eating fire amid chants of "the fire will not consume us, we take it and make it our own."

In the Avengers, younger radical activists shaped by realities of the late 1980s and early 1990s collided with older Lesbian Feminists who'd helped build the Movement. "Sometimes," Colburn said, "the younger women and I are on two different planes because they take a lot of things for granted. . . . I know that at any moment everything we've won can all be taken away."

"My ultimate dream," she said, "is that if you walk down the street and someone calls you a dyke, it's not because they want to bash you, it's because it's your best friend."[75]

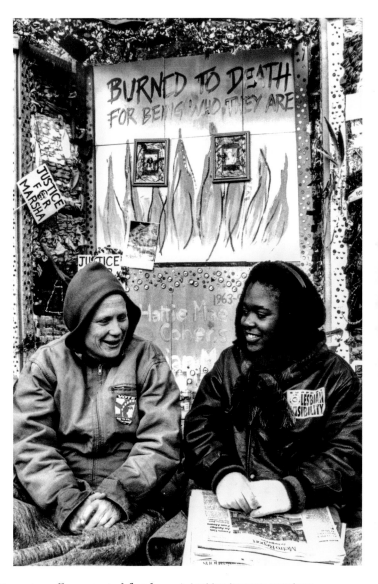

▲ Lesbian Avengers members keep vigil in memory of Hattie Mae Cohens and Brian Mock; "Justice for Marsha" signs, a reference to Marsha P. Johnson and the lack of meaningful police investigation following her death, hang in the background, New York City, Nov. 1992. Photo/copyright © by Carolina Kroon.

With a relatively friendly president in the White House, mainstream gay and lesbian leaders roared back into D.C., refocusing efforts on federal legislation and executive orders. Picking up where the National Gay Task Force and Leonard Matlovich had left off before Anita Bryant, well-connected fundraisers such as Los Angeles's David Mixner emphasized Clinton's promise to lift the ban on queer military members. The mainstreamers, said Mark Harrington, "kind of hijacked the whole gay agenda and turned it into gays in the military." And, in the first of many disappointments, Clinton balked, unveiling the "Don't Ask, Don't Tell" policy as an alternative to lifting the ban. Under the "compromise" policy, military officials no longer asked inductees about sexuality, and queer servicemembers were "allowed" to serve without harassment, provided they did not tell anyone they were queer. Queer people's obligation to "Don't Tell" was nonnegotiable, whereas the military could generally ignore the "Don't Ask" side of the bargain if a soldier or sailor was "suspected" of being queer. In practice, the policy of the "gay-friendly" new president helped create homophobia rather than ease it. "We fell for his pitch hook, line and sinker," Larry Kramer wrote.

Although a third March on Washington had been in the works for years, Clinton's victory and subsequent backtracking convinced mainstream organizations it was more important than ever to focus on majority-friendly gays and lesbians. The Movement, the reasoning went, "should not demand explicit support for homo*sexual* practices, but

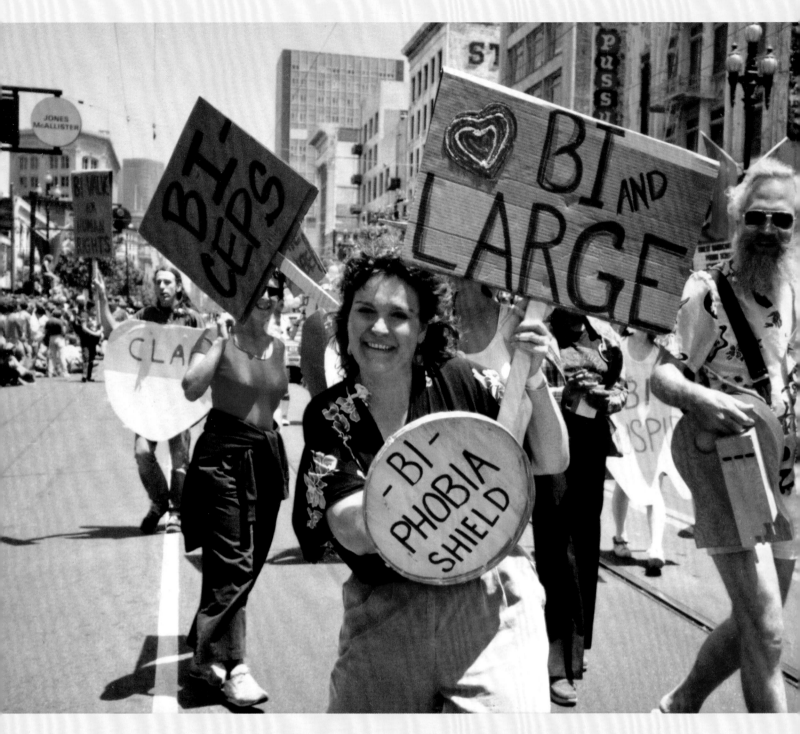

▲ **Above** Lani Ka'ahumanu, International
Lesbian & Gay Freedom Day, San Francisco,
June 24, 1984. Photo by Arlene Krantz. Used
with permission of Lani Ka'ahumanu.

▶ **Opposite** Anti-biphobia pinback, Bisexual
Information Center, New York City, c. 1988. From
the authors' collection.

should instead take *antidiscrimination* as its theme," focusing on *human* rights as opposed to *homosexual* rights. And that required the end of "gay pride marches featuring men in tutus, dykes on bikes, or other shock tactics" in favor of marches, like the April 1993 March on Washington, led by gays and lesbians in uniform.[76]

Try as they might, though, mainstream organizers couldn't silence the radicals.

"As a longtime activist," Lani Ka'ahumanu wrote, "the last five years have been incredibly rewarding." After the 1987 March on Washington, which Ka'ahumanu described as the moment "our national movement was born," bisexuals came under withering assault. "The male bisexual," the *New York Times* said, "cloaked in myth and his own secretiveness, has become the bogeyman of the late 1980s," as doctors and the media blamed an increase in AIDS among heterosexual women on dishonest bisexual men. Straight women, one doctor said, "are going to discover some very unpleasant news about some men they have known."

In response to the virulent ignorance, and with support from militant younger queers, activists formed BiNET USA, a national network dedicated to fighting biphobia through increased visibility. Virtually as soon as planning for a third national March started, BiNET began lobbying for bisexual inclusion in the official title of the event. At a National Steering Committee meeting in early 1992, a heated debate unfolded, with the Bisexual Caucus and its allies pushing for "The March on Washington for Lesbian, Gay and Bisexual Rights." Forced by moderate gays and lesbians into a compromise that left transgender people out, again, *and* erased the word "sexual," the *Bi* Caucus prevailed with "The 1993 March on Washington for Lesbian, Gay and Bi Equal Rights and Liberation."

"Are bisexuals visible yet?" Lani Ka'ahumanu asked the crowd of hundreds of thousands in D.C. on April 25, 1993. "You bet your sweet ass we are!" Explicitly tying the fight for bisexual inclusion to the struggles of the transgender community, Ka'ahumanu demanded a "sincere effort to confront biphobia and transphobia by the established gay and lesbian leadership in this country."

"Remember," she declared, "assimilation is a lie. It is spiritual erasure. Our visibility is a sign of revolt. We cannot be stopped. We are everywhere. We are bisexual, lesbian, gay, and transgender people."

While Ka'ahumanu's address was meaningful to transgender activists, an earlier speech had been "the most exhilarating moment" of a weekend that marked a turning point for the "newly-emergent transgender movement." What was expected to be a "gracious thank-you to the queer community for the newfound recognition" became a stern dressing down for ongoing transphobia, and "a demand for an immediate end to it." The speaker, Houston's Phyllis Frye, had waited long enough.[77]

The Lesbian Avengers who'd been to previous national marches knew "the focus was always on gay men and that lesbians disappeared in the media coverage." Determined to avoid that this time, New York's Avengers worked with lesbian and

bisexual activists around the United States—many from within ACT UP and Queer Nation, others from independent groups like L.A.'s Puss n' Boots—to plan an unofficial March the night before the big event. Using sheer grassroots power, the word spread, and twenty thousand dykes showed up on April 24 for the first Dyke March. As the huge crowd passed the White House, a group of Avengers ate fire while the masses chanted, "the fire will not consume us, we take it and make it our own."[78]

The next day, an even bigger group—about four hundred thousand people—marched by the White House, where Frank Kameny and the homophiles had picketed on one side and David Robinson and the mourners had scattered ashes on the other; past Lafayette Park, once an epicenter of romance and vice arrests; down Pennsylvania Avenue, where Phyllis Frye and Clint Moncrief had marched in 1979 and hundreds of PWAs had led the community in 1987; and finally to the Mall, where Audre Lorde had insisted "not one of us will ever be free until we are all free" and the Quilt grew with each passing year.

Troy Perry was in D.C. for the 1993 March, as were Jeanne Córdova and her partner Lynn Harris Ballen. José Sarria was there, and, of course, Frank Kameny wouldn't miss a hometown affair. Larry Kramer and Virginia Apuzzo talked, and Urvashi Vaid mingled with drag sensation RuPaul. Big names from outside the community—Jesse Jackson, Judith Light, David Dinkins—spoke to the crowd, but the warmest welcome of all went to a man introduced as "one of the great, great heroes of our movement."

"You're a sight for sore eyes," said a beaming Michael Callen, who'd moved to New York City years earlier to be a singer. Remarkably, even as a full-time activist, he'd managed to find musical success, achieving some fame with "Love Don't Need a Reason," considered the anthem of the early AIDS years. "Love don't need a reason," an emaciated Callen sang in D.C., "love's never a crime, and love is all we have for now, what we don't have is time."

Michael Callen died on December 27, 1993; he was thirty-eight.[79]

"People used to say we 'looked gay,'" Leslie Feinberg said, "but in fact it was not our sexual preference that made us visible, it was our *gender expression*. We were transgendered." Feinberg was in Kansas City, Missouri, during Pride 1993, where they spoke with Davina Anne Gabriel for *TransSisters*, a journal "dealing specifically with issues of transsexuality from a feminist perspective."

"For a long time," Feinberg summarized, "it was the transgendered community that was the observable tip of a huge submerged population. We fought the battles resulting from our intertwined oppressions and those struggles ignited the four day uprising in 1969," the Stonewall Riots. Despite their role in starting the fight, though, "butches, femmes and drag queens" were soon dismissed as embarrassing stereotypes, and transgender women "were charged with 'mocking women's oppression.' We were labeled *oppressors*," Feinberg emphasized. The problem stemmed from language and

◀ **Left** Eric von Schmetterling, ADAPT (formerly Americans Disabled for Accessible Public Transit; and Americans Disabled Attendant Programs Today), March on Washington for Lesbian, Gay, and Bi Equal Rights and Liberation, Washington, D.C., Apr. 25, 1993. Photo by Fred W. McDarrah. Copyright © by Getty Images and the Estate of Fred W. McDarrah.

▼ **Below** Jeanne Córdova (left) and Urvashi Vaid (right), March on Washington for Lesbian, Gay, and Bi Equal Rights and Liberation, Washington, D.C., Apr. 25, 1993. Photo/copyright © by Lynn Harris Ballen. Courtesy of the ONE Archives at the USC Libraries (Córdova collection; 2008-064).

▼ **Bottom** Dyke March, Washington, D.C., Apr. 24, 1993. Photo/copyright © by Dona Ann McAdams.

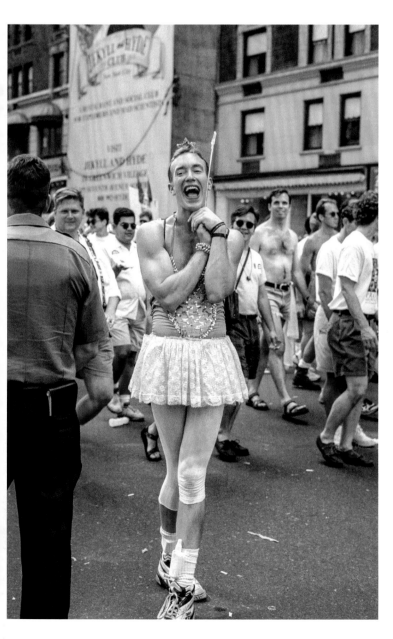

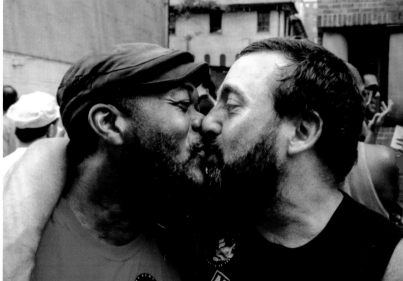

▲ **Top** March on Washington for Lesbian, Gay, and Bi Equal Rights and Liberation, Washington, D.C., Apr. 25, 1993. Photo by William S. Tom. Courtesy of the ONE Archives at the USC Libraries (Tom photographs; 2008-017).

▲ **Above** Ken and Mark, Gay and Lesbian Pride Day, Washington, D.C., June 1994. Photo by Elvert Barnes Photography. Licensed under a Creative Commons Attribution 2.0 Generic License, available at creativecommons.org/licenses/by/ 2.0/legalcode.

◀ **Left** Stonewall 25, New York City, June 26, 1994. Photo/ copyright © by Robert Fisch.

◀ **Opposite** Lesbian Avengers eat fire in front of the White House, Dyke March, Washington, D.C., Apr. 24, 1993. Photo/ copyright © by Carolina Kroon.

the confusion it caused in historical narratives. "We didn't have the language to explain that we are in fact an integral part of the oppressed. We didn't have the history at our fingertips to prove that transgender has always been a part of human self-expression." But if the recent National March showed anything, it was that a new movement had emerged—"the movement for transgender liberation."[80]

In New York, Yvonne Ritter joined the Transgender Liberation Movement decades after she'd first been involved with Gay Lib. She still remembered the big plans she'd had for her eighteenth birthday in June 1969: sneaking the perfect dress from her mom's closet, she trekked to her friend Kiki's in Brooklyn, where the friends dressed, did their makeup, and drank as their excitement grew. They'd never been out together "as women."

"I was nervous," Yvonne remembered. "People would say I was a drag queen, but I always felt like a woman, so this was more natural dress than I'd usually be in." Once they were ready, she and Kiki headed for their favorite Village bar: the Stonewall Inn. Later that night, Yvonne was one of a handful of "drag queens" arrested and paraded outside into a paddy wagon. As opposed to other raids, though, each time a cop led a queen out that night, the crowd in Sheridan Square got rowdier, until eventually a butch lesbian put up a fight and all hell broke loose. During the melee—the start of the Stonewall Riots—Yvonne sneaked out of the wagon and joined the action.

In 1994, twenty-five years later, she excoriated organizers of Stonewall 25 for again refusing to include the word *transgender* in the title of a queer event. At Stonewall, she said, "I protested shoulder to shoulder with my lesbian, gay, bisexual, and transgendered brothers and sisters for the right to be validated and treated like a person. I wasn't a second-class citizen then and won't be treated like one now!"

There was significant backlash to Stonewall 25's exclusionary decision, as Phyllis Frye guaranteed massive civil disobedience, and Denise Norris and Riki Wilchins launched a direct-action group, the Transsexual Menace, to fight back. The transgender community was more visible than ever during Stonewall 25, as contingents marched in both the official parade and the Alternative March. The enormous Second Annual Dyke March, held the night before the competing Stonewall 25 marches, welcomed countless transgender lesbians, including Wilchins, a proud Avenger.[81]

Two months later, as Transsexual Menace members handed out literature at Camp Trans—the protest area set up across from August's Michigan Womyn's Music Festival—Hillary Smith, a Portland Avenger, recognized Wilchins from Stonewall 25. Although both were Avengers, only Smith could enter the festival itself; if Wilchins tried, she'd face expulsion due to the ambiguous-but-cruel "womyn-born-womyn" policy.

"We're having an Avengers meeting on Saturday and you should come," Smith said. "Send me an escort," Wilchins replied. And that's how it happened.

On Saturday, August 13, 1994, "a sundry mix of Avengers and leather women" surrounded a group from Camp Trans—Wilchins, Rica Frederickson, Jessica Xavier, April Fredricks, Zythyra Austen, Davina Anne Gabriel, Leslie Feinberg, Minnie Bruce

Pratt, Kodi Hendrix, Sandra Cole, and photographer Mariette Pathy Allen—and walked into the Michigan Womyn's Music Festival.

It was a symbolic event, as they all knew; but, like so many previous symbolic events, it was a start.

"The only way we can build real solidarity in our movements," Feinberg told a crowd, "is to be the best fighters of each other's oppressions. It's the kind of solidarity that's forged in the heat of struggle that makes lasting bonds."[82]

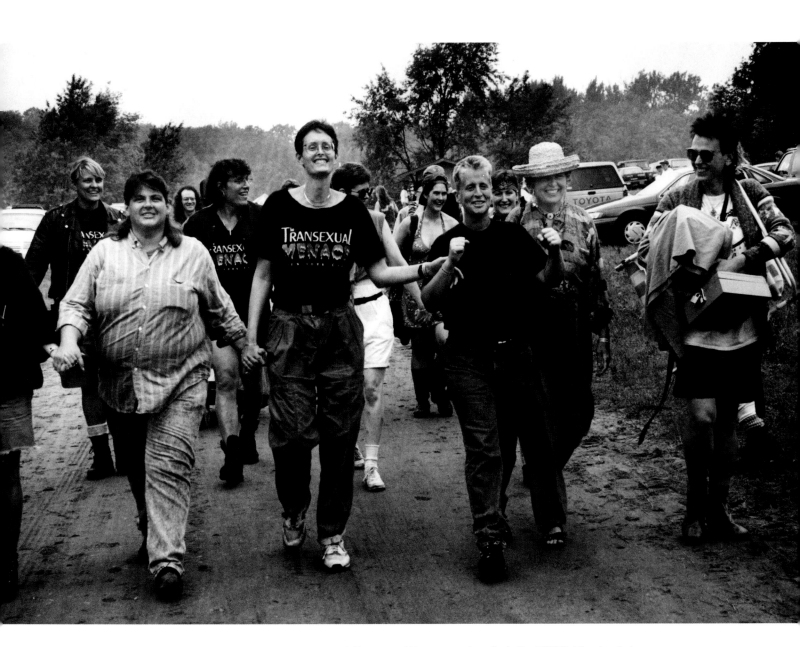

▲ Transsexual Menace members (including Riki Wilchins, fourth from right, Leslie Feinberg, third from right, and Professor Minnie Bruce Pratt, in hat), surrounded by Lesbian Avengers and other lesbian activists, walk onto the grounds of the Michigan Womyn's Music Festival, Oceana County, Michigan, Aug. 13, 1994. Photo/copyright © by Mariette Pathy Allen, www.mariettepathyallen.com.

Until Next TIME

We are at once marginal and mainstream, at once assimilated and irreconcilably queer.

—URVASHI VAID, 1995

Provincetown, 2017

After an August 2017 gathering of neo-Nazis in Charlottesville, Virginia, predictably turned violent, the president of the United States condemned the "egregious display of hatred, bigotry, and violence on many sides," explaining two days later, there'd been "a group on one side that was bad [and] a group on the other side that was also violent." Days of large-scale protests followed, though neither Charlottesville nor the president's false equivalence between Nazis and their ideological opponents were anomalous. After decades of successfully blurring the lines between church and state, piety and power, and faith and fascism, the New Right was responsible both for what happened at Charlottesville and the political success of a president who tacitly endorsed Nazi aggression. As the Greenwich Village protester had said of Roger Fulton's Neighborhood Church in 1981, Charlottesville was just another "part of something that seems to be growing in this country, something that's racist, that's sexist, that's homophobic."

August is busy in Provincetown; that the local "Solidarity with Charlottesville" event started right as the Boatslip's Tea Dance got under way didn't help attendance. Locals made up most of the seventy-five demonstrators outside the church on Commercial Street, and it felt less like a protest than a wake, complete with final moments for self-reflection and quiet discussion.

▲ Solidarity with Charlottesville vigil, Provincetown, Aug. 2017. Photo by Leighton Brown. Copyright © by Matthew Riemer and Leighton Brown.

That's when the chant started.

"ACT UP! Fight back! Fight Trump!"

Urvashi Vaid, who'd been fidgeting the whole time, looked around as she shouted, and soon others joined: Kate Clinton, the trailblazing comic and Vaid's life partner; Mary Kate Ellis, executive director of GLAAD; and Sue Hyde, the legendary activist who'd once told a crowd in front of the U.S. Supreme Court that it was their obligation to commit sodomy. When a few other voices chimed in, Vaid led the group through town, urging vacationing queers to join the resistance; none did.

With another funereal vigil over, another group of angry queers was making a scene. It was summer in Provincetown.

Reaching the west end of Commercial Street, the group numbered only half a dozen or so, including a D.C. couple—the one writing this book—who couldn't believe they'd found themselves marching with legends.

"This was fun," Vaid said. "Until next time."[1]

Twenty-three years earlier, in April 1994, Urvashi Vaid told a group of queer conference goers at Harvard that the "gay and lesbian liberation movement has turned into a gay and lesbian marketing movement." Stonewall 25, she said, "plans fairs, pavilions, souvenirs, catalogs to 'commemorate' the occasion, while voting to ban from the March's title the very drag queens and transvestites who made history at the Stonewall Inn." A year after stepping down from the National Gay and Lesbian Task Force (NGLTF) and two months before Stonewall 25, Vaid was on the speaking circuit, previewing ideas she'd fleshed out in her new book, *Virtual Equality*. While acknowledging the progress made since mid-century, she lambasted the notion of "mainstreaming," calling it "an illusion we hunger deeply to believe, because of our years spent in exile." Moreover, by aspiring to join the dominant culture, as opposed to changing it, "we risk losing our gay and lesbian souls in order to gain the world." Until everyone is safe, she said, "the movement continues."[2]

Later that summer, Professor Rusty Mae Moore and her partner Chelsea Goodwin moved into a house they'd bought in Brooklyn, inviting their friend and one-time lover Julia Murray along. Goodwin and Moore had met in 1991 when Times Square was still home to bars and clubs serving the trans community, including Sally's Hideaway, where the legendary Dorian Corey performed regularly, and after-hours balls featuring Octavia St. Laurent, Pepper LaBeija, and Paris Dupree got mainstream attention with the release of Jennie Livingston's 1991 film *Paris Is Burning*. The original Sally's, featured prominently in Livingston's film, opened in 1986 in the same space that had housed Blues Bar, which never really recovered from the 1983 raids.

Chelsea Goodwin performed at Sally's, and she and Moore were known at Sally's II, the new bar down the street that had opened when a fire closed the original. Whereas Moore was a "nice middle-class college professor" type, Goodwin was a hell-raiser, active in ACT UP and Queer Nation, friends with activists like Kathryn Otter, the proud transsexual lesbian who'd been arrested inside St. Patrick's during Stop the Church. Otter's in-your-face activism inspired Goodwin, as did stories of Marsha P. Johnson and Sylvia Rivera.

By the time Goodwin and Moore moved to Brooklyn, though, Marsha was dead and Sylvia was homeless, living on Christopher Street Pier with a tight-knit group of queer people. Although Goodwin had heard of S.T.A.R. House, she and Moore hadn't planned on bringing Sylvia's dream to life; it just happened that way. "It was sort of unique for trans people to own a house," Moore said, "so other people started to say, 'I need a place to live, can I come live with you?'"

For almost two decades, Transy House, as they called it, was *the* safe space for trans and queer youth in New York, home to as many as thirteen people at one time.[3]

▶ Sylvia Rivera, Christopher Street Pier, New York City, 1996. Photo/copyright © by Mariette Pathy Allen, www.mariettepathyallen.com.

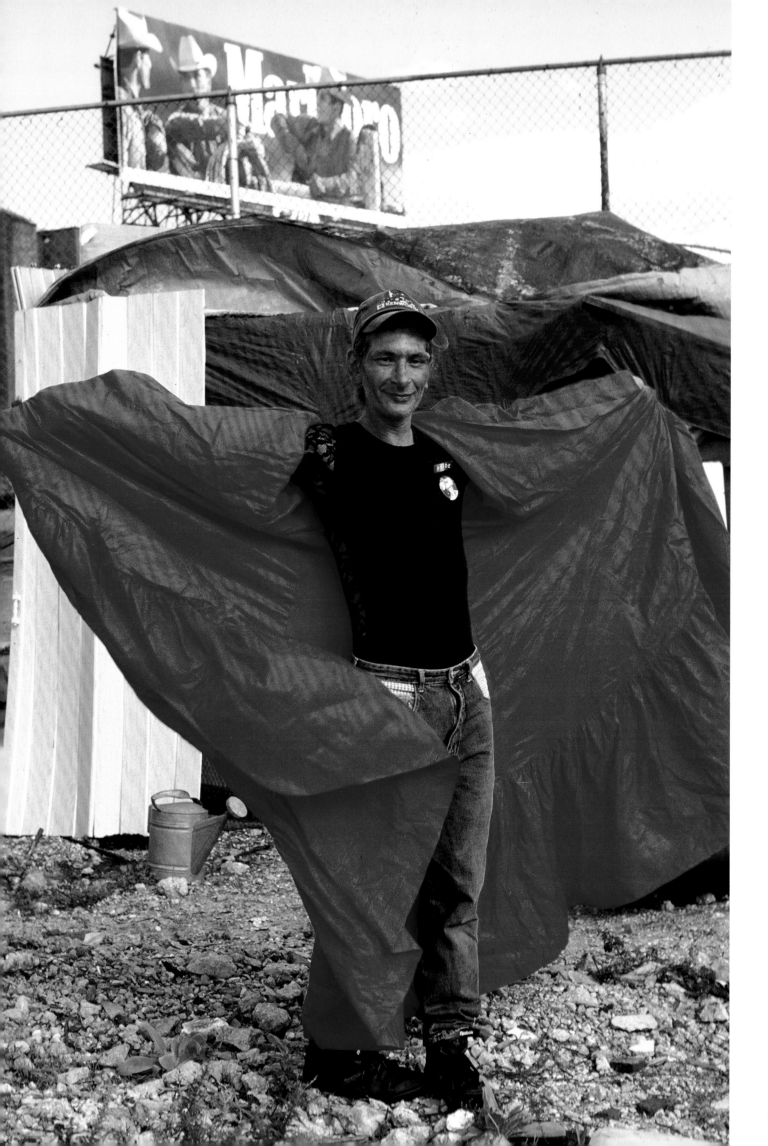

The *Village Voice* had a spotty record on gay and lesbian issues, and gays and lesbians had a spotty record on transgender issues. So in April 1994, when the *Voice* published lesbian writer Donna Minkowitz's exposé on the New Year's Eve 1993 murder of a small-town genderqueer person, it was safe to assume they'd get it wrong. And they did.

"Love Hurts," Minkowitz's 1994 article, purported to tell the story of Brandon Teena, "a woman [*sic*]" who'd been killed because "she lived and loved as a man." Despite having access to multiple sources with whom Brandon had discussed his gender identity, Minkowitz focused on tales of Brandon's preference for giving rather than receiving sexual pleasure in order to cast the narrative as one of a butch lesbian who'd been brutalized sexually—as Brandon had—rendering "her" incapable of experiencing pleasure "as a woman." The article was *the* leading account of Brandon's story, though it brought more attention to gender battles than to the nauseating details of Brandon's death: after being beaten and raped by John Lotter and Tom Nissen, Brandon bravely reported the crime, despite threats of retribution. Subjecting Brandon to a disgusting interrogation (". . . he stuck it in your box or your buttocks?"), Sheriff Charles Laux then waited days to take action, leaving Lotter and Nissen free to find Brandon and kill him along with Lisa Lambert and Phillip DeVine.

Days after Minkowitz's story ran, Leslie Feinberg stood outside the *Voice*'s offices and called the piece "sleazy, salacious psycho-sexual babble." What was worse, Feinberg said, it let the police "off the hook for their culpability in instigating the violence." As Feinberg spoke, a group of activists clad in Transsexual Menace shirts picketed and handed out flyers.[4]

In May 1995, Feinberg, Nancy Nangeroni, Kate Bornstein, Davina Anne Gabriel, Riki Wilchins, and other Menace members headed toward the Richardson County Courthouse in Falls City, Nebraska, for a vigil on the first day of John Lotter's trial. As forty activists stood on the courthouse steps, a group of neo-Nazis circled the block, stopping every so often to spit and shout at the Menace. Later that night, the activists "shared a small sense of empowerment, a sense that maybe things could change," while almost at the same moment, a transgender woman of color in Massachusetts, Deborah Forte, was being brutally murdered.[5]

A few months later in September, the Christian Coalition—founded by New Right icon Pat Robertson—held its annual convention at the Washington Hilton in D.C. Since Ronald Reagan's election in 1980, the evangelical conservative lobby had grown stronger with each passing year. A movement run by wealthy white men, the New Right had the privilege of playing the long game, focused not just on the next election, but on building an immovable draconian bloc. As Republicans lined up in 1995 to challenge Bill Clinton for the presidency, the Christian Coalition boasted nearly two million members, all staunchly anti-choice and anti-queer.

Equally problematic, according to Urvashi Vaid, was the increasing number of queer people who openly identified as conservative and/or Republican. As the New Right's

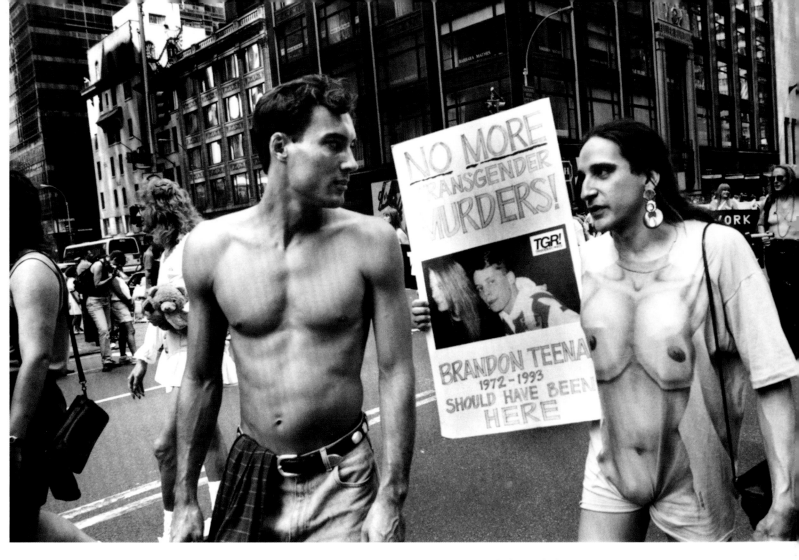

conservatism continued to thrive, Vaid said, the queer community needed to rededicate itself to fighting the "racist, sexist gay and lesbian right." With conservative queers attempting to poison the Movement under the cover of "a big tent," progressive activists had an obligation to "call them on it, name it, risk being called all kinds of names." At the Human Rights Campaign Fund (HRCF), however, newly named executive director Elizabeth Birch took a different approach, staging a press conference down the hall from the Christian Coalition's convention to read an "open letter" to evangelicals. Despite stereotypes, Birch said, "there are many conservative Americans within the nation's gay and lesbian communities." And if she was "confident in anything at all," it was that "our communities have more in common than we care to imagine," requiring them to "engage in an ethic of basic respect and decency."

While Birch spoke, proudly anti-queer candidates like U.S. senator Phil Gramm and Pat Buchanan received huge receptions down the hall.[6]

In early October 1995, Phyllis Frye and Vermont activist Karen Kerin coordinated National Gender Lobbying Day, as one hundred transgender activists visited the D.C. offices of every member of Congress. Although they had a number of issues to cover, the activists focused on the Employment Non-Discrimination Act (ENDA), a bill protecting gays, lesbians, and bisexuals from workplace discrimination *without* providing any protections based on gender identity. When first introduced in 1994, word spread

that the lack of transgender protections was the work, at least in part, of HRCF, which feared losing "gay-friendly" votes. For a year, trans activists worked to add language covering gender identity, only to have their efforts thwarted when ENDA reappeared in its original form in 1995.

According to one senator's aide, the transgender protections were removed after a direct request from HRCF lobbyists, who issued a press release in support of federal protection "for all Americans," adding that "we do not believe that changing the language of ENDA in its current form is the best way of accomplishing this goal."[7]

Chanelle Pickett and her twin sister, Gabrielle, worked in Marlborough, Massachusetts, before being transferred to an office in Braintree in early 1995. Almost immediately, Chanelle's new supervisor made her uncomfortable, apparently saying horrible things about the fact that Chanelle was a "pre-op" transsexual. Chanelle spoke to her supervisor's boss, but that made things worse. She was fired six weeks later, just before the Human Rights Campaign Fund (HRCF) removed protections for transgender employees from the Employment Non-Discrimination Act (ENDA). Lacking other options, Chanelle returned to sex work for survival. In November 1995, she went home with thirty-four-year-old William Palmer, a white man known for cruising the Playland and other trans-friendly bars. Palmer's roommates heard arguing after Chanelle arrived, but Palmer told them he had it under control. At some point after that, Palmer strangled Chanelle to death.

▲ National Gender Lobbying Day, Washington, D.C., Oct. 4, 1995. Photo/copyright © by Mariette Pathy Allen, www.mariettepathyallen.com.

Despite a parade of witnesses testifying to his preference for transgender women, Palmer claimed he hadn't known Chanelle was trans, and that "discovering" that fact sent him into a murderous rage. The so-called "trans panic" defense worked, and Palmer was acquitted of the murder charge, receiving only two years for assault and battery.[8]

Chanelle Pickett's murder should have been a turning point for every queer person in the United States, just as so many other acts of unchecked anti-queer aggression should have been. Maybe it's not fair to say that HRCF's efforts to keep transgender protections out of ENDA directly contributed to Chanelle's death; it's not unreasonable, however, to assume she might still be alive had the mainstream queer leaders honored the activism of Sylvia Rivera and Phyllis Frye as much as they had the work of Harvey Milk and Leonard Matlovich. At every step, though, the gay mainstream proved itself so eager to be "just like everybody else" that even the deviates cast their heroes out for being "freaks."

After Hal Call and David Finn orchestrated the end of Harry Hay's Mattachine Foundation, they preached that anti-queer discrimination would disappear once each queer person "adjust[ed] themselves to a respectable, productive position in the dominant culture." If we want to be treated the same, the theory goes, we have to act the same. But Chanelle Pickett held up her side of that bargain, yet she faced violent—and deadly—discrimination. She wasn't fired from her "respectable, productive" job because of her work product or her attitude, and she wasn't murdered because she had somehow "deceived" William Palmer; Chanelle was fired, and killed, for being queer. In the end, then, there are no standards we can meet to satisfy those who insist on "unity" or that we act "like everybody else." "Unity does not mean unanimity," Audre Lorde taught, and our differences—those that render us freaks—are our greatest strengths.

History proves the power of queer diversity. Too often, though, we either "ignore the past or romanticize it, render the reason for unity useless or mythic." In so doing, Lorde wrote, "we forget that the necessary ingredient needed to make the past work for the future is our energy in the present."[9]

On January 30, 1996, 5,324 days after publishing his first article on the "rare cancer," Lawrence Altman reported the cautious optimism of researchers who'd seen viral levels in a small group of HIV patients drop by 99 percent as a result of a new three-drug therapy. The drug cocktail—a combination of licensed drugs that attack reverse transcriptase and a new class of experimental drugs, protease inhibitors, that attack HIV's capacity to replicate—was reason to hope. And although Altman didn't mention it, AIDS activists had been a driving force in making the cocktail possible.

The optimism was well-founded: as drugs got fast-tracked into bodies, the sick seemed miraculously to rise from near death; they called it the *Lazarus Effect*. But the press surrounding the cocktail's release also brought attention to the fact that people of color had no confidence in "the middle-class, white gay men" running major AIDS groups, who hadn't proved themselves "capable of providing adequate attention and services" to communities of color. There wasn't a plan to treat the "future face of AIDS in America—women, drug addicts and minorities," and with white men rising from the dead, would America show even a slight interest in fighting AIDS?

On the same day researchers revealed their cautious optimism about the cocktail, the government cut funding to three New York drug trial clinics, research sites that provided treatment to at-risk communities. The "outrageous" cuts, said the city's AIDS coordinator, specifically impacted "low-income people, women and substance abusers." The news of the day reflected the remarkable successes, and tragic shortcomings, of militant AIDS activism: in an era of death and destruction, activists with relative access to the machines of power used that access to benefit themselves and as many others as they thought they could. These activists weren't perfect, however, despite the heroic battles they fought and sometimes won. To celebrate history and those who made it— to use our past to inform a better future—it's our obligation to ask what might have been had some white gay men in ACT UP/Portland and Chicago not felt threatened by women and people of color, or if New York's lifelong activists hadn't been dismissed because of their "aspirations toward impossible Utopias."

"I feel like it's the poorer areas that are getting forgotten," said a patient from one of the defunded New York trials in 1996. "Don't forget about them."[10]

In May 1996, the Supreme Court struck Colorado's Amendment 2, the law banning "special protections" for gays, lesbians, and bisexuals. With that significant victory, many activists wondered on which of the infinite challenges the Movement would focus next. Hate crimes? Employment? Biphobia? Transgender protections? HIV/AIDS in communities of color? The mental health of PWAs who faced a future for the first time in years?

"Gay marriage," Elizabeth Birch announced, "is the next battleground between our community and the religious political extremists." But "religious political extremists" weren't the only problem. Bill Clinton, the "relatively friendly" president, for example, waited only two days after the Supreme Court victory to announce that if Congress passed

legislation prohibiting federal recognition of same-sex marriages, he'd sign it. It was "an act of political cowardice," said David Mixner, a Clinton ally and fund-raiser who'd helped mainstream the Movement. With Clinton's early endorsement, congressional Democrats were free to support the so-called Defense of Marriage Act, which passed the Senate—85 to 14—on September 10, becoming law on September 21. For many, Clinton's inexplicably premature endorsement of a discriminatory bill was the last straw; "Gay Rights," for straight liberals, was nothing more than a talking point.

The same day the Defense of Marriage Act passed, the Senate also rejected the Employment Non-Discrimination Act by one vote; as of this writing, it's still not law.[11]

◀ Reverend Troy Perry, Christopher Street West, West Hollywood, c. 2000. Photo by Eugene Bricker. Courtesy of the ONE Archives at the USC Libraries (Kight papers and photographs; 2010-008).

By 1997, Chelsea Goodwin and Rusty Mae Moore had come to see Transy House as the direct descendant of Sylvia Rivera's S.T.A.R. House. Then, said Rusty, "lo and behold, Sylvia Rivera showed up."

Transy House gave Sylvia the support network she'd never had; returning to activism, she got healthy and sober. Sylvia had a community—a family—who loved, honored, and supported her. When not giving speeches or protesting, claiming her rightful place as "the most well-known transperson in the queer community," she worked for Randy Wicker, who by then was one of the most outspoken trans allies anywhere. And Sylvia fell in love, spending years in a relationship with Julia Murray.

She remained focused, as always, on her transgender children, but she'd still show up when the larger queer community needed her. It's no surprise, then, that she was on the front lines of Manhattan's massive political funeral for Matthew Shepard in October 1998. The death of Shepard, a young, femme gay man brutally beaten and left for dead in Wyoming, had captured the country's attention as no other anti-queer violence had before. Chanel Chandler, a transgender woman murdered in California a few weeks earlier, barely got noticed, and Rita Hester's murder a month after Shepard's death got attention only because of dogged activism by transgender activists. "I wish I looked like Matthew Shepard," Yoseñio Lewis wrote on behalf of Chanel Chandler, Rita Hester, and Chanelle Pickett.[12]

As the new millennium started, Sylvia Rivera declared war on the Human Rights Campaign (which had dropped the "Fund" from its name) and its local affiliate, the Empire State Pride Agenda, both of which pressed for federal and state employment non-discrimination laws without transgender protections. At a speech to younger queer people in 2001, Sylvia reflected on the Movement since Stonewall: "*You* have acquired your liberation from that night. I've got shit." She understood the desire for "mainstreaming, normality, being normal," saying she'd "love to marry my lover [Julia], but for political reasons, I will not do it because I don't feel that I have to fit in that closet of normal." The danger lay in "forgetting your grass roots, forgetting your own individual identity." You can "never be *like them*."

"I still continue the struggle," Sylvia said. "I will struggle 'til the day I die."

Sylvia Rivera died of complications from cancer of the liver on February 19, 2002. She was fifty. Funeral services were held at Metropolitan Community Church-New York,

▲ Sylvia Rivera protests the Sexual Orientation Non-Discrimination Act (SONDA), an antidiscrimination bill adding legal protections for gays, lesbians, and bisexuals *without* providing additional protections for transgender people, New York City, Feb. 2002. Photo/copyright © by Mariette Pathy Allen, www.mariettepathyallen.com.

Sylvia died two weeks after this protest; she was fifty. SONDA became law in early 2003.

where Bob Kohler, Leslie Feinberg, and others remembered their friend. A short memorial service was held at the reopened Stonewall Inn, before mourners followed a horse-drawn carriage to the waterfront, depositing Sylvia's ashes right where they'd said good-bye to Marsha almost a decade earlier.[13]

Fifteen years later, in August 2017, as the United States erupted over Donald Trump's implicit endorsement of the Nazi-led violence in Charlottesville, Virginia, Randy Wicker paid a quiet visit to D.C.'s Congressional Cemetery. He stopped first to pay his respects to Barbara Gittings, who'd died in 2007 after a long battle with breast cancer. The headstone she shared with Kay (Tobin) Lahusen, who was still going strong, said it all: *Partners in life, married in our hearts.* In San Francisco, Phyllis Lyon lost Del Martin in 2008, though Del died a married woman after Mayor Gavin Newsom ordered the city-county clerk to issue same-sex marriage licenses and a lengthy court battle ensued.

Wicker also knelt at Frank Kameny's headstone, saying a few words to the combative old man who never gave in and never gave up. Kameny had died peacefully in October 2011, but not before he'd gotten a formal apology on behalf of the federal government for the pain he and so many others had faced as a result of the Lavender Scare–era ban on queer government workers. As the apology was read during a formal ceremony, a surprised and tearful Kameny shouted, "Apology accepted!"

Carrying two purple roses, Wicker went to a spot where he hoped to place a memorial to the transgender heroes lost in the struggle. "This rose is for Marsha," he said, holding up the larger one. "It's a bigger flower for a bigger heart." He placed it on the ground. "And this rose is for Sylvia," he said of the smaller flower. "She was harder and stronger in a way, and she lasted longer."

Setting Sylvia's rose down, Wicker paused and added, "Actually Sylvia did more, but she didn't win people's hearts the way Marsha P. Johnson did."[14]

◀ Leslie Feinberg speaks at Sylvia Rivera's memorial service, Metropolitan Community Church, New York City, Feb. 2002. Photo/copyright © by Mariette Pathy Allen, www.mariettepathyallen.com.

▲ **Above** José Sarria (a.k.a. Empress Norton I, The Widow Norton) stands before his headstone, San Francisco, Feb. 2006. Photo/copyright © by Rick Gerharter.

▶ **Right** Virginia Prince at a seminar during Fantasia Fair, an annual conference established in 1976 for self-identified heterosexual cross-dressers, which eventually grew to include all people identifying as transgender, Provincetown, 1992. Photo/copyright © by Mariette Pathy Allen, www.mariettepathyallen.com.

▼ **Below** Harry Hay (center) and John Burnside (standing) celebrate Hay's ninetieth birthday, San Francisco, Apr. 2002. Photo/copyright © by Rick Gerharter.

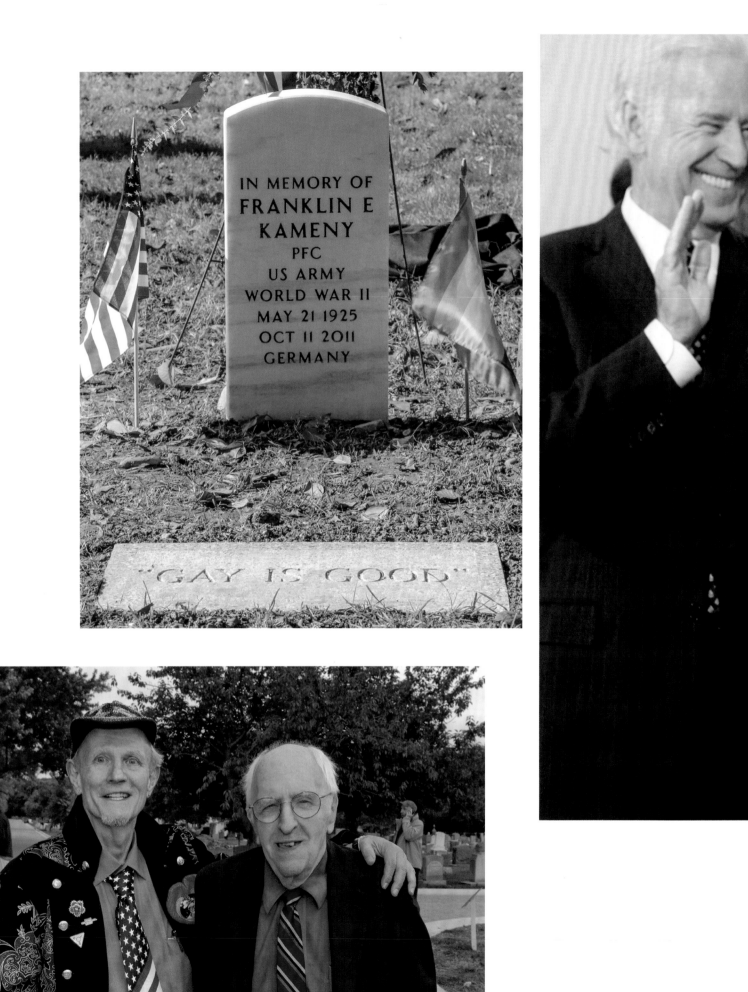

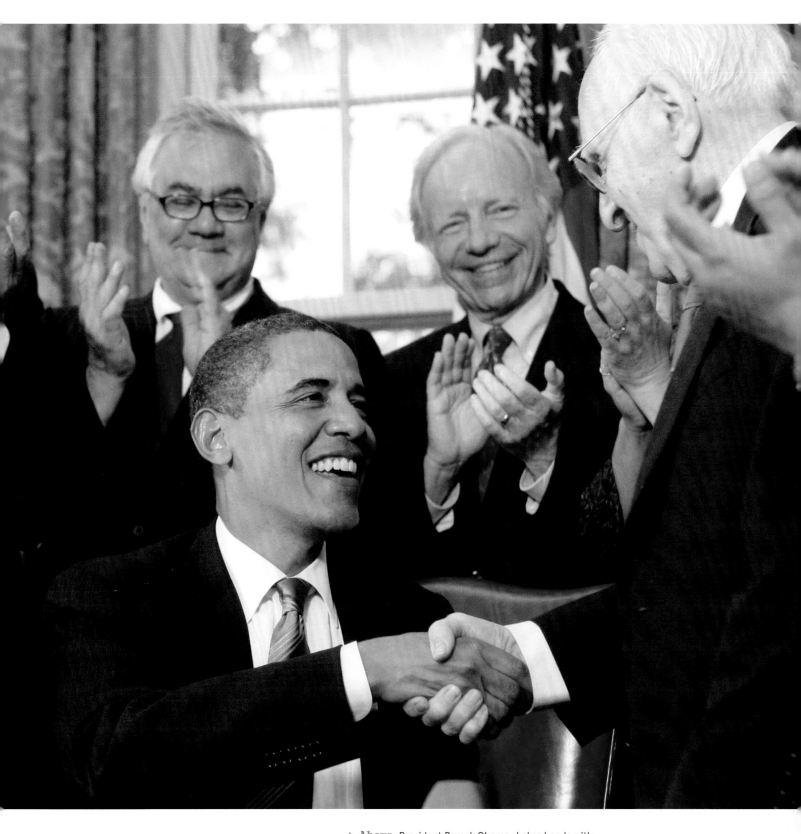

▲ **Above** President Barack Obama shakes hands with Frank Kameny in the Oval Office after signing a Presidential Memorandum extending some partnership rights to federal employees in same-sex relationships, Washington, D.C., June 17, 2009. Photo by Haraz N. Ghanbari. Copyright © by the Associated Press.

◀ **Opposite, top** Frank Kameny Memorial, Congressional Cemetery, Washington, D.C., Nov. 11, 2015. Photo by Leighton Brown. Copyright © by Matthew Riemer and Leighton Brown.

◀ **Opposite, bottom** Randy Wicker (left) and Frank Kameny (right), Congressional Cemetery, Washington, D.C., Oct. 11, 2009. Photo/copyright © by Daniel Nicoletta.

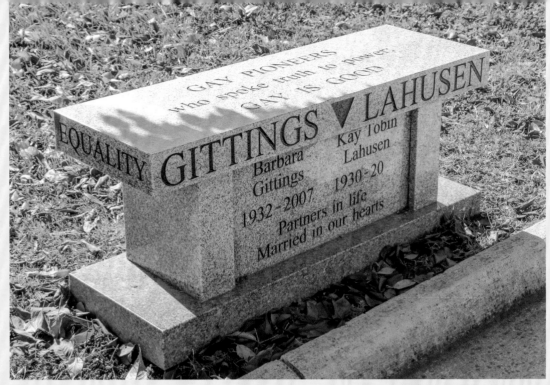

▲ **Above** Barbara Gittings and Kay (Tobin) Lahusen's headstone, Congressional Cemetery, Washington, D.C., Nov. 2015. Photo by Leighton Brown. Copyright © by Matthew Riemer and Leighton Brown.

▶ **Right** Barbara Gittings and Kay (Tobin) Lahusen at a demonstration against *Bowers v. Hardwick*, Philadelphia, July 1986. Photo by Tommi Avicolli Mecca. Courtesy of John J. Wilcox, Jr. Archives, William Way LGBT Community Center (Mecca collection; Ms. Coll. 25).

▲ **Above** From left: Phyllis Lyon, Rikki Streicher, and Del Martin, San Francisco, c. 1980. Photographer unknown. Courtesy of San Francisco History Center, San Francisco Public Library (Streicher and Sager photographs; GLC 131).

◀ **Left** Phyllis Lyon and Del Martin's marriage celebration, San Francisco, June 16, 2008. Photo/copyright © by Daniel Nicoletta.

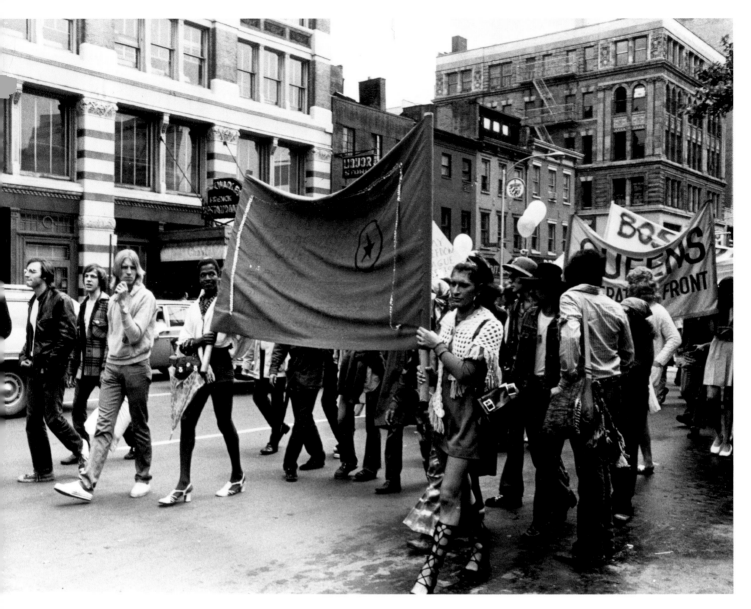

▲ **Above** Marsha P. Johnson and Sylvia Rivera carry the Street Transvestite Action Revolutionaries (S.T.A.R.) banner, Christopher Street Liberation Day, New York City, June 25, 1972. Photo by Leonard Fink. Courtesy of The LGBT Community Center National History Archive (Fink collection; 26-25).

▶ **Right** Street art, San Francisco, c. 1990. Photo/copyright © by Marc Geller.

▶ **Opposite** Carrying Sylvia's message, Equality March for Unity and Pride, Washington, D.C., June 11, 2017. Photo by Leighton Brown. Copyright © by Matthew Riemer and Leighton Brown.

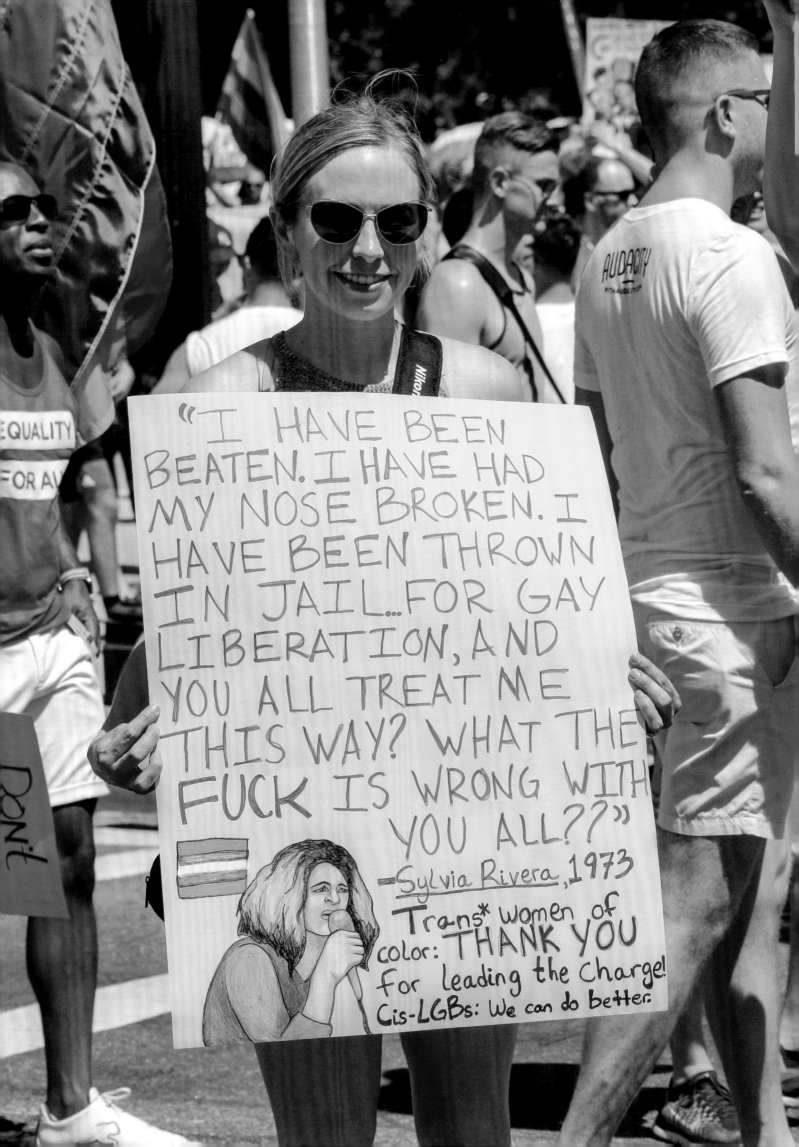

▲ **Above** Pride flag flies at half-mast after Del Martin's death, Harvey Milk Plaza, San Francisco, Aug. 28, 2008. Photo by and courtesy of Professor Max Kirkeberg.

▶ **Right** @lgbt_history pinback, 2017. Design by Leighton Brown, Matthew Riemer, and Andy Simmonds. From the authors' collection.

▶ **Opposite** Timothy Hough (foreground) and other activists, Milk/Moscone Memorial March & Vigil, San Francisco, Nov. 1983. Photo by Paul Sakuma. Copyright © by the Associated Press.

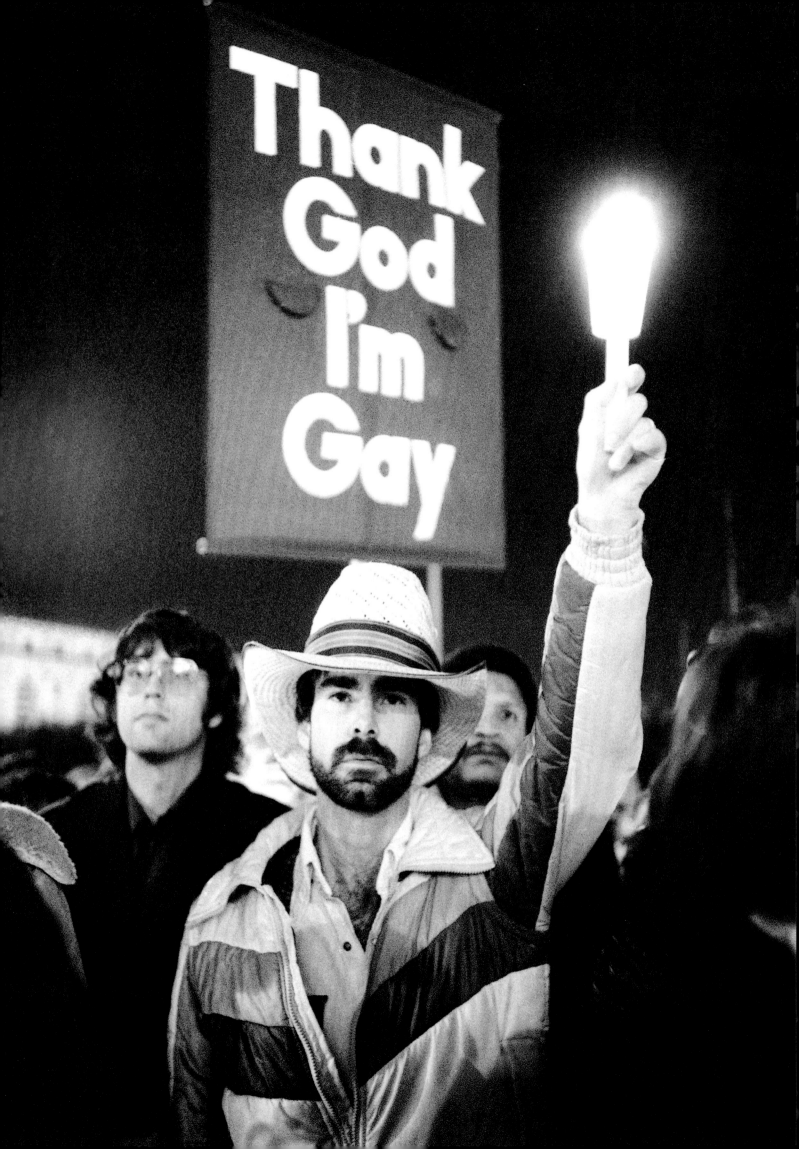

Endnotes

Introduction: Seeing Queer History

1. (*Ioläus*). George Chauncey, *Gay New York: Gender, Urban Culture, and the Making of the Gay Male World, 1890-1940* (New York: Basic Books, 1994), 284. (**Saroyan**). William Saroyan in Barbie Zelizer, *Remembering to Forget: Holocaust Memory through the Camera's Eye* (Chicago: Univ. of Chicago Press, 1998), 5.

2. ("bearing a great burden"). James Baldwin, "Letter from a Region in My Mind," *New Yorker*, Nov. 17, 1962. ("historical amnesia"). Audre Lorde, "Age, Race, Class and Sex: Women Redefining Difference," *Sister Outsider: Essays & Speeches by Audre Lorde* (Berkeley: Crossing Press, 2007), 117.

3. ("responsible for our liberation"/"Each one of us . . ."). Lorde, "Learning from the 60s," *Sister Outsider*, 144, 138. (**Gwenwald**). Morgan Gwenwald, Letter to Editor, *OutWeek* 96 (May 1, 1991); 9.

4. ("character of our people"). Joan Nestle, *A Restricted Country* (New York: Firebrand Books, 1987), 11. ("stifle the new or institutionalize the old"). Nestle, "Voices from Lesbian History," *Restricted Country*, 119. ("*like them*"). Sylvia Rivera, "Bitch on Wheels" (June 2001), *Street Transvestite Action Revolutionaries: Survival, Revolt, and Queer Antagonist Struggle* (Untorelli Press: Web, n.d.), 37. ("a people who were called freaks"). Nestle, "Voices from Lesbian History," *Restricted Country*, 112.

5. ("principal access to realities"). Susan Sontag, "Photography: A Little Summa" (1976), in Sontag, *At the Same Time: Essays & Speeches*, Paolo Dilonardo and Anne Jump, eds. (New York: Farrar, Straus, and Giroux, 2007). ("daring and risky"). Steven F. Dansky, "The Look of Gay Liberation," *Gay & Lesbian Review*, Mar.–Apr. 2009. ("a sign of revolt"). Lani Ka'ahumanu, Address to the 1993 March on Washington for Lesbian, Gay, and Bi Equal Rights and Liberation, in "How I Spent My Two Week Vacation Being a Token Bisexual," 1993, available at lanikaahumanu.com/mow.shtml. (**Wojnarowicz**). David Wojnarowicz, "Do Not Doubt the Dangerousness of the 12-Inch Politician," *Close to the Knives: A Memoir of Disintegration* (New York: Vintage Books, 1991), 156.

6. ("an immense responsibility"). Deborah Gould, *Moving Politics: Emotion and ACT UP's Fight against AIDS* (Chicago: Univ. of Chicago Press, 2009), 44. (what we're "trying to get across"). Susan Stryker, *Transgender History* (Berkeley: Seal Press, 2008), 23–24. ("more generous rewards"). Catherine Lord and Richard Meyer, *Art & Queer Culture* (London: Phaidon Press Limited, 2013), 9–10. ("not aimed at *defining* but at *defending*"). Leslie Feinberg, *Transgender Warriors: Making History from Joan of Arc to Dennis Rodman* (Boston: Beacon Press, 1996), ix.

7. ("indebted to my queer ancestors"). James T. Sears, *Behind the Mask of the Mattachine: The Hal Call Chronicles and the Early Movement for Homosexual Emancipation* (Binghamton, NY: Haworth Press, 2006), xix.

Part I: A Century of Subtle Attack, 1867-1968

1. ("Where shall I begin?"). Manuel boyFrank to Roger Austen, Dec. 16, 1974, in Sears, *Behind the Mask*, 73. (**homophile**). Stuart Timmons, *The Trouble with Harry Hay: Founder of the Modern Gay Movement* (Boston: Alyson Publications, 1990), 149 (homosexual as "clinical and pathological"); "Homophile: A Definition" in "East Coast Homophile Organization Conference '64," 6, ECHO General, Feb. 8–Dec. 5, 1964, Lyon/Martin papers, 19/22, GLBT Hist. Soc. (**restless**). Dal McIntire (pseud. of Jim Kepner), "Tangents," *Tangents*, Oct. 1968, 22. (**Kameny**). Dr. Franklin E. Kameny in Eric Marcus, *Making Gay History: The Half-Century Fight for Lesbian and Gay Equal Rights* (New York: HarperCollins eBooks, 2002), 80. (**The Trip**). After the raid on The Trip, a bar with a largely white, middle-class male clientele, queer activists in Chicago started to "catch up to the pattern of legal challenges to the bar-raid regime that had begun earlier in other cities." Timothy Stewart-Winter, *Queer Clout: Chicago and the Rise of Gay Politics* (Philadelphia: Univ. of Pennsylvania Press, 2016), 80–81. (**strong statement of ideology/bill of rights**). Kameny, "What Concrete Steps I Believe Can and Must Be Taken to Further the Homophile Movement," address, National Planning Conference of Homophile Organizations, San Francisco, California, Aug. 25, 1966, NACHO, 1966, Lucas Papers, 1997-25, 11/15, GLBT Hist. Soc. ("militant"). Kameny, "Does Research Into Homosexuality Matter?" *The Ladder: A Lesbian Review* 9, no. 8 (May 1965), 14. (**Black is Beautiful**). See, e.g., Yasmin Ibrahim, "The Negro Marketing

Dilemma: Dominant Marketing Discourses in the US from the 1950s to the 1970s," *Journal of Historical Research in Marketing* 8, no. 4 (2016): 545–63. ("**GAY IS GOOD**"). Kameny to Dick Leitsch, June 19, 1968, in Michael G. Long, ed., *Gay Is Good: The Life and Letters of Gay Rights Pioneer Franklin Kameny* (Syracuse, NY: Syracuse Univ. Press, 2014), 159–61. (**motion passed**). Minutes, NACHO, Chicago, Illinois, Aug. 17, 1968, 8, Gerber/Hart Library & Archives, William B. Kelley & Chen K. Ooi Collection.

2. ("moral weakness, criminality, or pathology"). John D'Emilio, *Sexual Politics, Sexual Communities: The Making of a Homosexual Minority in the United States, 1940-1970* (Chicago: Univ. of Chicago Press, 1998), 10. (*do and be better*). See, e.g., Don Lucas, Address to the Fourth Annual Matt. Soc. Convention, Sept. 1957 ("social reform, to be effective, must be preceded by personal reform"), Matt. Soc. Annual Meetings Fourth, Aug. 30–Sept. 2, 1957, Lucas Papers, 1997-25, 3/4, GLBT Hist. Soc. ("century of subtle attack"). Letter from Del Shearer to Governing Board of DOB, "Re: Daughters of Bilitis, Inc. Participation in ECHO and Specifically Picketing," June 10, 1965, Corr., Admin. Files, DOB-Nat'l, Jan. 6–Nov. 6, 1965, Lyon/Martin papers, 6/12, GLBT Hist. Soc.

3. ("not a true man"). Karl Heinrich Ulrichs, "Araxes: Appeal for the Liberation of the Urning's Nature from Penal Law. To the Imperial Assemblies of North Germany and Austria (1870)," James Steakley, trans., in Mark Blasius and Shane Phelan, eds., *We Are Everywhere: A Historical Sourcebook of Gay and Lesbian Politics* (New York: Routledge, 1997), 64. (**Redefining sexuality**). See Robert Beachy, *Gay Berlin: Birthplace of a Modern Identity* (New York: Vintage Books, 2014), 5. ("homosexual"). See Károly Mária (Kertbeny) Benkert, "An Open Letter to the Prussian Minister of Justice (1869)," in Blasius and Phelan, *We Are Everywhere*, 67–79; see also Beachy, *Gay Berlin*, 31. (the "third sex" and *sexual intermediacy*). Beachy, *Gay Berlin*, 88. (**Wilde's case**). Edward Carpenter in John Lauritsen and David Thorstad, *The Early Homosexual Rights Movement (1864-1935)* (New York: Times Change Press, 1974), 33.

4. ("great increase of sex perversion"). *The Social Evil in Chicago: A Study of Existing Conditions with Recommendations by The Vice Commission of Chicago* (Chicago: Gunthorp-Warren Printing Company, 1911), 296. (**lodging-houses**). Chad Heap, "Gays and Lesbians in Chicago: An Overview," in Tracy Baim, ed., *Out and Proud in Chicago: An Overview of the City's Gay Community* (Chicago: Surrey Books, 2008), 8; see also D'Emilio, *Sexual Politics*, 10. (**Henry Gerber**). Henry Gerber, "The Society for Human Rights—1925," *ONE* 10, no. 9 (Sept. 1962), 5, 6; Sears, *Behind the Mask*, 45–46. (**decided to organize**). Gerber, "Society for Human Rights," 6. ("abused and hindered"). Charter, Society for Human Rights (1924), in Jonathan Ned Katz, *Gay American History* (New York: Avon, 1978), 386–87. (**officers**). Gerber, "Society for Human Rights," 7. (*Friendship and Freedom*). The title of Gerber's publication, *Friendship and Freedom*, was the same as, and therefore presumably was an homage to, Adolf Brand's *Freundschaft und Freiheit*; like Hirschfeld, Brand was a German homosexual emancipation activist. Moreover, the Society for Human Rights itself was named after German publisher and activist Friedrich Radszuweit's Bund für Menschenrecht. See Tracy Baim, "Gay News: In the Beginning," in Tracy Baim, ed., *Gay Press, Gay Power: The Growth of LGBT Community Newspapers in America* (Chicago: Prairie Avenue Productions, 2012). (**The Society unravels**). See Gerber, "Society for Human Rights," 6–11.

5. (**life moved to the cities**). D'Emilio, *Sexual Politics*, 11; Chauncey, *Gay New York*, 11. (**women and people of color**). See, e.g., James F. Wilson, *Bulldaggers, Pansies, and Chocolate Babies: Performance, Race, and Sexuality in the Harlem Renaissance* (Ann Arbor: Univ. of Michigan Press, 2014). (**population exploded**). By 1910, for example, "almost a third of Manhattan's residents were foreign-born Jews or Italians and their children." Chauncey, *Gay New York*, 137.

6. (**found each other**). By 1908, one writer had identified at least eight "homosexual capitals" of the United States: New York, Boston, Chicago, St. Louis, San Francisco, Milwaukee, New Orleans, and Philadelphia. See Xavier Mayne (pseud. of Edward Stevenson), *The Intersexes: A History of Similisexualism as a Problem in Social Life* (privately printed, 1908), 640. Stevenson's remarkable book is as enlightening to the modern reader as it is offensive. (**The nation's queers**). Chicago: *The Social Evil in Chicago*, 297; **Southern California**: See "Long Beach Recital of Shameless Men," *Los Angeles Times*, Nov. 19, 1914, 13; **New York**: Stryker, *Transgender History*, 41 ("The Cercle Hermaphroditos was the first known organization in the United States to concern itself with what we might now call transgender social justice issues, but it does not appear to have had any lasting influence

or inspired any direct successors."); *Report of the Special Committee of the Assembly appointed to investigate the Public Offices and Departments of the City of New York and of the Counties Therein Included* (Albany, NY: J. B. Lyon, 1900), Joel S. Harris testimony, 1429 ("The Mazet Committee's investigation of Paresis Hall," Professor Chauncey notes, "was first drawn to the attention of historians by Jonathan Katz's landmark collection of documents, *Gay American History*," Chauncey, *Gay New York*, 382, n. 2); **New Orleans:** "Sodom and Gomorrah Discounted," *The Mascot*, Oct. 21, 1893, quoted in Katz, *Gay/Lesbian Almanac: A New Documentary* (New York: Carroll & Graf Publishers, Inc., 1994), 245; **Salt Lake City:** See Vern Bullough and Bonnie Bullough, "Lesbianism in the 1920s and 1930s: A Newfound Study," *Signs* 2, no. 4 (Summer 1977), 896–97. ("**spheres of relative cultural autonomy**"). Chauncey, *Gay New York*, 2. (**The changing closet**). See Chauncey, *Gay New York*, 7. A note on **Chauncey:** Professor Chauncey's essential work, *Gay New York*, focuses almost entirely on what he referred to as the "gay male world"; readers may take issue with our reformulation of Chauncey's work to include *queer people* as opposed to just *gay men*. Please note that we do not universally apply Chauncey's analysis to other communities, though we do so in some circumstances. Most important, we identify transgender lives when warranted by the evidence, whereas historians of earlier generations— or even of just a few years ago—may have been less inclined to identify transgender individuals or communities. There is, in our minds, no question that some, if not many, of the fairies exhaustively researched by Professor Chauncey for *Gay New York* were not men "adopting the female role"; they were, instead, women, born before the language, cultural environment, and/or medical possibility to align their sex and gender. See, e.g., Feinberg, "Building Bridges," *TransSisters* 1 (Sept./Oct. 1993), 11–12; see also Davina Anne Gabriel, "The Life and Times of a Gender Outlaw: An Interview with Leslie Feinberg," *TransSisters* 1, 4–10. "We didn't have the language to explain that we are in fact an integral part of the oppressed," Feinberg said. "We didn't have the history at our fingertips to prove that transgender has always been a part of human self-expression." (**Extending history**). Chauncey, *Gay New York*, 5; see also Madeline D. Davis and Elizabeth Lapovsky Kennedy, *Boots of Leather, Slippers of Gold: The History of a Lesbian Community* (New York: Penguin Books, 1993), 6.

7. (tools of oppression/YMCA). See Chauncey, *Gay New York*, 138, 154–55; see also Ina Russell, ed., *Jeb and Dash: A Diary of Gay Life, 1918–1945* (Boston: Faber and Faber, 1993). (**Prohibition**). *The Social Evil in Chicago*, 330; Chauncey, *Gay New York*, 143; see also Chauncey, 140 (tracking a dramatic increase in the number of arrests under the state's anti-sodomy law around the turn of the twentieth century). ("**respectability and criminality**"). Chauncey, *Gay New York*, 307. (**Savoy & Norman**). Darryl W. Bullock, *David Bowie Made Me Gay: 100 Years of LGBT Music* (New York: Overlook Duckworth, 2017), 58. (**Guinan & Blackstone**). Bullock, *David Bowie Made Me Gay*, 60. (**Eva Kotchever**). Chauncey, *Gay New York*, 240. After running her popular club from 1925 to 1926, Kotchever (a Polish Jewish émigré born Chawe Zlocsewer who also went by Eve Addams and was sometimes known as "the Queen of the Third Sex") was arrested for disorderly conduct and obscenity, the latter charge resulting from the discovery of a book of her short stories, *Lesbian Love*; her conviction led to her deportation. In Paris, Kotchever started a club before joining the resistance against General Francisco Franco in Spain. In 1943, she was detained in France and sent to Auschwitz, where she was murdered. See generally www.nyclgbtsites.org/site/eve-addams-tearoom. We thank Jay Shockley and others at the NYC LGBT Historic Sites Project for their work piecing together the sad conclusion of Kotchever's story. (**Casal's *Stone Wall* & *The* Stonewall**). Mary Casal (pseud.), *The Stone Wall: An Autobiography* (Chicago: The Eyncourt Press, 1930); David Carter, *Stonewall: The Riots That Sparked the Gay Revolution* (New York: St. Martin's Press, 2004), 8.

8. A note on **Hughes:** Some question the sufficiency of evidence regarding Langston Hughes's queerness. See, e.g., Wilson, *Bulldaggers, Pansies, and Chocolate Babies*, 30. Because "proving" historical figures' queerness is often an impossible task (as the burden of proof is set by those who have a vested interest in erasing queer history), we note only that, from our perspective, evidence of Hughes's homosexuality can be found throughout his work. See Hilton Als, "The Sojourner: The elusive Langston Hughes," *New Yorker*, Feb. 23 & Mar. 2, 2015. ("**Every last one of them**"). Wilson, *Bulldaggers, Pansies, and Chocolate Babies*, 30. ("**an avowed 'bulldagger'**"). Wilson, *Bulldaggers, Pansies, and Chocolate Babies*, 157. (**Drag balls grow**). "N.Y. Pansies' Ball Outgrew Three Halls in Ten Years," (Baltimore) *Afro-American*, Mar. 7, 1936, 13. (**Parade of the Fairies**). Chauncey, *Gay New York*,

297; see also David K. Johnson, "The Kids of Fairytown: Gay Male Culture on Chicago's Near North Side in the 1930s," in Brett Beemyn, ed., *Creating a Place for Ourselves: Lesbian, Gay, and Bisexual Community Histories* (New York: Routledge, 1997), 97–118.

9. (Hollywood). See generally Vito Russo, *The Celluloid Closet: Homosexuality in the Movies* (New York: Harper & Row, 1987), 14; see also Lillian Faderman and Stuart Timmons, *Gay L.A.: A History of Sexual Outlaws, Power Politics, and Lipstick Lesbians* (New York: Basic Books, 2006), 40. (**Valentino & Dietrich**). Russo, *Celluloid Closet*, 15, 18, 30; see also Faderman and Timmons, *Gay L.A.*, 49, 59. (**Hays' Code**). See Russo, *Celluloid Closet*, 30–32.

10. (moral crusade). See "Police Make 4 Dry Raids," *New York Times*, Jan. 29, 1931; "1 A.M. Curfew Would Be Final Washup on B'way Clubs; 'Pansy' Stuff Dying," *Variety*, Feb. 4, 1931, 84; "Police 0-0ing Unlicensed Niters," *Variety*, Feb. 11, 1931; "Drastic Police Curb Put on Night Clubs; Many Face Closing," *New York Times*, July 21, 1931, 1, 4; see also H. Allen Smith, "End of Gotham Night Life Seen as Curfew Threatens," United Press article (publishing paper unclear), Jan. 30, 1931, available at www.queermusicheritage.com/may2010l.html. We thank J. D. Doyle, creator and administrator of Queer Music Heritage, for his tireless efforts on behalf of the Texas queer community and all those who seek a queer music heritage. (**pushed into the closet**). Chauncey, *Gay New York*, 334.

11. ("a crucible for politics"). Davis and Kennedy, *Boots of Leather*, 29. ("**should get together**"). Chuck Rowland in Marcus, *Making Gay History*, 23.

12. (*gender performance*). See generally Chauncey, *Gay New York*; Davis and Kennedy, *Boots of Leather*; Judith Butler, *Gender Trouble: Feminism and the Subversion of Identity* (New York: Routledge, 1999); Stryker, *Transgender History*; Feinberg, *Transgender Warriors*. ("**disorderly**" **laws**). See Carlos A. Ball, *The First Amendment and LGBT Equality: A Contentious History* (Cambridge, MA: Harvard Univ. Press, 2017), 60. ("**illegal patrons**"). William N. Eskridge Jr., "Law and the Construction of the Closet: American Regulation of Same-Sex Intimacy, 1880–1946," *Faculty Scholarship Series*, Paper 3804 (New Haven: Yale Univ., 1997), 1084. ("**powerful, emasculating, immoral force**"). David K. Johnson, *The Lavender Scare: The Cold War Persecution of Gays and Lesbians in the Federal Government* (Chicago: Univ. of Chicago Press, 2004), 95–96. (**Something of a safe haven & weren't "particularly secretive"**). Johnson, *Lavender Scare*, 41, 43, 45, 46.

13. (military expansion & peacetime draft). See, e.g., "Roosevelt Calls For Preparedness; May Ask Big Fund," *New York Times*, May 15, 1940, 1, 14; "Senate, 74–0, Votes $1,823,000,000 Fund for Army's Costs," *New York Times*, May 23, 1940, 1, 14; "Nation's Armed Forces at 919,807, with Reserves, a Peacetime Peak," *New York Times*, Aug. 28, 1940, 8; "Millions Register in City and Nation; Draft Roll Completed Without Hitch; Figure Here Is Estimated at 991,000," *New York Times*, Oct. 17, 1940, 1, 13; "Text of the Selective Service Measure as It Was Finally Passed by Congress Yesterday," *New York Times*, Sep. 15, 1940, 30, 31. ("**strict qualification standards**"). Allan Bérubé, *Coming Out Under Fire: The History of Gay Men and Women in World War II* (Chapel Hill: Univ. of North Carolina Press, 2010), 2; see also Eskridge, "Law and the Construction of the Closet." (**Pearl Harbor**). "Japan Wars on U.S. and Britain; Makes Sudden Attack on Hawaii; Heavy Fighting at Sea Reported," *New York Times*, Dec. 8, 1941, 1; "Japs Open War On U.S. with Bombing of Hawaii," *Los Angeles Times*, Dec. 8, 1941, 1; "U.S. Declares War, Pacific Battle Widens; Manila Area Bombed; 1,500 Dead in Hawaii; Hostile Planes Sighted at San Francisco," *New York Times*, Dec. 9, 1941, 1. (**Enlistment numbers/queer numbers**). Bérubé, *Coming Out Under Fire*, 2–3. (**ineffective screening**). Bérubé, *Coming Out Under Fire*, 19–20, 33.

14. (Queer military communities). D'Emilio, *Sexual Politics*, 24; see also Manuel boyFrank to Frank McCourt, Feb. 2, 1942, in Sears, *Behind the Mask*, 92 (". . . the war will spread the seeds of enlightenment as soldiers and sailors learn things and take the new wisdom home."). ("**uprooting an entire generation**"). Bérubé, *Coming Out Under Fire*, 126. (**Buffalo**). Davis and Kennedy, *Boots of Leather*, 39. ("**butches defied convention**"). Davis and Kennedy, *Boots of Leather*, 7. (**male drag & butch lesbian**). Allen Drexel, "Before Paris Burned: Race, Class, and Male Homosexuality on the Chicago South Side, 1935–1960," in B. Beemyn, *Creating a Place for Ourselves*, 123.

15. (mostly white bar crowds). Chauncey, *Gay New York*, 274; see also Davis and Kennedy, *Boots of Leather*, 43. (**house parties**). Davis and Kennedy, *Boots of Leather*, 43. (**middle-class women**). Davis and Kennedy, *Boots of Leather*, 43. ("**Fun Gay Ladies**"). Esther Newton, "The 'Fun Gay Ladies':

Lesbians in Cherry Grove, 1936–1960," in B. Beemyn, *Creating a Place for Ourselves*, 146. ("the foundations for a future society"). Sears, *Behind the Mask*, 92.

16. ("military areas"). Exec. Order No. 9066, Feb. 19, 1942. (consequences were clear). H. W. Brands, *Traitor to His Class: The Privileged Life and Radical Presidency of Franklin Delano Roosevelt* (New York: Doubleday, 2008), 658–59. (Jiro Onuma). Tina Takemoto, "Jiro Onuma," Densho Encyclopedia, available at encyclopedia.densho.org/Jiro%20Onuma; see also Takemoto, "Looking for Jiro Onuma: A Queer Meditation on the Incarceration of Japanese Americans during World War II," *GLQ: A Journal of Lesbian and Gay Studies* 20, no. 3 (2014), 241–75; John Howard, *Concentration Camps on the Home Front: Japanese Americans in the House of Jim Crow* (Chicago: Univ. of Chicago Press, 2008). Jiro Onuma's papers are maintained at the GLBT Historical Society in San Francisco.

17. ("enlightened" officials & validating psychiatry). Bérubé, *Coming Out Under Fire*, 131, 133; see also Eskridge, "Law and the Construction of the Closet," 1091. (blue discharge). See generally Bérubé, *Coming Out Under Fire*, 147. ("kind of crumbled"). Bérubé, *Coming Out Under Fire*, 230.

18. (leaving the service without prejudice). D'Emilio, *Sexual Politics*, 32; Morris Foote in Marcus, *Making Gay History*, 51 ("Once I knew what I was, I started going into Boise. . . . Main Street was . . . bar after bar after bar."); Davis and Kennedy, *Boots of Leather*, 39. ("tranquil family environment"). D'Emilio, *Sexual Politics*, 38. ("virulent antihomosexuality" & containing threats). Davis and Kennedy, *Boots of Leather*, 68, 69. ("just the assumption"). Shirley Willer in Marcus, *Making Gay History*, 11; see also "Shirley Willer," 2017, *Making Gay History* 1, ep. 12, produced by Eric Marcus and Sara Burningham, podcast, makinggayhistory.com/podcast/episode-12-shirley-willer.

19. ("more and more aware"). Edythe Eyde (a.k.a. Lisa Ben) in Marcus, *Making Gay History*, 9. (drove many queer people away). Davis and Kennedy, *Boots of Leather*, 68. (privacy of public spaces). Chauncey, *Gay New York*, 195–97. (*Vice Versa*). See Edythe Eyde (a.k.a. Lisa Ben) in Marcus, *Making Gay History*, 9; see also Faderman and Timmons, *Gay L.A.*, 107; Marcia M. Gallo, *Different Daughters: A History of the Daughters of Bilitis and the Rise of the Lesbian Rights Movement* (Emeryville, CA: Seal Press, 2007), xxxiv.

20. ("admitted homosexuals"). Letter from Subcommittee of the Senate Appropriations Committee to Secretary of State George Marshall, June 10, 1947, in Congressional Record, vol. 96, pt. 8, 10806, Sen. Ferguson (July 24, 1950). ("moral panic"). Johnson, *Lavender Scare*, 55. ("degenerate sex offenders"). J. Edgar Hoover, "How Safe Is Your Daughter?" *American Magazine* 144 (July 1947), 32.

21. ("privacy could only be had in public"). Chauncey, *Gay New York*, 195; see also Johnson, *Lavender Scare*, 48. ("epicenter of the gay male world"). Johnson, *Lavender Scare*, 47. (Gerber's cruising). Genny Beemyn, *A Queer Capital: A History of Gay Life in Washington, D.C.* (New York: Routledge, 2017), 19. ("more or less a haven for perverts"). *Washington Post*, Aug. 27, 1947, in Johnson, *Lavender Scare*, 56, n. 33. ("Pervert Elimination Campaign"). Johnson, *Lavender Scare*, 56.

22. ("blasted this damn country wide open"). Samuel Stewart in Johnson, *Lavender Scare*, 55; see also Timmons, *Trouble with Harry Hay*, 111 (Harry Hay was among those interviewed by Kinsey); Lillian Faderman, *The Gay Revolution: The Story of the Struggle* (New York: Simon & Schuster, 2015), 53. (Kinsey's 37 percent). Alfred C. Kinsey, Wardell B. Pomeroy, and Clyde E. Martin, *Sexual Behavior in the Human Male* (Philadelphia: W. B. Saunders Company, 1949), 650 ("37 per cent of the total male population has at least some overt homosexual experience to the point of orgasm between adolescence and old age. This accounts for nearly 2 males out of every 5 that one may meet."). (the Kinsey Scale). Kinsey, Pomeroy, Martin, *Sexual Behavior in the Human Male*, 651. ("a central place"). Johnson, *Lavender Scare*, 54. ("a reservoir of protest"). Donald Webster Cory (pseud. of Edward Sagarin), *The Homosexual in America: A Subjective Approach* (New York: Castle Books, 1960), 91. (Hay, Simmons & Gerber). Timmons, *Trouble with Harry Hay*, 43. ("The Call"). Timmons, *Trouble with Harry Hay*, 135; Faderman, *Gay Revolution*, 55. (the sober light of day). Faderman, *Gay Revolution*, 55. ("Outlaws"). Gerber to Manuel boyFrank, June 18, 1957, Sears, *Behind the Mask*, 435.

23. (*The Sexual Criminal*). Faderman and Timmons, *Gay L.A.*, 75. ("underlying psychological problem"). Joanne Meyerowitz, *How Sex Changed: A History of Transsexuality in the United States* (Cambridge, MA: Harvard Univ. Press, 2002), 48. ("'mayhem'"). Stryker, *Transgender History*, 44.

24. (Communists at the State Dept.). Whenever Joseph McCarthy spoke of the State Department, he traded on a longstanding image of a bastion of elite and effete liberals that stemmed from an incident a decade earlier that Lillian Faderman called "the ripple that began the tidal wave of Washington's homosexual witch hunts." In September 1940, Sumner Welles, the under secretary of state, traveled to Alabama with President Franklin D. Roosevelt and members of his cabinet for the funeral of former Speaker of the House William B. Bankhead. On the train trip back to D.C., Welles retired to his cabin, rang for assistance, and then sexually propositioned a number of porters. While the incident stayed out of the papers, Welles's indiscretion was valuable ammunition for political enemies, who threatened Roosevelt with a senatorial inquiry unless he dismissed Welles. See Faderman, *Gay Revolution*, 16; see also Johnson, *Lavender Scare*, 66–67. (perverted minds, "a tinge of lavender" & the dam breaking). Johnson, *Lavender Scare*, 16, 17–18.

25. (Loyalty vs. security). Johnson, *Lavender Scare*, 8. In addition to homosexuals, government officials frequently cited "those who talked or drank too freely—or did both" as examples of potential security risks. In practice, however, few, if any, alcoholics or chronically loose-lipped individuals were separated from the government as security risks. Based on his exhaustive research, David K. Johnson concluded that "[a]lthough 'security risk' covered a variety of offenses, it often functioned as a euphemism for homosexual." (diminishes the scope). Johnson, *Lavender Scare*, 4. (*every* government agency). Johnson, *Lavender Scare*, 114. (one in five employed adults). Johnson, *Lavender Scare*, 137. (remained for decades). Johnson, *Lavender Scare*, 4.

26. (Harry & Rudi). Timmons, *Trouble with Harry Hay*, 141. (Foundations). Faderman, *Gay Revolution*, 57; Timmons, *Trouble with Harry Hay*, 143. ("fire in our eyes"). Harry Hay in Timmons, *Trouble with Harry Hay*, 143. ("an oppressed cultural minority"). Faderman, *Gay Revolution*, 57.

27. (Society of Fools/Knights of the Clock). See Faderman, *Gay Revolution*, 59–60; see also USC/ONE Archives, Knights of the Clock Records, 2014–087, 1/1. (part of the Movement). See, e.g., Sears, *Behind the Mask*, 251 (including Rene Lyle d'Arcy, a transsexual woman, among a "new group of leaders" in the Mattachine Society); Sears, 543 (providing an overview of the contributions of men of color); Harry Hay, *Radically Gay: Gay Liberation in the Words of Its Founder*, Will Roscoe, ed. (Boston: Beacon Press, 1996), 75, n. 3 (detailing Harry Hay's recollections of "the role of women in early Mattachine"). (Mattachine). Harry Hay in Timmons, *Trouble with Harry Hay*, 130; see also Feinberg, *Transgender Warriors*, 71 ("Just as the Church authorities were mocked by cross-dressers during the Feast of Fools, so the comic uses of transvestism slowly despiritualized religious drama. . . . By the late fifteenth century, the Catholic Church fathers were slowly banishing the Feast of Fools from cathedrals. Transgender was one of many targets of the landowner's war, waged under a religious banner."). ("the Masons and the Communists"). Faderman, *Gay Revolution*, 60. ("leaders and the rank-and-file were separate"). Faderman and Timmons, *Gay L.A.*, 112. (early meetings & "homosexual culture"). Faderman and Timmons, *Gay L.A.*, 112; Timmons, *Trouble with Harry Hay*, 147. (Stem). Timmons, *Trouble with Harry Hay*, 151.

28. (Jennings entrapped). See Dale Jennings, "To Be Accused Is to Be Guilty," *ONE* 1, no. 1 (Jan. 1953), 10–13; Timmons, *Trouble with Harry Hay*; Faderman, *Gay Revolution*, 61–62. (plan to fight). Faderman, *Gay Revolution*, 63–64; Timmons, *Trouble with Harry Hay*, 164–65. ("only true pervert"). Faderman, *Gay Revolution*, 65; Sears, *Behind the Mask*, 163. ("until Hell froze over"). Sears, *Behind the Mask*, 163; Jennings, "To Be Accused Is To Be Guilty," 10–13. ("respectability and accommodationism"). Sears, *Behind the Mask*, 164.

29. (*ONE* & Mattachine). Sears, *Behind the Mask*, 167. Because Mattachine brought *ONE*'s founders together, it's often said that the magazine "was a break from Mattachine, that it was an outgrowth," a claim that infuriated Dorr Legg until the day he died. *ONE*'s founders, he'd point out, published a magazine for all the world to see; Mattachine, on the other hand, was a "secret" society. Sears, *Behind the Mask*, 150–51; but see Timmons, *Trouble with Harry Hay*, 173, fn. ("There is some debate as to the details of the beginnings of *ONE* magazine; Dorr Legg has stated that he started *ONE* independently of Mattachine, though neither Block nor Rowland recalled his attendance at the initial meeting. And in keeping with his [Communist] background, Harry proposed 'that we set up a second homophile corporation around the journal project so that the two organizations could begin a dialogue and reach a wider public.' But Legg recalled that the founders of *ONE*, especially Dale Jennings, were determined not to work 'under' Hay,

and insisted on operating separately."). (*ONE's* founders). Faderman and Timmons, *Gay L.A.*, 115–16; Sears, *Behind the Mask*, 543. (five thousand copies each month). Faderman and Timmons, *Gay L.A.*, 116.

30. (culturalists & assimilationists). Timmons, *Trouble with Harry Hay*, 168; Jeff Winters (pseud. of Dale Jennings), "Homosexuals Are Not People," *ONE* 1, no. 3 (Mar. 1953), 4; David L. Freeman (pseud. of Chuck Rowland), "The Homosexual Culture," *ONE* 1, no. 5 (May 1953), 10. ("nearly like the average man"). Dr. Karl M. Bowman, "Report to the California State Legislature," *ONE* 1, no. 1, 8. (Homophiles & gender warriors). See, e.g., Faderman and Timmons, *Gay L.A.*, 114. (The queens . . . were the reason). Sears, *Behind the Mask*, 151; Jim Kepner in Marcus, *Making Gay History*, 31.

31. ("made *sex change* a household term"). Meyerowitz, *How Sex Changed*, 51–52. (question everything). Meyerowitz, *How Sex Changed*, 52. ("I am now your daughter"). Christine Jorgensen in Meyerowitz, *How Sex Changed*, 61.

32. (Stryker on *Transgender*). Stryker, *Transgender History*, 1. (Transsexuals & transvestites). Stryker, *Transgender History*, 16, 18. (Hirschfeld's Transvestites). Meyerowitz, *How Sex Changed*, 19. (Brief history). Meyerowitz, *How Sex Changed*, 43–45. ("our entire spirit"). Feinberg, *Transgender Warriors*, xi; see also "Welcome to *Transgender Tapestry*: Celebrating the diversity of gender expression," *Transgender Tapestry* 74 (Winter 1995), 1 (explaining the magazine was "for everyone who is transgendered," which includes "crossdressers (also known as transvestites, ninety percent of whom are heterosexual), transsexuals (who generally elect to have surgery to make their bodies conform to the gender with which they identify), gay and lesbian drag queens and kings, transgenderists (who elect to live in the social role of the other sex from which they were born, but do not have surgery), and many others . . . In fact, anyone and everyone is transgendered who *transgresses gender* lines even slightly in their behavior or attitudes. As one definition on the Internet puts it, you are transgendered if you 'manifest characteristics, behaviors or self-expression,' which in your own or someone else's perception, 'is typical of or commonly associated with persons of another gender.'").

33. (surgery as a "solution"). Dale Jennings, "As for me . . . ," *ONE* 1, no. 2 (Feb. 1953), 11–13. ("beamed a message that I wasn't alone"). Feinberg, *Transgender Warriors*, 7. ("almost like a miracle"). Meyerowitz, *How Sex Changed*, 93. ("happy but lonely life"). Letter from Richard to *ONE* (Mar. 18, 1958), in Craig M. Loftin, ed., *Letters to ONE: Gay and Lesbian Voice from the 1950s and 1960s* (Albany, NY: SUNY Press, 2012), 14. ("nowhere to go for your freedom"). George Mendenhall in Mariposa Film Group, *Word Is Out: Stories of Some of Our Lives* (New Yorker Films: 1977). (G.S.). Letter from "G.S.," *ONE* 1, no. 7 (July 1953), 22. ("esoteric hogwash"). Letter from Anon. to *ONE* (1955), in Loftin, *Letters to ONE*, 101.

34. ("safe"). See *"ONE* Is Not Grateful," *ONE* 1, no. 10 ("Incredible as it may seem to everyone else but us, we have been pronounced respectable."). (another issue seized). See generally *ONE* 2, no. 8 (Oct. 1954); see also Faderman and Timmons, *Gay L.A.*, 117–19. Olesen declared the issue obscene based on a lesbian love story, an advertisement for a Swiss homosexual magazine, and a satiric poem. Perhaps coincidentally, the same issue also included an article by attorney Julber on what constituted "obscenity" under federal law. (the suggestion). *ONE, Inc. v. Olesen*, No. 18764-TC, Civil Order on Motions for Summary Judgment (S.D. Cal., Mar. 1, 1956).

35. (Hal Call's intro). See Hal Call in Marcus, *Making Gay History*, 29. ("on the fringes"). Michael Robert Gorman, MA, *The Empress Is a Man: Stories from the Life of José Sarria* (Binghamton, NY: Harrington Park Press, 1998), 134. (Sarria's army life). "In the military, I drove, cooked, got some officers in trouble, and shopped." José Sarria in Gorman, *The Empress Is a Man*, 95. (How A "Social Hostess . . . became the Black Cat"). Gorman, *The Empress Is a Man*, 125–26. ("The crime is getting caught" & "be proud"). Randy Shilts, *The Mayor of Castro Street: The Life & Times of Harvey Milk* (New York: St. Martin's Press, 1982), 47. ("'we have our rights, too'"). George Mendenhall in *Word Is Out*. (Halloween). For an overview of the festival days to which we trace our modern celebrations of Halloween, see Feinberg, *Transgender Warriors*, 75–80. ("I am a boy"). Gorman, *The Empress Is a Man*, 179.

36. ("a raunchy, Bohemian bar"). Hal Call in Sears, *Behind the Mask*, 22. ("erase the stigma"). Call in Sears, *Behind the Mask*, 147. ("started working against the Foundation"). Call in Sears, *Behind the Mask*, 152. (Paul Coates). Faderman, *Gay Revolution*, 67; Sears, *Behind the Mask*, 153–54. ("This is a fact"). Chuck Rowland, "Opening Talk: California State Constitutional

Convention of the Mattachine Society," Apr. 11, 1953, Matt. Soc. Conventions, Homophile Movement, 2/20, GLBT Hist. Soc.; see also Sears, *Behind the Mask*, 181–83. ("wanted to be assimilated into society," "evolutionary *not* revolutionary"). Call in Sears, *Behind the Mask*, 181, 182–83.

37. (E.O. 10450). Exec. Order No. 10,450, 3 CFR 936 (1949–53). (patriots or otherwise). See Letter from "Or Sarua," *ONE* 1, no. 5, 23. ("irrelevant to our ideals"). Marilyn Rieger in Sears, *Behind the Mask*, 209. (Stripping the constitution). Sears, *Behind the Mask*, 209–10. ("faggots"). See Sears, *Behind the Mask*, 235. ("Moderation is a form of fear"). See David L. Freeman (Rowland), "Who Is This Man?" *ONE* 2, no. 3 (Mar. 1954), 16–18; Sears, *Behind the Mask*, 264. (David Finn snaps). See Freeman (Rowland), "Who Is This Man?" at 16–18; see also Sears, *Behind the Mask*, 267. (assimilation as "a contract"). Harry Hay in Sears, *Behind the Mask*, 229.

38. ("good taste and good sense" in L.A.). "Mayor Bowron Against Slacks for Women at City Hall," *Los Angeles Times*, Apr. 22, 1942, 1. (Dorothy Foster). "She Doesn't Agree with mayor, So Wears Slacks in City Hall," *Los Angeles Times*, Apr. 23, 1942, 1; "Public Works Chief Gives His Approval," *Los Angeles Times*, Apr. 24, 1942, II-2. (Chicago). See Jessica Herczeg-Konecny, "Chicago: Queer Histories at the Crossroads of America," 29-4, in Megan Springate, ed., *LGBTQ America: A Theme Study of Lesbian, Gay, Bisexual, Transgender, and Queer History* (Washington, D.C.: National Park Service, 2016). ("Never before"). Edythe Eyde (a.k.a. Lisa Ben), *Vice Versa*, Sept. 1947, in Marcus, *Making Gay History*, 107. (Working-class lesbian bars). See Gallo, *Different Daughters*, xl; Faderman and Timmons, *Gay L.A.*, 88; Nestle, "The Bathroom Line," *Restricted Country*; Davis and Kennedy, *Boots of Leather*. ("tough bar lesbian"). Davis and Kennedy, *Boots of Leather*, 68. ("creating gay space"). Davis and Kennedy, *Boots of Leather*, 91; see also Faderman, *Gay Revolution*, 76. ("indelibly working-class"). Davis and Kennedy, *Boots of Leather*, 90. ("citywide panic"). Gallo, *Different Daughters*, xli; see also "Cops Close 2 Bars," *San Francisco Examiner*, Sept. 9, 1954.

39. (Del & Phyllis). Gallo, *Different Daughters*, xliii. (repelled & dependent). Del Martin and Phyllis Lyon, *Lesbian/Woman* (Volcano, CA: Volcano Press, 1991), 11; Faderman and Timmons, *Gay L.A.*, 75. (Rose Bamberger). Faderman and Timmons, *Gay L.A.*, 76. ("so we'd be able to dance"). Phyllis Lyon in Gallo, *Different Daughters*, 1–2. (Four couples). Del Martin, Phyllis Lyon, Rose Bamberger, Rosemary Sliepen, Noni Frey, Mary (last name unknown), Marcia Foster, June (last name unknown). As Marcia Gallo points out, there were "racial, ethnic, and class differences among the eight of them: Rose was Filipina, Mary was Chicana, and both were involved in relationships with white women. Two founders had children, two worked in typically 'blue-collar' trades, and two held 'white-collar' administrative positions. Some of them wanted only to have a place to socialize with other lesbians; others wanted to mix socializing with social action." Gallo, *Different Daughters*, 6. (the name). "Resumé of First Meeting, September 21, 1955," Admin. Files, DOB San Francisco Chapter, Sept. 21, 1955–Apr. 25, 1959, Lyon/Martin papers, 2/2, GLBT Hist. Soc.; see also Gallo, *Different Daughters*, 2–3.

40. ("deeply affected" . . . "vulgar and limited"). Davis and Kennedy, *Boots of Leather*, 67–68. (DOB founders clash). See generally Meeting Minutes, Oct./Nov. 1955, Admin. Files, DOB San Francisco Chapter, Sept. 21, 1955–Apr. 25, 1959, Lyon/Martin papers, 2/2, GLBT Hist. Soc. ("gay girl of good moral character"). "Special Meeting, November 9, 1955" (DOB), Lyon/Martin papers, 2/2, GLBT Hist. Soc. ("very masculine-appearing types"). Martin and Lyon, *Lesbian/Woman*, 220; DOB Minutes, Oct. 19, 1955, Lyon/Martin papers, 2/2, GLBT Hist. Soc. ("must be women's slacks"). "Special Meeting, November 9, 1955," Lyon/Martin papers, 2/2, GLBT Hist. Soc. ("Hiding in the catacombs"). J.M. in "Readers Respond," The Ladder, No.2 (Nov. 1963), 26.

41. (Meeting Mattachine). DOB Minutes, Jan. 18, 1956, Admin. Files, DOB San Francisco Chapter, Sept. 21, 1955–Apr. 25, 1959, Lyon/Martin papers, 2/2, GLBT Hist. Soc. (Stella Rush/ONE). DOB Minutes, Feb. 1, 1956, Lyon/Martin papers, 2/2, GLBT Hist. Soc.; Gallo, *Different Daughters*, 7. (ONE Institute). Faderman and Timmons, *Gay L.A.*, 120–21. (Clashes). See Gallo, *Different Daughters*, 8. ("decided to throw a party"). Billye Talmadge in Gallo, *Different Daughters*, 9. ("all-out publicity campaign"). DOB Minutes, June 14, 1956, Lyon/Martin papers, 2/2, GLBT Hist. Soc. (statement of purpose). Gallo, *Different Daughters*, 13. ("no different"). Davis and Kennedy, *Boots of Leather*, 67. ("acceptable to society"). "DAUGHTERS OF BILITIS—PURPOSE," in Gallo, *Different Daughters*, 11. (upwardly mobile lesbians). Davis and Kennedy, *Boots of Leather*, 139.

42. (Dr. Hooker). See generally Eric Marcus, "Episode Notes, Episode 4: Dr. Evelyn Hooker," MakingGayHistory.com, Nov. 2, 2016, available at makinggayhistory.com/podcast/episode-1-4. (Sam Morford & Mattachine). D'Emilio. *Sexual Politics*, 89–90. (B. Dwight Huggins). See Johnson, *Lavender Scare*, 172–74. (Huggins & Gerber). Letter from B. Dwight Huggins to Henry Gerber, Nov. 8, 1956, Matt. Soc. Corr., Jan. 10, 1955–Jan. 11, 1957, Homophile Movement, 3/21, GLBT Hist. Soc.

43. (Kameny's dismissal). See generally Johnson, *Lavender Scare*, 181. (Barbara arrives). Minutes, Sept. 13, 1956, Admin. Files, DOB San Francisco Chapter, Sept. 21, 1955–Apr. 25, 1959, Lyon/Martin papers, 2/2, GLBT Hist. Soc. (Barbara & DOB). See Faderman, *Gay Revolution*, 85.

44. (*The Ladder* 1). In one of many symbolic "passings of the torch" captured in *The Ladder*, *ONE*, *Mattachine Review*, and other homophile publications, the first issue of DOB's magazine included a letter written by Dr. Harry Benjamin in tribute to the recently deceased Dr. Alfred Kinsey. See *The Ladder* 1, no. 1 (Nov. 1956); see also Gallo, *Different Daughters*, 27–28. (Lorraine Hansberry). See Kevin J. Mumford, *Not Straight, Not White: Black Gay Men from the March on Washington to the AIDS Crisis* (Chapel Hill: Univ. of North Carolina Press, 2016), 17. Unfortunately, as is the case with many queer figures from the past, it is difficult to access evidence of Hansberry's lesbianism. As Kevin J. Mumford explains in his essential *Not Straight, Not White*: "In donating Hansberry's personal and professional effects to the New York Public Library, [Hansberry's estranged widower, Robert] Nemiroff separated out the lesbian-themed correspondence, diaries, unpublished manuscripts, and full runs of the homophile magazines and restricted them from access to researchers." Mumford, 19. ("trousers and definitive haircuts"). "LHN" to *The Ladder*, May 1957, in Mumford, *Not Straight, Not White*, 17–18.

45. (DOB grows). Gallo, *Different Daughters*, 43. Edythe Eyde (a.k.a. Lisa Ben), who declared in *Vice Versa* a decade earlier that the homosexual was "here to stay," was an early L.A. DOB member. ("young and Black and gay and lonely"). Audre Lorde, *Zami: A New Spelling of My Name* (Berkeley: Crossing Press, 1982), 176. ("exotic sister outsiders"). Lorde, *Zami*, 177, 179. ("convention of deviates"). "Sex Deviates Make S.F. Headquarters," *San Francisco Progress*, Oct. 7, 1959, 1. ("Joe and Suzy San Francisco"). Columnist Jack McDowell in Wes Knight, "Smear Drive," *Mattachine Review* 5, no. 11 (Nov. 1959), 14. (Wolden's address). Radio speech by Russell L. Wolden, "The Truth About the Mayor's 'Clean' City—An Expose [*sic*]!", Matt. Soc. Wolden Campaign Libel Suit, Oct. 7, 1959–Feb. 5, 1960, Lucas Papers, 7/7, GLBT Hist. Soc. ("gutter politics"). "Wolden in 'Smear' Campaign," Ron Johnson, *San Francisco Examiner*, Oct. 8, 1959, 1. (publicly associated). "Wolden Cites S.F. Vice in Campaign Attack," *San Francisco News-Call Bulletin*, Oct. 8, 1959, 6.

46. ("in the self-interest of the Lesbian"). Martin and Lyon, *Lesbian/Woman*, 229. ("stand our ground"). Martin and Lyon, *Lesbian/Woman*, 230–31.

47. (The Patch). Faderman and Timmons, *Gay L.A.*, 158; Dudley Clendinen and Adam Nagourney, *Out for Good: The Struggle to Build a Gay Rights Movement in America* (New York: Simon & Schuster, 1999), 180; Troy Perry in Phillip Zonkel, "Former Long Beach Resident Lee Glaze was a pioneer in the fight for gay rights," *Long Beach Press-Telegram*, Feb. 3, 2014; *Advocate* quotes in Bettina Boxall, "Fight for Gay Rights Started Early in L.A.," *Los Angeles Times*, June 26, 1994.

48. ("consider ME"). Kameny to Secretary of Defense Neil McElroy, June 1, 1959, in Long, *Gay Is Good*, 30–31. (desperate but determined). See Kameny to *ONE*, Aug. 27, 1960, ONE/USC Archives, ONE, Inc. Records, Box 29. ("10% of our population"). Charles Francis, ed., *Petition Denied. Revolution Begun. The 50th Anniversary of Kameny at the Court: Frank Kameny's Petition to the United States Supreme Court* (2011), 5. ("a violation of all this nation stands for"). Francis, *Petition Denied. Revolution Begun*, 17. "I must say," Kameny said of his brief in 2010, "after fifty years, it is still reading well." Francis, 3. ("I am right and society is wrong"). Kameny to Rae Kameny, June 3, 1972, in Long, *Gay Is Good*, 1–2.

49. ("we must fight"). Letter from "D.S." (Del Shearer), *The Ladder* 5, no. 7 (Apr. 1961), 21–23. (Kameny & Nichols contact Mattachine-NY). Jack Nichols in Sears, *Behind the Mask*, xiii. (Al de Dion). "Al de Dion," the pseudonym of an active member of Mattachine-NY in the 1950s and 1960s, signed his adopted surname in a number of different ways over the years, including "deDion," "de Dion," and "De Dion." Based on our review of contemporaneous correspondence, he likely used "de Dion" in communications with Frank Kameny and Jack Nichols. See Long, *Gay Is Good*, 20 ("de Dion"); Sears,

Behind the Mask, 391-92 ("deDion"); Mattachine Book Service, "A Note to 'MSNY' Members," c. 1967 ("De Dion"), MSNY Records, 1951–1976: Series 2, 4/6, NYPL. (Fouchette's report). Faderman, *Gay Revolution*, 133.

50. (Tay-Bush raid). "FLASH!" *The Ladder* 5, no. 12 (Sept. 1961), 25; see also "Tangents," *ONE* 9, no. 12 (Dec. 1961), 16. (doubting Hal). See "Tangents," *ONE* 9, no. 12, 16. ("not even liked"). *The Rejected (A Transcript)* (San Francisco: Pan-Graphic Press, 1961), 13; see also "T.V.–'The Rejected,'" *The Ladder* 5, no. 12, 10. The courage it took to appear on a program that ultimately aired across the country and around the world cannot be overlooked, and the danger assumed by Call and other homophile spokespeople isn't diminished by our modern views on their approach. (José Sarria was pissed). Gorman, *The Empress Is A Man*, 197; see generally *The LCE News*, digitalassets.lib. berkeley.edu/sfbagals/LCE_News; see also "The List Grows," *The Ladder* 5, no. 12, 9. ("The world knew"). José Sarria in Gorman, *The Empress Is a Man*, 206; see also "Advertisements," *The LCE News* 1, no. 1 (Oct. 16, 1961), 2. (one of thirty-three). At the time, San Francisco held citywide supervisor elections, meaning everyone in San Francisco voted for all city supervisor positions (later, due in large part to Harvey Milk, the city shifted to a district model), and there were five seats open. "Twelve hours before the filing deadline," Sarria remembered, "there were nine people running. My chances for winning were very, very good." Just before the deadline, though, "the people who didn't want me running went out and got almost 30 people to apply for the office." The diluted field ruined Sarria's chances. See Gorman, *The Empress Is a Man*, 206–07. (made his point). See Del Martin, "The Homosexual Vote," *The Ladder* 6, no. 4 (Jan. 1962), 4–5. ("From that day"). José Sarria in Gorman, *The Empress Is a Man*, 207.

51. ("by any lawful means"). "Constitution of the Mattachine Society of Washington," Aug. 28, 1962, in Long, *Gay Is Good*, 20. (political transformist). Long, *Gay Is Good*, 21. (screening process). Many, if not most, members used pseudonyms; in fact, some didn't learn their colleagues' given names until the group's twenty-fifth anniversary in 1986. See Johnson, *Lavender Scare*, 184. (Kameny & Congress). See Johnson, *Lavender Scare*, 185–90.

52. (Meet Virginia). See Katherine Cummings, *Katherine's Diary: The Story of a Transsexual* (Tascott, Australia: Beaujon Press, 2008), 142. In the 1940s and 1950s, Dr. Karl Bowman's Langley Porter Clinic became a hub of research into gender and sexuality variance. Through Louise Lawrence, a transgender woman who maintained correspondence with an extraordinary network of people she'd found by placing ads in personals sections and by reaching out to those whose arrests for cross-dressing made the papers, Bowman met a postdoctoral researcher named Virginia Prince (at the time, however, Prince would have introduced herself as Muriel). See Virginia Prince, "The How and the Why of Virginia," *Transvestia* 3, no. 17 (Oct. 1962), 2; see also Stryker, *Transgender History*, 44. Virginia Prince used Lawrence's network to launch the first iteration of *Transvestia* in 1952, though the edition was short-lived. See Stryker, *Transgender History*, 46. (more enlightened). See Virginia Prince, "Targets, Titles, and Terminology," *Transvestia* 2, no. 12 (Dec. 1961), 61; see also Stryker, *Transgender History*, 53. (*Transvestia* & *Turnabout*). See Virginia Prince, "A Restatement of Purpose," *Transvestia* 3, no. 18 (Dec. 1962), 13; Quiven Enright, "Cherish Your Guilt!" *Turnabout* 1, no. 1 (June 1963), 13 (referring to transsexuals as "the human nonentity—a not-man and a not-woman"); Harry Benjamin, M.D., "Clinical Aspects of Transsexualism in the Male and Female," *Turnabout* 1, no. 2 (Oct. 1963), 10–11. ("Come on, honey!"). Susanna Valenti, "I Hate Men," *The Ladder* 9, no. 8 (May 1965), 24–26. ("be a lady"). Virginia Prince, "The Art of Female Impersonation," *Transvestia* 2, no. 11 (Oct. 1968), 68.

53. (Radical changes *to The Ladder*). See, e.g., Jaye Bell, "Double Tribute: Del Martin, Barbara Gittings," *The Ladder* 7, no. 6 (Mar. 1963), 4. (Meeting Kay). See Barbara Gittings to Marion Glass, Aug. 1, 1961, Other Chapters, DOB NY—Financial, Dec. 31, 1960–Dec. 1965, Lyon/Martin papers, 14/12, GLBT Hist. Soc. (Willer in NYC). Shirley Willer in Marcus, *Making Gay History*, 14. Among other reasons, Willer was indispensable because of her connection to DOB's "angel," a wealthy friend who anonymously bankrolled the organization for years. ("Time for Reappraisal"). See "Minutes of Meeting," Apr. 28, 1963, ECHO General, Jan. 18–Aug. 27, 1963, Lyon/Martin papers, 19/21, GLBT Hist. Soc. (McIlvenna). Laurie Mansfield, "San Francisco: Homophiles and Neatniks," *The Ladder* 8, no. 8 (May 1964), 12–13. ("recognition of a common humanity"). Martin & Lyon, *Lesbian/Woman*, 239. (CRH). See "Meeting Minutes," July 7, 1964, CRH Board of Directors, Meeting Minutes & Related Docs., Jan. 5, 1964–Oct. 14, 1970, Homophile Movement, 9/10, GLBT Hist. Soc.

54. (**Wicker**). See Jack Nichols, "Randolfe Wicker (1938–)," *Before Stonewall: Activists for Gay and Lesbian Rights in Historical Context* (Binghamton, NY: Haworth Press, 2002), Vern L. Bullough, RN, PhD, ed. (**Rodwell**). See Carter, *Stonewall*, 31–32, 35. ("**fiery Old Testament prophet**"). Carter, *Stonewall*, 38. ("**These rights *are* ours**"). Kameny, Address to Mattachine Society of New York, New York City, July 22, 1964, "Civil Liberties: A Progress Report," *New York Mattachine Newsletter* 10, no. 1 (Jan. 1965), 7–23. (**Wicker vs. Dince**). See Kay Tobin, "'Expert' Challenged," *The Ladder* 9, no. 5 (Feb. 1965), 18. ("**not a sickness**"). See Mattachine Society Washington, Policy Statement, Mar. 4, 1965, in Long, *Gay Is Good*, 85–87.

55. ("**we'd done it**"). See J. Louis Campbell III, *Jack Nichols, Gay Pioneer: 'Have You Heard My Message?'* (New York: Routledge, 2012), 94. (**Dewey's**). *Drum*, Aug. 1965, 5–6, in Marc Stein, *City of Sisterly and Brotherly Loves: Lesbian and Gay Philadelphia, 1945–1972* (Philadelphia: Temple Univ. Press, 2004), 245. (**Dewey's & transgender history**). Stryker, *Transgender History*, 62. ("**heterosexual, whatever that is**"). *Janus Society News* (May 1965), 2, in Stein, *City of Sisterly and Brotherly Loves*, 245–46. (**Reminder Days**). Carter, *Stonewall*, 40. (**State Department & Rusk**). The State Department action received wide press attention due largely to Secretary of State Dean Rusk answering a reporter's question about the protest: "I understand that we are being picketed by a group of homosexuals. [*Laughter*]. The policy of the Department is that we do not employ homosexuals knowingly, and that if we discover homosexuals in our department we discharge them. [This] has to do with the fact that the Department of State is a department that is concerned with the security of the United States. . . . This has to do with problems of blackmail and problems of personal instability and all sorts of things. So that I don't think we can give any comfort to those who might be tempted to picket us tomorrow." See generally Long, *Gay Is Good*, 106. ("**a different mood**"). "Warren D. Adkins" (Jack Nichols) and Kay Tobin, "Part One: Sidelights of ECHO," *The Ladder* 9, no. 4 (Jan. 1965), 4.

56. (**ECHO insurgency & constitutional language**). See "Daughters of Bilitis: Constitution, 1964–1966," Article C, Sec. 11, San Francisco-Corr. & Docs., Nat'l Convention, DOB Nat'l., 1964–August 28, 1966, Lyon/Martin papers, 7/17, GLBT Hist. Soc. ("**understanding and Christian concern**"). See Martin and Lyon, *Lesbian/Woman*, 239–41; see also "Council on Religion and the Homosexual—Agenda," Nov. 5, 1964, CRH Board of Directors Meeting Minutes & Related Docs., Jan. 5, 1964–Oct. 14, 1970, Homophile Movement, 9/10, GLBT Hist. Soc. ("**it's been fun**"). Del Martin to "Coree," Dec. 18, 1964, Corr.-General, Admin. Files, DOB Nat'l., May 16, 1963–Jan. 1965, Lyon/Martin papers, 6/9, GLBT Hist. Soc. ("**shades of the debate**"). A. Mathys to Governing Board, "Re: Council on Religion and the Homosexual," Dec. 30, 1964, Corr.-General, Admin. Files, DOB Nat'l., May 16, 1963–Jan. 1965, Lyon/Martin papers, 6/9, GLBT Hist. Soc. ("**openly declared war**"). See Kay Tobin, "After the Ball, . . ." *The Ladder* 9, nos. 5 & 6 (Feb.–Mar. 1965), 4–5; "Private Benefit Ball Invaded," *Vector* 1, no. 2 (Jan. 1965), 1; "'After the Ball Was Over . . .'—What Really Happened," *Town Talk*, no. 8 (Jan. 1965), 1, 4; see also Herb Donaldson and Evander Smith in Marcus, *Making Gay History*, 99–104. (**Donaldson & Smith**). Herb Donaldson and Evander Smith in Marcus, *Making Gay History*, 99–104. ("**Mr. Average Citizen**"). Del Martin in Tobin, "After the Ball, . . ." at 5. ("**no time for debate**"). Del Martin to Barbara Gittings, Jan. 6, 1965, Corr.-RE Participation in Homophile Organizations and Picketing, Admin. Files, DOB Nat'l, Jan. 6–Nov. 6, 1965, Lyon/Martin papers, 6/12, GLBT Hist. Soc.

57. ("**we are not sick**"). Kameny, "Does Research Into Homosexuality Matter?" at 16. ("**we ARE right**"). Kameny, "Does Research Into Homosexuality Matter?" at 14. ("**DEMAND our rights**"). Kameny, "Does Research Into Homosexuality Matter?" at 14–15. (**DOB & picketing**). Gallo, *Different Daughters*, 116, 117. ("**picketing… is ridiculous**"). Del Shearer, "Re: Daughters of Bilitis, Inc. Participation in ECHO and Specifically Picketing," June 10, 1965, Corr.-Re Participation in Homophile Organizations and Picketing, Admin. Files, DOB Nat'l., Jan. 6–Nov. 6, 1965, Lyon/Martin papers, 6/12, GLBT Hist. Soc. A note on **context:** It's important to remember that homophiles weren't picketing in a vacuum. Kameny, Nichols, and other D.C. Mattachine members, for example, attended the 1963 March on Washington days before the first ECHO conference. By that time, Bayard Rustin, the key organizer of the March, had "become perhaps the most visible homosexual in America," followed closely by James Baldwin, who also was at the March. See Mumford, *Not Straight, Not White*, 32; John D'Emilio, *Lost Prophet: The Life and Times of Bayard Rustin* (New York: Free Press, 2005), 348. A few weeks before Kameny's seminal speech to Mattachine-NY, President Johnson signed the 1964 Civil Rights Act. A month after the Mardi Gras Ball raid in San Francisco, Malcolm X

was assassinated in Harlem, and the world witnessed Selma's Bloody Sunday weeks before ECHO first picketed the White House. Moreover, trailblazers like Ernestine Eckstein fought for freedom both as Black women and Black lesbians. See Gallo, *Different Daughters*, 117. ("**contrary to the policy or welfare**"). "Statement of DOB Policy," June 7, 1965, Corr.-RE Participation in Homophile Organizations and Picketing, Admin. Files, DOB Nat'l, Jan. 6–Nov. 6, 1965, Lyon/Martin papers, 6/12, GLBT Hist. Soc. ("**keep up with the movement**"). Kameny to the President and Governing Board, DOB, June 8, 1965, Corr.-RE Participation in Homophile Organizations and Picketing, Admin. Files, DOB Nat'l., Jan. 6–Nov. 6, 1965, Lyon/Martin papers, 6/12, GLBT Hist. Soc.

58. (**ECHO '65**). Notes, ECHO 1965, Oct. 17, 1964–Sept. 1965; MSNY Records, 1951–1976, Series 2: 3/24, NYPL.

59. (**NPCHO '66—Kansas City**). See generally National Planning Conference of Homophile Organizations (San Francisco), Feb. 19–Aug. 1966, Lyon/Martin papers, 20/18, GLBT Hist. Soc.

60. (**Harry Hay & the war**). As the progressive antiwar movement took shape, Hay, like many older activists, saw no contradiction between his antiwar stance and his fight for equal treatment of gays in the military. "You can't say 'Shaft the Draft' if you're excluded," he'd say. See Timmons, *Trouble with Harry Hay*, 221. (**Armed Forces Day**). See generally Don Slater, "Protest on Wheels," *Tangents* (May 1966), 4–8.

61. (**Mattachine-NY opts out/sips-in**). See Timmons, *Trouble with Harry Hay*, 223; Kameny, "Civil Liberties: A Progress Report," 10–11; Carter, *Stonewall*, 49–51. (**Kameny's influence**). The plan adopted by Leitsch and the others was directly inspired by Frank Kameny's 1964 speech to Mattachine-NY, in which he'd suggested: "One homosexual or several homosexuals in a group, *as homosexuals*, and as potential or actual patrons of otherwise legal establishments which, by stated public policy, they may not patronize, should bring the necessary suit against the proper officials. I feel that it is very much the role of the homophile organizations to encourage, to support, and to create such test cases." Kameny, "Civil Liberties: A Progress Report," 10–11. (**The "Sip-In"**). See Thomas A. Johnson, "3 Deviates Invite Exclusion By Bars," *New York Times*, Apr. 22, 1966, 43; see also Carter, *Stonewall*, 49–50. A word on **Julius':** Julius' is still in business and looks very much the same as it did in the days of the Sip-In. Thanks to the work of those at the NYC LGBT Historic Sites Project—Jay Shockley, Ken Lustbader, Amanda Davis, and others—Julius' is listed on the National Register of Historic Places for its significance to queer history.

62. (**Buffalo picket**). Davis and Kennedy, *Boots of Leather*, 50. ("**potential power of our people**"). Nestle, "Lesbian Memories 1: Riis Park, 1960," *Restricted Country*, 48. (**Philadelphia wedding**). Although it wasn't returned to the customers, miraculously the photo shop owner didn't destroy the film; over half a century later, the wedding film was donated to the USC/ONE Archives. Looking at the couple and their friends, one can't help but think of the countless numbers of memories queer people have had stolen from them, pictures that they—and we—will never see. (**Drag**). See, e.g., Gorman, *The Empress Is a Man*; Esther Newton, *Mother Camp: Female Impersonators in America* (Chicago: Univ. of Chicago Press, 1979).

63. (**Tenderloin's street queens**). Stryker, *Transgender History*, 66–67. ("**middle-class standards**"). Christina B. Hanhardt, *Safe Space: Gay Neighborhood History and the Politics of Violence* (Durham, NC: Duke Univ. Press, 2013), 52–68. ("**undermine the image of the so-called respectable homosexual**"). Minutes, Mar. 29, 1966, CRH Board of Directors Meeting Minutes & Related Docs. Jan. 5, 1964–Oct. 14, 1970, Homophile Movement, 9/10, GLBT Hist. Soc.

64. (**Vanguard**). "Statement of Purpose for Vanguard," *Vanguard* (Summer 1966); see also "Council on Religion and the Homosexual—Minutes of the Meeting of the Board of Directors," June 21, 1966, Lucas Papers, 1997–25, 11/15, GLBT Hist. Soc.; Stryker, *Transgender History*, 70. (**Compton's**). Stryker, *Transgender History*, 72–73. The "service charge" really was just a way to screen customers and eject them; it was used most often to exclude transgender women. (**Riots**). Stryker, *Transgender History*, 64–65.

65. (**Cooper's**). Stryker, *Transgender History*, 62.

66. (**Steve Ginsburg**). Although often misspelled, Steve Ginsburg's last name was not Ginsberg, but rather Ginsburg. See, e.g., S. Ginsburg, "To Members and Friends of PRIDE," Mar. 15, 1968, ONE/USC Archives, P.R.I.D.E. Records,

2013-077, 1/7. (P.R.I.D.E.). See "PRIDE: Accomplishments & A Look at the Future," Jan. 1967, ONE/USC Archives, Personal Rights in Defense and Education Records, 2013-077, 1/1. As Faderman and Timmons note, the acronym "P.R.I.D.E.," in this context, may have been "the first application of the word to gay politics," or at least on an organizational level. See Faderman and Timmons, *Gay L.A.*, 155–56. ("truly effective drive"). "PRIDE Organizes Homophiles," *Los Angeles Free Press*, Mar. 31, 1967, ONE/USC Archives, P.R.I.D.E. Records, 2013-077, 1/5. (male-only). See "Proposed By-Laws for P.R.I.D.E.," Art. II, Sec. 1, June 1966, ONE/USC Archives, P.R.I.D.E. Records, 2013-077, 1/3 ("Membership is open to all males, aged 21 or over, regardless of race or religion"); but see "Agenda—Meeting of the Board of Directors," Oct. 18, 1967, ONE/USC Archives, P.R.I.D.E. Records, 2013-077, 1/15 (considering "Resolution allowing women to join as active members"). (L.A.'s Black Cat). See Faderman and Timmons, *Gay L.A.*, 156–57. (*Los Angeles Advocate*). The first issue of the *Los Angeles Advocate* had on its front page both the word PRIDE ("a PRIDE publication"), and one of the earliest recorded uses of the phrase "Gay Power." See "U.S. Capital Turns On to Gay Power," *Los Angeles Advocate* 1, no. 1 (Sept. 1967); see also Faderman and Timmons, *Gay L.A.*, 161. (dropping the geographical qualifier). See Christianne Anastasia Gadd, "*The Advocate* and The Making of a Gay Model Minority, 1967–2007" (2012), dissertation, Lehigh Univ., 5–6.

67. (NACHO). Minutes, NACHO, Chicago, Ill., Aug. 17, 1968, 11, Gerber/Hart Library & Archives, William B. Kelley & Chen K. Ooi Collection. ("you must agree with me"). Letter from ECHO Delegates and Board Members to ECHO members, Sept. 23, 1965, East Coast Homophile Organizations, Mar. 28, 1964–Sept. 13, 1965, MSNY Records, 1951–1976, Series 2: 3/23, NYPL.

68. ("undermine the wall"). Henry Gerber to Manuel boyFrank, Feb. 19, 1940, in Sears, *Behind the Mask*, 87. ("unyielding stone wall"). Kameny to Robert Martin, Jr., May 8, 1968, in Long, *Gay Is Good*, 151–55.

Part II: Freaking Fag Revolutionaries, 1968-1973

1. ("you're going to have to fight for it"). Sylvia Rivera, *Survival, Revolt, and Queer Antagonist Struggle*, 18. ("we are everywhere!"). Barbara Gittings, Christopher Street Liberation Day 1973, Manuscripts and Archives, Vito Russo Papers, audio recording (transcribed by authors), NYPL. (Liberation explodes). See Kameny to Tom Brokaw, et al., Nov. 26, 2007, Kameny Papers Project. (Examples of various subgroups). See Angela Douglas, "Transvestites & transsexuals' teach-in," *Los Angeles Free Press*, June 5, 1970, 12 (Transsexual Action and Social Organizations or T.A.O.); "Lesbian Moms to Court for Kids," *Berkeley Barb*, Feb. 4–10, 1972, 7 (Lesbian Mothers' Union); "The Effeminist," *Berkeley Barb*, May 7–13, 1971, 7 (Effeminists); "3rd World Gay Revolution: Platform," *Gay Flames* 7, Nov. 14, 1970, 4–5 (Third World Gay Revolutionaries); LGBT Community Center National History Archive, Leonard Fink Collection, 1/25, Christopher Street Liberation Day 1972 (Gay Vietnam Vets). (Wittman's manifesto). Carl Wittman in Donn Teal, *The Gay Militants* (New York: Stein and Day, 1971), 111. ("Not as different segments"). Sylvia Rivera in Stephan L. Cohen, *The Gay Liberation Youth Movement in New York: "An Army of Lovers Cannot Fail"* (New York: Routledge, 2008), 96.

2. ("drag queens . . . Yippies"). Karla Jay, *Tales of the Lavender Menace: A Memoir of Liberation* (New York: Basic Books, 2000), 77. ("no such thing as a single-issue struggle"). Lorde, "Learning from the '60s," *Sister Outsider*, 138. ("institutionalized rejection of difference"). Lorde, "Age, Race, Class, and Sex, Women Redefining Difference," *Sister Outsider*, 115–16. (Tensions all over). See Cohen, *Gay Liberation Youth Movement in New York*, 155. Los Angeles canceled its Pride celebration altogether and San Francisco's lesbian community nearly boycotted the city's festivities. See "Gay Pride 1973," www.morriskight.com/2012/10/gay-pride-1973.html; "Gay Women May Not Join in Gay Parade," *Berkeley Barb*, Mar. 9–15, 1973, 13. ("could have been much worse"). Randolfe Wicker, "Behind the Lines on Gay Pride Sunday," *GAY* 4, no. 106 (July 1973). Since his days as a young radical, Wicker, like many activists of his generation, seemed to have stayed in place while the world around him spun out of control. Just days after the Stonewall Riots, for example, he denounced the demonstrations, telling a group of angry New Yorkers, "Rocks through windows don't open doors." Wicker later recanted the statement. See Wicker to Eric Marcus, "Marsha P. Johnson & Randy Wicker," 2017, *Making Gay History* 2, ep. 1, produced by Eric Marcus and Sara Burningham, podcast, makinggayhistory.com/podcast/episode-11-johnson-wicker. ("constant commotion"). Wicker, "Behind the Lines on Gay Pride Sunday." Wicker's description was misleading—or simply inaccurate—on a

number of levels. *First*, as Karla Jay summarized, "insanity is so often a charge used to control women that at the time [most] never would have labeled a sister in those terms"; transgender women like Sylvia Rivera, however, were (and are) often labeled "mentally disturbed"—by men and women, gay and straight—simply by virtue of having to voice frustration more intensely than non-transgender people. Jay, *Tales of the Lavender Menace*, 121. *Second*, Rivera's organization technically was called Street *Transvestite* Action Revolutionaries, *not* Street Transvestite*s* Action Revolutionaries. See *Come Out!* 1, no. 7 (Dec. 1970), 5; "Street Transvestite Action Revolutionaries," Manuscripts and Archives, IGIC, Box 19, STAR file, NYPL; but see Silvia Lee Rivera, "Transvestites: Your half sisters and half brothers of the Revolution," *Come Out!* 2, no. 8 (1972), 10 (referring to the group as "Street Transvestites Action Revolutionaries"). *Third*, while Christopher Street Liberation Day was an annual event, the 1973 gathering was the first time the post-parade rally was held in New York City's Washington Square Park. Significantly, this shift marked the beginning of the commercialization of Christopher Street Liberation Day, with bar owners and organized crime figures seeing an opportunity to capitalize off of the "annual gathering of love." Two decades later, Randy Wicker dedicated much of his activist life to ridding Pride in New York City of the influence of such profiteers. *Fourth*, and perhaps most importantly, despite being a self-described "transphobic creep" for many years, Wicker ultimately evolved into a radical advocate for Transgender Liberation. Near the end of her life, Sylvia Rivera described Wicker as "one of my best friends." Sylvia Rivera, "Bitch on Wheels" (June 2001), *Survival, Revolt, and Queer Antagonist Struggle*, 35. (The fight/"been brewing"). Cohen, *Gay Liberation Youth Movement in New York*, 9; Wicker, "Behind the Lines on Gay Pride Sunday."

3. (Sylvia "*was gay liberation*"). Lee Brewster in Abby Saypen, "A Little Bit of Our History: An Interview with Lee Brewster," *Tapestry* 70 (Winter 1995), 64. (easily manipulated). Bebe Scarpi in Cohen, *Gay Liberation Youth Movement in New York*, 96; see also Lee Brewster in Abby Saypen, "A Little Bit of Our History," 64 ("When you read in the paper that some gay person had turned the police car over . . . she was their energy. They would manipulate her, and they'd stick her in the background when it came time to talk to the press.") ("sister queens"). Sylvia Rivera in Arthur Bell, *Dancing the Gay Lib Blues: A Year in the Homosexual Liberation Movement* (New York: Simon and Schuster, 1971), 64. ("need for unity"). Lorde, "Age, Race, Class, and Sex, Women Redefining Difference," *Sister Outsider*, 119. ("Happy Birthday"). Arnie Kantrowitz, Christopher Street Liberation Day 1973, Manuscripts and Archives, Vito Russo Papers, audio recording (transcribed by the authors), NYPL.

4. (CSLD rally). Lee G. Brewster, "Drags & TV's Join March," *Drag: The International Transvestite Quarterly* 3, no. 11 (July 1973), 10; Cohen, *Gay Liberation Youth Movement in New York*, 155. ("all groups are in favor"). Lee G. Brewster, "Drags & TV's Join March," 11. We note that we find no evidence of Sylvia having approached organizers beforehand; that, of course, doesn't mean she hadn't. There are fairly comprehensive minutes from the meetings of the Christopher Street Liberation Day Committee leading up to CSLD 1973, however, and Sylvia does not appear in them. We're not convinced that Brewster's optimism was well founded; in other words, we have doubts that Sylvia would've gotten to speak had she approached the CSLDC beforehand. ("Y'all better quiet down"). See archive.org/details/SylviaRiveraYallBetterQuietDown1973. (crowd agreed). See vimeo.com/234353103.

5. ("Stonewall Nation"). For lyrics, see *Queer Music Heritage*, www.youtube.com/watch?v=tR8BK56mHOw. Singer Madeline D. Davis later coauthored the seminal *Boots of Leather, Slippers of Gold: The History of a Lesbian Community* with Elizabeth Lapovsky Kennedy. ("No pamphlets get read, I'm loving instead"). Lucy Wilde, "Since I Met You, I Dropped Out of the Movement," CSLD 1973, Vito Russo Papers, audio recording (transcribed by authors), NYPL. We made attempts to identify and locate Lucy Wilde in order to obtain permission to include these lyrics; we note, however, that we've been unable to track the singer-songwriter down. In the end, we included the specific verse of Wilde's song because of the amazing window it provides into a specific place and time. The trials and tribulations of Sylvia Rivera and Marsha P. Johnson, in other words, were already part of Gay Liberation lore as of 1973. ("as was right"). Vito Russo, CSLD 1973, Vito Russo Papers, audio recording (transcribed by authors), NYPL. (days in advance). See Executive Committee of Gay Activists Alliance, Minutes, June 20, 1973, GAA Committee Files, Exec.–Minutes, 1973, GAA, Series 1: 15/19, NYPL; but see Jean O'Leary

in Marcus, *Making Gay History*, 155 ("We stayed up the whole night before the rally and typed up this little statement."). Elsewhere in her interview with Eric Marcus, O'Leary says "I'm sure we had protested for weeks," which they had. Again, the statement had been prepared and presented to the committee well before "the night before the rally." (**"one person—a man"**). Jean O'Leary, CSLD 1973, Vito Russo Papers, audio recording (transcribed by authors), NYPL. (**exploitation**). We emphasize that drag per se wasn't the concern, rather that LFL took issue with drag *for profit*, which didn't just mean drag performance in a traditional entertainment setting. Another concern were "drag queens" who engaged in sex work, as Sylvia Rivera, Marsha P. Johnson, and many others did. The theoretical lines of reasoning get a bit crossed here, as LFL generally viewed prostitution as part of the patriarchy's exploitation of women, but transgender women engaged in sex work were *not* viewed as victims of exploitation. Instead, "drag queens" engaging in sex work helped perpetuate the patriarchy's exploitation; in the minds of many in LFL, in other words, "drag" prostitutes were men, "dressed up" like women, having sex with men. (**startled her**). See vimeo.com/236308070. (**Queen Lee**). See vimeo.com/236308070; Brewster, "Drags & TV's Join March," 44; Lee Brewster, CSLD 1973, Vito Russo Papers, audio recording (transcribed by authors), NYPL. (**response to Brewster**). See Wicker, "Behind the Lines on Gay Pride Sunday"; see also "A Challenge," *Gay Liberator* 31 (Oct. 1973), 6. (**"Don't start a riot"**). Vito Russo, CSLD 1973, Vito Russo Papers, audio recording (transcribed by authors), NYPL.

6. (**"There are murmurings"**). Kameny to Mattachine Midwest, Feb. 22, 1968, Gerber/Hart Library & Archives. (**RFK's assassination**). See "New Left Revives Plans for Convention Protests," *New York Times*, June 26, 1968. (**spectacular wave of rioting**). See Ben A. Franklin, "Washington Turmoil Subsides; Hundreds Homeless, Eight Dead," *New York Times*, Apr. 8, 1968; Donald Janson, "5,000 Troops Are Flown To Chicago for Riot Duty," *New York Times*, Apr. 7, 1968; "Violence Spreads to Kansas City, Trenton," *Los Angeles Times*, Apr. 10, 1968; Jack Jones, "City Reacts Emotionally to Dr. King Tragedy," *Los Angeles Times*, Apr. 6, 1968, 1. (**law and order**). "Fears of Protests at '68 Convention Allayed by Bailey," *New York Times*, May 28, 1968. (**occupied territory**). Just three days after NACHO adopted "Gay Is Good," Chicago police raided two popular gay bars, Sam's and The Annex, leading to seventeen arrests. See W. E. Beardemphl, "Parries & Thrusts," *Vector* 4, no. 9 (Sept. 1968), 9 (patrons and employees of the Inner Circle, a gay bar across from Lincoln Park that remained open so "the kids have some place to go," witnessed some of the week's worst brutality); see also Stewart-Winter, *Queer Clout*, 85 (at some point during the chaos, poet Allen Ginsberg came to the Inner Circle; "we talked and he got drunk," said former bartender Buddy King; but see D. J. R. Bruckner, "Tense Chicago 'Policed Up' for Convention," *Los Angeles Times*, Aug. 25, 1968, 12 (although not explicitly stated, Bruckner clearly implies that gay bars in "the tawdry mecca of the homosexual set" were closed for fear of police reprisal). (**"Maybe now people will listen"**). Earl Caldwell, "Violence Stirs Chicago Negroes," *New York Times*, Aug. 30, 1968 (quoted in Stewart-Winter, *Queer Clout*, 85); see also James Q. Wilson, "Why We Are Having a Wave of Violence," *New York Times*, May 19, 1968 (assuming throughout that "riots" mean those acts of civil unrest among "Negroes"). "Much of white America," Stewart-Winter notes, "sided with Daley and the police." (**"freaking fag revolution"**). "Federal Prosecutor Criticizes the Chicago 7 Defendants and Their Lawyers," *New York Times*, Feb. 28, 1970. During the same speech, Foran told the crowd that "Bobby Seale had more guts and more charisma than any of them and he was the only one I don't think was a fag."

7. (**"tiny, angry man"**). Jim Kepner to Donn Teal, Nov. 23, 1970, Teal, *Gay Militants*, 46. (**Laurence, S.I.R., etc.**). Notably, Bill Beardemphl, whom Leo Laurence replaced as editor of *Vector*, returned from NACHO completely frustrated with the state of homophile affairs, calling the Chicago meeting "the most depressing experience of his life." W. E. Beardemphl, "Conference Trip Bummer," *Vector* 4, no. 9, 5; Leo Laurence, "Homo Revolt: Don't Hide It," *Berkeley Barb*, Mar. 28–Apr. 3, 1969, 5, 23; Leo Laurence, "Gay Revolution," *Vector* 5, no. 5 (Apr. 1969), 11; "States Line" technically was the States Steamship Company, see "Gay Rebel Gets Shafted Uptight Boss," *Berkeley Barb*, Apr. 4–10, 1969, 11. (**"first full-fledged Gay Lib type group"**). Kepner to Teal, Nov. 23, 1970, Teal, *Gay Militants*, 45; see also Kepner, *The Advocate*, June 1969 (published before Stonewall), in Teal, *The Gay Militants*, 49. (**predicted confrontations**). See Leo Laurence, "Gays Still After State," *Berkeley Barb*, June 27–July 3, 1969, 11.

8. (**early hours of Saturday**). Technically, the raid on the Stonewall Inn started at around 1:20 a.m. on the morning of Saturday, June 28. Informally speaking, this was a Friday night; the anniversary of Stonewall, however, is marked on June 28. See Carter, *Stonewall*, 137. (**the story of Stonewall**). Contemporaneous accounts of the events at Stonewall include Howard Smith, "Full Moon Over Stonewall," *Village Voice*, July 3, 1969; Lucian Truscott, "Gay Power Comes to Sheridan Square," *Village Voice*, July 3, 1969; Dick Leitsch, "The Hairpin Drop Heard Around the World," *New York Mattachine Newsletter*, Aug. 1969; Ronnie Di Brienza, "Stonewall Incident," *East Village Other* 4, no. 32 (July 9, 1969); and "Queen Power: Fags Against Pigs in Stonewall Bust," *Rat* 2, no. 14 (July 9-23, 1969). For a comprehensive, and essential, overview of Stonewall, see David Carter, *Stonewall: The Riots That Sparked the Gay Revolution* (New York: St. Martin's Press, 2004). See also *Stonewall Romances: A Tenth Anniversary Celebration* (New York: Flower Beneath the Foot Press, 1979), Vito Russo Papers, 20/2, NYPL. A note on **Duberman**: Upon its release, Martin Duberman's *Stonewall* (New York: Dutton, 1993) was heralded as *the* definitive account of the nights of rage on Christopher Street; the book is, at this point, treated as canonical. There are, however, significant problems with Duberman's book and, although it has informed our understanding of the popular myths surrounding Stonewall, we did not rely on the book in any meaningful way. To be specific, Duberman's *Stonewall* is an oral history of six individuals, all of whom had competing personal and political interests, compiled by a historian who has never claimed to be objective. The book is important as evidence of historical memory, but its value in terms of accurate history is questioned and questionable. (**Rodwell**). Carter, *Stonewall*, 146. (**hated the Stonewall**). See Craig Rodwell, "Mafia on the Spot," *Hymnal* 1, no. 1 (Feb. 1968), 1–2 ("New York HYMNAL received a report . . . that the Stone Wall was going to be closed by the Health Department because it was alleged that a number of cases of Hepatitis . . . had been traced to the Stone Wall's bar"); Carl Lee, "It's What's Happening," *Hymnal* 1, no. 5 (June–July 1968) (calling the Stonewall "the tackiest joint in town"); "Get the Mafia and the Cops out of Gay Bars," Homophile HYMN Youth Movement flyer, July 1969 ("Legitimate Gay businessmen are afraid to open decent Gay bars with a healthy social atmosphere (as opposed to the hell-hole atmosphere of places typified by the Stonewall) because of fear of pressure from the unholy alliance of the Mafia and the elements in the Police Dept. who accept payoffs and protect the Mafia monopoly"). (**other raids**). See Teal, *Gay Militants*, 20–21; David Bird, "Trees in a Queens Park Cut Down as Vigilantes Harass Homosexuals," *New York Times*, July 1, 1969, 1, 29; "Queens Resident Says the Police Stood By as Park Trees Were Cut," *New York Times*, July 2, 1969, 38.

9. (**"deviated from the script"**). Elizabeth A. Armstrong and Suzanna M. Crage, "Movements and Memory: The Making of the Stonewall Myth," *American Sociological Review* 71 (Oct. 2006), 757. (**"everything came together"**). Craig Rodwell in John Scagliotti, *After Stonewall* (After Stonewall, Inc.: 1999). (**beat the cops back into the very bar**). See Smith, "Full Moon over the Stonewall." (**butch dyke**). See Smith, "Full Moon over the Stonewall" ("The turning point came when the police had difficulty keeping a dyke in a patrol car"); Carter, *Stonewall*, 152 ("There seems no doubt that the lesbian who twice escaped the police car played a leading role in increasing the crowd's anger that Saturday morning in June"). A note on **Stormé DeLarverie**: It's sometimes said that the butch lesbian at the center of the storm, so to speak, was famed drag king and Greenwich Village icon Stormé DeLarverie; we agree with David Carter's conclusion that, while Stormé almost certainly was there those nights, she was *not* the dyke who triggered the beginning of the riots. Of the many reasons Carter presents, we find most convincing the fact that, by the time of the Stonewall Riots, Stormé was well-known in Greenwich Village and, had she been the one who kick started the riots, many of those there would have been able to put a name to the face. Instead, there is no consensus on who that person was; actually, the consensus is that no one knows. See Carter, *Stonewall*, 309 ("Conclusions," #10). (**"Stonewall Girls."**) See generally Carter, *Stonewall*, 176–91 ("Ironically, the [Tactical Police Force's] psychology of using machismo to try to intimidate protesters whom society had branded as deficient in masculinity—and hence courage—ultimately raised the question of who, indeed, was braver: the TPF hiding behind their shields and helmets, equipped with guns and billy clubs, with all the force of the law and the approval of society behind them, or the gay men—with most of those in the kick line being effeminate to some degree—the objects of society's scorn and ridicule, offering their vulnerable bodies as targets and armed with nothing more than their intelligence and humor?"). As opposed to San Francisco, New York's "street queens" did not necessarily identify as transsexuals or transvestites, though they certainly transgressed

the boundaries of gender, often donning "scare drag"—outrageous, over-the-top, "trashy" outfits, wigs, and makeup. With that said, there's almost no question that among the Stonewall Girls were transgender women like Yvonne Ritter, Zazu Nova, and others. (**Marsha P. Johnson**). See Leitsch, "The Hairpin Drop Heard Around the World," 22; Carter, *Stonewall*, 188 (citing Craig Rodwell). **notes on legends**: There is a self-defeating quality to the common narrative surrounding the role that Marsha P. Johnson and Sylvia Rivera played at Stonewall; we refer specifically to the "first brick" or "first shot glass" legend, wherein Marsha or Sylvia threw an object and ignited the nights of rage. *First*, the shot glass tale, we think, can be dismissed out of hand. Most importantly, the riots didn't start inside, so unless someone took a shot glass outside (or had one on them), we see no reason to believe that a shot glass had anything to do with it. See generally Carter, *Stonewall*, 79–80. *Second*, according to all available evidence—including multiple accounts *by* Marsha and Sylvia—the "first object" tales are apocryphal. While everyone agrees Marsha was there near the beginning of the first night—and multiple sources confirm seeing her climb a lamppost to drop a bag on a cop car—she told Eric Marcus that she arrived *after* "the riots had already started . . . the place was already on fire." Neither Marsha nor Bob Kohler, an advocate of the street queens and trans women who fought hardest, recalled seeing Sylvia at the riots on the first night, though she no doubt took part in the multiple days of demonstrations. Even if she had been there as it started, Sylvia herself often said she didn't throw the first brick or Molotov cocktail. See "Marsha P. Johnson & Randy Wicker," 2017, *Making Gay History* 2, ep. 1, produced by Eric Marcus and Sara Burningham, podcast, makinggayhistory.com/podcast/episode-11-johnson-wicker; Cohen, *Gay Liberation Youth Movement in New York*, 90. *Third*, the emphasis on Stonewall put intense pressure on activists of the era to amplify, and sometimes fabricate, their participation in those nights. *One did not have to be at Stonewall to be a trailblazer*. By focusing on this *one* event, we refuse so many of our heroes the respect they deserve. And, bizarrely, while, for example, Marsha and Sylvia so often are used—as they were in the Gay Lib era—as tokens of mainstream transgender inclusion, the focus on those two heroes lets us off the hook when it comes to learning about the large number of other trans women (and men) who were there during the riots. *Fourth*, Stonewall created false prophets. Just as one didn't have to be there to be a hero, those who were there weren't necessarily destined for greatness. The record is rife with historical inaccuracies, thanks in large part to self-aggrandizing "Stonewall Vets" more concerned with their own stories than with historical accuracy. See, e.g., Jim Fouratt, "The Question Remains: What Do We Want?" *Lesbian & Gay New York*, Jul. 1, 1996, 8, 40. Although there are others, Fouratt seems to be among the most destructive forces in the pursuit of accurate queer history, using his questionable (and questioned) participation at Stonewall as license to attack provable accounts that don't include tales of his supposed heroism. Fouratt is largely responsible, for example, for shaping the overly simplistic narrative of "GAA-as-assimilationist" and "GLF-as-truly-liberationist." See, e.g., Jim Fouratt (interview by Sarah Schulman), ACT UP Oral History Project, Nov. 28, 2006, 31; but see, e.g., Teal, *Gay Militants*; Bell, *Dancing the Gay Lib Blues*. Perhaps most unsettling are Fouratt's ongoing claims of loyalty to and friendship with Sylvia Rivera, who described him as follows: "A once oppressed white gay male, now free and liberated, [Fouratt] has become the enemy and oppressor of the Transgender Community around the World." See Jack Nichols, "Controversial Activist Slammed at New York Pride Rally," *GayToday*, June 19, 2000, available at gaytoday.badpuppy.com/garchive/events/061900ev.htm. ("**lost that wounded look**"). Truscott, "Gay Power Comes to Sheridan Square."

10. ("**Can you imagine?**"). Chris Babick in Carter, *Stonewall*, 185. ("**turned upside down**"). Joan Nestle in Kate Brandt, "It Wasn't Just One More Raid . . . Stories From '69," *Deneuve*, May/June 1994, 20, in David Carter, Andrew Dolkart, Gale Harris, and Jay Shockley, "Stonewall National Historic Landmark Nomination," Jan. 1999. (**Riots, Uprising, Rebellion**). bell hooks, "A Successful Rebellion, And . . ." (excerpted from *Feminist Theory: from margin to center*), *Matrix* 10, no. 2 (Apr. 1985), 5. ("**a hell of a lot of hard work**"). Dorr Legg in Brad Mulroy, "The Gay Movement: Beginnings and Ends, An Interview with Dorr Legg," *New York City News*, June 21, 1981, 31; see also Armstrong and Crage, "Movements and Memory," 744 (the popular account of Stonewall "does not distinguish between the processes generating riots and those attributing significance to them"). ("**the movement successfully promoted**"). Armstrong and Crage, "Movements and Memory," 725, 743. (**organizing on the ground**). See Carter, *Stonewall*, 209–10.

11. (**Kameny's rules**). See Long, *Gay Is Good*, 101–03. (**Final Reminder**). See Teal, *Gay Militants*, 30; "Fifth Annual Homophile Demonstration in Philadelphia," *Daughters of Bilitis New York Chapter Newsletter* 1, no. 5 (Aug. 1969); see also Faderman, *Gay Revolution*, 188–89. ("**militancy . . . themselves and society**"). "Gay Revolution Comes Out," *Rat*, Aug. 12–16, 1969; see also Carter, *Stonewall*, 220. (**GLF generally**). For a relatively comprehensive overview of GLF chapters, see ONE/USC Archives, Gay Liberation Front, Los Angeles (GLF-L.A.) Records, 2012-031. (**L.A.**). Jay, *Tales of the Lavender Menace*, 174–75. (**Louisville**). James T. Sears, *Rebels, Rubyfruit, and Rhinestones: Queering Space in the Stonewall South* (New Brunswick, NJ: Rutgers Univ. Press, 2001), 62–63. (**Wash. State Penitentiary**). ONE/USC Archives, GLF-L.A. Records, 2012-031, 1/35. (*Village Voice*). See Mike Brown, Michael Tallman, and Leo Louis Martello, "The Summer of Gay Power and the Village Voice Exposed!" *Come Out!* 1, no. 1 (Nov. 1969). (**San Francisco**). See George Mendenhall, "Examiner Attacks," *Vector* 5, no. 9 (Sept. 1969) (describing anti-gay policies and procedures of the *Examiner*); "Gay Liberation Front," *Berkeley Barb*, Oct. 31–Nov. 9, 1969, 6; William B. Kelley, "L.A., S.F. Papers Picketed," *Mattachine Midwest Newsletter*, Nov.–Dec. 1969, 7; Teal, *Gay Militants*, 70–72. (**L.A.**). Kelley, "L.A., S.F. Papers Picketed," 7; Teal, *Gay Militants*, 73.

12. (**Periodicals**). See, e.g., *Gay Power*. Published by entrepreneur Joel Fabricant, New York City's *Gay Power* first appeared in the summer of 1969 and immediately caused controversy within the fledgling Gay Lib Movement. As one Gay Liberation Front member wrote in *Come Out!*: "It has been the sad plight of the homosexual in our society to be the victim of the money-hungry opportunist: the mafia bar owner, the blackmailer, the sticky fingered rough trade. A recent and deplorable perverting of the gay movement for profits can be found in the bi-weekly 'Gay Power,' third issue on newsstands now." "Joel Fabricant Perverts Gay Power," *Come Out!* 1, no. 1, 3; *The Gay Blade*. Originally conceived as a project of the Mattachine Society of Washington, *The Gay Blade* launched in October 1969 as "An Independent Publication Serving the Gay Community" of D.C. See *Gay Blade* 1, no. 1 (Oct. 1969); Larry Sheehan, "Changing of the Guard," *Gay Blade* 5, no. 1, (Oct. 1973), 1–2. More so than anyone, Nancy Tucker, *The Blade*'s first editor, was responsible for the success of the paper, which is still in publication today; *Homosexual Renaissance*. The newsletter of Homosexuals Intransigent!, the boldly named student group at The City College in New York. Notably, Homosexuals Intransigent! and its founder, L. Craig Schoonmaker, espoused radical Gay Liberation ideals months before Stonewall. See Teal, *Gay Militants*, 44–45; *Come Out!* Marketed as the newspaper that aimed "to give voice to the rapidly growing militancy within our community." *Come Out!* 1, no. 1, 1. While technically the paper had "no single editor or publisher" and "was intended to function as a community forum," *Come Out!* was produced by a GLF-NY subgroup, the 28th of June Cell. *Come Out!* 1, no 2. (Jan. 1970), 2, 16; *GAY.* Jack Nichols and Lige Clarke launched *GAY* in December 1969 in the hopes of creating "a newspaper which is interesting, entertaining and informative on its *own* account, and not simply because it deals with the tabooed world of the homosexually-inclined." L. Clarke & J. Nichols, "The Editors Speak," *GAY* 1, no. 1 (Dec. 1969). The success of the paper made Nichols and Clarke one of the most recognizable gay couples in the United States; *Off Our Backs.* A bi-weekly radical feminist publication that first appeared in February 1970; based out of the Washington, D.C. area, the *Off Our Backs* collective published the periodical until 2008. See generally *Off Our Backs* archives, Special Collections, Univ. of Maryland Libraries, 2010-89; 2010-112; *Gay Liberator.* Published by the Gay Liberation Front of Detroit, Michigan, first appearing in mid-1970. See, e.g., *Gay Liberator* 1, no. 6 (Dec. 1970); *Gay Flames.* As the "Bulletin of the Homofire Movement," *Gay Flames* sought "the right of self-determination for all third world and gay people, as well as control of the destinies of our communities." "What We Want, What We Believe," *Gay Flames* 12 (May 1971), 4. *Gay Flames*, in other words, focused on the intersection of issues impacting queer people and people of color.

13. (**Lorde**). Audre Lorde in Greta Schiller, Robert Rosenberg, and John Scagliotti, *Before Stonewall: The Making of a Gay and Lesbian Community* (First Run Features: 1984). (**Lesbian Feminist**). Jay, *Tales of the Lavender Menace*, 145 (discussing the emergence of Radicalesbians after the Lavender Menace action). (**Transgender**). See, e.g., Angela Douglas, "Transvestites & transsexuals' teach-in," June 5, 1970, 12; "Transvestites Legal Committee," *Chicago Gay Alliance* 1, no. 10 (Nov. 1971). (**Third World & Gay Youth**). See generally Cohen, *Gay Liberation Youth Movement in New York*; Mark Segal, *And Then I Danced: Traveling the Road to LGBT Equality* (Brooklyn, NY: Akashic Books, 2015). ("**cannot develop in a vacuum**"). Allan Warshawsky and

Ellen Bedoz, "G.L.F. and the Movement," *Come Out!* 1, no. 2, 5. (**Zazu Nova**). Cohen, Gay Liberation Youth Movement, 48, 100.

14. (**GAA**). Bell, *Dancing the Gay Lib Blues*, 17–19; see also "Schism in Chicago Gay Lib!" *Chicago Gay Liberation Newsletter* 1, no. 9 (Oct. 1970), 1, 2. (**Pronunciation of "GAA"**). See Bell, *Dancing the Gay Lib Blues*, 19 ("Gay, get it!"). (**Working from within**). "Homophiles Need Support," *GAY*, Apr. 13, 1970. (**Ideological shift**). See "Conflicts Between Political and Cultural Leaders," Toby Marotta, *The Politics of Homosexuality* (Boston: Houghton Mifflin, 1981), 162–95; Teal, *The Gay Militants*, 128 ("GAA represented a new direction for gay militancy, a sort of 'conservative radicalism'—or 'middle-of-the-road radicalism' if the old-line homophile movement, gay-civil-rights-oriented too, be considered radical."); Joann B. Lublin, "Student Homosexual Movement Gains, but Groups Fragmented by Dissension," *Wall Street Journal*, Dec. 16, 1971. (**Rubin**). Marc Rubin in Randy Wicker, *Gay Marriage Bureau Takeover 1971*, available at www.youtube.com/watch?v=Z7NU8B1EGnU. (**Doerr and zaps**). Bell, *Dancing the Gay Lib Blues*, 31. The significance of the lambda (λ), dismissed by Frank Kameny as "metaphysical bullshit," is actually "a bit of GAA lore that was entirely fanciful." Nowhere does the symbol signify what Doerr claimed; in reality, he chose the lambda "because he thought it was pretty." Clendinen and Nagourney, *Out for Good*, 56; Kameny, quoted in John Paul Hudson, "Stonewall 25 Reunion," April 1994, available at groups.google.com/forum/#!topic/soc.motss/da5ytLs5VGA.

15. (**Vinales**). See Bell, *Dancing the Gay Lib Blues*, 35, 38–40, 46. ("**that boy was PUSHED**"). The Vinales action very much was the work of GLF-affiliated activists, GAA, and a number of lesbian collectives, one of the few such coordinated efforts at the time. As the night ended, however, GAA leaders Marty Robinson and Jim Owles announced gratitude to "their brothers" for participating, making no mention of the large contingent of women who had lent support; the slight wouldn't be forgotten. Bell, *Dancing the Gay Lib Blues*, 41, 47.

16. (**Zaps**). See Faderman, *Gay Revolution*, 218. (**Fidelifacts**). See Peter Fisher, "Fidelifacts: Sex-Snooping Agency Draws Gay Fire," *GAY*, Feb. 15, 1971. Members of the gay community had been aware of Fidelifacts almost since the agency opened its doors in the mid-1950s. Writing to Don Lucas, then-national president of the Mattachine Society, D.C. Chapter president Dwight Huggins worried that "part of their object is to prevent homosexuals from obtaining positions in industrial firms." B. Dwight Huggins to Don Lucas, Oct. 1, 1956, Matt. Soc. Corr., Jan. 10, 1955–Jan. 11, 1957, Don Lucas Papers, 3/21, GLBT Hist. Soc. (**Vito Russo**). Vito Russo's activism provides an interesting illustration of the problematic Stonewall-as-origin story. While the extent of Russo's participation during the events around Stonewall isn't clear, he consistently claimed it was the Snake Pit raid—and the Diego Vinales incident—that drew him into activism. Upon seeing the "that boy was pushed" flyer, Russo told Eric Marcus, "I realized that if he didn't have to be so scared of being deported, he wouldn't have jumped. So for the first time, the organized response reached me on a gut level. It was the following Thursday when I went to my first Gay Activists Alliance meeting." While GAA no doubt reinvigorated Russo's activism, he'd been involved in the struggle for years. Namely, as a college student, Vito urged the student lecture committee to invite Dick Leitsch to speak at an event. As Vito recalled, a professor who knew he was gay told him, "I'm warning you, if you push this thing, someday they'll shoot you in the streets. You're making a mistake.' I invited Dick anyway." The emphasis on post-Stonewall activism has perpetuated the idea that pre-Stonewall activism meant virtually nothing, so much so that even those, like Vito Russo, who were engaged in such early activism downplayed its importance. See Russo in Marcus, *Making Gay History*, 110, 140; see also letter from Dick Leitsch to Russo, Feb. 27, 1968 ("Dear Mr. Russo: This letter is to confirm speaking engagement on Wednesday, March 6th, at Fairleigh Dickinson University at 10 A.M."), MSNY-Leitsch Corr., 1951–76, Series 1: 1/17, NYPL. (**Marriage zap**). See "Municipal Wins Lindsay Support," *Gay Activist* 1, no. 3 (June 1971), 10; "Intro 475 Hearings Begin," *Gay Activist* 1, no. 7 (Nov. 1971), 9; Wicker, *Gay Marriage Bureau Takeover 1971*. (**Katz & Jorgensen**). See "Bars Marriage Permit," *New York Times*, Apr. 4, 1959, 20; see also Meyerowitz, *How Sex Changed*, 51. (**Provincetown, Bridgeport**). See "Straights Harass Bridgeport Gays," *Gay Activist* 1, no. 4 (Aug. 1971); "Out of the Dunes & Into the Streets!" *Come Out!* 1, no. 5 (Sept.–Oct. 1970), 6.

17. (**Barney's**). See Timmons, *Trouble with Harry Hay*, 230; Angela Douglas (as Douglas Key), "Gays Plan Marches, Leather Sunday," *Los Angeles Free Press*, Mar. 13, 1970, 3; "Décor Improves at Barney's," *Los Angeles Free Press*, Mar. 27, 1970, 5; see also Faderman and Timmons, *Gay L.A.*, 174–75. (**The Farm**). See

Faderman and Timmons, *Gay L.A.*, 175–76; see also Jay, *Tales of the Lavender Menace*, 178 ("Actions of the LA group paralleled those in New York, although there was almost an exclusive focus on men's issues"). (**White Horse, Astro, Morrie's, etc.**). Leo E. Laurence, "Shit on a White Horse," *Berkeley Barb*, Sept. 18–24, 1970, 7; Robert Stanley, "Gays Picket Restaurant," *Mattachine Midwest Newsletter*, Sept. 1970, 9; Philip Dixon, "GLF Holds Sit-In at Eddy St. Bar," *Cornell Daily Sun*, Oct. 16, 1970, 1; *Gay Blade* 3, no. 2 (Nov. 1971), 1; Teal, *Gay Militants*, 283–93. (**Murders**). See, e.g., "Gunned Down," *Los Angeles Free Press*, Mar. 13, 1970, 3 (re Laverne Turner); "Transvestite Killed in West Side Clash," *Chicago Gay Alliance Newsletter* 1, no. 2 (Dec. 1970), 2–3 (re James Clay); "Support Lesbian, Transvestite, & Gay inmates," *Gay Flames* 10, Feb. 12, 1971, 1 (re Raymond Lavon Moore). (**Lavender Menace**). See Radicalesbians, "The Woman-Identified Woman"; 2 Radicalesbians, "The Lavender Menace Strikes"; Arlene Kisner, "Women Coming Together with Women"; Judy Cartisano, "Lavender Menace Does It"; Sandy, "Two Views," all in *Come Out!* 1, no. 4 (June–July 1970), 12–15; Teal, *Gay Militants*, 179–83; see also Jay, *Tales of the Lavender Menace*, 137–46.

18. (**personal is political**). Carol Hanisch, "The Personal is Political," in Shulamith Firestone and Anne Koedt, eds., *Notes from the Second Year: Women's Liberation—Major Writings of the Radical Feminists* (New York: self-pub., 1970), 76–78. (**Austin**). See "Announcements," *Rag* 6, no. 15 (Feb. 21, 1972), 13; "GLF Boogies Despite Arrests," *Rag* 6, no. 16 (Feb. 28, 1972), 4; "Gay Dance," *Rag* 6, no. 17 (Mar. 6, 1972), 5. While the years after Stonewall saw the beginning of militant Gay Liberation–based activism in Austin, there'd been homophile activism in the Texas capital for years prior. Namely, former University of Texas student Randy Wicker had attempted on a number of occasions to organize homophile groups. (**Athens**). See CJ Bartunek, "Dance Revolution '72," *The Big Roundtable* (Feb. 2, 2016), avail. at thebigroundtable.com/dance-revolution-72-34d1e9089b5d. (**community centers**). See, e.g., "Community Center," *Come Out!* 1, no. 7, 6; "Gimme Womans Shelter," *Ain't I A Woman?* 1, no. 12 (Feb. 19, 1971), 9; Ric Hanson, "Gay Community Center Now a Reality," *Mattachine Midwest Newsletter*, Mar. 1971, 6; "Two Gay Centers Open," *Everywoman* 1, no. 4, is. 15 (Mar. 5, 1971), 13; "MCC/San Francisco Has A Community Center!" *MCC Speaking Up* 2, no. 13 (Mar. 28, 1971), 1; "Ohio Gays Open Community Center," *GAY*, Sept. 27, 1971, 3; "GAA-D.C. Opens Community Center," *GAY*, Apr. 3, 1972, 6; Carol Strong, "Benefits, Dances Held at [Seattle] Gay Center," *Pandora*, Apr. 18, 1972, 2. (**liberating bars**). See, e.g., "Where the Action Is," *Gay Activist*, n.d., GAA, Series 2: 18/10, NYPL.

19. ("**The time will come**"). In a 1989 interview, Chuck Rowland recalled the April 1953 Mattachine Foundation convention, telling Eric Marcus he specifically remembered saying: "The time will come when we will march arm in arm, ten abreast down Hollywood Boulevard proclaiming our pride in our homosexuality." Rowland in Marcus, *Making Gay History*, 42. This accords with an earlier account given to Stuart Timmons, reproduced here. See Rowland in Timmons, *Trouble with Harry Hay*, 177. The transcript of Roland's fiery speech, however, does not include this language or any reference to a march. See Chuck Rowland, "Opening Talk: California State Constitutional Convention of the Matt. Soc., April 11, 1953," Matt. Soc. Conventions, Apr. 1953, 2/20, GLBT Hist. Soc. Given Rowland's radical insistence on visibility and early emphasis on pride, however, the absence of this particular line in the official transcript doesn't mean he didn't express the sentiment then or generally in the early 1950s. (**collective memory**). Armstrong and Crage, "Movements and Memory," 725. (**Christopher Street Liberation Day**). "ERCHO Report," *Homophile Action Newsletter* 2, no. 2 (Jan.–Feb. 1970), 5–7; Carter, *Stonewall*, 230; Teal, *Gay Militants*, 322–23. (**no guarantee/the Stonewall myth**). Armstrong and Crage, "Movements and Memory," 724–51; Morris Kight, "How It All Began," *Christopher Street West: Gay Pride Week 1972*, ONE/USC Archives, CSW Association Collection, 2012–135, 4/1; see also Duberman, *Stonewall*, 270.

20. ("**could not sort it out**"). Kight, "How It All Began." (**Effland**). For a full description of the circumstances surrounding the death of Howard Effland (who also was known as J. McCann), see United States Mission, Inc. to Mattachine-NY, Apr. 1969, MSNY Records, Corr., Richard Leitsch, 1968–1969, Series 1: 2/1, NYPL. (**Coincidence**). See Teal, *Gay Militants*, 117, fn. (**Laverne Turner**). See "Gunned Down," *Los Angeles Free Press*, Mar. 13, 1970, 3; "Laverne Family Seeks Inquest," *Los Angeles Free Press*, Apr. 10, 1970, 2. Depending on the source, Laverne was known either as "Larry" or "Laverne," and referred to either as a homosexual or a transvestite; given all the information available, we choose to err on the side of respecting Laverne's

chosen name. Moreover, given her identification as a "transvestite" and our broad definition of transgender, we identify Turner as transgender. (**Gay-Ins**). Jay, *Tales of the Lavender Menace*, 179. The 1970 Gay-Ins were *not* the first Gay-Ins in Los Angeles, rather, they were the first Gay-Ins after Stonewall. See Faderman and Timmons, *Gay L.A.*, 157; see also *The Advocate*, Mar. 29, 1970, ONE/USC Archives, GLF-L.A. Records, 2012–031, 1/8. (**Be-Ins**). See ED Denson, "What Happened at the Hippening," *Berkeley Barb*, Jan. 20, 1967, 1; Jerry Hopkins, "Human Be-In in the Park," *Los Angeles Free Press*, Jan. 20, 1967, 1; Simon Rycroft, "Global Undergrounds: The Cultural Politics of Sound and Light in Los Angeles, 1965–1975," in *The Place of Music*, eds. Andrew Leyshon, David Matless, and George Revill (New York: Guildford Press, 1998); Lisa Leff, "Human Be-In' begat the '60s' Summer of Love," *Los Angeles Times*, Jan. 14, 2007.

21. (**April '70 Gay-In**). Angela Douglas (as Douglas Key), "2,000 Homosexuals hold Los Angeles Gay-In," *Los Angeles Free Press*, Apr. 10, 1970, 4; Angela Douglas (as Douglas Key), "Police raid Gay-In," *Los Angeles Free Press*, June 5, 1970, 8; see also Jay, *Tales of the Lavender Menace*, 179. Notably, Angela Douglas's "Police Raid Gay-In" article prompted Marcus Overseth's vicious letter to the *Free Press* editor, described *infra* at note 35. (**"reign of terror"**). Don Jackson, "L.A. Gay Power," *Berkeley Barb*, Dec. 12–18, 1969, 6. (**"victory over police"**). Armstrong and Crage, "Movements and Memory," 740; see also Don Jackson, "L.A. Gay Riots Threatened," *Los Angeles Free Press*, May 15, 1970, 16. (**Chief Davis**). Paul Houston, "Homosexuals Receive ACLU Aid in Parade Permit Fight," *Los Angeles Times*, Jun. 13, 1970, B4; see also Kight, "How It All Began." (**CSW**). Kight, "How It All Began"; Paul Houston, "Homosexuals Stage Hollywood Parade," *Los Angeles Times*, June 29, 1970, 4, 22; Jay, *Tales of the Lavender Menace*, 185. It's worth noting that New York City's first march did *not* have floats; although L.A.'s floats tended to be militantly themed, the presence of the traditionally celebratory parade vehicles planted the seed for a shift in tone in years to come.

22. (**"new militancy"**). Jim Bradford, "The New Militancy Emerges," *Mattachine Midwest Newsletter*, Oct. 1969, 2; see also "A.T.," "Our readers talk back," *Mattachine Midwest Newsletter*, Nov.–Dec. 1969, 5 ("Though I don't consider myself immoral or insane, or sick, I would be stupid to picket at the Civic Center. One does not throw away 43 years of work."). (**Chicago Gay Liberation**). "Chicago Gay Liberation group forms," *Mattachine Midwest Newsletter*, Nov.–Dec. 1969, 3; Steve Robertson, "Gay Lib Continues to Grow," *Mattachine Midwest Newsletter*, May 1970, 9. The growth of Chicago Gay Liberation was fueled in large part by the number of college campuses in and around the city. (**Chicago Gay Lib's first protests**). "Gays Stage Loop Protest" and "Citywide Gay-In at Coliseum," *Mattachine Midwest Newsletter*, May 1970, 1, 7, 11; Stewart-Winter, *Queer Clout*, 97–100. (**Chicago's Gay Pride**). Bob Stanley, "Gay Pride Week, 1970, That Was the Week That Was," *Mattachine Midwest Newsletter*, July 1970, 1; William B. Kelley, "'Gay Pride Week' June 21–28," *Mattachine Midwest Newsletter*, June 1970, 1.

23. (**"completion of the American Revolution"**). W. Beardemphl, "Homosexuals Call for Completion of the American Revolution," *Vector* 4, no. 8 (Aug. 1968), 5; "January Program to Examine Pre-Stonewall Gay Demonstrations," *San Francisco Bay Area Gay & Lesbian Historical Society Newsletter* 2, no. 2 (Dec. 1986), 1. (**Link to Reminders**). W. Beardemphl, "Homosexuals Call for Completion of the American Revolution," 5. (**S.F. distaste for direct action and Stonewall**). See Armstrong and Crage, "Movements and Memory," 733, 741. (**"Did not think a riot should be memorialized"**). Greg L. Pennington, "Mirrors of Our Community: A History of the Gay Parades in San Francisco," *San Francisco Bay Area Gay & Lesbian Historical Society Newsletter* 1, no. 4 (June 1986), 4. (**had no interest**). Armstrong and Crage, "Movements and Memory," 741. (**Gay-In**). Phil Pukas, "Lonely Porkers Crash Gay-In," *Berkeley Barb*, July 2–9, 1970, 1. (**Allowed the story to spread**). Pukas, "Lonely Porkers Crash Gay-In," 1 ("The show of [police] force was gotten together to break up the Gay Liberation of the Stonewall riots in New York about a year ago, the first time in U.S. history that homosexuals took to the streets and fought with police. The rioting went on for three weekends. [sic]"). (**Broshears & Compton's**). Armstrong and Crage, "Movements and Memory," 741–42. Notably, if it hadn't been for the stubbornness of both San Francisco's homophiles *and* radicals like Ray Broshears, the Compton's events might still be among the countless acts of resistance about which we know nothing. Broshears's attempts to focus San Francisco's celebrations on Compton's left a record of the event that later gave Dr. Susan Stryker her first hint that something monumental had happened. Stryker's discovery, in turn, led to efforts to learn more, which has given us the picture of Compton's we have

today. See Stryker, *Transgender History*, 65 (citing Broshears, "History of Christopher Street West—SF," *Gay Pride: The Official Voice of the Christopher Street West Parade '72 Committee of San Francisco, California* [June 25, 1972]). A further note on **Broshears/SF 1972**: In 1972, San Francisco's first official Pride, much like New York's the following year, erupted into a skirmish when Ray Broshears physically attacked a group of lesbian separatists carrying a sign reading, "OFF THE PRICKS!" As Dr. Stryker explains, "Feminists and some of their gay male supporters . . . announced that they never again would participate in a gay pride event organized by Broshears, or in one that permitted drag queens to 'mock' women. In 1973, two separate San Francisco Pride events were organized, one by Broshears, and the other by gays and lesbians who opposed drag and expressly forbid transgender people from participating. . . . That same year, across the continent in New York, Stonewall veteran and STAR founder Sylvia Rivera was forcibly prevented from addressing the annual commemoration of Christopher Street Liberation Day." Stryker, *Transgender History*, 101–02.

24. (**got to Sheridan Square early**). Carter, *Stonewall*, 253. (**Weinstein Hall**). Bell, *Dancing the Gay Lib Blues*, 77, 81–82; Teal, *Gay Militants*, 324. (**Low turnout**). Carter, *Stonewall*, 253. (**"There weren't many at first"**). Two Lesbians, "Christopher Street Liberation Day," *Come Out!* 1, no. 5 (Sept.–Oct. 1970), 19 (this piece is a poem, though we've removed line breaks for clarity). (**"The courage . . . to finally come clear"**). Perry Brass, "We Did It!" *Come Out!* 1, no. 5, 11. (**"first run"**). Carter, *Stonewall*, 253. (**"We felt liberated and free"**). Jason Gould, "Out of the Closets Into the Streets," *GAY*, July 20, 1970, 6. (**Sylvia leads the march**). Teal, *Gay Militants*, 326. (**"Come on out"**). Gould, "Out of the Closets into the Streets," 5. (**"Tearing off the masks"**). Two Lesbians, "Christopher Street Liberation Day," 19.

25. (**"In that March . . . five years ago!"**). Kameny in Kay Tobin and Randy Wicker, *The Gay Crusaders* (New York: Paperback Library, 1971), 105. (**San Juan, Pueblo**). Timmons, *Trouble with Harry Hay*, 236. (**few had any idea**). Gould, "Out of the Closets into the Streets," 6. (**Sheep Meadow; "known and unknown friends"**). Teal, *Gay Militants*, 329; Angelo d'Arcangelo, "Gay-In=Joy-In=Love-In!" *GAY*, July 20, 1970, 10. (**hugged, many cried**). Gould, "Out of the Closets into the Streets," 6; Teal, *Gay Militants*, 329–31. (**no program**). Teal, *Gay Militants*, 330. (**"a family reunion . . . the sum of one soul"**). d'Arcangelo, "Gay-In=Joy-In=Love-In!" at 10; see also Kiyoshi Kuromiya (as Steve Kuromiya), in Teal, *Gay Militants*, 335 ("We came battle-scarred and angry to topple your sexist, racist, hateful society. We came to challenge the incredible hypocrisy of your serial monogamy, your oppressive sexual role-playing, your nuclear family, your Protestant ethic, apple pie and Mother. We came to New York holding hands and kissing openly and proudly, waving 15-foot banners and chanting 'Ho-ho-homosexual!' In one fell swoop, we came to destroy by our mere presence your labels and stereotypes with which you've oppressed us for centuries. And we came with love and open hearts to challenge your hate and secrecy."). (**"unafraid . . . can only do it once"**). Two Lesbians, "Christopher Street Liberation Day," 19. (**work had just begun**). Eben Clark in Bell, *Dancing the Gay Lib Blues*, 84.

26. (**Crackdown/went peacefully**). See generally Steven F. Dansky, "Hot August Night/1970: The Forgotten LGBT Riot," in Steven F. Dansky, ed., *Hot August Night/1970: The Forgotten LGBT Riot* (Middletown, DE: Christopher Street Press, 2012), 11; N. A. Diaman, "Greenwich Village in Flames," in Dansky, *Hot August Night/1970*, 27. (**bottles crashed**). Teal, *Gay Militants*, 199. (**The Haven**). Teal, *Gay Militants*, 200. The August 29 raid was the fourth raid on The Haven in August 1970, with police previously targeting the bar on August 15, 26, and 28. Teal, *Gay Militants*, 195. Despite, or perhaps because of, the chaos that followed the August 29 raid, police came back to The Haven on September 4, giving the bar "its coup de grace, smashing bars, discotheque machines, railings, speakers, refrigerators, and toilets and searching eighty people. Of the ten arrested, charges of loitering to secure narcotics were dismissed by the court. The *New York Post* quoted The Haven owner's assessment of damages as $75,000." Teal, *Gay Militants*, 200. (**"the Forgotten Riot"**). See generally Dansky, ed., *Hot August Night/1970*. Notably, on August 28 (i.e., the night before the "Forgotten Riot" led to even more arrests), the charges against Sylvia Rivera from her arrest in April—the first in GAA's history—were dropped. See Cohen, *Gay Liberation Youth Movement in New York*, 110. (**"a fact of our lives"**). A Flaming Faggot (pseud.), "We're Not Gay, We're Angry," *RAT*, Sept. 11–25, 1970, 3, 27; see also "42 St. Again!" *Gay Flames* 7, 3; Angela Keyes Douglas, "Freedom Parade Looks Good," *Berkeley Barb*, June 16, 1972 (referencing the 1970 violence as "the second Christopher Street riots" and the "Stonewall Rebellion repeated.").

27. (canceled gay dance). See "NYU Breaks Gay Dance Contract," *GAY*, Sept. 21, 1970; "MSNY/NYU," *Mattachine Times* (New York), Sept. 1970; Teal, *Gay Militants*, 202–05. (Weinstein occupation). See Bell, *Dancing the Gay Lib Blues*, 110–15; Teal, *Gay Militants*, 205–10; Jay, *Tales of the Lavender Menace*, 225–28; Cohen, *Gay Liberation Youth Movement*, 111–13. (Sylvia & Lesbian Feminists). Bell, *Dancing the Gay Lib Blues*, 115; see also Cohen, *Gay Liberation Youth Movement in New York*, 113. Sylvia's interjection with the word "transvestite," correcting the term "drag queen," is important insofar as it clearly answers the question as to whether Sylvia preferred to be identified as a drag queen (she didn't). See also "Rapping with a Street Transvestite Revolutionary: An Interview with Marcia [*sic*] P. Johnson," in Karla Jay and Allen Young, eds., *Out of the Closets: Voices of Gay Liberation* (New York: Jove/HBJ, 1977), 119 ("A drag queen is one that usually goes to a ball, and that's the only time she gets dressed up."). (TPF storms Weinstein). Cohen, *Gay Liberation Youth Movement in New York*, 114; see also "Out of the Closets and into the Subcellar," *RAT*, Oct. 6–27, 1970; "Gays Siege NYU; Demonstrate! Monday, Oct. 5," *Gay Flames* 5 (Oct. 1970); Allan Cartter, "The Weinstein Affair," *Washington Square Journal*, Sept. 29, 1970; GAA Statement, GAA, Series 2: 18/1, NYPL. And, as Stephan Cohen details, when 'the protest spilled outside,' GLFer Jim Fouratt "recklessly encouraged Sylvia to take to the streets, a provocative and even life-threatening act given the heated atmosphere." It was neither the first nor the last time a "radical gay liberationist," and Fouratt specifically, put his politics before the safety of a transgender woman. Cohen, *Gay Liberation Youth Movement in New York*, 115.

28. ("heterosexuals and homosexuals of both sexes"). "Street Transvestite Action Revolutionaries," IGIC, Box 19, STAR file, NYPL; see also Cohen, *Gay Liberation Youth Movement in New York*, 35. ("We don't believe in cooperating with The Man"). John Francis Hunter, *The Gay Insider, USA* (New York City: Stonehill Pub., 1972), 48–49. ("starting a revolution if necessary"). "Rapping with a Street Transvestite Revolutionary," Jay and Young, *Out of the Closets*, 113. (S.T.A.R. House). Cohen, *Gay Liberation Youth Movement in New York*, 131. S.T.A.R. House's residents were "a floating bunch of 15 to 25 queens, crammed in those rooms, with all our wardrobe," Sylvia remembered. Steve Watson, "Sylvia Rivera, founder of S.T.A.R. (Street Transvestite Action Revolutionaries)," in *Stonewall Romances*. In an interview alongside Marsha P. Johnson, Randy Wicker described S.T.A.R. House as "a bunch of flakey, fucked up transvestites living in a hovel and a slum somewhere calling themselves revolutionaries. That's what it was in my opinion. Now Marsha has a different idea." Although Marsha had fonder memories, she didn't dispute the gist of Wicker's description. "Marsha P. Johnson & Randy Wicker," 2017, *Making Gay History* 2, ep. 1, podcasts produced by Eric Marcus and Sara Burningham.

29. ("gay solidarity"). Cohen, *Gay Liberation Youth Movement in New York*, 129. ("crux of the problem with Sylvia"). Bebe Scarpi in Cohen, *Gay Liberation Youth Movement in New York*, 154. Bebe's view was shared by Lee Brewster, who said in 1995 that "when you read in the paper that some gay person had turned the police car over," it was Sylvia. But the more prominent activists "would manipulate her, and they'd stick her in the background when it came time to talk to the press." Lee Brewster in Saypen, "A Little Bit of Our History," 64. (simply didn't "fit"). Arthur Bell, "STAR Trek," *Village Voice*, July 15, 1971, 1, 46.

30. (Bebe on CSLDC). See Minutes, "Christopher Street Liberation Day: Planning Subcommittee," Oct. 14, 1972, GAA, Series 2: 18/1, NYPL. (Lee Brewster). See generally Brewster in Saypen, "A Little Bit of Our History," 56–64 ("Sylvia Rivera at that time had been a little uncomfortable for me too."); see also Cohen, *Gay Liberation Youth Movement in New York*, 93. Our use of the pronoun "he" in reference to Brewster is based on the most recent interview of Brewster we uncovered, namely, Abby Saypen's 1995 interview for *Tapestry* (which would soon be renamed *Transgender Tapestry*), in which a number of trans women, and Brewster himself, use masculine pronouns to refer to Queen Lee.

31. (butch & femme lesbians). Davis and Kennedy, *Boots of Leather*, 6, 90–91; Feinberg, *Transgender Warriors*, 7. ("a world in which I fit"). Feinberg, *Transgender Warriors*, 8. We use the singular "they" in reference to Feinberg, who often explained that pronoun usage was a matter of context, because "it makes it impossible to hold on to gender/sex/sexuality assumptions about a person you're about to meet or you've just met," something Feinberg appreciated about gender-neutral pronouns. We note they referred to themselves using "ze/hir," and we mean no disrespect in employing the increasingly common "they" in this context. See, e.g., Bruce Weber, "Leslie Feinberg, Writer and Transgender Activist, Dies at 65," *New York Times*, Nov. 25, 2014, A34. (Córdova). Talia M. Bettcher, "A Conversation with Jeanne Córdova," *TSQ: Transgender Studies Quarterly* 3, nos. 1–2 (May 2016), 287. (disassociated from gender roles). See, e.g., Davis and Kennedy, *Boots of Leather*, 11; Bettcher, "A Conversation with Jeanne Córdova," 286–87.

32. ("sisterhood of all women"). Beth Elliott, "Elections . . . Candidates—V.P. & Sect.," *Sisters* 2, no. 9 (Sept. 1971), 13. ("Little evidence" of "common cause"). Shirley Willer, "What Further Steps Can Be Taken to Further the Homophile Movement?" address, National Planning Conference of Homophile Organizations, San Francisco, Aug. 25, 1966, NACHO, 1966, Lucas Papers, 1997-25, 11/15, GLBT Hist. Soc. Soon after NACHO '68, Willer and her lover Marion Glass "quit the movement entirely." Gallo, *Different Daughters*, 143. (DOB's shift under LaPorte). Rita LaPorte, "Of What Use NACHO?" *The Ladder* 13, nos. 11–12 (Aug.–Sept. 1969), 18. (End of "A Lesbian Review"/end of national DOB). See *The Ladder* 14, nos. 7 & 8 (Apr.–May 1970) ("A Lesbian Review" removed); Gene Damon, "Women's Liberation Catches Up To *The Ladder*," and Rita LaPorte, "The Undefeatable Force," *The Ladder* 14, nos. 11 & 12 (Aug.–Sept. 1970); see also Gallo, *Different Daughters*, 159–71 (overview of the "takeover" of *The Ladder*); Bettcher, "A Conversation with Jeanne Córdova," 289.

33. (Lesbian primacy). Although Córdova was a leader of the Lesbian Feminist community, she preferred the term Lesbian Primacist to describe her politics. "That meant I wanted to give my primary energy to creating a strong and independent lesbian movement," she explained. Jeanne Córdova, *When We Were Outlaws: A Memoir of Love & Revolution* (Midway, FL: Spinsters Ink, 2011), 61. The authors are infinitely grateful to Lynn Harris Ballen for, among many other things, giving us access to Jeanne Córdova's papers at the ONE/USC Archives and the Córdova-Ballen personal collection, sharing beautiful memories of her life with Jeanne, helping us imagine the world that Jeanne envisioned, and letting Matthew crash in the guesthouse. (in addition to "all the oppressions that are laid on straight women"). Jeanne Córdova, "Their Problem: The Lesbian in Focus," *Lesbian Tide*, Dec. 1971, 7; see also Martha Shelley, "Stepin Fetchit Woman," *Come Out!* 1, no. 1, 7; Radicalesbians, "The Woman-Identified Woman," *Come Out!* 1, no. 4, 12; Rita Mae Brown, "Say It Isn't So," *The Ladder* 14, nos. 9 & 10 (June–July 1970), 29–30; Sally Gearhart, "Lesbianism as a Political Statement," *Sisters* 1, no. 2 (Dec. 1970), 2–5. (Córdova's early accomplishments). See generally Córdova, *When We Were Outlaws*, 34–46. (*The Tide's* radicalism). See Bettcher, "A Conversation with Jeanne Córdova," 289 (Bettcher: "How was it too radical?" Córdova: "It talked about lesbian feminism a lot of different ways. Rape, abortion, marches, lesbians going to court and losing, nonmonogamy, trying to change the country!").

34. ("alive and well"). See Karen Wells and Terry, "DOB Lives!" *Sisters* 1, no. 1 (Nov. 1970). ("bid adieu"). Del Martin, "If That's All There Is," *The Ladder* 15, nos. 3 & 4 (Dec. 1970–Jan. 1971), 4–6. As it appeared in *Sisters* in November 1970, Martin's article carried the title, "Del Martin Blasts Men," though the section in which she "bid adieu" to activism ran under the heading, "Empty Resolutions." When the piece reappeared in *The Ladder* the following month, it had been retitled, "If That's All There Is," which is how we refer to it here. See *The Ladder* 15, nos. 3 & 4 (Dec. 1970–Jan. 1971). (inconsistent with DOB's aims). Beth Elliott, "DOB Down on March," *Berkeley Barb*, Nov. 5–11, 1971, 6.

35. (most visible transgender activist). Angela Douglas, like Sylvia Rivera and Beth Elliott, dedicated her life to Gay Liberation, only to be scorned by other queer people. After facing blatant discrimination from within GLF-L.A., for example, Douglas established Transvestite Action Organization (T.A.O.), a move that *Gay Power* announced under the headline, "TRANSVESTITES SPLIT GLF." *Gay Power* 19, June 1970, 6. In 2000, Radicalesbian Karla Jay had the following to say about her experience with West Coast Gay Lib: "I naturally found myself drawn to the more radical members of the group, although there were some characters who proved too difficult for me. There was one radical transvestite/preoperative transsexual, Angela (Douglas) Key, who wrote for the Los Angeles *Free Press*. In a 'Letter to the Editor' of the *Free Press*, Marcus Magnus Overseth accused Angela of 'constantly disrupting GLF meetings and social events.' When Angela told me that she wanted to become a lesbian and that it was my political duty to help her with her sexual transformation, our friendship came to an abrupt end." Jay, *Tales of the Lavender Menace*, 176. That a trailblazing Lesbian Feminist like Karla Jay cited Marcus Overseth for support in condemning a transgender

woman shows just how far many of those in the early Gay Lib era would go to distance themselves from and/or impugn gender nonconforming activists. Although she accurately quoted one clause from Overseth's article (Overseth did, in other words, accuse Angela Douglas of "constantly disrupting GLF meetings and social meetings"), Jay failed to provide the rest of what can only be described as Overseth's painfully misogynistic and transphobic letter: "Not *cunt*ent with writing up an incident involving Lenin's birthday which she herself had *cunt*rived and passed off as legitimate GLF action, not *cunt*ent with constantly disrupting GLF meetings and social events and not *cunt*ent with attempting to turn a newly-organized squad of transsexuals and transvestites against Gaylib, this *power mad bitch* now has proceeded to make it look as if the May 30 Gay-In was actually busted by [the LAPD]." Marcus M. Overseth, "Gay-in a success," *Los Angeles Free Press*, June 12, 1970, 10, ONE/USC Archives, GLF-L.A. Records, 2012-031, 1/7 (emphasis added); see also *supra* at note 21. (**Angela Douglas re peace march**). Angela Douglas, "Peace Banner Helps Sisters Bridge Sex," *Berkeley Barb*, Nov. 12–18, 1971, 7.

36. (**Beth's family**). Beth Elliott (as Geri Nettick), *Mirrors: Portrait of a Lesbian Transsexual* (Oakland, CA: self-pub., 2011), 108, 112. And, "given how wonderful my acceptance in the community felt compared to those last, harrowing few months at home, I felt compelled to dedicate myself altruistically to the well-being of the lesbian community." ("**ending . . . all hatred and exploitation**"/**well-regarded**). Beth Elliott, "Elections . . . Candidates—V.P. & Sect."; Jeanne Córdova, "D.O.B. Says No," *Lesbian Tide* 2, no. 5 (Dec. 1972), 21, 29; see also Julia (last name unknown) (DOB NJ) to Del Martin, Apr. 12, 1972 ("Transsexual men [*sic*] are women in feeling and emotions, not men. . . . So far as I personally, and DOB NJ is concerned—our support is 100% behind Beth."); Board and Members of DOB NJ to DOBSF, Apr. 17, 1972; Karen Wells, Maxine (last name withheld), Lyndall (last name unknown), "Transsexuals in DOB," Sept. 1972; Corr.-General, Admin. Files DOBSF, 1972, Lyon-Martin Papers, 1/22, GLBT Hist. Soc. (**Reaction to Beth's admittance to DOB**). Beth Elliott, "Of Infidels and Inquisitions," *Lesbian Tide* 2, nos. 10/11 (May–June 1973), 15–16 ("I didn't 'infiltrate' anything. SFDOB admitted me knowing full well I was a pre-operative transsexual. Only one member objected."); but see Gallo, *Different Daughters*, 190 ("She was honest about her transition and, after heated controversy and disagreements among the members, was accepted, even becoming vice president of the local chapter."); Julia (last name unknown) (DOB NJ) to Del Martin, Apr. 12, 1972, Corr.-General, Admin. Files DOBSF, 1972, Lyon-Martin Papers, 1/22, GLBT Hist. Soc.

37. (**Radical Feminism**). "Toward the Liberation of Women: A Struggle for Identity," *It Ain't Me Babe* 1, no. 2 (Jan. 1970), 2; Barbara Burris, "What Is Women's Liberation?" *It Ain't Me Babe* 1, no. 3 (Feb. 1970), 3; see also Robin Morgan, "The Wretched of the Hearth" and "Goodbye to All That," Robin Morgan, *Going Too Far: The Personal Chronicle of a Feminist* (New York: Vintage Books, 1978), 94–106, 121–30. (**political lesbians**). Jay, *Tales of the Lavender Menace*, 66. (**Ti-Grace Atkinson**). See Anne Koedt, "Lesbianism and Feminism," Chicago Women's Liberation Union pamphlet, 1971, available at www.cwluherstory.org/classic-feminist-writings-articles/lesbianism-and-feminism; see also Pat Buchanan, "The Living Contradiction," *Lesbian Tide* 2, nos. 10/11, 6–7. (**expanding "the definition of lesbianism"**). Bettcher, "A Conversation with Jeanne Córdova," 288; Beth Elliott (as Geri Nettick), *Mirrors*, 251; see also Martin and Lyon, *Lesbian/Woman*, 272–73. (**freedom of self-definition**). Karen Wells, Maxine, Lyndall, "Transsexuals in DOB," Sept. 1972, Lyon-Martin Papers, 1/22, GLBT Hist. Soc.

38. (**"instant Lesbians"**). Martin and Lyon, *Lesbian/Woman*, 272–73. (**who a lesbian was**). Gallo, *Different Daughters*, 186. (**honest about her identity**). See Beth [Elliott], "Letter from a Transsexual??" *It Ain't Me Babe*, no. 14 (Dec. 1970) (Although only signed "Beth," this letter is clearly from Beth Elliott; most notably, she describes her relationship with Bev Jo Von Dohre consistently with other accounts); "Our Response," *id*. (In contrast to descriptions of Beth's demeanor in post-1973 sources, the Radical Feminists of *It Ain't Me Babe* described her as follows: "There was a softness/relaxedness about him [*sic*] that felt good; a giving, a nonstiffness. He [*sic*] did not try to dominate with body language or voice as so many men do, nor did he [*sic*] look through us or patently cope with us as so many homosexual men do. He [*sic*] did not push/pull against our reality. We could see that he [*sic*] was into a higher form of behavior although his [*sic*] idea/understanding of woman was too man-identified, too passive/submissive."). (**Support from Martin & Lyon**). In April 1972, Julia, an activist from DOB-NJ, responded to a letter from Del Martin about Beth Elliott; although we've not seen the letter from Martin to Julia, the response seems to parrot much of what Martin wrote. Specifically,

Julia reports to Martin that she'd passed along the message "almost to a word what you [Martin] expressed in your letter to me: Lesbians have NO business oppressing ANYONE. Transsexual men [*sic*] are women in feeling and emotions, not men. Beth undoubtedly was a contributing member to DOB . . . I also wrote Beth a short personal note, telling her . . . I hoped she is o.k." Julia (last name unknown) (DOB NJ) to Del Martin, Apr. 12, 1972, Lyon-Martin Papers, 1/22, GLBT Hist. Soc. (**Everyone knew**). See Karen Wells, Maxine, Lyndall, "Transsexuals in DOB," Lyon-Martin Papers, 1/22, GLBT Hist. Soc. (*Sisters* **resignation**). Sisters Collective, *Sisters* 3, no. 12 (Dec. 1972). Notably, the issue was "dedicated to the past staff members, especially the Editor, Karen Wells. We miss you." (*Lesbian Tide*). "A Collective Editorial," *Lesbian Tide* 2, no. 5 (Dec. 1972), 21, 29.

39. (**it wasn't clear**). See Barbara McLean, "Diary of a Mad Organizer," *Lesbian Tide* 2, nos. 10/11, 36 ("Yes, we were aware of the anti-transsexual feelings within the movement. We were aware of the split in San Francisco D.O.B. over Beth. We thought that was over a long time ago. We thought it was just a 'power struggle' in S.F. D.O.B."); see also Beth Elliott (as Geri Nettick), *Mirrors*, 252. (**West Coast Lesbian Conference/Lesbian Nation**). Gallo, *Different Daughters*, 187; see also Jan Oxenberg, "Lesbian Nation: A Review," *Lesbian Tide* 2, nos. 10/11, 13. (**Beth Elliott as organizer**). McLean, "Diary of a Mad Organizer," 36 ("Beth was on the San Francisco steering committee for the conference, a part of the original group that gave birth to the idea last October in Sacramento. She's written some far-out feminist songs. That's why she's here. No. We do not, cannot relate to her as a man. We have not known her as a man."); see also Bettcher, "A Conversation with Jeanne Córdova," 288. When asked if she knew during the 1973 conference that Beth Elliott was the same transsexual woman about whom the *Lesbian Tide* Collective earlier had written its supportive editorial, Jeanne Córdova told Talia M. Bettcher that "at the conference, I didn't realize that it was the same woman. . . . I suppose I knew it was Beth sometime later when I read some of the articles about the conference a few weeks after it. I should have known it was Beth. Maybe the organizer from Orange County, Linda (Tess) Tessier, did know. We organizers were loosely coordinated, with different subcommittees." (**Organizing generally**). McLean, "Diary of a Mad Organizer."

40. (**almost as soon as it started**). See McLean, "Diary of a Mad Organizer," 35 ("God. There's women here already and it's only 3:00. We'll have to start early. UhOh. A woman has come to complain about the noise . . . Have to make everyone leave because she's called the dean. The signs aren't up! Got to have the signs up. I can't believe this crowd already!"). (**"A new trend of men [*sic*]"**). McLean, "Diary of a Mad Organizer," 36. (**Vote/Gutter Dykes**). See McLean, "Diary of a Mad Organizer," 36-38. "The audience is split between those who do not want Beth to perform, those who do, and those who are totally confused, some of them absolutely bewildered. . . . The vote was overwhelming in favor of permitting Beth to perform. She begins . . . but that small but vocal anti-Beth group makes so much noise she can't be heard. I don't know when I've been so scared. What the hell can we do? There's a pro-Beth group here that is saying that if Beth doesn't perform NO ONE will perform. . . . Another vote is taken. It's 3 to 1 in favor of Beth performing. Someone has asked for a few seconds or minutes or something of silence and it quiets down. Beth begins to play. Looks like about 90 women are walking out! Damn. Beth continues to play, though I can't understand how she can even do it. She is shaking so bad. . . . Yes, we were aware of the anti-transsexual feelings within the movement. We were aware of the split in San Francisco D.O.B. over Beth. We thought that was over a long time ago. We thought it was just a 'power struggle' in S.F. D.O.B. . . . We believe this issue *should* be discussed since it has serious implications for the whole women's movement. There IS a contradiction here. Do we or do we not believe that anatomy is destiny?" The following day, April 14, according to organizer Barbara McLean, the Gutter Dykes "literally confiscated the mike" during a lesbian oppression workshop and started "talking about the transsexual issue again." To be fair, the Gutter Dykes no longer wanted to focus on the "transsexual issue" per se, but rather "the way it was *handled* by the organizers." McLean continued: "There's a blind woman who wants to come up on the stage. God, what now? I help her up. She's furious about something! I'm afraid to hear WHAT. She pounds on the podium, insists on speaking. I plead with the audience, with the Gutter Dykes, God. What else can I do?! I can't just let her stand there, flailing her arms. Finally they let her speak. She's a TRANSSEXUAL! So emotional, trembling so bad she can hardly stand up, clutching the mike she cries out that these women are crucifying Beth and all transsexuals: 'How much pain must she bear. Why do you torment her? You are more oppressive than our oppressors.'" Decades

later, Professor Emma Heaney noted that "the blind trans woman's insurgent act of trans-feminist resistance and solidarity lives only as a brief mention in the *Lesbian Tide* article. Retrieval of this more perishable archive is an urgent trans-feminist scholarly priority," to which Heaney—and the authors of this book—seeks to contribute. Emma Heaney, "Women-Identified Women: Trans Women in 1970s Lesbian Feminist Organizing," *TSQ: Transgender Studies Quarterly* 3, nos. 1–2 (May 2016), 139.

41. **(Credentials; marriage; ambiguous definition of lesbian).** See generally Robin Morgan, "Lesbianism and Feminism: Synonyms or Contradictions," Keynote Address, West Coast Lesbian Conference, L.A., Apr. 14, 1973, printed in *Lesbian Tide* 2, nos. 10/11, 30–34. **(famous "political lesbian").** See Buchanan, "The Living Contradiction," 6 ("Robin Morgan is not a Lesbian & not one by *her* own definition. She is, & has been for some time, a feminist. Why then does she need the identification with the real Lesbians? . . . What I am trying to say, is that there is no need to identify yourself as something that you are not. If one is a feminist, remain a feminist. Lesbians & feminists can work together without pretense. . . . I see Robin Morgan as being a very threatened woman. Threatened by men, by society, but above all, by Lesbians. She is not a Lesbian & must realize that when Lesbians start to unify & work together, age old stigmas begin to fall. She has been for some time, a voice & a leader in the feminist movement. All of a sudden the dawn breaks for Robin Morgan—Lesbians are the feminist movement & she is in serious danger of no longer being able to lead."); see also Bettcher, "A Conversation with Jeanne Córdova," 288. **("call for further polarization").** Morgan, "Lesbianism and Feminism: Synonyms or Contradictions," 33. **(naming names).** In fairness, if it can be called that, Robin Morgan did not say Beth Elliott's name during the keynote; in fact, she refused to do so: "And I will not name this man [*sic*] who claims to be a feminist." The sources clearly illustrate that everyone at the conference knew to whom Morgan referred. Morgan, "Lesbianism and Feminism: Synonyms or Contradictions," 32.

42. **(separating from male-dominated GAA).** Jean O'Leary, "New Lesbian Organization Planned," *Gay Activist*, Mar. 1973, 3 ("I feel our need for a separate group stems from a positive identification of ourselves as women, united with other women in our existing and turbulent struggle to assert ourselves as total human beings.") **(Melee in L.A. & expectations for CSLD 1973).** See McLean, "Diary of a Mad Organizer," 37–38 ("I wonder how many of the women out there realize what is happening up here. Do they think I voluntarily and graciously handed the mike to these women [the Gutter Dykes], or are they aware of the fact that I am being physically blocked?"); Jean O'Leary in Marcus, *Making Gay History*, 154–55.

43. **("strengthen lesbian identity").** GAA, "Minutes of Executive Meeting for Wed., June 6, 1973," GAA, Committee Files, Exec.-Minutes, 1973, Series 1: 15/19, NYPL. **(concerns about direction/"gone the full circle").** Arthur Bell, "Hostility Comes Out of the Closet," *Village Voice*, June 28, 1973, 16; GAA, "Minutes of Executive Meeting for Wed., June 6, 1973." **("last in the parade"/lobbied for a chance to speak).** See GAA, "Minutes Executive Committee Gay Activists Alliance Inc. June 13 & 20, 1973," GAA, Committee Files, Exec.-Minutes, 1973, Series 1: 15/19, NYPL. Although O'Leary later claimed LFL had written the statement the night before CSLD 1973, minutes from June 20 show that Ginny Vida "read the statement that LFL had adopted in relation to the appearance of transvestites" at Pride. **("leitmotifs of the day").** Bell, "Hostility Comes Out of the Closet," 16. **("The whole thing . . .").** Bell, "Hostility Comes Out of the Closet," 1, 16, 18. **("institutionalized rejection of difference").** Lorde, "Age, Race, Class, and Sex, Women Redefining Difference," *Sister Outsider*, 115–16.

Part III: Sissy, The Closet Done Burned Down! 1973–1979

1. **("you can always break their windows").** Bebe Scarpi in "Introducing Ms. Bebe," *Drag* 4, no. 13 (1974), 23. **(March demands).** This one general demand was the overall theme of five specific demands laid out by organizers: "(1) Repeal all anti-lesbian/gay laws; (2) Pass a comprehensive lesbian/gay rights bill in Congress; (3) Issue a presidential executive order banning discrimination based on sexual orientation in the Federal Government, the military and federally-contracted private employment; (4) End discrimination in lesbian mother and gay father custody cases; (5) Protect lesbian and gay youth from any laws which are used to discriminate against, oppress and/or harass them in their homes, schools, jobs and social environments," National March on Washington for Lesbian and Gay Rights, "Organizer's Handbook," ONE/

USC Archives, MOW 1979 files, 2013-087, 1/1. **(Pope's reception).** See Apul W. Valentine & Douglas B. Feaver, "Coping Proved Easier Than Expected," *Washington Post*, Oct. 8, 1979 (Regarding Pope John Paul II's 1979 Mass on the National Mall: "Planners had prepared for 500,000 to 1 million people. . . . The Park Service said that 175,000 came."). **("you're better!").** Robin Tyler, Address to National March on Washington for Lesbian and Gay Rights, Oct. 14, 1979 (transcribed by authors). **("don't owe apologies to anyone").** Troy Perry, Address to National March on Washington for Lesbian and Gay Rights, Oct. 14, 1979 (transcribed by authors).

2. **(Hostility in L.A./Cockapillar).** See Martin St. John, "No gay parade in Los Angeles this year—why?" *Advocate* 115, July 4, 1973, 4 (with picture of "The 'Cockapillar'"); Faderman and Timmons, *Gay L.A.*, 181 (quoting Brenda Weathers); Mother Jackson, "Free the Caterpillar!" *Berkeley Barb*, July 2–9, 1971, 9; Mary Ann Cherry, "Gay Pride 1973," excerpt from *The Kight Affect: The Authorized Biography of a Gay Liberationist*, available at www.morriskight.com/2012/10/gay-pride-1973.html (adding that the Cockapillar "ejaculated white fluid as it weaved down Hollywood Boulevard"); Córdova, *When We Were Outlaws*, 72. **(Kight at Christopher Street Liberation Day).** See Cherry, "Gay Pride 1973," *The Kight Affect*. Because the 1973 L.A. festivities were cancelled, Morris Kight, CSW's main organizer, was free to accept an invitation to speak at New York's Christopher Street Liberation Day, where he'd be witness to the tense scene in Washington Square Park.

3. **(Post-Patch & MCC).** Rev. Troy D. Perry (as told to Charles L. Lucas), *The Lord Is My Shepherd and He Knows I'm Gay: The Autobiography of the Rev. Troy D. Perry* (Los Angeles: Nash Publishing, 1972), 7; Faderman and Timmons, *Gay L.A.*, 158; Troy Perry in Phillip Zonkel, "Former Long Beach resident Lee Glaze was a pioneer in the fight for gay rights," *Long Beach Press-Telegram*, Feb. 3, 2014. **(Announcing MCC).** Perry, *The Lord Is My Shepherd and He Knows I'm Gay*, 119. **(MCC's growth).** See John Dart, "Growing Homosexual Churches Aid Many," *Los Angeles Times*, Feb. 14, 1973, 24.

4. **(Perry learns about New Orleans).** Sears, *Rebels, Rubyfruit, and Rhinestones*, 100; see also Clayton Delery-Edwards, *The Up Stairs Lounge Arson: Thirty-Two Deaths in a New Orleans Gay Bar, June 24, 1973* (Jefferson, NC: McFarland & Company, Inc., 2014), 60. **(Arson).** See "Fires, Arson in Gay Community," *Lesbian Tide* 3, no. 2 (Sept. 1973), 21; see also "Two San Francisco Bars Burn—Toad Hall, the Exit," *Advocate* 116, July 18, 1973 ("Two San Francisco area gay bars were destroyed by fire the same weekend as the New Orleans blaze"). **("Sissy, the closet done burned down!").** Faderman and Timmons, *Gay L.A.*, 261.

5. **(Manford & Kight).** See Telegram, Bruce Voeller to Metropolitan Community Church, New Orleans, June 25, 1973, GAA, Series 2: 20/5, NYPL; Cherry, "Gay Pride 1973," *The Kight Affect*. **("a place to go," a beer bust & a scuffle).** Sears, *Rebels, Rubyfruit, and Rhinestones*, 101–02.

6. **(Fatalities).** See Sears, *Rebels, Rubyfruit, and Rhinestones*, 99–102; see also John LaPlace and Ed Anderson, "29 Killed In Quarter Blaze, Arson Possibility Is Raised," *Times-Picayune*, June 25, 1973, 1, 3; LaPlace, "Scene of French Quarter Fire Is Called Dante's 'Inferno', Hitler's Incinerators; Victims Reported Burnt to Death Fleeing Spreading Blaze," *Times-Picayune*, June 25, 1973, 1, 2; Bruce Nolan, "Past Underlines Tragedy of French Quarter Fire; Nothing Close to Death Toll of Disaster," *Times-Picayune*, June 25, 1973, 2; Roy Reed, "Flash Fire in New Orleans Kills at Least 32 in Bar," *New York Times*, June 25, 1973, 1, 66; Barbara McLean, "Death Claims 29," *Lesbian Tide* 3, no. 1 (Aug. 1973), 9; Bill Rushton, "Fire Tragedy Confuses Both Straights, Gays," *Advocate* 116, July 18, 1973, 2, 9; George Schwandt, "Holocaust in New Orleans," *Advocate* 116, 2, 9; "Aid asked for survivors," *Advocate* 116, 9; Rushton, "New Orleans toll 32; arson evidence cited," *Advocate* 117, Aug. 1, 1973, 1. **(Rev. Larson/Ferris LeBlanc).** Sears, *Rebels, Rubyfruit, and Rhinestones*, 102–04; Delery-Edwards, *Up Stairs Lounge Arson* (dedicated to Ferris LeBlanc and two unidentified victims). **(New Orleans history).** See Nolan, "Past Underlines Tragedy of French Quarter Fire," 2. **(Lack of respect).** Roy Reed, "Arson Suspected in Deaths of 29 in New Orleans Bar," *New York Times*, June 26, 1973, 26; see also Rushton, "Fire Tragedy Confuses Both Straights, Gays," 2, 9 (contemporaneous analysis of straight media's inability to cover the fire respectfully). **("Fruit jars").** Sears, *Rebels, Rubyfruit, and Rhinestones*, 100.

7. **(Castigated the media).** Sears, *Rebels, Rubyfruit, and Rhinestones*, 100. ("It's high time that you people in New Orleans got the message and joined the rest of the Union!"). **(spread the word).** See, e.g., *Gay Community News* 1, no. 6 (July 26, 1973); "Death Claims 29," *Lesbian Tide* 3, no. 1 (Aug. 1973), 9. **(Memorial Services & "United We Stand").** Martin St. John, "'A part of

our souls was ignited . . . ,'" *Advocate* 117, 1 ("The best-attended services were . . . in San Francisco, Los Angeles, New York, San Diego, Calif., and in New Orleans."). **(television cameras/heads held high)**. Sears, *Rebels, Rubyfruit, and Rhinestones*, 106; see also Mary Ann Cherry, "Gay Pride 1973," *The Kight Affect* ("The only suspect—and the only person who was arrested in relation to the attack—was a customer of the Upstairs [*sic*] Lounge who had been thrown out of the bar earlier in the night for unruly behavior. On his way out of the bar, Rodger Dale Nunez [*sic*], was overheard threatening to 'burn you all out.' He was never convicted of the crime, but he did confess on at least four occasions while drunk and said that he didn't realize the damage he would cause. Nunez, full of remorse, killed himself a year later.")

8. ("hindered by neurotic 'camping'"). "N.P.S.," "Letters to the Editor," *Gay Scene* 4, no. 3 (Aug. 1973), 2. **("better sort of homosexuals")**. Henry Gerber to Manuel boyFrank, May 25, 1944, in Sears, *Behind the Mask*, 92. **("*like other people*")**. Marilyn Rieger in Sears, *Behind the Mask*, 209. **("assimilated into society")**. Hal Call in Sears, *Behind the Mask*, 182.

9. ("decent, respectable people"). Shilts, *The Mayor of Castro Street*, 74. **(comfortably in the straight world)**. Ron Gold in Allen Young, "An Airing of Differences on the 'Need' to Fit In," *Gay Liberator*, Feb.–Mar. 1975, 4–5. **(businesslike national effort)**. Bruce Voeller, "What Is the National Gay Task Force?" *It's Time* 1, no. 1 (May 1974), 2–3; Gold in Allen Young, "An Airing of Differences on the 'Need' to Fit In," 4–5; "Susskind Show," *It's Time* 1, no. 1, 5.

10. (recently come out). Marcia Chambers, "Ex-City Official Says He's Homosexual," *New York Times*, Oct. 3, 1975, 1, 42. **(NGTF)**. Ralph Blumenthal, "Homosexual Civil Rights Group Is Announced by Ex-City Aide," *New York Times*, Oct. 16, 1973, 37. **("Socialist Workers Party")**. Mary Perot Nichols, "New Gay Task Force: Dr. Brown's Coming Out," *Village Voice*, Oct. 18, 1973, 37. **("unmitigated nonsense")**. Morty Manford to editor, *Village Voice*, Oct. 19, 1973, GAA, Series 2: 18/16, NYPL. **(NGTF Board)**. See Perot Nichols, "New Gay Task Force: Dr. Brown's Coming Out," 37; see also "Board of Directors," *It's Time* 1, no. 1, 8. In the first issue of *It's Time*, Bebe Scarpi was listed as a member of NGTF's Board of Directors. See "Board of Directors," 8. If true, Scarpi, director of Queens Liberation Front and former S.T.A.R. leader, almost certainly was the only openly transgender person on the NGTF Board during NGTF's early years (and probably during NGTF's first decades), though we've been unable to locate any records of her time at NGTF beyond the inclusion of her name—*once*—as a board member. **("the whole gay movement is public relations")**. Ronald Gold, "Gays and Public Relations," *It's Time* 1, no. 1, 8.

11. ("Per se" distinction). See "The instant cure," *Gay Liberator* 34, Feb. 1974. **("Gay Not Sick")**. "Psychiatrists Say Gay Not Sick," *Gay People's Union News*, Jan. 1974, 1, 7. **(called for the repeal)**. Until then, as Alix Spiegel—granddaughter of Dr. John Spiegel, then-president-elect of the APA (who came out as gay years later)—wrote, "psychiatrists had always thought of homosexuality as a pathology, a problem so profound it affected the total personality." This, in turn, "gave scientific sanction for the rest of the country to see it the same way and Gays were routinely fired from teaching jobs, denied security clearances and U.S. citizenship." Alix Spiegel, "81 Words," *This American Life*, NPR, Jan. 18, 2002. **("We have been 'cured'!")**. Kameny to contributors to Honolulu trip, Dec. 15, 1973, in Long, *Gay Is Good*, 281.

12. ("matter of personal taste"). Kameny to U.S. Public Health Service, Aug. 3, 1962, in Long, *Gay Is Good*, 43–44. **("stand or fall")**. Kameny, "Civil Liberties: A Progress Report," 13. **("abysmally poor sampling")**. Kameny, "Does Research Into Homosexuality Matter?" at 15. **(few of whom had reason to listen)**. Decades later, psychiatrists on opposite sides of the nomenclature debate agreed that, in 1970, "well over 90%" of the APA believed that homosexuality was a pathology. See Spiegel, "81 Words" (Charles Socarides: "Oh, well over 90%" . . . John Fryer: "95, 98, 99. Even the ones of us who were gay.")

13. (Militants invaded). "Our confrontation with the American Psychiatric Association began in May 1970," Barbara Gittings recalled, "when a large group of feminists and a few gays invaded a behavior therapy meeting at the American Psychiatric Association's convention in San Francisco." Gittings in Marcus, *Making Gay History*, 146. **(Bieber & Alinder)**. Gary Alinder, "Confrontation I: San Francisco," *Gay Flames Pamphlet No. 6: Gay Liberation Meets the Shrinks*, 1970; "GLF and Women's Lib Zap Shrinks," *GAY*, June 8, 1970. **(Chicago AMA zap)**. Teal, *Gay Militants*, 296; Step May, "Confrontation II: Chicago," *Gay Flames Pamphlet No. 6: Gay Liberation Meets the Shrinks*," 1970. **(L.A. modification zap)**. See Teal, *Gay Militants*, 297–301; Jay, *Tales of the Lavender Menace*, 211–12; Faderman and Timmons, *Gay L.A.*, 177 ("Don

Kilhefner, who counseled gay youth for the Gay Liberation Front, told the stunned doctors: 'You have imprisoned us in your mental institutions and brainwashed us into hating ourselves. I'm working with a teenage boy right now who wants to kill himself because of you people—and you're going to, by God, sit there and listen to us for a change.'")

14. (Massive unrest). See, e.g., Richard Halloran, "30,000 Protesters Routed in Capital," *New York Times*, May 3, 1971, 1, 41. **(APA convention)**. See generally Faderman, *Gay Revolution*, 281–82; see also "the Militant Homosexual," *Newsweek*, Aug. 23, 1971, 47; William N. Eskridge, Jr., *Dishonorable Passions: Sodomy Laws in America, 1861–2003* (New York: Viking, 2008), 174. **("The most revolutionary things")**. Perry Brass, "Gay May Day," *Come Out!* 2, no. 7 (Spring–Summer 1971), 15. Brass's article includes a stunning firsthand account of the D.C. zap: "The zap was utterly incredible. . . . Half of the men [waiting to get in] were in really fabulous drag, with wildly painted faces that accentuated the spontaneous, liberating attitude of brothers in drag who are not merely putting down women but are affirming the pleasures of this part of Gay culture. . . . We got out of the van and began walking slowly in pairs while pigs in cars and vans cruised back and forth in front of the hotel. I was really frightened . . . The queens were so good at eluding the police that sometimes I did not know where they were. . . . The noise coming from the Regency Room was like out of the Inferno. I tried to open the door, but a shrink was pulling it tight. I managed to get it open for a minute. 'Get out of here. We don't want any more of you people in here!' he was shouting. I heard voices from inside the room shouting, 'Faggots! Drag queens!' . . . Then I saw all of our people start streaming out of the garage entrance virtually followed by this posse of cursing shrinks. . . . The feelings at that time were so high that I could hardly control myself. I just wanted to kiss and hug everyone. We had done this incredible thing—we had got into that hotel, many of us in full, flaming drag, ringed with pigs . . . Our feelings were so together and so high.") **(it worked)**. See Faderman, *Gay Revolution*, 282.

15. (Dallas). See Barbara Gittings in Marcus, *Making Gay History*, 146–47. **(Lahusen's idea)**. Gittings in Marcus, *Making Gay History*, 178; Faderman, *Gay Revolution*, 288–89. **(few doubted)**. Kameny was "absolutely against the mask," Kay (Tobin) Lahusen recalled. "I know," Barbara Gittings replied, "but it went off so well that Frank had to admit afterwards that it was a great gamble. Kay took a wonderful photograph of that panel, and you can see the smile on Frank's face." Lahusen and Gittings in Marcus, *Making Gay History*, 178. **(Dr. H. Anonymous)**. "Dr. H. Anonymous Speaks," Association of Gay and Lesbian Psychiatrists Newsletter, August 2002. The "H." stood for Homosexual; Dr. Fryer spoke through a voice-altering microphone. **(Audience response)**. See, e.g., Faderman, *Gay Revolution*, 290.

16. (Spitzer). Mark Jackson, "John E. Fryer: Masked Alumnus, Unmasked Prejudices," *Transylvania Treasures* 6, no. 2 (Summer 2013), 7. A note on **New York '72**: The zap at the APA convention in New York City in the fall of 1972 was led by GAA member Bill Bahlman. During a panel on homosexuality, Bahlman said later, "we began to pop up challenging the panelists. 'How dare you say I am sick?'" Not only is this notable for its similarities to Randy Wicker's prezap of a mental health professional in 1964, it's also important to flag Bill Bahlman's early contributions to the queer community. Bahlman went on to become a force in the Lavender Hill Mob and ACT UP. See Andy Humm, "Ron Gold, Pioneer in Challenging Sickness Label, Dies," *Gay City News*, May 16, 2017, available at gaycitynews.nyc/ron-gold-pioneer-challenging-sickness-label-dies. **(Nomenclature presentation)**. Dr. Evelyn Hooker's decades-old research was included in the presentation. Unsurprisingly, "most of the committee members seemed never to have heard" of Hooker's work. Lillian Faderman, *Gay Revolution*, 292. **("Being told you're sick makes you sick")**. Faderman, *Gay Revolution: The Story of the Struggle*, 292, n. 44; Spiegel, "81 Words." **(Final symposium)**. See Kameny, "Report from Honolulu," in Long, *Gay Is Good*, 266–68 ("Drs. Bieber and Socarides underwent what they must have found to be the unaccustomed, unexpected, and unpleasant experience of being jeered, booed, and laughed at by their professional colleagues"); Lahusen and Gittings in Marcus, *Making Gay History*, 178–79. **(GayPA, "dimwitted questions" & resolution)**. Spiegel, "81 Words"; Faderman, *Gay Revolution*; Kameny, "Report from Honolulu," in Long, 266–68. Postscript on **Gold & Spitzer**: The removal of homosexuality from the *DSM* was an event of monumental significance; those who played *any* part in the process, and certainly those who took a leading role, changed history. With that said, as is always true, none of them were perfect. In 2001, Dr. Robert Spitzer delivered a paper claiming that some homosexuals were able to change their sexual orientation; in 2012, after years of outrage, Spitzer recanted the earlier paper

(which by then had helped the "ex-gay" movement blossom) and apologized for the work. See, e.g., Gabriel Arana, "My So-Called Ex-Gay Life," *American Prospect*, Apr. 11, 2012, available at prospect.org/article/my-so-called-ex-gay-life. In 2009, Ron Gold wrote a piece entitled, "'No' to the Notion of Transgender," for a queer website, in which he repeated a very common line of bigotry-as-political-theory among gay men (from Dale Jennings to Jim Fouratt): "There is no such thing as a male or a female personality. Personality is not a function of gender. So where does this leave the concept of transgender. In my view, down the tubes!" And while agreeing discrimination against trans people should be prohibited, Gold wrote, "I would, however, get after the doctors—the psychiatrists who use a phony medical model to invent a disease that doesn't exist, and the surgeons who use such spurious diagnoses to mutilate the bodies of the deluded." See Humm, "Ron Gold, Pioneer in Challenging Sickness Label, Dies."

17. (**unambiguous**). See Kameny to Barbara Gittings, Apr. 8, 1974, in Long, *Gay Is Good*, 293–94 "Of 17,905 APA members qualified to vote, 10,555* (58.4%) voted. Almost all of those voted on 'our' referendum. Of those, the vote was: 5854 (58.4%) to support the Board of Trustees; 3810 (37.8%) opposed; and 367 (3.8%) abstaining. . . . So we are permanently healthy!!!" (*According to Michael G. Long, Kameny erred here; the number of those casting ballots had been 10,091.) (**Resolutions**). "Psychiatrists Say Gay Not Sick," 1, 7. (**Title 34**). Patricia Kolar, "Mayor Signs Title 34: D.C. Gays Gain Legal Protection," *Gay Blade* 5, no. 3 (Dec. 1973), 1. (**Ordinances**). See generally "HERE & THERE," *Gay People's Union News*, Jan. 1976, 28 ("Here is a list of [approximately 30] cities that now prohibit discrimination on the basis of sexual orientation and the dates the laws were passed"); see also Peter Fisher, "The Spirit of Boulder," *It's Time* 1, no. 1, 5; "Lesbians Attacked; Hit City for Inaction," *Gay Liberator* 32 (Nov. 1973), 2 (re Ann Arbor); "but reforms keep rolling in," *Gay Liberator* 32, 2 (re Seattle and Toronto).

18. (**antisodomy laws**). See Eskridge, *Dishonorable Passions*, 201–02.

19. (**Milk's first run**). See Jennifer L. Thomson, "Pro-Gays Out for Supervisor," *Berkeley Barb*, Nov. 2–8, 1973, 5 ("Harvey Milk has been an active campaigner, picking up support from beer truck drivers, Filipino nurses, senior citizens, and black actors, which may be one of his greatest assets considering the lack of coverage given his campaign. Milk has an on-the-street personality which draws in the votes. . . . Milk's headquarters, his camera shop, is an easy place to drop in and hang out at. While I was there interviewing Milk, the cop on the beat, the mailman, assorted friends, mothers and children dropped in. In the back of the store several of Milk's friends were hard at work silk screening posters and getting together leaflets. . . . Milk told me that politically he was completely naïve, he simply wants to make San Francisco a better place to live by planning for the future now.") (**Weschler & DeGrieck**). "Lesbians Attacked; Hit City for Inaction," 2. (**Kozachenko elected**). "Lesbian Election Victory," *Gay Liberator* 36 (May 1974), 2.

20. (**Noble**). See, e.g., Steve Freiss, "The First Openly Gay Person to Win an Election in America Was Not Harvey Milk," *BloombergPolitics*, Dec. 11, 2015 (". . . when Elaine Noble in Massachusetts was elected the first out candidate elected to a state legislature, the national LGBT magazine *The Advocate* wrote a long piece that didn't mention Kozachenko."). (**not a victory for the gay community**"). Nancy W. Porter, *A Woman's Place is in the House: A Portrait of Elaine Noble* (WGBH Educational Foundation: 1975).

21. (**Spear**). "Legislator Comes Out," *Gay Blade*, Feb. 1975, 1.

22. (**Abzug's bill**). See "Federal Gay Rights: Bella's New Bill," *Gay Blade*, July 1974, 2. (**many waged by Frank Kameny**). In June 1965, for example, the same month that ECHO members picketed the Civil Service Commission, the U.S. Court of Appeals issued a landmark ruling in favor of Bruce Scott, a D.C. Mattachine member who became "one of the first victims of the Park Service's Pervert Elimination Campaign" when he was arrested in Lafayette Park in 1947. A government employee, Scott kept his job for over a decade, but the arrest caught up to him, and he was barred from federal employment in 1962. In the *Scott* decision, Chief Judge Bazelon chided the CSC for its vague charges of "immoral conduct," insisting the government "must at least specify the conduct it finds 'immoral' and state why that conduct is related to 'occupational competence or fitness.'" It was not enough to rely "only on such vague labels as 'homosexual' and 'homosexual conduct.'" See *Scott v. Macy, et al.*, 349 F.2d 182 (D.C. Cir. 1965); see also Johnson, *Lavender Scare*, 61. In 1969, Bazelon again sided with the victim of a Lafayette Park sweep, Clifford Norton, who lost his job with NASA in 1963 on the basis of "immoral conduct." Building on the *Scott* decision, Bazelon rejected the idea

that "immorality" served as "adequate rational basis" for termination. See *Norton v. Macy, et al.*, 417 F.2d 1161 (D.C. Cir. 1969). (**Gayer**). See *Gayer, Ulrich, and Wentworth v. Schlesinger*, 490 F.2d 740 (1973); see also Larry Sheehan, "Courts Uphold Gays," *Gay Blade* 5, no. 4 (Jan. 1974), 3. (**Demanded the government end**). See *Society for Individual Rights, et al. v. Hampton*, 528 F.2d 905 (N.D. Cal. 1973); see also Sheehan, "Courts Uphold Gays," 3.

23. (**Kameny's persistence & new rules**). See Long, *Gay Is Good*, 314. ("brought the very government . . . to its knees"). Kameny to Rae Kameny, Aug. 2, 1975, in Long, *Gay Is Good*, 319.

24. (**read an article on gays in the military**). Patricia Kolar, "Hot Flashes: News and Stuff," *Gay Blade* 5, no. 7 (Apr. 1974), 3. ("a man by the name of Dr. Frank Kameny"). Mike Hippler, "Interview with Leonard Matlovich," Mar. 2, 1984, GLBT Hist. Soc., OHP #95-118, 88. (**homosexual ban**). Specifically, in this case, *Air Force Manual 39-12*, chapter 2, section H: "Homosexuality is not tolerated in the Air Force." See Faderman, *Gay Revolution*, 474. (**Matlovich's letter & discharge proceedings**). Faderman, *Gay Revolution*, 475. After incredulous military investigators told the war hero, "You can't have a Bronze Star and a Purple Heart and suck cock," Matlovich provided a written statement to the effect that he'd (1) been awarded both medals, among many others, and (2) engaged in homosexual intercourse—including "sucking cock"—in Florida, Louisiana, Virginia, and D.C.

25. (**Cover of Time**). See *Time*, Sept. 8, 1975 ("'I Am a Homosexual': The Gay Drive for Acceptance"). (the "real ones"). Gold, "Gays and Public Relations," *It's Time* 1, no. 1, 8; see also "Leonard Matlovich, NGTF Veterans Committee co-chairperson . . . ," *It's Time* 2, no. 2 (Nov. 1975), 2. (*Time* Article). "Gays On The March," *Time*, Sept. 8, 1975, 32–36. ("sexual marketplaces" & "promiscuity"). "Gays on the March"; see also David Goodstein, "Opening Space," *Advocate* 181, Jan. 14, 1976 (citing "the many new, well-lighted, expensively decorated bars and clubs that are rapidly replacing the dingy toilets of old"); David Harris, "Gay Baths are Big Business," *Blade* 7, no. 9 (Sept. 1976), 7.

26. (*Time* re lesbians). "Gays on the March," 35. (*Time* re other subcommunities). "Gays on the March," 32–36. ("six years ago"). "Gays on the March," 32. (**Kepner**). "Kepner Talks," *Gay People's Union News*, Jan. 1974, 3.

27. (**Events at Rubaiyat**). See "Last Tango," *Midwest Gay Academic Journal* 1, no. 1 (Apr. 1977), 7–8; "Lesbians Attacked; Hit City for Inaction," *Gay Liberator* 32, 2. (**both came out**). "Lesbians Attacked; Hit City for Inaction," 2. ("Discrimination . . . will not end"). "Lesbians Attacked; Hit City for Inaction," 2. (**Kozachenko**). See "Lesbian Election Victory," *Gay Liberator* 36, 2; Freiss, "The First Openly Gay Person to Win an Election in America Was Not Harvey Milk."

28. ("safety of their closets"). Bruce Voeller, "Gay Progress and Gay Support," *It's Time* 1, no. 4 (June–July 1975), 3; Goodstein, "Opening Space," *Advocate* 181. ("Silent Majority" & "self-demeaning personal patterns"). Voeller, "Gay Progress and Gay Support," 3; Nathalie Rockhill, "Movement Shows Grass-Roots Strength," *It's Time* 1, no. 4, 3; Gold in Young, "An Airing of Differences on the 'Need' to Fit In," 4–5.

29. (**Lavender Panthers**). Jay, "San Francisco Scene: Gay Vigilantes," *Gay Scene* 4, no. 3, 18 ("flanked by two drag queens—Woody and Finis—all armed with rifles"); see also "S.F. 'Lavender Patrol' to Combat Anti-Gay Violence," *Advocate* 117, Aug. 1, 1973, 15. (**Sweeps, bomb threats, raids**). See "L.A. Police Sweep Nets 39," "We Are Not Obscene," and "Church Raid," *Gay Liberator* 32, 4–5. (**Lost & Found**). Patricia Kolar, "Discrimination Charges Against the Lost and Found," *Gay Blade* 5, no. 2 (Nov. 1973), 5. (**Florida's antisodomy statue**). See *Wainwright v. Stone*, 414 U.S. 21 (Nov. 5, 1973); see also Patricia Kolar, "Supreme Court Upholds Florida Sodomy Law," *Gay Blade* 5, no. 4, 3. (**Lynda Chaffin**). Rita A. Goldberger, "Lesbians Fight for Jobs—Children," *Lesbian Tide* 3, no. 6 (Jan. 1974), 9. (**Anti-trans violence**). See, e.g., Alfred E. Clark, "Gang Mutilates and Kills Bronx Man [*sic*]," *New York Times*, Nov. 25, 1973, 54; "Transvestite Murdered in New York," *Drag* 4, no. 15, 5 (using masculine and feminine pronouns in reference to the victim); see also Morty Manford to NYPD Comm. Cawley, Dec. 4, 1973, GAA, Series 2: 18/16, NYPL ("The brutal murder of a Bronx transvestite November 24, 1973 was widely reported by the media. . . . Yet none of the hoodlums alleged to have been responsible have been reported arrested. . . . Much of the hostility against transvestites is the same prejudiced sickness targeted against all Gay people"); see also "Jae Stevens, 1947–1974," *Drag* 4, no. 16, 9. ("We should not seek"). See Allen Young, "An Airing of Differences," *Gay Liberator* (Feb./Mar. 1975), 4–5.

30. (Texas drag law). See "Legal Notes," *Gay Liberator* 37 (May 1974), 5; "Highest Court Leaves Texas TVs Illegal," *Drag* 4, no. 15 (1974) (re *Mayes v. Texas*), 4. (D.C.'s anti-sodomy law & arrests). P. Kolar, "Police Crackdown," *Gay Blade* 5, no. 8 (May 1974), 1; Kolar, "D.C. Sodomy Laws Upheld," *Gay Blade* 5, no. 8, 2. (fought for the bill from the beginning). Sylvia Rivera, Bebe Scarpi, and Lee Brewster all were active in the fight for the gay rights bill from 1971 to 1973. Brewster, for his part, funded much of the lobbying campaign; Scarpi testified during city council hearings; and Sylvia, among more traditional organizing efforts (petitioning, picketing, leafleting, etc.), literally scaled the exterior of City Hall after the bill's 1973 defeat. See Edward Ranzel, "10 Gay Activists Are Seized in City Hall," *New York Times*, May 1, 1973, 53 (specifically describing the arrest of Sylvia Rivera [using her name] for trying to climb the north wall of City Hall). (Used as a "scapegoat"). "TVs Excluded from Gay Civil Rights Bill," *Drag* 4, no. 14 (1974), 8; see also Sylvia Rivera, "Bitch on Wheels" (June 2001), *Survival, Revolt, and Queer Antagonist Struggle*, 35 ("Two or three years into the movement and the bill is being presented and we're going back and forth to City Hall. They have a little backroom deal without inviting Miss Sylvia and some of the other trans activists to this backroom deal with these politicians. The deal was, 'you take them out, we'll pass the bill.' So, what did nice conservative gay white men do? They sell a community that liberated them down the river . . ."). (bill still failed). See "New York Gay Rights Bill Defeated," *Gay Blade* 5, no. 9 (June 1974), 3; Sylvia Rivera, "Bitch on Wheels" (June 2001), *Survival, Revolt, and Queer Antagonist Struggle*, 35 (". . . it still took them 17 years to get the damn bill passed! And I hate to say it, but I was very happy.").

31. ("homosexual takeover"). See "Washington MCC Church Ousted," *Gay Blade* 5, no. 9, 1–2. (GAA Firehouse burns). "GAA Center Burned and Looted," *Gay People's Union News*, Nov. 1974, 3. (Toad Hall raid, tensions, Milk). See "Gays Air Bitches at Cops," *Berkeley Barb*, Sept. 20–26, 1974, 2; see also Shilts, *The Mayor of Castro Street*, 91–93.

32. (still zapped and picketed). See, e.g., "L.A. Police Sweep Nets 39," 4 ("In response, 40 gays rallied Oct. 4 outside the Hollywood headquarters of the LA Police Dept. to protest the discriminatory enforcement of fire hazard laws and to announce the formation of a Gay Patrol."); Kameny to D.C. chief of police Jerry Wilson, Nov. 6, 1973, in Long, *Gay Is Good*, 279 (to protest anti-sodomy laws, Kameny propositioned D.C.'s police chief "to engage with me in an act or acts of oral and/or anal sodomy of your choice, in the role or roles of your choice, in a mutually agreeable, indisputably private place in the District of Columbia, at an early time of our mutual convenience. Try it; you'll like it.") ("A letter of complaint"). Gold, "Gays and Public Relations," *It's Time* 1, no. 1, 8. (Backlash as beneficial). "The Benefits of Backlash," *It's Time* 1, no. 2 (June/July 1974), 2 ("So New York's Intro 2 was lost, and a great victory was won.") There are, to be sure, "benefits of backlash," insofar as rallying support to a cause is concerned, but the major moderate gay rights organizations in the United States—first NGTF (which radicalized), then Human Rights Campaign (which has not)—have typically used the theoretical "benefits of backlash" to spin (i.e., distract from) their inability to produce results. A very oversimplified version of the story goes like this: (1) a queer person experiences *Oppression A* and, after subtly attacking *Oppression A* for as long as they can individually, they connect with others to form an informal network of activists to draw attention to *Oppression A*; (2) this informal structure leads the fight for a set amount of time; (3) eventually, a leadership hierarchy takes shape (this is generally a necessary organizational reality, one that can be quite helpful); (4) the new leadership often wants to be "taken more seriously" than the informal (i.e., "ragtag" or "radical") activist group that preceded it, so the new leadership formally incorporates as *Gay Group X*; (5) *Gay Group X* seeks funding from donors by announcing plans to get *Bill Y* through City Hall, but *Bill Y* only tangentially addresses *Oppression A*, the very issue that got the founders of *Gay Group X* involved in the first place; (6) *Gay Group X* fails to get *Bill Y* passed, but the press takes notice of *Gay Group X*'s efforts, running process pieces with themes like "*Gay Group X* Gets Serious," "*Gay Group X* Grows Up," etc.; (7) *Gay Group X* puts its press clippings on mailers and seeks more donations, with which *Gay Group X* leases office space and hires more staff; (8) when *Bill Y* comes up again, *Gay Group X*, having learned from the previous attempt, compromises with officials who voted no, leaving *Bill Y* almost unrecognizable and even less relevant to addressing *Oppression A*; (9) *Bill Y* still fails; (10) various members of *Gay Group X* and a handful of the group's bigger donors start pointing fingers, blaming certain people and/or strategy decisions; (11) the executive director of *Gay Group X* is fired and/or resigns, taking their closest compatriots with them; (12) a search committee for a new executive director is launched, as is a big funding drive for *Gay Group X*'s "rededication" or "fresh start"; and (13) repeat from step 5. Thus, every time *Gay Group X* fails (i.e., experiences "backlash"), there are benefits for *Gay Group X*. This is *not* to say that *Gay Group X* wants to fail or that its staff is insincere in seeking to further the interests of the community (nor is this to say that the oversimplified process described above isn't slowly pushing the proverbial ball forward); an organization, however, cannot possibly have as much to lose as the individuals impacted by the organization's failures. We also note that "victory" can have negative consequences; namely, after focusing on *one* issue for an extended period of time, progress in that one area can distract from the overall fight against oppression. (Goodstein). "Advocate Sells Out," *Gay News* (London), Dec. 5–18, 1974, 3.

33. ("middle-class professional people" & exclusionary bars). Rockhill, "Movement Shows Grass-Roots Strength," *It's Time* 1, no. 4, 3; see also Dave Johnson, "Studio One Hit with Charges of Racism, Sexist Discrimination," *Los Angeles Free Press*, June 13–19, 1975, 33; Alyn Hess, "Bar's License Questioned," *Gay People's Union News*, July 1977, 6 ("Charges of discrimination against blacks and women by The Red Baron bar have been filed with the City of Milwaukee."); Jon L. Clayborne, "Poll Tax Mentality in a Gay Bar," *Gaysweek* 20, July 4, 1977, 16–17 ("Unfortunately little is being done to halt the discrimination in gay bars . . .").

34. (white gay men). See generally Faderman and Timmons, *Gay L.A.*, 201–08; Córdova, *When We Were Outlaws*, 4, 76–101, 109–20, 167–78, 216–24, 240–45, 269–285, 335–58; see also Jeff Sternberg, "Mismanagement plagues local Gay Community Services Center," *Los Angeles Free Press*, May 3–9, 1975, 4; Sternberg, "Problems Surround Local Gay Community Center," *Los Angeles Free Press*, May 10–16, 1975, 2. (Weathers, Glasscock). See Sternberg, "Mismanagement Plagues Local Gay Community Services Center," 4; "ON STRIKE!" *Come Out Fighting*, no. 2 (June 1975), 1; "Mass Firings & Strike at GCSC: Feminist Lesbians Purged," *Sisters* 6, no. 2 (June 1975), 3–4; see also Córdova, *When We Were Outlaws*, 82–90. (strike). "ON STRIKE!" at 1; "Mass Firings & Strike at GCSC: Feminist Lesbians Purged," 3–4; see also Córdova, *When We Were Outlaws*, 114–19. (Liberation Contingent). See Dave Johnson, "Gay Parade, Celebration Troubled," *Los Angeles Free Press,* June 22–July 3, 1975, 4; "Liberation Contingent," *Come Out Fighting*, no. 4 (Aug. 1975), 1.

35. (drag & "the gay lifestyle"). "Gay Is Not Proud . . . of Queens on Parade," *Drag* 5, no. 18 (1975), 31–33; see also "Not All Quiet on the Gay Lib Front," *Drag* 5, no. 17 (1975), 5–6. (The Pink Triangle). Ira Glasser, "The Yellow Star and the Pink Triangle," *New York Times*, Sept. 10, 1975, 45; see also "Editorial: The State of the Movement," *Vector* 12, no. 6 (June 1976), 4 (describing Glasser's article as "the best explanation we've found" regarding why "Gays everywhere have begun to use the pink triangle as our symbol").

36. ("welcome mats are out"). "Strolling Castro Street: A New 'Polk Street' Comes Alive," *Vector* 7, no. 7 (July 1971), 30–31. (Demonstrations swept the United States). See, e.g., "Nixon Sends Combat Forces to Cambodia to Drive Communists from Staging Zone," *New York Times*, May 1, 1970, 1; "Trouble on Campus," *New York Times*, May 1, 1970, 1; "Ohio State Students Clash with Troops," *Los Angeles Times*, May 1, 1970, 1, 9; Philip Hager, "Stanford Violence Renewed in Protest over ROTC, Cambodia," *Los Angeles Times*, May 1, 1970, 3; "Violence on Campuses," *New York Times*, May 3, 1970, 5; Michael T. Kaufman, "Campus Unrest over War Spreads with Strike Calls," *New York Times*, May 4, 1970, 1, 10; John Kifner, "4 Kent State Students Killed by Troops," *New York Times*, May 5, 1970, 1, 17. (Harvey's radical left turn & meeting Scott Smith). Shilts, *The Mayor of Castro Street*, 40, 44. ("Yes, We Are Very Open"). Shilts, *The Mayor of Castro Street*, 65.

37. ("early invaders"). "The Early Invaders" is the title of Chapter Six in Shilts, *The Mayor of Castro Street*. (make the Castro home). Shilts, *The Mayor of Castro Street*, 86. (Replacing outside norms with inside norms). See Stryker, *Transgender History*, 95 ("At the cultural level, it is possible to trace the current 'homonormativity' of mainstream gay culture [an emphasis on being 'straight-looking and straight acting'], as well as the perceived lack of meaningful connection to transgender communities among mainstream gays and lesbians, to 1973.")

38. ("never given power"). Shilts, *The Mayor of Castro Street*, 75. (one prominent queer). Notably, in 1975, S.I.R.'s rank-and-file members overwhelmingly voted to endorse Milk, but the moderate leadership conspicuously broke with protocol and did *not* give endorsements, "in order

to avoid divisiveness." "S.I.R. Election Poll 1975," *The Insider*, Oct. 1975, 3. (**Harvey & José**). Shilts, *The Mayor of Castro Street*, 75; see also Mike Newton, "The Insider," *Vector* 9, no. 10 (Nov. 1973), 34–35 (listing Milk among the candidates given S.I.R.'s "Stamp of Approval," but *not* including Milk on the official endorsement/paid political advertisement). (**Moscone Hires/Fires Milk**). M. David Stein, "Political Clash between SF Mayor and Gay Appointee," *Pittsburgh Gay News* no. 31 (Apr. 1976), B4; see also Shilts, *The Mayor of Castro Street*, 129–34.

39. (**Goodstein's lament, 1973**). David Goodstein, "Gay Subcultists and the California Senate," *Vector* 9, no. 7 (Aug. 1973), 32–33. (**Goodstein's lament, 1976**). Goodstein, "Opening Space," *Advocate* 181; but see "Judas Iscariot Revivivus, or The Old Viper-in-the-Bosom Hustle," *Maine Gay Task Force Newsletter* 3, no. 3 (Mar. 1976) (describing Goodstein's "leftist and Third World" barb as "racism and Red-baiting.") (**"well-lighted bars" & "counseling couches"**). Goodstein, "Opening Space," *Advocate* 181. A note on **the closet**: When discussing moderate gay politics circa 1973–1995, expressions of support for and critiques of those in the closet shouldn't be confused with how the queer community tends to talk about those in the closet in the twenty-first century. Queer people in 2019, in our view, generally have the privilege of assuming the world *should be* safe (whether or not it is); thus, if someone is closeted, we collectively assume there are "legitimate" extenuating circumstances precluding the individual from coming out (e.g., fear, lack of a support network, lack of access to a community, threats of violence, financial or housing instability, etc.). Our collective default, in other words, is to assume one *would* come out *if* one could. There was no such default at virtually any point in the twentieth century, and few people ever assumed it was safe to come out; it was *always* dangerous. That was the whole point: queer people *had* to come out—their monumental bravery was necessary—in order to create space for other queer people. In that context, then, those who wished to work "from the safety of their closets" were specifically asking to profit off the risks that others took; Goodstein's article, for example, confusingly attacked the most visible queer activists—those who created space—while asking the community to respect those who were hiding in the far corners of that space. And, lest we be misunderstood, we emphasize the following: coming out is still a monumental act of bravery; we urge every queer person to come out on their own terms and to do so only when they are safe, supported, and ready. (**"the enemy is among us"**). "D. B. Goodstein: Advocate for the Right," *Gay Liberator* 48, Spring 1976. (**Advocate Invitational Conference**). See "Goodstein Actions Provoke Ire From 'Movement' Gays," *Maine Gay Task Force Newsletter* 3, no. 3; see "'Advocate' Conference Spawns Lobby Group," *Blade* 7, no. 4 (Apr. 1976), 1, 6 ("A movement dies at the first breath of autocracy," one speaker said); "'Gay Rights National Lobby' Becomes a Reality," *Blade* 7, no. 5 (May 1976), 3.

40. (**Milk vs. Agnos**). Donald Cameron Scot, "Win Some . . . Lose Some . . . ," *Different Beat* 2, June 17, 1976, 25; Shilts, *The Mayor of Castro Street*, 147–50; but see "Gay Person of the Year—Elaine Noble," *Gay People's Union News*, Jan. 1977, 12–13 (describing Noble as "adamant in saying, 'We can never expect other liberal people to speak for us (gay people). It is our responsibility to speak for ourselves. Nobody is going to do it for us.'") (**District elections**). Shilts, *The Mayor of Castro Street*, 151–52.

41. (**Productive year**). Jean O'Leary and Bruce Voeller, "1976: A Year of Growth," *It's Time* 3, no. 4 (Jan. 1977), 1, 4. (**Open delegate**). See "Gay Delegate Elected to Convention," *Blade* 7, no. 5, 1; "O'Leary on Carter Committee," *It's Time* 3, no. 3 (Dec. 1976), 2. (**Houston activists**). "NGTF Board to Explore Regional Expansion," *It's Time* 3, no. 3, 1. (**Mark Segal**). "Governor Shapp Proclaims Gay Week in Pennsylvania," *Blade* 7, no. 7 (July 1976), 3.

42. (**Supreme Court & sodomy**). See *Doe v. Commonwealth's Attorney of Richmond,* 425 U.S. 901 (1976); see also "High Court Upholds Sodomy Law," *Gay People's Union News*, Apr. 1976, 2 ("Dr. Bruce Voeller, executive director of the National Gay Task Force in New York, said his group would seek different avenues to bring the question before the highest court again"). As it turned out, the two anonymous plaintiffs ("John Does") in the Virginia case were NGTF member Bill Bland and his lover, NGTF co-executive director Bruce Voeller. See O'Leary and Voeller, "1976: A Year of Growth," *It's Time* 3, no. 4, 1; see also Eskridge, *Dishonorable Passions*, 186. (**"raise the consciousness of lawmakers and the courts"**). O'Leary and Voeller, "1976: A Year of Growth," 1 (another instance of the "benefits of backlash" theory). (**"the Moses of gay liberation"**). Ray Hill, "Comment," *This Week in Texas*, Aug. 21–27, 1976, 38.

43. (**"your life may depend"**). Bob Salamone, "Into the Streets," *Gaysweek* 18 (June 20, 1977), 11–12. (**ordinance adopted**). "Miami Passes Rights Law," *Gay People's Union News*, Feb. 1977, 3. (**"condones immorality"**). "Bias Against Homosexuals Is Outlawed in Miami," *New York Times*, Jan. 19, 1977, A14. (*Save Our Children*/*"must recruit"*). See "Anti-Gay Drive Formed," *Lakeland Ledger*, Feb. 13, 1977, 6A; Save Our Children, Inc., "The Civil Rights of Parents: To Save Their Children from Homosexual Influence," c. 1977, Lesbian Herstory Archives: Homophobia: Anita Bryant, Apr. 1977–Jan. 3, 1979; folder no. 06620. (**"welcomed the possibility of a referendum"**). "Miami Passes Rights Law," 3. (**sixty-four thousand signatures**). See "Gay Rights Vote Called," *Lakeland Ledger*, Mar. 15, 1977. See R.B. Smith, "Background: Bob Kunst and the Miami Victory Campaign," *Gayweek* 13 (May 13, 1977), 14; "Transperience to Sue Consurium over CETA $," *Gayweek* 56 (Mar. 13, 1978), 2.

44. (**even the most cynical**). See John Paul Hudson to Jean O'Leary and Bruce Voeller, Feb. 20, 1977, ONE/USC Archives, NGLTF Papers, 2012–001, 1/4 (". . . it will do a lot of good in helping many of our blatantly and even subtly oppressed sisters and brothers enjoy a sense of progress . . . "). (**NGTF at the White House**). See generally Faderman, *Gay Revolution*, 298–303; "Gays Meet at White House," *Gay People's Union News*, Mar. 1977, 3; Lou Romano, "Gays Meet with Carter Aides," *Blade* 8, no. 4 (Apr. 1977), 1, 6; Jeanne Córdova, "Carter Aide Wants Nation to 'Hear What I Heard,'" *Lesbian Tide* 6, no. 6 (May–June 1977), 13–14. (**Bryant's thoughts**). "Anita Bryant Scores White House Talk With Homosexuals," *New York Times*, Mar. 28, 1977, 56.

45. (**Miami campaign**). See Shilts, *The Mayor of Castro Street*, 156. (**repeal the gay rights ordinance, "normal majority," other cities**). "Reactions to Gay Loss in Miami," *Gay People's Union News*, July 1977, 4; "Human Rights Lose 2-to-1," *This Week in Texas* 3, no. 11 (June 11-17, 1977), 7; see also "Anti-Gay Anita Loses TV Show," *Gay People's Union News*, Mar. 1977, 2; "Human Rights Lose 2-to-1," 7. "Ironically," *This Week in Texas* noted, "the National Hurricane Center in Miami announced on election day that the first hurricane of the season will be named 'Hurricane Anita.' . . . A hurricane is a destructive force of nature that is recognized as an aimlessly wandering storm without regard for human life or property." In 1971, the National Weather Service selected names, at random, to apply to tropical storms and hurricanes for a ten-year period. The first name on the 1977 list was, in fact, Anita. This information seems to have been public at least as early as 1971, and we can find no record of it having been "announced" on Election Day; more likely, a press release was issued on June 1, the start of hurricane season, and news of the irony spread as the Dade County vote neared.

46. (**"when you walk out of here tonight"**). Leonard Matlovich in "Reactions to Gay Loss in Miami," *Gay People's Union News*, July 1977, 4. (**Greenwich Village & San Francisco**). "Reactions to Gay Loss in Miami," 4; B. Drummond Ayres Jr., "Miami Votes 2 to 1 to Repeal Law Barring Bias Against Homosexuals," *New York Times*, June 8, 1977, 1, 16; Ayres, "Miami Vote Increases Activism on Homosexual Rights," *New York Times*, June 9, 1977, 1, 46; Pennington, "Mirrors of Our Community," 1, 4–5; Shilts, *The Mayor of Castro Street*, 159. (**Indianapolis**). Ayres, "Miami Vote Increases Activism on Homosexual Rights," 1, 46. (**Norfolk**). "Reactions to Gay Loss in Miami," 6; "Entertainer Weeps After Walkout," *New York Times*, June 10, 1977, 16. (**New York, San Francisco & more**). Dena Kleiman, "Thousands Backing Homosexuals March Uptown to Columbus Circle," *New York Times*, June 9, 1977, D21; Pennington, "Mirrors of Our Community," 1, 4–5; see also Ken Greves, "Gay Pride Week," *Blade* 8, no. 6 (June 1977), 2; Sharon McDonald, "9,500 March Against Bryant," *Lesbian Tide* 7, no. 1 (July–Aug. 1977), 4, 6; "Protest in Hollywood," *Los Angeles Times*, June 14, 1977, 24; "California Senator Joins Fight Against Gay Rights in Florida," *Los Angeles Times*, June 8, 1977, 12. (**Chicago & Houston**). "Chicago Holds Anti Anita Rally," *Gay People's Union News*, July 1977, 5; "HUMAN RIGHTS RALLY," *This Week in Texas* 3, no. 13 (June 24–July 1, 1977), 34. (**"matches our 1969 birth"**). McDonald, "9,500 March Against Bryant," 4, 6.

47. (**"reject gay rights as our focus"**). Cha Cha Heels, "Not Gay Rights Only," *Gay Community News* 5, no. 2 (July 9, 1977), 6. (**Shively**). See Charley Shively, "Speaking Out: Bible Burning as an Act of Illumination," *Gay Community News*, 5, no. 4 (July 23, 1977), 5; Jim Downs, *Stand By Me: The Forgotten History of Gay Liberation* (New York: Basic Books, 2016), 59–61; Alexander Cockburn, *Corruptions of Empire: Life Studies & the Reagan Era* (London: Verso, 1988), 235–36; Michael Bronski, "We Remember Charley Shively, Visionary of the Gay Liberation Movement," *Beacon Broadside* (blog), Oct. 18, 2017, available at www.beaconbroadside.com/broadside/2017/10/we-remember-charley-shively-visionary-of-the-gay-liberation-movement.html. We note Shively

also burned a letter he'd received from Boston State College refusing his request to teach a gay history course.

48. (Mondale). "Mondale Shouted Down by Gay Activists," *Redlands Daily Facts*, June 18, 1977, 1; "SF Gays Zap Mondale," *Gaysweek* 20, 2. ("I do not view it as normal"). "Jimmie [sic] Carter on Gay Rights," *This Week in Texas* 3, no. 13, 11. (just random violence). Shilts, *The Mayor of Castro Street*, 161. ("this one's for Anita!"). "Mother of Murdered S.F. 'Gay' Files Suit Against Anita Bryant," *Los Angeles Times*, July 1, 1977, 28; Shilts, *The Mayor of Castro Street*, 162–63. (Moscone responds). David Johnston, "S.F. Mourns Slain Gay City Worker," *Los Angeles Times*, June 25, 1977, 1, 7. ("massive opening of closet doors"). Pennington, "Mirrors of Our Community," 1, 4–5. (dramatic contingent & shrine). Pennington, "Mirrors of Our Community," 1, 4–5. (Milk's announcement). Shilts, *The Mayor of Castro Street*, 165.

49. (New York Pride 1977). "GAY PRIDE MARCH '77," *Drag* 7, no. 25 (1977), 20; "Homosexuals March for Equal Rights," *New York Times*, June 27, 1977, 1, 20. (Karla Jay, Kathy Kozachenko & more). "Smith, Reed Entertain at Rally," *Gaysweek* 21 (July 11, 1977), 3. (Sylvia Returns). "GAY PRIDE MARCH '77," 22.

50. (a dilemma). See, e.g., Ellen Levi, "Lesbians and Gay Men: Do We Have a Common Cause?" *Blade* 8, no. 9 (Sept. 1977), 4. (rampant misogyny). See, e.g., Jerry Fitzpatrick, "Money Talks," *Gaysweek* 18, 11 ("If every gay man and woman had boycotted orange juice when the hag from Dade County started spouting her hate-filled rhetoric, she would have been silenced fast."); Allen Young, "Thoughts on Anita Bryant," *Gaysweek* 22, July 18, 1977, 17 ("This woman is a bigot, and she should be attacked for her bigotry, not for her womanhood. Calling Bryant a 'bitch' is attacking her as a woman.") (Córdova, Freespirit, Bottini). "Coalition Politics: A Necessary Alliance," *Lesbian Tide* 7, no. 2 (Sept.–Oct. 1977), 4–5, 36–37.

51. (Wichita). See "Wichita—the Next Miami?" *Blade* 8, no. 11 (Nov. 1977), 5. (Milk wins). See "Milk Elected to San Francisco Supervisors Board," *Gaysweek* 40, Nov. 21, 1977, 6 ("Stokes was endorsed by the *Advocate* and had the support of Leonard Matlovich, Elaine Noble and Jim Foster in his campaign.") (National Women's Conference). See, e.g., Jeanne Córdova, "Gay, Feminist Coalition Sweeps IWY," *Lesbian Tide* 7, no. 1, 8–11 (among others, Jeanne Córdova, Del Martin, and Phyllis Lyon represented California at the National Conference); Jean O'Leary, "Lesbians Plan for IWY Finale," *It's Time* 3, no. 9 (Aug.–Sept. 1977), 3; Córdova, "Freedom Riders Bus to Houston," *Lesbian Tide* 7, no. 2 (Sep.–Oct. 1977), 8–9; Córdova, "IWY: Most States Back Lesbian Rights," *Lesbian Tide* 7, no. 2, 10; Córdova, "IWY, Houston Here We Come!" *Lesbian Tide* 7, no. 3 (Nov.–Dec. 1977), 16; Jo Delaplaine, "Victory in Houston: 'We Are Everywhere,'" *Blade* 8, no. 12 (Dec. 1977), 1, 16; Women's Caucus of NGTF, "National Women's Conference Supports Sexual Preference," *It's Time* 5, no. 1 (Jan. 1978), 1, 4; Córdova, "Those Lesbians Are Everywhere!" *Lesbian Tide* 7, no. 4 (Jan.–Feb. 1978), 12–16.

52. (Milk & Goodstein). See "Milk Inaugurated; 'Advocate' Throws Party," *Gaysweek* 50 (Jan. 30, 1978), 5; see also Shilts, *The Mayor of Castro Street*, 191 ("The best media event of inauguration day came not from Milk, but from his old nemesis David Goodstein, who sponsored a series of inaugural night parties at the city's three most popular gay discos.") (Ed Koch). "Koch Delivers on Promise to Issue Anti-Discrimination Order," *Gaysweek* 50, 2. Demanding the new mayor—who had a spotty record on queer rights—follow through with certain campaign promises, a group of radical gay activists zapped Ed Koch's inaugural festivities. See "GAA Zaps Koch During Inaugural," *Gaysweek* 47 (Jan. 9, 1978), 2. In an already tense era, the small protest gave rise to a remarkable debate between moderates and militants, best captured in the pages of *Gaysweek*. See, e.g., David Rothenberg, "Gay People Are Our Own Worst Enemy," *Gaysweek* 48, Jan. 16, 1978, 12 ("Anyone who bears battle scars from civil rights and anti-war protests should be sensitive to the possibility of *agents provocateurs*. No one is better served by gay protesters of the Koch inaugural than people of the homophobic right. . . . I am very wary of groups which provoke backlash feelings . . . "); David Thorstad, "Guttersniping Journalism," *Gaysweek* 49 (Jan. 23, 1978), 6 ("We were there because we don't believe promises are enough. We were there because we knew that some of our pro-establishment gay sisters and brothers . . . didn't expect to see any action on the gay rights bill for at least a year and a half."); Brian O'Dell, "Vicious and Stupid Columns," *Gaysweek* 49, 6 (". . . it is my personal opinion, as other friends of mine have agreed, that *this* was probably the added pressure that Mayor Koch needed to announce his proposed executive order . . ."). (Bryant in D.C.). Lou Romano and Bill

Evans, "Rally Draws Record Crowd," *Blade* 9, no. 2 (Feb. 1978), 3. (New Right Rises). See, e.g., "High School Ku Klux Klan Terrorizes Gays in Oklahoma City," *Gaysweek* 51, Feb. 6, 1978, 2; Larry Bush, "Anti-Gay Lobby Surfaces," *Blade* 10, no. 5 (Mar. 1, 1979), 1. (Falwell). See, e.g., "Anita Bryant Update," *Gay People's Union News* (Aug. 1977), 7 (Bryant and husband Bob Green said "that the couple has been considering purchasing a summer home in the Lynchburg, Va. area . . . plan a closer relationship with Lynchburg's Thomas Road Baptist Church and its fundamentalist minister, the Rev. Jerry Falwell.")

53. (St. Paul & Briggs). See Ginny Vida, "NGTF Responds to Defeat of Gay Rights Ordinance in St. Paul," Apr. 26, 1978; Judith Michaelson, "Briggs Submits Signatures for Anti-Gay Initiative," *Los Angeles Times*, May 2, 1978, 22. (Wichita & Eugene). "Wichita Gay Rights Law Falls 5 to 1; New Yorkers Plan Demonstration," *Gaysweek* 64 (May 15, 1978), 1; "Defeat in Eugene?" *Gay People's Union News* (July 1978), 5. (NGTF). Vida, "NGTF Responds to Defeat of Gay Rights Ordinance in St. Paul." (Seattle). See generally *Seattle Gay News* 5, no. 12, June 23, 1978. (Marsha P. Johnson). See "New Yorkers March Over Rights Setback," *Gaysweek* 65 (May 22, 1978), 1 ("Street transvestite Marsha. . . ."). (Houston). See "Town Meeting 1 Defines Community Needs," *Upfront* 1, no. 7, July 7, 1978, 1.

54. (Milk at Freedom Day 1978). See Shilts, *The Mayor of Castro Street*, 364–71. Many sources incorrectly refer to Milk's speech from Freedom Day 1978 as "The Hope Speech," when, in fact, Milk delivered what's known as the "That's What America Is" speech. (MECLA). See generally Faderman and Timmons, *Gay L.A.*, 218–23. (Kight & Perry). See generally Faderman and Timmons, *Gay L.A.*, 218–25. (Reagan). Richard West, "Prop. 6 Dangerous, Reagan Believes," *Los Angeles Times*, Sep. 23, 1978, 26. (Polls). "Opposition to Proposition 6 Growing, California Poll Finds," *Los Angeles Times*, Oct. 6, 1978, 24. (Final vote). See Faderman and Timmons, *Gay L.A.*, 220. (California & Seattle). See "Victory in California and Seattle," *Gay People's Union News*, Dec. 1978, 4.

55. (quintupled/Castro Camera closes). Shilts, *The Mayor of Castro Street*, 119, 226–27. ("they all look alike!"). Shilts, *The Mayor of Castro Street*, 115. (Harvey's star rises & White resigns). See "News in Brief: The State," *Los Angeles Times*, Nov. 12, 1978, 2.

56. (Jones & Moscone). See Marshall Kilduff and Phil Tracy, "Inside Peoples Temple," *New West*, Aug. 1, 1977, 30–38, available at jonestown.sdsu.edu/wp-content/uploads/2013/10/newWestart.pdf. (Retreat to Jonestown). See Kilduff and Tracy, "Inside Peoples Temple," 30–38. (Hell). See, e.g., Joseph B. Treaster, "Survivor Says He Heard 'Cheers' and Gunshots After Cult Deaths," *New York Times*, Dec. 17, 1978, 42. ("poison or a bullet"). Leonard Greenwood, "Bodies of Jim Jones, 409 Cultists Found," *Los Angeles Times*, Nov. 21, 1978, 1, 22. (Jonestown Massacre). See "Rep. Ryan, 4 Others Reported Shot, Killed," *Los Angeles Times*, Nov. 19, 1978, 1, 20; "Guyana Official Reports 300 Dead at Religious Sect's Jungle Temple," *New York Times*, Nov. 20, 1978, 1, 16; "U.S. Says Guyana Toll Has Nearly Doubled; Deaths In Jungle Commune Could Reach 780," *New York Times*, Nov. 25, 1978, 1, 8; Jerry Cohen and Jerry Belcher, "Cult's Toll Rises to at Least 775," *Los Angeles Times*, Nov. 25, 1978, 1, 7; "Guyana Toll Is Raised to at Least 900 By U.S., With 260 Children among Victims at Colony," *New York Times*, Nov. 26, 1978, 1, 22.

57. (White & Moscone). Shilts, *The Mayor of Castro Street*, 267–68. ("special bullets"). Shilts, *The Mayor of Castro Street*, 268. ("just kind of smirked"). "The Dan White confession tape," produced by Helen Mickiewicz, KPFA Los Angeles, May 30, 1979. (White shoots Milk). Shilts, *The Mayor of Castro Street*, 269.

58. ("most eloquent expression"). Prof. Sally Gearhart in Robert Epstein, *The Times of Harvey Milk* (Black Sand Productions: 1984). ("If a bullet should enter my brain"). Shilts, *The Mayor of Castro Street*, 372–75. Milk recorded three versions of his political will, though they all follow the same outline. Notably, only one copy, which went to friend and speechwriter Frank Robinson, included the line about the bullet opening closet doors (Shilts, 372). ("always part of the movement"). Shilts, *The Mayor of Castro Street*, 373. ("No more!"). Cleve Jones and Chris Perry, "HARVEY MILK MEMORIAL—NATIONAL DAY OF FREEDOM," press release, Nov. 28, 1978, ONE/USC Archives, MOW 1979 Records, 2013-07, 1/2.

59. (Kramer). Larry Kramer, "Gay 'Power' Here," *New York Times*, Dec. 13, 1978, A27. (lesbian moms). "Lesbian Mother Denied Custody," *Gay People's Union News*, Feb. 1979. (anti-gay lobby). Bush, "Anti-Gay Lobby Surfaces," *Blade* 10, no. 5, 1. (anti-gay violence). Shilts, *The Mayor of Castro Street*, 307.

(bar raids). Shilts, *The Mayor of Castro Street*, 306; David W. Linger, "Bar Raids in Chicago," *Gay People's Union News*, June 1979.

60. (White Night riots). See generally "Gays Riot: WHY—WHY NOT?" *Bay Area Reporter* 9, no. 11 (May 24, 1979); Bruce Pettit, "Gays Explode at Manslaughter," *Bay Area Reporter* 9, no. 11, 1, 4. (Britt's response). "'Establishment Failed Us,' Britt Says," *Bay Area Reporter* 9, no. 11, 8. (Harvey's Birthday). "Harvey Milk's Birthday," *Bay Area Reporter* 9, no. 12 (June 7, 1979), 8.

61. ("street Gays and drag queens"). The organizations were known as Gay Walk for Freedom and the Stonewall Family. See "Stonewall Plaque Gets Ripped Off," *Blade* 10, no. 15 (July 19, 1979), 6.

62. (Controversy erupted). "March Delegates Debate, then Agree—Washington March Is On," *Montrose Star* 148 (July 20, 1979), 1. (Robin Tyler's idea). See Faderman, *Gay Revolution*, 409 ("[Robin] Tyler took the microphone again and solemnly roused her audience to fight with all their might. 'Forget about being nice. How long will lesbians and gay men tolerate not having rights in this country? We must organize for a national march on Washington, D.C.!'"); "Minutes of the National Conference for the March on Washington, D.C.," Philadelphia, Feb. 23–25, 1979, ONE/USC Archives, MOW 1979 files, 2013-087, 1/1. (main point of contention). See Lou Chibbaro, Jr., "Plans Firm for October March on Washington," *Blade* 10, no. 15, 5; "March on Washington," *This Week in Texas* 5, no. 16 (July 13–19, 1979), 7; "GRS Hosts National March Conference," *Upfront*, July 25, 1979, 6. (Paul Boneberg's compromise). Chibbaro, "Plans Firm for October March on Washington," 5.

63. (March lineup). The official March lineup was as follows: "(1) Women, with Third World Women Leading; (2) Physically Challenged; (3) Children and Aged; (4) International Lead by Puerto Rico [sic]; (5) Parents and Friends; (6) Regions: *Prairie*: TX, OK, KS, NE, ND, SD; *Rocky Mountain*: MT, ID, WY, CO, NM, AZ, NV; *West*: CA, WA, OR, AR, HI; *Midwest*: OH, IN, IL, MI, WI, MN, IA, MO; *South*: VA, NC, SC, GA, FL, AL, MS, LA, TN, KN*, AR; *Northeast*: ME, NH, VT, MA, CT, RI, NY, PA, NJ; *Mid-Atlantic*: MD, DC, DE, WV, NORTHERN VA; (7) National Organizations; (8) Supporters." National March on Washington for Lesbian and Gay Rights, "Organizer's Handbook," ONE/USC Archives, MOW 1979 files, 2013-087, 1/1. (*Presumably "KN" refers to Kentucky.) (Third World conference). See Tony Henry, "Report on the Third World Lesbian and Gay Conference," *Philadelphia Gay News* 4, no. 2 (Nov. 16–29, 1979), 5, 26. (Michiyo Cornell). Michiyo Cornell, Address to National March on Washington for Lesbian and Gay Rights, Oct. 14, 1979 (transcribed by authors). (Lorde at rally). Audre Lorde, Address to National March on Washington for Lesbian and Gay Rights, Oct. 14, 1979 (transcribed by authors). ("Gay pride to Gay politics!"). Arlie Scott, Address to National March on Washington for Lesbian and Gay Rights, Oct. 14, 1979 (transcribed by authors).

64. (a new enemy). See Randy Shilts, *And The Band Played On: Politics, People, and the AIDS Epidemic* (New York: St. Martin's Griffin, 1987, 2007), 28; Jeanie Russell Kasindorf, "The Plague," *New York Magazine*, Apr. 19, 1993, 166; "Clint Moncrief," obituary, *This Week in Texas* 7, no. 51 (Mar. 12–18, 1982), 65. (Lorde at Third World conference). Audre Lorde, "When Will the Ignorance End? Keynote Speech at the National Third World Gay and Lesbian Conference, October 13, 1979," in Rudolph P. Byrd, Johnnetta Betsch Cole, & Beverly Guy-Sheftall, eds., *I Am Your Sister: Collected and Unpublished Writings of Audre Lorde* (Oxford, UK: Oxford Univ. Press, 2009), 208.

Part IV: Fighting For Our Lives, 1980-1994

1. ("always the storm that strike you"). Gaétan Dugas to Ray Redford, Jan. 22, 1982, Redford's personal papers, in Richard A. McKay, "'Patient Zero': The Absence of a Patient's View of the Early North American AIDS Epidemic," *Bulletin of the History of Medicine* 88 (Spring 2014), 162. In his essential article on the real story of Gaétan Dugas and the mythical tale of "Patient Zero," Richard McKay quotes directly from personal correspondence, "reproduc[ing] the original spelling and grammatical errors without marking each one with *sic*." We similarly quote Dugas's words: exactly as written. Moreover, whereas most writers "have spelled Dugas's first name in various ways, with or without a diaeresis above the 'e' (i.e., Gaetan or Gaëtan)," we follow McKay's lead and employ the spelling used in Dugas's obituary notice and various Québécois sources, "with an acute accent above the 'e.'" McKay, 162, fns. 1–2. (Legg Memorial). Karen Ocamb, "Los Angeles News: W. Dorr Legg: Pre-Stonewall Pioneer Remembered," *Gay and Lesbian Times*, Sept. 1, 1994, 23.

2. (Stonewall 25 was chaos). Mustang Sally (pseud. of Beth Elliott), "Suddenly Last Stonewall," *TransSisters* 6, Autumn 1994, 17. (Mich. Festival & Mustang Sally). Mustang Sally, "Suddenly Last Stonewall," 17–18. (Alternative March & Sylvia). Jim Provenzano, "Stonewallorama," *Bay Area Reporter* 24, no. 26, 16; see also Karen Ocamb, "Stonewall Souvenirs," BAR 24, no. 26, 1; press release, "SOS Liberation Contingent at Stonewall 25 Includes NAMBLA," June 3, 1994, NGLTF, 1973–2000, Series I: 20/21, NYPL. A note on NAMBLA: The North American Man/Boy Love Association (NAMBLA) is a particularly troublesome topic falling within the broad category of "queer history." In many ways, NAMBLA was a self-fulfilling prophecy; at first focused on issues related to overly ambiguous age-of-consent laws (those, for example, that could send a seventeen-year-old man's twenty-year-old boyfriend to prison for statutory rape, while the heterosexual equivalent almost certainly wouldn't face punishment) and forces, like Anita Bryant, who equated "gay" with "pedophilia," NAMBLA and its direct predecessor, the Boston-Boise Committee, were supported by progressive thinkers in the broader queer community. Over time, though, as the mainstream gay movement painted all those within NAMBLA with the same brush as the dominant culture had—i.e., as pedophiles—NAMBLA did, for the most part, become an organization whose primary message sought to legitimize physical and/or sexual relationships between men who unquestionably were capable of consent and boys who almost certainly were not. We don't know of any attempted history of NAMBLA, which says a great deal about both queer culture itself and an organization that has played some part—even if only as a measure of what "we're *not*"—in that culture. (physical coalescence). Provenzano, "Stonewallorama," 16; Chris Bull, "Stonewall 25," *Advocate*, July 26, 1994, 15. ("being Gays"). Harry Hay in Timmons, *Trouble with Harry Hay*, 143.

3. (Paid it no mind). Marsha P. Johnson always said that her middle initial stood for "Pay It No Mind," and, according to most sources, the first anyone heard her use the line was when a municipal judge asked her to provide her middle name. Marsha snapped her fingers and gave her answer; the judge let her walk. See, e.g., Bob Kohler in Michael Kasino, "Pay It No Mind: The Life and Times of Marsha P. Johnson," 2012, available at www.youtube.com/watch?v=rjN9W2KstqE. (recognizing Sylvia and Marsha). John Hammond, "A Successful March," *West Sider*, 1980, 4–5. (Eve Adams). "Gay Liberation Allows Drag (G.L.A.D.)" flyer, 1980, GAA, Reel 18, 22/13, NYPL, available at stonewallhistory.omeka.net/items/show/62. (NYC vs. San Francisco). Andrew C. Irish, "Community Voices: Divisions," *Gay Community News* 8, no. 4 (Aug. 9, 1980), 5.

4. ("festive feeling"). Shilts, *And the Band Played On*, 11; see also "Backstage Struggle Mars Gay Pride Celebration," *Sentinel* 7, no. 14 (Jul. 11, 1980), 1. (outsiders who once marched). Shilts, *And the Band Played On*, 17. (Alberta Maged). Shilts, *And the Band Played On: Politics*, 15.

5. (Houston Pride 1980). See, e.g., "GPC Secretary Fred Paez Shot and Killed," *This Week in Texas* 4, no. 10 (Jul. 4, 1980), 10–11.

6. ("influx of transvestite prostitutes"). "Influx of Transvestite Prostitutes Plaguing Manhattan Plaza Area," *New York Times*, Sept. 2, 1979, 41. The "influx" language was, in and of itself, a public relations strategy. Queer sex workers had been a constant presence in Midtown Manhattan since at least the early twentieth century; calling the community an "influx" was simply an attempt to make "the problem" seem new. ("They just shot everyone"). "Influx of Transvestite Prostitutes Plaguing Manhattan Plaza Area," 41. (Marsha's arrest). Robert D'Avanzo, "The Activist Scene," *West Sider*, 1980, 3.

7. (Bagneris's tone). "An Interview with Larry Bagneris, Jr., Delegate, Texas Fifteenth Senatorial District, Democratic National Convention 1980," *This Week in Texas* 6, no. 24 (Sept. 5, 1980), 38 ("Learn their system and use it for our benefit.") (Apuzzo, Kraus, Craig, Boozer, Córdova). See generally Gay Vote 1980 files, NGLTF, 1973–2000, Series IV: 171/2, Cornell Univ. Libraries. (Boozer's speech). See generally Gay Vote 1980 files, NGLTF, 1973–2000, Series IV: 171, Cornell Univ. Libraries.

8. (Falwell/Moral Majority, 1980). Joseph F. Sullivan, "Falwell Warns Jersey Liberals at Capitol Rally," *New York Times*, Nov. 11, 1980, B2. (rise of the New Right). David E. Rosenbaum, "Narrow Issues May Sway Voting," *New York Times*, Oct. 27, 1980, A1, B7; Debra Kessler, "Behind the Religious Right," *Big Apple Dyke News*, June 1981, 7; Sheila Tucker, "Moral Moral Everywhere and Not a Stop to Think," *Hagborn* 1, no. 4 (Winter 1980), 4, 6; see also "Reagan's Backlash," *Campaign*, no. 61 (Jan. 1981), 7 ("Things won't get better," a gay man said, "they will get worse.") (The Ramrod shooting).

Charles Ortleb, "The West Street Massacre," *New York Native* 1, Dec. 5–18, 1980, 7. More on **Ortleb**: Charles Ortleb was a longtime presence in the New York gay periodical world, coming to prominence as publisher and editor of *Christopher Street*, a successful magazine founded in 1976. Founding the *New York Native* in late 1980, Ortleb provided a source for many of the early groundbreaking articles on what came to be known as AIDS, publishing lifesaving information as the mainstream press ignored a plague. In the early years, there were a myriad of theories as to what caused AIDS, and Ortleb remained doubtful as to the single-virus explanation (he was not alone in his doubts); as the epidemic wore on, however, his refusal to accept reality led to what many reasonably saw as inexcusable editorial decisions. The *New York Native* ended in disrepute. See Judy Klemesrud, "For Homosexuals, It's Getting Less Difficult to Tell Parents," *New York Times*, Sept. 1, 1972, 32 ("In 1970 Chuck Ortleb had been leading a double life . . . "); N. R. Kleinfield, "Homosexual Periodicals Are Proliferating," *New York Times*, Aug. 1, 1978, D4; Robin Pogrebin, "Controversial Gay Magazine Shuts Down," *New York Times*, Jan. 9, 1997.

9. (**Roger Fulton & another Stonewall**). "Gayvine: Moral Majority Become Village People," *Big Apple Dyke News*, Apr. 1981, 1. It's unclear whether the writer(s) of this particular article was merely being tongue-in-cheek or malicious with the "man enough" language; either way, the offhand remark is further evidence that by 1981, few questioned that transgender people led the Stonewall Riots. (*They* **were everywhere**). See "Fundamentalists Declare Campaign Against SF Gays," *Gay Community News* 8, no. 30 (Feb. 21, 1981), 1 ("'I agree with capital punishment, and I believe homosexuality is one of those that could be coupled with murder and other sins,' said Dean Wycoff, spokesman for the Santa Clara Moral Majority.") (**Reagan's plans & White House protest**). See, e.g., Carl Goodman, "Womancare Funding Cut, Well-Woman Care Attacked," *Update* (San Diego), June 12, 1981, 6; "White House Police Arrest Non-Violent Demonstrators," *Gay Community News* 8, no. 48 (June 27, 1981), 3. (**San Diego lesbians**). Goodman, "250 Women March to Stress Lesbian Issues," June 12, 1981, 6. (**CRASH & Fulton**). CRASH included members of Dykes Against Racism Everywhere, Black & White Men Together, Lesbian and Gay Male Socialists, Salsa Soul Sisters, Radical Women, and the Coalition for Abortion Rights and Against Sterilization Abuse. See Joan Gibbs and Sara Bennett, "New Yorkers Protest at Village Church," *Gay Community News* 8, no. 48, 3. (**"the best thing . . . in years"**). Maxine Wolfe (interview by Jim Hubbard), ACT UP Oral History Project, Feb. 19, 2004, 28. (**"seems to be growing"**). Gibbs and Bennett, "New Yorkers Protest at Village Church," 3. (**"a nice place to live"**). Roz Calvert, "CRASHing the Neighborhood Church, *New York City News*, June 21, 1981, 4. (**PCP**). "*Pneumocystis* Pneumonia—Los Angeles," *Morbidity and Mortality Weekly Report* 30, no. 21 (June 5, 1981), 250–52. (**"gay pneumonia"**). "Gay Pneumonia," *Gay Community News* 8, no. 48, 2.

10. (**handful of physicians**). See Shilts, *And the Band Played On*, 64–65, 84; David France, *How to Survive a Plague: The Inside Story of How Citizens and Science Tamed AIDS* (New York: Alfred A. Knopf, 2016), 19–21. (**no health alerts**). By the time Lawrence K. Altman's "rare cancer" piece ran, gay and bisexual men in the "center of the storm," so to speak—those in Greenwich Village, the Castro, West Hollywood, and other areas of L.A.—"didn't need the *New York Times* to anoint the AIDS crisis," Avram Finkelstein said. Because of the *Times*' prestige, and the dominant culture's ability to identify with it, the Altman piece is the beginning of "a very skewed idea of the historiography of HIV/AIDS." Although "we've chosen markers that suit a dominant narrative," Finkelstein noted, friends and lovers were inexplicably dying *for years*, and the *New York Native*—thanks to Dr. Larry Mass—had already started covering the epidemic before Altman's report. See oral history interview with Avram Finkelstein, April 25–May 23, 2016, Archives of American Art, Smithsonian Institution, available at www.aaa.si.edu/collections/interviews/oral-history-interview-avram-finkelstein-17347#transcript. (**"Rare Cancer"**). Lawrence K. Altman, "Rare Cancer Seen in 41 Homosexuals," *New York Times*, Jul. 3, 1981, A20; see also "Kaposi's Sarcoma and *Pneumocystis carinii* Pneumonia Among Homosexual Men—New York and California," *MMWR* 30, no. 25 (Jul. 3, 1981), 305–08. Notably, although the CDC report clearly covered *both* Kaposi's sarcoma (the "rare cancer") and *Pneumocystis* pneumonia (the "rare pneumonia"), Altman seemed to conflate the two opportunistic diseases. Of the forty-one cases covered in Altman's story, twenty-six specifically were in the KS cluster, fifteen in the PCP cluster; four of the KS patients also had PCP, while two PCP patients also had KS. (**"no apparent danger to nonhomosexuals"**). Altman, "Rare Cancer Seen in 41 Homosexuals," A20. (**Legionnaires' Disease coverage**). See Altman, "Deaths of 6 to 14 Who Attended Convention Studied," *New York Times*, Aug. 3, 1976, 12; see also *New York Times*, Aug. 4, 5, 6, 7, 8, 9, 14, and 26, 1976. (**Response to Legionnaires'**). See Gould, *Moving Politics*, 49–50. (**at least 43 people had died**). See Friedman, et al., "Follow-Up on Kaposi's Sarcoma and *Pneumocystis* Pneumonia," *MMWR* 30, no. 33 (Aug. 28, 1981), 1–2. (**national infrastructure**). See generally Shilts, *And the Band Played On*. (**"Language destined to offend"**). Douglas Crimp, "How to Have Promiscuity in an Epidemic," *Melancholia and Moralism: Essays on AIDS and Queer Politics* (Cambridge, MA: MIT Press, 2002), 47–64.

11. (**back to reality**). Larry Kramer, "The First Defense," *New York Native*, no. 27, (Dec. 21, 1981–Jan. 3, 1982), reprinted in Kramer, *Reports from the Holocaust: The Story of an AIDS Activist* (New York: St. Martin's Press, 1994), 12; see also Kramer in Marcus, *Making Gay History*, 246. (**Friedman-Kien's plea**). France, *How to Survive a Plague*, 22. ("**dirty and unwashed**"). Kramer, *Reports from the Holocaust*, xxxii. (**Kramer, Milk & the *Times***). Kramer, "Gay 'Power' Here," A27; Kramer, *Reports from the Holocaust*, 5. ("**highly personal . . . seemingly impossible**"). Peter Burton, "Faggots Reviewed," *Gay News* (London) 195 (July 10–23, 1980), 21. (**Vito & thoughtful critics**). Vito Russo, "Misguided Attitudes About Morality," *Gaysweek* 100 (Jan. 22, 1979), 5; see also Robert Chesley, "It's Hard to Walk Away from a Good Blowjob: 'Faggots' Author Larry Kramer Says New Yorkers Haven't Earned Their Rights, An Interview (and Dispute) by (and with) Robert Chesley," *Gaysweek* 97 (Jan. 1, 1979), 15 (Chesley called *Faggots* "a genuine cry of pain from the midst of today's urban gay life"). ("**an entire lifestyle**"). Russo, "Misguided Attitudes About Morality," 5; see also "Gays on the march," 32; Joseph F. Lovett, *Gay Sex in the 70s* (Lovett Productions: 2005). ("**butch posturing**"). The Red Queen (pseud. of Arthur Evans), "Them and Us," *Bay Area Reporter* 13, no. 14 (Apr. 7, 1983), 6. ("**being tested**"). Faderman and Timmons, *Gay L.A.*, 194–95; see also Russo, "Misguided Attitudes About Morality," 5 ("We do not have the responsibility of making gay life look good to straights. . . . The only responsibility we have as gay people is to treat each other with kindness, not rape other people, and get a blood test every three months.") ("**go to the barricades**"). See Chesley, "It's Hard to Walk Away from a Good Blowjob," 15; see also Kramer in Marcus, *Making Gay History*, 247 (years after the Chesley interview, during a discussion with Eric Marcus, Kramer used the "going to the barricades" language to paraphrase a particular point of contention he'd had with Chesley; what he actually told Chesley was as follows: "I'm asked to sign petitions to help people who have been nabbed by policemen for sucking off guys in the toilets of the IRT! *I won't!*"). ("**punishment and repression**"). Chesley, "It's Hard to Walk Away from a Good Blowjob," 15.

12. (**Donald Krintzman**). Kramer, "The First Defense," *Reports from the Holocaust*, 11. (**At Kramer's apartment**). Larry Kramer has consistently said that eighty men were at his apartment on August 11, 1981. The only other primary source we've found, however, puts the number at 150. See Andy Humm, "Gay Men," *New York City News*, Aug. 25, 1981, 2. Hence, we chose to go with "about a hundred." ("**This is our disease**"). Kramer, "A Personal Appeal," *New York Native*, no. 19 (Aug. 24–Sep. 6, 1981). ("**something else is happening here**"). Robert Chesley, letter to the editor, *New York Native*, Oct. 18, 1981, 4. ("**unspoken but widespread anxiety**"). Gould, *Moving Politics*, 71. (**Popham & Lynch**). Gould, *Moving Politics*, 71. (**Someone had to tell them**). See Cindy Patton, "Resistance and the Erotic: Reclaiming History, Setting Strategy as We Face AIDS," *Radical America* 20, no. 6 (Facing AIDS: A Special Issue), 72 ("Perhaps the single most misunderstood 'fact' about transmission of HIV is that promiscuity is the chief culprit. Despite wide media and even scientific reporting, epidemiologic studies show that it is not primarily number of sexual partners, but rather exchange of infected semen or blood that creates risk for contracting the virus.") ("**Our lifestyle**"). Michael Callen and Richard Berkowitz with Richard Dworkin, "We Know Who We Are: Two Gay Men Declare War on Promiscuity," *New York Native* 50 (Nov. 8–21, 1982), 23. ("**we were never immoral**"). Marie Godwin, "AIDS and the New Morality," *Gay Community News* 11, no. 5 (Aug. 13, 1983).

13. ("**I'm Bobbi Campbell**"). Bobbi Campbell, "I Will Survive!" *The Sentinel* 9, no. 2 (Dec. 10, 1981), 1, 5. By way of comparison, a few days later, the *New York Native* ran a letter from Larry Kramer, ending: "I am not glorifying in death. I am overwhelmed by it. The death of my friends. The death of whatever community there is here in New York. The death of any visible love." Kramer, "The First Defense," *Reports from the Holocaust*, 22. (**Bay Area response**). "Local Physicians Probe Cancer Outbreak; Incidence among Gay Men Raises Alarming Possibilities," *Sentinel* 8, no. 16 (Aug. 7, 1981), 1, 7; Shawn P. Kelly, "Health Officials Step Up Program to Monitor Cancer Outbreak," *Sentinel* 8, no. 18 (Sep. 4, 1981), 2; see also Shilts, *And the Band Played On*, 76. (**Campbell,**

Turner & PWA self-empowerment). Michael Callen and Dan Turner, "A History of the PWA Self-Empowerment Movement," 1988. Available at web .archive.org/web/19990503115605/http://members.aol.com/sigothinc/pwahist1.htm. (perhaps "the first"). Callen and Turner, "A History of the PWA Self-Empowerment Movement." It's important to note that GMHC predated PWA San Francisco, but GMHC was distinctly *not* "for and by people with AIDS." For much of the 1980s, it was only by unfortunate coincidence that GMHC had any PWAs on its board. (*Play Fair*). Sisters of Perpetual Indulgence, *Play Fair* (1982), Univ. of Calif. San Francisco, Special Collections, AIDS History Project Ephemera Collection, MSS 2000-31.

14. (Acquired Immune Deficiency Syndrome). Mirko D. Grmek, *History of AIDS: Emergence and Origin of a Modern Pandemic* (Princeton, NJ: Princeton Univ. Press, 1990) (transl. Russell C. Maulitz & Jacalyn Duffin), 32. ("**We know who we are**"). Callen and Berkowitz with Dworkin, "We Know Who We Are, 23, 27; see also France, *How to Survive a Plague*, 45. Berkowitz had been a sex worker, and Callen had been with an estimated three thousand men (counting only anal penetration). (**Gay Men with AIDS**). Gay Men with AIDS, "A Warning," *New York Native* 51, (Nov. 22–Dec. 5, 1982), 16. After the backlash over the "War on Promiscuity" piece, Charles Ortleb refused to run the second article; the "Warning" from Gay Men with AIDS only appeared after Callen, Berkowitz, Sonnabend, and Richard Dworkin raised enough money to buy enough ad space in the *New York Native*. ("**How progressive**"). Callen and Turner, "A History of the PWA Self-Empowerment Movement." ("**New York chauvinism**"). Kevin Berrill, NGTF Interoffice memo re Weekly NYC AIDS meeting, Nov. 18, 1982, NGLTF Records, 1973–2000, Series II: 124/48, Cornell Univ. Libraries. (**all the funding they could use**"). Shilts, *And the Band Played On*, 187; see also George Mendenhall, "U.S. Report Blasts Anti-AIDS Effort," *Bay Area Reporter* 15, no. 9 (Feb. 28, 1985), 1, 12. (**Tylenol**). See Shilts, *And the Band Played On*, 190–91. ("**Let them die**"). Allen White, "Candlelight March Honors Hundreds; Names of AIDS, ARC Victims Taped to Fed'l Bldg.," *Bay Area Reporter* 15, no. 49 (Dec. 5, 1985), 1.

15. (GMHC—NY AIDS Network). Kramer, *Reports from the Holocaust*, 57. (**Apuzzo**). See Larry Kramer, "1,112 and Counting," *New York Native*, Mar. 14–27, 1983. For an example of the ongoing sexism Apuzzo faced, and fought, in order to forge ahead in the battle against the epidemic, see, e.g., David Rothenberg, "Another Voice," *New York City News* 77 (Aug. 24, 1983), 4 ("The battle against AIDS is important. It is not everything. We can contribute to a benefit without sacrificing lesbians or black gay men along the route.") (**AIDS Network & Koch**). Letter to Hon. Edward I. Koch, Mar. 7, 1983, NGLTF Records, 1973–2000, Series II: 124/48, Cornell Univ. Libraries; see also Letter to Hon. Edward I. Koch, Mar. 25, 1983, NGLTF Records, 1973–2000, Series II: 124/48, Cornell Univ. Libraries ("[we] are concerned that you have not yet responded to all the concerns expressed in that letter"). (**Kramer's anger & call for civil disobedience**). Kramer, "1,112 and Counting." (**Shilts re Kramer**). Shilts, *And The Band Played On*, 244–45. (**Mendenhall re Kramer**). Gould, *Moving Politics*, 93. (**Lorch explains**). Paul Lorch, "Gay Men Dying: Shifting Gears, Part I," *Bay Area Reporter* 13, no. 11 (Mar. 17, 1983), 6. (**San Francisco Response to "1,112"**). See, e.g., Randy Shilts, "From a Colleague," *Bay Area Reporter* 13, no. 13 (Mar. 31, 1983), 6 (Shilts said the editorials made him "proud both as a gay person and as a journalist"); see also AIDS patients and activists to Dr. Marcus Conant, president, Kaposi's Sarcoma Foundation, reprinted in "AIDS & Co. Strikes Back," *Bay Area Reporter* 13, no. 16 (Apr. 21, 1983), 1. (**Bobbi Campbell re "1,112"**). Bobbi Campbell, R.N., "1 from the 1,112," *Bay Area Reporter* 13, no. 15 (Apr. 14, 1983), 6. ("**a shockwave**"). Gould, *Moving Politics*, 98.

16. (First marches). See "AIDS Awareness Week," *Sentinel* 10, no. 9 (Apr. 28, 1983); "A Solemn Vigil," *New York City News* 70 (May 11, 1983), 1, 7; Gould, *Moving Politics*, 92–93. ("**Sex doesn't make you sick**"). Richard Berkowitz and Michael Callen (with editorial assistance by Richard Dworkin; medical and scientific consultant: Joseph Sonnabend, M.D.), *How to Have Sex in an Epidemic: One Approach* (New York: Tower Press, 1983), 3–4. (**Gay people invented safe sex**). See Patton, "Resistance and the Erotic," 68; Crimp, "How to Have Promiscuity in an Epidemic," *Melancholia and Moralism*, 64. ("**Our challenge**"). Berkowitz and Callen, *How to Have Sex in an Epidemic*, 4. (**an overview**). Berkowitz and Callen, *How to Have Sex in an Epidemic*, 15–17, 18–33. ("**misplaced morality**"). Berkowitz and Callen, *How to Have Sex in an Epidemic*, 36–37. ("**What's over isn't sex**"). Berkowitz and Callen, *How to Have Sex in an Epidemic*, 39. (**Note on safe sex got chic/transmission rates plummeted**). See, e.g., "Introduction," "Facing AIDS: A Special Issue," *Radical America* 20, no. 6 (Nov.–Dec. 1986).

17. (Denver conference). Callen and Turner, "A History of the PWA Self-Empowerment Movement." (**Activists' names**). Later, Callen and Turner made an effort to recall the names of those present, producing the following list: Bobbi Campbell, Dan Turner, Bobby Reynolds (San Francisco) (Michael Helquist, though not a PWA, joined the group at the final dinner to represent his lover, Mark Feldman, who'd just died); Phil Lanzaretta, Artie Felson, Michael Callen, Richard Berkowitz, Bill Burke, Bob Cecchi, Matthew Sarner, and Tom Nasrallah (New York City); Gar Traynor (L.A.); Elbert [last name unknown] from Kansas City; and "one individual from Denver whose name we unfortunately cannot recall." Callen and Turner, "A History of the PWA Self-Empowerment Movement." (**hospitality suite**). France, *How to Survive a Plague*, 107. (**different approaches**). See Sean Strub, *Body Counts: A Memoir of Activism, Sex, and Survival* (New York: Scribner, 2014), 142. Berkowitz, the only survivor from the group, recalled specific differences about treatment approaches and, most contentiously, the role of promiscuity, which Callen still very much believed caused AIDS. One night at dinner, Callen "suddenly asked 'Who knows how to take two dicks at once?' a trick question intended to reveal what, other than AIDS, [we] had in common: we were all sluts." It was Callen's way of convincing San Francisco to spread the word about safe sex; and it worked. (**founding document**). Strub, *Body Counts*, 142. (**Denver Principles**). Advisory Committee of People With AIDS, "Denver Principles," reprinted in Callen and Turner, "A History of the PWA Self-Empowerment Movement." (**Based on feminist health principles**). See, e.g., Strub, *Body Counts*, 143. ("**a new form of patient advocacy**"). France, *How to Survive a Plague*, 108. ("**this antipathy is killing us**"). Phil Nash, "Spirit of Unity Closes Health Conference," *Connection* (Long Island) 2, no. 17 (June 29, 1983), 17. (**PWAs storm the closing session**). See Callen and Turner, "A History of the PWA Self-Empowerment Movement"; Nash, "Spirit of Unity Closes Health Conference," 17; France, *How to Survive a Plague*, 107–10. (**Apuzzo in Denver**). Nash, "Spirit of Unity Closes Health Conference," 17.

18. (Fauci & casual contact). See "Family Contact Studied in Transmitting AIDS," *New York Times*, May 6, 1983, A21; see also Shilts, *And The Band Played On*, 302. (**rubber gloves & violence**). See, e.g., "Pool Disinfected after Gay Group's Swimming Party" and "AIDS-Related Bashings Surge in Seattle," *Gay Community News* 11, no. 5 (Aug. 15, 1983), 2; Robert Patrick "Straight People," *New York City News* 77 ("'Homosexual panic,' as the psychologists term it, is a curious disease. . . ."), 5; see also Shilts, *And The Band Played On*, 301. (a Feud/ setting "**treatment and research back immeasurably**"). Gould, *Moving Politics*, 110.

19. (Dugas). See generally McKay, "'Patient Zero,'" 1861–94.

20. (Pride 1983). Joe Boon, "Parade '83: A Diverse Display of Pride and Passion," *Connection* 2, no. 17, 27. In San Francisco, threats of rooftop snipers required undercover police to mix in among the PWA contingent at the head of the Freedom Day parade. Allen White, "'83 Parade: More Coverage, Less Hoopla," *Bay Area Reporter* 13, no. 26 (June 30, 1983), 1, 10. (*Normal Heart*). Kramer, *Reports from the Holocaust*, 66; but see Crimp, "How to Have Promiscuity in an Epidemic," *Melancholia and Moralism*. (**D.C. murders**). See Lou Chibbaro, Jr., "Brutality Marks Recent Murders," *Washington Blade* 12, no. 12 (June 12, 1981), 1, 13. (**anti-trans violence in San Francisco**). "Fourteen Transvestites Murdered in San Francisco So Far This Year," *San Francisco Crusader*, no. 127 (July 9, 1981), 3. (**bar raids**). See "72 Arrests in New Orleans of Lesbians and Gays in Front of Gay Bars," *San Francisco Crusader*, no. 124, (May 28, 1981), 3; Larry Goldsmith, "Organizing Follows Arrests in Chicago," *Gay Community News* 9, no. 2 (July 25, 1981), 3; Larry Goldsmith, "Gay Man Commits Suicide After Arrest in Bar Raid," *Gay Community News* 9, no. 6 (Aug. 22, 1981), 1. (**Paez's killer**). "Jury Finds McCoy Not Guilty," *This Week in Texas*, Sept. 11–17, 1981, 9. (**immigration protests**). See Andy Humm, "Anti-Gay Immigration Protests," *New York City News* 19 (Oct. 6, 1981), 3. (**Congress steps in**). See Mitchell Halberstadt, "Congress Crushes D.C. Rights: Sodomy Laws Restored After Right-Wing Mail Blitz," *New York City News* 19, 1 (explaining the process by which either house of Congress can override a DC ordinance by simple majority vote). (**Evangelical might**). See Halberstadt, "Congress Crushes D.C. Rights," 1.

21. (Brinkin's suit). See David Lester, "Man Wants Spouses, Lovers Treated Same," *Sentinel* 9, no. 17 (July 8, 1982), 1. A note on **Brinkin:** In March 2014, Larry Brinkin was sentenced to one year in county jail for possessing child pornography. As part of a plea agreement, the sixty-seven-year-old agreed to serve six months of the sentence in county jail and six months in home detention; he also would have to register as a sex offender for the rest of his life. See Vivian Ho, "S.F. Gay Rights Advocate Sentenced for Child Porn,"

San Francisco Chronicle, Mar. 6, 2014, available at www.sfgate.com/crime/article/S-F-gay-rights-advocate-sentenced-for-child-porn-5292163.php. There's little question that Larry Brinkin deserved to go to jail, but the vile details of *his* crime do not justify erasing key details of *our* history. We don't aim to rehabilitate Brinkin, but only to provide information deemed disposable by mainstream forces. "An invented past," James Baldwin said, "can never be used." Baldwin, "Letter from a Region in My Mind." (**Brinkin lobbies & Feinstein vetoes**). See San Francisco Human Rights Commission, "Two Year Report on the San Francisco Equal Rights Ordinance," Aug. 12, 1999, 4; Cynthia Gorney, "Making It Official: The Law Live-Ins," *Washington Post*, July 5, 1989; Andy Humm and Mitchell Halberstadt, "S.F. Mayor Vetoes Love Relationships," *New York City News* 60 (Dec. 15, 1982), 1. (**Waddell's fight**). See "Olympic Committee Awarded $96,000 in Gay Court Costs," *Connection*, June 13–27, 1984, 8; Drew Blakeman, "Supervisors Blast Walker Nomination," *Bay Area Reporter* 19, no. 26 (June 29, 1989), 3. (**Nasty lawyer**). See Dennis McMillan, "Senate Rejects Walker Nomination; USOC Attorney Named by Wilson Will Not Be U.S. District Judge," *Bay Area Reporter* 18, no. 41 (Oct. 13, 1988), 1; Blakeman, "Supervisors Blast Walker Nomination," 3. (**Proposition 8**). See *Perry v. Schwarzenegger*, 704 F. Supp. 2d 921 (N.D. Cal. 2010). (**Walker**). See Chris Johnson, "Federal Judge Who Struck Down Prop 8 Comes Out: Report," *Washington Blade*, Apr. 6, 2011, available at www.washingtonblade.com/2011/04/06/federal-judge-who-struck-down-prop-8-comes-out.

22. (**ALOEC/"I have no question about who I am"**). Katherine Hall, *A.L.O.E.C. Newsletter* 1, 1983, 25–27. (**East meets West**). Doreena Wong, "Discover a New Direction," *Asian Lesbian Newsletter* 1 (May 1984), 1; see also L. Lai, "Asian Lesbians of the East Coast," *Asian Lesbian Newsletter* 1; C. Sam, "East Meets West," *Phoenix Rising*, no. 8 (Sept.–Oct. 1985), 2. (**BBWN story**). See "Dear Sisters," *Boston Bisexual Women's Network* 1, no. 2 (Nov. 1983), 1. (**Bisexual Center & BiPol**). See, e.g., Megan Morrison, "Bisexuality: Loving Whom We Choose, Part II—WHAT WE ARE DOING," *BBWN*, May–June 1984, 2, 7. (**"empowered themselves"**). C. Sam, "East Meets West," 2; see also Harriet Leve, "Bisexual Center," *New Direction for Women*, Spring 1978, 9; Sylvia Rubin, "How Bisexuals Face a Hostile World," *San Francisco Chronicle* (Sept. 2, 1983), 45.

23. (**Credle speaks**). James Credle, "Police Brutality: The Continual Erosion of Our Most Basic Rights," Brooklyn, NY, Nov. 28, 1983, in Robert B. Ridinger, ed., *Speaking for Our Lives: Historic Speeches and Rhetoric for Gay and Lesbian Rights (1892–2000)* (New York: Routledge, 2012), 423–425. Black and White Men Together (BWMT), Credle explained, "is an interracial gay male, anti-racist organization." (**Blues Bar Generally**). "BLUE'S RAID: Community Gears for Fri., Oct. 15 Demo in Times Sq.; Bar Attacked Again," *New York City News* 56 (Oct. 13, 1982), 1; Andy Humm, "Blues Demo: We Respond," *New York City News* 57 (Oct. 27, 1982), 1.

24. (**HRCF banquet**). Michael Oreskes, "Dinner by Homosexuals Will Aid Political Drives," *New York Times*, Sept. 4, 1982, 25. (**Goodstein & HRCF**). See, e.g., David Goodstein, "Opening Space," *Advocate*, June 10, 1982, 6 ("I want to raise at least $100,000 for HRCF"); David Goodstein, "Opening Space," *Advocate*, Dec. 8, 1983, 6 ("Until and unless you give generously to gay organizations, you're just another useless faggot or dyke."); see generally Gadd, "*The Advocate* and the Making of a Gay Model Minority." (**Mondale**). Andy Humm, "The Men Who Came to Dinner," *New York City News* 56, 4. (**San Francisco 1977**). See "Mondale Shouted Down by Gay Activists," *Redlands Daily Facts*, June 18, 1977, 1; "SF Gays Zap Mondale," *Gaysweek* 20, 2. ("**Moral Majority types**"). Humm, "The Men Who Came to Dinner," 4.

25. (**Dan White released**). See Brian Jones, "White Protests Bigger Than Expected; Anger at Noon, Music in the Evening," *Bay Area Reporter* 14, no. 2 (Jan. 12, 1984), 1, 4; Dion B. Sanders, "SF Protests Mark White's LA Release," *Bay Area Reporter* 14, no. 2, 4. (**rage turned inward/Littlejohn**). See George Mendenhall, "Pride Founder Will Circulate Stop Sex Petition for Ballot," *Bay Area Reporter* 14, no. 13 (Mar. 29, 1984), 1, 3 ("Littlejohn has one public supporter at this time—Leonard Matlovich, who recently formed a Gay right-wing group in Washington, D.C. Matlovich will be in Europe for one month and states that he will return to San Francisco to campaign for the measure."); Allen White, "Milkers Toss-Pot Around Bathhouse Closure," *Bay Area Reporter* 14, no. 13, 3. (**Bath controversy**). See, e.g., Mendenhall, "Close the Baths? Community Voices Respond," *Bay Area Reporter* 14, no. 14 (Apr. 5, 1984); A. White, "Small Turnout to Protest Sex Club Closing," *Bay Area Reporter* 14, no. 14, 5; Paul Lorch, "Viewpoint: Killing the Movement," *Bay Area Reporter* 14, no. 14, 6; B. Jones, "Baths Close, Reopen in Hours; Gay Lawyers, Club Owners Defy City Order; Refrains from Using Medical Quarantine Power; Declares 'Nuisance' Instead," *Bay Area Reporter* 14, no. 41 (Oct. 11, 1984), 1, 2; "Gay Doctors Say Closure 'Not Medically Justified,'" *Bay Area Reporter* 14, no. 41, 4; B. Jones, "Judge Orders Baths to Close; Refuses to Hear Pleas of Civil Rights Groups," *Bay Area Reporter* 14, no. 42 (Oct. 18, 1984), 1; Mendenhall, "300 At Rally to Decry Baths Closure; The Beginning, Not the End Says String of Speakers," *Bay Area Reporter* 14, no. 44 (Nov. 1, 1984), 3–4; see also B. Jones, "Plan to Close 'Baths' Seen as Ineffective; Sex Club Business Down, Safe Sex Popular; Focus on Baths Diverts Attention from Behavior," *Bay Area Reporter* 15, no. 46 (Nov. 14, 1985); "NEW YORK CLOSES ST. MARK'S BATHS," *Update*, Dec. 11, 1985, 1. (**slept with the wrong person**). McKay, "'Patient Zero,'" 174; see also Crimp, "How to Have Promiscuity in an Epidemic," *Melancholia and Moralism*, 47–64.

26. (**"Silence is death"**). Ludwig Frey, *Der Eros und die Kunst* (1896), 317 ("*Die Welt weik von ihm und kann nicht mehr itumm uber dasfelbe hinweggehen. . . . Stillschweigen ist der tod.*") (**Reagan's reelection**). See, e.g., Howell Raines, "Reagan, Taking 49 States and 59% of Vote, Vows to Stress Arms Talks and Economy; Gets 525 Electors," *New York Times*, Nov. 8, 1984. (**independent government analysis**). See, e.g., George Mendenhall, "U.S. Report Blasts Anti-AIDS Effort," *Bay Area Reporter* 15, no. 9, 1, 11–12. (**Sandmire**). See Charles Linebarger, "The Spark Lives at Memorial Vigil; 5,000 March on Memorial Day to Support the Living, Honor the Dead," *Bay Area Reporter* 15, no. 22 (May 30, 1985), 3; see also Gould, *Moving Politics*, 109. ("**confrontational tactics**"). Allen White, "NY to New Orleans Hold AIDS Vigils," *Bay Area Reporter* 15, no. 22, 5. (**Overwhelming number of rainbow flags**). A. White, "Somber to Zany, Thousands Turn Out for Gay Day '85; Rainbows Take Over San Francisco as Gays and Lesbians 'Honor Our Past, Secure Our Future,'" *Bay Area Reporter* 15, no. 27 (July 4, 1985), 11. (**international symbol of Pride**). See, e.g., Heritage of Pride, Gay/Lesbian Pride Day 1986, Registration Materials/Registration Packet ("The rainbow flag was adopted in October as the national [*sic*] symbol of lesbian/gay pride. . . . The flag has been used on the West Coast successfully for several years to denote lesbian/gay-owned businesses and homes."), Lesbian Herstory Archives, Christopher Street Liberation, part 2, folder no. 03300; see also Heritage of Pride, Gay/Lesbian Pride Day 1987, Registration Materials/Information Packet ("The rainbow flag was adopted two years ago by the International Association of Lesbian/Gay Pride Coordinators as the symbol of gay/lesbian pride."), Lesbian Herstory Archives, Gay Pride Celebrations, part 3, folder no. 05540. (**Lorenzini & Thunderhawk**). Stephen Kulieke, "Pressure Put on Feds to Hike AIDS Funds; Native Americans, Gays Protest at SF Fed Bldg," *Bay Area Reporter* 15, no. 37 (Sept. 12, 1985), 1, 2. (**White's suicide & start of PWA vigil**). Ray O'Loughlin, "Dan White Takes His Own Life," *Bay Area Reporter* 15, no. 43 (Oct. 24, 1985); Brian Jones, "Protesters Chain Selves to Fed Bldg.," *Bay Area Reporter* 15, no. 44 (Oct. 31, 1985), 15.

27. (**"Feeling anger"**). See Gould, *Moving Politics*, 91. (**"horrors accumulating all around"**). See Gould, *Moving Politics*, 104–05 (quoting Eric Rofes). (**Bringing names**). See White, "Candlelight March Honors Hundreds," *Bay Area Reporter* 15, no. 49, 1. Of the March's changed format, Milk's longtime partner, Scott Smith, said: "I think Harvey would find it appropriate that we are honoring all of our dead. Remember, before the death of Harvey and Robert Hillsborough, the bodies of people in our community who died were usually silently spirited away to somewhere in Middle America and forgotten." (**Let them die**). Cleve Jones in A. White, "Candlelight March Honors Hundreds," 1. The walk to the Federal Building was a show of solidarity with the group of PWAs who'd chained themselves to the building earlier in the year. See, e.g., A. White, "AIDS Vigil Goes Into Third Week," *Bay Area Reporter* 15, no. 46 (Nov. 14, 1985); see also A. White, "Candle March to Honor AIDS Dead," *Bay Area Reporter* 15, no. 48 (Nov. 28, 1985), 5. (**It looked like a quilt**). See Cleve Jones, *When We Rise: My Life in the Movement* (New York: Hachette Books, 2016), 209.

28. (**GLADL/GLAAD**). See Naphtali Offen, "NYC Paper Stirs Gay Wrath," *Bay Area Reporter* 15, no. 48, 18; see also "Gays Get Tough with New York Post," *Update*, Dec. 11, 1985, 34. GLADL was later forced to change its name to the Gay and Lesbian Alliance Against Defamation (GLAAD). (**Swift & Terrible**). See generally "The Rise of Militant AIDS Activism," handout, ACT UP/New York, Nov. 27, 1989, Lesbian Herstory Archives, Activism, Jan. 1987–Oct. 2, 1998, part 1, folder no. 00140. (**NYC bill passes**). See George Mendenhall, "NYC Passes Gay Bill—Finally; Success After 15 Year Struggle; Religious Leaders Promise Retaliation," *Bay Area Reporter* 15, no. 13 (Mar. 27, 1986), 4; see also David W. Dunlap, "Judge Upsets Koch Order Barring Bias Against Homosexuals in Jobs," *New York Times*, Sept. 6, 1984, A1, B9.

29. (San Francisco AIDS marches/Dan Turner). See, e.g., "AIDS Awareness Week," *Sentinel* 10, no. 10 (May 12, 1983), 12; Linebarger, "The Spark Lives at Memorial Vigil" (1985), 3; Linebarger, "Candlelight March Draws Thousands in Mourning, Anger; Memorial Vigil Lashes Out at LaRouchers," *Bay Area Reporter* 16, no. 22 (May 29, 1986), 2; Charles Linebarger, "Still Fighting For Our Lives; Candle March Draws 5000," *Bay Area Reporter* 17, no. 22 (May 28, 1987), 16. ("we need our rage"). Linebarger, "Candlelight March Draws Thousands in Mourning, Anger," 2. (NYC Pride 1986). See Mitchell Halberstadt and Kathy Tepes, "Pride Marches on as Storm Gathers; Koch's Sidestep to Stonewall," *New York City News* 98 (June 27, 1984), 1 ("CSLDC has been able to defray all costs incurred since April in putting on the actual march, but remains in debt in the wake of an embezzlement scandal which resulted in the ouster of its former co-chair, Anthony Gambino, and several other officers"); J. Robbins, "Are You Happy with GLAAD?" *Womanews* 7, no. 8 (Sept. 1986), 5 ("the sense of collective accomplishment and affirmation was strong.")

30. (Hardwick). See J. Robbins, "Are You Happy with GLAAD?" at 5 ("The Supreme Court's ruling late the next day . . ."); see also *Bowers v. Hardwick*, 778 U.S. 186 (1986). (it was the Court's reasoning). See 778 U.S. at 191–92; see also 778 U.S. at 195–96 (positing a right to privacy for homosexual sodomy would make it impossible to uphold laws against "adultery, incest, and other sexual crimes even though they are committed in the home"); see also J. Robbins, "Are You Happy with GLAAD?" at 5; Gould, *Moving Politics*, 121 ("In the context of ever-increasing AIDS-related deaths, continuing government failure to address the crisis, and increasingly repressive legislation, the *Bowers v. Hardwick* decision was a turning point, an event that profoundly affected the emotional habitus in lesbian and gay communities and the prevailing political horizon.") ("facetious claim"). See Editors, "Crime in the Bedroom," *New York Times*, July 2, 1986, A30; but see 778 U.S. at 196 (Warren, C. J., concurring) ("in constitutional terms, there is no such thing as a fundamental right to commit homosexual sodomy"). ('the right to be let alone'). 778 U.S. at 199 (Blackmun, J., dissenting). (Wojnarowicz). David Wojnarowicz, "Being Queer in America: A Journal of Disintegration," *Close to the Knives*, 80–81. ("not *all* like that"). See generally Feinberg, *Transgender Warriors*; see also Feinberg, "Building Bridges," *TransSisters* 1, 11–12 ("The timid denial from a handful of prominent lesbians and gays that 'We're not all like that,' only serves to weaken the movement. We need to defend the most oppressed segments of the lesbian and gay community from attack—that will enhance our strength.")

31. (It's Hard to Be Angry). See Gould, *Moving Politics*, 91. ("Gratuitous and Petty"). *New York Times* Editors, "Crime in the Bedroom," 26; see also George Mendenhall, "Media Pans Peeping Court," *Bay Area Reporter* 16, no. 28 (July 10, 1986), 3, 10. ("Freedom"). Ray O'Loughlin, "Editorial: A Day of Shame, Part I," *Bay Area Reporter* 16, no. 28, 6. ("Most Apolitical Queers"). David Deitcher in Gould, *Moving Politics*, 123 (and sources cited therein). We note that our use of "most apolitical queers" seems to differ from the phrase's meaning in its original context; Gould quotes David Deitcher as observing that "news of the *Hardwick* decision was enough to awaken the radical in most apolitical queers." In other words, Deitcher was expressing that the *Hardwick* decision enraged *many* apolitical queers, whereas we use the words to reflect that *Hardwick* enraged even those queers who were *extremely* apolitical.

32. ("a prophecy"). John Wetzl, "Into the Bedrooms! Top Court's Decision Bashes Gays," *Sentinel* 14, no. 13 (July 4, 1986), 1, 2, 4. (Boston, Dallas, D.C., etc.). See generally "Sodomites Versus the Supremes," *Gay Community News* 14, no. 1 (July 13–19, 1986), 1, 12; Peg Byron, "Georgia Decision Ignites Demonstrations Nationwide," *Washington Blade* 17, no. 28 (Jul. 11, 1986), 1, 7; Joe Berger, "Onward Sissy Soldiers!" *Weekly World News*, Aug. 12, 1986, 37; "Texas Gays Outraged," *This Week in Texas*, Jul. 11–17, 1986, 12. The Supreme Court granted certiorari in *Bowers* because there appeared to be a "Circuit Split," wherein two federal circuits had different takes on the constitutionality of state sodomy laws. Specifically, federal judges in the 11th Circuit found Georgia's anti-sodomy law unconstitutional, while their counterparts in the 5th Circuit upheld a Texas law. The *Bowers* decision, therefore, was of particular interest in Texas. See *Baker v. Wade* 563 F. Supp. 1121 (N.D. Tex. 1982), *rev'd* 769 F.2d 289 (5th Cir. 1985) (en banc), *cert. denied* 478 U.S. 1022 (1986).

33. ("the most intense mobilization"). J. Robbins, "Are You Happy with GLAAD?" at 5. This particular article caused a great deal of debate within New York's lesbian activist community; or, perhaps more accurately, it reflected an ongoing debate. The author, ostensibly having tried to integrate into the larger gay community as it responded to *Hardwick* and AIDS, found herself victimized by rampant sexism, racism, and classism, concluding that "the final, and most decisive, reason we [lesbians] don't belong in the gay movement is because we don't have the same issues. . . . AIDS hasn't changed my sexual practices or killed my closest friends. Sodomy laws, when they are enforced, are almost always enforced against men. Anti-gay street violence, though it affects us, is predominantly directed at gay men." *Id*. In response, Maxine Wolfe and Joan Nestle penned a letter reiterating calls for a "visible, activist lesbian movement in this city," but *not* for the reasons provided by J. Robbins, "namely, her view that we don't have the same issues as gay men." Do lesbians "have to wait until one of our lesbian sisters dies before AIDS is part of our political agenda?" they asked. "By selecting as criteria for political activity only those issues which have such a seemingly explicit and direct effect on our personal lives, J. Robbins falls into the same line of thinking as the gay male community she criticizes." Elaborating, Wolfe and Nestle articulated what in a few years would be central to queer identity politics: "We, personally, identify as lesbians as much as we do as women. Our experiences working in progressive groups, in general, and in mixed straight/lesbian women's groups has been that when push comes to shove we are 'queer,' . . . and we have not yet figured out how to work, as lesbians on lesbian and gay issues, in a context in which racism, classism, anti-semitism, ableism, ageism and other forms of oppression get addressed as central and not peripheral to one another or to issues of sexuality." Maxine Wolfe and Joan Nestle, "For Lesbian Leadership," *Womanews* 7, no. 9 (Oct. 1986), 2 (emphasis in original). (6th Avenue sit-in). See Jerry Rosco, "Letter from New York," *Bay Area Reporter* 16, no. 29 (July 17, 1986), 11; see also William G. Blair, "Sodomy Ruling Prompts Protest on 4th of July," *New York Times*, July 3, 1986, 14. ("remember Stonewall"). Marty Robinson, "Remember Stonewall," speech given after the Supreme Court decision, *New York Native*, Sept. 1, 1986, reprinted in "The Rise of Militant AIDS Activism." ("Look like Americans"). Marty Robinson in France, *How to Survive a Plague*, 230 (France also puts Michael Callen and Richard Dworkin at the protest). (Inside the park). See Rosco, "Letter from New York," 13; see also Alan Finder, "March by Homosexual Activists to Lower Manhattan Stopped," *New York Times*, July 5, 1986, 9; Richard Goldstein, "Zapping the Fourth," *Village Voice*, July 15, 1986, 15 (Goldstein offers a number of interesting details, including the following: "At Uncle Charley's Downtown (a bar where, legend has it, 'S&M means stand and model'), they played videos of civil rights marches Friday night. No one thought it queer.") ("Nudge the Community"). Marty Robinson in Mitchell Halberstadt, "Bringing Back the Zap," *New York Native* (Nov. 17, 1986), reprinted in "The Rise of Militain AIDS Activism".

34. (O'Connor protest). Charles Linebarger, "Court Protest Takes Anger to the Streets," *Bay Area Reporter* 16, no. 30 (July 24, 1986), 1–2; see also Louis Trager, "Business Cheers While Gays Protest Speech by Justice O'Connor," *San Francisco Examiner*, July 18, 1986, A3. (LaRouche Initiative). See, e.g., Will Snyder, "LaRouche Surprises Demos in Balloting; California Initiative Proposes Quarantine," *Bay Area Reporter* 15, no. 15 (Apr. 10, 1986), 5; Wojnarowicz, "Living Close to the Knives," *Close to the Knives*, 107 ("And you get these self-righteous walking swastikas claiming this is god's punishment . . . and LaRouche in California actually getting a bill up for vote that would isolate people with AIDS in camps and when I react with feelings of murder I feel horrified . . ."); but see Wayne Friday, "Voters Nix LaRouche! '64' Trounced . . . ," *Bay Area Reporter* 16, no. 45 (Nov. 6, 1986), 1. (Burger demonstration). Philip Bockman, "A Fine Day," *New York Native*, Aug. 25, 1986, 12–13; see also Byron, "Georgia Decision Ignites Demonstrations Nationwide," 1, 7. (Feinberg). "Protestors Make Burger Burn While Steak Cools," *Bay Area Reporter* 16, no. 34 (Aug. 21, 1986), 12 (reprint from *Philadelphia Gay News*). The article quotes "Lesley" Feinberg.

35. (Lavender Hill). See generally "The Rise of Militant AIDS Activism." (Citizens for Medical Justice). See Gould, *Moving Politics*, 128; see also "Non-Violence Training Set for May 16," *Bay Area Reporter* 17, no. 19 (May 7, 1987), 23 ("Community interest in the use of non-violent civil disobedience has increased in the past few months. Last September, Citizens for Medical Justice, a group of AIDS activists, blockaded Gov. George Deukmejian's office to protest his inaction on AIDS discrimination legislation. Members of the Lavender Hill Mob in New York City disrupted Wall Street traffic in Wall Street of this year to protest the unavailability of AIDS treatment drugs.") (DAGMAR/C-FAR). William Burks, "Chicago Activists: Life After the Supreme Court CD," *Outlines: The Voice of the Gay and Lesbian Community* 1, no. 35 (Feb. 11, 1988), 16 ("What the acronym DAGMAR stands for varies, depending on who you ask or at what point in their history you asked it.

It's the letter *R* that has been in question. Sometimes it stood for the Right Wing or just the Right, or Reagan, or—more recently—Repression. Most often now, DAGMAR stands for Dykes and Gay Men Against Repression"); see also Gould, *Moving Politics*, 129.

36. ("Security closes in"). Marty Robinson, "The Lavender Hill Mob Zaps the Cardinal," *New York Native*, Nov. 17, 1986, reprinted in "The Rise of Militant AIDS Activism." (**Vatican condemnation**). See Ray O'Loughlin, "Pope to Gays: 'Drop Dead,'" *Bay Area Reporter* 16, no. 45, 1, 14. (**St. Patrick's zap**). Mitchell Halberstadt, "Bringing Back the Zap; The Lavender Hill Mob is Reviving Early Gay Liberation Activist Tactics," *New York Native*, Nov. 17, 1986. (**point facing up**). Like so much of queer history, the story of the pink triangle, and specifically its reclamation, is muddled due to a combination of a lack of access to history, apathy, and lore. As discussed elsewhere in this book, the Holocaust-era pink triangle (the apex [or top point] of which points down) had been reclaimed by queer activists in the mid-1970s as a symbol of resistance. The SILENCE=DEATH triangle (which appears "upright"), however, did not appear until 1986, when the SILENCE=DEATH Project—six gay men who'd been meeting for over a year before ACT UP started—blanketed New York City with their design. According to one account, the members of SILENCE=DEATH—Avram Finkelstein, Brian Howard, Oliver Johnston, Charles Kreloff, Chris Lione, and Jorge Socarrás—"were men who needed to talk to each other and others about what the fuck they were going to do, being gay men in the age of AIDS. Several of them were designers of various sorts—graphic designers—and they ended up deciding that they had to start doing wheat-pasting on the streets, to get the message out." It is often said that the redesign of the triangle—specifically, with the apex pointing up—was "a conscious attempt to transform a symbol of humiliation into one of solidarity and resistance"; that's not entirely true. "When we went into production," Finkelstein told Theodore Kerr in 2017, "Oliver [Johnston] said he would do the research [on the direction of the triangle], but he didn't." So, Kerr explains, it was "only after the poster was done, when Finkelstein approached businesses to hang it in their windows, were they told by some, including [Craig Rodwell's] Oscar Wilde bookshop, that they wouldn't participate because of the misdirection of the triangle. Sensing an opportunity, [Charles] Kreloff suggested that they own the flip and tell people it was a reclamation of past violence—much like the vogue for the word 'queer' that was soon to come." Theodore Kerr, "How Six NYC Activists Changed History With 'Silence=Death,'" *Village Voice* (online), June 20, 2017, available at www.villagevoice.com/2017/06/20/how-six-nyc-activists-changed-history-with-silence-death. Later, SILENCE=DEATH gave the design to ACT UP, the organization with which the triangle most often is identified. A number of the SILENCE=DEATH Project's members were also involved with other seminal groups, including ACT UP, Gran Fury, Queer Nation, and Homocore. See www.actupny.org/reports/silencedeath.html. Finkelstein's incredible oral history interviews provide an essential overview of the Project. See oral history interview with Avram Finkelstein, Archives of American Art; see also France, *How to Survive a Plague*, 243–44.

37. (**Matlovich**). See "Opinion: Never Forget," *Bay Area Reporter* 17, no. 4 (Jan. 22, 1987), 6; see also Leonard Matlovich, "Monumental Dreams: Remembering Our Lesbian and Gay Heroes," *Advocate*, June 23, 1987, 9. A note on **Matlovich**: Although Leonard Matlovich tends to be credited with coining the phrase famously etched on his headstone—*When I Was In The Military They Gave Me A Medal For Killing Two Men And A Discharge For Loving One*—the quote already had appeared well before Matlovich's brave rise to prominence. In June 1971, for example, *The Gay Blade* in D.C.—which was then just a two-page newsletter—included the blurb "Graffito in the men's room of a restaurant in San Francisco: 'The Government gave me a medal for killing many men, and a dishonorable discharge for loving one.' THINK ABOUT IT. . . ." *Gay Blade* 2, no. 9 (June 1970), 2. Based on our research, and we emphasize that we have no way of confirming our suspicions, we assume Matlovich learned the phrase from Frank Kameny. In fact, we wouldn't be surprised if Kameny actually coined the phrase from scratch, presenting it for publication in *The Gay Blade* with a story about San Francisco as cover.

38. (**CDC conference**). Lawrence K. Altman, "Mandatory Tests for AIDS Opposed at Health Parley," *New York Times*, Feb. 25, 1987, A1, 18; see also "My Friends Do The Coolest Shit, Episode 1: Michael Petrelis," March 2018, available at www.youtube.com/watch?v=Fs-Cz6VrxK4. (**The Mob zaps the CDC**). "The Lavender Hill Mob Calls the CDC Conference in Atlanta a Hoax!" *Lavender Hill News*, no. 2 (Apr. 1987); see also Philip M. Boffey, "Homosexuals

Applaud Rejection of Mandatory Tests for AIDS," *New York Times*, Feb. 26, 1987, B07. (**Dowdle & Vaid**). Boffey, "Homosexuals Applaud Rejection of Mandatory Tests for AIDS," B07. (**"No One Liked the Lavender Hill Mob"**). Michael Petrelis in "My Friends Do the Coolest Shit", Ep. 1.

39. (**Kramer's visit to Houston**). Kramer, "The Beginning of ACTing Up," speech given at the Gay and Lesbian Community Center [*sic*], New York City, Mar. 10, 1987, *Reports from the Holocaust*, 136. (**Kramer & the Mob**). "My Friends Do The Coolest Shit." (**The speech**). Kramer, "The Beginning of ACTing Up," *Reports from the Holocaust*, 127–36.

40. ("gay grapevine"). Kramer, "The Beginning of ACTing Up," *Reports from the Holocaust*, 137. (**first meeting**). Minutes, AIDS Coalition, Mar. 12, 1987, ACT UP, Series II: 3/1, NYPL. (**scouted logistics**). See Mike Salinas, "Kramer, Mob, Others Call for Traffic Blockade; More Than One Kind of Fury on Wall Street," *New York Native* 206, (Mar. 30, 1987). (**ACT UP**). Minutes, AIDS Coalition to Unleash Power (A.C.T. U.P.), Mar. 19, 1987, ACT UP, Series II: 3/1, NYPL. (**the name**). Avram Finkelstein remembers that Steve Bohrer raised his hand at the second official meeting and said, "'I always had this idea it would be great to form a group called ACT UP, and it would be the AIDS Coalition to—and I don't know what the UP would stand for, but it would be a great name,' and then people started tossing around ideas and that's how Unleash Power came about, but it was basically Steve Bohrer who named it." Oral history interview with Avram Finkelstein, Archives of American Art. (**ACT UP takes Wall Street**). See, e.g., Brian Jones, "Gay Protest Hits Wall St. Demands OK of AIDS Drugs," *Bay Area Reporter* 17, no. 13 (Mar. 26, 1987), 3 (". . . organized by a militant gay group called the 'Lavender Hill Mob'"); see also "Non-Violence Training Set for May 16," *Bay Area Reporter* 17, no. 19, 23.

41. ("hasty step"). "Forced AIDS Tests. Then What?" *New York Times*, June 7, 1987, 28E. (**Boos**). Kramer, *Reports from the Holocaust*, 160 ("[Reagan] is not accustomed to being booed in public and he was mad."); see also Charles Linebarger, "64 Arrested in White House Sit-In; Reagan Calls for Testing; Health Officers Rap Plan," *Bay Area Reporter* 17, no. 23 (June 4, 1987), 1. (**White House Protest**). See Linebarger, "64 Arrested in White House Sit-In," 1. Despite a specific arrangement with organizers, D.C. police wore yellow latex gloves (ostensibly in order to avoid the transmission of HIV) as they moved in to make arrests. See Lisa M. Keen, "D.C. Police Gloves Cancel Planned Reconciliation," *Washington Blade* 18, no. 23 (June 5, 1987), 1. ("the entire gay leadership"). See Linebarger, "64 Arrested in White House Sit-In," 1.

42. (**CMJ & AZT**). See Linebarger, "Lots of Red Tape but No Arrests in S.F. Sit-In," *Bay Area Reporter* 17, no. 23, 13; Linebarger, "CMJ Zaps Drug Maker for AIDS Profiteering; 7 Arrested in Burlingame Protest," *Bay Area Reporter* 17, no. 23, 14; see also Kramer, "The F.D.A.'s Callous Response to AIDS," *New York Times*, Mar. 23, 1987, A19; Lineberger, "FDA Approval of AZT Brings New Worries," *Bay Area Reporter* 17, no. 13, 3. (**Freedom Day 1987**). See Linebarger, "1987 Parade: A Mixed Bag," *Bay Area Reporter* 17, no. 27 (Jul. 2, 1987), 14. (**Waddell**). See Allen White, "AIDS Claims Olympian Waddell; Gay Games Organizer Honored by City," *Bay Area Reporter* 17, no. 29 (Jul. 18, 1987), 1, 23.

43. (**old guard & new wave**). See generally Minutes, Mar.–May, 1987, ACT UP, Series II: 3/1-3, NYPL; see also France, *How to Survive a Plague*, 237. (giving the **power**). See "My Friends Do The Coolest Shit." ("**you could do it**"). Maxine Wolfe, ACT UP Oral History Project, 41. "This Is about People Dying: The Tactics of Early ACT UP and Lesbian Avengers in New York City (excerpt); based upon interviews with Maxine Wolfe by Laraine Sommella," *Queers in Space: Communities, Public Places, Sites of Resistance*, Gordon Brent Ingram, Anne-Marie Bouthillete, and Yolanda Retter, eds. (Seattle: Bay Press, 1997), available at www.actupny.org/documents/earlytactics .html. (**Iris Long, PhD**). See France, *How to Survive a Plague*, 277–78. (**very real threat of quarantine**). See, e.g., "Forced AIDS Tests. Then What?" at 28E ("If there were an effective way to rid the body of the AIDS virus, widespread testing should begin immediately. . . . There is an inevitable outcome to the logic of those who advocate the dragnet testing of low-risk groups: quarantine. The idea is that society, facing a millennial plague, must be prepared to take unflinching measures. Once all carriers are identified, they will somehow have to be put in detention. That's a shocking idea but it's not foolish. . . . Detention camps across the country would be a shrieking departure from American tradition; all the more reason for the subject to be openly discussed. . . . Using voluntary testing, public health officials have an approach that is effective and humane. Mandatory testing, a hasty

step toward detention camps, would be neither."); see also William F. Buckley, Jr., "Identify All the Carriers," *New York Times*, Mar. 18, 1986, A27. ("concentration camp float"). "This Is about People Dying," *Queers in Space*.

44. (Lesbian leaders). See J. Robbins, "Are You Happy with GLAAD?" at 5; Maxine Wolfe and Joan Nestle, "For Lesbian Leadership," 2. ("We should remember these things"). Ortez Alderson, "The 'Disease' Fights Back," *Gay Flames*, no. 6 (Oct. 24, 1970), 1. (Ortez in Gay Lib & Kentucky). Ortez Alderson also helped establish Chicago's first transgender liberation group, Transvestites Legal Committee. See "Transvestite Beaten," "Black Caucus Meetings," and "Ortez Out on Bail," *Chicago Gay Liberation* 8, (Sept. 1970); see also Stewart-Winter, *Queer Clout*, 90; "On Being Black, Gay, and in Prison: 'There is no humanity,' An interview with Ortez Alderson," *Motive* 23, no. 2 (1972), 26–27; see also Alderson, "The 'Disease' Fights Back," 1. (Ortez in New York). See, e.g., Craig G. Harris, "The NCBLG Family Gathers," *Black/ Out* 1, no. 1 (Summer 1986), 11. Over Thanksgiving weekend 1985, the National Coalition of Black Lesbians & Gays held a remarkable conference in St. Louis. In a joyous article, Craig Harris describes the reunion of generations of Black queer trailblazers: Joseph Beam, Gwendolyn Rogers, Barbara Smith, Mabel Hampton (to whom a Lifetime Achievement Award was given), Pat Parker, Essex Hemphill, Jewelle Gomez, Assotto Saint, Gwen Avery, Blackberri, and Ortez Alderson. (From the minute). See generally Minutes, Aug. 1987, ACT UP, Series II: 3/5, NYPL. ("all the time"). Robert Vazquez-Pacheco (interview by Sarah Schulman), ACT UP Oral History Project, Dec. 14, 2002, 13. (Housing Works). See, e.g., Kendall Thomas (interview by Sarah Schulman), ACT UP Oral History Project, May 3, 2003, 18. ("the most militant queen"). Kendall Thomas, ACT UP Oral History Project, 16; see also "Nation & World," *Update*, Dec. 14, 1988, 2 ("'You are a liar, a fraud and a self-promoting demagogue and this meeting is over!' said New York health commissioner Stephen C. Joseph, stomping out of the room. He was responding to ACT UP member Ortez Alderson, who had asked if it wasn't 'the essence of corruption' for Joseph's department to accept a $500,000 CDC grant to investigate under-reporting of AIDS data by Joseph's own department."); "Milestones: Ortez Alderson," *OutWeek* 29 (Jan. 14, 1990), 34. ("After we kick"). Vito Russo in Rex Wockner, "1,500 Besiege FDA Headquarters in Maryland; 200 arrested in Civil disobedience," *Bay Area Reporter* 18, No. 42 (October 1988), 130.

45. ("Gays have nothing to lose"). National March on Washington for Lesbian and Gay Rights, Press Advisory, "Hundreds to Non-Violently Protest at Supreme Court for Lesbian and Gay Rights," Oct. 5, 1987, Lesbian Herstory Archives: Subject Files: part 4: International Women's Day-Peace Camps, folder no. 09570. (The Ashworths). Dick Ashworth spoke at the 1979 March on Washington, "call[ing] upon the silent millions of parents of lesbians and gays to come out of the closet and join us in supporting our children." Dick Ashworth, Address to National March on Washington for Lesbian and Gay Rights, Oct. 14, 1979 (transcribed by authors); see also "Grief is Transformed in a Tapestry of Love," *Bay Area Reporter* 17, no. 42 (Oct. 15, 1987), 14. Eric Ashworth, Tucker's brother, died from AIDS-related illness in July 1997. See "Eric Ashworth, 39, A Literary Agent," obituary, *New York Times*, Jul. 24, 1997. (Leading the march). See Mary Richards, "For Love and for Life, We're Not Going Back! 500,000 March on Washington," *Bay Area Reporter* 17, no. 42, 15.

46. (Milk memorial). From leonardmatlovich.com: "Although Milk was cremated and his ashes scattered in the Pacific Ocean, Scott Smith, his former partner and heir, gave Leonard a few mementos including a lock of Milk's hair, an audio cassette, 'Harvey Milk speech in Dallas June 10, 1978,' a letter from Milk to Smith, a sheet of his supervisorial letterhead, and a photo negative of him. Smith still had the box which had held his ashes, and a small rainbow flag was wiped across its interior which Leonard then folded into a triangle and secured with a 'Harvey Milk for Supervisor' campaign button. . . . All were placed in a small wooden urn which sat on top of a rainbow flag during the dedication ceremony, and decorated with flowers by attendees. The plan was for the urn to be eventually interred beneath a monument for which a design competition and fundraising campaign were started. . . . Sadly, after Leonard's own passing eight months later no one with national prominence sufficient to complete the project came forward, and . . . it was eventually abandoned." Reproduced at www.youtube .com/watch?v=k9BdrfFV22c. (Matlovich at Congressional Cemetery). See Richards, "For Love and for Life, We're Not Going Back!" at 16; Mike Hippler, "An (A.C.)-D.C. Journal," *Bay Area Reporter* 17, no. 42, 17; see also "1987 Harvey Milk Memorial Dedication—Leonard Matlovich," clip, 1987, available at www.youtube.com/watch?v=k9BdrfFV22c.

47. (Supreme Court Siege). See Mike Hippler and Mary Richards, "5,000 Protest, 840 Arrested at Supreme Court," *Bay Area Reporter* 17, no. 42, 1, 20 (". . . the marathon civil disobedience, lasting more than seven hours as wave after wave of protesters crossed the barricades, occurred without violence. In fact, the protest had a distinctly gay flavor."); Mike Hippler, "Go to Jail; An Arresting Experience; A Capitol Crime," *Bay Area Reporter* 17, no. 43 (Oct. 12, 1987), 1. (ACT UP in D.C.). See, e.g., Minutes, Aug. 24, 1987, ACT UP, Series II: 3/5, NYPL ("ACT UP/March on Washington Subcommittee on Supreme Court C.D.: there will be a training for C.D. trainers on Sunday, 8/30").

48. (Quilt returns to D.C.). See Allen White, "Smithsonian to Display Part of Names Quilt; 150,000 Visit Quilt in Capital; 40,000 Join in Candlelight March," *Bay Area Reporter* 18, no. 41 (Oct. 13, 1988), 1. (Matlovich). See Mike Hippler, "An American Hero: Leonard Matlovich Dies in West Hollywood," *Bay Area Reporter* 18, no. 26 (June 30, 1988), 1, 19. ("jet-sets . . . spreading the AIDS virus"). Paul Reed, "Shilts' Book Shows Politicization of AIDS; *And The Band Played On: Politics, People, and the AIDS Epidemic*," *Bay Area Reporter* 17, no. 41 (Oct. 9, 1987), 29. (The impact of Patient Zero). Just as *And the Band Played On* hit stores, the gay press uncovered internal Republican Party memos specifically crafting a campaign to "incite a public groundswell" against Democratic candidates perceived as soft on AIDS. With increased calls for the criminalization of the spread of HIV/AIDS, Patient Zero provided ample fuel for the fire. See Jay Newquist, "Making Hay from AIDS; Republicans Plan a Scare Campaign; Memos Reveal Strategy for '88," *Bay Area Reporter* 17, no. 41, 14; see also McKay, "'Patient Zero,'" 185–91 ("*And the Band Played On* was published in a year that proved to be pivotal in the emergence of a discourse advocating for the use of criminal law to address HIV transmission.") (may be reason enough). Crimp, "How to Have Promiscuity in an Epidemic," *Melancholia and Moralism*, 46; see also McKay, "'Patient Zero,'" 161–94. A word on Shilts: Randy Shilts was a trailblazing queer journalist whose work was of monumental significance on a number of levels, *many* of which were personal (and, of course, the personal is political). His was a well-regarded voice and his story was one of "gay success" in the "straight world." Shilts deserves a great deal of respect and credit as a person, an activist, a journalist, a writer, and one of the hundreds of thousands murdered by the government inaction he helped uncover; he does not, however, deserve the canonization of a community (nor does anyone). It's well past time that Gaétan Dugas's name be cleared, not just because he was a human being who did nothing wrong but because the warped telling of his story continues to harm those impacted by HIV/AIDS. One of the two quilt panels we've seen honoring Gaétan says it all: "Tell my story, clear my name, why do they need someone to blame?"

49. (ACT UP spreads). See, e.g., Terry Boughner, "Act-Up Has 100 Chapters; Uses Slogan 'Silence=Death,'" *Wisconsin Light* 1, no. 10 (Aug. 12–Sep. 8, 1988), 12. (ACT UP/FDA action). Wockner, "1,500 Besiege FDA Headquarters, 12–13; see also France, *How to Survive a Plague*, 237–30. (FDA announcement). See Miranda Kolbe, "FDA Changes Rules for Drug Approval; AIDS Activists Critical, Call Move 'A Media Event' for Bush Campaign," *Bay Area Reporter* 18, no. 43 (Oct. 27, 1988), 19.

50. (CMJ/Terry Sutton). See Dennis McMillian, "Sit-In Protests Exclusion from CMV Drug Trial; Group Takes Over SFGH Pharmacy Demanding Foscarnet; Experimental Drug May Prevent AIDS Blindness," *Bay Area Reporter* 19, no. 3 (Jan. 19, 1989), 1–2. (Golden Gate Bridge). Allen White, "Protest Brings Gate Bridge to Standstill; To 'Wake People Up' to AIDS; CHP Arrests 28 Protesters," *Bay Area Reporter* 19, no. 5 (Feb. 2, 1989), 1–2. (Chicago). See Rex Wockner, "Two Arrested in Pink Triangle Protest," *Bay Area Reporter* 19, no. 10 (Mar. 9, 1989), 4. (ACT UP anniversary). Rex Wockner, "190 Arrested in NYC AIDS Protest," *Bay Area Reporter* 19, no. 14 (Apr. 6, 1989), 17. (South Carolina). See Matt Moline, "41 Arrested in Protest of S.C. Law," *Bay Area Reporter* 19, no. 17 (Apr. 27, 1989), 19.

51. (Mourning Sutton). See Dennis McMillan, "ACT UP Marches for Sutton, Blasts FDA, Drug Manufacturer," *Bay Area Reporter* 19, no. 17, 5; see also Gerard Koskovich, "Remembering a Police Riot: The Castro Sweep of October 6, 1989," in Winston Leyland, ed., *Out in the Castro: Desire, Promise, Activism* (San Francisco: Leyland Publications, 2002), 189–98. ("Be well everyone"). Terry Sutton in Carolyn Helmke, "Remembering Terry Sutton; AIDS Activist Dies at 33," *Gay Community News* 16, no. 42 (May 14–20, 1989), 3.

52. (Harrington & Callen). France, *How to Survive a Plague*, 308. ("a full reconsideration"). France, *How to Survive a Plague*, 368; see also Jennie McKnight, "AIDS Activists Seize Stage in Montreal; Five Days of Spotlighting the Needs of People Living with HIV Culminate in a Push for the 'Montreal

Manifesto,'" *Gay Community News* 16, no. 46 (June 11–17, 1989), 1, 13. (**Harrington, Montreal, Denver**). See Mark Harrington, interview by Sarah Schulman, ACT UP Oral History Project, Mar. 8, 2003, 12, 18, 42–43 ("I always thought that the Denver Principles which had been put out in 1983 were—they were about empowering people with AIDS by putting them into positions of power in every institution that had any kind of choice or power over people with AIDS's life.") (**foot in the federal door**). See generally France, *How to Survive a Plague*, 369–74. ("**Activism is the intervention**"). Mark Harrington, "Political Science: Treatment Decisions," *OutWeek* 1 (June 26, 1989), 33. (**caused strife**). See France, *How to Survive a Plague*, 373–74. ("**revolutionaries**" & "**reformists**"). Gerard Koskovich in Rachel Pepper, "Schism Slices ACT UP in Two; San Francisco Chapter Splits in Debate over Focus," *OutWeek* 67 (Oct. 10, 1990), 13.

53. (Stonewall reunion). All quotes from transcript in Michael Scherker, "Stonewall Reunion: Voices from the Nights of Rage," *Gay Community News* 16, no. 48 (June 25–30, 1989). Scherker's piece also included quotes from Philip Eagles and Jim Fouratt, who were on the panel, and Craig Rodwell, who apparently wasn't. (**Stonewall's real meaning**). Vivian Carlo, "Racism and Remembering," Gay Community News 16, no. 46 (June 11–17, 1989), 14.

54. ("details of the riot"). There were some who pushed back on the "Stonewall-as-origin" narrative. See, e.g., Allen White, "300,000 Join in Parade," *Bay Area Reporter* 19, no. 26, 1 ("Leading the [Freedom Day] Parade were three grand marshals representing San Francisco's early gay-rights movement, which pre-dates Stonewall"; the grand marshals were José Sarria, Del Martin, and Phyllis Lyon); Michael Bronski, "They lost that wounded look that fags all had ten years ago; Stonewall: myth and reality," and Joan Nestle, "Those who were ridiculed the most risked the most," *Gay Community News* 16, no. 46, 14, 15; Nestle, "Many Days of Courage" *OutWeek* (text of speech delivered at the Celebration 20! Pride rally on June 24, 1989), 3 (July 10, 1989) 28; Harry Hay, "Remarks on the Stonewall Rebellion's 20th Anniversary" (*Gay Community News* 17, no. 5 (Aug. 6–12, 1989); text of speech delivered at the Celebration 20! Pride rally on June 24, 1989), 5; James Waller, "It's A Wonderful Strife: The Story of Stonewall," *OutWeek* 1, 74. ("**Who were they?**"). Colin Robinson, "Imagining Stonewall at Age 27," *Gay Community News* 16, no. 46, 17. ("**If she hadn't been there**"). Waller, "It's A Wonderful Strife," 74. (**Duberman's "real differences"**). Martin Duberman, "Duberman Addresses Stonewall Dedication," *OutWeek* 1, 20. Despite his words at the 1989 commemoration of Stonewall, Martin Duberman had fully immersed himself in the downplaying of real differences by 1994, telling *The Advocate* (naturally) that he worried that "Stonewall 25 was so fractionalized that we are overlooking our commonalities." Then he doubled down: "For too long the gay movement was dominated by square white men who wanted to shut drag queens out. All the talk about drag queens at Stonewall righted this injustice, but now I think it's gone a bit too far. The Stonewall was my bar of choice, and I'm certainly not a drag queen, hustler, or drug dealer. There was a wonderful mix of people there, and using what went on there for your own partisan agenda is bad politics and bad history." Duberman, a white gay man, apparently felt "all the talk" about *other* types of gays had "gone a bit too far." Bull, "Stonewall 25," 19. (**Rice on Judy Garland**). Randy Rice, "A Sense of What It Was Like," *Gay Community News* 16, no. 46, 17. (**It wasn't about Judy**). See, e.g., Sylvia Rivera, "Bitch on Wheels" (June 2001), *Survival, Revolt, and Queer Antagonist Struggle*, 32 ("Some people say that the riots started because of Judy Garland's death. That's a myth."); Mark Segal, *And Then I Danced*, 35 ("The biggest fallacy of Stonewall is when people say, 'Of course they were upset, Judy Garland was being buried that day.' That trivializes what happened and our years of oppression, and is just culturally wrong. Many of us in Stonewall who stayed on Christopher Street and didn't run from the riot that day were people my age. Judy Garland was from the past generation, an old star. . . . The riot was about the police doing what they constantly did: indiscriminately harassing us."); Carter, *Stonewall*, 259–61 (providing a comprehensive overview of evidence *against* the theory that Garland's funeral fueled the Stonewall rioters; among other things, Carter notes that "[n]o eyewitness account of the riots written at the time by an identifiably gay person mentions Judy Garland, [and the] only account written in 1969 that suggests that Garland's death contributed to the riots is by a heterosexual who sarcastically proposes the idea to ridicule gay people and the riots.") ("**everyone has a different story**"). Maria Maggenti, "Wall of Stone? A Girl's Guide to Stonewall," *OutWeek* 1, 41. ("**on the fringes**"). Mab Segrest, "A Riot is a Radical Thing," and Martin Hiraga, "Angry Rather Than Proud," *Gay Community News* 16, no. 46, 21. ("**ridiculed the most**"). Nestle, "Those who were ridiculed the most risked the most," 15. ("**the Stonewall**

vision"). Mickey Wheatley, "Creating a Strong and United Lesbian and Gay Liberation Movement," *Gay Community News* 16, no. 41 (May 7–13, 1989), 5; Hiraga, "Angry Rather Than Proud," 21. ("**some sense of promise**"). Maggenti, "Wall of Stone? A Girl's Guide to Stonewall," 41. ("**It will happen again**"). Mama Jean Devente in Scherker, "Stonewall Reunion," 8–9.

55. ("unorganized rabble"). Jennie McKnight, "Radical Stonewall commemoration planned," *Gay Community News* 16, no. 40 (Apr. 30–May 6, 1989), 2. (**the mood changed**). Andrew Miller, "Riot Erupts at Stonewall Faerie Gathering; Re-enactment Turns Real After Motorists Ram Crowd," *OutWeek* 3, 8. (**A reenactment of a riot turned into a riot**). Miller, "Riot Erupts at Stonewall Faerie Gathering," 8; see also Brian Jones, "Protest Erupts at N.Y. Commemoration; Theater Evokes Reality on Streets of Greenwich Village," *Bay Area Reporter* 19, no. 26, 14; McKnight, "Radical Stonewall Commemoration Planned," 2.

56. (100,000th). See, e.g., "Outspoken: Do the Right Thing," *OutWeek* 8 (Aug. 14, 1989), 4. As discussed below, this number was woefully inaccurate, due both to inevitable human error and avoidable failures by the government to expand the clinical definition of HIV/AIDS. According to a 1995 CDC report, the number of cases diagnosed in the United States by July 1, 1989 was actually 125,763. See Centers for Disease Control and Prevention, *HIV/AIDS Surveillance Report* 7, no. 2 (1995), available at www.cdc.gov/hiv/pdf/library/reports/surveillance/cdc-hiv-surveillance-report-1995-vol-7-2.pdf. (**It is hard to feel good**). Larry Kramer, "100,000 And Counting," *OutWeek* 8, 39.

57. ("good friends"). Allan R. Gold, "Provincetown Journal; Summer of Tension in a Haven of Civility," *New York Times*, Sept. 13, 1989, A14. (**P-Town Pride**). Andrew Miller, "P-Town in Furor Over Pride March; Shooting of PWA Ignored in Clamor Over Sign," *OutWeek* 8, 10; Leigh Peake, "'Vulgar' Sign at Pride Splits Provincetown," *Gay Community News* 17, no. 5; Susan Lumenello, "P'town Pride March Marred by Discord," *Bay Windows*, Aug. 3, 1989; Jeff Fennelly, "Provincetown Journal: Home Is Anywhere They Bash Your Pride," *OutWeek* 8; Sharon Wilkey, "Hundreds March in Provincetown for Gay Pride," *Cape Cod Times*, July 24, 1989, 1.

58. (Wigstock bashing). See Gabriel Rotello, "Gay Bashing Mars Wigstock Festival," *OutWeek* 13 (Sept. 18, 1989), 12–13. "Adding insult to injury," Rotello reported, when ACT UP member David Robinson accompanied his boyfriend, who'd been attacked, to the emergency room, staff at St. Vincent's Hospital ridiculed his appearance and called him "faggot." ("**angry mobs chasing down Fag-bashers**"). Sandor Katz, "Queers Fighting Back," *OutWeek* 14 (Sept. 25, 1989), 31, 56. ("**We did *not* create the situation**"). David Robinson, "Bash Rehash," *OutWeek* 16 (Oct. 8, 1989), 8.

59. (The Castro Sweep). Koskovich, "Remembering a Police Riot," in Leyland, *Out in the Castro*, 189–90. (**the cops hadn't forgotten**). Gerard Koskovich's investigation of the Castro Sweep revealed quite plainly that "revenge might indeed have been one element in the Castro Sweep." See Koskovich, "Remembering a Police Riot," in Leyland, *Out in the Castro*, 196.

60. (Humane Housing Now zap). T. L. Litt (photo) and Andrew Miller, *OutWeek* 13, 27. (**Stock Exchange**). Michelangelo Signorile, "AIDS Activists Storm Stock Exchange, Halting Trading," *OutWeek* 14, 10; France, *How to Survive a Plague*, 381–82. (**Trump Tower**). Ben Currie, "Police Violence at Trump Tower; 6 Arrests at ACT UP Homelessness Demo," *OutWeek* 21 (Nov. 12, 1989), 22–23. (**White House**). Cliff O'Neill, John Zeh, and Andrew Miller, "AIDS Service Chiefs Arrested at White House," *OutWeek* 26 (Dec. 17, 1989), 12–13. (**AZT price**). See Andrew Miller, "Burroughs Cuts AZT Price 20 Percent," *OutWeek* 15 (Oct. 1, 1989), 12. (**Fauci in NYC**). Jon Nalley, "NIAID's Fauci Attends ACT UP Forum," *OutWeek* 20 (Nov. 5, 1989), 29. ("**parallel track**"). Cliff O'Neill, "FDA Releases AIDS Drug on Parallel Track; Move Follows Intensive Pressure from Activists," *OutWeek* 17 (Oct. 15, 1989), 14; see also France, *How to Survive a Plague*, 305, 371–74. (**women with AIDS**). See, e.g., Nalley, "NIAID's Fauci Attends ACT UP Forum," 29; Mark Harrington, ACT UP Oral History Project, 12, 18, 46–47 ("There was a lot of legitimate anger at NIH at that time about not dealing well with women with AIDS.") (**people of color**). Minutes, Jan. 15, 1990, ACT UP/NY, Series II: 4/8, NYPL (Majority Action Committee members' attempt to lead discussion on cultural sensitivity meets significant pushback).

61. (Operation Rescue). See William M. Reilly, "Cardinal Would Like to Get Arrested over Abortion," *UPI*, Oct. 2, 1989; Nadine Brozan, "O'Connor Proposes Order of Nuns to Fight Abortion and Euthanasia," *New York Times*, Nov. 4, 1989, 31. (**adamantly condemned safe-sex**). See "Bishops: Don't Condone Condoms," *Newsday*, Oct. 16, 1989, 15; Peter Steinfels, "Bishops

Intensify Fight on Abortion," *New York Times*, Nov. 7, 1989, A16; Peter Steinfels, "Bishops Warn Politicians on Abortion," *New York Times*, Nov. 8, 1989, A18; see also Anthony M. Petro, "Protest Religion!: ACT UP, Religious Freedom, and the Ethics of Sex," in *After the Wrath of God: AIDS, Sexuality, & American Religion* (Oxford, UK: Oxford Univ. Press, 2015); Victor Mendolia, interview by Sarah Schulman, ACT UP Oral History Project, Aug. 15, 2008, 16–24. **(December debates)**. Minutes, Dec. 11 & 18, 1989, ACT UP/NY, Series II: 4/7, NYPL. These are direct quotes, unless otherwise noted. **(Stop the Church)**. See Jason DeParle, "111 Held in St. Patrick's AIDS Protest," *New York Times*, Dec. 11, 1989, B3; Linda Stevens, "Protests," *New York Post*, Dec. 11, 1989, 2; Ray Kerrison, Editorial, *New York Post*, Dec. 11, 1989, 2 (Kerrison, a well-known homophobe, took the pity approach: "Disruption of a religious service is a violation of the law, but beyond that there was something unspeakably sad and tragic about what happened yesterday. The homosexual community has been mortally wounded by the AIDS epidemic. It is bewildered, confused, angry, frustrated. Most of all, it is hurting profoundly, so it lashes out blindly. To assign blame to Cardinal O'Connor for their plight is just plain witless."); "Sacrilege at St. Pat's," *New York Post*, Dec. 12, 1989, 26; "Civil disobedience vs. Uncivilized Behavior," *Daily News*, Dec. 12, 1989, 28; Maralyn Matlick, "Backlash-Wary Gays Rip Protest at St. Pat's," *New York Post*, Dec. 13, 1989; "No Apology for St. Pat's Protest," *New York Post*, Dec. 14, 1989; Rex Wockner, "ACT UP Stops Mass at NY Cathedral," *Bay Area Reporter* 19, no. 50 (Dec. 14, 1989), 3; "Over Whose Dead Bodies?" *OutWeek* 27 (Dec. 24, 1989), 4; Andrew Miller and Rex Wockner, "AIDS/Abortion Rights Demo Halts High Mass at St. Pat's; "Condemnations, Controversy Sweep Through Community," *OutWeek* 27, 12–16; see also France, *How to Survive a Plague*, 391-94. **("shit hit the fan")**. Kramer, "Toward a Definition of Evil: Further Reports," *Reports from the Holocaust*, 291. **(Distracting Tactics)**. See, e.g., "Gay Men's Health Crisis Statement on Action at St. Patrick's Cathedral," Dec. 13, 1989, ACT UP, Series IV: 15/1, NYPL ("We are in complete sympathy with the rage and pain that motivated the protesters, and feel that the need for direct action has never been more urgent than now. . . . However, the action shifted public attention from the real issues raised by Cardinal O'Connor's damaging positions and actions on AIDS. For that reason alone, we feel that the action by ACT UP and WHAM inside St. Patrick's Cathedral was a mistake.") **(painfully submissive)**. Matlick, "Backlash-Wary Gays Rip Protest at St. Pat's"; see also "Editorial Viewpoints: Condemn the Church, Not the Protesters," *Philadelphia Gay News*, Dec. 7-13, 1989 ("The 43 demonstrators who disrupted the mass by Cardinal John O'Connor last Sunday were condemned by the press, politicians and even a prominent New York gay/lesbian movement leader. . . . But we will *not* condemn them.") **("No apologies")**. See, e.g., ACT UP/New York, "Position Statement," Dec. 13, 1989, ACT UP, Series IV: 15/1, NYPL ("As long as the epidemic rages and the Church fights in direct opposition to the policies recommended by responsible doctors, scientists and public health officials, ACT UP will never be silent—not in the streets, not in the capital, and not even in the Church itself"); see also Joel Beneson and Adam Nagourney, "Mass Protesters not Sorry," *Daily News*, Dec. 14, 1989. **(Renewed "Focus")**. See Minutes, Dec. 1989, ACT UP/NY, Series II: 4/7, NYPL. **("the moment in time")**. Kramer, "Toward a Definition of Evil: Further Reports," *Reports from the Holocaust*, 291.

62. **(Evans: 1969)**. Bell, *Dancing the Gay Lib Blues*, 18–25. **(Evans: 1989)**. Allen White, "Small Crowd Turns Out for Candlelight March," *Bay Area Reporter* 19, no. 48 (Nov. 30, 1989), 12. A note on **numbers**: The numbers cited here reflect those reported through December 31, 1989. See Centers for Disease Control, *HIV/AIDS Surveillance Report*, Jan. 1990, 1–22, available at www.cdc.gov/hiv/pdf/library/reports/surveillance/cdc-hiv-surveillance-report-1989-vol-2.pdf. These numbers, however, do *not* represent the actual toll of the epidemic. In addition to underreporting and misdiagnoses, a substantial number of AIDS cases and deaths wouldn't be counted until AIDS activists pressured the U.S. government to revise its limited definition of HIV/AIDS. As Risa Denenberg explained in 1990: "In brief, AIDS is diagnosed in an HIV-positive individual when a predetermined set of unusual (opportunistic) infections or cancers are discovered and can be medically documented or when either a wasting syndrome (large weight loss) or HIV dementia (change in mental alertness) are identified. Since the CDC definition for AIDS was developed from observations of men, women often die of an opportunistic infection before they are even considered eligible for an actual AIDS diagnosis. Women are thus excluded from the total statistical picture. They not only won't get counted, they also won't get treated; they won't qualify for health benefits, child care, rent subsidies, or other support services PWAs and AIDS activists have pressured the government to provide, and they

won't be provided with information on how to take care of themselves and how to protect the people with whom they are having sex or sharing needles. Statistics, in other words, only count women who already fit into the CDC's narrow definition for AIDS; all the other women just remain invisible. Many women (and of course there are no statistics for this) are diagnosed with HIV infection only after they have died." Risa Denenberg, "What the Numbers Mean," in *Women, AIDS, and Activism*, ACT UP/New York Women and AIDS Book Group (Boston: South End Press, 1990), 2–3. As reported in 1995, the adjusted numbers for the period through December 31, 1989 were 146,977 cases and 88,707 deaths. See Centers for Disease Control and Prevention, *HIV/AIDS Surveillance Report* 7, no. 2, 1995, available at www.cdc.gov/hiv/pdf/library/reports/surveillance/cdc-hiv-surveillance-report-1995-vol-7-2.pdf.

63. **("Stop G.O.P. Death Squads")**. See *OutWeek* 36 (Mar. 4, 1990), 20. **("Talk is cheap")**. See Cliff O'Neill, "NGLTF Chief Heckles Bush at AIDS Speech," *OutWeek* 41 (Apr. 11, 1990), 14. **(Chicago & Marlboro)**. See Rex Wockner, "National AIDS Activists Clog Chicago Loop; 129 Arrested," *OutWeek* 45 (May 9, 1990), 14; James Waller, "Marlboro-Helms Connection Prompts Boycott," *OutWeek* 44 (May 2, 1990), 24. **(Sixth International Conference)**. See Wockner, "AIDS Activists Seize Center Stage at World AIDS," *OutWeek* 53 (July 4, 1990), 20, 86; Nina Reyes, "Gay Activists Blast Border Laws on Eve of SF AIDS Confab," *OutWeek* 53, 24; Wockner, "ACT UP Outshines Scientists Again at SF AIDS Confab," *OutWeek* 54 (July 11, 1990), 22–24.

64. **(Day of Desperation)**. See Nina Reyes, "ACT UP Storms Network TV, Seizes Grand Central Station; 313 Jailed," *OutWeek* 84 (Feb. 8, 1991); John Weir, "We're Here, We're Queer, We Take Credit Cards!" *OutWeek* 87 (Feb. 27, 1991), 40. **(Kennebunkport)**. See Andrew Rosenthal, "Bush Plays Down Protest on AIDS," *New York Times*, Sept. 3, 1991, A20. **(Treatment Action Guerrillas)**. The Helms action, according to Peter Staley, was supposed to put Treatment Action Guerrillas (later, Treatment Action Group), an organization separate and distinct from ACT UP, "on the map." See "Putting TAG on the Map," interview with Peter Staley, Apr. 2002, Treatment Action Group, available at www.treatmentactiongroup.org/tagline/2002/april/flying-coop; see also France, *How to Survive a Plague*, 445–47.

65. **(internal debates)**. See Pepper, "Schism Slices ACT UP in Two," 12–13; Rex Wockner, "Trouble in Chicago, Too," *OutWeek* 67, 14; Carrie Wofford, "Portland's ACT UP Dissolves," *OutWeek* 89 (Mar. 13, 1991), 21. **(Portland)**. Wofford, "Portland's ACT UP Dissolves," 21. **(Chicago)**. Wockner, "Trouble in Chicago, Too," 14. **("inside/outside")**. See Mark Harrington, "A Fifth Anniversary Letter to ACT UP," Mar. 9, 1992, ACT UP/NY, Series V: 22/7, NYPL; Mark Harrington, ACT UP Oral History Project, 55–56. **("fire and brimstone")**. Cliff O'Neill, "Demonstrators Rain Fire and Brimstone on NIH Headquarters; Action Provokes More Than 80 Arrests," *OutWeek* 49 (June 6, 1990), 14. **("true reform")**. France, *How to Survive a Plague*, 414. **(Women with AIDS)**. See France, *How to Survive a Plague*, 435–36 (noting, for example, in major cities, AIDS was the leading cause of death for women ages fifteen to forty-four).

66. **("movement parasites")**. Harrington, "A Fifth Anniversary Letter to ACT UP"; see also Harrington, ACT UP Oral History Project, 63-64; Wolfe, ACT UP Oral History Project, 81-102. **("number-one fight")**. Nina Reyes, "QUEERLY SPEAKING," *OutWeek* 59 (Aug. 15, 1990), 42.

67. **("I Hate Straights")**. *Queers Read This*, published anonymously by queers, 1990, available at www.qzap.org/v8/index.php/57-queers-read-this (reprint 2009). Much, if not all, of the text of "I Hate Straights" was written by David Robinson and Avram Finkelstein; "the broadsheet itself, including "graphic intervention" of the title placed over the text, was designed by various members of anonymous queers, including Finkelstein and Vincent. See Reyes, "QUEERLY SPEAKING"; see also Avram Finkelstein, *After Silence: A History of AIDS Through Its Images* (Oakland: Univ. of California Press, 2018), 161–62 (discussing the relationship between anonymous queers and Queer Nation). **("an alive and functioning queer")**. *Queers Read This*. **("standing up and fighting back")**. Gerri Wells, quoted in Erin J. Rand, *Reclaiming Queer: Activist & Academic Rhetorics of Resistance* (Tuscaloosa: Univ. of Alabama Press, 2014), 3. **("the second epidemic" & "mind-numbing speed")**. See John Voelcker, "The Second Epidemic," *OutWeek* 54, 48. In the first five months of 1990, reported cases of anti-queer violence in New York City rose 122% compared to the same period in 1989. **(wasn't just New York)**. Voelcker, "It Can Happen Anywhere II," *OutWeek* 21, 28. **(Queer bashing everywhere; lesbians, transgender people, Studds, Julio Rivera)**. Duncan Osborne,

"Anti-Gay Violence at Record Level," *OutWeek* 47 (May 23, 1990), 25; Voelcker, "Unrelenting Gay-Bashing Spate Continues; Transvestite Murdered, Two Men Beaten," *OutWeek* 50 (June 13, 1990), 14; Voelcker, "Surge in Gay-Bashing May Swamp Victim Advocates; Bias Crimes up 122 Percent," *OutWeek* 50, 16–17; Barbara Seyda, "Violence, Silence and Lesbians," *OutWeek* 50, 36–37; Voelcker, "Lesbians Bashed in Queens," *OutWeek* 52 (June 27, 1990), 16; Cliff O'Neill, "Studds Attacked in Dupont Circle," *OutWeek* 52, 36–37; Victoria A. Brownworth, "Anti-Lesbian [sic] Murders in Philly Coincide with Bias-Bill Defeat," *OutWeek* 55 (July 18, 1990); Voelcker, "Gay Man Beaten to Death in Queens; Three Men Sought in Hammer Slaying," *OutWeek* 56 (July 25, 1990), 12. (**Specific crimes in specific cities**). See generally Voelcker, "The Second Epidemic"; Cliff O'Neill, "National Antigay Violence Stats Are Grim," *OutWeek* 52, 18; Rex Wockner, "FBI Nabs Would-Be Aryan Bar Bombers," *OutWeek* 48 (May 30, 1990), 15.

68. (**"Do whatever you need"**). *Queers Read This*. (**"felt constrained"**). Rand, *Reclaiming Queer*, 2. (**"BASH BACK"**). Andrew Miller and Duncan Osborne, "Bombing at Gay Bar Raises Community Ire," *OutWeek* 46 (May 16, 1990), 12–13.

69. (**"regardless of how"**). Reyes, "QUEERLY SPEAKING," 42. (**"brave, strong queers"**). "I Hate Straights," *Queers Read This*. (**David Robinson & Avram Finkelstein**). See Reyes, "QUEERLY SPEAKING" ("'For the record, I wrote about half of 'I Hate Straights.' I agreed to let it be used anonymously not from fear . . . but because I wanted to follow the example of other anonymous collectives—like the Silence=Death Project, like early lesbian and gay liberation groups—where the focus was not on the individual personalities who copyrighted and owned their works, but instead solely on the works themselves. What was important to me was that the piece and the broadsheet were written by queers to queers.'—David Robinson, gay AIDS activist, in an open letter to ACT UP"); see also Finkelstein, *After Silence*, 161–62. (**"raw nerve"**). Reyes, "QUEERLY SPEAKING," 42. (**Andrade & McVey**). Omar Andrade and Robert McVey, "The Truth of Queer Lives," *OutWeek* 56, 7–8. (**Queer Nation**). See, e.g., "Queer Nation Goes National," *OutWeek* 58 (Aug. 8, 1990), 22–23.

70. (**Bob Rafsky & Bill Clinton**). See Minutes, Mar. 1992, ACT UP/NY, Series II: 5/8, NYPL; Robin Toner, "AIDS Protester Provokes Clinton's Anger," *New York Times*, Mar. 27, 1992, A21; "Verbatim: Heckler Stirs Clinton Anger: Excerpts from the Exchange," *New York Times*, Mar. 28, 1992, 9; Robert Rafsky, "An Open Letter to Bill Clinton," *QW* 53 (Nov. 8, 1992), 21–22. (**Dying of neglect**). See, e.g., Vito Russo, "Why We Fight," Albany, NY, May 9, 1988; Washington, D.C., Oct. 10, 1988, available at www.actupny.org/documents/whfight.html. (**Marty Robinson & ACT UP**). Marty Robinson, according to Mark Harrington, "taught us about using the media, because he was from the 70s. . . . He did the duck zap, in the early 1970s, where somebody who was running for governor said, if it walks like a duck and talks like a duck, it's a duck. And it was some kind of anti-gay thing. So, he dressed up like a duck and went to that candidate's office. Anyway—so, he's like, you have to use the press." Harrington, ACT UP Oral History Project, 32. Whether Harrington was told an incorrect story, personally conflated the Fidelifacts zap with Robinson's famous zaps of New York governor Nelson Rockefeller, or simply misremembered is unclear. Either way, an exceedingly influential activist (Harrington) was directly influenced by activists of the past, but a lack of familiarity with history resulted in the perpetuation of inaccurate stories. At the very least, Robinson is remembered as an influential member of the seminal Gay Liberation groups; his role in the creation of ACT UP, however, is often forgotten. If it hadn't been for the Lavender Hill Mob, which Robinson helped build using the tactics he'd developed in GAA (tactics that, in turn, emerged from Women's Liberation groups), it's not at all clear that ACT UP would have existed (and it almost certainly wouldn't have existed as we know it). On April 1, 1990, during a meeting of the group's coordinating committee, Robinson asked that ACT UP/NY's "documentation of our history be more accurate." Printed material, he pointed out, "omitted reference to Lavender Hill Mob," and, he emphasized, "ACT UP was founded by a group, not one person." Marty Robinson helped lead queer people out of darkness twice; he deserves more than what he's gotten from historians, and we owe it to him and ourselves to learn more of his story. Minutes, Coordinating Committee, Apr. 1, 1990, in Published and near Print Material, Media, Mar. 13–Apr. 30, 1990, ACT UP/NY, Series X: 138/1, NYPL. (**Marty Robinson's death**). Bruce Lambert, "Martin Robinson, 49, Organizer of Demonstrations for Gay Rights," *New York Times*, Mar. 24, 1992, D22. (**Russo, Alderson**). See Stephen

Holden, "Vito Russo, 44; A Historian of Film and a Gay Advocate," *New York Times*, Nov. 9, 1990, B7; Larry Kramer, "Who Killed Vito Russo?" (transcript of Kramer's eulogy of Russo), *OutWeek* 86 (Feb. 20, 1991), 26–27; Machon, "Milestones: Ortez Alderson," 34. (**"supreme act of the imagination"**). Rafsky, "An Open Letter to Bill Clinton," 21–22. (**Bob Rafsky's death**). Marvine Howe, "Robert Rafsky, 47, Media Coordinator for AIDS Protesters," *New York Times*, Feb. 23, 1993, B7.

71. (**Marsha's good-bye**). See Kasino, "Pay It No Mind: The Life and Times of Marsha P. Johnson."

72. (**David Robinson**). Gould, *Moving Politics*, 229–32; David Mager, "Funeral at the White House," *PWA Coalition Newsline* 83, Dec. 1992, 19–21 (Mager referred to Robinson's lover as "Warren Pierce," presumably due to either a typo or misunderstanding; born Warren Krause, he was also known as Warren *Piece*), 19; Minutes, Sept. 1992, ACT UP/NY, Series II: 5/14, NYPL. (**This is Ortez**). Gould, *Moving Politics*, 8. (**Ashes Action**). See Charles Babington, "AIDS Activists Throw Ashes at White House," *Washington Post*, Oct. 12, 1992; Simon Watney, "Political Funeral," *Village Voice*, Oct. 20, 1992, 18; Warren Johansson, "The Quilt and the Ashes," *In* (Boston) 2, no. 9 (Nov. 2, 1992), 4; Mager, "Funeral at the White House," 19–21 (David Mager carried the ashes of Michael Vernaglia, whose family was unable to attend the action and left Michael's remains in David Robinson's care; Mager fulfilled the family's wish of having Michael's ashes scattered on the White House lawn); James Wentzy, *Political Funerals*, 1995, video, AIDS Community Television; David Robinson, interview by Sarah Schulman, ACT UP Oral History Project, July 16, 2007, 58–64; Alexis Danzig, interview by Sarah Schulman, ACT UP Oral History Project, May 1, 2010, 39–42. (**Quilt 1992**). Howard Schneider, "15 Acres of Anguish and Healing," *Washington Post*, Oct. 11, 1992, A1, A26–27. Because mourners could bring panels in person, organizers expected the Quilt to grow from approximately 20,000 panels to approximately 26,000 panels by the end of the October 1992 display. (**"a cross-section of America"**). Johansson, "The Quilt and the Ashes," 4. (**"best friends" & "they haven't been doing enough"**). Fern Shen and Michele L. Norris, "Youngsters Learn of Life and Death from Patches on a Quilt," *Washington Post*, Oct. 12, 1992, C1, C7. (**"Each individual AIDS death"**). Watney, "Political Funeral," 18. (**"Out of every corner of my eye"**). Jon Henri-Damski in Gould, *Moving Politics*, 7. (**"an unparalled tragedy"**). Watney, "Political Funeral," 18.

73. (**"the Quilt come to life"**). Avram Finkelstein, "The Other Quilt," *QW*, Oct. 25, 1992, 25; see also Mager, "Funeral at the White House," 19–21.

74. (**Measure 9, Amendment 2, legal battle**). See "National Gay and Lesbian Task Force Backs Boycott: Report Shows Shocking Increase in Anti-Gay Violence in Colorado," *Stonewall News* 19, Jan. 4, 1993, 1; see also *Romer v. Evans*, 517 U.S. 620 (1996). (**Mock & Cohens**). See "Oregonians Oppose Anti-Gay Legislation," *Stonewall News* 19, 2; Keith Clark, "Fears of Anti-Gay Violence Come True in Oregon Campaign," *Bravo! Newsmagazine*, Oct. 8, 1992, 7; "Hate Crimes: Murder in Salem," *Womyn's Press*, no. 6 (Nov./Dec. 1992); Sarah Schulman, "Lesbian Avengers: Marlene Colburn Interviewed," *Radical Chick* 3 (Nov.–Dec. 1992), 10–11.

75. (**eating fire**). See Kelly Cogswell, *Eating Fire: My Life as a Lesbian Avenger* (Minneapolis: Univ. of Minnesota Press, 2014), chap. 4 (providing context and background of eating fire, the Avengers' "circus trick transformed into a sacrament"). (**My ultimate dream**). Marlene Colburn in Schulman, "Lesbian Avengers: Marlene Colburn Interviewed," 10–11.

76. (**"hijacked"**). Harrington, ACT UP Oral History Project, 68. (**Don't Ask, Don't Tell**). See, e.g., Thomas L. Friedman, "President Admits Revised Policy Isn't Perfect," *New York Times*, July 20, 1993, 1, 16. (**"hook, line, and sinker"**). Kramer in Cathy Seabaugh, "President Clinton Hosts Historic Meeting with Gays and Lesbians," *Outlines*, May 1993, 13. (**"antidiscrimination"**). Marshall Kirk and Hunter Madsen, *After the Ball: How America Will Conquer Its Fear and Hatred of Gays in the 90s* (New York: Plume Books, 1990), 187. (**shock tactics**). Kirk and Madsen, *After the Ball*, 114.

77. (**"our national movement"**). Lani Ka'ahumanu, "It's Official! The 1993 March on Washington For Lesbian, Gay and Bi (*yes!*) Equal Rights And Liberation," *Anything That Moves*, no. 4 (1992). (**"bogeyman of the late 1980s"**). Jon Nordheimer, "AIDS Specter for Women: The Bisexual Man," *New York Times*, Apr. 3, 1987, A1. (**Bi inclusion**). Ka'ahumanu, "It's Official!" (**"assimilation is a lie"**). Lani Ka'ahumanu, Address to the 1993 March on Washington for Lesbian, Gay, and Bi Equal Rights and Liberation, "How I Spent My Two Week Vacation Being a Token Bisexual." (**"newly-emergent transgender movement"**). Davina

Anne Gabriel, "'We're Queer Too!': Trans Community Demands Inclusion," *TransSisters* 1, 16.

78. (Dyke March). See "Dyke March History," Lesbian Herstory Archives: Dyke Marches, part 2, folder no. 04440.

79. (Callen at the March). See "Michael Callen—Love Don't Need A Reason—1993 March on Washington," video, uploaded by D. Prasad, available at www.youtube.com/watch?v=_wlwCTqFeUk; David W. Dunlap, "Michael Callen, Singer and Expert on Coping With AIDS, Dies at 38," *New York Times*, Dec. 29, 1993.

80. ("an integral part of the oppressed"). Feinberg, "Building Bridges," *TransSisters* 1, 11–12; see also Davina Anne Gabriel, "The Life and Times of a Gender Outlaw," *TransSisters* 1, 4–10.

81. (Yvonne Ritter at Stonewall). See Carter, *Stonewall*, 129–30, 138–40, 149–50 (in Carter's *Stonewall*, Yvonne Ritter was still referred to either as "Steve," her dead name, or Maria, the name she preferred before identifying as Yvonne); Betsy Kuhn, *Gay Power! The Stonewall Riots and the Gay Rights Movement, 1969* (Minneapolis, MN: Twenty-First Century Books, 2011), 73 (for information on Ritter's first name); Transcript, Kate Davis and David Heilbroner, *American Experience: Stonewall Uprising* (PBS: 2011), available at www.pbs.org/wgbh/americanexperience/films/stonewall. ("I wasn't a second-class citizen then"). Yvonne Ritter, "An open letter to the Queer Community from a Transsexual Woman and Stonewall Survivor," Mar. 1994, NGLTF Records, Series I: 20/18, Cornell Univ. Libraries. (Stonewall 25's exclusionary decision). See Phyllis R. Frye, "A Transgender Call to Protest 'Stonewall 25' In New York[;] Organizers Continue to Refuse to Inclusify the Title," Mar. 5, 1994, NGLTF Records, Series I: 20/17, Cornell Univ. Libraries ("To the Stonewall 25 organizing committee: either inclusify the TITLE of this event and we will march with you, or continue to exclude us from the TITLE and we will march against you. To exclude the transgendered from title of THIS event is absurd"); but see "ICTLEP Calls Off Planned Disruption of Stonewall 25," *TransSisters* 6, 11 ("In a last minute surprise move, the International Conference on Transgender Law and Employment Policy (ICTLEP) . . . canceled its previous threat to conduct civil disobedience disrupting the International March on the United Nations to Affirm the Human Rights of Lesbian and Gay People. . . . ICTLEP Executive Director Phyllis Randolph Frye . . . cited 'the movement towards inclusion by the Stonewall 25 events' . . ."); Jessica Meredith Xavier, "Stonewall 25 Revisited: Queer Politics, Process Queens and Lessons Learned," *TransSisters* 6, 14–16, 19; Mustang Sally (Beth Elliott), "Suddenly Last Stonewall," *TransSisters* 6, 17–19; Riki Wilchins, *Trans/gressive: How Transgender Activists Took on Gay Rights, Feminism, the Media & Congress . . . and Won!* (New York: Riverdale Avenue Books, 2017), 78–80.

82. ("that's how it happened"). Hillary Smith, "'My Summer Vacation in Michigan' or, 'How the Lesbian Avengers brought Trans Women onto the Land," *Lesbian Avenger Communique*, Fall 1994, 3–4; Davina Anne Gabriel, "Mission to Michigan III: Barbarians at the Gates," *TransSisters* 7, Winter 1995, 22–23; Edward [last name unknown], "Ed's report from Camp Trans," Aug. 1994, Lesbian Herstory Archives, part 6, folder no. 14780. ("the heat of struggle"). Leslie Feinberg, "Excerpts from 'Sisterhood: Make It Real!'" *TransSisters* 7, 26.

Conclusion: Until Next Time, 1994-2017

1. ("marginal and mainstream"). Urvashi Vaid, *Virtual Equality: The Mainstreaming of Gay and Lesbian Liberation* (New York: Anchor Books, 1995), 4. ("on many sides"). See generally Maggie Astor, Christina Caron, and Daniel Victor, "A Guide to the Charlottesville Aftermath," *New York Times*, Aug. 13, 2017, available at www.nytimes.com/2017/08/13/us/charlottesville-virginia-overview.html. ("something that seems to be growing"). Gibbs and Bennett, "New Yorkers Protest at Village Church," 3. (obligation to commit sodomy). See Sue Hyde in Cliff O'Neill, "Kiss-In Marks Hardwick Anniversary," *OutWeek* 4 (July 17, 1989), 22. (the D.C. couple). The authors were among the queer masses in Provincetown, and we'd gone to the solidarity event not knowing it was going to be (a) so reserved an atmosphere, or (b) attended by queer icons. We add ourselves into the narrative with great caution and a bit of embarrassment; we were unable to find other primary sources about the Provincetown march, however, and we thus felt it necessary to explain our firsthand knowledge.

2. ("the movement continues"). Urvashi Vaid, "The Status Quo of the Status Queer," *Gay Community News* 20, nos. 1, 2 (June 1994), 17. (Vaid post-NGLTF). See Carrie Wofford, "Power Lesbian to Head Home," *Gay Community News* 19, nos. 41, 42 (May 22–June 4, 1992), 3; see also Vaid, *Virtual Equality*.

3. (Moore & Goodwin). See generally Z. A. Martohardjono, *Changing House* (Frameline Pictures: 2009), available at www.youtube.com/watch?v=cAdc-D8iZtI; Deborah Rudacille, *The Riddle of Gender: Science, Activism, and Transgender Rights* (New York: Pantheon Books, 2005), 147–49; Rusty Mae Moore, PhD, "Satan and Lady Babalon: Polyamory Again at 64," in Tracie O'Keefe & Katrina Fox, eds., *Trans People in Love* (New York: Routledge, 2008), 153–55. (Sally's). See generally "Sally's Hideaway: A History," available at www.sallys-hideaway.com/A_History.html; see also Chelsea Goodwin and Dr. Rusty Mae Moore, interview by Nadia Awad, New York City Trans Oral History Project, May 4, 2017, available at s3.amazonaws.com/oral-history/transcripts/NYC+TOHP+Transcript+006+Chelsea+Goodwin+and+Rusty+Mae+Moore.pdf. (Goodwin & Otter). Goodwin and Moore, New York City Trans Oral History Project; Martohardjono, *Changing House*; see also Kathryn Otter, "Crossing the Gender Line," *OutWeek* 45, 24; Nina Reyes, "Trial of St. Patrick's Protesters Underway at Last," *OutWeek* 72 (Nov. 14, 1990), 18. (Sylvia on the Pier). See generally Bebe Scarpinato and Rusty Moore, "Transitions: Sylvia Rivera," *Transgender Tapestry* 98 (Summer 2002), 34–39. ("It was sort of unique"). Rudacille, *Riddle of Gender*, 148.

4. ("Love Hurts"). Donna Minkowitz, "Love Hurts," *Village Voice*, Apr. 19, 1994, 24; see also Minkowitz, "How I Broke, and Botched, the Brandon Teena Story," *Village Voice* (online), June 20, 2018, available at www.villagevoice.com/2018/06/20/how-i-broke-and-botched-the-brandon-teena-story; but see Han Koehle, "How Donna Minkowitz Nailed, and Botched, Her Apology," *Medium*, June 22, 2018, available at medium.com/@johannkoehle/how-donna-minkowitz-nailed-and-botched-her-apology-1073feb1a711. (Botching the story). Minkowitz, "How I Broke, and Botched, the Brandon Teena Story." In preparing her 1994 piece, Minkowitz spoke with Leslie Feinberg, who told her, "It's not so much how I see Brandon Teena, as how Brandon Teena saw himself. I use the pronoun 'he' because a), it's the pronoun Brandon Teena chose, but b), it's ultimately what he died for." Minkowitz ignored Feinberg and misgendered Brandon in the *Voice* story, something for which she apologized years later. (Feinberg). See Workers World, "Transgendered Picket Village Voice," *NY Transfer News Service*, May 4, 1994, available at www.qrd.org/qrd/media/print/1994/transgendered.picket.village.voice-05.04.94.

5. (Falls City). See Nancy R. Nangeroni, "Trans-Actions," *Transgender Tapestry* 74 (Winter 1995), 53; Wilchins, *Trans/gressive*, 55–60. ("small sense of empowerment"). Wilchins, *Trans/gressive*, 60. (Deborah Forte). See Nangeroni, "Trans-Actions," 53; "Vigil Held as Forte Murderer Pleads Guilty," *Anything That Moves*, no. 12 (Fall 1996), 63; Wilchins, *Trans/gressive*, 60.

6. (Christian Coalition). See Richard L. Berke, "Politicians Woo Christian Group," *New York Times*, Sept. 9, 1995, A1; see also Chris Bull and John Gallagher, *Perfect Enemies: The Religious Right, The Gay Movement, and the Politics of the 1990s* (New York: Crown Publishers, 1996). ("call them on it"). Vaid, "The Status Quo of the Status Queer," 17. (HRCF's approach). "Elizabeth Birch Calls for New Ethic of Respect and Decency," *The Slant* 6, no. 9 (Oct. 1995), 12.

7. (Karen Kerin). Karen Kerin was an interesting figure about whom not a lot has been written. According to her 2014 obituary, though, she was a frequent candidate for political office in Vermont, and she ran as an outspoken fiscal conservative (a libertarian, she said, though she did run as a Republican). See "Frequent Vermont Candidate Kerin Dies," *Burlington Free Press*, Feb. 3, 2014, available at www.burlingtonfreepress.com/story/news/2014/02/03/frequent-vermont-candidate-kerin-dies/5192539. (ENDA). Petr Pronsati, "Transgenders Say HRCF, ENDA Discriminate, *Update*, no. 705, A-1, A-5; "National Gender Lobbying Day Takes Off," *In Your Face*, no. 2 (Fall 1995), 1–2.

8. (Chanelle Pickett). See *GenderTalk*, "Another TS [Transsexual] Murder in Boston Area," Nov. 1995, available at www.gendertalk.com/articles/archive/chanelle.shtml; Nancy Nangeroni, "Transgendered Community Shocked by Verdict," *Sojourner* 22, no. 10 (June 1997), 26; Nangeroni, "The Chanelle Pickett Story," unpublished, May 17, 1997, available at gendertalk.com/articles/victims/chanelle-revisit.shtml.

9. ("respectable, productive" job). David Finn in Sears, *Behind the Mask*, 235. ("unity"). Lorde, "Learning from the '60s," *Sister Outsider*, 136.

10. (drug cocktail). Altman, "3-Drug Therapy Shows Promise Against AIDS," *New York Times*, Jan. 30, 1996, C5; Altman, "A New AIDS Drug Yielding Optimism As Well as Caution," *New York Times*, Feb. 2, 1996. (the "lazarus effect"). See, e.g., "The End of AIDS?" *Newsweek*, Dec. 2, 1996. (people of color). David W. Dunlap, "Three Black Members Quit AIDS Organization Board," *New York Times*, Jan. 11, 1996, B2. (There wasn't a plan, "outrageous" cuts, "Don't forget about them"). Carey Goldberg, "Cutting a Lifeline To AIDS Study; 3 Drug-Testing Programs in New York Are Eliminated," *New York Times*, Jan. 30, 1996. We note the New York cuts, though not directly related, came just a week after Bill Clinton's 1996 State of the Union (which itself came just weeks after a government shutdown); in the speech, Clinton famously declared, "the era of big government is over." See "Clinton Offers Challenge to Nation, Declaring 'Era of Big Government Is Over,'" *New York Times*, Jan. 24, 1996, A1. (HIV/AIDS in communities of color). In 2016, according to the *New York Times*, "the Centers for Disease Control and Prevention, using the first comprehensive national estimates of lifetime risk of H.I.V. for several key populations, predicted that if current rates continue, one in two African-American gay and bisexual men will be infected with the virus." That's compared to a one in eleven lifetime risk for white gay and bisexual men. Not surprisingly, the hardest hit areas in the United States are southern states, where an ongoing confluence of racism, homophobia, urban arrogance, voting disenfranchisement, and countless other factors keep at-risk populations from accessing the necessary tools to avoid transmission. See Linda Villarosa, "America's Hidden H.I.V. Epidemic," *New York Times Magazine*, June 6, 2017.

11. (focus next). See "Lesbian, Gay Activists React to ENDA, DOMA Votes," *Sojourner* 22, no. 2 (Oct. 1996), 22 ("Ruthann Robson, writer, lesbian and professor at the City University of New York Law School, said ENDA 'would really change the landscape in important ways. . . . It really needs to be pushed, even though it has got some problems. . . . Those rights would be very equalizing. Marriage rights are equalizing only for some people.'") ("next battleground"). Elizabeth Birch, "Amendment 2 Victory Means No Rest for the Righteous," *Wisconsin Light* 9, no. 13 (June 20–July 3, 1996), 9. ("act of political cowardice"). David Mixner in Todd S. Purdum, "President Would Sign Legislation Striking at Homosexual Marriages," *New York Times*, May 23, 1996, A1. (DOMA/ENDA). Eric Schmitt, "Senators Reject Both Job-Bias Ban and Gay Marriage," *New York Times*, Sept. 11, 1996, A1; Purdum, "Gay Rights Groups Attack Clinton on Midnight Signing," *New York Times*, Sept. 22, 1996, 22. A note on ENDA: The 1996 ENDA vote was surprisingly close, 50 to 49, with Arkansas Democrat David Pryor missing the vote because, according to his office, his adult son was undergoing surgery. Had he been there, Pryor would've voted for ENDA, forcing Vice President Al Gore to break a tie; given that Pryor hailed from Clinton's home state and that history is full of senators heroically getting to the floor for close votes, it seemed clear to some that gay rights truly was little more than a slogan for straight liberals. See, e.g., Bob Roehr, "DOMA Passes," *In Newsweekly* 6, no. 4 (Sept. 22, 1996), 1, 6; Roehr, "Gays Protest DOMA," *In Newsweekly* 6, no. 4, 1, 10; "Lesbian, Gay Activists React to ENDA, DOMA Votes," 22.

12. ("Sylvia Rivera showed up"). Rusty Mae Moore in Martohardjono, *Changing House*. ("most well-known"). Rusty Mae Moore in Rudacille, *Riddle of Gender*, 149. (Sylvia's activism). See, e.g., Sylvia Rivera, "Bitch on Wheels" (June 2001), *Survival, Revolt, and Queer Antagonist Struggle*. ("I Wish I Looked Like Matthew Shepard"). Yoseñio V. Lewis, "I wish I looked like Matthew Shepard," *Anything That Moves* 20 (Summer 1999), 17.

13. ("'til the day i die"). Sylvia Rivera, "Bitch on Wheels" (June 2001), *Survival, Revolt, and Queer Antagonist Struggle*. (Sylvia's good-bye). Scarpinato and Moore, "Transitions: Sylvia Rivera," 34–39.

14. (Barbara's good-bye). See Margalit Fox, "Barbara Gittings, 74, Prominent Gay Rights Activist Since '50s, Dies," *New York Times*, Mar. 15, 2007. "Before Barbara died, we went jointly into an assisted-living facility here," Ms. Lahusen said by telephone. "Our last bit of activism was to come out in the newsletter of our assisted-living facility." (Del's good-bye). See William Grimes, "Del Martin, Lesbian Activist, Dies at 87," *New York Times*, Aug. 27, 2008. (Frank's good-bye). See, e.g., Bill Browning, "US Government apologizes to Frank Kameny," *Bilerico Project*, June 24, 2009, available at bilerico.lgbtqnation.com/2009/06/us_government_apologizes_to_frank_kameny.php. ("this rose is for Sylvia"). Randolfe Wicker, "Trans Monument Memorial Cross," video, Aug. 23, 2017, available at www.youtube.com/watch?v=KbSZYRsmdhk.

About the Authors

Matthew Riemer and **Leighton Brown**, creators of @lgbt_history, live in Washington, D.C., where Leighton is an attorney and Matthew, a former attorney, is a writer and lecturer. They enjoy fighting fascists, spending time with their dog, and disrupting fundamentalists' worldviews. *We Are Everywhere* is the couple's first book.

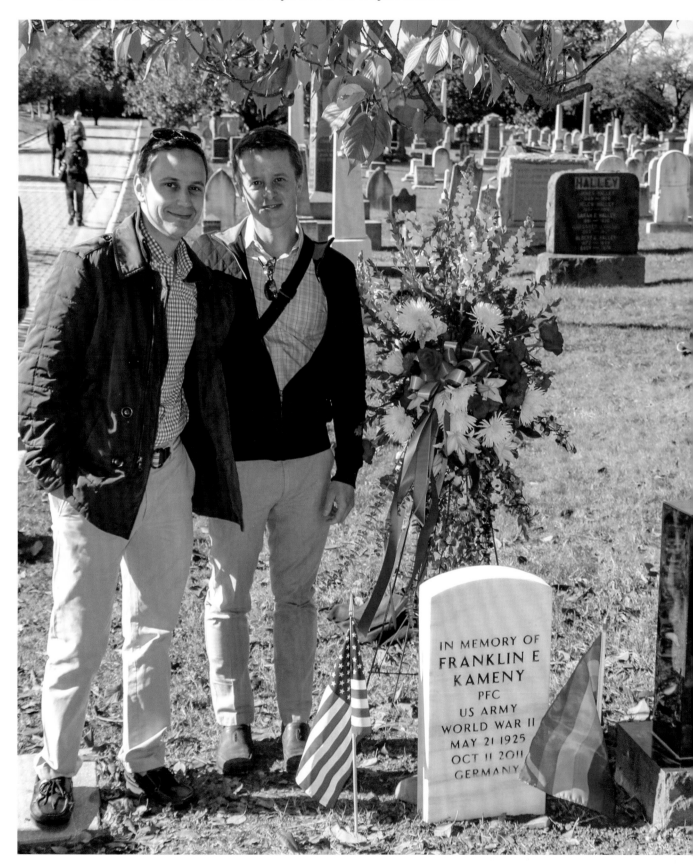

Index

Spitzer, Robert, 167–68
Sprinkle, Annie, 24
Staley, Peter, 257, 269, 276, 280, 283
S.T.A.R. (Street Transvestite Action Revolutionaries), 110, 111, 112, 122, 143, 146, 147, 174, 187, 218, 326
S.T.A.R. House, 147, 312, 319
States Line Company, 114, 116
Stein, Andrew, 218
Stein, Gertrude, 262, 300
Stevens, Konrad "Steve," 68, 70
St. Laurent, Octavia, 312
Stokes, Rick, 174, 175, 186
Stonewall Inn, 114, 116, 177, 205, 308, 312, 320
Stonewall Riots, 15, 113, 114–16, 119, 130, 137, 139, 143, 177, 203, 239, 270–71, 304, 308
Stonewall 25 celebration, 214–15, 307, 308, 312
Stop AIDS Now Or Else (SANOE), 266
Stop the Church, 275–77, 280, 312
St. Patrick's Cathedral, 253, 275, 276, 312
Street Transvestite Action Revolutionaries (S.T.A.R.), 110, 111, 112, 122, 143, 146, 147, 174, 187, 218, 326
Streicher, Rikki, 325
Stryker, Susan, 20, 72, 92, 103
Studds, Gerry, 286
Sullivan, Lou, 254, 282
Sutton, Terry, 266, 269, 274
Swift & Terrible Retribution Committee, 248, 253
Szymansky, Michael, 23

T

TAG (Treatment Action Group), 283
Tangents, 95, 96, 106
Tavern Guild, 95
Tay-Bush Inn, 88
Taylor, Jerry, 185
T&D (Treatment & Data Committee), 269, 274, 283
Teena, Brandon, 314, 315
Thackery, David, 46
Third World Gay Liberation, 259
Third World Gay Revolutionaries, 122
Third World Gay Women's Organization, 185
Third World Lesbian and Gay Conference, 206
Thomas, Kendall, 259
Thompson, Merritt, 82
Thunderhawk, 246
The Tide. See Lesbian Tide
Times Square, 56, 143, 144, 218, 239, 241, 312
Timmons, John, 96, 99
Timmons, Stuart, 82
Toad Hall, 174
Toklas, Alice B., 262, 300
Tommy's on Broadway, 80
Tommy's Place, 23, 80
Tompkins Square Park, 272
Town Meeting I, 189
transgender, use of, 72, 74
Transgender Liberation Movement, 308
transsexual, use of, 72, 74
Transsexual Menace, 215, 308, 309, 314
TransSisters, 214, 304
Transvestia, 89
transvestite, use of, 72, 74
Transy House, 312, 319
Treatment Action Group (TAG), 283
Treatment Action Guerrillas, 283
Treatment & Data Committee (T&D), 269, 274, 283

The Trip, 50
Trump, Donald, 311, 320
Trump Tower, 274
Truscott, Lucian, 115
Turnabout, 89
Turner, Dan, 214, 228, 231, 232, 248
Turner, Laverne, 137
Tylenol scare, 229–30
Tyler, Robin, 160, 203

U

Ubangi Club, 56
Ukrainian-American Village Restaurant, 96
Ulrichs, Karl Heinrich, 51
Uncle Charlie's, 286
Underwood, Julian "Woody," 82
Up Stairs Lounge, 162, 163, 164
USC, 15

V

Vaid, Urvashi, 254, 280, 304, 305, 310, 311–12, 314–15
Valdez, Tony, 86, 87, 160, 162
Valenti, Susanna (Tito), 89–90
Valentino, Rudolph, 58
van Braam, Ger, 90
Vanguard, 103
Van Ooteghem, Gary, 181
Vaughn, Sarah, 102
Vazquez-Pacheco, Robert, 259
Vector, 114, 177, 178
Vera, Veronica, 24
Vice Versa, 63, 65, 80
Vida, Ginny, 165
Vietnam War, 132, 149, 177
Viguerie, Richard, 219, 234
Village Voice, 122, 314
Vinales, Diego "Tito," 125, 137
Virtual Equality, 312
Voeller, Bruce, 165, 171, 181, 183, 228
von Schmetterling, Eric, 305

W

Waddell, Tom, 234, 236, 257, 262, 263
Wahl, John, 252
Waldorf Astoria, 239, 253
Walker, Vaughn, 236
Wallace, Henry, 66
Wanstrom, Rita, 106
Warren, Eddie and Jimmy, 162, 164
Warren, Inez, 162, 164
Washington Square Park (New York), 110–13, 118, 119, 152
Washington State Penitentiary, 118
Watney, Simon, 299
Waxman, Henry, 229
Weathers, Brenda, 175
Webster Hall, 56
Wechsler, Nancy, 168, 170–71
Weiss, Ted, 229
Wellikoff, Rick, 209, 230
Wells, Gerri, 257, 271, 284
Wells, Karen, 150
West Coast Lesbian Conference, 149, 150–51, 152, 160, 215
WHAM! (Women's Health Action and Mobilization), 275, 282
Whitaker, Bailey (a.k.a. Guy Rousseau), 69, 71
White, Dan, 160, 198–99, 203, 205, 244, 245, 246, 277

White, Edmund, 225
White Horse, 127
White House, 63, 91, 92, 140, 183, 221, 257, 259, 262, 274, 296, 297, 300, 304, 307, 323
White Night Riots, 160, 203, 205, 272
Whittington, Gale, 114, 116
Wicker, Randy, 90–91, 92, 96, 99, 107, 111, 215, 280, 296, 319, 320, 323
The Widow Norton. *See* Sarria, José
Wigstock, 272
Wilchins, Riki, 308–9, 314
Wilcox, John J., Jr., 15
Wilde, Lucy, 112
Wilde, Oscar, 51
Wilkinson, Steve, 46
Willer, Shirley, 50, 63, 90, 95, 96, 106, 147
Williams, Cecil, 176
Williams, Stan, 129
Witt, Cliff, 166
Witt, Stan, 68
Wittman, Carl, 110
Wojnarowicz, David, 8, 17, 251, 300
Wolden, Russell, 85
Wolfe, Maxine, 221, 257, 259, 276, 300, 301
Wolfred, Tim, 248
Women's Health Action and Mobilization (WHAM!), 275, 282
Wong, Doreena, 236
World War II, 59, 60, 79–80

X

Xavier, Jessica, 309

Y

Yeager, Henry, 253
YMCA (Young Men's Christian Association), 54
Young, Allen, 172

Z

zaps, 125–27, 239, 252–57, 266–67, 269, 274, 277, 280, 293
Zerilli, Frank, 176
Zusten, Zythyra, 309